THE IDEAL OF PAINTING

THE IDEAL OF PAINTING

Pietro Testa's Düsseldorf Notebook

ELIZABETH CROPPER

PRINCETON UNIVERSITY PRESS : PRINCETON, NEW JERSEY

Copyright ©1984 by Princeton University Press
Published by Princeton University Press, 41 William Street, Princeton, New Jersey 08540
In the United Kingdom: Princeton University Press, Guildford, Surrey

All Rights Reserved
Library of Congress Cataloging in Publication Data will be found on the last printed page of this book
ISBN 0-691-04021-4

This book has been composed in Linotron Caledonia type

Clothbound editions of Princeton University Press books are printed on acid-free paper, and binding
materials are chosen for strength and durability. Paperbacks, although satisfactory for personal
collections, are not usually suitable for library rebinding

Printed in the United States of America by Princeton University Press, Princeton, New Jersey

For John Theodore Ingham Cropper
and Helena Isabel Cropper

Porto per esempio d'una stravagante fortuna,
e di un nobil genio, Pietro Testa.
—*G. B. Passeri*

Contents

List of Illustrations xi

Preface xvii

List of Abbreviations xix

Introduction 3

PART ONE

1. A Lucchese Artist in Rome 11
2. Bound Theory and Blind Practice: *Il Liceo della Pittura* 65
3. The Garden of Letters 96
4. Pietro Testa and Roman Classicism 147

PART TWO

Pietro Testa's Notebook in the Kunstmuseum, Düsseldorf 179

Note to the Reader 187

Editorial Symbols 188

Transcription of the Düsseldorf Notebook and Commentary 189

Appendix One. Sources Cited by Testa in the Düsseldorf Notebook 273

Appendix Two. Mounting, Size, and Numbering of Folios 274

Bibliography 275

Index 283

Illustrations 289

List of Illustrations

UNLESS otherwise indicated below, photographs have been supplied by the owners of the works. All works are by Pietro Testa, except where indicated. Figures I-XXXV appearing in the text of Part Two reproduce folios from Pietro Testa's Notebook, Kunstmuseum, Düsseldorf (including all those with drawings); photos are from Landesbildstelle Rheinland.

1. *Elephant*, Bellini 41. Photo: Gabinetto Fotografico Nazionale.

2. *The Martyrdom of St. Erasmus*, Bartsch 14; Bellini 7. Photo: Gabinetto Fotografico Nazionale.

3. *Saints Interceding with the Virgin on Behalf of the Victims of the Plague*, Bartsch 13; Bellini 8. Photo: Gabinetto Fotografico Nazionale.

4. Study for the fresco of Liberty, Ashmolean Museum, Oxford, Inv. no. 959; 304 x 218 mm., pen and brown ink with black chalk.

5. Study of Justice, Cabinet des Dessins, Musée du Louvre, Paris, Inv. no. 907; 201 x 141 mm., pen and brown ink. Photo: Cliché Musées Nationaux.

6. *Allegory in Honor of the Arrival of Cardinal Franciotti as Bishop of Lucca*, Bartsch 30, Bellini, 14. Collection of A. Percy.

7. Collage of studies for *Allegory in Honor of the Arrival of Cardinal Franciotti as Bishop of Lucca*, Staatliche Kunstsammlungen im Schlossmuseum, Weimar, DDR, Inv. no. KK3069; 284 x 212 mm., pen and brown ink.

8. Study of *The Triumph of Honest Pleasure*, Ashmolean Museum, Oxford, Inv. no. 958; 275 x 194 mm., pen and brown ink.

9. Study of *Venus Submitting to the River Serchio*. Cabinet des Dessins, Musée du Louvre, Paris, Inv. no. 1910; 200 x 290 mm., pen and brown ink. Photo: Cliché Musées Nationaux.

10. Study of *Venus Submitting to the River Serchio*, British Museum, London, Inv. no. 1943-7-10-15; 183 x 278 mm., pen and brown ink.

11. Study of *Venus Submitting to the River Serchio*, Nationalmuseum, Stockholm, Inv. no. 535/1863; 373 x 304 mm., pen and brown ink.

12. *The Vision of St. Dominic of Soriano*, S. Romano, Lucca; 3.60 x 2.10 m. Photo: Ghilardi.

13. *Allegory of Painting*, Bartsch 29, Bellini 15.

14. Figure Studies, Teylers Stichting, Haarlem, Inv. no. N15; 247 x 359 mm., pen and brown ink.

15. Study for the *Allegory of Painting*, British Museum, London, P.p. 5-95; 270 x 346 mm., pen and brown ink over black chalk, with some red chalk.

16. *St. Jerome in the Wilderness*, Bartsch 15, Bellini 9.

17. Study for *St. Jerome in the Wilderness*, Cabinet des Dessins, Musée du Louvre, Paris, Inv. no. 1887; 282 x 208 mm., pen and brown ink with touches of white lead (probably added later). Photo: Cliché Musées Nationaux.

18. *The Garden of Love* (horizontal version), Bartsch 27, Bellini 4, The Metropolitan Museum of Art, New York, 59.597.6, Whittelsey Fund, 1959.

19. *The Garden of Love* (vertical version), Bartsch 28, Bellini 11.

20. *The Garden of Venus*, Bartsch 26, Bellini 12. Photo: Gabinetto Fotografico Nazionale.

21. Study for *The Garden of Venus*, Gabinetto dei Disegni, Gallerie degli Uffizi, Florence, Inv. no. 1716 Esp.; 350 x 435 mm., pen and brown ink with some wash; inscribed "visto" (?) bottom left, with other scribbles in black chalk. Photo: Soprintendenza alle Gallerie, Florence.

22. *Venus and Adonis*, Bartsch 25, Bellini 13. The Metropolitan Museum of Art, New York, 51.501.4248, Whittelsey Fund, 1951.

23. Study for *Venus and Adonis*, Gabinetto dei Disegni, Gallerie degli Uffizi, Florence, Inv. no. 1717 Esp.; 335 x 460 mm., pen and brown ink with some wash. Photo: Soprintendenza alle Gallerie, Florence.

24. Fragment of a study for *Venus and Adonis*, Gabinetto dei Disegni, Gallerie degli Uffizi, Florence, Inv. no. 776F; 196 x 225 mm., cut from top right to bottom left and laid down, pen and brown ink. Photo: Soprintendenza alle Gallerie, Florence.

25. Artist's proof of a section of *The Garden of Venus*, The Metropolitan Museum of Art, New York, 67.745, Gift of Raymond E. Lewis, 1967.

26. *Allegory of the Flight into Egypt*, Bartsch 4, Bellini 10. Photo: Gabinetto Fotografico Nazionale.

27. *Venus and Adonis*, Gemäldegalerie der Akademie der bildenden Künste, Vienna, Inv. no. 215; 0.98 x 1.33 m., oil on canvas.

28. *The Massacre of the Innocents*, Galleria Spada, Rome, Inv. no. 226; 1.74 x 2.35 m., oil on canvas. Photo: Gabinetto Fotografico Nazionale.

29. *The Adoration of the Shepherds*, National Gallery of Scotland, Edinburgh, Inv. no. 2325; 0.88 x 1.25 m., oil on canvas.

30. Study for *Allegory of Carnival and Lent*, collection of Henry, Prince of Hesse, Rome; 160 x 445 mm., pen and brown ink over black chalk.

31. Nicolas Sale (?), relief of *Allegory of Carnival and Lent*, Raimondi Chapel, S. Pietro in Montorio, Rome. Photo: Gabinetto Fotografico Nazionale.

32. Study of *Allegory of Penance and Death*, The Metropolitan Museum of Art, New York, 1973.117, Rogers Fund, 1973; 136 x 357 mm., pen and brown ink, over a little black chalk.

33. Study for *The Adoration of the Shepherds*, Ashmolean Museum, Oxford, Inv. no. 957; 161 x 383 mm., pen and ink with some black chalk.

34. *The Presentation of the Virgin*, The Hermitage, Leningrad.

35. Letter and Study of *The Consecration of a Church*, collection of Loriano Bertini, Calenzano; 275 x 410 mm. (folded vertically in the center), pen and dark brown ink over traces of black chalk.

36. Study of *The Confiscation of Spoils by the Church*, collection of Loriano Bertini, Calenzano; glued to the reverse of the left half of Fig. 35, pen and brown ink over traces of black chalk.

37. Study for *The Presentation of the Virgin*, The Metropolitan Museum of Art, New York, 1971.241, Rogers Fund, 1971; (verso) 367 x 262 mm., pen and brown ink.

38. Study for *The Apotheosis of St. Lambert*, Royal Library, Windsor Castle, Inv. no. 5933; 186 x 229 mm., pen and brown ink with wash. Reproduced through the gracious permission of Her Majesty Queen Elizabeth II.

39. Study for *The Apotheosis of St. Lambert*, Cabinet des Dessins, Musée du Louvre, Paris, Inv. no. 1885; 224 x 395 mm., pen and brown ink with brown wash over black chalk. Photo: Cliché Musées Nationaux.

40. Study of *Fame Conquering Time and Envy*, Cabinet des Dessins, Musée du Louvre, Paris, Inv. no. 1909; 240 x 170 mm., pen and brown ink over black chalk. Photo: Cliché Musées Nationaux.

41. *The Adoration of the Magi*, Bartsch 3, Bellini 16. Photo: Gabinetto Fotografico Nazionale.

42. *The Sacrifice of Iphigenia*, Bartsch 23, Bellini 18. Photo: Gabinetto Fotografico Nazionale.

43. Study for *The Sacrifice of Iphigenia*, Fogg Art Museum, Harvard University, Cambridge. Gift of Meta and Paul J. Sachs, 1948.26; 185 x 239 mm., red chalk.

44. Study for *The Sacrifice of Iphigenia*, Gabinetto dei Disegni, Gallerie degli Uffizi, Florence, Inv. no. 777F; 170 x 139 mm., pen and brown ink with traces of black chalk. Photo: Soprintendenza alle Gallerie, Florence.

45. Study for *The Sacrifice of Iphigenia*, The Victoria and Albert Museum, London, Inv. no. E. 3231-1934; 374.5 x 409.5 mm., pen and ink with some black chalk.

46. *The Death of Sinorix*, Bartsch 19, Bellini 19. Photo: Gabinetto Fotografico Nazionale.

47. Study for *The Death of Sinorix*, British Museum, London, Inv. no. 1895-9-15-667; 285 x 192 mm., pen and brown ink with wash.

48. Study for *The Death of Sinorix*, Staatliche Museen Preussischer Kulturbesitz, Berlin-Dahlem, Inv. no. 15208; 321 x 245 mm., pen and brown ink over black chalk.

49. Study for *The Death of Sinorix*, The Pierpont Morgan Library, New York, Inv. no. IV 180h; 225 x 300 mm., pen and brown ink, brown wash, and black chalk.

50. Study for *The Death of Sinorix*, Gabinetto dei Disegni, Gallerie degli Uffizi, Florence, Inv. no. 5734S; 286 x 435 mm., pen and brown ink over black chalk. Photo: Soprintendenza alle Gallerie, Florence.

51. Study for *The Death of Sinorix*, Teylers Stichting, Haarlem, Inv. no. NF35; 206 x 270 mm., pen and light brown ink over black chalk.

52. Study for *The Death of Sinorix*, Nationalmuseum, Stockholm, Inv. no. 534/1863; 276 x 417 mm., pen and brown ink over black chalk.

53. *Venus Giving Arms to Aeneas*, Bartsch 24, Bellini 17. Photo: Gabinetto Fotografico Nazionale.

54. *The Triumph of Painting on Parnassus*, Bartsch 35, Bellini, 29. Photo: Warburg Institute.

55. *Spring*, Bartsch 36, Bellini, 30. Photo: Warburg Institute.

56. *Summer*, Bartsch 37, Bellini 31. Photo: Warburg Institute.

57. *Autumn*, Bartsch 38, Bellini 32. Photo: Warburg Institute.

58. *Winter*, Bartsch 39, Bellini, 28. Photo: Warburg Institute.

59. Study for *Spring*, Staatsgalerie, Stuttgart, Inv. no. 1383; 177 x 230 mm., pen and brown ink over black chalk.

60. F. Collignon after Pietro Testa, *Virtute Duce Comite Fortuna*, Bibliothèque Nationale, Paris.

61. *Genius Escaping from Time*, Teylers Stichting, Haarlem, Inv. no. ND 30, recto; 360 x 217 mm., pen and brown ink with light brown wash and heightened with white chalk, over black chalk, on blue paper; squared in black chalk.

62. Drawing after Prometheus Sarcophagus, Gabinetto dei Disegni, Gallerie degli Uffizi, Inv. no. 7076A; 141 x 142 mm., pen and brown ink with brown wash. Photo: Soprintendenza alle Gallerie, Florence.

63. Drawing after Prometheus Sarcophagus, Gabinetto dei Disegni, Gallerie degli Uffizi, Florence, Inv. no. 7075A; 142 x 655 mm., pen and brown ink with brown wash. Photo: Soprintendenza alle Gallerie, Florence.

64. P. S. Bartoli, Prometheus Sarcophagus, from *Admiranda romanarum antiquitatum* (Rome, 1691), plate 66. Photo: Dimler.

65. P. S. Bartoli, Prometheus Sarcophagus, from *Admiranda romanarum antiquitatum* (Rome, 1691), plate 67. Photo: Dimler.

66. Study of *The Elements*, The Pierpont Morgan Library, New York, Inv. no. IV, 180e; 253 x 346 mm., black chalk on light brown paper.

67. *Allegory in Honor of Innocent X*, Bartsch 31, Bellini 25. Photo: Warburg Institute.

68. Study of Iris and Peace for the *Allegory in Honor of Innocent X*, Gabinetto dei Disegni, Gallerie degli Uffizi, Inv. no. 5727S; 187 x 144 mm., pen and brown ink with some red chalk. Photo: Soprintendenza alle Gallerie, Florence.

69. *The Young Artist Arriving on Parnassus*, Bartsch 33, Bellini 33.

70. Study for *Autumn*, Royal Library, Windsor Castle, Inv. no. 5937; 234 x 197, pen and brown ink over red chalk. Reproduced through the gracious permission of Her Majesty Queen Elizabeth II.

71. *The Vision of S. Angelo Carmelitano*, S. Martino ai Monti, Rome; 4.63 x 2.40m., oil on canvas. Photo: Gabinetto Fotografico Nazionale.

72. Study for *The Vision of S. Angelo Carmelitano*, Teylers Stichting, Haarlem, Inv. no. NB 86; 340 x 255 mm., pen and brown ink with brown wash over red chalk.

73. *The Miracle of St. Theodore*, S. Paolino, Lucca; 2.40 x 1.47m., oil on canvas. Photo: Gabinetto Fotografico Nazionale.

74. Study for *The Miracle of St. Theodore*, Collection of the Duke of Devonshire, Inv. no. 604; 303 x 229 mm., pen and ink with grayish-brown wash. Reproduced by permission of the Trustees of the Chatsworth Settlement.

75. *Galatea*, Soprintendenza ai Monumenti e Gallerie per le Provincie di Pisa, Livorno, Lucca e Massa Carrara; 2.08 x 2.78m., oil on canvas. Photo: Gabinetto Fotografico Nazionale.

76. *The Sacrifice of Iphigenia*, Galleria Spada, Rome; 1.49 x 1.95m., oil on canvas. Photo: Gabinetto Fotografico Nazionale.

77. *The Prophecy of Basilides*, Museo di Capodimonte, Naples; 0.97 x 1.32m., oil on canvas. Photo: Gabinetto Fotografico Nazionale.

78. *The Dead Christ*, Ashmolean Museum, Oxford; 0.29 x 0.45m., oil on canvas.

79. *The Death of Cato*, Bartsch 20, Bellini 39. Photo: Gabinetto Fotografico Nazionale.

80. *The Symposium*, Bartsch 18, Bellini 38. Photo: Gabinetto Fotografico Nazionale.

81. *Achilles Dipped in the Waters of the Styx and Consigned to Chiron*, Bartsch 21, Bellini 36. Photo: Gabinetto Fotografico Nazionale.

82. Study for *The Education of Achilles*, Cabinet des Dessins, Musée du Louvre, Paris, Inv. no. 1897; 263 x 418 mm., pen and brown ink over black and red chalk, with gray wash. Photo: Cliché Musées Nationaux.

83. *Achilles Dragging the Body of Hector*, Bartsch 22, Bellini 37. Photo: Gabinetto Fotografico Nazionale.

84. *The Prodigal Son: Departure*, Bartsch 5, Bellini 21. Photo: Warburg Institute.

85. *The Prodigal Son: The Wasting of his Substance*, Bartsch 6, Bellini 22. Photo: Gabinetto Fotografico Nazionale.

86. *The Prodigal Son: The Prodigal among the Swine*, Bartsch 7, Bellini 23. Photo: Warburg Institute.

87. *The Prodigal Son: The Return of the Prodigal*, Bartsch 8, Bellini, 24. Photo: Gabinetto Fotografico Nazionale.

88. *Altro diletto ch'imparar non trovo*, Bartsch 32, Bellini 34. Photo: Warburg Institute.

89. *Il Liceo della Pittura*, Bartsch 34, Bellini 20. Photo: Landesbildstelle Rheinland.

90. *Filosofia secondo Boetio*, from C. Ripa, *Iconologia* (Padua 1625), p. 234. Photo: Warburg Institute.

91. Fragments of Studies for *Il Liceo della Pittura*, Cabinet des Dessins, Musée du Louvre, Paris, Inv. no. 1908 and 1908 bis; 118 x 97 and 110 x 88 mm. (cut and mounted on a single sheet), pen and brown ink. Photo: Cliché Musées Nationaux.

92. Study for *Il Liceo della Pittura*, Gabinetto dei Disegni, Gallerie degli Uffizi, Florence, Inv. no. 775F; 133 x 235 mm., pen and brown ink over black chalk. Photo: Soprintendenza alle Gallerie, Florence.

93. Study of *The Immortal Fame of the Arts overcoming Time and Envy*, Cabinet des Dessins, Musée du Louvre, Inv. no. 1912; 360 x 254 mm., pen and brown ink. Photo: Cliché Musées Nationaux.

94. Diagram of *Parte ragionevole per essenza* from B. Segni, *L'Ethica d'Aristotile* (Florence, 1550), p. 280.

95. Diagram of *Potenza ragionevole*, from B. Segni, *L'Ethica d'Aristotile* (Florence, 1550), p. 290.

96. *Mattematica*, from C. Ripa, *Iconologia* (Padua, 1625), p. 410. Photo: Warburg Institute.

97. *Prattica*, from C. Ripa, *Iconologia* (Padua, 1625), p. 522. Photo: Warburg Institute.

98. *Povertà in uno ch'habbia bell'ingegno*, from C. Ripa, *Iconologia* (Padua, 1625), p. 521. Photo: Warburg Institute.

99. *Theoria*, from C. Ripa, *Iconologia* (Padua, 1625), p. 666. Photo: Warburg Institute.

100. Study for *Il Liceo della Pittura*, British Museum, London, Inv. no. 1874-8-8-143; 190 x 258 mm., pen and brown ink with some black chalk.

101. Study for *Il Liceo della Pittura*, National Gallery of Scotland, Edinburgh, Inv. no. D 4990; 160 x 202 mm., pen and brown ink.

102. Domenichino, *The Last Communion of St. Jerome*, Pinacoteca Vaticana, Rome. Photo: Musei Vaticani, Archivio Fotografico.

103. Agostino Carracci, *The Last Communion of St. Jerome*, Pinacoteca Nazionale, Bologna. Photo: Alinari.

104. François Perrier, *The Last Communion of St. Jerome*, after Agostino Carracci. The Metropolitan Museum of Art, New York, 26.70.4(56), Harris Brisbane Dick Fund, 1926.

105. Giovanni Cesare Testa, *The Last Communion of St. Jerome*, after Domenichino. The Metropolitan Museum of Art, New York, 51.501.2490, Whittelsey Fund, 1951.

106. Nicolas Poussin, study of *The Artists' Studio*, Gabinetto dei Disegni, Gallerie degli Uffizi, Florence, Inv. no. 6121F; 119 x 190 mm., pen and brown ink with red chalk. Photo: Soprintendenza alle Gallerie, Florence.

107. Matteo Zaccolini, MS Ashb. 1212, iv, fol. 13v, Biblioteca Laurenziana, Florence. Photo: Pineider.

108. Nicolas Poussin, *Rebecca and Eliezer at the Well*, Musée du Louvre, Paris; 1.18 x 1.97m., oil on canvas. Photo: Cliché Musées Nationaux.

109. Salvator Rosa, *The Genius of Salvator Rosa*, Bartsch XX.24. Photo: Warburg Institute.

110. Giovanni Benedetto Castiglione, *The Genius of Castiglione*, Bartsch XXI.23. Photo: Warburg Institute.

111. *Pan*, from V. Cartari, *Le Imagini* (Venice, 1580), p. 133. Photo: Warburg Institute.

112. Study of *The Flight into Egypt*, Gabinetto dei Disegni, Gallerie degli Uffizi, Florence, Inv. no. 12007F; 268 x 345 mm., pen and dark brown ink with wash. Photo: Soprintendenza alle Gallerie, Florence.

113. Study for the decoration of the apse of S. Martino ai Monti, British Museum, London, Payne Knight, P.p. 5-94; 120 x 266 mm., pen and brown ink with wash over red chalk.

114. Study of *The Victory of the Cross*, Graphische Sammlung Albertina, Vienna, Kat. III.525, Alb. Inv. 973; 284 x 224 mm., pen and brown ink over red chalk. Photo: Fonds Albertina, Bildarchiv d. öst. Nationalbibliothek.

115. Figure studies, including Temperance for the apse of S. Martino ai Monti, Gabinetto dei Disegni, Gallerie degli Uffizi, Florence, Inv. no. 5706S; 240 x 193 mm., black chalk on blue paper. Photo: Soprintendenza alle Gallerie, Florence.

116. Figure study for the apse of S. Martino ai Monti, Stanza del Borgo, Milan. Photo: Pineider.

117. F. Collignon after a drawing by Pietro Testa, *Temperance and Prudence*, Bibliothèque Nationale, Paris.

118. Study of *Venus before Jupiter*, Graphischen Sammlungen der Staatsgalerie, Stuttgart, Inv. 1382; 109 x 182 mm., pen and brown ink over red chalk.

119. Study of *Venus giving Arms to Aeneas*, National Galleries of Scotland, Edinburgh, Inv. no. D. 4948; 180 x 268 mm., pen and brown ink over black chalk.

Preface

MY STUDY of Pietro Testa's Notebook in the Kunstmuseum, Düsseldorf, began as a doctoral dissertation for Bryn Mawr College. From the very beginning I enjoyed the support of Dieter Graf, then Curator of Drawings in the Kunstmuseum, and now Director of the Fototeca at the Bibliotheca Hertziana. Without his enthusiasm for the project and without the generosity of the Kunstmuseum, under its former Director Wend von Kalnein, in allowing me to publish the Notebook, this study could not have been undertaken. My thanks are also extended to Dr. Hans Albert Peters, currently Director of the Kunstmuseum, and Dr. Friedrich W. Heckmanns, Curator of Prints and Drawings, for their continuing interest.

The transcription of Testa's erratic hand presented the greatest challenge in my work. The decisions about how to edit and present the transcription were the most difficult to make. For sensible advice about the latter and careful checking of the former, I am especially grateful to Gino Corti, Research Associate, Villa I Tatti. Salvatore Camporeale, O. P., also Research Associate, Villa I Tatti, took the time and trouble to discuss problems that might otherwise have seemed insoluble. Mistakes that may remain are mine, but without their help there would have been many more.

In addition to the curators of all the public collections I have visited, I am indebted to Her Majesty Queen Elizabeth II, the Trustees of the Chatsworth Settlement, to Armide Oppé, Loriano Bertini, and Henry, Prince of Hesse for their gracious hospitality in allowing me to study their drawings. Onofrio Speciale was particularly helpful in making it possible for me to work in the Calcografia Nazionale, Rome, in difficult circumstances. I would also like to thank Susan Bandes, Hugh Brigstocke, Dieter Graf, Frances Huemer, Jennifer Montagu, Mary Myers, Fiorella Superbi, and Nicholas Turner for special assistance in providing photographs.

Parts of my text first appeared, in rather different form, in the *Journal of the Warburg and Courtauld Institutes*, *Grafica Grafica*, and the *Art Bulletin*. My thanks go to the editors of these journals for permission to incorporate this material in the book.

My early research was supported by a Dissertation Award from the Woodrow Wilson Foundation and by a Research Award from the Leverhulme Trust. Under the terms of the latter, as a Fellow of Clare Hall in the Department of the History of Art, Cambridge University, I was able to return to Düsseldorf and to study Testa's drawings in many European collections. A grant from the American Philosophical Society (Penrose Fund), and a summer stipend from the National Endowment for the Humanities made further visits to these collections possible.

My greatest debt, if such distinctions can be made, is to Villa I Tatti, the Harvard Center for Renaissance Studies, where I was a Fellow in 1978-1979. My year in Florence was supported by Harvard University, The Leopold Schepp Foundation, and by a Research and Study Leave from Temple University, Philadelphia. I would like to thank them all. At I Tatti I enjoyed the perfect combination of a study, a library, and good-humored company that made it possible to concentrate on writing the text. John D'Amico and David Quint, and, on a later occasion, Alan Perreiah, all read parts of the manuscript and made important suggestions for improvement from the perspectives of their own, quite different, disciplines. The book was completed on a return visit to Florence in 1981 when I was a Visiting Scholar at I Tatti and a Research Fellow of The Johns Hopkins University at The Johns Hopkins Center for Italian Studies, Villa Spelman.

Temple University, my own institution, has given additional support from its scarce resources at important moments; first with a summer stipend, and last with a Grant-in-Aid of Research to support the cost of typing.

Over the years friends and colleagues have helped in many ways, and I cannot thank them enough. Several colleagues in particular have sustained my energies by their moral support and confidence in the project. Here I would like to mention Diane DeGrazia, Ann Sutherland Harris, Michael Jaffé, Rensselaer W. Lee, Charles Mitchell, Ann Percy, Giovanna Perini, Craig Hugh Smyth, and Matthias Winner. To my editor, Rita Gentry, I am indebted for her patience and imagination throughout the production of a complicated book. Only Charles Dempsey himself can know how much this book has benefited from his generosity and good judgment.

1981

List of Abbreviations

Bartsch A. Bartsch, *Le peintre graveur*. 21 vols. Leipzig, 1867. All references to prints by Pietro Testa appear in volume XX.

Bellini P. Bellini, *L'opera incisa di Pietro Testa*. Vicenza, 1976.

DBI *Dizionario biografico degli italiani*. Rome, 1960————.

Vasari-Milanesi *Le vite de' più eccellenti pittori, scultori ed architettori scritte da Giorgio Vasari pittore aretino con nuove annotazioni e commenti di Gaetano Milanesi*. 9 vols. Florence, 1906.

THE IDEAL OF PAINTING

Introduction

THIS STUDY of the life and thought of Pietro Testa is neither a conventional monograph devoted to an artist's work, nor is it a contribution to the history of art theory considered in isolation from artistic practice. The arguments presented are based to a great extent upon the material to be found in the collection of Testa's notes and drawings that was bound together soon after his death in 1650 and that is now in the Kunstmuseum in Düsseldorf. These notes and drawings were first discussed in detail by Marabottini in 1954, but they are published here in their entirety for the first time in Part Two. In his study of Testa's so-called "Trattato della pittura ideale"—the title Testa gave to only one group of notes—Marabottini worked exclusively with a late seventeenth-century copy of the original fragmentary manuscript. His use of the copy, now in the Biblioteca Casanatense in Rome, led to an overall distortion of the character and contents of the original. The original material in Düsseldorf is neither a treatise nor a sketchbook but a gathering of fragmentary notes on different subjects made at different moments in Testa's life; they were assembled after his death and Testa never intended for them to be published as a whole. Unlike the manuscript in Düsseldorf, the Casanatense copy is easy to read: what is gained in legibility, however, is lost to comprehension, for the copy renders Testa muddled and incoherent. Combined with the traditional romantic interpretation of Testa's short life, the results of studying the Casanatense manuscript rather than the original have proved disastrous.

In Part Two I present a complete transcription of the Düsseldorf Notebook. I discuss the history of the Notebook at the beginning of Part Two and the principles adopted in editing it are explained in the Note to the Reader preceding the Transcription. The fragmentary nature of many of the notes renders translation impossible. To recover Testa's meaning for the reader, and to establish the coherence of the sections, I have provided a Commentary to the Transcription, following the same numbered order. The opportunity to observe how a seventeenth-century artist read a text is a rare one, and I have, therefore, generally limited the references in the Commentary to the specific sources Testa had to hand, reserving the discussion of broader issues for the chapters of Part One. In many cases whole sections of the books read by Testa are reproduced in the Commentary, for without context it would be impossible to understand why Testa wrote a particular word or phrase. What becomes clear in comparing Testa's notes with their sources is that he read with purpose and with understanding. The approximately twenty books that Testa unquestionably consulted (listed in Appendix One) are few in number compared with Andrea Sacchi's collection of more than sixty books, but comparable to Poussin's nineteen.[1] There is no

[1] Harris, 1977, pp. 123-125, publishes the list of books from the inventory of Sacchi's house; see also p. 36 for comparison with Poussin.

reason to believe that Testa was, then, any more learned or well read than Sacchi, Poussin, Domenichino, or Albani, and this makes the chance survival of his notes all the more valuable for understanding the history of seventeenth-century art. Although the Düsseldorf Notebook is unique, it should be considered representative of the kind of material that Testa's friends and contemporaries also gathered up to plant, as Socrates put it, in the gardens of letters they hoped to cultivate in their old age.

In Part One I place Testa's ideas presented in his works and the Notebook in relation to seventeenth-century notions of the theory and practice of art. My first chapter brings together as much of the factual information about Testa's life and work as is appropriate or possible within its confines. In writing his biography I have tried to say something about Testa's novel approach to printmaking, both in terms of invention and execution, and several drawings are published here for the first time. But a catalogue was not my purpose, and I have in general limited my choice to dateable works of biographical interest. One of my main purposes is to suggest that an alternative justification exists for the failure of Testa's public career as an artist to the one that sees stylistic change as an indication of temperamental crisis. The latter view typifies the way in which Testa's modern biography has been cast, by Lopresti (who characterized the Lucchese as a Venetian plant transplanted to Roman soil), by Marabottini, by Wittkower, and by Hartmann. In their view Testa's more spontaneous painterly manner was destroyed by his familiarity with classic idealist theories in Rome and his study of ancient art. This representation of Testa, who was capable of fashioning both luminous mythological landscapes and allegorical compositions of the utmost complexity, as a protoromantic at odds with his intellect seemed consistent with the evidence for his suicide in the waters of the Tiber and with the tradition that he had written a confused treatise. No biographer can ignore Testa's suicide, but the evidence of the Notebook now supports a view of his life as a rational one, if one that was in the end overwhelmed by the pressures of poverty and a fickle patronage. We can also see that, far from being an obstacle to his development, the study of antiquity was a positive and consistent feature of Testa's approach to the study and practice of art from the very beginning. Furthermore, as I have tried to suggest, the tension between the tradition for which antiquity stood, and different kinds of stylistic innovation, if not yet a fully fledged "Querelle des anciens et modernes," was a tension that was consciously recognized in all areas of intellectual life in seventeenth-century Italy, not just by artists and critics. A factor that made Testa's case especially difficult was that he came from Lucca, and could count on little support from patrons at home or in Rome, where to be a Lucchese in Testa's day was not an advantage. The artistic situation in Lucca in the Seicento is little understood, with serious implications for Testa studies, given that the traditions of the republic were so important for his personal views.

In certain ways, given the new evidence of the notes, Testa becomes a test case for the romantic theory of biography that has pervaded Seicento studies in general. The model for this theory was established most solidly by Denis Mahon in his *Studies in Seicento Art and Theory* (1947). The problem Mahon posed was the change in Guercino's style from one characterized as "Baroque" to one more "classical." This change Mahon traced to the influence of a Roman *ambiente*, in which a more classical artistic language was encouraged

by critics, and by Agucchi's classic-idealist theories in particular. Confronted by this critical situation, according to Mahon, Guercino lost confidence in his own instincts and struggled to modify his style accordingly. He accomplished this only by turning against his own temperament and his natural bent as a painterly painter.[2] With regards to Testa, it was the fact of his own dedication to the study of theory, and of the same kind that Mahon argued was inflicted upon Guercino, that has been interpreted as leading to a similar denial of his own natural instincts. This view is not easily altered, for Mahon's work continues to exert a powerful influence that reaches well beyond the study of Guercino himself. Having established the negative role of criticism in the case of Guercino (for such it was, despite Mahon's attempt to define true criticism as "a matter of instinct in relation to a work of art," opposing this to the more intellectual-sounding "art theory" that brought negative pressures to bear on Guercino),[3] Mahon then posed a second question: what was the relationship between the theory and practice of art in the Seicento? His conclusion, which is well known, was that Seicento theory "was above all literary and interpretive rather than artistic and creative." The power of "classic-idealist" theory, which Mahon saw as opposed to the "Baroque" language of artistic practice, relied upon the preferences of antiquarian *letterati*, "or, if artists, principally minor ones with literary tendencies." He allowed a few exceptions: Guercino is one, Domenichino possibly another. Mahon, however, seizing upon Blunt's discovery that Poussin's notes on painting were quotations from his reading, took this as a cautionary tale for anyone seeking to establish that painters thought for themselves about art theory and criticism, and that any genuine influence of theory upon the practice of painting existed in the Seicento.[4]

In its broadest application Mahon's argument touches upon the whole question of the relationship between art and theory, or criticism, and in the thirty-four years since *Studies in Seicento Art and Theory* was published there have been many fruitful attempts to question his thesis—to show how theory, without being necessarily "academic" or prescriptive, is bound to the production of works of art. In the context of Seicento studies we must acknowledge that Blunt's monograph on Poussin is predicated upon the perception that the same antiquarian *ambiente* that influenced Guercino also deeply affected Poussin, for whom theory is inseparable from artistic practice. Even more specifically, Dempsey's reexamination of the problem of eclecticism and the Carracci, and of the creative role of theory in the Carracci Academy, which had been denied by Mahon, has established ways in which theory and practice can be understood to be united in the formation of seventeenth-century styles. We might, in accordance with Mahon's views, look upon Testa's notes as of interest to the history of theory only, the remains of one of those minor artists with literary tendencies. But Testa is not a minor artist, comparable to, say, Du Fresnoy. Furthermore, my first discovery in editing his notes was that they did not convey the impression of a muddled or irrational mind, nor of an artist pretending to be a writer. I found, as Blunt had found with the much smaller group of Poussin's notes published by Bellori, that the majority of Testa's notes derived from his reading and that in many instances his sources could be located precisely. Rather than concluding, however, that this made the notes less interest-

[2] Mahon, 1947, pp. 101-108. [3] *Ibid.*, p. 3. [4] *Ibid.*, pp. 2-7.

ing or important (the general reaction to Blunt's discovery that Poussin's notes were not "original" statements), I came to see that this only made them more so. An artist who both writes and discloses his sources reveals more rather than less about himself and gives us the opportunity to discover the specific context of his own thought. Even as the identification of formal sources is only the beginning for an analysis of a work of art, especially one created in the tradition of mimesis, so is the identification of written sources (the appropriation of which the poet Marino wryly proclaimed to be the only point of reading) only the beginning for an analysis of an idea.

Many of Testa's notes were never fully incorporated into a final argument, and much of my work has been devoted to the reconstruction of his thoughts, in order to make hypotheses about his conclusions. In many cases, however, as I have indicated, such reconstruction was helped by the fact that the notes relate to projects that Testa did conclude, namely his allegorical prints about the arts. One group stands out in particular. This is the series of notes and drawings made in connection with Testa's most complex allegory on the subject of the education of the ideal artist, the etching entitled *Il Liceo della pittura*. The second chapter of this book is accordingly devoted to a detailed analysis of this print and its development as revealed by the evidence provided in the notes and drawings of the Düsseldorf Notebook, in other related drawings, and in the academic tradition defining the ideal education for an artist and the goals of painting itself, a tradition to which the print belongs.

A second group of notes was made in preparation for a closely related project—a treatise on painting to have been entitled "Il Trattato della pittura ideale," which would also have been devoted to Testa's educational ideals. For this Testa outlined a partial table of contents and a preface. In Chapter Three of this book his projected treatise is analyzed, both in terms of Testa's own arguments and of their implications regarding the critical issues affecting painting in Rome in the 1630s and 1640s. Although Testa casts his ideas in the form of a treatise on education, it must also be recognized that such a work is concerned with an ideal of mature artistic practice. In Testa's day ideals of performance in all fields of intellectual and cultural endeavor had come to be expressed through the model of ideal education.

The study of the relationship of theory to practice in the Seicento is complicated by the fact that the issue is still attached to the Wölfflinian categories of "classic" and "baroque" styles. Mahon himself, who acknowledges Wölfflin's influence upon his thinking, is indebted to these categories. Theory, especially the theory of ideal painting, has tended to become associated, and indeed confused with a particular ideal of style, the style of Domenichino and Poussin, a style that is called "classical." Painterliness, recession, and open compositional structure, qualities that are called "baroque," have correspondingly come to be associated with spontaneity and freedom from theory. This opposition is perhaps not as sharply drawn as it once was, since increasing knowledge of seventeenth-century art and its complexities has caused many art historians to question the usefulness of a simple opposition of "classic" and "baroque" polarities in characterizing the period. But the fundamental association of the two problems remains and cannot be ignored when considering

the writings and works of an artist whose interest in theory has been perceived as going hand in hand with his adoption of a style that betrayed his spontaneous genius.

The marriage of certain of the theories discussed in this book to a particular classical style was in the end effected by the French Academy. The invocation of the authority of Bellori and Poussin at the end of the century encouraged the belief that this association held true in the Roman milieu in which they had originally formulated their ideas. This belief has been strengthened by modern scholarship, and especially by the reading of Panofsky's fundamental study of the origins and meaning of the *beau idéal* in his *Idea* (1924). In my concluding chapter I have offered a radically different interpretation of Bellori's *L'Idea* from that proposed by Panofsky, to which Mahon and almost all scholars of Seicento theory have acknowledged their debt. I have sought to indicate how the character of Roman Classicism could embrace a wide range of stylistic possibilities within the bounds set by an emerging sense of the historical tradition of art, for which antiquity provided authentication. This will not surprise students of Seicento literature, but historians of art, overwhelmed by Panofsky's brilliant study, have failed as yet to come to terms with the issue.

My two goals—to establish the complete text of Testa's Düsseldorf Notebook so that it may find its place in the corpus of seventeenth-century writings on art and to interpret this collection of notes in the broader context of theory and practice in mid-seventeenth-century Rome—are united by my understanding that a consciousness of critical theory was inseparable from artistic practice in Testa's lifetime. This understanding derives in part from the implications of academic teaching, especially in the Carracci Academy, where Testa's first teacher Domenichino was trained, and in part from the legacy of Leonardo da Vinci whose chief executors were Testa's friend Nicolas Poussin and their mutual friend Cassiano dal Pozzo. The Düsseldorf Notebook, however, when considered in relation to Testa's own work, provides the strongest evidence for this point of view. Not only did Testa struggle with the problem of the relationship of theory to practice on a theoretical level, but also he produced works of art that, regardless of their individual styles or particular content, reveal throughout the direct evidence of his thinking upon his making.

I want to make one concluding remark about my approach to the relationship between theory and practice in the middle of the Seicento, and this concerns my concept of theory, or criticism. If we are prepared to include in our corpus of seventeenth-century art theory only completed texts, published or in the last stages of preparation for publication, then we might come to the conclusion that theory had little to do with practice, and that major artists had no true or significant theories concerning their art. Indeed, Friedlaender made this very argument on the basis of the almost complete absence of such texts in the first fifty years of the century. If, however, we admit the considerable body of more informal and fragmentary writing that exists by artists on the subject of art, together with the evidence provided by the reflection of critical thinking in the works of art themselves, then the picture changes radically. If we do not, then we run the danger of arguing in a closed circle; without accepting that artists had theories it will follow that we can find no evidence for the influence of theory on practice—with the consequent danger, in my view, that we will be denying ourselves the basis for a complete critical understanding of the works of art

themselves. As I argue in Chapter Four, the very character of artists' writings in the middle of the century testifies to the vital importance of the theories they discuss. Testa's, Poussin's, Du Fresnoy's, and even Bernini's statements and practical investigations of the traditions and means of their art denote the creative participation of theory in practice, rather than the study of theory in abstraction. The importance of the role of literary theories revealed in Testa's notes, as well as in his pictorial inventions, only supports this conclusion.

In 1969 when I began this study Testa was one of those little-studied artists who, like Mola, Castiglione, and Rosa, were generally included in the convenient but unfortunate category of the circle of Poussin. With equal imprecision he, like Poussin, was also described as a *peintre-philosophe*. Although his drawings and paintings had always been valued by connoisseurs and although biographies by Passeri, Baldinucci, and Sandrart attested to his fame, there existed no catalogue of his work and no discussion of him outside Italy. Regrettably, a catalogue is still wanting, despite recent contributions by Harris, Brigstocke, and Bellini. Karin Hartmann's catalogue of the paintings, prints, and drawings, which was undertaken at the same time as my own original study, remains an unpublished dissertation at the University of London, its usefulness limited by the stringency of the rules imposed upon readers. I had hoped publication of this would provide the perfect complement to this book for, despite the many omissions and problematic interpretations in its present state, Hartmann's catalogue presents the most complete available inventory of Testa's work, and I have acknowledged it frequently, together with the contributions of those mentioned above.[5]

Because of the particular focus of this study several important problems have to be held in reserve. One of the most conspicuous is the problem of the attribution of the drawings after ancient works of art made by Testa for Cassiano dal Pozzo's *Museum chartaceum*. This constitutes an independent study involving a whole group of artists. I have only touched upon the question of the states of Testa's etchings and his mastery of the medium. The importance of the evidence of Testa's plates, still preserved in the Calcografia Nazionale in Rome, brought to my attention by Onofrio Speciale, remains to be evaluated. Testa was a prolific and superlative draughtsman, and yet even his well-known drawings in public collections remain largely unpublished. The discovery of the character of this lonely artist through the study of his private thoughts recorded in the Düsseldorf Notebook should now make it possible to look at all these aspects of his work in a new way.[6]

[5] For complete references to these studies, see Note 1, Chapter One. I would also like to acknowledge two significant publications that have appeared in the three years since this book went to press. L. Mendelsohn makes important observations about sixteenth-century Aristotelianism and art theory in her *Paragoni: Benedetto's Varchi's "Due Lezzioni" and Cinquecento Art Theory* (Studies in the Fine Arts: Art Theory 6), Ann Arbor, 1982. All references to Domenichino should now include R. E. Spear, *Domenichino*, 2 vols., New Haven and London, 1982.

[6] The publication of El Greco's notes on his reading, especially of Barbaro's translation of Vitruvius, by F. Marias and A. Bustamente Garcia, 1981, provides another example of the sort of evidence recorded in the Notebook. It is to be hoped that other similar publications will follow.

PART ONE

1. A Lucchese Artist in Rome

THE EARLY YEARS: FROM LUCCA
TO ROME

PIETRO TESTA was born in Lucca in 1612 to Giovanni di Bartolomeo Testa, a dealer in second-hand goods, and his wife Barbara.[1] He continued to be known as "Il Lucchesino," the painter from Lucca, until 1650, when he died by his own hand in the waters of the Tiber.[2] Before ending his life, as he burned drawings and said veiled farewells to his few friends, Testa may well have reflected with bitterness upon the fact that Lucca was not an auspicious place in which to be born a painter in his day. The persistent bad luck he experienced, which Passeri, his most reliable biographer, blamed upon his stars, only added to the problems arising from his birth in a city politically and economically in decline.[3] And yet, at the very beginning of his career, Testa had some reason to hope that he might become a favorite, well-patronized son of his native republic. Because there was no local academy where he might learn to draw, Testa determined to lay the foundations for his success in Rome.

In making the pilgrimage from Lucca to Rome Testa was following an established path. Paolo Guidotti (c. 1560-1630) had left Lucca for Rome, where he was knighted by the Borghese and became president of the Academy of St. Luke. He played several musical instruments and set about writing an epic poem, *La Gerusalemme distrutta*, in which the last line of every octave would repeat the last line in the same octave of Tasso's *Gerusalemme liberata*.[4] In an emulation of Leonardo Guidotti tried to fly from a hill outside Lucca on wings made of bone and feathers, resulting in a wild plunge through the roof over a peasant's kitchen and a broken leg.[5] Guidotti managed to combine a more regular career with this bizarre behavior, and in 1628, just as Testa was preparing to leave home, he received one of the commissions for the overdoors in St. Peter's.[6] In 1619 a more conven-

[1] Boschetto, 1968, pp. 65-66 (for Testa's baptism on June 18, 1612); Passeri, ed. 1934, p. 182. The other extensive seventeenth-century biography is by Baldinucci, ed. 1847, 5: 310-321. Modern studies are by Lopresti, 1921; Petrucci, 1936; Marabottini, 1954; Harris, 1967; Hartmann, 1970; Schleier, 1970; Brigstocke, 1976 and 1978; Bellini, 1976; Speciale, 1977; works by the present author are listed in the bibliography.

[2] Harris, 1967, p. 60, publishes the death certificate, dated March 3, 1650, in which Testa is identified as *Petrus Testa Lucensis*, and where it is noted that the report was received on the previous day.

[3] Passeri, ed. 1934, p. 188, claims that these stories of Testa's last days are inventions; Harris, 1967, pp. 43-49, presents a convincing argument that they are not. See Mezzei, 1977, for a recent study of the economic decline of Lucca.

[4] Baglione, 1649, 1: 303-304; Baldinucci, ed. 1847, 3: 634-638. Modern studies by Faldi, 1957 and 1961.

[5] Baldinucci, ed. 1847, 3: 637; Manni, 1816, 8: 77-78.

[6] Pollak, 1928-1931, 2: 547-549, publishes payments to Guidotti from January 29, 1628, to March 6, 1629, and to Romanelli (who replaced Guidotti's work) from the end of 1635. Harris, 1977, pp. 56-57, summarizes the history of these commissions, in which Sacchi was also involved. Baldinucci, ed. 1847, 3: 636, reports that Guidotti was responsible for the apparatus for the canonization of Saints Isidore, Ignatius Loyola, Francis Xavier, Teresa, and Philip Neri in 1622; see Lavin, 1968, figs. 5, and 6, for engravings of the decorations.

tional aspiring Lucchese painter closer to Testa's age, Pietro Paolini (1603-1681), had gone to Rome for his artistic education after finishing grammar school at home, and he quickly found a place for himself in Caroselli's studio.[7] Testa probably went to Rome at the same age, after completing grammar school, but without any training as an artist. He may have arrived, therefore, some time in 1628. By the time he entered Domenichino's studio he would have been seventeen. This was older than the ideal expressed by Domenichino, who lamented that Canini had come to him at fourteen, rather than eleven or twelve.[8] For young artists from Lucca, however, there was no alternative until Paolini returned to the city in 1640 and opened his academy there.[9]

Relations between Lucca and the pope were strained in the 1620s and 1630s, but Testa could, nonetheless, expect to find support among the influential Lucchese community in Rome. Girolamo Buonvisi (1607-1667) was a cleric of the Apostolic Camera. He possessed the finest collection of paintings in Lucca and came to be Testa's most loyal patron.[10] Buonvisi, together with Marcantonio Franciotti (another Lucchese cleric who played an important role in Testa's career), must have had considerable influence with Urban VIII, for in 1631 in a gesture of reconciliation toward the republic the pope provided the Lucchese with their own church in Rome.[11]

Testa's expectations were not based solely upon these rather recently established Lucchese clerical connections with the Barberini. One of the best known literary figures in Rome when Testa arrived there was Lelio Guidiccioni, another Lucchese, like Guidotti, with close ties to the Borghese. In 1623 he wrote the description of the funeral of Paul V, providing thereby a precious record of Bernini's catafalque figures.[12] After this he went on to find favor with the Barberini; it was Guidiccioni's translation of the *Aeneid* into Tuscan, published in 1642 with a dedication to Cardinal Antonio Barberini, that Testa himself read.[13] Guidiccioni could have introduced the young painter to the pope's close friends, Cardinal Giulio Sacchetti and his brother Marcello, fellow patrons of the arts, whose favorite was Testa's second master, Pietro da Cortona.[14] Although Guidiccioni was said to overpraise his

[7] Baldinucci, ed. 1847, 3: 106-109 (who mistakenly states that Paolini went to Rome in 1623); Marabottini Marabotti, 1963; Ottani, 1963, 19-35, esp. p. 21 for evidence that he left for Rome when sixteen and trained in grammar; Moir, 1967, 1: 221-223. Paolini would appear to have stayed at school somewhat beyond the average, which was about fourteen; for a discussion of the education of artists, especially in grammar, see Dempsey, 1980.

[8] Pascoli, 1730-1736, 2: 116. Domenichino himself, of course, had not followed the pattern he approved of here, for which see Dempsey, 1980, pp. 560-569.

[9] Ottani, 1963, p. 21.

[10] See M. Trigari's biography in *DBI*, *s.v.* "Girolamo Buonvisi"; Marabottini, 1954, p. 117, n. 4, cites a 1776 inventory of Buonvisi pictures (MS 3299, Misc. Lucchese Bernardi, sec. XVIII); Hartmann, 1970, p. 40, cites a second eighteenth-century inventory now in the library of the National Gallery, London. Both include six works by Testa.

[11] Pollak, 1928-1931, 1: 124-125, publishes documents establishing that the Capuchin church of S. Bonaventura sotto Monte Cavallo was conceded to the Lucchese community on May 10, 1631; on May 31 it was decided that chapels would be assigned to Monsignors Franciotti, Buonvisi, and Spada.

Cardinal Antonio Barberini contributed to the fabric of the building and the decoration of chapels throughout 1632. Buonvisi, Franciotti, and members of the Lucchese Spada family were all members of the Accademia degli Oscuri, founded in Lucca in 1584. Vincenzo Malpiglio, the friend of Tasso, had been influential in establishing the academy, which met in the Palazzo Buonvisi.

[12] Berendson, 1957-1959, p. 68, states that the *Breve racconto della Trasportatione del Corpo di Papa Paulo V* is anonymous, but it is attributed to Guidiccioni by Allacci, 1633, p. 172, who also attributes a Latin text of 1623, *De Paulo V Oratio* to Guidiccioni, together, among other works, with *De Urbano VIII ad Summum Pontificatum erecto* (Rome, 1624); Ciacconius and Olduini, 1677, 4: 338D, report that Guidiccioni gave the oration at the funeral and record his celebration of Bernini in the *Ara Maxima Vaticana*; see also D'Onofrio, 1966, p. 129; and *Bernini in Vaticano*, 1981, pp. 250-251, in which M. Worsdale also names Guidiccioni as author of the *Breve racconto*.

[13] Notebook, 51.

[14] Haskell, 1963, pp. 38-39, for a summary of the patronage of the Sacchetti brothers.

own collection, his palace in the Piazza di Spagna, with its great library and its paintings, would have offered Testa the opportunity to learn many new things. The opportunity to study, for example, the famous volume of seventy-five drawings by Annibale Carracci of Bolognese artisans and tradesmen (later to be engraved by Simon Guillain) would have been all the encouragement Testa needed to take advantage of the Lucchese poet's enthusiasm for showing off his collection.[15] He probably sought out Guidiccioni as soon as he arrived in Rome.

All Testa's seventeenth-century biographers agree that the young man made a promising, if difficult start in Rome, gaining entry to the studio of Domenichino, work from Cassiano dal Pozzo, and early training and employment as a printmaker from Joachim von Sandrart.[16] The sequence of these events is not clear. Sandrart himself claims to have been the first to discover the young man as he drew assiduously in the Colosseum, on the Palatine, and in the Campidoglio without a penny in the world. He took pity on Testa and asked him to work on the drawings for the plates of the *Galleria Giustiniani* as a way of earning a little money. Sandrart began work on this lavish publication of the ancient sculptures in the collection of the Marchese Vincenzo Giustiniani around 1628, and so his claim to have given Testa his start is probably true.[17] Without any training at all Testa would not have been useful to Cassiano dal Pozzo, who later employed him in making drawings after the antique for his famous *Museum chartaceum*, and it would have been natural for him to be a student initially of the great free academy that was the city, where Sandrart found him, drawing after ancient reliefs and the frescoes of Polidoro da Caravaggio and Raphael.[18]

While working for Sandrart Testa no doubt became acquainted with Duquesnoy, who was similarly employed, and whose work was to influence his own during the next decade. Duquesnoy, in turn, may have been the first to introduce him to Nicolas Poussin.[19] Most important in the long run, however, was the fact that Testa spent his early months in Rome in the company of some of the finest printmakers in Europe brought together by Sandrart for the Giustiniani project, and from them he learned how to engrave and to etch. Sandrart's original kindness to the poor student he discovered starving in the ancient ruins of Rome proved to be the most important foundation for his achievement, and even survival as an artist. From the very beginning his training as a printmaker distinguished Testa from most of the other artists working for Cassiano dal Pozzo, and it provided him with a skill that never failed.

The earliest print to be associated with Testa with any confidence is a clumsy little engraving of an elephant (Fig. 1), the awkwardness of which has been explained away by

[15] Mahon, 1947, pp. 236-237, neatly summarizes seventeenth-century biographies of Guidiccioni, with special reference to Massani's Preface to the 1646 publication of Simon Guillain's etchings after the Carracci drawings. Massani explains how Cardinal Ludovico Ludovisi (1595-1632) gave the drawings to Guidiccioni, who then took great pride in showing them. Mahon also points to the poet's friendship with the Sacchetti, his connections with the Borghese, and, subsequently, with Cardinal Antonio Barberini.

[16] Passeri, ed. 1934, pp. 182-183; Baldinucci, ed. 1847, 5: 310-312; Sandrart, ed. 1925, pp. 288-289.

[17] Sandrart, ed. 1925, p. 293, lists Cornelius Bloemart, Theodor Matham, Renier Persin, and Michaël Natalis, as engaged on the project; see also Haskell, 1963, p. 95.

[18] Passeri, ed. 1934, p. 182.

[19] Nava Cellini, 1966, p. 43, refers to Duquesnoy's frontispiece for the *Galleria Giustiniani*; on p. 46 he states that Sandrart presented Duquesnoy to Giustiniani in 1629. Poussin was living with Duquesnoy in 1626, for which see Bousquet, 1960, 1: 2-3, and 2: 4; Bellori, ed. 1976, pp. 289, 426; Passeri, ed. 1934, pp. 105-106; see also Faldi, 1959, p. 60, for Giustiniani's continuing support for Duquesnoy in 1633.

the fact that he found this medium unsympathetic, and did not use it again.[20] It is also quite possible that the engraving is after a lost painting of an elephant by Testa, formerly in Cassiano dal Pozzo's collection.[21] The first state, dated 1630, was dedicated by Testa to the Cavaliere Gualdo of Pisa, a collector of paintings, but whose house adjoining Trajan's forum was also full of ancient treasure, including sacrificial instruments, gems, Egyptian and Roman sculpture, bones for casting lots, a remora, and the knee bone of a giant.[22] Gualdo was an admirer of Cardinal Antonio Barberini, in whose honor he placed an ancient sarcophagus from his own collection in the portico of Santa Maria Maggiore in 1632.[23] The print, like Testa's painting, was inspired by the appearance of an elephant in Rome in March of 1630, and it appears that the second state of the print was used as the frontispiece to the commemorative *Epistula de elephanto Romae viso*, published in the same year by the antiquarian Giulio Cesare Bottifango with a dedication to Gualdo.[24] Although the status of this little print remains in question, its existence is in many ways prophetic. Bottifango's interests were similar to those of Gualdo and Cassiano dal Pozzo, and his pamphlet about the elephant was modelled on a work by Pietro della Valle, another great antiquarian who had returned to Rome in 1626.[25] Sandrart's *Galleria* was similarly an antiquarian venture. Testa's grounding in antiquity and in the classification of the objects of its culture was thus securely established from the very first.

It may have been Sandrart, or Gualdo, or (as Baldinucci suggests) simply the quality of Testa's own drawings that led to Domenichino's accepting him as a student, and to his subsequent introduction to Cassiano dal Pozzo, collector, scholar, and favorite of the Barberini.[26] Dal Pozzo also employed Duquesnoy in making drawings for his *Museum chartaceum*, and when he added Testa to his team of draftsmen he may have hoped that he, like the Sienese engraver Bernardino Capitelli, might eventually produce not only drawings but also engravings after the antique.[27] As it turned out, Testa was responsible, almost certainly, for the largest number of drawings in the collection, although great problems of attribution still attach to the drawings of the *Museum chartaceum*.[28] Throughout his life Testa drew upon this great store of ancient motifs that he had helped to record, even as Cassiano dal Pozzo intended.

[20] Petrucci, 1936, p. 409, argues for a drawing by Testa, but for the execution of the print (on Testa's behalf, given the dedication by Testa) by another; Donati, 1961, p. 437, attributes the print to Testa; Bellini, 1976, p. 69, includes it among doubtful attributions.

[21] The dal Pozzo inventory lists two paintings of an elephant, one by Testa, the other by Poussin; see Haskell and Rinehart, 1960, p. 325; Blunt, 1966, no. 157. The elephant, which was the first to be seen in Rome since 1513, was purported to have belonged to the King of England. Gigli, ed. 1958, p. 112, describes the impact of its arrival.

[22] The inscription reads: "Perill.ri D. Equiti Gualdo Ariminen. nuper Romae visi Elephantis effigiem typis excusam. Petrus Testa pictor Lucensis. DDD. 1630." John Evelyn visited the collection on January 26, 1645 and describes some of the objects in it; see De Beer, ed., 1955, 2: 314-315, and notes. See also Pastor, vol. 29, ed. 1938, pp. 529-30. Salerno, 1967, pp. 40-41, comments on Gualdi's mania for giving away parts of his collection, which he finally willed to Queen Christina of Sweden.

[23] John Evelyn, transcribes the inscription recording this gift, for which see De Beer, ed., 1955, 2: 245.

[24] Donati, 1961, p. 437. The only copy of the pamphlet I have seen (in the Biblioteca Casanatense, Rome) did not carry the frontispiece.

[25] M. Capucci, *DBI, s.v.* "Bottifango," who states that the Italian version of the *Lettera dell'elefante* is dated June 15, 1630, whereas the much rarer Latin version is undated.

[26] Haskell, 1963, pp. 98-114, provides the best recent summary of Cassiano's career; see also Dati, 1664; Lumbroso, 1874.

[27] A. Cornice, *DBI, s.v.* "Bernardino Capitelli." Capitelli engraved the *Aldobrandini Wedding* in 1627.

[28] Haskell, 1963, p. 101, n. 3, provides a summary of the bibliography. The most recent discussion by A. Blunt, in Schilling, [1971], pp. 121-123, attributes a group of drawings to Testa, pointing correctly to Baldinucci's well-known argument that Testa produced the majority of the drawings. The difficult problem of the precise attribution of the whole collection, however, remains.

If the work for the *Museum chartaceum* provided Testa with an education in ancient art and culture, the months he spent in Domenichino's studio, again in the regular company of Poussin, provided him with the opportunity to develop that theoretical understanding that he came to see as inseparable from the practice of any art. Testa's relationship with Domenichino has been called, oddly enough, "fatal" by a recent historian, whereas others have suggested, equally oddly, that Domenichino had little influence on his work.[29] Yet it is difficult to imagine how the embattled, melancholic, older artist could have had a more profound effect on his student in the short time they were together, or to imagine a student more eager to listen to his views. Testa was already dedicated to drawing, something that won him the title of "Il Lucchesino, esquisito disegnatore," and he applied himself especially to drawing after the antique, Polidoro, and Raphael (as we have seen).[30] Domenichino would certainly have encouraged this, but would also have impressed upon Testa the importance of drawing from the model. Domenichino's influence is reflected in the remark made about Testa by his friend, Pier Francesco Mola, that he never failed to draw from life; and, in his projected "Trattato della pittura ideale" Testa insisted that only nature could teach anything.[31] Domenichino regularly took his students to the Farnese Gallery to see how his own teacher, Annibale Carracci, had profited from both nature and the antique.[32] These visits bore fruit late in Testa's life when he revealed his own profound understanding of Annibale's work in the gallery, and, as we shall see, became involved in the historical reassessment of the Carracci that followed upon the death of Domenichino.

Another principle that Testa learned from Domenichino was that the very value of art lay in the exposition and revelation of the mind and the spirit. According to Bellori, Domenichino trained himself first to identify and then to present significant action; in this way the study of the *affetti* became an aspect of invention itself, and not of disposition only. Through close reading of history and poetry, Domenichino isolated moments of significant action; through training his memory he was able to represent the transient movements of the soul, and their effects upon the body, without recourse to the pose of a model. All this allowed him to embellish the bare bones of a depicted moment with that convincing illusion of movement and emotion without which painting is twice dead.[33] Both of these methods for the training of the hand and the mind, which had been promulgated by Leonardo, were instilled in Domenichino at the Carracci Academy.[34] They were practiced by Testa and are recorded in his notes.[35] As we shall see, the ability to draw upon an inexhaustible storehouse of memory, derived from the close, analytical study of nature, was, for Testa, the greatest treasure an artist could possess. He espoused completely Domenichino's view of the meaninglessness of painting that failed to convey an illusion of the movements of life.

[29] Marabottini Marabotti, 1963, pp. 312-313, writing of Domenichino's influence on Paolini, states, "Al Domenichino fatalmente si accostava poco prima del '30 un altro giovane lucchese, cioè Pietro Testa." Hartmann, 1970, p. 26, argues that Testa's antiquarian studies were more important for the development of his style than the association with Domenichino, "from whom he seems to have learned little of immediate importance. In fact, Domenichino's principle function appears to have been to encourage the young Testa further to study antiquity, Raphael, and Polidoro."

[30] Passeri, ed. 1934, pp. 182-183.

[31] Baldinucci, ed. 1847, 5: 317; see Notebook, e.g., 53.E., 59.E.-59.F., 60. A.6.

[32] Pascoli, 1730-1736, 2: 47, describes how Domenichino sent Barbalonga to draw in the Farnese Gallery especially. See also the interpretation of this by Pope-Hennessy, 1948, no. 1756.

[33] Bellori, ed. 1976, p. 360; in her note to Bellori's work, Borea stresses the connection between this view and Bellori's own *L'Idea*.

[34] Dempsey, 1977, esp. pp. 48-51.

[35] A whole section of the Trattato was to have been devoted to the *affetti*, for which see the Notebook, 59.H.

When Testa entered Domenichino's studio, the older artist was putting the final touches to the altarpiece for S. Petronio dei Bolognese in Rome, and was working on the pendentives in S. Carlo ai Catinari.[36] Both commissions aroused strong criticism, and became the focus for attacks on Domenichino for his ruthlessness toward his students. Algardi, prompted by Domenichino's destruction of Ruggieri's contributions to the S. Petronio altarpiece, dismissed the invention of the work as old-fashioned, worthy of a Francia or a Giovanni Bellini.[37] In the same scornful language he used for Domenichino's *Flagellation of St. Andrew* in S. Gregorio Magno (which in his view moved the spectator only to pity for the labor involved), Algardi attacked the stiffness of Domenichino's overworked figures. Pietro da Cortona, who shared Algardi's lack of interest in the expression of the *affetti*, took up this popular line of criticism.[38] He accused Domenichino of impeding students who threatened to outstrip him. Domenichino's secrecy earned him the title of "the painter of the grotto," and an accusation of wanting to be the only painter in the world. Cortona claimed that he had sabotaged the career of Giovanni Battista Ruggieri, and had subjected him to threats that made him tremble, all because Ruggieri had the facility and speed of execution that Domenichino himself lacked.[39] The suffering of Giacomo Sementi, a former pupil of Guido Reni, was said to be even more severe. Sementi had barely finished the lantern in San Carlo ai Catinari when Domenichino persuaded Scipione Borghese to deny him any further work in the church. Sementi fell ill, and eventually died a broken man.[40]

Testa would certainly have known Ruggieri, and doubtless admired him, for he too worked for Giustiniani and dal Pozzo, and he was moreover famous for his knowledge of Latin and Greek, as well as for his wit.[41] Unlike Ruggieri or Sementi, however, Testa had no allegiances to Domenichino's rivals. He was too young and too inexperienced to become involved in these battles, which in the late 1620s were led by artists like Pietro da Cortona and Giovanni Lanfranco, for whom Domenichino's ox-like slowness was intolerable.[42] Testa seems to have accepted without question Domenichino's insistence on the importance of the time-consuming intellectual effort that must be devoted to the invention and disposition of a major work and that must precede any thought of execution.

One important effect of Domenichino's deeply contemplative attitude toward his art is that the seed was planted in Testa's mind at an early stage, as it was in Poussin's, that he should write about his own activity. Through his knowledge of Giovanni Battista Agucchi's writings, in particular, Domenichino could provide younger painters with a sense that there was a tradition for painters to record their thoughts about the meaning and purpose of making. Denis Mahon has shown that Agucchi took the manuscript of his *Trattato della pittura* with him to Venice when he was made papal nuncio in 1623 and that upon his

[36] Passeri, ed. 1934, pp. 50-53; Pope-Hennessy, 1948, pp. 46-47, 79-80.

[37] Malvasia, ed. 1841, 2: 226.

[38] Montagu, 1970, p. 285, underlines Algardi's lack of interest in the *affetti*, relating his criticism of the S. Gregorio Magno frescoes specifically to this.

[39] Malvasia, ed. 1841, 2: 233-234. Domenichino had taken Ruggieri away from Francesco Gessi quite deliberately in order to ruin him, it was felt.

[40] Baglione, 1649, 1: 344-345; Bellori, p. 342; Malvasia, ed. 1841, 2: 233, 249-251; for Sementi's career see also Baldi-nucci, ed. 1847, 4: 39-40. Even Passeri, ed. 1934, p. 52, is forced to recognize that it was widely held that Domenichino seized the commission through favoritism.

[41] Baglione, 1649, 1: 360-361; Baldinucci, ed. 1847, 4: 37-38.

[42] According to Bellori, ed. 1976, p. 309, Antonio Carracci even called Domenichino "the ox," thus associating him with that other slow ox, Ludovico Carracci. Passeri, ed. 1934, p. 68, seeks to defend Domenichino's slow practice by pointing to the size of his output.

death in 1632 he willed it to Monsignor Massani, who remained in Venice as internuncio for several months. This manuscript was not, therefore, available to Testa while he was in Domenichino's studio. On the other hand, it is inconceivable, as Mahon suggests, that by 1632 Domenichino could have forgotten its contents simply because he had not read it for nine years, and, in a letter to Angeloni, he expressed a wish to do so. Agucchi's *Trattato* was based on conversations with Annibale Carracci and with Domenichino himself, Annibale's pupil.[43] Furthermore, Testa's own commitment to the study of Vitruvius, documented in the notes, points to the fact that in the late 1620s Domenichino was as interested as ever in studying the intellectual foundations of his art. Domenichino made a close study of Vitruvius, focussing especially upon the relationship between music, painting, and architecture—sister arts linked by the principles of harmony.[44] Like Domenichino, Testa sought to understand arithmetic, perspective, and architecture, not for their own sake, but in order to discover a universally valid foundation for his own art and to be able to discourse about this with others. Many of the arguments presented by Testa in his notes concerning the necessity for the thorough training of the mind and hand may be seen as justifying Domenichino's theoretical foundations.

Mahon has also argued that Domenichino's presence in Frascati in the summer of 1634 and in Rome during the following winter provided the occasion for renewed discussions with Angeloni, with Bellori, and probably with Poussin—discussions that were prompted by the growing success of Pietro da Cortona on the one hand, and of the Bamboccianti (as well as, in Naples, of the continuing success of the Caravaggisti) on the other.[45] This is no doubt true, but the visit to Frascati did not mark any change in Domenichino's views or a sudden return to forgotten ideas. His position in 1629-1630, when he began to shape Testa's way of thinking about painting, was entirely consistent with the views he held in 1615 or in 1634. Needless to say, the argument put forward by Mahon, in which a sharp distinction is drawn between the position of the critic, Agucchi, as a justification of taste and the position of the painter, Domenichino, as founded on practical common sense does justice to neither.[46]

To this picture Testa's life in Domenichino's studio, and its importance for his own writings as well as for his art, must be added the friendships he would have made there. Regular converse with Poussin must have led in turn to a greater familiarity with other

[43] Mahon, 1947, pp. 111-124. Mahon restates this position in "Poussin au carrefour des années trente," 1960, p. 240. He arrives at this position through a prejudiced reading of Domenichino's letter to Angeloni, ignoring the important point disclosed by the letter, which is that, c. 1632, and following Agucchi's lead, Domenichino was setting out to write about the individual styles of regional schools of painting in Italy. This was a critical endeavor consistent with the classification of paintings by the Carracci, upon which their teaching rested, but still a remarkable one in terms of the state of published criticism in the early 1630s.

[44] Baldinucci, ed. 1847, 4: 75; Passeri, ed. 1934, pp. 44, 67; Malvasia, ed. 1841, 2: 241.

[45] Mahon, 1960, pp. 252-259.

[46] Mahon, 1947, p. 119, argues that Domenichino's contribution to Agucchi's writings, "was rather that of a profes-sional executant whose critical views were of an unsystematized empirical nature—intuitive deductions from the particular, not reasoned generalizations." This contradicts everything we know about Domenichino's serious interest in the general principles of music, architecture, and perspective. See Chapter Two below for a demonstration of how far this is from Testa's own views. Mahon's characterization of Agucchi, p. 125, is equally unjust: "In short, Agucchi's inclinations having led him to regard the pictures of the Carracci, and those of Annibale in particular, as the best of their time, he looks round for a plausible theory which will enable him to justify his taste." For further criticism of Mahon's position, based on the view that Annibale Carracci's own art was predicated on the same principles espoused by Agucchi, see Dempsey, 1977, esp. pp. 1-6, 47-74; see also Chapter Four below.

foreign artists in Rome.[47] More significantly, he could not have failed to become acquainted with Bellori. The specific relationships between Testa's recorded views about painting, and those of Agucchi and Bellori will be discussed in my concluding chapter, but it should be noted here that Domenichino provided the important link between these two men and Testa.[48]

When Domenichino finally left Rome for Naples in the middle of 1631 Testa was not yet a competent painter, and could not have been asked to complete any of his master's projects.[49] Testa had been trained only in drawing, and so, according to Baldinucci, he elected to work in the studio of Pietro da Cortona, despite all the rivalries, because he admired his use of color.[50] Unlike Romanelli, who seems to have made the same change of studios with ease, Testa found the experience miserable, and there is general agreement that Cortona eventually threw him out.[51] Pascoli's account is the most detailed, and is almost certainly based on reliable gossip, even though it is not contemporary. Apparently Cortona put a stop to Testa's constant criticism of his work and manner of teaching by asking him to correct one of his, Cortona's, own paintings one day when the studio was full. Testa was humiliated, and could reply only with stunned silence. His teacher urged him to work harder and talk less, so that he would learn the difference between being a painter and being a critic; only then would he earn the right to do both. In the end Cortona threw Testa out anyway, because of his arrogance, ingratitude, and his conceit.[52] Baldinucci tells the same story in less detail, but he also points to Testa's arrogance, which, he claims, his large physical presence only served to emphasize.[53] Even Passeri, who does not refer to the incident at all, and who always seeks to justify Testa's personal failings, admits that his unsophisticated behavior was easily misunderstood for pride and ambition.[54]

The argument that Testa could not accept criticism is substantiated by later events in his life, but Passeri's account of Cortona's remarks also reflects the latter's opposition to the whole approach to painting that Testa had learned from Domenichino, in which criticism

[47] Bellori, ed. 1976, p. 427, records Poussin's presence in Domenichino's studio. Sterling, 1960, pp. 219, 226, suggests that Poussin worked from the model there from c. 1627-31, after which he went to work in Sacchi's studio. Sandrart, ed. 1925, p. 258, refers to Poussin's conversations with himself, Duquesnoy, and Claude. For a discussion of Poussin's French friends, to whom he might have introduced Testa, see Thuillier, 1960. Although Testa probably did not meet Brebiette, who left for Paris in 1626, several of his early etchings, e.g. *The Garden of Love*, in two versions (Figs. 18 and 19), reflect the influence of Brebiette's *Infant Bacchanals*, etc., for which see Thuillier, 1960, figs. 36-38.

[48] K. Donahue, *DBI, s.v.* "Bellori"; now that Donahue has established that Bellori was born in 1613 there is no reason to postpone his experience in Domenichino's studio until 1634. Mahon, 1947, p. 147, n. 128, provides a summary of the evidence for the relationship, but naturally places this in 1634; in "Poussin au carrefour," Chastel ed., 1960, p. 252, n. 13, he notes the discovery of the date of birth, but does not revise his argument accordingly. As Mahon himself notes, Pascoli states that Bellori became friendly with Canini while the slightly older student (b. 1609) was studying with Domenichino; he also mentions this before recording Domenichino's departure for Naples. By 1634 Domenichino considered Canini competent to restore the Passignano frescoes at Frascati. This new chronology makes more plausible the possibility that Bellori was already a member of the Academy of St. Luke in 1633, for which see Mahon, 1960, p. 254, n. 16.

[49] Mahon, 1962, p. 64, draws attention to documents indicating that Domenichino settled in Naples only in June, 1631. Francesco Cozza would finish the pendentive of Temperence in S. Carlo ai Catinari; see Bellori, ed. 1976, p. 346, n. 1.

[50] Baldinucci, ed. 1847, 5: 310.

[51] Passeri, ed. 1934, pp. 305-306, reports that Domenichino actually advised Romanelli to try working with Cortona.

[52] Pascoli, 1730-1736, 1: 9-11.

[53] Baldinucci, ed. 1847, 5: 310-311.

[54] Passeri, ed. 1934, p. 184, "E quel che gli aggiungeva di maggior danno, ne veniva incolpato il suo costume, e la sua troppo fastosa baldanza di presunzione; e pure non poteva essere accusato d'altro vizio, che d'una semplice naturalezza, così pura, che veniva battezzata per rozzezza; perche egli non seppe essere di quegli aveduti, che sanno portare nella labbia il riso, tenendo sotto il mantello il rasoio, e la scure per recidere, e troncare affatto l'altrui riputazione, e buono incaminamento."

played a central role, and in which action was to be preceded by contemplation. Testa, who always championed the principle of the mean, recognized that this approach was not without its dangers. Bellori himself suggests that Domenichino might have done better to devote more of his energy when in Naples to painting rather than to thinking abstractly about the theory of harmony, and Testa fully realized that others felt that he too had lost his way in abstract theory when he should have been getting down to work.[55] Such criticism sounds so practical that it is easy to forget the historical context underlying it. Cortona's defense of Sementi, for example, as a young artist whose ease of execution and *franchezza* threatened Domenichino, was not simply a defense of a certain type of natural talent. The *prontezza* of Cortona and the *diligenza* of Domenichino were antithetical as articulated modes of practice and theory as well. In the 1630s the slow-working Sacchi would play out Domenichino's role anew.

According to Passeri, Testa did begin to show some ability as a colorist in Cortona's studio, though he did not remain long enough to allow this to mature.[56] The *Joseph sold to the Ishmaelites* in the Capitoline Museum, formerly in the Sacchetti Collection has been instanced as an example of Testa's Cortonesque manner of around 1631, but the attribution is by no means secure.[57] More certainly from this period is the etching of the *Martyrdom of St. Erasmus* (Fig. 2), which, together with the preparatory drawing for it, relates to Poussin's famous altarpiece for St. Peter's, completed in 1629 after Pietro da Cortona had abandoned the commission in the preceding year.[58] Even more than Poussin, Testa emphasized the expression of violent emotion in the contorted faces of the executioners and by focussing on the central horror of the saint's disembowelment. The small figures of the spectators in the background recall Domenichino's manipulation of scale in mediating foreground and background figures, as in the *Flagellation of St. Andrew* in S. Gregorio Magno. It is, however, Testa's extreme expression of the *affetti* that declares his sympathy with the way Domenichino, Poussin, and Sacchi all approached their themes.[59] The details of Cortona's design are not known, but there is no reason to believe that any such emphasis would have been placed on the expression of emotion.[60] In reworking this particular composition of Poussin's, which was associated with Cortona through the original commission, Testa pointedly dissociated himself from the blandness of his teacher's representation of figures in action.

[55] Bellori, ed. 1976, p. 361; for Testa's comments see the Notebook, 60.A.5. and Chapter Three below.

[56] Passeri, ed. 1934, p. 183. Baldinucci, ed. 1847, 5: 310, also points to his mastery of Cortona's manner.

[57] Harris, 1967, p. 39, accepts the work, dating it c. 1631; Hartmann, 1970, pp. 43-45, 123-124, cites Ramdohr's early attribution to Testa, which she accepts cautiously, pointing to the attribution to Raffaellino Bottalla in an eighteenth-century inventory of the Sacchetti collection; Schleier, 1970, p. 667, rejects the work, proposing an attribution to Pier Francesco Mola; Waterhouse, 1976, p. 116, points to the smaller version in the Galleria Spinola, Genoa, and states of the Capitoline picture that, "It is fashionable at present to doubt the attribution," while continuing to give the picture to Testa. I remain skeptical about the attribution.

[58] The drawing is in the collection of the Duke of Devon-
shire, Chatsworth, Inv. no. 603; 266 x 202, pen and brown ink. The history of the St. Peter's commission is summarized by Blunt, 1966, no. 97.

[59] Compare, for example, to Sacchi's *St. Anthony of Padua reviving a dead man*, c. 1632/3, for which see note 98 below.

[60] The two drawings previously believed to record Cortona's design have now been rejected. I agree with Blunt's recent determination, 1979, pp. 141-142, that Uffizi 3032S should be considered a later studio drawing. This means that it now follows Testa's print in showing Minerva in a background niche, rather than *vice versa*. Blunt also notes U. V. Fischer's attribution of the other drawing associated with Cortona's *St. Erasmus*, i.e., Windsor 11991 (originally catalogued by Blunt among the French drawings as a "feeble imitator of Poussin" before he gave it to Cortona), to Giacinto Gimignani.

THE RETURN TO LUCCA IN 1632

Testa dedicated the second state of the *Martyrdom of St. Erasmus* to Stefano Garbesi, a Lucchese cleric, and this serves as a reminder that Testa, like other young Lucchese painters, continued to maintain the closest ties with the republic, even while seeking to establish himself in Rome.[61] The etching of *Saints Interceding with the Virgin on Behalf of the Victims of the Plague* (Fig. 3) reveals Testa's concern for affairs at home especially vividly.[62] Plague struck Lucca in 1630, having passed from Milan to the duchies of Parma and Modena, and thence to Ferrara and Bologna.[63] The pestilence abated with the coming of winter, only to return with new fury in the spring of 1631.[64] Testa's print refers quite specifically to Lucca, for the Torre Guinigi appears in the background, and two of the saints praying to the Virgin can be identified as S. Martino and S. Paolino, patrons of the city.[65] They beseech the Virgin on behalf of the dead and dying at their feet, rather than giving thanks, and so the print must have been made in Rome in 1631 when the plague was at its height and when the quarantine regulations would have prevented Testa from going to Lucca.

The vertical emphasis of the architecture to the right and the delicate contours defining the clouds to the left, both point to the close relationship between this etching and the *Martyrdom of St. Erasmus*. In both prints Testa accomplishes the same exaggeration of facial features through the inflection of eyebrows and mouths by simple flicks of the etching needle. In both prints Testa creates folds in draperies through delicate parallel hatchings, always avoiding contours in the internal modelling (though he does not yet draw these hatchings across whole groups of figures, as he was to do in the later 1630s). Whereas the architectural background of the plague print is, as we have noted, closely modelled on the *Martyrdom of St. Erasmus*, and so ultimately derived from Poussin, there is little to connect it to Poussin's contemporary, and equally topical work, the *Plague at Ashdod*.[66] Already, early in his career, Testa shows his independence of Poussin and his dedication to the invention of new compositions specifically designed for his native city.

Testa's return to Lucca in 1632 must have been prompted by his concern for affairs at home; his embarrassment at being thrown out of Cortona's studio made an escape from Rome doubly attractive.[67] He hoped, according to Passeri, that a success in Lucca would make it possible for him to return to Rome as an artist with a reputation, no longer as a struggling student.[68] The commission to paint a fresco over the gate in the old west wall of the Cortile degli Svizzeri in the Palazzo degli Anziani gave Testa a start in the impoverished

[61] First and second states bear the inscription "S. Erasmo ora pro nobis." The second state is inscribed: "Allo spirito nobile del mio Benefattore il Sig.ʳ Stefano Garbesi suo servo Pietro Testa Dona et Dedica." A print of the first state in the Albertina carries a draft of the inscription of the second in pen, together with other corrections, in the artist's hand. Hartmann, 1970, p. 27, establishes that Garbesi was a canon of S. Martino, Lucca, from 1653-1658, and is not known to have been in Rome. The pattern of Testa's career may be compared with that of Giovanni Marracci (c. 1637-1704), who also worked in Cortona's studio, after benefitting from Paolini's Academy, but who also continued to work for local patrons.

[62] Hartmann, 1970, pp. 28-30, 128; Harris, 1967, p. 36,

connects the print only with the general outbreak of plague in 1629.

[63] Tommasi, 1847, pp. 542-547.

[64] Tommasi, 1847, pp. 547-548. The winter of 1631 witnessed no such abatement and the quarantine was severely enforced within the city itself.

[65] Cropper, 1977, pp. 90-93; much of what follows concerning Testa and Lucca first appeared in this little known periodical.

[66] Blunt, 1966, no. 22.

[67] See note 91 below for Testa's letter from Lucca to Cassiano dal Pozzo in Rome that establishes his presence there in 1632.

[68] Passeri, ed. 1934, p. 183.

and depopulated city.[69] The fresco has been removed, but in 1973 it was still possible to see how closely it conformed to a drawing in the Ashmolean Museum, Oxford, one of two preliminary drawings known (Fig. 4).[70] This is confirmed by a photograph taken several years earlier, before the wall was allowed to become overgrown with ivy.[71]

The Ashmolean drawing has been traced through to the verso and is in bad condition, but it clearly shows a woman with the fasces of Justice in her right hand. She wears a crown, also an attribute of Justice, and her left breast is bare. A snarling panther, emblematic of the city of Lucca, is to her left, and a second panther is indicated lightly at her other side.[72] Winged Time, around whose knee two putti battle, lies vanquished at her feet, and two other putti fly above her head, displaying a banner. The other preliminary drawing, now in the Louvre (Fig. 5), much more vigorous, with parallel hatchings and strongly gestural lines, represents an earlier idea for the fresco.[73] Its theme, however, is also justice. A seated woman holds scales in her right hand, and the olive branch of peace (which justice brings) in her left. One panther lies at her feet, a ribbon-like banner behind him, and another rears up in the lower right corner, accompanied by putti, and held in rein by the figure of Justice. In the center foreground a putto stands before a schematically rendered shield of the city.

The portrayal of Justice in both drawings accords with Passeri's statement that the fresco showed, "an ideal composition devoted to the administration of good justice in that Republic."[74] Baldinucci was more specific, however, in describing the subject of the fresco as "Liberty in the act of commanding, with Time in chains at her feet," and this, of course, calls to mind the Oxford drawing.[75] The different emphases of the two writers, the one on Justice, and the other on Liberty, have led to some unnecessary confusion about the subject of the fresco. This is easily resolved by setting Testa's civic commission in the context of his understanding of the political traditions of Lucca. A knowledge of this context is doubly important because not only does such knowledge justify the use of the Oxford drawing as the basis for any restoration of the fresco, but also it supports the conclusion, based on the stylistic evidence of the drawings, that Testa worked on this commission in 1632, rather than during his second documented visit in 1637.

Baldinucci's definition of the subject of the fresco as Liberty, a concept at once broader and more peculiarly important to Lucca than that of simple Justice, was indeed the more accurate. The principles of Liberty had been shared by other Tuscan republics, but they

[69] Passeri, ed. 1934, pp. 183-184; Baldinucci, ed. 1847, 5: 313; Hartmann, 1970, pp. 31-33, 123, argues for the same date proposed here; Harris, 1967, p. 55, n. 62, summarizes references to the fresco. The Palazzo degli Anziani, part of an old Ghibelline fortress traditionally attributed to Giotto, was redesigned by Ammanati after an explosion in 1539. Only the northern and eastern walls of the Cortile degli Svizzeri were involved, however, and Testa's fresco was above the gate in the old west wall. For the history of the renovation see Belli Barsali, 1960, esp. p. 51.

[70] The inscription in the lower left corner, *p. testa 1637*, is not autograph and does not, therefore, establish a secure date. See Parker, 1956, p. 482; Harris, 1967, pp. 55-56. The fresco was removed from the wall in the spring of 1976.

[71] The photograph from the archives of the Museo Nazio-nale di Lucca was published by N. d. R., in Pizzi, 1976, p. 7.

[72] Ripa, ed. 1625, p. 279, gives the fasces to the figure of Tribunal Justice. The rather strange form of the panther should be compared to the sculptured panther by Vincenzo Civitali, placed over the Porta Santa Maria in 1593. There is no reason to suggest that the panther stands for anything other than the Republic of Lucca (as suggested by Harris, 1967, p. 51, n. 22 and by Thiem, 1973, p. 20).

[73] Bacou and Viatte, 1968, no. 94, suggest that Testa altered the olive branch to represent the sword of Justice; however the lines across the olive are a form of hatching typical of this period.

[74] Passeri, ed. 1934, p. 183.

[75] Baldinucci, ed. 1847, 5: 313.

were especially important in the political imagery of Lucca, the longest-lived of those republics.[76] The anniversary of the Festa della Libertà, inaugurated in 1369, was celebrated there annually on the first Sunday after Easter, Domenica in Albis, until the Napoleonic suppression in 1798. This first festival celebrated the Emperor Charles IV's liberation of the city, which had been under Pisan rule since 1342. To mark the occasion, the motto "Libertas" was added to the arms of Lucca, and an altar dedicated to Liberty in S. Martino.[77] It was, in fact, liberty gained at a price, but in the following year, 1370, the citizens were able to create an independent republican government with a popularly elected council, from which the Anziani for each *terziere* were drawn by lot.[78] Another event of 1370 links the location of Testa's fresco in the courtyard of the Palazzo degli Anziani even more closely to the Festa della Libertà. Many citizens at first found the broadly based constitution unacceptable, but Francesco Guinigi defended it. As a result the Anziani, together with the Gonfaloniere di Giustizia swore to uphold the constitution. The citizenry followed, gathering together in the Cortile degli Svizzeri itself to swear, hand in hand, to defend the popular republic.[79]

One of the most important moments in the celebration of the annual festival was the parading of the Gran Gonfalone della Libertà, surmounted by olive branches symbolizing peace, unity, and concord.[80] Testa adopted this traditional element of Lucchese political iconography in his first drawing (Fig. 5), showing the central figure with the scales of justice in one hand and the olive branch of peace in the other. The association is, of course, a familiar one, based on the embrace of Justice and Peace in Psalm 85.[81] In the second drawing (Fig. 4) Testa abandoned this theme, and showed instead Justice with the fasces triumphant over Time. The new implication is that, with regard to the health of the republic, justice must work to secure the common good for all time, not just for a generation.[82] Between these two drawings Testa refined his invention, seeking out an image that would present the idea of justice in the Republic of Lucca as precisely as possible, in accordance with his own knowledge of the traditions of Lucca, and of his close reading of Aristotle and Plato.[83] By 1632 the constitution of the republic had changed drastically, but Testa chose to present the virtues of his native city by emphasizing a traditional republican vocabulary that recalls, for example, Ambrogio Lorenzetti's frescoes in Siena, rather than more recent prototypes such as Valentin's *Allegory of Rome*.[84] The survival of Lucca as a republic was

[76] After the fall of Siena in 1555 Lucca was the only republic left in Tuscany.

[77] Angelini, 1969, esp. pp. 27-28; Banti, 1970.

[78] Sismondi, ed. 1906, pp. 396-404; Tommasi, 1847, pp. 216-247; Mancini, 1950, pp. 153-171; Ross and Erichsen, 1912, pp. 51-60.

[79] Tommasi, 1847, p. 244.

[80] Angelini, 1969, p. 19, cites from the description in V. Marchio, *Il forestiere informato delle cose di Lucca* (Lucca, 1721): "Tre Senatori de' tre Terziere portano a vicenda il Gran Gonfalone della Libertà ed in cima alla sua asta vi si rimira l'Uliva segno di Pace, d'Unione e di Concordia."

[81] Psalm 85. 10. Hartmann, 1970, p. 33, n. 2, draws attention to a Lucchese *grosso*, minted in 1668, showing peace and justice represented in the single figure of a woman holding the scales, olive branch and inverted torch in one hand and the sword and palm in the other. The inscription reads "Pax et Iustitia." A star above the woman's head associates her with Astrea and with Aristotle's statement, based on Euripides, that justice is more powerful than the evening or morning star. A leafy crown lies at her feet, together with a book and an axe. The reverse shows two rampant panthers, united by a crown, and with a scroll bearing the inscription "Libertas." Several versions of this design, based on the iconography of the Festival, were minted in the first half of the eighteenth century.

[82] A commonplace statement about Justice, expressed, for example, by Aquinas, S. T. II. i. Q. 96, art. 1.

[83] See Notebook, 57.B., for Testa's reading of Plato's *Republic*, and see Chapter Two below for his extensive reading of Aristotle's *Nicomachean Ethics*. See also Cropper, 1974, pp. 378-381, for Testa's concern for Cato's dedication to republican virtue.

[84] Documents for the establishment of an aristocratic re-

closely tied to such an ability to conserve traditional rhetoric. At the same time, however, as we shall see, Testa appears to have identified his own character and virtue with the traditional virtues of Lucca to an extraordinary extent. For Testa the nostalgia that his contemporaries expressed in terms of Arcadia, was rather prompted by the belief that the moral values he espoused had once flourished in Lucca's Golden Age.

In more immediate terms, the question arises of why the magistrates decided to commission the fresco from Testa at this particular moment. Tyranny is the greatest enemy of liberty (as the Lorenzetti frescoes also show), and the single greatest threat to Lucchese liberty after 1370 arose from Paolo Guinigi's usurpation of power in 1399.[85] His tyrannical rule lasted until August 15, 1430, when a powerful group of citizens expelled him during the war with Florence. A republican government was restored, though the war continued around Lucca until the city was finally freed by Niccolò Piccinino, at the behest of the Visconti, on December 2, 1430.[86] Lucca had regained first its liberty and then its peace, and the grateful citizens, mindful as ever of the rule of law, presented two of their most precious codices, the *Decretals* of Gratian, and three Decades of Livy, to the Duke of Milan in thanks. Thereafter Piccinino's triumphal entry into Lucca was celebrated annually with bonfires and public rejoicing, celebrations that also came to an end only with the Napoleonic suppression.[87] Testa's fresco would have marked the bicentenary of this event, even as a fresco of a panther over the door of the Palazzo degli Anziani itself, commissioned from Zacchia il Vecchio a hundred years before, must have been intended to mark its centenary.[88] A second reason was the plague. In 1631 the Gonfaloniere di Giustizia himself died in the palazzo.[89] When the situation improved the magistrates must have been eager to emphasize the security of the republic by providing a monument to its tradition of liberty. The iconography of Testa's fresco was simple, but appropriate; it provides the first indication of his interest in allegorical invention, something that often tempers even his mythologies and poetic *fantasie*.

In spite of Testa's understanding of the requirements of the commission, his fresco did not please. Passeri records only that the Anziani found the coloring poor.[90] Given Testa's high hopes for success in Lucca, and his personal identification with the ideals of liberty and virtue for which the republic had stood in more prosperous times, it is understandable that he should have wished to leave at once. In August, 1632, he wrote to Cassiano dal Pozzo, begging him to arrange to have the quarantine regulations for travellers to Florence and the Papal States reduced on his behalf.[91] When he left for Rome, Testa bitterly dismissed the lack of recognition he had received and the ungratefulness of his patrons with the old proverb, "I saw you in Lucca, but I only really got to know you in Pisa."—a reference to the tale recorded by Tommaso Buoni of Lucca in his *Nuovo thesoro de' proverbi* (Venice, 1604) about the Lucchese who was not recognized by a Pisan gentleman

public in 1628 are published by Tommasi, 1847, pp. 45-47. See Rubinstein, 1958, esp. pp. 179-189, for the Lorenzetti frescoes, with an explanation of the significance of Justice and the common good.

[85] Rubinstein, 1958, pp. 188-189.

[86] Tommasi, 1847, pp. 278-315; Ross and Erichsen, 1912, pp. 66-74.

[87] Tommasi, 1847, pp. 314-315; Ross and Erichsen, 1912, p. 74.

[88] Pope-Hennessy, 1938, p. 213.

[89] Tommasi, 1847, p. 548.

[90] Passeri, ed. 1934, p. 183.

[91] Bottari and Ticozzi, 1822-1825, 1: 357-358. The letter is dated August 26, 1632.

whom he had entertained in Lucca when he repaid him the visit in Pisa.[92] Testa determined to abandon painting for a while and take up printmaking in earnest.[93]

EVENTS IN ROME, 1632-1637

Little that is certain is known about Testa's life and work between 1632 and his return to Lucca in 1637. Whether or not Cassiano dal Pozzo was able to have the regulations for quarantine relaxed or not, Testa was probably back in Rome by the end of 1632, or early 1633, although his presence there is not documented until two years later. In 1634, as Harris has shown, he was living in the Parish of SS. Vincenzo ed Anastasio. He was twenty years old, living in a rented house, together with a servant, not too far from Poussin and close to the neighborhood of S. Croce de' Lucchese.[94] He had moved by 1635, but this does not necessarily signal a crisis. Passeri describes Testa's struggle for survival in Rome as an existence passed "buscando il vivere," but at this point in the 1630s his life may have held considerable interest and promise.[95] There is every reason to believe that he enjoyed the company of other artists and was involved in the major critical issues they discussed.

Testa was required to make a small non-member's contribution toward the rebuilding of SS. Martino e Luca in 1634, which he may well not have paid, especially considering his feelings toward Pietro da Cortona, president of the Academy of St. Luke from 1634-1636 and architect and promoter of the church.[96] He did, however, attend the famous meeting of the academy on November 14, 1936. This is the only meeting at which Sacchi and Duquesnoy were also both present, and when, therefore, the celebrated debate between Sacchi and Cortona is presumed to have taken place.[97] Since Testa's arrival in Rome, he had been regularly in touch with precisely those artists whose views Sacchi represented, especially Domenichino, Poussin, and Duquesnoy. His own concentration on the expression of the *affetti*, though originally inspired by Domenichino, suggests a careful study of Sacchi's work.[98] Far from being the natural savage, which role he played in emulation of that other consciously uncultivated provincial, Annibale Carracci, Testa was in a position to understand the issues involved as well as any other young painter at the academy.[99] Far from being an unwilling or misled convert he participated in the discussions in and around the academy as a member of a partisan faction.[100]

[92] Passeri, ed. 1934, p. 184: "Sichè egli dicendo in proposito quel trito proverbo, *à Lucca vi rividi*, tornassene à Roma, e si diede con più fervore allo studio." In his note, Hess restates the proverb, "A Lucca ti vidi e a Pisa ti conobbi." Pauli, 1740, p. 257, CXLIII, cites the use of the proverb as Passeri gives it in L. Lippi's *Il Malmantile racquistato*, and, in the form cited by Hess, by Paolo Giovio and others. The proverb could be turned either way to make the Lucchese ingrates in the eyes of the Pisans, or *vice versa*. In Tuscany the saying as reported by Passeri is still used to mean that one will never meet again (because one would never go to Lucca), and stands, therefore, for disbelief.

[93] Passeri, ed. 1934, p. 184.

[94] Testa stayed at this address for only one year; see Harris, 1967, p. 42, esp. n. 67.

[95] Passeri, ed. 1934, p. 185.

[96] Harris, 1967, p. 42. In 1977, p. 34, however, Harris points out that even painters loyal to Cortona regularly failed

to pay dues in this period.

[97] Mahon, 1962, p. 97, presents cogent arguments for this; to his arguments must be added Harris's discovery that Sacchi attended the November 14 meeting (1977, pp. 34, 45, n. 64). Originally Harris believed the meeting to be an unimportant one (1967, p. 42).

[98] In etchings such as the *Martyrdom of St. Erasmus* (Fig. 2), and the *Adoration of the Magi* (Fig. 41), Testa emulates the expression of emotion through inflection of eyebrows and bending of torsos, characteristic of works by Sacchi, such as *St. Anthony of Padua reviving a Dead Man* (dated 1632/3 by Harris, 1977, no. 35), and *Adam Grieving over the Dead Abel* (no. 41).

[99] On Annibale's character as the prototype for Testa, Rosa, and other philosopher-painters of the seventeenth century, see Dempsey, 1977, pp. 41-42.

[100] This issue cannot be challenged often enough. Mahon, 1962, p. 97, even while associating Testa with Du Fresnoy

Testa's circle of fellow artists was enlarged on his return from Lucca by the arrival of Du Fresnoy (1633/4) and his companion Mignard. Du Fresnoy began to gather together material for his *De arte graphica* in the late 1630s, just as Testa was also turning his mind to writing a treatise and to presenting his views on the education and activity of an artist in the etching *Il Liceo della Pittura* (Fig. 89).[101] The similarity of Du Fresnoy's and Testa's ideas, which will be discussed in Chapter Four, strongly suggests that the two artists shared frequent discussions.

Our understanding of Testa in the 1630s as an artist among artists, keeping a lively eye on contemporary issues, is broadened by the evidence for his involvement in a lawsuit brought by the painter Swanevelt against his former pupil Francesco Catalano.[102] Catalano was accused of stealing three paintings by his master and two works by Van Laer from Swanevelt's collection as well as a quantity of azure. The two Van Laer's, which the artist himself had originally given to Swanevelt, were difficult to sell because of their doubtful provenance and obvious value. For a while they were in the shop of a Flemish picture dealer called Botman near the Trevi fountain, where they were seen some time between April and May, 1636, by Giovanni del Campo, another of Swanevelt's pupils. When Botman realized that they were stolen he returned the two pictures to Catalano's partner, Lorenzo da Brocchetti. In his testimony del Campo reported that Pietro Testa, the painter from Lucca, had seen the paintings in Catalano's house and had alerted Swanevelt.[103]

This story indicates that Testa was on friendly terms with the Dutch and Flemish artists who worked around the Via Margutta, as well as with the French. His interest in Swanevelt is not surprising, for Testa shared his feeling for landscape painting; the hermit-painter who took lonely walks around the city and who also experimented with etching must have attracted him. At the same time the evidence of the trial proves, if proof is needed, that Testa's criticism, expressed most vividly in the notes, of artists like Van Laer for demeaning painting through the representation of lowly objects for display in unworthy places was not simply based on conventional hierarchies or borrowed prejudice, but upon his own observation of particular works on the market.[104] One further detail, this concerning the *marchand-amateur* Simonelli, also emerges from the story. According to the testimony, the two paintings by Van Laer were at one point seen in Nicolò Simonelli's rooms. Simonelli proceeded to exchange them with another dealer, Casimiro Roggieri, even though the whole neighborhood knew they were stolen.[105] Simonelli's apparent preparedness to make money on stolen property suggests that Testa's later caricature of him as Midas was not entirely exaggerated.[106]

in the mid-1630s, follows the view that Testa's romantic temperament was in disastrous conflict with his theories of classic idealism.

[101] Mahon, 1960, p. 259, n. 27, cites Bousquet's evidence for the fact that Du Fresnoy, Mignard, and Tortebat were living together in the Parish of S. Maria del Popolo in 1635/6. For Du Fresnoy's arrival in Rome 1633/4, see Thuillier, 1964, pp. 196-197.

[102] Bertolotti, 1880-1885, pp. 127-138.

[103] *Ibid.*, p. 134; this testimony appears to be dated February 24, 1637.

[104] See, e.g., Notebook, 57.B., and also Chapter Three be-

low. Sacchi also owned a Van Laer, according to the inventory published by Harris, 1977, p. 113; see p. 45, n. 63, for evidence that he was made responsible for foreign artists at the Academy of St. Luke on January 8, 1634.

[105] Bertolotti, 1880-1885, pp. 132-133; Dario Ferri, a painter and gilder testified to this.

[106] The drawing is published, with a partial transcription of the letter from Testa to Simonelli on the verso, by Blunt and Cooke, 1960, pp. 115-116, no. 983; see further Haskell, 1963, p. 124, who points to Simonelli's good relations with Rosa and Castiglione, and his role as *marchand-amateur*.

RETURN TO LUCCA, 1637

Two works by Testa, *Moses striking Water from the Rock*, and *Laban Searching for the Idols Concealed by Rachel*, are documented in the Giustiniani inventory of 1638.[107] Apart from these two paintings, which are now in the Bildegalerie, Potsdam-Sanssouci, few works can be dated securely between Testa's return to Rome in 1632/3 and his second documented visit to Lucca in 1637. Testa's employment in connection with this second visit provides a sort of closing bracket to this part of his career, and so it is best considered first, before we consider the attribution of other projects to the intervening years. By 1637 Testa's hopes for success in Lucca had revived. They were pinned on two major opportunities: the appointment of Marcantonio Franciotti as bishop of Lucca in 1637 and the commission Testa received in 1636 from Cosimo Bernardini to paint an altarpiece for his family chapel in San Romano, Lucca.

Franciotti had been made cardinal *in petto* in 1633, but he did not take up the title of San Clemente until August, 1637, after his appointment was announced as bishop of Lucca in March of that year.[108] Apparently Testa was so anxious to accompany Franciotti to Lucca that Cassiano dal Pozzo suspected he was prepared to leave work owed to him unfinished, and so had the artist thrown into the Tor di Nona. Testa wrote to Cassiano from prison, insisting that he had intended to take proper leave of him, and that Nicolas Poussin would vouch for this.[109] Cassiano must have let him go, for Pier Francesco Mola signed and dated a portrait drawing of Testa in Lucca before the end of the year.[110]

Testa's desire to win the support of Franciotti is illustrated by the two etchings he dedicated to the new bishop, the *Allegory in Honor of the Arrival of Cardinal Franciotti as Bishop of Lucca* and the *Allegory of Painting* (Figs. 6 & 13). The first of these was probably published as soon as possible after Franciotti's appointment, and in fact Testa seems to have adapted another composition for the occasion as quickly as possible. In the etching, the Franciotti griphon, accompanied by the Theological Virtues, flies on a cloud toward a figure representing the River Serchio who is flanked by personifications of the habits of fortitude, wisdom, temperance, and justice. The griphon is identified as the emblem of the new bishop by the staff held by two putti on the bank of the river; the implication is that the Serchio welcomes its new governor since the moral virtues of the Republic of Lucca (which must be inculcated) will thereby be strengthened by the theological virtues (which are the gifts of grace). The inscription emphasizes that the arrival of the bishop will inspire the devotions of love (something that is implied in any case by the advent of Christian love or charity):

> All' apparir del' indico Pastore
> Ecco che ride il suol l'onda festeggia

[107] Bildegalerie, Staatliche Schlösser und Gärten, Potsdam-Sanssouci, Inv. no. I 2368, and Depot no. 5048. See Salerno, 1960, pp. 97-98. Brigstocke, 1976, illustrates *Laban Searching for the Idols Concealed by Rachel* as fig. 32. For the *Moses Striking Water from the Rock* Testa drew inspiration not only from Poussin's painting of the same theme, but also from his two pendant paintings for Amadeo dal Pozzo, *The Crossing of the Red Sea* and *The Adoration of the Golden Calf*.

[108] Cardella, 1792-1797, 6: 319-323; Pastor, ed. 1938, 29: 163-164; Harris, 1967, p. 51, n. 22. The Franciotti were an ancient Lucchese family, related to the della Rovere. Marcantonio was known for his simple, austere life and was buried in the Gesù in 1666. His will is preserved in Lucca (BGL Arnolfini 17).

[109] Bottari and Ticozzi, 1822-1825, 1: 359-360.

[110] Musée Fabre, Montpellier, Inv. no. 864-2-228.

D'innocente desio l'Aria vezzegia
Tutto di gioia intorno avanza Amore
Qua del purpureo Griffo il volo augusto
Scorto e da fè da Carità da Speme
Serchio gl' applaude e qua gl' accorre insieme
Il forte il saggio il temperato il Giusto

With the exception of a dismembered drawing, now in Weimar (Fig. 7), which includes the figures of the three Theological Virtues, none of the drawings relating most closely to the print includes the features described in the inscription and appearing in the final work; it is on this account that it seems most likely that Testa adapted a composition originally intended for another purpose when the opportunity suddenly came to recommend himself to Franciotti.[111] Because the group of drawings for this unidentified and abandoned project is so closely related to the 1637 print dedicated to Franciotti, it provides a clear point of reference for Testa's drawings of c. 1636/7, as well as providing a means for watching the artist evolve his invention. All the drawings express a kind of celebration of Lucca that is related iconographically to the fresco of Liberty, as well as to the theme of the Triumph of Love from Petrarch's *Triumphs*, the first book ever to be published in Lucca and an important inspiration to Testa.[112] An analysis of the development of the iconography of the original project toward the moment when Testa decided to adapt the design for the Franciotti print makes it possible to order the drawings.

A drawing now in the Ashmolean Museum, Oxford (Fig. 8), stands at the furthest remove, both iconographically and compositionally, from the final stage. Its theme develops out of ideals presented in the fresco of Liberty, with which it has, therefore, even been associated; it is, rather, a link between the two projects.[113] The scene is set in an arbor of trees, garlanded with swags, with buildings set against a hilly landscape indicated in the background. Venus appears in her chariot in the center, together with a winged Cupid, putti, and a globe. She scatters petals upon the ground as a second, winged Cupid forces two bound *amorini* to draw her chariot (thus suggesting that this Venus has to do with restrained pleasures rather than licentiousness). To the left and right appear groups of figures whose similarity to those in the second print dedicated to Franciotti, the *Allegory of Painting* (Fig. 13), argues for their identification as philosophers.[114] A general theme is therefore struck, that this Venus, and the Loves who shoot down arrows from above, inflame men with the love of learning. The presence of the Lucchese panther, moreover, indicates that this philosophers' grove has a more specific dedication. At the bottom of the sheet Testa wrote two statements concerning the opposition of the pleasure of men in a state of liberty to the enslavement of licentiousness. The first reads, "Libertà [onestà] di piaceri honesti e virtuosi," and the second, which refers to the satyr across whose figure it runs, reads, "Satiro legato per la lussuria figurare." Testa returns here to a theme expressed five years earlier in the fresco: Honest pleasure can only exist where licentious desires are moderated and restrained by laws. The pleasures of the philosopher and the poet are the

[111] See also Thiem, 1973, p. 24, n. 1, and pl. 8.
[112] Published May 17, 1477, by B. de Civitali; see the discussion of the etching *Altro diletto ch'imparar non trovo* (this inscription being a line from Petrarch) in Chapter Two below.
[113] Parker, 1956, p. 482.
[114] Their relationship to similar figures in Poussin's *Parnassus* serves to underscore this.

kind Testa believed to be appropriate to free men in a free republic. This was an idea he would also develop with particular reference to the philosopher-painter in the *Altro diletto ch' imparar non trovo* (Fig. 88) in the first half of the 1640s.[115]

In the next two drawings in the group (Figs. 9 & 10) Testa treats the theme of Love willingly surrendering to the restraints of Virtue rather differently. In the Louvre drawing (Fig. 9), the Triumph of Love progresses from the left background across a verdant river valley overlooked by craggy peaks. The procession is led by the Graces followed by Cupid in a chariot, seated upon a globe, with a torch in his hand, thus expressing the familiar theme "Omnia vincit Amor." The destination of the procession is clear, for in the foreground Venus (identified by the doves in her chariot) has dismounted to kneel in homage at the foot of a river god to whom she is presented by a little Love with his bow and arrows. Behind the river god a panther rears his snarling head, and two putti crown the arms of Lucca. The river is, then, the Serchio, whose winding path had been traced out by S. Frediano, and whose mercurial changes in mood were the source of disaster and salvation to the city. As a result the Serchio came to stand for the government of Lucca as well as any constitution.[116] Here the River appears in his most benign aspect, attended by Minerva (or Fortitude) and a figure with the snake of Prudence in her right hand. Testa's argument is that the virtues that govern Lucca are so worthy of love that Venus herself, at the head of a procession of universally triumphant love, submits to them.

The drawing in the British Museum (Fig. 10) is very similar in subject, although some of the figures are less clearly defined. Despite this it probably stands in a closer relationship to the final drawing in the series, now in Stockholm (Fig. 11) because the procession moves in a shallower space from right to left than in the drawings just discussed. Cupid's chariot has drawn closer and is surrounded by dancing figures, one of them clearly a satyr, whose presence indicates that unrestrained passions are about to submit themselves at the foot of the Serchio. Venus leads the way, and as she makes her obeisance, again presented by a little Love who holds out his bow and arrows, the Serchio makes a welcoming gesture by stretching out his left hand.[117] The group attending the Serchio is larger than in the Louvre drawing, including not only Prudence and Fortitude, but also a pair of nymphs and four unidentifiable figures. There is no coat of arms, but putti crown the Serchio, and the Lucchese panther reclines in the left foreground; he too is crowned by a Love, while another rides upon his back.

The Stockholm drawing (Fig. 11) presents both a new departure and a reassembling of elements from the earlier drawings. Like the Oxford drawing it is vertical in format, and the scene is set in a grove of trees, decorated with swags now carried aloft by putti. The

[115] See Ripa, ed. 1625, p. 513, for "Piacere honesto." Testa could also have drawn upon his reading of Plato's *Republic*, in which the soul maddened by the tyranny of passion and lust is described as suffering the same misery as a state enslaved by a tyrant, whereas the philosopher can experience and ensure true freedom and happiness through his pursuit of wisdom. Testa also digested Aristotle's argument concerning the meaning of pleasure and its role in the life of a virtuous man in the *Nicomachean Ethics*, where almost the whole of Books 7 and 10 are dedicated to the question. In Aristotle's free republic public felicity (a theme addressed directly by

Testa in the etching *Il Liceo della Pittura*, discussed in Chapter Two) can only be won by those who have first won their liberty through the exercise of Virtue, the greatest form of which is, of course, justice.

[116] The frescoes by Amico Aspertini in S. Frediano illustrate this story. The most famous occasion on which the Lucchese showed their respect for, and understanding of, their river was when they succeeded in thwarting Brunelleschi's plans to flood it in 1430, for which see Tommasi, 1847, pp. 304-305. In the 1620s the need for embankments was a continuing source of friction between Lucca and Florence.

whole of the lower section, however, is a clarification of the composition of the British Museum drawing. The theme is again the submission of love and desire to the Serchio and its city, although Venus presents Amor to the river, rather than bending in homage herself. Love now surrenders his weapons to the Serchio willingly and Cupid's chariot brings up the rear, accompanied by a satyr, appropriately bound. Behind the Serchio only the figures of Fortitude and Prudence, now at the center of a group of four, are identifiable.[118] Putti play fearlessly with the Lucchese panther in the foreground, but they do not crown him, for Testa has introduced the arms of the city in a new way. In the upper left corner putti hang a swag before a tablet intended to bear an inscription and set in an architectural frame. Above this two figures support a crowned shield inscribed with the motto of the Republic of Lucca, "Libertas." Again the moral is the same: love, desire, and the unrestrained passions, willingly submit to the restraints of liberty, realized in the government of Lucca. It seems that the decision to convert this project into a print dedicated to Franciotti came in the process of making this drawing, for although the theme of Love's Triumph and submission is perpetuated in the lower section, in the upper half Testa created the space for the inscription, quoted above, that would ultimately require the removal of the Triumph of Love theme and its substitution by the griphon from Franciotti's family crest. The four figures behind the Serchio in this drawing appear as they do in the print, Fortitude and Wisdom being clearly identifiable on the left. Their presence indicates that Testa had decided to dedicate the print to Franciotti, in accordance with the words of the inscription, but that he had not yet fully adapted the whole invention.

The inscription provides the key to understanding the springtime scene that greets the bishop, to identifying the Serchio and the Theological Virtues, and also to the identities of the virtues who stand behind the River. Testa (who must have been working closely with the anonymous Marinist verse) did not choose to personify the usual group of cardinal virtues. He presented instead only three of them, Justice, Temperance, and Fortitude, or rather the personifications of the active habits of those virtues. For the fourth, Prudence, he substituted Il Saggio, the Wise. This immediately identifies Testa's source for the virtues of Lucca as Plato's *Republic*, wherein Plato identifies the civic virtues (and those of the individual citizen) as justice, temperance, fortitude, and wisdom. In Plato's scheme wisdom as a civic virtue includes the habit of being prudent; Plato does not make Aristotle's clear distinction between wisdom and prudence. We have here, therefore, a series of political virtues with a Platonic bias, rather than a straightforwardly Aristotelian system.[119] This Platonic bias recalls the theme of the fresco of Liberty, where Justice holds the fasces, rather than the sword of juridical punishment. Testa wished to underline the fact that Lucca

[117] This figure closely resembles the figure of the nymph of the Castalian Spring in Poussin's *Parnassus*.

[118] The figure stooping to collect water is adapted from the Venus in Fig. 10, but also reflects Testa's study of Poussin's *Moses Striking the Rock*.

[119] Plato *Republic* 427D-434C, 441C-443B. These same qualities of the soul are also defined in *Phaedo* 69B, 114E-115A; in the first of these two passages Plato argues that courage, temperance, and justice cannot exist without wisdom. Testa shows Temperance, or the Temperate, as a woman holding a bridle; Minerva represents the Courageous; the fig-

ure on the far right in magisterial robes is the Just, involved in judging lawsuits, and therefore also holding the sword of justice in her hand; the wise is given the appearance of Prudence through the attribute of the snake. Testa may be seeking to reconcile Plato and Aristotle in this way, for in the *Nicomachean Ethics* Aristotle is concerned to show how prudence creates the conditions for the development of wisdom. Possibly Testa's inscription is related to the *Gryphus Purpuratus* of Michelangelo Tortigliani, or to Guido Vannini's *Panegyricum Carmen*. I have not located a copy of either of these poems, published in 1637.

was dedicated to the ideal of justice in the broadest and most perfect sense, that its government commanded the consent of the governed, and, paradoxically, given its early history, was free from licentiousness, which Plato associated with pure democracy. Testa accomplished this by making it clear that the virtues of the Republic of Lucca were, in his ideal vision, identical with those of Plato's republic, itself founded on the ideal of justice.[120]

By the 1630s the association of a group of virtues with the arms of a bishop or cardinal was commonplace.[121] Testa's originality, apart from his translation of Plato's ideas into visual form, lies in the way in which he transformed the conventions of heraldic and allegorical imagery into a poetic fiction, very much as Bernini succeeded in doing in, for example, the tomb of Urban VIII. His desire to endow familiar conceits with a personal, and peculiarly Lucchese significance, in such a fiction explains one last detail in the composition. The Lucchese panther, who in the earlier drawings submitted so readily to the attentions of love, now roars at the advent of Franciotti and has to be restrained by the putti around his head and shoulders. This fierce reaction is Testa's way of representing the proud independence of the city. A lengthy conflict between Lucca and Rome, which gradually focused upon the differing legal claims of ecclesiastical immunity and civil liberty, had become especially bitter during the long tenure of Bishop Alessandro Guidiccione, Franciotti's immediate predecessor.[122] The Anziani had campaigned continually for his removal, and so it was that Testa expressed in his print the hope that, with the arrival of a new bishop, the theological virtues would at last be united with those of the state. Unfortunately, Franciotti's career was disastrous. The open disputes between civil and ecclesiastical authorities, especially between the Anziani and members of Franciotti's family, became so bitter that Urban VIII was compelled to remove the bishop in September of 1639. Lucca was placed under interdict from 1640-1643, and the reconciliation staged by Testa in his print never materialized.[123] With this failure came Testa's own failure to secure a powerful local patron, and the improvement of his status in Rome that might have followed.

In 1637 all this lay in the future, however, and Testa had further reason to be optimistic about a success in Lucca, for in that year he also completed his first altarpiece for a Lucchese church, *The Vision of St. Dominic of Soriano*, for the Bernardini Chapel in San Romano, seat of the powerful Dominican order in the city (Fig. 12).[124] The church contained many of the city's greatest treasures, most notably Civitali's tomb of San Romano and Fra Bartolommeo's *Madonna della Misericordia*. The commission also placed Testa in the company of more contemporary artists, such as Coppola, Viola, Passignano, Manetti, and Paolini, all of whom were at work on altarpieces for newly dedicated chapels from the mid-1630s on.[125]

[120] The dangers of democracy are described by Plato in *Republic* 555B-569C.

[121] See, for example, Bertelà and Ferrari, 1973, nos. 263, 646, 688, 689, and 944, this last being Girolamo Buonvisi's stemma accompanied by personifications of justice and prudence; see also DeGrazia Bohlin, 1979, pp. 48-50, for Agostino Carracci's responsibility for the popularization of this type of print.

[122] Pastor, ed. 1938, 29: 175; Tommasi, 1847, pp. 493-529. The long-standing bad relations between Lucca and the pope had been exacerbated by the accusation that Lucca had harbored Protestants during the pontificate of Paul III.

[123] Pastor, ed. 1938, 29: 175; Tommasi, 1847, pp. 553-571.

Franciotti resigned the bishopric completely in 1645.

[124] The Bernardini Chapel is the second on the left side of the nave. Hartmann, 1970, p. 51, transcribes an eighteenth-century copy of a document (Memorie del Convento di S. Romano di Lucca da B. Garbesi, Arch. Conv. S. Rom., MS, fol. 36v.) referring to Bernardini's commissioning of the painting from Testa. This document was first mentioned in the publication of the work by Abbrescia and Lera, 1966, p. 30, pl. 11.

[125] Abbrescia and Lera, 1966, pp. 27-34. The reorganization culminated in the rebuilding of the interior in 1661, on the designs of Giovanni Buonvisi and Francesco Buonamici.

Testa had to incorporate within his painting an icon of St. Dominic, and because this requirement played such an influential role in Testa's invention (for which no drawings have yet come to light) the peculiarly Dominican subject must be considered if Testa's treatment of it is to be fully understood.[126] The vision had occurred in 1530 at the Convent of Soriano in the year of its establishment. On September 15, one of the friars in the new community was presented with an image of St. Dominic by the Virgin herself, accompanied by St. Catherine and the Magdalen. Consequently this image was revered as a sign of the Virgin's good will toward the order, and miracles soon came to be attributed to it.[127] The subject was still rather unusual in 1636/7, and Testa's altarpiece undoubtedly had a direct influence on the later versions painted by two of his contemporaries: Pier Francesco Mola, who saw Testa's picture when he was in Lucca in 1637, and Giovanni Benedetto Castiglione. Testa's version differs from theirs, however, in that it physically incorporates an existing replica of the acheiropoetic image.[128] It is because of this that Testa gave great emphasis to the actual creation of the image and not simply to the vision of the friar. One of the little angels floating on a cloud in the lower-left corner holds a palette and brushes to indicate that this is indeed an image not made by human hands, but painted by divine love.[129]

The altarpiece is outstanding among Testa's few known canvasses, despite the fact that its appearance is now marred by the lights later placed around the image of the saint and by the gilded crown attached to the Virgin. The colors are light in value, often acid in hue, particularly the lime green and blue of St. Catherine's sleeve set against the pink of her skirt and her violet blue drapery and the green and orange drapery of the putto on the cloud below her. This acid quality recalls passages in *The Presentation of the Virgin* (Fig. 34) of a few years later, but the strangely contrasting dark areas that appear there are lacking here; so much so that Baldinucci remarked upon the fact that the *Vision* resembled a fresco.[130] Baldinucci intended this as a criticism of Testa's light values at this point in his career, for he seems to have preferred Testa's darker manner, seen especially in works of the 1640s. His objections are not entirely just, however, for although the overall tonality of this painting is indeed very blonde, Testa was also concerned to model in light. This is especially clear in his treatment of the flesh tones; one side of the Magdalene's arm, for

[126] "Nella chiesa di San Romano è altresì una sua tavola, che contiene un vano in mezzo, ove è l'immagine di San Domenico" (Baldinucci, ed. 1847, 5: 313).

[127] Frangipane, 1621; Mâle, 1932, pp. 470-471; Barilaro, 1968.

[128] The earliest representation I have found is by Carlo Bonone for S. Domenico in Ferrara. Closest to Testa's version in incorporating a framed replica of the image is a painting in the S. Domenico Chapel in S. Marco, Florence. Baldinucci, ed. 1847, 4: 167, attributes this to Matteo Rosselli, whereas Richa, 1754-1762, 3: 137-138, refers to A. F. Gori's view that the original was by Simone Ferri and may then have been replaced by Rosselli. The painting is in very bad condition. Zurbaran painted the theme for the former Church of San Pablo, Seville, in 1626, for which see Brown, 1973, pl. 3; for Mola's version of 1648 see Cocke, 1972, pp. 60-61, pl. 34; for Castiglione's painting see Percy, 1971, pp. 41-42, and fig. 33. That most of these images date to almost a century after the vision reflects the fact that it was some time before the image in the remote foundation received official recognition. Graces were awarded to it only in 1609, and the fame of the image and the convent grew accordingly until, in 1629, it was determined that no more novices could be admitted. In 1636 St. Dominic was made the protector of the Kingdom of Naples, the decree being confirmed by Urban VIII, for which see Barilaro, 1968, pp. 10-18, and 56-68. In 1638 Gigli records that a painting of St. Dominic, based on the image at Soriano, had been placed in the Minerva and that many miracles were worked by it as the crowds flocking to see it grew daily. Most of the artists who made copies of the image had never seen it, and, indeed, Frangipane, 1621, p. 49, reports that copying the original was nearly impossible because a great light emanated from it to impede those who tried. The convent was littered with half-finished copies, abandoned in despair. Nanni, 1650, p. 756, records that the original is tempera on canvas!

[129] The version attributed to Rosselli shows none of this inventiveness in accounting for the creation of the image.

[130] Baldinucci, ed. 1847, 5: 313.

example, is exposed to the glory of light around the Virgin and appears as a brilliant, creamy white; immediately beside this, where the flesh curves away from the light, Testa made a line of dark shadow, but then, where the lower part of the arm picks up reflected light from the Magdalene's drapery, this flesh becomes silvery again.

A preoccupation with the rendering of reflected light and the modulation of forms through the delicate juxtaposition of dark shadow and highlight also emerges in Testa's prints and in his notes from the late 1630s on. In the *Vision of St. Dominic of Soriano*, however, several elements suggest a more specific interest. The smooth high foreheads of the women, their delicate eyebrows, softly shaded eyes, and small mouths, the very simple, clear folds in their draperies forming distinct planes of light about their ridges, and especially the pastelled limes, oranges, and gray-blues that made Baldinucci think of fresco rather than of oils, all irresistibly recall the work of Federico Barocci. Nor is it surprising that Testa, having been criticized for his use of color in his previous Lucchese commission, should have turned to Barocci as a coloristic exemplar. Barocci's fame as a colorist was universal, and Testa would have learned from Domenichino of the esteem in which he was held by the Carracci and the painters of the Bolognese reform.[131] Moreover, there existed in the Buonvisi Collection in Lucca a famous work by the artist, the *Noli me tangere*. Francesco Vanni, the greatest of Barocci's immediate followers, seems to have been popular in Lucca, and his *Crucified Christ speaking to St. Thomas Aquinas* hangs in another chapel in San Romano.[132]

The San Romano altarpiece represents only a brief experiment in terms of Testa's painting, but the lessons he learned from Barocci's use of value, both in his paintings and his rare prints, continued to bring rewards in Testa's own etchings. In these the increasing attention to the richness of the surface and to the use of chiaroscuro full of coloristic suggestiveness could only have been achieved by a close study of Barocci's use of the medium and of Agostino Carracci's earlier emulation of it.[133] Indeed, Testa's increasing preoccupation with richly contrasting values of black and white in his prints, which renders them, in their rare best states so much more vibrant than those by Salvator Rosa, no doubt contributed to the sharpening of the contrast between *chiaro* and *scuro* in his paintings, where the results were much less attractive. The *Allegory in Honor of the Arrival of Cardinal Franciotti as Bishop of Lucca*, however, displays the delicacy of the values of Barocci's paintings and of the morphology of his female figures.

The final work that can be dated securely to this moment in Testa's career is the second etching dedicated to Franciotti, the *Allegory of Painting* (Fig. 13).[134] In the dedication to

[131] Dempsey, 1977, pp. 7-36, esp. pp. 7-20.

[132] Emiliani, 1975, p. 159, no. 178; both Bellori and Baldinucci mention the work, which was commissioned by the Buonvisi. The Vanni is in his later, darker manner; see Abbrescia and Lera, 1966, p. 27 and pl. 6.

[133] See, e.g., Barocci's etching of the *Annunciation*, in Pillsbury and Richards, 1978, pp. 105-106. This etching illustrates both the type of physiognomy that Testa favored in the *Vision of St. Dominic* and the emphasis upon a full range of values that he adopted in his prints.

[134] The inscription reads: "All' Eminent.mo et Rev.mo Sig.re et Prōn mio col.mo Il Sig.re Card. Franciotti/Divotiss.mo è l'o-

sequio mio verso V. Em. ma tanto abbandonato dalle forze, che non trova modo da comparire. Compenserò il difetto della fortuna, con l'ingegno dell'arte, e chia/mando la Pittura cō suoi seguaci, otterò forse, che riceva tra l'ombre sue un debil lume almeno del mio sinceriss. affetto, e cō suoi colori riduca, come si puo sotto gli occhi/ di V. Em. una forma di sua natura invisibile, cioè l'animo mio colmo di riverenza, e di fede. Di V. Em. divotiss.mo servitore Pietro Testa." Any etching with an inscription not conforming to this in terms of the arrangement of lines is almost certainly a copy. Because of this problem of the copies I have left all abbreviations in the inscription.

Franciotti Testa refers to his own weakened state, to the dark shadows cast by his bad fortune, sentiments quite opposed to the optimism expressed in the first Franciotti print. The *Allegory of Painting* was, therefore, most likely issued upon Testa's return to Rome, when disappointments began to set in, both for himself and for the cardinal bishop, and it marks in an important way the beginning of Testa's interest in using his prints as a highly personal vehicle for expressing ideas about the foundation of the art of painting. Both the print itself and the preparatory drawings for it are closely related to Testa's single most important published theoretical statement, the etching *Il Liceo della Pittura* (Fig. 89). The general composition of this latter print is indebted to Raphael's *School of Athens*, and several drawings that can be associated with both *Il Liceo della Pittura* and the *Allegory of Painting* reveal Testa's close study of the fresco. The most significant of these is a sheet of figure studies, swiftly and fluently drawn, now in Haarlem (Fig. 14).[135] Although the drawing itself exists quite independently of the two prints, many of the figures it presents, based on Raphael's *School of Athens*, ultimately found their place in one or the other. The priest in the upper right-hand corner, for example, prefigures the sacrificing priest in the background of the *Liceo*, and the female figure above the cluster of orators at the center of the drawing is the model for the statue in the attic of the *Liceo* that appears to the left of the right-hand arch.[136] The seated woman at the center of the drawing, on the other hand, who appears as the object of intense philosophical discourse, is as closely related to the similarly discussed figure at the center of the *Allegory of Painting* (notwithstanding her changed attributes), as are the philosophers around her to their counterparts in *Il Liceo della Pittura*. Although the etched line in the *Allegory* is much looser and more coloristic than in the *Liceo*, where the small figures are dominated by the elegant, sharply delineated architecture, the preparatory drawings are close in style; for example, the preparatory drawing in the British Museum for the *Allegory of Painting* (Fig. 15), compares very closely in its broad hatchings and slender figure proportions to the Haarlem drawing and to other drawings for the *Liceo*, such as the cut-out figure drawings in the Louvre (Fig. 91). It would seem, therefore, that, given the clear association of the *Allegory of Painting* with Franciotti and the consequent dating of it c. 1637/8, that *Il Liceo della Pittura* must also be dated c. 1638. From the time that Testa returned to Rome from Lucca, this year seems to have been a turning point in his career.

WORK IN ROME, 1632-1637

A group of works may now be assigned to the years intervening between the Lucchese projects of 1632 and 1637 with some confidence. The absence of documentation in most cases and Testa's frequent practice of making different kinds of drawings in preparation for each print, however, make the establishment of a precisely detailed chronology impossible. Bellini, following the general opinion of others and relying especially upon Harris, has placed the etching of *St. Jerome in the Wilderness* (Fig. 16), the two versions of *The Garden*

[135] Inscribed by the artist in pen and brown ink: "Guarda dove le savi/ Verità/ Ironia opposta al' vanto/ metafisica tratta di Dio." See Cropper, 1974, p. 377.

[136] These statues may also be based on those in the frontispiece to D. Barbaro's edition of Vitruvius, *I Dieci Libri dell'Architettura* (Venice, 1556).

of Love (Figs. 18 & 19), and the *Allegory of the Flight into Egypt* (Fig. 26) in this period.[137] The *St. Jerome* stands closest to the *St. Erasmus*, both in terms of the relative lack of contrast in the silvery effect of the etching and in terms of the lack of fluency in the preparatory drawing (Fig. 17).[138] The print reveals Testa's growing interest in landscape and his ability to achieve a brilliant luminosity in the contrast between shady trees and summer sky through the simple contrast of black lines on white paper.

In the first version of *The Garden of Love* (Fig. 18), Testa attempted to expand the range of chiaroscuro somewhat, especially in the landscape, but he was not entirely successful, and the rarity of the print suggests that he abandoned the plate because of foul biting. In the second vertical version (Fig. 19), dedicated to Girolamo Buonvisi, Testa overcame these technical difficulties. Dense shadow in the dark masses of tree trunks to the left is created by many delicate and quite distinct lines; these are, however, still contained within the forms they modulate. These shadows are also enhanced by small patches of light, often next to the deepest shadow, where the whiteness of the paper comes through. In the airy landscape in the distance, by contrast, craggy peaks are outlined against a clear white sky; vertical parallel hatchings create a middle value. Two leafy trees are drawn in simple contour in the middleground, and since they are pure white against the delicate greyness of the hills, they seem to glisten in the heat of the sun, rendering the shady foreground all the more inviting. This is exactly the kind of organized chiaroscuro that Testa endorses in his notes, opposing it to mindless and exaggerated *sfumato* that suggests that the artist is polishing a mirror rather than modelling a tree trunk.[139]

The large number of preparatory drawings for *The Garden of Venus* (Fig. 20) and *Venus and Adonis* (Fig. 22) reveals that such variety of chiaroscuro in the final plate was accomplished by the same careful preparation that Testa brought to the invention of a subject. Sometimes Testa used a delicate wash as well as hatching (Figs. 21 & 23), and he also varied the intensity of the lines (something that does not appear in the drawings for the *St. Erasmus* and *St. Jerome*). In several of these drawings, for example, the drawing for *The Garden of Venus* now in the Uffizi (Fig. 21), Testa appears to have divided the composition into working areas, making crosses where he wanted to achieve a spot of *chiaro* on the plate. Often the drawings have been cut, and in several cases at least it appears that Testa himself cut out figures and important pieces of his composition drawings in order to concentrate on particular sections of the plate. A drawing in the Uffizi for the upper-right corner of the *Venus and Adonis* (Fig. 24) illustrates this most clearly. These divisions in the drawings, however, do not appear to reflect the stages of working on the plate, for an artist's proof of a section of *The Garden of Venus* now in the Print Room of the Metropolitan Museum, New York (Fig. 25), does not correspond to the divisions established in the composition drawing.

Testa's dedication to printmaking in these years led to his rapid mastery of the medium and his increasing exploitation of its technical possibilities. The *Allegory of the Flight into Egypt* (Fig. 26), with its dedication to Cassiano dal Pozzo supporting a date of c. 1636/7,

[137] Harris, 1967, p. 36.
[138] Hartmann, 1970, p. 129, calls the drawing a copy of a lost original; Harris, 1967, accepts the drawing, reproducing it as her fig. 39b.
[139] Notebook, 43.

displays an even greater luminosity than the prints just discussed.[140] The obvious influence of Duquesnoy upon Testa's crowds of flying putti with potbellies and tousled forelocks suggests that this quality of illumination was inspired by the optical effects of light upon carved marble. In this etching, as in the nearly contemporary prints dedicated to Franciotti, Testa drew parallel hatchings diagonally across a whole group of figures (in this case Joseph and the angel). This enabled him to enclose figures in a unified atmosphere of half shadow more successfully than he could through interior modelling. The *Allegory in Honor of Cardinal Franciotti* is the most adventurous of the three closely contemporary prints in this respect. Here Testa sought a delicate plate-tone, perhaps by immersing the whole plate for a moment, to provide a silvery middle value out of which he burnished highlights and into which he etched shadows.[141]

The shimmering values that Testa began to work for in his etchings in the middle of the 1630s (especially in areas of landscape) could also be translated into color, and not all the paintings from this period are as consistently light in value as the *Vision of St. Dominic*. Brilliance of contrast between an acidic, shining landscape, and a darker area enveloping the figures sets the *Venus and Adonis* (Fig. 27, generally dated 1635/6, slightly before the print) and *The Massacre of the Innocents* (Fig. 28, probably from the very end of the 1630s) at some distance apart from the picture in Lucca that Baldinucci had compared to a fresco.[142] The atmospheric effects in these two works depend upon the experiments of the etchings. Testa has rarely been given credit for his experiments in etching, as opposed to the originality of his inventions. Petrucci, because he considered the slow and careful preparation for actual work on the plate that this sort of controlled chiaroscuro demands antithetical to the process of etching (and to those traits in Testa's personality that attracted him to the medium), concluded that some of the more experimental prints, in which more than one biting may have been involved, were not etched by Testa himself.[143] Yet there is every reason to believe that Testa maintained complete control over the process of etching the plate; the number of preparatory drawings and his study of other artist printmakers (especially Barocci) point to this. Certainly he was not interested in the kind of spontaneity that etching had offered Parmigianino, and he does not seem to have shared Rembrandt's interest in reworking the plate once he had achieved his intended effect; changes in state

[140] The inscription reads: "All' Ill.mo S.re et Prone mio Oss.mo il Sig. Cav. Cassiano dal Pozzo/ Fuggendo il benedetto Giesù ancor fanciullo, in Egitto, per alluntanarsi dall'ira d'Erode, cominciò a calcare il faticoso sentiero de' primi affanni,/ onde nell'istesso punto, in cui l'Angelo portò l'aviso della fuga à Gioseppe, si rappresenta ch'egli in effetto abbracciasse la croce decretatagli ab eterno/ dal Padre, et accettata da esso nel primo instante della sua Concezzione. l'espressione di questo divoto pensiero vien' da me presētata al merito incomparabile/ di V.S. Ill.ma, quale supplico à gradir nell angustia del presēte foglio la grandezza della mia osservanza, et humilmente la riverisco. P. Testa." Haskell, 1963, pp. 110-111, points to the unusual character of Testa's invention. Although it was not uncommon to combine Joseph's Dream with the Flight into Egypt, Testa has complicated the subject even more here, by including the Angel of the Annunciation, who proffers the nails of the Crucifixion, indicating that Christ's Passion began at his conception.

[141] That the effect of a middle value is a true plate-tone, and not merely the result of irregular wiping on a few examples, is confirmed by the fact that it also appears in the second state, published by the Antwerp printmaker F. V. Wyngaerde. The two rare states of this etching are often confused with careful copies in the opposite sense, in which this tone does not appear. Obviously the plate used by Wyngaerde and not to be found in the Calcografia Nazionale with Testa's others, left Rome fairly soon after Testa's death, if not before. See note 134 above concerning the inscription on these copies.

[142] Brigstocke's argument, 1976, pp. 19-20, for this dating of *The Massacre of the Innocents* is convincing.

[143] Petrucci, 1936, pp. 413-416. His argument is based on an interpretation of Testa's personality as too impatient to become involved in such processes. Again, the determination to cast Testa as a neurotic, unable to concentrate, completely flies in the face of all the evidence of his painstaking work.

tend to be limited to the addition of inscriptions or minor corrections. Testa looked upon printmaking in an entirely different way. For him the process of making an etching was the same as the traditional process of making a painting in oil on canvas requiring as many preliminary drawings, figure studies, and studies of chiaroscuro. As time passed, his prints indeed came to assume the status of paintings and engaged his full attention. Testa used the etching needle not as an instrument of drawing, but as a substitute for his brush.

Testa's practice of making so many preparatory drawings for his prints was not, however, prompted by technical needs only; it cannot be separated from the increasingly complicated inventions of his designs, what Passeri calls Testa's "favole" or "concetti di suo capriccio."[144] The similarity of the themes treated by Testa to those of Poussin and Pietro da Cortona in the 1630s has tended to obscure the emergence of Testa as an independent poet-painter in these years. The increasing importance of landscape, on the other hand, often populated by crowds of putti has caused much of this work to be characterized as "neo-Venetian."[145] Undoubtedly, Testa, like Poussin, studied Titian's mythologies in the Aldobrandini Collection.[146] In terms of simple morphology, however, Testa's putti with their bulging stomachs and windblown forelocks, as we have seen in the case of the *Allegory of the Flight into Egypt*, more closely resemble the sculptured putti of Duquesnoy than the painted forms of Titian; the resemblance suggests that he tended to see Titian's work through the eyes of this intermediary.[147]

If Testa, like Poussin, studied Titian directly, he did this in the context of the larger issue of the nature of poetic invention, of the ways in which simple themes from Ovid or Philostratus, for example, could be embellished to give them new meaning, rather than in terms of a general taste for "neo-Venetian" style. Titian's inventions offered guidance in the debate about the difference between fable, allegory, and history, but any notion of a general neo-Venetian movement in a purely eclectic sense is meaningless; the Carracci had looked long and hard at the Venetians fifty years before Poussin and Testa, and Venetian painting had entered the mainstream of the academic tradition at that point. We should rather consider that about 1636 Testa, following Poussin's lead, began to incorporate syncretistic interpretation in his mythologies (the *Venus and Adonis*, for example) and to combine several episodes, together with exegesis, in his religious inventions (as in the *Massacre of the Innocents* and the *Allegory of the Flight*); he also began to render what Passeri calls "cose ideali" (such as the *Allegory in Honor of Franciotti*) as poetic fictions. The latter example has been discussed in some detail; the *Massacre of the Innocents*, in which the Flight into Egypt and Innocence with her lamb are combined with the main scene, is relatively straightforward;[148] the *Allegory of the Flight*, which combines the Annunciation

[144] Passeri, ed. 1934, p. 184.

[145] Harris, 1967, p. 36, for example, connects these works with a "Neo-Venetian movement current in Rome during the late 1620's and early 1630's," even while pointing to the important influence of Duquesnoy on Testa. Hartmann, 1970, p. 31, also persists in the notion of a neo-Venetian movement, tracing its origins back to Longhi, 1916, pp. 245-314; see especially p. 280 for Longhi's judgment that all of Testa's best work belongs to this period.

[146] See Blunt, 1967, text vol., pp. 59, 122-123, 146-147, for

references to Poussin's study of the Este Bacchanals.

[147] Hartmann, 1970, p. 31, cites Mariette's notice of this similarity between Testa and Duquesnoy; see also Stampfle and Bean, 1967, p. 61.

[148] Hartmann, 1970, p. 46, connects the work with Poussin's Chantilly *Massacre of the Innocents* and the Dulwich *Return from the Flight* and identifies the female figure in the heavens as Innocence, rather than as St. Agnes. See also Mitchell, 1937-1938, pp. 340-343, and Voss, 1957.

to the Virgin, the foretelling of the Passion (in the form of the Angel proffering the nails), the Dream of Joseph, and the main theme of Christ's assumption of his Passion at the moment of the Flight, all of them associated with the theme of the Triumph of the Cross, is less so, but the inscription helps to make much of this clear.[149] The meaning of the *Venus and Adonis*, in both the painted and etched versions, is more complex. A closer examination of it shows how deep was Testa's relationship to Poussin at this moment when both artists were interested in the kinds of poetic themes treated by Titian in the Aldobrandini *Bacchanals*.

Testa's painting, now in Vienna, is unusual in its representation of a dead boar and a living Adonis who succumbs to the appeals of Venus (Fig. 27).[150] In reversing the conventional mythological relationships of the fable, Testa is closely following Poussin's *Venus and Adonis* in the Rhode Island School of Design.[151] Both the painting and the print after it are, like Poussin's painting, determined by a Macrobian analysis of the meaning of myth.[152] Accordingly, the death of Adonis represents the loss of the sun's power at the onset of winter, symbolized by the boar, when the sun enters into the lower hemisphere of the zodiac, over which Proserpina presides. The death of Adonis is, however, only temporary, and with the springtime ascent of the sun into the upper hemisphere, whose tutelary spirit is Venus, the boar of winter dies and the god returns to life.[153] Testa's *Venus and Adonis*, which Menghini described in dedicating the print to Antinori as a "singularissima inventione," follows Poussin's painting in being concerned, through the reversal of the sequence of the myth, not with simple narrative exposition, but with a presentation of the philosophical principles underlying the poetic fable, making of the painting and the print an allegory of spring.[154]

Passeri reports that this kind of embellishment of narrative was critized by some, and he himself expressed the opinion that, although he admired Testa's inventions, such amplifications had no place in histories, whether sacred or profane.[155] Passeri's view almost certainly reflects a sharpening of criteria for the invention of different kinds of subject—history, fable, or allegory—that resulted from discussions in and around the Academy of St. Luke in the mid-1630s. Toward the end of this decade, Testa himself began to make clearer distinctions between his mythologies and his ideal conceptions.

By 1637, Testa's intellectual character was formed. His admiration for Domenichino

[149] See note 52 above; see also Percy, 1971, p. 124, for reference to C. Minott's discussion of Fulgentius's comment that it was proper for Christ to flee into Egypt, even as it was fitting for him to die on the Cross. See also Voss, 1957, pp. 33-34, figs. 5, and 7, for examples by Nuvolone and Calvaert.

[150] In spite of the fact that Passeri, ed. 1934, p. 184, describes Testa's etching of this work as the first after one of his own paintings, Poch-Kalous, 1961, pp. 62-63, argues that the painting is after the print rather than before. There is no evidence to support this.

[151] Blunt, 1966, no. 185, dates the work, which is badly rubbed, soon after 1630.

[152] Testa gave the print to Niccolò Menghini the sculptor, who, after restoring Roman sculpture in the Palazzo Barberini, became supervisor of the Barberini collection of antiqui-

ties until his death in 1655. For his employment as superintendent of antiquities see Minto, 1953, p. 13; see further Pollak, 1928-1931, 1: 3, 164; and 2: 131 and 499-501. An additional note on Menghini's sculpture is provided by Lavin, 1968, p. 230, n. 52.

[153] This interpretation of the myth according to Macrobius is put forward by F. Castellini in Ripa, ed. 1645, pp. 292-298, in the entry entitled "Invernata da Macrobio."

[154] For a discussion of this interpretation of the Adonis myth in relation to Poussin, see Dempsey, 1966, pp. 224-233. The inclusion of Macrobius's interpretation in Ripa's *Iconologia*, of course, further supports the view expressed by Dempsey that syncretistic ideas were widely accepted and disseminated in the seventeenth century, with Macrobius being an important source.

[155] Passeri, ed. 1934, p. 186.

inspired him to persist in his study of Vitruvius. Cassiano dal Pozzo encouraged his love of antiquity and especially of the historiated sarcophagi that would play such an important role in the invention and composition of his own histories and allegories.[156] Friendship with Poussin could only reinforce his own views concerning the moral and intellectual foundations of painting. Both Poussin and Cassiano dal Pozzo afforded direct access to the writings of Leonardo da Vinci—in themselves as important as any formal debates for turning the minds of those who studied them toward the problem of acquiring and teaching the art of painting.[157] Poussin made it easier for Testa to become acquainted with the French community in Rome, and the presence of Du Fresnoy could only encourage Testa to formulate his philosophy of art. In the remaining thirteen years of his life Testa set out to do this with great consistency, both in his prints and in his notes. The beginnings of this introspection were already evident in 1637 in the *Allegory of Painting*. What then changed was Testa's attitude toward himself and his own career. After his return from Lucca in 1637, Testa began to believe that he was a victim of fortune, dogged by envy, and increasingly engaged in a psychomachean battle to maintain his own virtue against all odds. He was only twenty-five years old, but already compelled to recognize that he would always stand outside the mainstream of success in Rome and that his native city could provide no substitute. Unlike Du Fresnoy, however, who gave himself over almost entirely to speculation at this time, Testa continued to produce, struggling persistently to gain recognition.

THE MIDDLE YEARS, 1637-1644

The years from 1637-1644 are equally difficult to document. Testa's relations with Cassiano dal Pozzo seem to have cooled after the misunderstanding in 1637, and Poussin's absence from Rome between the autumn of 1640 and December, 1642, must have contributed to this. After the *Allegory of the Flight* no further works were dedicated to Testa's early patron. Testa's own presence in Rome, as Harris has shown, is confirmed by his attending a meeting of the Academy of St. Luke in August, 1641.[158] Two letters document his continued presence in the city; these are dated August 29, 1642, and October 21, 1642. In the second Testa addresses an unnamed patron in Lucca, requesting a small sketch of the particular landscape he was to include in a painting.[159] As this implies, Testa was still dependent on his Lucchese patrons, and among them Girolamo Buonvisi emerges as the most loyal.

Brigstocke, in his excellent summary of Testa's paintings from these years, has argued that *The Adoration of the Shepherds* in the National Gallery of Scotland (Fig. 29), together with the related drawings, should be dated c. 1640.[160] His argument, which takes Poussin's *Adoration of the Shepherds* in London (c. 1637) and the San Romano altarpiece as *termini post quem* now has received confirmation through the discovery of a drawing by Testa for one of the sarcophagus reliefs in the Raimondi Chapel in S. Pietro in Montorio (Figs. 30 &

[156] For an example of the importance of these sarcophagi upon Testa's allegories, see the discussion of the etchings of the *Four Seasons* below.

[157] See Cropper, 1980, for a summary of Poussin's and Cassiano's studies of Leonardo.

[158] Harris, 1967, p. 42.

[159] Published by Campori, 1866, p. 108; present whereabouts unknown.

[160] Brigstocke, 1976, pp. 17-19.

31). This drawing, together with another drawing for the project now in the Metropolitan Museum (Fig. 32), is very close in style to the preparatory drawings for the *Adoration of the Shepherds* (e.g., Fig. 33).[161] In both projects Testa adopted the same slender, often contorted, and twisted figures. The chapel in S. Pietro in Montorio, commissioned by Francesco Raimondi in his will (opened upon his death in May, 1638), was conceded to Francesco's brother, Marcello, in February, 1640.[162] While the project was not finished for several years, a date of 1640/1 established for the beginning of the decorative scheme fits very well with the stylistic evidence of the drawings by Testa. The execution of the two sarcophagus reliefs is traditionally ascribed to Bernini's pupil Nicolas Sale, and nothing is known of any official charge to Testa in connection with this commission. Both historiated coffins, which are closely related to the relief executed by Stefano Speranza for the tomb of the Countess Matilda in 1634-1636, reflect a taste for ancient sarcophagi, which of course Testa shared.[163] If indeed Wittkower is correct in stating that Sale was not available before 1642, then it is possible that Testa was involved in the design before the sculptor, who then merely executed it.[164] Certainly, the unique subject, a combination of Carnival and Ash Wednesday, supports the idea that Testa was involved in the invention in a significant way (and, though there are no drawings to support this, the conclusion would follow that he also had a hand in the design of the *Vision of Ezechiel* on the other sarcophagus). Wittkower, who did not know the Testa drawings, pointed to the relationship between the dancing figures to the left of the relief and Poussin's *Dance to the Music of Time* from the late 1630s, then in the Palazzo Rospigliosi.[165] This group in the finished relief differs from the figures in the known drawings, but the similarity to Poussin's painting suggests that it was a drawing by Testa that provided the final solution. The physiognomies of several of the individual figures and the morphology of forms, all point to this.[166] Possibly Testa met Bernini through their mutual friend Lelio Guidiccioni. Testa, Poussin, Mignard, Du Fresnoy, and Sale all lived in the same neighborhood, close to Bernini. He could also have become involved with the project through his Lucchese connections. Francesco Raimondi (whose will provided for the chapel) was a cleric of the Apostolic Camera of Urban VIII and so in touch with Girolamo Buonvisi, who held the same office at the same time.[167] Cardinal Franciotti had close ties to S. Pietro in Montorio, for he was a friend of the Irish Franciscan historian, Luke Wadding, who lived there. If this last relationship does not account for Testa's work in the Raimondi Chapel, it certainly does explain how his nephew, Giovanni Cesare, came to etch the frontispiece for Wadding's great book, the *Scriptores Ordinis Minorum*, published in 1650 with a dedication to Franciotti.[168] We can only spec-

[161] For Fig. 32 see Bean, 1979, pp. 278-279, no. 366. For Fig. 33 see Parker, 1956, p. 481. Brigstocke, 1976, publishes another, similar drawing, formerly in the Aschaffenburg Collection, as his fig. 29.

[162] Lavin, 1980, text vol., pp. 188-192, for the documents.

[163] These reliefs also resemble ceremonial biers, or *cataletti*, one of which actually appears in the right-hand Raimondi relief; see Pollak, 1928-1931, 2: 204-215 for payments for the tomb, 1633-1637.

[164] Wittkower, 1966, p. 214.

[165] *Ibid.*, p. 215.

[166] Compare, for example, the forms of the naked breasts of the female figures, especially the one in the rear of the group receiving the ashes, to those of Testa's figures in, e.g., the drawing for the *Allegory in Honor of Innocent X* (Fig. 68); compare also the physiognomy and hairstyle of the child in the foreground of the same group to Testa's putti, whose resemblance in turn to Duquesnoy's putti has already been noted.

[167] Raimondi so describes himself in his will, dated May 6, 1634; Lavin, 1980, p. 191.

[168] Harris, 1967, pp. 58-59, n. 106, records that Wadding was one of the two chief executors of the will of the "Aegidius Ursinus de Vivariis" in whose chapel in Santa Maria dell'Anima Testa painted his ill-fated frescoes. The design for the print, whose purpose as the frontispiece to Wadding's book has never

ulate about the Raimondi reliefs, but it would seem certain that Testa's involvement was direct and that Bernini knew of it. Testa was a natural choice for the execution of such designs given his unparalleled knowledge of ancient sarcophagi based on his work for Cassiano dal Pozzo and his ability to endow his drawings of them with the illusion of relief.

Brigstocke dates *The Presentation of the Virgin*, from S. Croce dei Lucchese (Fig. 34), slightly after the *Adoration of the Shepherds* (i.e., 1640/1).[169] Another recently discovered drawing, this one precisely dated, lends support to his argument. The drawing (Fig. 35) appears on the same sheet as a letter dated August 29, 1642, which it illustrates. In the letter, again to an unnamed patron, Testa presents his drawing as a rough sketch of his first idea explaining that a more finished drawing would leave him less fresh for the work itself.[170] The subject of the drawing, the dedication of a church, is very rare, and there is no record of Testa having completed the project.[171] As a document of pontifical ceremony it should be associated with Poussin's first series of *Sacraments*, six of which were completed before his departure for Paris in 1640. The Raimondi relief also reflects an interest in the documentation of the Liturgy, of course, and the scene of the Ash Wednesday ritual ties it, too, to Poussin's *Sacraments*, especially to the *Confirmation*, now in the collection of the Duke of Rutland at Belvoir Castle.[172]

Although the theme of the drawing on the letter of 1642 is so closely allied to the theme of the Raimondi relief, the figures themselves are quite different from those in the drawing, and, in fact, more similar to those in the relief itself. Their proportions are more voluminous, and their faces share the same craggy features as the figures in the preparatory drawings for the *Presentation of the Virgin* (e.g., Fig. 37).[173] In drawings for both projects the faces are modelled in the same way, one half left entirely white, the other almost cancelled by parallel, diagonal hatchings that stop abruptly beside the lighted half. Similar lines are used to model the full draperies, which are delineated by freely curving lines from a forcefully moving pen. The stricter organization of contrasts of light and shade in these drawings is also found in the *Presentation of the Virgin* itself, which, now that it can be more securely dated 1641/2, provides an important link between the San Romano altarpiece of 1636/7, and the altarpiece for S. Martino ai Monti discussed below. Brigstocke has also suggested that the *Massacre of the Innocents* in the Palazzo Spada, and an apparently unfinished project for a *Holy Family with St. Anne* belong to the period 1638-1641, and

been recognized, must have been produced under Testa's supervision. For his nephew's career, see Bellini, 1976. Bellini lists the frontispiece but fails to recognize its purpose.

[169] Brigstocke, 1976, pp. 19-22.

[170] A separate drawing has been glued to the verso of the left half, behind the *Consecration* (Fig. 36). The letter reads as follows:

Molto Illustre Signor et Padron mio Osservandissimo: Eccoli la prima fantasia del pens[ie]ro della Consecratione che vostra Signoria accenna, non posso in queste cose limar molto per esser frescho tanto piu nel'hop[er]a; a lei basti una certa dispositione, e come io m'appiglio, e mi fermo ne' suoi cenni; e aspettando cio che stabilira e la misura. Li faccio humilissima reverenza.

Roma di 29 Ag[os]to 1642
Di Vostra Signoria Molto Illustre
Servitore Affetionatissimo

Sono molti (come Vostra Signoria sa) l'atti della Consecratione, qui s'accenna quando il Pastore va per via di certi gradi, mettendo i lumi a quel n[ume]ro di 12 croce che lei sa. Lontano, accennato le arche de' corpi s[anti] e vasi, e che so io.

Pietro Testa

[171] The scene is quite rare outside pontifical illustrations. It appears in Gaspare Mola's medal, commissioned by Urban VIII to commemorate the consecration of St. Peter's on November 18, 1626, thirteen hundred years after its original consecration by Constantine. It is even possible that Testa's painting would have recorded the same event, though some years later, but there is not sufficient evidence to be sure of this.

[172] Blunt, 1966, no. 106; see also pp. 73-74 for establishment of the chronology of the series.

[173] A second drawing for the same project appears on the

this seems essentially sound. To this group I would now add the group of drawings for another unfinished project for an altarpiece devoted to *The Virgin and Child with SS. Martino and Paolino.*[174]

Testa's ill-fated commission to paint frescoes in the St. Lambert Chapel in S. Maria dell'Anima must antedate the group of works associated with the etching of *Winter*, dated 1644. Passeri discusses these frescoes immediately after the etching *Il Liceo della Pittura*, but before the *Triumph of Painting*, which was almost certainly finished by 1644.[175] While he is highly selective in the works he chooses to discuss, Passeri tends to follow the actual sequence of works quite accurately. Harris has suggested that the frescoes must date c. 1642/4, partly on the basis of this, and partly through circumstantial documentary evidence.[176] Several preparatory drawings help to confirm this view (Figs. 38 & 39).[177] They show Testa moving toward a bolder chiaroscuro manner, employing washes to suggest increasingly ample forms and draperies—all quite different from the earlier delicacy of form and illumination derived from Duquesnoy, whose van der Eyden and Vrybuch tombs also in S. Maria dell'Anima obviously no longer served as inspiration. Unfortunately, writes Passeri, this new brilliance and bravura in Testa's drawings turned to coldness in the final work.[178] There is every reason to believe that Testa was again immediately criticized for his shortcomings as a fresco painter, and even, as Harris has argued, that shortly before his death Testa knew that Miel had been asked to repaint the chapel.[179] It is an irony that Miel, an artist who represented everything Testa despised, should have been asked to undertake the destruction of Testa's work.[180]

Although it is now possible, as Brigstocke has shown, to assign more works to the middle years of Testa's working life, it is also clear that his career as a painter was not flourishing. Not only were the St. Lambert frescoes badly received and a significant number of projects never finished, but also the completed works reflect an extremely limited range of patronage. The St. Lambert commission came almost certainly as a result of the friendship between a member of the Ursinus family, whose chapel it was, and Cardinal Franciotti, although Franciotti himself does not appear to have commissioned paintings from Testa.[181] Cardinal Spada probably bought the *Massacre of the Innocents* and the *Sacrifice of Iphigenia.*[182] The S. Croce altarpiece was for Testa's most supportive Lucchese patron, Girolamo Buonvisi.[183] Despite his connections with Buonvisi, Franciotti, Cassiano dal Pozzo,

recto, but this is less similar to the *Consecration* drawing because of the use of wash; see Bean, 1979, pp. 273-275, n. 362.

[174] Brigstocke, 1976, pp. 19-24. In my 1977 article, pp. 90-93, I suggested a date c. 1632-36 for these drawings. See also Brigstocke, 1978, p. 123. At the time of these publications Brigstocke agreed with my view of the importance of Lucca at this moment in Testa's career. I, however, disagreed with his dating of this group of drawings. On the basis of the new evidence I would now agree with his conclusions.

[175] For the date of *The Triumph of Painting*, based on its dedication to Buonvisi as cleric of the Apostolic Camera, and therefore before the death of Urban VIII in 1644, see Harris, 1967, p. 38.

[176] *Ibid.*, pp. 45-46.

[177] For Fig. 38 see Blunt and Cooke, 1960, p. 114. For Fig. 39 see Bean, 1959, p. 33. Hartmann, 1970, pp. 97-98,

suggests that Testa's original plan was to fresco the wall above the altarpiece, and the indication of the frame of an altarpiece in Fig. 38 supports this. She also points to other studies in the Teylers Stichting, Haarlem (B 84 verso) and the London art market.

[178] Passeri, ed. 1934, p. 185, "quella bravura, che mostrava con la penna, e con lo stilo, si convertiva in altrettanta freddura nel pennello, e nel colore."

[179] Harris, 1967, pp. 46-49. See Chapter Three below for Testa's opposition to Miel's type of painting.

[180] Passeri, ed. 1934, p. 222, records that Miel painted over "quelle istorie del santo che vi haveva dipinto il Lucchesino."

[181] Harris, 1967, pp. 45, 58-59, and n. 106.

[182] Zeri, 1953, pp. 131-132.

[183] See Note 11 above for the assignment of chapels in 1631; the *Presentation* was in Buonvisi's chapel, the second to the right, for which see Passeri, ed. 1934, p. 187. The picture

and possibly the Raimondi, however, he seems to have failed to recommend himself to the Barberini. He had missed his opportunity to work with Pietro da Cortona in the Gran Salone of the Palazzo Barberini, and his poor relations with his former teacher may have sealed his fate. Only one drawing, possibly for a frontispiece, includes the Barberini bees (Fig. 40).[184] Unlike Poussin, who also avoided large fresco commissions for the Barberini, or anyone else, Testa failed to inspire the friendly, confident support of a wide enough group of private collectors. By 1644 it must have been obvious to him that he had failed to build a reliable foundation for success as a painter, whether in Rome or in Lucca.

Yet Passeri, Baldinucci, and Sandrart all chose to include Testa in their biographies, while ignoring other unsuccessful pupils of Domenichino and Cortona, and while, with the exception of Sandrart, generally paying little attention to printmaking. Of all the biographers Passeri is the most explicit about the significance of Testa's life. Passeri was concerned with the character of individual artistic genius, and he saw in Testa the perfect example of the melancholic artist whose virtue was destined to be unaided by Fortune from the very moment of his birth.[185] This interpretation was only partially grounded in Passeri's theories of artistic genius; it was also based on Testa's own prints, in which the artist took as his subject the theme of the oppression of artistic virtue by invidious vice, and which in turn influenced the subsequent imagery of artistic genius. The emergence of this theme in his etchings parallels the dwindling of Testa's hopes of success as a painter. The affair of the St. Lambert frescoes in particular prompted Testa to make his melancholic view of himself and his fate into the major theme of his art. It is to this area of his work in the period 1637-1644 that we now turn, recognizing that it brought Testa a special kind of fame.

THE MIDDLE YEARS, 1637-1644: THE ETCHINGS

Passeri was attracted to Testa's prints, not only for their subject matter, but also for their technical virtuosity, their prolific inventiveness, and their ambitious scale; indeed, the new importance that Testa began to accord his prints in the late 1630s can hardly be overestimated. Beginning with the *Venus and Adonis* (Fig. 22), and especially after the success of *Il Liceo della Pittura*, Testa discovered, even created, a new public for himself, and for the art of the print. Passeri concedes that Testa would have become much more famous had the *Liceo* been a painting rather than a print. However, Testa's prints were in fact admired in the same critical terms as paintings, for their variety, distribution of parts, richness of costume, expression of the *affetti*, and so on. Passeri also singles out the *brio* with which Testa handled his medium, the novelty of his peregrine inventions—and these, we should remember, could not have been so easily expressed in a traditionally commis-

was sold to Cardinal Valenti Gonzaga in 1746, who sold it to Triebl in Berlin in 1763. Catherine the Great purchased the work in 1771; see Hartmann, 1970, p. 227.

[184] This allegory, showing the Fame of the Barberini overcoming Time and Envy, is probably for a frontispiece, but none is known. See also the related drawing at Windsor,

Royal Library, Inv. no. 5935 (Blunt and Cooke, 1960, p. 116, no. 987). Both drawings must date before 1644, and their similarity to the drawings for the St. Lambert frescoes supports the dating of both projects c. 1642/3.

[185] See Hess's comments in his introduction to Passeri, ed. 1934, p. xvi.

sioned work.[186] During these years prints begin to replace paintings as Testa's prime concern and assume for him the status of paintings as independent works.

The argument has already been advanced that *Il Liceo della Pittura* (Fig. 89) is closely related to the *Allegory of Painting*, c. 1638. This confirms Passeri's implication that the print, which will be discussed in detail in Chapter Two, was the first of Testa's major efforts on large paper, *in foglio papale*. Passeri places the etchings of *The Adoration of the Magi*, dedicated to Buonvisi (Fig. 41), and *The Sacrifice of Iphigenia* (Fig. 42) immediately after *Il Liceo della Pittura*.[187] The dedication of the former to Buonvisi as cleric of the Apostolic Camera means that this surely antedates the death of Urban VIII in 1644.[188] The figures are also similar to those in the dated drawing of the *Consecration of a Church*. The relationship between architecture and landscape, primary and secondary events, combined with the way in which the stage is set back from the foreground plane, creating the illusion that we are looking across a sort of trough at the bottom of the composition, all also recall similar features in the *Massacre of the Innocents*. The *Sacrifice of Iphigenia* and related drawings (Figs. 42-45) on the other hand, show the increasing clarity of drawing and restraint of emotion that characterizes works of the 1640s.[189] The print like the slightly later painting of the same subject is a set-piece in the representation of emotion, the explicit reactions of the soldiers and priests providing a foil to the Timanthean concealment of the face of Agamemnon, whose grief is too great to be expressed.[190] Although Testa began his study of the *affetti* very early in his career, it is in the later 1630s that this study becomes systematic, partially inspired by similar interests on the part of Domenichino, Poussin, and Sacchi, as we have seen, but now furthered by Testa's direct study of Xenophon and Aristotle.[191] On one of the drawings for the *Death of Sinorix* discussed below (Fig. 52) Testa made nine caricatured profiles, unconnected with the main drawing. It was only at the moment when his belief in the cathartic moral power of the representation of emotion in tragic scenes led him to a thorough study of the *affetti* that Testa, like the Carracci and Domenichino before him, turned to the game of reverse effects, opposing the exaggerations of caricature to those of expression.[192]

Despite the similarities often noted between it and the *Martyrdom of St. Erasmus* (Fig. 2), and the obvious relationship to works by Domenichino and Cortona, I would argue that *The Death of Sinorix* (Fig. 46) must date to these transitional years.[193] This seems justified when the drawings are taken into consideration. These may be roughly divided into two groups for a horizontal and a vertical composition respectively (Figs. 49, 50, 51, 52 and Figs. 47, 48).[194] Harris argued that these were for two different projects, with only

[186] Passeri, ed. 1934, pp. 184-186.

[187] Harris, 1967, pp. 37-38, and p. 51, n. 20. Hartmann, 1970, pp. 130-131, places these prints before 1637, but without justification.

[188] Harris, 1967, p. 38.

[189] A second, similar study appears on the verso of Fig. 43. For Fig. 45 see Brigstocke, 1976, p. 23, fig. 47.

[190] Pliny, *Natural History* xxxv. 36.73. For the painting see p. 60 below.

[191] Testa records his study of Xenophon in the Notebook, 56; for his study of Aristotle in connection with the expres-

sion of the *affetti* see Cropper, 1974, pp. 377-382.

[192] In *The Triumph of Painting* (Fig. 54) Testa requires the conquest of the emotions, and of their expression, by any painter striving for Parnassus.

[193] Bellini also suggests a date c. 1640. Harris, 1967, p. 36, dates the print c. 1631, but places some of the drawings later, c. 1640. Hartmann, 1970, p. 35, dates print and drawings c. 1632/3.

[194] With the exception of the Uffizi drawing, the group reproduced was gathered together by Vitzthum, 1964. Vitzthum also argues for the progression of drawings argued here.

the horizontal version being completed. The drawings now in the Pierpont Morgan Library for a horizontal composition (e.g. Fig. 49), however, are every bit as bold and dramatic in their use of wash, gesture, and scale, as the drawing for a vertical composition, now in the British Museum (Fig. 47), which Harris uses as evidence for a second, more dramatic, vertical composition, c. 1640. On the other hand, these drawings are very different from the delicate, small-scale, horizontal composition in the Uffizi (Fig. 50). The problem of establishing the date for this whole project, as for the *Sacrifice of Iphigenia*, can only be resolved by recognizing that at this point (c. 1638-1644) Testa experimented with many types of drawing often employing standard motifs. In these years Testa began to use pen and ink and chalk as poles between which he could move as he sought to create clearly defined forms in rich relief. Sometimes he would use chalk to realize ideas quickly, as in the case of a figure drawing for the *Sacrifice of Iphigenia* (Fig. 43). Gradually he began to work more slowly with chalk using black and white on tinted paper in order to analyze the relationship between highlight and shadow.[195] In some preparatory drawings from the early 1640s, like the brilliant study for the St. Lambert fresco (Fig. 38), Testa turned to pen and wash, sometimes over chalk, as a means of uniting light with line, combining the emphatic chiaroscuro that characterizes the later chalk drawings with the graphic clarity of the earlier drawings in pen. This effect of powerfully contrasting chiaroscuro (quite different from the delicate, carefully disciplined wash that suggests relief, rather than plasticity, in the dal Pozzo drawings), especially when the wash is combined with chalk and with broad, parallel hatchings in pen, is not found in drawings that can be securely dated before the late 1630s.

If we return to the recto of the Pierpont Morgan drawing for *The Death of Sinorix*, for example, with this in mind, the appropriateness of dating these drawings to the middle years of Testa's career should become clearer. The brilliant pen and wash technique can be compared to that in the drawings for the St. Lambert fresco (Figs. 38 & 39). The soft chalk drawing on the left-hand side, on the other hand, is almost identical, both in technique and motif, to the drawing for the *Sacrifice of Iphigenia* in the Fogg mentioned above. The drawing in the Uffizi, on the other hand, given its delicacy of scale, should be compared to the drawings for the *Allegory of Painting*, and indeed the two final prints are also comparable in many ways. This great variety of manners was admired by Passeri, who felt that it showed how successfully Testa avoided the slavish imitation of a single master.[196]

The *Death of Sinorix*, the *Sacrifice of Iphigenia*, and *Venus giving Arms to Aeneas* (Fig. 53) reflect Testa's discovery of ancient history as a source of themes for his etchings in the late 1630s and early 1640s. Several of these themes were also treated by Poussin and Cortona, but there can be no doubt that the careful textual research upon which the inventions of the *Venus and Adonis* and *Il Liceo della Pittura*, for example, relied also underlies this new interest. A new, literal treatment of history, based especially upon his reading of Virgil, Plutarch, and Homer separates the works of the later 1630s and early

Harris, 1967, p. 52, n. 27, publishes a related figure study in the Metropolitan Museum, for which see now Bean, 1979, p. 277, no. 365. For the verso of Fig. 49 see Stampfle and Bean, 1967, pp. 61-62, no. 84; see also no. 85 for a later,

squared composition drawing.

[195] As, for example, in the drawing of a female head in the Notebook, 40 (Fig. XVIII).

[196] Passeri, ed. 1934, p. 186.

1640s from the mythological fables of the earlier years. In the notes Testa insists upon the study of history as part of the education of the perfect painter.[197]

Testa did not abandon the kind of poetic inventiveness that characterizes *favole* like the *Venus and Adonis* altogether. Instead he began to apply it to the expression of his understanding of his own life and art, now clothed increasingly in the *concettismo* of complex figurative allegories. In *The Triumph of Painting*, dedicated to Girolamo Buonvisi, and almost certainly from the early 1640s and before 1644, Testa consolidated the view, first expressed in the *Allegory of Painting* and *Il Liceo della Pittura*, that the very activity of painting from its necessary foundation in philosophy and sustaining patronage to its ultimate place on Parnassus should be a major theme of his work (Fig. 54). Here Testa shows the chariot of Painting, drawn by piebald horses (identified as *Chiaro* and *Scuro* in the preparatory drawing in Frankfurt) moving from left to right.[198] At the bottom of the print are three inscriptions that help to identify the main themes.[199] To the left the inscription reads "Affectus exprimit," and above this Testa illustrates the passions that the painter must both conquer and express, especially the extremes of pleasure and pain (in the form of the Laocoon figure and the pair of lovers).[200] In the center the wheels of the chariot of Painting roll over the figure of Envy, who tries to brake its progress; beside the chariot, in the form of the figure putting his hand down the throat of the lion, Magnanimity—the virtue of patronage that is worthy of only the greatest honors—is contrasted to the slender, bent figure of Fear, or Pusillanimity, according to Aristotle one of the extremes that the magnanimous man avoids.[201] In this way the figure of Painting comes to be crowned by the Graces, and, in the manner of an ancient triumph, is awarded a triumphal arch: "Arcum meretur," reads the central inscription. The arch through which Painting passes, however, is no ordinary one, but rather the bow of the rainbow, upon which Iris sits, shielding her eyes from the brilliant light of the sun that comes from Parnassus; the colors of the rainbow are created by Apollo himself.[202] These colors are gathered in a bowl by two putti who offer them to Painting as she paints the Buonvisi star upon a shield. The figure beside her wearing a wreath and with a quill in his hand draws attention to the fact that it is now Painting, rather than Poetry or History, who will assure the immortal fame of Buonvisi by recording it on the shield in the manner of an ancient Victory.[203] The Buonvisi star is a

[197] Notebook, 57.A., and 60.A.3.

[198] Städelsches Kunstinstitut, Inv. no. 4405. 394 x 705mm., pen and ink; see Harris and Lord, 1970, fig. 18.

[199] Passeri, ed. 1934, p. 186, records that some criticized the inscriptions on Testa's prints because they made interpretation even more difficult.

[200] See Ettlinger, 1961, for the figure of Laocöon.

[201] These figures, closely modelled on Ripa's personifications, are all identified in the Frankfurt drawing, for which see again Harris and Lord, 1970, pp. 16-19. The views expressed concerning these figures by Martone, 1969, can only be dismissed as fanciful. In showing Magnanimity and Pusillanimity in this relationship Testa was again guided by his reading of the *Nicomachean Ethics* (Segni, 1550, pp. 187-195), wherein the great-souled man is described as claiming what he deserves, and greatly deserving of honor above all—hence the association with the tag "Arcum meretur." The

magnanimous man possesses the greatest fortune and the greatest virtue (having conquered in Testa's exemplification all the affections) and is often thought to be haughty, never accepting help or pursuing ordinary ambitions. He cares more for the truth than for what others think, despises flattery, and bears no grudges. Smallness of soul, i.e. timidity or pusillanimity, is the opposite of all this, and presented by Testa in the drawing by the scrawny figure with the rabbit, labelled "timore" in the Frankfurt drawing, but who appears without his attribute in the print.

[202] In the Frankfurt drawing Fame appears instead of Iris. Here I must disagree with Harris and Lord, 1970, p. 16, who suggest that Iris shields her eyes from the light of inspiration.

[203] Such a figure appears on the vase into which Achilles is dipped in Testa's print of the *Birth and Education of Achilles* (Fig. 81).

colored star (and identified by Testa in the closely contemporary *Autumn* with Provinde-mia, the brilliant star of the harvest), and so it is appropriate that it should be painted in the hues of the rainbow.[204] Testa is also declaring that drawing and color are united at this point: the piebald horses, *Chiaro* and *Scuro*, lead the way through the triumphal arch of the colors of the rainbow. To the right is the destination of Painting on Parnassus: "Parnaso triumphat." The Muses come to greet her, and the Muse of Poetry, carrying a book, is specifically encouraged to meet her sister. Meanwhile, the poets who have already attained Parnassus come out to welcome the new arrival. In this print, the mastery of the representation of the passions, the relationships between color and chiaroscuro, the magnanimity of fearless patronage, and the sisterhood of poetry and painting, all are presented as ideal concepts. They are isolated as themes in themselves and are no longer reserved for the unspoken dialogue between painter and critic conducted through the intermediary of the representation of an altogether independent theme.

In the *Triumph of Painting* only the victory of virtuous painting is represented. To find representations of the embattled virtuoso who is oppressed by vice described by Passeri we have to turn to other prints from the early 1640s, specifically the *Summer* and *Winter* from the series of the *Four Seasons* (Figs. 56 & 58), which Sandrart numbered among Testa's most remarkable works.[205] *Spring* and *Autumn* (Figs. 55 & 57) were partially inspired by Poussin's *Triumphs* and were the first to be made.[206] The *Autumn* is linked to the *Triumph of Painting*, and is probably closely contemporary, that is dating to c. 1642/3. Once again the procession moves from left to right, and one of the figures in the upper section pointedly displays the star of Girolamo Buonvisi. The theme is again a triumph, this time the Triumph of Bacchus. The *Spring* is organized around a central pivot, though it too might be considered to represent a triumph, the Triumph of Love. As in the *Autumn* there is a strong horizontal division between earthly and heavenly realms, though here there is a vestige of the ladder of the zodiac itself, and the remainder of the sky is crowded with gods of the weather, who precede Apollo and Venus, whereas the comparable area in the *Autumn* is populated with the personified stars and the moon. The proportions of the figures are more elongated here, but I would argue that the *Spring*, nonetheless, should be dated only very shortly before the *Autumn*.[207] The Stuttgart drawing for the figure reclining against a vase in the bottom left corner, for example (Fig. 59), should be compared with the 1641 drawing of *The Consecration of a Church* (Fig. 35), where the hatchings, proportions, and draperies are all similar.[208] Only the *Winter* is securely dated with an inscription to 1644. *Summer* may be assigned approximately to the same year, for the two are stylistically inseparable, and the composition of each is arranged with two lateral foreground groups about a central recess. The whole series then dates from c. 1641-1644.

While the four prints are linked by their large size and their themes, which demand that they be considered as a series, they fall, nonetheless, into two groups. The allegories of *Summer* and *Winter* are complicated by the introduction of allegories of art into those of

[204] See Note 209 below.
[205] Sandrart, ed. 1925, p. 293.
[206] See Cropper, 1974.
[207] In 1974 I suggested that the *Spring* might date to as

early as 1637/8. The print does not, however, conform to the much clearer picture we now have of Testa's activity c. 1637/8.
[208] See Thiem, 1977, p. 217, no. 400.

the seasons, which is not true of *Spring* and *Autumn* (except for the reference to Buonvisi's fruitful patronage in the form of his star as the augur of the harvest, Provindemia, in the *Autumn*).[209] The etchings of *Spring* and *Autumn* are organized around no particular protagonists or heroes, but are instead representations of states of nature according to physical laws whose workings are expressed by mythological personifications. In the *Summer* and *Winter*, however, Testa deepened the allegory by adding to his representation a hero in the guise of a winged soul, conceived, as we shall see, as the virtuous *ingegno* of the true artist, struggling to be free of the mortal bondage of time and passion. These two prints most completely illustrate Passeri's remarks about the new thrust of Testa's work in the early 1640s, and so I shall concentrate on them exclusively here.[210]

In the *Summer* Apollo appears as the sun in Leo, presiding over the painful life of the winged soul in the elemental world; he is about to draw an arrow from his quiver to shoot down upon the earth below.[211] Despite its power to bring plagues, dramatically evident in the figure of the youth languishing in the right foreground, the sun is past its fiercest point, being now in the tail of Leo, rather than in its head and paws: the decline of Apollo's power is imminent and relief from his pestilential rays will soon end the near fatal swoon of the young hero.[212] The Dog Star gnaws feverishly at the head of his master Orion, and this too promises the passage of the summer, for the moment of the rising of the Dog Star, which brings the fiercest plagues, is clearly past.[213] Thus it is that Juno, the spirit of the air, is able to squeeze a few drops from the gathering clouds; the winds are, however, still chained by the constancy of the sun's heat, and the jugs of the river gods beneath drained and empty, although the plentiful streams at the end of Juno's rainbow indicate the refreshing rains that will soon follow.[214]

The few drops that Juno is able to precipitate fall to the earth below, where Cybele, *Terra altrix*, is still unable to feed those who depend upon her.[215] In order to focus upon

[209] For Provindemia, or Protrygetes, see Hyginus, 1587, p. 89; Vitruvius 9. 6. Daniele Barbaro, in his commentary on the Vitruvian passage, which Testa certainly read, emphasized the changing colors of the star. He writes that above the shoulder of the Virgin: "si vede una lucidissima stella, che si chiama Antivindemia, perche quando nasce, cio è quando esce da i raggi del Sole, promette la maturità della vindemia, della cui materia segni manifesti sono gli acini dell' sua mutati di colore. Questa stella è simile al ferro affocato, però Vitruvio dice, che è piu presto candens, cio è rovente, che colorata, perche gli scrittori gli danno uno mirabile splendore. I Greci la chiamano Protrygetum, che in latino provindemia si dice" (*I Dieci Libri* ed. 1567, p. 392).

[210] For the relationship between Testa's first two prints and the kind of syncretistic interpretation of myth that characterizes such works by Poussin as the *Triumph of Bacchus* in Kansas City, see Cropper, 1974, pp. 255-260.

[211] The image of Apollo with his deadly bow and arrows is drawn from Macrobius's figure of Apollo, *Saturnalia*, 1. 17, in which the god also has the three Graces to his right, balancing the deadly force on his left. In Macrobius's interpretation according to physical principles, the arrows are indicative of the plague-striking powers of Apollo, whose slaying of the python represents the final drying up of the moisture that has collected during the winter and that becomes stagnant and putrefied with the return of the sun. This interpretation is based on the Stoic Antipater, and Macrobius is re-

ferring to the creation of the world rather than to its annual regeneration, but it was widely given a seasonal meaning; see, e.g., Aleandro, 1617, p. 75. On the image itself see Pfeiffer, 1954, pp. 20-32.

[212] For the strength of the sun in the head and paws of Leo see Macrobius, *Saturnalia*, 1. 21. 16-17, and, among others, Aleandro, 1617, pp. 26-27 (who cites Macrobius) and Barbaro, ed. 1629, pp. 386 and 389.

[213] Aleandro, 1617, p. 75, in discussing the frenzy of the Dog Star at the coming of the Lion, cites Horace, *Epistles*, 1. 10, 15-17; in these lines the lover of the country, extolling a life led according to nature, says of the countryside: "Est ubi plus tepeant hiemes, ubi gratior aura/Leniat et rabiem Canis et momenta Leonis,/Cum semel accepit Solem furibundus acutum?" The connection between this and Testa's own inscription is significant in relation to what is said below about Testa and the philosophy of Stoicism.

[214] The figure of Juno is based upon the Leon Davent engraving of *Jupiter pluvius* after Primaticcio (Bartsch 16: 326, 54).

[215] Cybele rests upon a lion, her traditional attribute. Her headdress is, however, a variation upon the usual crenellated crown worn by Cybele, for it is almost a plain cube. Here Testa has incorporated a detail from Cartari, who attributes the conventional turreted crown to Cybele, but who adds, in discussing the etymology of her name, that he agrees with Festus Pompeius that her name is related to *Cubo*; this in-

the bitterness of her plight Testa has adapted a figure from Ripa's *Iconologia*. Ripa describes Terra as holding a child to her right breast indicating her support for life and embracing a dead man with her right arm showing her care for the dead before the final resurrection; a river flows from her left breast, and on her head she wears a city.[216] In Testa's print, however, she can barely reach out to shade the child from the sun, and tries in vain to nourish the fallen winged figure with her left breast from which no river flows.

Quite different from this scene of dryness and aridity is the cycle of moist vapors in the pendant print of *Winter*. Whereas in the *Summer* the slender crescent of the new moon is relegated to the background by the all-powerful sun, in the *Winter* Selene rises in a full circle as the chariot of Apollo disappears below the horizon.[217] The onset of winter is indicated by the men huddled about the fire, and the wetness of the season by the moisture gathered in the air about the moon, with which such moisture is conventionally associated.[218] The river gods hold up an overflowing bowl to the clouds, who suck up the water in it, while the wind and rain gods next to Selene cast this vapor back down upon the earth in the form of icy rain. These are the dark days of the year over which the moon holds sway.

Thus far Testa's representation of the two seasons is entirely consistent with the cosmic scenes presented in the other two. Moreover, these conventional seasonal schemes are essential to the psychomachean drama he added at this point. This drama may be characterized as drawing the moral corollary to the physical state of nature portrayed in the prints following the logic of the ancient Stoics who insisted that knowledge of the principles of natural philosophy precedes the study of moral philosophy, for the reason that the latter is useless without a correct understanding of the nature of the universe and of man's place in it.[219] At this point we come closest to understanding why Sandrart should have called Testa "a shy Stoic."[220]

The drama is centered upon the winged figure in the two pendants, a young man in the *Summer*, an old man in the *Winter*, where, in an upward struggle against the forces of Envy, he reaches his final apotheosis becoming, in the end, identified with Virtue itself and so transcending the mortal coil of the elements that binds all of the earthly creatures in the other three prints. The dedicatory inscription of the *Summer* makes it clear that this figure is the artist, more particularly Testa himself.[221] In it he relates the pestiferous breaths of the envious to the evil attacks in the Dog days; Testa wishes to place himself under the

dicates the firmness of the earth, for a cube, or die, always lands firmly on one side when it is thrown; see Cartari, ed. 1614, p. 197. Valeriano, 1625, p. 802, points to the correct source for this in the *Timaeus* (55E), where Earth is given a cubic form.

216 Ripa, ed. 1625, pp. 196-197.

217 The figure of Selene is closely modelled on Giulio Romano's *Psyche carried by Zephyr* in the Palazzo del Tè, probably through the intermediary of Pietro del Pò's print (Bartsch 20: 255, 31).

218 Poussin represented this phenomenon explicitly in his *Landscape with Orion*, which is a double representation of the myth of Orion, and also of this myth allegorized according to cosmological principles, Orion being the principle of moisture, which rises to the moon, from which it falls back upon the earth as rain and sleet. See Gombrich, 1944.

219 See, e.g., Plutarch, *De Stoicorum repugnantiis*, 1035C-D. Stoic debate on this question is summarized and discussed in great detail in the opening chapters of Justus Lipsius's *Physiologia Stoicorum*.

220 Sandrart, ed. 1925, p. 288.

221 The inscription reads: "Sfiorita la Primavera, hò fatto passaggio alla state: ma perche non tanto m'assicuro di bionda messe nell'applauso del Mondo, quanto temo i latrati della canicola nella detrattion de' maligni, mi pongo sotto l'ombre dell'Amicitia che hò con V. S. acchioche la grata aura di lei prenda la difesa dei pochi fiori che mi si permette di fa vedere trà l'arsure della stagione. s'opporrà ella a' pestiferi fiati degl'Invidi, ond'io potrò giungere ad un temperato Autunno, e produr frutti non meno dilettevoli per la vagezza, che grati per la maturità."

shade of the friendship of his patron (in this case Giovanni della Bornia), the gentle breeze of whose protection will take care of the few flowers he has been able to bring forth. In this way the artist may survive into the autumn and produce beautiful and mature fruits. Testa's invocation to his patron here, likening the appreciation of his work to the aridity of the season, and the support of his patron to relief from its harshness, promised in the coming rains of June, is closely related to Zuccaro's statements in his letter to the "Princes and Nobles devoted to Drawing and Painting, Sculpture and Architecture," first published in 1605, and included in the preface to *L'Idea*.[222] Zuccaro also compares the protection of princes to the falling rain or dew without which the most perfect talent would lie lifeless like dry, arid earth.

The similarity here is more than coincidence, for the left-hand side of the *Summer* derives specifically from Zuccaro's allegory of the *Calumny of Apelles*.[223] Zuccaro's invention is based upon traditional representations of the story, deriving ultimately from Lucian, in its portrayal of a Midas-eared figure in a judgment seat, accompanied by two women, Ignorance and Suspicion, who whisper into his ears. To the original allegory, however, Zuccaro added Minerva, and she as patroness of the arts and protectress of prudent judgment restrains the king from reaching out and unlocking the chains of Fury, allowing Mercury to lead Innocence, or Truth, away to safety at the right. The motto, in garbled Greek, admonishes that "The harvest of the upright shall not be destroyed." Corresponding to this sentiment, which reinvokes in a new context the agricultural metaphor describing the relation of patrons to painters, there appears a view through the back wall showing peasants harvesting a rich crop of grain, despite the storms raging about them.[224]

In the *Summer* Testa adapted the composition of Zuccaro's meditation upon the judgment of patrons, but its moral is countered (something that should come as no surprise in the context of Testa's acute difficulties). Instead of the Midas-eared judge, Ceres herself sits on the left, accompanied by her dragon, and proffers the fruits of the season toward the fallen figure on the side opposite. But it is the Midas-eared figure Bad Judgment who, replacing Zuccaro's figures of Ignorance and Suspicion, restrains her arm with his left hand as he whispers into her ear and with his right hand grasps the grain stalks for himself. Minerva stands in the background helpless, denied access to the ear of Ceres, while Painting, naked like Truth (whose role she has taken), is unable to claim the fruits that are her due. In consequence the victim of the malign attacks and pestilential breaths of those who envy him, of those who flourish in the climate of the feverish Dog, is denied the harvest of his summer years and lies collapsed and near death. His suffering is cruelly contrasted to the pleasures of the figures in the background, who frolic in pools and streams, drinking

[222] In Heikamp ed., 1961, p. 116. Zuccaro writes as follows (translation mine): "And finally one thing remains for me to say, that study and the opportunity to study will not be enough if there is not added to it that vital and invigorating substance which makes plants produce flowers and fruits, and the earth grain and crops, because just as the good earth and vigorous and fruit-bearing plants do not produce fruits in abundance simply through diligent cultivation, if they do not also have rain or dew from heaven, without which the earth remains arid and dry, and the plants lifeless; so the student, even if

enlivened by fine talent and intellect, if he lacks the dew and rain of the favor and protection of princes, will remain as arid and dry earth, and like a lifeless tree."

[223] Cornelis Cort's engraving after this dates to 1572. See Heikamp, 1957, for Zuccaro's treatment of the theme; see also McGrath, 1962, p. 222.

[224] The vindicated figure on the right combines the roles of the calumniated victim and Truth, and Ottaviano Zuccaro identifies him as Innocence on account of the ermine he bears, for which see Heikamp, 1957, p. 220.

and making music around a cave set in the base of the hillside. Within the cave sits an obscene and grotesquely obese Pan, to whom the revelers pay court. Rejoicing in the easily won fruits of the season they are spendthrift of its substance, while the painter dedicated to the harsh service of Truth languishes under the force of Apollo's rays.[225]

In straightforward terms, as Testa's inscription signifies, vindication is soon to follow in the refreshing rains of enlightened patronage. But it is not the easily won patronage of the ass-eared critic who pushes the spirit of Painting aside and allows only the drunken and lascivious courtiers of Pan (who, as we shall see, correspond to the wine-seeking apes in the *Winter*) to enjoy the cooling waters behind that he seeks. Testa rather claims the just rewards of virtue, a notion made explicit in the pendant *Winter*, where the principles of Minerva, eclipsed in the *Summer*, are triumphant. Here the winged soul rises above the earthbound passion of Envy and reaches for the wreath of immortal laurel held before him by Virtue, who lends him her support.[226] This group can be compared to another image by Federigo Zuccaro, this time the fresco in the Palazzo Zuccaro, which shows Federigo's own apotheosis. Here the painter rises upon a cloud with the shield of Minerva, or Philosophy, at his side and is supported by the sun and moon who bear the attributes of knowledge and wisdom, the foundations of virtue. They help him to rise above Time, who appears within the serpent of eternity, and to conquer Fraud and Envy, who lie vanquished in the corners below, while the trumpets of Fame herald his ascent. This victory over Time and the passions, especially Envy, is accompanied by the motto "Virtute Duce."[227]

This is, of course, an abbreviation of the famous phrase from Cicero, "virtute duce, comite fortuna," expressive of a more predictable and favorable kind of fortune than normally portrayed, and one that Testa himself considered in a late drawing, now known only from an engraving by Collignon.[228] Here Testa shows Fortune leading a young man out of the clutches of Time and Envy, as he struggles to reach the temple of Virtue and Fame where he is directed by the putto with a laurel wreath (Fig. 60).[229] In both this design and in the similar group in the *Winter*, Testa invigorated the motif by composing his psychomachean struggle so that it closely resembles the famous Marcolino emblem of "Veritas Filia Temporis," thereby suggesting that the triumph of virtue is synonymous with the triumph of truth.[230]

[225] For Midas's worship of Pan, whose dwelling is in the mountain caves, see Ovid, *Metamorphoses* XI, 146-149. The story of his poor judgment follows, 150-193. The fact that Pan is here seated within a cave supports the identification of the revelers with painters, for according to Pausanias there was a cave dedicated to Pan at the foot of Mount Parnassus. It may be that Testa has here touched upon the *topos* also treated by Poussin in his *Bacchus-Apollo* of a twin-peaked Parnassus, the higher sacred to Apollo, the lower to Bacchus, by placing the revelers at the very foot of the mountain, where, in drunken and ribald revelry they give court only to Pan. For Poussin's painting see Panofsky, 1960. Musée du Louvre, Paris, Inv. no. 1895 is a preliminary study for the figure with the vase above the cave.

[226] Ripa, ed. 1625, pp. 332-333, identifies Envy as the enemy of Virtue, following the authority of Petrarch.

[227] See Koerte, 1935, pl. 19. The inscription, which now reads "Virtute Duce," was, according to Koerte, p. 26, n.

21, incorrectly restored in 1904-1906.

[228] The phrase, from *Ad familiares* 10. 3, had already been used to accompany the device of the printer Stephanus Gryphius of Lyons, where it accompanied a winged globe (*fortuna*) attached to a firm cube (*virtus*), for which see Wind, 1967, p. 102, n. 16.

[229] Harris and Lord, 1970, p. 20, n. 39, do not consider the relationship to Cicero's view of the supremacy of virtue in assuring the benefits of fortune. In Testa's design Chance offers her hand to the youth just as she offers her forelock in the Mantegna design discussed by Wind. See Speciale, 1977, p. 29, no. 26 recto, for a discussion of the print, which is described by Baldinucci, ed. 1847, 5: 320, as "Una figura di un giovane, che, favorito dalla Fortuna, vien rapito di mano al Tempo ed all'Invidia, e portato al Tempio dell'Eternità: ed è cosa notabile, che tutto mostra l'artefice che si faccia col porgerli la Fortuna un sol dito."

[230] See Saxl, 1936, pp. 197-222.

Both Testa's and Zuccaro's conceptions of the apotheosis of the genius of the virtuous painter are related in their psychomachean themes to the designs for the funeral of Michelangelo, and Testa's conception was, moreover, specifically derived from these designs, as a preparatory study for the struggling genius in the *Winter* testifies (Fig. 61).[231] Michelangelo's catafalque was adorned with sculptural groups representing different virtues conquering various vices (and the influence of these groups upon subsequent images of the artist was tremendous). According to the author of the descriptive pamphlet, one of these groups, sculptured by Vincenzo Danti, portrayed: "a slender youth, all animation and beautiful liveliness, symbolizing Genius, with two small wings at his temples such as one sometimes sees in representations of Mercury. Under this youth was a marvellous figure with asses' ears signifying Ignorance, mortal enemy of Genius."[232] A second group, by Lazzaro Calamech, showed Minerva, or Art, conquering Envy, for Michelangelo "had so entirely overcome Envy that without anyone's dissent and by common agreement he had obtained the rank and name [of a man] of the foremost and greatest excellence."[233] These two groups define the fundamental set of ideas with which Testa and Zuccaro were both working, Zuccaro quite straightforwardly representing himself as the philosopher-painter supported by Wisdom and overcoming Envy in his ascent to the stars and Testa staging his genius locked in a dramatic and human struggle with the passions assaulting him. Moreover, the preparatory drawing suggests a direct familiarity with the first design. The genius here is shown conventionally youthful, not as the aging hero of the final conception of *Winter*, and the very rare representation of wings at his temples is a feature in common with Vincenzo Danti's statue. However, while Danti's statue showed Genius triumphant over Ignorance, Testa reversed the *concetto* and in the *Summer* showed his genius lying temporarily defeated by the powers of ass-eared Ignorance; in the *Winter* Envy is overcome, not by Minerva (as in the Calamech group) but by the virtuous embattled genius of the artist himself. The result, however, is the same as in the program of Michelangelo's funeral, upon which Testa is playing these variations—the achievement of immortality by the artist.

Important too, it would seem, as a precedent for the *Winter* was the design for a painting executed for the funeral by Buontalenti. The design showed the rivers of the world grieving in company with the Arno with two figures revealing the scene by drawing back a curtain; to show that Michelangelo's soul had ascended to heaven, the artist illuminated the sky brightly and depicted the artist's soul in the form of a little angel flying toward the light.[234] Testa cleverly adapted this image of an infant soul flying through the sky. The scroll held by the flying child remains empty, but this infant provides a direct contrast to the second child below, who similarly is clad in a shirt. This earthbound child lies prostrate

[231] It is possible that Testa was planning to use this composition in an independent work, but its relationship to the *Winter* is very close.

[232] Translation from R. and M. Wittkower, 1964, p. 97. R. and M. Wittkower, p. 96, n. 71, translate Ingegno as Genius, by which they mean natural talent that makes sound judgment possible. That Testa knew and studied the designs for the funeral provides an important insight into why, for example, he endowed the figure of Giuditio in *Il Liceo della Pittura* with wings at his temples, rather than using the image from Ripa; his combination of the figures of Povertà and Otio in a drawing in the notes (Fig. XIV) may also be a variation on another group for the funeral by Andrea Calamech, depicting Study and Idleness, for which see Wittkower, eds., p. 98.

[233] *Ibid.*, p. 98.

[234] *Ibid.*, p. 114. The painting bore the inscription "Vivens orbe peto laudibus Aethera."

in a drunken sleep.[235] The winged genius of the artist thus moves in transition between the earthbound infant spirit who is drunkenly in the thrall of the senses (even as the monkey artists in the background seek no higher prize than the jug of wine at the top of the trophy pole) and the freely flying infant spirit who rises with the virtuous artist toward the wreath of immortal life awarded those who leave the world of sense and *affectus* behind.

In this way we can see how Testa's conception of the genius of the artist partakes of a consistent tradition of philosophic speculation stemming from the Florentine Academy and continuing through Vasari (who includes in the *Lives* most of the pamphlet describing Michelangelo's funeral) and Zuccaro into the seventeenth century. This tradition, as we shall see in the examination of *Il Liceo della Pittura* in Chapter Two, also determines Testa's whole notion of the meaning and purpose of art and the education of the painter. Beyond this, however, in terms of Testa's presentation of his own character in the *Seasons*, it is important to understand the broader and more fundamental origins of Testa's thought in the antique philosophy that underlies this tradition and in which his notes show him to have been extremely well read. Moreover, Testa's familiarity with contemporary mythographical and antiquarian research, which he shared with Poussin, plays an extremely important part in supplying the framework through which his ideas were expressed in the *Seasons*. In synthesizing his views on the nature of the elemental world, the proper study of natural philosophy, with his understanding of the soul's life on earth that pertains to moral philosophy, and with the eventual return of the soul to a condition of pure virtue, Testa's imagination was stimulated not only by the inventions of artists who followed in the steps of Michelangelo, but also by his close association with scholars and antiquarians who interpreted ancient sculpture according to cosmological principles. Preeminent among these scholars were Cassiano dal Pozzo, Girolamo Aleandro, Jr., and Giovanni Pietro Bellori.

The nature of this type of interpretation of myth has already been touched upon in the discussion of the *Venus and Adonis*. Of immediate significance in this context is the famous sarcophagus for a child, now in the Capitoline Museum, but in the Pamphili Collection in Testa's day, decorated with scenes from the story of Prometheus. Testa certainly knew the sarcophagus directly, and his drawing of it is now in the Uffizi (Figs. 62 & 63).[236] The most extensive interpretation of its iconography was put forward by Bellori, and first published in his *Admiranda romanarum antiquitatum ac veteris sculpturae vestigia* (Figs. 64 & 65) in 1691. Although this publication appeared only after Testa's death, and indeed only after the death of its author, the interpretation it contained was certainly one that Testa would have known, given his close familiarity with Bellori, and the antiquarian circle to which he belonged.[237]

[235] The figure of the small child in a shirt should be compared to the similarly indecently exposed child in Titian's *Andrians*.

[236] The two parts, now mounted separately, were originally a single sheet. Robert, 1919, pt. 3: 441, states that the sarcophagus was known from the time of dal Pozzo, citing two drawings in the A. W. Franks Collection, British Museum, nos. 37 (486), and 38 (389-91). These drawings are certainly not by Testa. They are included in the dal Pozzo drawings by Vermeule, 1960, p. 12. The provenance of the Uffizi drawing is still unclear, although it must be closely associated

with the dal Pozzo-Albani drawings at Windsor and in the British Museum. The strongest argument for associating the group of Uffizi drawings, including the one published here, with the dal Pozzo-Albani drawings is made by Conti, 1974-1975, esp. pp. 152-153 for Testa's contribution.

[237] The sarcophagus is reproduced and described by Sandrart, 1680, pp. 197-198, pls. DD and EE. Figs. 64 & 65, are from the *Admiranda*. It seems most likely that the explanation was first proposed by Bellori, despite the fact that Sandrart published before him. The *Admiranda* was published only after the death of its authors and contained ma-

Bellori identified the subject of the first side of the sarcophagus as "the life and death of man as taken from the fables and mystic philosophy of the ancients." On the right side (Fig. 64) he identifies (1) the naked male and female figures as the twofold genus of man, masculine and feminine, descending from the happy regions into elemental existence. The authorities for this interpretation and for the sarcophagus as a whole, Bellori gives as Plato, Hierocles, and Macrobius. He goes on to explain (2) Vulcan at his forge as the creative heat of nature, followed by (3) Terra altrix as the nourishing earth with her cornucopia. Neptune (4) appears as the principle of moisture attending creation, and a wind (5) is shown over Terra's shoulder as the spirit of the air. Minerva (6), on the extreme left, signifies the purest aether. Prometheus (7) is shown making man from clay, but it is Minerva who places the butterfly (8), that is, the immortal soul, into the head of the fabricated body. Between Terra and Vulcan there appears Amor (9) embracing the soul, for, as Bellori points out, the soul is bound by affections after its descent into elemental existence, fashioned by Prometheus. A woman who writes upon a globe (10) stands behind Prometheus, representing Fate as described in Plato's *Timaeus*, while next to her a second Fate (11) spins the thread of human life. Finally the sun (12) drives his chariot up into the heavens.

The second side of the sarcophagus (Fig. 65), again according to Bellori's exposition, shows the death of man according to ancient philosophy. First, Love appears (13), extinguishing the torch of *affectus* in the breast of man. The butterfly soul (14) is thus released from the prison of the body, over which the mourning woman grieves. At the head of the corpse a Praefica (16) reviews the deeds and reputation of the dead man. Mercury (17) leads the soul back into the happy regions from whence it had descended into elemental existence. In the center, Prometheus (18) is shown chained to the Caucasian Rock and lacerated by the eagle for having given the spark of life to man. Hercules (19) comes to free him, loosing his soul from the mortal cares of this life, for which Prometheus then shows the virtuous hero the way to the Hesperides. On the left (20) is Mount Atlas, guarded by a snake, and on the right (21) rises the biga of the Moon.

The interpretation presented by Bellori, a kind of outline Platonism, offers a view of the universe and the life of the soul that accords precisely with that elaborated by Testa in the *Seasons*. On the sarcophagus, as in the *Summer* and *Winter*, the sun presides over the mortal life of the soul, the moon over its dissolution from the bonds of the body. The life of the soul descended into elemental existence is, moreover, characterized by its affliction with passion, *affectus*, from the agonized awakening of passion in the *Spring* to the frenzied expense of spirit of the *Autumn*, from the near death of the soul affected by calumnious assault in the *Summer* to its release and apotheosis beyond the clutches of Envy in the *Winter*. That Testa perceived this suffering specifically in the context of the soul's imprisonment by the elements was understood by Sandrart and is furthermore explicitly stated in a black chalk drawing, preparatory to the *Summer*, now in The Pierpont Morgan Library in New York (Fig. 66). Here Testa shows Cybele with her lion reaching out toward Juno, identified by her peacock and rainbow, standing between a male figure and a fallen figure with a vase. The autograph note at the bottom, "per gli elementi," permits the identifica-

terial collected by them over a long period of time. For the sarcophagus itself, see also Raggio, 1958, esp. pp. 47f.; Cu-mont, 1942, pp. 318-325.

tion of Juno as air, Cybele as earth, and hence the standing figure as Vulcan or fire, and the figure with the vase as a river god or water. Here we have the origin of the group at the right of the *Summer*, the elements that are governed by time, the passage of the sun through the zodiac, and that afflict the fallen genius. Similarly the condition of the winged figure in the *Winter* is akin to the situation portrayed on the second side of the Prometheus sarcophagus where the separation of the soul from the mortal body is conceived as its liberation from *affectus*.

And yet despite the basis of his conception of the cycle of life and death as expressed in the progressive stages of both the life of a man and the life of the year, Testa was not simply concerned with his own physical death when he executed the *Winter*, even though winter is the season of death and Capricorn the tropic through which souls reascend. Rather, as we have seen, he was concerned to conquer the passions of this life (even as he was in the *Triumph of Painting*) and hence to achieve a kind of terrestrial immortality through the escape of the soul from its bondage to the elements.[238] For there is a middle way, the way of philosophy and the cultivation of virtue, that is available to man caught in earthbound existence. This was the theme of the drawings made in connection with the Lucca fresco and the Franciotti print where Testa sought to associate his personal view of such virtue with the virtue of his republic and the political implications of such virtues put forward by Plato and Aristotle. Now in the *Seasons*, following contemporary interpretations of Platonic philosophy as applied, for example, to the Prometheus sarcophagus, Testa draws a fundamental distinction between the mortal and immortal realms. Souls do not originate in the sublunar realm of change, but are merely exiled to earth, sojourning here for a while. Man is not made from the four elements alone, but animated with a spark of aetherial fire, a notion directly expressed in the Prometheus sarcophagus (which, it should be pointed out, was itself produced in the climate of late antique Neoplatonic philosophy), where Prometheus fashions man from the elements, but Minerva, "the purest part of the aether" according to Bellori, adds the butterfly soul.[239] In the prints of *Summer* and *Winter* created man appears enmeshed in the elements, his wings representing the fiery soul aspiring to ascend, but held fast to the prison of the body—one of the most fundamental of all Platonic metaphors.[240] With the extinction of the passions either through the physical decay of the body or through the pursuit of philosophy, the soul is liberated. Philosophy, leading to a sort of death in life, turns man from the senses and fortifies his soul, giving its wings the power to lift him from the earth.[241]

As we can see, however, from the lonely struggle of the virtuous hero in the *Summer* and *Winter*, the pursuit of virtue and the rejection of mortal *affectus* is attempted only by the few—heroes strengthened for the journey by philosophical combat.[242] The majority of

[238] The paradox that the life of the soul involves the conquering of the passions, and conversely that the life of the passions results in the death of the life of the soul, is most concisely expressed, among the authors cited by Bellori, by Hierocles Alexandrinus in his commentary *On the Golden Verses of Pythagoras*. He describes the soul as, "sometimes enjoying the happiness of an intellectual life, and sometimes plunged by the defilements of sense. It is therefore rightly said by Heracleitus that we live the death of one and die the life of the other." (Translated from the text of D. Bembo's Italian translation, published in 1604, and so available to Testa, p. 141.)

[239] See, e.g. Macrobius, *In Somnium Scipionis*, 1. 21. 33, and 35.

[240] See, e.g. Hierocles, in Bembo, 1604, pp. 142-151.

[241] See, e.g., Macrobius, *In Somnium Scipionis*, 1. 3. 6 and 11; 1. 17. 12, in addition to the *Phaedrus*.

[242] Hierocles, in Bembo, 1604, p. 145, describes the majority of men as conquered by passion, and even mad because of their attachment to the earth.

men remain conquered by passion, preoccupied with material existence which drags them earthward, confusing the soul and—again a famous Platonic metaphor—making it dizzy like a drunken man; such souls spend their lives as though asleep, and indeed the more bestial of them even pass in subsequent lives into the bodies of beasts.[243] These notions play an important role in Testa's imagery, notably in the drunken boy of the *Winter* (as well as the melancholic inebriation of the *Autumn*), the lascivious devotees of Pan in the *Summer*, and in the monkeys who crowd together in the *Winter* to reach for the bottle of wine hanging from the trophy pole. These monkeys exemplify the corporeal bestial soul in search only of the rewards of experiential reality in contrast to the winged genius who aspires, aided by Virtue, to reach beyond the world to the true reality beyond.

In Testa's *Winter* the monkeys provide more than a moral contrast, however, to the purified soul who is supported by Virtue. The palette and brushes that lie on the ground before the trophy pole and the monkeys sketching in the distance identify them as artists. The print, and consequently the pendant *Summer*, has therefore to do not only with the antithesis of two ways of life, but also of two kinds of painter—those painters whose vision is limited to apparent truth and those who aspire to understand and to reveal a higher truth. In his notes Testa repeats the familiar metaphor distinguishing true painters from the common herd whom he calls the "scimie sporche e ridicole della natura."[244] In calling them this he is criticizing them both for their character and for the way in which they approach reality in their art, for the contrasting aspirations of the two kinds of soul described by Plato are clearly implicit in Testa's portrayal of the souls of the two kinds of painter in the *Summer* and *Winter*.

Testa's decision to use this series of prints as a way of publicizing his sufferings and hopes for ultimate vindication was almost certainly a reponse to the criticism of his frescoes in S. Maria dell'Anima as well as to the cumulative blows to his aspirations in the previous decade. The choice of the monkey-painters aping reality as his adversaries in the *Winter* suggests that he was attacking the Bamboccianti and their successes in particular, but, as we shall see in Chapter Three, his attack on the imitation of accidents of experience was not limited to those artists. More than anything, as the *Summer* indicates, Testa felt the lack of sustaining and nourishing patronage that would permit him, as it did Poussin, to allow his talents to mature and grow. Despite the fact that he shows Fortune favoring the young artist in the drawing engraved by Collignon and, in the *Winter*, postulates that his own struggle will be successful, Testa's situation was never to improve. In many ways these etchings are his master works as Joachim van Sandrart recognized. Testa realized here a personal statement of remarkable philosophical complexity and consistency and of great psychological profundity, and all this, it should be said, through a brilliant manipulation of technique on an unusually large and difficult scale. Although the two earlier prints, the *Spring* and *Autumn*, can be associated with works by Poussin, such as the *Triumph of Flora* or *Triumph of Bacchus*, the series as a whole shows Testa to be a fully independent artist, a thinker of great subtlety, and a poet of imagination. The *Seasons* are without rival in painted philosophy or as images of the artist's soul.

[243] *Phaedo*, 79C and 81E.
[244] Notebook, 57.A.

THE LAST YEARS, 1644-1650: THE REDISCOVERY OF ANNIBALE

Testa's personal disappointments must also be set against the difficulties of working in Rome in the early 1640s. In 1641 the Barberini embarked upon the disastrous War of Castro. Barely had peace been made when Urban VIII died. For many artists in Rome, especially those who had prospered under the patronage of the Barberini, the election of Innocent X brought hard times.[245] For Testa it meant the departure of his strongest supporter, Girolamo Buonvisi, for Lucca.[246] Testa himself stayed in Rome, however, and immediately attempted to win favor with the Pamphili through publishing the *Allegory in Honor of Innocent X* (Figs. 67 & 68).[247] Testa portrays the arrival of Innocent X as the beginning of a new Golden Age, and punning upon the Pamphili crest of the dove and the olive branch, he shows Iris, as in the *Triumph of Painting*, now lending her colors to Peace so that she may paint the effigy of Innocent. To the left the crouching figure with the hare, again recalling the *Triumph of Painting* (especially the preparatory drawing for it), suggests the pusillanimity of the previous regime, whose evils are also suggested by the hungry wolf of avarice, who is now leaving the city. Whereas in the ceiling in the Barberini Palace Pietro da Cortona had shown Hercules driving out the Vices in order to emphasize the virtue of the Barberini regime, Testa now adopts the same image, in the background of his print, to show that the vices of the Barberini are being driven out of the ruined city of Rome by a Hercules in the service of the Pamphili Pope.

Although Testa had benefited only indirectly from the Barberini papacy, through Buonvisi and dal Pozzo in particular, he had little justification for thus taking up the popular attack on Urban summarized in the street cry, "Quam bene pavit apes tam male pavit oves."[248] That he did so suggests increasing desperation and alienation on his part, and the print won him no favor with the new pope. A painter like Dughet could turn his lack of previous papal associations to advantage because he was also able to work expeditiously, which Testa could not. Bernini's talents were in the end too great to be ignored. Testa, like Sacchi, however, found it increasingly difficult to secure patronage, and he was to receive only one more public commission before his death.

The prints made around 1644, as we have seen, mark a psychological crisis of confidence for Testa, now compounded by a political one. They also mark a stylistic change in Testa's work that can be seen in other prints devoted to the life of the artist closely contemporaneous with the *Summer* and *Winter*. Whereas the *Spring* and *Autumn* still betray the influence of Poussin, this group of prints, in fact beginning with the *Autumn* and including the *Summer* and *Winter*, *The Young Artist arriving on Parnassus* (Fig. 69), and the *Allegory in Honor of Innocent X*, all demonstrate one important new influence. Testa's new fascination with the work of Annibale Carracci is evident in each. The explosion of clearly delineated figures in the *Young Man arriving on Parnassus* was prompted by Testa's admiration for the Farnese Gallery. Some of the figure drawings for the *Seasons* (for example, Fig. 70) also reflect a direct study of the ceiling.[249]

[245] Haskell, 1963, pp. 146-150.

[246] Ciacconius and Olduini, 1677, 4: 731.

[247] Fig. 68 is inscribed, "equali/ [indicating the three parts of the profile, each the length of the nose]; con na [so] / per

l'amore vedi la carta di D / Pietro Testa."

[248] Campi, 1878, p. 3, n. 1. See also Poussin's critical remarks about Urban, cited by Blunt, 1967, text vol., p. 178.

[249] See Blunt and Cooke, 1960, p. 155, no. 982, fig. 103.

Testa would have been encouraged to draw in the gallery by Domenichino, and drawings by Annibale had been available to him from his arrival in Rome. And yet the influence of Annibale is not pronounced in the works of the 1630s. It is only in the prints of the 1640s that Testa begins to endow his figures with that petrified muscularity that would give them such an appeal for artists of the eighteenth century, despite their lack of neoclassical spareness.

Some indication of Testa's new interest in Annibale is provided in the notes where he includes the Carracci in the company of artists on his ideal Parnassus together with their followers Domenichino and Reni.[250] In these notes Testa describes the greatness of the Carracci in terms of the way in which they mastered that union of *disegno* and *colore* that he himself had failed to accomplish as a painter. He also points specifically to the hardship and adverse turns of fortune they suffered. After witnessing the harsh treatment of Domenichino in Rome and finding himself so misunderstood, Testa must have felt an almost filial bond in this respect. The growing realization that he too was one of those artists who would never receive his just rewards could only have encouraged him to turn to a special study of Annibale's most renowned work in Rome, and for which he too had been rewarded so poorly. According to Agucchi whose views, of course, Domenichino had shared, the Farnese Gallery, in which *disegno* and *colore* were perfectly joined together, represented the culmination of the tradition of Raphael and the antique; it revealed Annibale to be a perfect painter, master of invention and the expression of the *affetti*.[251] The ceiling provided Testa with a model precisely at the moment when his own career as a fresco painter in Rome had been challenged once again.

Testa was not alone in his rediscovery or reaffirmation of Annibale's mastery. In the 1640s Sacchi's work in the lantern of S. Giovanni in Fonte also bears witness to the profound influence of the late Annibale and of his followers Albani and Domenichino, although his major homage to the Farnese Gallery came in the 1650s, in his designs for the frescoes in S. Luigi dei Francesi.[252] In 1646 Grignani published Simon Guillain's engravings of the *Diverse figure*, those same drawings by Annibale of the street people of Bologna that had been in the collection of Lelio Guidiccioni.[253] They were published together, as Mahon has shown, with a preface by Giovanni Antonio Massani and, more important, with passages from Agucchi's *Trattato* in which, as we have seen, the Farnese Gallery is singled out for special praise.[254] French artists in particular studied and copied the ceiling in these years. Pierre Mignard made his copies of the frescoes in 1644, some few years after his brother Nicolas had recorded some of the designs in prints.[255] All of these activities point to the new myth that was being woven around the figure of Annibale Carracci in the 1640s.

[250] Notebook, 61.§4.
[251] Mahon, 1947, p. 257: "può certamente un'intelletto elevato, e delle belle arti ben capace, rinvenirvi per entro quell'Idea del perfetto Pittore, che si forma Aristotile dell'ottimo Poeta, e Cicerone dell'Oratore." See further Chapter Four below.
[252] Harris, 1977, pp. 87-89, for the lantern; see p. 22 for reference to the models of Annibale, Albani, and Domenichino, though I would argue that more is involved here than a lack of confidence on Sacchi's part; see pp. 23-24, 100-101, for the S. Luigi project, there dated 1653-1660.

[253] Mahon, 1947, pp. 232-237.
[254] *Ibid.*, pp. 113-114; see pp. 233-275 for the texts of Massani's Preface and Agucchi's *Trattato*, and esp. pp. 254-257 for the Gallery.
[255] Martin, 1965, p. 164, points to the increased interest in the Gallery by French artists after Poussin's return from Paris in 1642 (reflecting Poussin's own study of it). He refers to P. Mignard's copies, some of which, in the form of drawings, are still in the Louvre, and to the fact that he is said to have made copies for Cardinal Alphonse du Plessis. P. Mignard also bought Angeloni's drawings in 1652, for which see Mar-

Of course Annibale Carracci had never been forgotten, but it was only in the 1640s that he began to be perceived as an Old Master. Massani recognized this when he compared Annibale's growing reputation to that of Raphael and the painters of the High Renaissance, saying that, as in their case, "the more time passes and sets the death of the artist at a greater distance, and as the number of good *cognoscenti* increases, so the more clearly is his virtue perceived, and the more famous his name becomes."[256] In the 1640s fewer and fewer Roman artists could remember Annibale as a working artist. Domenichino died in Naples in 1641, while Lanfranco, who outlived him by six years, chose not to return to Rome permanently. Albani and Guercino were never to return to live there. Guido Reni, who spent little time in Rome anyway, died in 1642. Baglione, whose biography of Annibale also contributed to the establishment of him as an Old Master, died in 1644, and he was one of the last artists in Rome to have known Annibale personally.[257] In the wake of these deaths, especially that of Domenichino, the younger generation of Sacchi and Testa began to sense a distance between themselves and Annibale not unlike that which separated them from Raphael.

The story of Annibale's death contributed to the new vision of the artist. Mancini had suggested that it was caused either by an insult or by melancholia. Massani pointed to the capriciousness of fortune.[258] It was Baglione in his biography of Annibale published in 1642 who told the story of the parsimonious Spanish courtier offering Annibale five hundred scudi in a saucer. He describes Annibale's decline, and his suffering caused by the malignant fever that flourishes when the sun is in Leo.[259] Baglione devotes less attention to Annibale in his series of biographies than to artists who lived longer and produced more, such as the Cavaliere d'Arpino (who had died only in 1640). But Testa was a generation younger than Baglione, and almost as soon as the story of Annibale's death was published he too became preoccupied by the effects of the pestiferous breath of the Dog Star in Leo and of the evils of greed and ignorant judgment upon the virtuous artist (Fig. 56). The inscription on the *Summer*, as we have seen, identifies the helpless dying figure as Testa himself, but Testa seems also, in the circumstances, to be identifying his own fate with Annibale's. The portrayal of his own ultimate achievement of fame in the *Winter* drew support from the vindication of Annibale's reputation by Time.

The new significance of Annibale Carracci's work in the Palazzo Farnese for Testa is not only evident in the etchings of *Summer* and *Winter*, but also in two other prints completed c. 1644, the *Altro diletto ch'imparar non trovo* (Fig. 88), and the *Young Artist arriving on Parnassus* (Fig. 69). In both of these prints, which will be discussed in greater detail in Chapter Two, the heroic figure of the young *intendente* makes the choice to dedicate himself to the delight of learning, rather than to the pleasure of the flesh with the evils of envy, sloth, and avarice that follow. Both, therefore, reflect an interest on Testa's

tin, p. 170. Angeloni's own *Historia Augusta* (Rome, 1641), is a part of this story, for in it he praises the Carracci as the restorers of painting.

[256] Mahon, 1947, p. 273, "che quanto più il tempo si è andato, e si và allungando doppo la morte dell'Artefice, e moltiplica il numero de' buoni conoscitori; tanto più si rende cospicua la virtù di lui, e maggiormente ne viene il suo nome celebrato."

[257] Baglione, 1649, 1: 106-109. In 1604 Annibale and Roncalli had together evaluated a work by Baglione, for which see Bertolotti, 1885, pp. 145-146.

[258] Mancini, ed. 1956, 1: 218. See Mahon, 1947, pp. 316-325, for Bellori's, Baglione's, Malvasia's and Baldinucci's access to the manuscript of Mancini; see Mahon, p. 273, for Massani.

[259] Baglione, 1649, 1: 108.

part in both the theme and the massive sculptural forms of Annibale's *Choice of Hercules* in the Camerino.[260] Testa's new stance toward the Bacchanalian side of life is most obvious in the *Altro diletto*. The dancing and feasting and the worship of love that appeared so idyllic and enchanting in works of the 1630s like the *Garden of Venus* has become a frightening reality in which maidens are deflowered and men vomit from drinking. The dark side of passion in the elemental world that was portrayed in the context of a grand cosmological vision in the *Seasons* is now presented on an immediate, personal scale in which the artist's view of the world around him is barely cloaked in the Petrarchan motto. Testa's interpretation of this line from the *Triumph of Love* to signify a divine and purer love that vanquishes the demands of the flesh is entirely consistent with the new interpretation that Bellori formulated for Annibale's frescoes in the Farnese Gallery. The same insistence on the love of learning in the virtuous artist characterizes both Testa's print, and Bellori's approach to the biographies of the artists. Bellori's *Argomento della Galleria Farnese* was published in 1657, and he was at work on the life of Annibale only in 1660.[261] Both projects were, however, indebted to the reassessment of Annibale that began in the 1640s and also to the value accorded to the morality of learning as the foundation for true painting that Testa sought to emphasize in these prints.

THE WORKS OF THE LAST YEARS

Testa was never to achieve fame through his painting. The only documented commission between 1644 and Testa's death in 1650 is *The Vision of S. Angelo Carmelitano* for an altar in S. Martino ai Monti in Rome (Fig. 71). Harris has established that the altarpiece was put in place on October 16, 1646 and that the payments began in October 1645.[262] She has also shown that the range of preparatory drawings is very wide, including a red chalk study, a brilliant chiaroscuro drawing in pen and ink and wash (Fig. 72), and a full study squared for transfer.[263] In the final work Testa appears to have carried out the intense oppositions of chiaroscuro that he achieved in the wash drawing more successfully than usual.

This strength of contrast also characterizes *The Miracle of St. Theodore* for S. Paolino in Lucca, which Passeri praised most highly (Fig. 73).[264] This altarpiece is not only dark, but also very dirty and in need of restoration. The subject is, therefore, easier to read through reference to the preparatory drawing now at Chatsworth (Fig. 74).[265] Here the figure of the bishop closely resembles that in the painting, except that he is set deeper in an architectural space and is turned more fully toward us. He is surrounded by three male figures, two of whom gesture dramatically to the left background, where several figures may be seen carrying water toward a conflagration. Above St. Theodore is a woman carrying the Host. She is accompanied by angels on clouds who carry vases under their arms.

[260] For which, see Martin, 1965, pp. 24-27, and pl. 9.
[261] Previtali in his Introduction to Bellori, ed. 1976, p. LXII.
[262] First altar on left wall. The document recording its installation is cited by Harris, 1964, p. 62.
[263] Harris, 1976, pp. 40-41, and p. 54, n. 52.
[264] Fourth altar on right wall. See Hartmann, 1970, p. 51, n. 2, for the proposal that Testa won this commission through his connections with Buonvisi. Girolamo's sister, Angela, was

married to Cosimo Bernardini, whose brother Bartolomeo was prior of SS. Paolino e Donato from 1634. Hartmann, p. 101, also points to the influence of Saraceni's *Martyrdom of St. Lambert* in the chapel in S. Maria dell'Anima where Testa had just completed his frescoes.
[265] See Harris, 1967, p. 41, for the copy of this drawing attributed to Mola. According to Ridolfi, 1844, p. 24, the painting was restored by Prof. Nardi of Florence in 1829.

The subtlety of Testa's invention once again bespeaks his determination to find images expressive of the myths of his native city, and indeed only Mazzarosa, a local historian, identifies it correctly.[266] St. Theodore was third bishop of Lucca, elected c. 324, and his first recorded miracle, here celebrated by Testa, was a testimony not only to his faith, but also to his charity and love for his flock. The Devil inspired one Rabiolus to set fire to the bishop's crops as they lay on the threshing floor in order to rob him of his faith. Theodore kept his faith, indicated by Testa in the drawing by the woman holding the Host, but the Lucchese farmers despaired and ran to the bishop to bewail the loss. Theodore flew to the burning harvest and prayed that it be spared, even as the three boys were spared from the fiery furnace. Miraculously the grain was left untouched by the flames and Theodore gave humble thanks to God and followed this act of faith with one of charity by instructing his servants to take the grain to their own homes.[267]

In both the drawing and the painting Testa gave special emphasis to St. Theodore by isolating him from the scene of the fire. In the painting he omitted the woman with the Host, but in both drawing and painting he approached the central mystery of the miracle, the strength of faith to rob even fire of its power, in a way that rendered it visible. In the drawing the angels who crowd behind the figure of Faith carry jars of water—water that has the miraculous power to hinder the flames of the Devil in a way that the terrestrial water of the farmers cannot. In the painting he refined the idea considerably, showing the angels squeezing the clouds above the fire to produce rain. The account of the miracle does not record that the flames were extinguished, but that, like Nebuchadnezzar's furnace, they failed to consume. Just as Testa had tried to present the acheiropoeitos of St. Dominic in a rationally clear way by showing the angel with palette and brushes, so here he tried to suggest through an image the way in which the flames were thwarted, without in either case denying that the events were inspired by faith. This is the same kind of invention that was at work in Testa's presentation of classical and cosmological myths in the late 1630s and early 1640s (such as the *Venus and Adonis* and the *Seasons*).

Several other paintings should be dated to the middle of the 1640s. These include the *Galatea* (Fig. 75), another work heavily influenced by the Farnese Gallery, and almost certainly from the Buonvisi Collection, the lost *Blinding of Homer, The Sacrifice of Iphigenia* (Fig. 76), *The Prophecy of Basilides* in Naples (Fig. 77), and the closely related *Dead Christ* (Fig. 78) in Oxford.[268] As far as we can tell, however, the Calced Carmelites at S. Martino ai Monti and especially their prior, Giovanni Antonio Filippini, were the only new patrons of public commissions that Testa was able to attract in Rome in the 1640s. The project to decorate the apse of S. Martino, however, came to nothing, and the nave was frescoed by the more businesslike Gaspare Dughet.[269]

Boase has analyzed Testa's skillful rationalization of the *Vindicta Salvatoris* theme in

[266] Mazzarosa, 1843, p. 88.

[267] *Acta Sanctorum* (T. IV May), 17: 327-330; Franciotti, 1613, pp. 58-72.

[268] Fig. 75 is now in the office of the Director of Prisons, Opere pubbliche, Florence. Hartmann, 1970, p. 180, identifies it with the "quadro grande . . . con Venere e Tritoni," in the two eighteenth-century inventories of the Buonvisi collection. Bean, 1979, p. 272, n. 361, publishes the squared composition study in the Metropolitan Museum. For the *Blinding of Homer*, formerly in the Wallraf-Richartz Museum, see Cropper, 1980. For Fig. 76, see Zeri, 1954, 132-133. For Fig. 78, see Parker, 1962, no. 429.

[269] Harris, 1967, p. 44, publishes the conclusions of her 1964 article. See now Heideman, 1980; Bandes, 1976.

the *Prophecy of Basilides*, almost certainly painted for Filippini, in which he substituted Titus for Vespasian. Titus was the true avenger of Christ's death and the first to build on the site of S. Martino, and so Testa made the theme of divine justice especially prominent.[270] There is every reason to believe that he would have made his design for the apse of the church (discussed in detail in the notes below) just as appropriate in terms not only of iconography, but also of style.[271] He intended to revive the early Christian tradition of placing the apocalyptic vision of St. John in the semidome, and to present it with all the clarity of a mosaic and as a sort of homage to Raphael's *Disputà*. Had the fresco been executed it would have been entirely consistent with Filippini's desires to emphasize the antiquity and continuous history of the church. It would have complemented the architecture and would have provided a focus for the whole program of decoration.

Passeri's story that Testa lost his chance to execute the design because the prior found him irresolute and slow rings true.[272] Testa had also become preoccupied by the need to defend the academic tradition of Domenichino, and his design for S. Martino, had it been executed, would have provided a response to Lanfranco's recent work in the apse of S. Carlo ai Catinari.[273] Passeri states that Testa was deliberately attacking the "uso comune" that went back to Correggio, in which the tranquil inhabitants of heaven were surrounded by swirling turbulent crowds. It may be that Testa appeared to have become too deeply involved in such critical issues and that he was trying to use the commission to further a point of view, rather than to satisfy the prior's immediate demands to finish the decoration in time for the jubilee in 1650.

Testa's apparent dilatoriness and unreliability must also be set, however, in the context of the extensive preparation that he, following Domenichino's example, devoted to each work. There was no model for the *Prophecy of Basilides*; no other painter could show him how to represent the miraculous effects of St. Theodore's prayers for the Lucca altarpiece; Testa's *Blinding of Homer* is the first of only two representations of the story known.[274] Poussin was indeed fortunate in having friends who allowed his work to mature and so spared him the psychological defeats that haunted so many of the artists around him. Testa suffered a continuing failure of confidence, so often perceived as pride, and had little to offer a patron working for a deadline.

Passeri emphasizes that all this while Testa continued to make prints and that they were sought out eagerly by men of intelligence. The major theme of the prints of the later 1640s continues to be the meaning and character of virtue, although Testa no longer expressed this theme autobiographically through allegories. Instead he began to seek out precedents for his vision of the world in the writings of Plutarch, Seneca, Plato, Xenophon, and Homer. His conspicious concern for historical accuracy in works like *The Death of Cato* (Fig. 79) and *The Symposium* (Fig. 80), both dated 1648, suggests the influence of

[270] Boase, 1939-1940. The *Dead Christ* (Fig. 78) is obviously closely related to this work and must also date to the mid-1640s.

[271] Notebook, 66.

[272] Passeri, ed. 1934, p. 187.

[273] Completed shortly before Lanfranco's death, 29 November, 1647; see Bellori, ed. 1976, p. 393, and n. 5.

[274] A drawing by G. B. Castiglione recently acquired by the National Gallery of Art, Washington, D. C., also represents this story. Castiglione was almost certainly following Testa's example, itself prompted by the publication of Leone Allacci's book, *De Patria Homeri*, for which see Cropper, 1980.

Poussin's recently completed *Sacraments* for Chantelou. The two artists' approaches to narrative are always to be distinguished from each other, however. Whereas Poussin shows every participant reacting to the main event in a way that serves to clarify the spectator's reading of it, Testa makes the *affetti* a part of the event itself. His meditations on the meaning of a kind of Stoic virtue, in which the affections are suppressed, transcend the narrative. In this way Testa comments upon the value of representation itself as a means of persuasion. For example, in contrast to the mourners in Poussin's *Extreme Unction*, Testa shows the violent emotions of Cato's friends as being without virtue, for Cato's own virtue is untouched by death; Testa presents him as a noble Laocoon.[275]

In the series dedicated to the life of Achilles, left unfinished at his own death, Testa presents the same argument about the nature of heroic virtue. In the very first scene (Fig. 81) the vase into which Achilles is dipped to make him immortal already provides a proleptic indication of the end of his story, for it is decorated with a Victory who records his deeds. The story itself, of course, also tells how Achilles's fate was sealed at this moment. The second scene, for which a preliminary drawing exists in the Louvre, making it possible to confirm Testa's invention, if not execution of this print (Fig. 82), depicts Chiron's education of the virtuous hero in the arts of music and hunting (again, as in *Altro diletto ch'imparar non trovo*, counterposed to passionate scenes in the background).[276] In the final print Achilles is grim-faced as he prepares to drag the body of Hector in the dirt (Fig. 83), for the armor he has removed from the corpse is the armor of Patroclus, and Achilles knows that he will be the next to die.[277] He has no alternative, however, but to live and die courageously, and Testa contrasts his virtuous impassivity with the helpless grief of Priam, Hecuba, and Andromache on the walls of Troy. It was by isolating the very nature of the passions rather than through the simple telling of a noble story, that Testa, following Aristotle, sought to justify tragedy, and especially the poetry of Homer, in the face of Plato's challenge that poets must tell the truth.

Passeri also records that Testa intended to devote a series of twelve prints to the life of Cato, but that he only completed four before his death.[278] Passeri may have confused the life of Cato with the Achilles series, for only the *Death of Cato* survives, but the notion of the narrative series appears to have become increasingly important to Testa in his last years. The series devoted to the story of the Prodigal Son reflects this interest, although in it Testa approaches narrative in an entirely different way (Figs. 84-87).[279] The oppositions of passion that characterize the Cato and Achilles prints form no part of this story. Even the lament of the prodigal son as he watches over the swine (Fig. 86) is private and restrained; the reunion of father and son is simple and intimate with a domestic touch added by the pet dog sniffing at the young man's feet. The rigorous archaeological purity of the

[275] See Cropper, 1974, p. 381, for discussion of the inscription.

[276] Fig. 82 is inscribed, "qua ci sia/ la consegnia/ d'Acille a ch/ irone."

[277] Testa illustrates *Iliad* 22. 395-474, including the scenes of Achilles preparing to drag Hector's corpse, and of Priam, Hecuba, and Andromache mourning on the walls. However, by concentrating on the detail of the manner in which Achilles lashed the body of Hector to his chariot by attaching thongs through his tendons, Testa underscores the relationship of the two prints—the representation of the dipping of Achilles suspended by his heel in the Styx when his destiny is sealed, and the moment of the fulfillment of that destiny in the death of Hector. Homer only alludes to this destiny (*Iliad*, 18. 94-124), but does not tell the story of Achilles's youth.

[278] Passeri, ed. 1934, p. 188.

[279] Hartmann, 1970, pp. 113-116 also places this series in the late 1640s.

Cato and Achilles prints has also been modified. The son leaves home against a background of ancient and medieval buildings. Although the axe and the fatted calf in *The Return* (Fig. 87) may suggest an ancient ritual, the reunion takes place in a courtyard bounded by a wall topped with crenellations. In this context, therefore, the antique setting in which the son wastes his substance takes on a particular significance (Fig. 85). The Prodigal reclines on his bed with his lover, contemplating not only his food and drink, but also a statue of *Pan Teaching Olympus to Play the Flute*, based on the group in the Villa Ludovisi.[280] Beyond the Corinthian arches servants prepare food on a goat-footed table. The fountain in the garden is flanked by statues of Bacchus and Ceres, without whom the young man's love would grow cold.[281] Now, toward the end of his life, Testa perceived that even in the ancient world the possibilities for debauchery and ignoble pleasure were as great as those for heroic virtue, no less than in his intolerable present.

The style in which Testa presents the story in this series can only be described as natural—not the debased naturalism of the Bamboccianti, for the story is still a moral one, but a new kind of naturalism that affects both the structure of the narrative and the actions of the characters. There is no real parallel for this in Poussin's work, and the strongest influence upon Testa at this point must have been Sacchi, who completed his brilliant narrative series of the life of John the Baptist for the lantern of S. Giovanni in Fonte between 1641 and 1649. In these pictures simple groups of large figures enact the story in a group of tableaux similar to those devised by Testa.[282]

Testa may have been drawn to Sacchi partly because Sacchi's own neurotic slowness and ineffectuality as a fresco painter struck a sympathetic chord. In turning toward the specific representation of natural rather than ideal actions, however, Testa was really reaching back once again to Annibale Carracci. When Massani introduced the *Diverse figure* in 1646, his purpose was to present a different side of Annibale from the ideal painter of the Farnese Gallery. He hoped that once these natural figures were known Annibale would be seen, not only as the equal of a Polygnotus or an Apelles, but also as a rival of the ancient painter Demetrius.[283] This, of course, was to set Annibale up as the rival of Caravaggio, and of his followers, for Agucchi had long ago associated Caravaggio with Demetrius for having chosen to represent likeness rather than the Idea.[284] At the same time Massani writes of Annibale's caricature studies as his ideal answer to the art of Piericus, whom Agucchi had compared to Bassano, in which the worst side of man was revealed.[285] In Massani's preface, therefore, Annibale is presented as master of all three types of painting, ultimately derived from Aristotle's definition of poetry, in which men are shown as better than they are, as they are, and as worse than they are.[286] It was this complete mastery of all types of painting that was to be the basis of Annibale's reputation in the 1640s, not just

[280] The group was engraved by F. Perrier, for Bellori's *Icones et Segmenta nobilium et statuarum quae Romae extant* (Rome, 1638) pl. 44; see Percy, 1971, p. 138, for reference to Poussin's and Castiglione's use of the motif.

[281] This theme derives from Terence, *Eunuchus* IV, 732. See DeGrazia Bohlin, pp. 342-343, for illustrations by Goltzius and Agostino Carracci.

[282] Harris, 1977, pp. 87-89. Sacchi's early study of Annibale's narrative simplicity in the frescoes in the Herrera

Chapel, is reflected in these works of his maturity; see Bellori, ed. 1976, p. 538, for his study of the chapel.

[283] Mahon, 1947, pp. 258-259.

[284] *Ibid.*, p. 257.

[285] *Ibid.*, pp. 259-260, for Massani; for Agucchi's remarks, see p. 256.

[286] Agucchi lays the ground for this whole argument; see Mahon, 1947, p. 257, and note 252 above.

the ideal beauty of the Farnese Gallery, and as a result the puny successes of a Van Laer, for example, could be put into perspective. Annibale had become a complete artist without compromising any part of his art.

By 1650 Testa had attempted to give the same breadth to his own art. In the *Achilles* and *Cato* prints, for example, he had shown men as better than they are; in his caricatures and in his studies of the extremes of passion he had represented them as worse than they are; finally, in the *Prodigal Son* series he attempted to show men as they are in nature. He was also forced to recognize, however, that fame would not reward him in his own lifetime, any more than it had Annibale, and he chose instead to identify the constancy of his virtue, for which he had struggled so hard, with that of Cato, Achilles, and of Socrates. In his last years Testa took Socrates for his closest companion, and through him he came to revere the courage of Achilles and to believe that to fear death is to think that one is wise when one is not.[287] On March 3, 1650 Testa's death was recorded in his parish church, S. Nicola in Arcione, although his body had already been buried at S. Biagio alla Pagnotta, close to the place where it had been removed from the Tiber.[288]

The idea that Testa's final melancholy was caused by an irreconcilable struggle between a "romantic temperament" and a mind attracted by "classical theories" is as implausible as Sandrart's story that he fell into the river in an attempt to save his hat.[289] Testa's whole life had been dedicated to the constant desire to be a virtuous artist in what he saw to be the tradition of Leonardo, Michelangelo, Raphael, Annibale Carracci, and Domenichino, all of whom populated his ideal Parnassus, described in the notes.[290] Despite the fact that his own life became increasingly lonely and his work was being destroyed almost faster than it was being produced, Testa always clung to an ideal of the artist's life in which friendly discourse was interspersed with labor. In the miserable condition of his last years, when even friends finally refused to lend him money (or so he believed), and when he thought that he had enemies who would laugh when he died, his etchings became his labor and his reading and writing became his discourse. It is to the study of these two inseparable aspects of Testa's life that the remainder of this book is dedicated.

[287] Plato, *Apology* 28C-D, records Socrates's reference, on the eve of his own death, to Achilles's willing embrace of his fate by killing Hector to avenge Patroclus, as an example of a man concerned with honorable action rather than danger, or fear. Socrates goes on to define the fear of death as a form of ignorance based on presumption.

[288] Harris, 1967, p. 60.

[289] Sandrart, ed. 1925, p. 289.

[290] Notebook, 61., 63.

2. Bound Theory and Blind Practice:
Il Liceo della Pittura

It follows from what has been said, that those Architects who have tried to labor and work with their hands without letters have not been able to achieve a reputation through their labors; and those who have put their trust in discourse and in the knowledge of letters alone seem to have followed the shadow rather than the thing itself. But those who have learned both of these things well, like men both protected with every weapon and decorated with credit and repute, have easily achieved their end.[1]

DANIELE BARBARO's translation of and commentary upon Vitruvius was the book perhaps most thoroughly studied and annotated by Testa.[2] His vision of the ideal artist was inspired by this book, as was his program for the education that would lead to this ideal. Here too is the basis for Testa's understanding of the relationship between theory and practice, labor and discourse, and the principles that he believed underlie all of the arts. Vitruvius and Barbaro together (of whom, as we have seen, he first became aware through Domenichino) provided him with his image of the philosopher-painter who seeks after knowledge and who has the ability and duty to teach what he knows to others. Testa filled out this image by ideas from other texts as well as by observations he made from the works of artists past and present, but its outlines and principal features derived from Vitruvius and Barbaro's commentary, with the latter playing an especially important part.

Testa's idea of the Vitruvian philosopher-painter is most succinctly illustrated in a print of about 1644 (Fig. 88), that bears the inscription "Altro diletto ch'imparar non trovo."[3] The motto expresses his outlook perfectly, and the nude male figure who supports the shield upon which it is written personifies the ideal artist Testa sought to be. The verse, however, is not Testa's own. It was written by Petrarch, and Testa found it where the architect Inigo Jones had found it before him, in the pages of Barbaro's edition of Vitruvius.[4] In Book I, chapter two, Vitruvius enumerates the principles of architecture, considering in their turn

[1] "Dalle dette cose ne segue, che quelli Architettori i quali senza lettere tentato hanno di affaticarsi, & essercitarsi con le mani, non hanno potuto fare, che s'habbiano per le fatiche loro acquistato riputatione, e quelli, che ne i discorsi, & nella cognitione delle lettere solamente fidati si sono, l'ombra, non la cosa pare che habbiano seguitato. Ma chi l'una, & l'altra di queste cose hanno bene appreso, come huomini di tutte armi coperti, & ornati, con credito, & riputatione, hanno il loro intento facilmente conseguito," Vitruvius (Preface to Book I), as translated by Daniele Barbaro (ed. 1567, p. 10).

[2] In addition to the references to Barbaro cited below, see

also, e.g. Notebook, 8, 28, 43, 54. For an earlier discussion of material presented in this chapter, here amplified and corrected, see Cropper, 1971.

[3] See Chapter One, p. 58, for the dating of this print.

[4] The quotation does not appear in Barbaro's first, 1556, edition and translation of *I dieci libri*, and so Testa must have consulted the edition of 1567 here (or a later printing of this edition). All references in this chapter are to the 1567 edition. Jones inscribed the line on the first page of his 1614 Roman sketchbook, for which see Gotch, 1928, pl. 4. For Jones and Vitruvius, see Gordon, 1975.

order, arrangement, eurythmy, symmetry, propriety, and economy. The second of these, arrangement, Vitruvius defines as ground plan, elevation, and perspective, all of which are born of reflection and invention. Reflection, in turn, involves study, industry, and vigilance, combined with delight (*dilettatione*).[5] In Testa's print the bust of Minerva surrounded by books, compasses, and a celestial globe broadly indicate that the artist-hero is being drawn toward wisdom; but the architectural drawings on the tablet below, a ground plan, elevation, and perspective diagram, leave no doubt that Testa's invocation to artistic virtue is founded in Vitruvius's discussion of architectural principles. And in fact the title he gave his print derives from Barbaro's commentary, in his second edition of 1567, to Vitruvius's use of the term "dilettatione" in the passage just quoted. In his commentary Barbaro expands upon the delight and pleasure that accompany beautiful things born of hard work and diligence, writing that pleasure follows the fulfillment of desire and that because the intellect desires truth the greatest delight is to be found in learning the truth, "onde si dice: *Altro diletto ch'imparar non trovo*."[6] Barbaro's quotation in this way of a verse from Petrarch's *Triumph of Love* led to its becoming a kind of artist's motto, which is how it was used, for example, not only by Inigo Jones, but also by Alessandro Allori to complement his signature in the *Sacrifice of Isaac*, dated 1601, now in the Uffizi.[7]

Barbaro's commentary to this passage in Vitruvius is based in Aristotle's claim at the beginning of the *Metaphysics* that all men naturally desire knowledge, and his invocation of Petrarch's delight in attaining knowledge in this context is in turn specifically based in contemporary Aristotelian interpreters of the poet, notably on the commentary to the *Trionfi* by Giovanni Andrea Gesualdo, published in Venice in 1541. Gesualdo's commentary to Petrarch's verse thus links it to the *Metaphysics*: ". . . because there is no other delight except in learning, given that all men naturally desire to learn and to know. And even though one learns through all the senses, nonetheless it is the sense of sight that provides information about the most beautiful and varied things, as Aristotle teaches in the introduction to the Metaphysics."[8]

Gesualdo's commentary is part of a new moralizing of Petrarch that appeared after the Sack of Rome within the context of contemporary debates over the need for spiritual reform.[9] Barbaro's commentary to Vitruvius also falls within this tradition of criticism that sought to defend poets and artists from the charges made against Michelangelo when the *Last Judgment* was unveiled, that he had valued his own art higher than the truth. The defense rested on the argument that on the contrary art was an indispensable means for discovering philosophical and religious truth. Indeed, Barbaro's remarks on this particular passage are

[5] "Queste nasceno da pensamento, e da Inventione. Pensamento è cura piena di studio, & effetto d'industria, & vigilanza d'intorno all'opera proposta con dilettatione," Barbaro, ed. 1567, p. 32.

[6] Barbaro, ed. 1567, p. 32.

[7] Inv. 1553. The inscription reads, "A.D. MDCI Alessandro Bronzino Allori ch'altro diletto ch'imparar non prova"; see Appel, 1901, pp. 180-181, n. 21, for the alternative reading of "trovo" for "provo."

[8] Gesualdo, 1541, "Del Triompho d'Amore," chap. 1: "perche altro diletto non pruova, che lo imparar, conciosia che tutti gli huomini naturalmente disiano apparare e savere.

E come che per tutti i sentimenti s'appari, pur la vista è quella, che di più vaghe e più varie cose ne dà notitia, si come ne 'nsegne Aristotele nel proemio de la Metaphisica."

[9] Toffanin, 1929, pp. 499-502, cites several examples of such interpretation, including G. B. Gelli, *Sette lezioni sul Petrarca* (Florence, 1549 and 1551); M. A. Segni, *Ragionamento sopra le cose pertinenti alla Poetica* (Florence, 1581); and L. Dolce, *Esposizione delle tre canzoni di M. F. Petrarca, chiamate le tre sorelle nuovamente mandate in luce* (Venice, 1561). He also underlines Benedetto Varchi's contributions here.

especially illuminating as an index of the tenor and concerns of Counter-Reformation criticism. What he translates in Vitruvius as *dilettatione* is in the original not *delectatio* but *voluptas*; pleasure, as distinct from delight, is a term that normally carried a negative connotation, referring to gratification of the senses and material rewards, and as such it was opposed to virtue in Prodicus's famous exemplary tale of Hercules at the Crossroads, a favorite theme for painters of the period, and one made famous by Annibale Carracci's painting in the Camerino Farnese.[10] Testa's print in fact makes explicit iconographic reference to Prodicus's theme of virtuous education by depicting the young hero, like Hercules, turning his back on the ways of sensual pleasure, represented in the bacchanalian and priapic revels behind, in order to savor the intellectual delight of learning and knowing the truth, presided over by Minerva. In this he is not only relying on the *Metaphysics*, but also on Aristotle's important discussion of the meaning of happiness as the end of human life in *Nicomachean Ethics* 10. This passage, as we have seen, was also significant for his understanding of "Piacere honesto," depicted in the Oxford drawing related to the Franciotti print (Fig. 8).

The alignment effected by Gesualdo and Barbaro of *diletto*, rather than *voluptà*, with the kind of pleasure provoked by poetry and painting, identifying it with the Aristotelian delight that comes from learning the truth, had implications that went far beyond the revision of Petrarch's reputation or the image of the artist, and this is why it was so attractive to Testa and to other artists. Such an alignment provided the philosophical means for reinterpreting Horace's famous definition of the ends of poetry, and hence painting, as the union of instruction with delight. This reinterpretation provided an effective response to Plato's criticism of the kind of pleasure provoked by the imitative arts that Plato banished from his republic precisely because they did not lead to the truth. Barbaro's substitution of *dilettatione* for Vitruvius's *voluptas* and his definition of it in accordance with Gesualdo's invocation of the *Metaphysics* to explain Petrarch's use of the term (a definition further popularized and amplified by Cesare Ripa in his *Iconologia*, where the authority of Aquinas is added to that of Aristotle and Petrarch) gave a defense for poets and painters against the criticisms of Plato by establishing that these arts were themselves philosophic disciplines in the pursuit of the truth.[11] Gesualdo could even be seen as having given primacy in this respect to the visual arts by his emphasis on the higher capacities of the sense of sight.[12] Testa, whose notes show him to have been greatly concerned to refute Plato's criticisms, understood the potential of this reinterpretation, and so rather than emphasizing the didactic half of Horace's union of instruction with delight, as many others had done, he rather redefined the second half to mean the delight that results from learning.[13]

Nicolas Poussin also grasped this meaning when he too defined the end of painting as

[10] See Dempsey, 1981, pp. 276-278.

[11] Ripa, ed. 1625, pp. 172-176. After treating of the pleasure derived from the senses, Ripa explains that the figure of Delight has a book entitled *Aristotelis* to signify, "il gusto, & il Diletto del Filosofare, o ratiocinare stando fondato sopra l'imparare, il che si essercita secondo Platone con quei cinque mezzi che hò detto di sopra, cioè Giuditio, Esperienza, Prudenza, Ragione, & Verità; Et perche Arist. hà nelle sue opere di ogni cosa appartenente alla Filosofia trattato, meritamente le si dà il detto titolo, onde disse il Petrarca. 'Ch'altro Diletto ch'imparar non trovo.' "

[12] For Leonardo's expression of a similar point of view, see Lee, 1967, pp. 56-61, esp. p. 57. Ripa, ed. 1625, p. 173, discusses the superior nobility of sight in his entry devoted to "Diletto," for which see Note 11 above.

[13] Notebook, 57.A. and B., for references to Plato.

single, not the union of instruction with delight, but simply as "la Délectation."[14] He under-stood that to add to this the term "instruction" was a redundancy, for all the writers we have so far cited, by substituting the *diletto* of learning that is the result of instruction for the *voluptà* or *piacere* derived from simple imitation and the charming ornaments of color (whether rhetorical or painted) thereby sought to associate the imitative arts with the third part of the soul as defined by Plato in the *Republic*, that part delighting in the knowledge of the truth. According to Plato the best judge is the man who delights in wisdom because his judgments alone are arrived at through discourse and based in intelligence and expe-rience, and this is exactly the argument employed by Barbaro in claiming that the architect is the best judge of the works of the other arts.[15] It is also the argument to which Testa alludes by placing a bust of Minerva, as Wisdom, in his print. Both Testa and Poussin recognized that delight realized in the pursuit of truth was the only justification for the teaching of art and indeed for the didactic claims of art itself. And for Testa, as we shall see, following in the path of Barbaro, it is the exercise of judgment through the union of intelligence and use that is the mark of a true painter, and that will ultimately lead him to wisdom. His application of Barbaro's vision of the architect as sage (and of Barbaro's expli-cation of Vitruvius's plan for educating such an architect) to his own vision for the training of the philosopher-painter is set forth most completely in his first large-scale etching, in *foglio papale*, entitled *Il Liceo della Pittura* (Fig. 89).[16] It is to this, published c. 1638, that we must now turn.

Notes and drawings that Testa made in preparation for this print form a significant proportion of the Düsseldorf notes. There are also a number of preparatory drawings for it in the Uffizi, the British Museum, the Louvre, and the National Gallery of Scotland, some-thing that supports the argument here advanced (in the Introduction to the Notebook) that the Düsseldorf volume is made up of a random gathering of sheets, rather than being a systematic collection. Some of the notes Testa made in preparation for the print, especially those derived from Barbaro, are also closely related to his projected treatise on painting. This has led to the suggestion that the print was intended to be the frontispiece to the Trattato, which is certainly not the case. The ideas represented in the print are, to be sure, consistent with the main principles outlined in the treatise. Whereas, however, Testa was satisfied enough to publish the print (although unfinished in some details), with a dedication to Girolamo Buonvisi, he ultimately abandoned the project for the treatise that was prob-ably conceived about the same time.

Il Liceo della Pittura is, therefore, Testa's most complex published statement of the principles he thought concerned the education and activities of the artist. At the same time the notes and drawings related to its conception provide a rare opportunity to look beyond the final formulation at Testa's developing attempts to come to terms with and to organize

[14] See Jouanny, 1911, p. 462, for Poussin's definition of painting in his letter to Chambray, March 1, 1665. Here I must disagree with Blunt's suggestion, 1937-1938, p. 349, that Poussin's source was St. Bonaventure or some popular-izer (made despite the fact that Blunt himself points out that the definition ultimately derives from Aristotle). Like Testa, Poussin was surely reading Aristotle through sixteenth- and seventeenth-century reinterpretations and translations, rather than reaching back to some mediaeval aesthetic. In any case, it is Aquinas, rather than Bonaventure, whose commentary on Aristotle is cited by Ripa.

[15] *Republic* 582-583A; Barbaro, ed. 1567, pp. 6-8.

[16] See Chapter One, p. 33, for the dating of this print.

the habits of thought that inform the philosophical idea of the print. The chance survival of Testa's preliminary notes makes it possible to ascertain with virtual certainty many of the books that lay open on the table before him as he worked, making references and cross-references in the study of a particular point. The development of his conception can be traced with some confidence because of the existence of these notes, as long as it is recognized that he was often reading in several sources simultaneously.

Folio 4[r] of the Düsseldorf Notebook contains in a sentence, a diagram, and a drawing the first three stages of the evolution of Testa's *concetto* (Fig. VI). Passeri, writing without benefit of the notes about how Testa had plundered Raphael's *School of Athens*, suggested (much as we can imagine the *intendenti* doing on the day of its issue) that the main groups of figures in the *Liceo* represent the scholastic union of theology, philosophy, and astrology, which he believed to be also at the heart of Raphael's scheme.[17] These groups, however, instead illustrate the three parts of the definition inscribed at the top of folio 4[r] from which the whole *concetto* evolves: "Filosofia secondo Platone è notitia di tutte le cose, cioè Divine, Naturale, Humane." Given Testa's intention to reply to Plato's criticism of the imitative arts by making of the painter a philosopher, it seems appropriate that he should have chosen to construct his School of Painting around a definition of philosophy derived from Plato himself (especially in the light of Baldinucci's statement that Testa delighted greatly in the philosophy of Plato).[18] But we are immediately faced with two puzzling facts. First, the print is not in its final version given the title *Accademia della Pittura*, but instead was issued under Aristotelian colors as *Il Liceo della Pittura*. Secondly, Testa's definition is not taken from Plato at all; it is copied instead, almost verbatim, from Ripa's *Iconologia*, where, in one of the definitions of Filosofia, the statement "Filosofia, secondo Platone, è una notitia di tutte le cose divine, naturale, & humane" is to be found.[19]

It is natural enough that Testa should have turned to Ripa as a source for specific images. But in view of what we know about his wide reading it may come as a surprise to learn that he also used the *Iconologia* for his starting definition. Before dismissing Testa as a cookery-book philosopher, however, it should be remembered that Ripa, himself a member of a literary academy, professed to despise images that were instantly recognizable, and he therefore organized the *Iconologia* not so much around images as such as around their definitions. This required the interweaving and reconciliation of different sources and authorities, and in so doing he was at pains to emphasize that his images were not simple illustrations of the exterior effects of inner essential qualities. This explicit Aristotelianism became even more pronounced as Ripa's fellow academicians added articles to later editions of the *Iconologia* in the first half of the seventeenth century. There is every reason to suppose that Testa, like many of his fellow artists, worked from an understanding of the principles behind the *Iconologia* (clearly expressed by Ripa himself in his introduction). In his use of the book Testa did not merely extract pertinent details and attributes (which he

[17] Passeri, ed. 1934, p. 185, and n. 2, where Hess relates this interpretation to the Ghisi print of 1550.

[18] Baldinucci, ed. 1847, 5: 315.

[19] Ripa, ed. 1625, p. 245. Ripa gives no source for this definition. Winner, 1957, p. 121, suggests a source in sixteenth-century Neoplatonism, but provides no precise origin. A similar definition was, however, taken up by Valeriano, ed.

1625, p. 501. Under the title of *La trinità delle scienze* he writes, "Tre parti sole di tutta la disciplina confessa, che sono, la Morale, la Naturale, e la Contemplativa." He ascribes this true ordering of the sciences to Solomon. Barbaro, ed. 1567, p. 11, also writes of the three principle agents as "Divino, Naturale, Artificiale: cioè Iddio, la natura, l'huomo," which correspond to Ripa's three-part division.

regularly felt free to alter), but rather worked from a more fundamental interest in the philosophical origins and implications that defined the images.[20]

In selecting his original definition of Filosofia Testa took from Ripa the simplest, most comprehensive statement about philosophy he could find there, and one for which there was not an accompanying illustration. Having copied it out, however, he immediately set about amplifying it, further defining each of the three parts of philosophy that he diagrammed in the form of a triangle. At the apex he wrote "Divina cioè separata dai sensi cioè Sapiensa," and beneath this "Platone" to indicate that Plato would be represented here. On the left he wrote "Naturale cioè Mattematica cioè contenplativa e questa mattematica a carte 308 del' Ripa," and indicated that Euclid would preside over this part of the print. And on the right he wrote "Humana cioè pulitica cioè attiva, e questa si fa donna con bilance in mano," again giving a reference to Ripa and indicating which philosopher (in this case Aristotle) is to appear at this point of the triangle.[21]

Although the original definition "secondo Platone" was to provide the rationale for the three main groups of figures inside Testa's *Liceo* until the end, the artist's further development of it in the diagram and the print shows him wrestling to reconcile the definition with various alternatives. In so doing he was still using his copy of Ripa. He not only read the brief entry written by Ripa from which the original sentence was taken, but also the much longer and more complex entry entitled "Filosofia secondo Boetio" written by Giovanni Zarattino Castellini (*l'Intrepido* of the Accademia de'Filopini of Faenza and Ripa's successor as editor of the *Iconologia*), which entered the expanded compendium in the edition of 1618.[22] Castellini's entry, where Philosophy is called the queen of all disciplines and the liberal arts, appealed to Testa because of the emphasis placed on theory and practice. Unlike Ripa's original entry consulted by Testa, Castellini's is also illustrated (Fig. 90) and would certainly have caught the artist's eye and imagination when he turned to a later edition of the *Iconologia*; Philosophy is shown in accordance with Boethius's personification of her, dressed in a gown imagined as a stair, the top rung of which is inscribed with the letter theta, and the bottom with the letter pi. These stand for theory and practice, and the same letters are also used to identify the personifications of these concepts in Testa's print, where, as we shall see, their relationship is changed in an important way.[23]

Castellini begins his definition of philosophy itself by disposing of Seneca's distinction between wisdom as the perfect good of the human mind and philosophy as the love of wisdom and the effort to attain it. Although Seneca himself had pointed out that certain of his colleagues, who identified the end of philosophy as virtue, maintained that the end and the means of achieving it could not be distinguished, Castellini counters Seneca instead by summoning Boethius's identification of philosophy with wisdom, which is also synonymous with virtue.[24] Testa followed him in this, for in the elevation of the building that he drew at the bottom of folio 4[r] he wrote that the statue in the center, appearing as Minerva in the

[20] See Ripa's own introduction to the *Iconologia*, and see also Mandowsky, 1939; Werner, 1977, esp. pp. 11-15.

[21] See Notebook, 11.B., for completion of damaged text here.

[22] The 1603 illustrated edition contained an illustration of Boethius's *Filosofia*, but no discourse. According to the entry in the 1645 edition, p. 206, the discourse was delivered as a lecture to the Accademia de' Filopini in Faenza, October 4, 1613, though the actual text in Ripa follows the text composed by Castellini, himself the editor of this new edition, "molti anni prima in Roma." See Werner, 1977, p. 42, and notes, for the medieval tradition of this image.

[23] Ripa, ed. 1625, p. 234 (for Fig. 90) and p. 211.

[24] *Ibid.*, p. 235.

final print, indicates "Sapiensa/ virtù." Castellini then attempts to reconcile the traditional tripartite division of philosophy into active, contemplative, and logical components with Cicero's famous definition of wisdom (as quoted by Seneca): "Sapientia est nosse, divina & humana, & horum causas." Castellini's first part of philosophy, "l'attiva che compone l'animo nelli buoni costumi," he accordingly identifies with Cicero's knowledge of things human, and this is reflected in Testa's definition at the right of his diagram where he shows his intention to treat those things that pertain to the active and the human, which he further identifies with politics.[25]

Castellini's second part of philosophy, "la contemplativa, che investiga i secreti della natura," also corresponds to Testa's definition at the left of his diagram, where he proposes to treat the contemplative and the natural, which he identifies with mathematics. Castellini, however, instead associated these things with Cicero's knowledge of divine things, separated from the senses, and with wisdom. Nevertheless Testa's conception is still governed by Castellini's discussion of Cicero's definition quoted above, which Castellini uses to develop his own argument for the identity of philosophy and wisdom. Characterizing the knowledge of divine things as contemplative, Castellini subdivides this part of philosophy into physics (which investigates "cose naturali") and metaphysics (which, "riputata da Aristotele divinissima contempla le intelligenze sostanze astratte, & la natura stessa Iddio"). Wisdom is therefore contained by Castellini's and Cicero's definitions of philosophy, especially, writes Castellini, "in vigore della Metafisica da lei contenuta, la quale per auttorità d'Aristotele merita il proprio nome di Sapienza." Testa's third branch of philosophy, which according to his original definition "secondo Platone" was concerned with the knowledge of divine things and is identified in his diagram with wisdom and those things separated from the senses, may thus be seen clearly to derive from Castellini's definition of metaphysics, for Castellini, appealing to the authority of Aristotle, had identified metaphysics with wisdom in its contemplation of pure intelligences and the nature of God. Testa's second branch of philosophy concerned with nature and mathematical operations likewise derives from Castellini's definition of physics. It will appear that a certain amount of mental gymnastics, both on the part of Castellini and Testa, was involved in reconciling a definition of wisdom with a definition of philosophy, and the difficulties thus created were to dog Testa throughout the planning and execution of the *Liceo*. It may be seen too that he shared the view of Boethius as reported by Castellini that wisdom in the broadest sense is further identifiable with virtue.

Testa also omitted at this stage the third part of Castellini's tripartite division, logic, and this may at first seem remarkable given the tremendous importance he attaches to dialectic in his notes, based upon his reading of the *Phaedrus*.[26] He was to deal with this later, however, and at this point he was still guided by the definition "secondo Platone" with which he had started and struggling to reconcile this with the refinements indicated by Castellini. He was moreover particularly concerned to define the opposition of active and contemplative philosophy that in the print is parallel to the bipartite opposition of Theory and Practice in the foreground. It was because of his desire to define the relation

[25] *Ibid.*, pp. 235-236, for this and the following statements about contemplative philosophy.

[26] Notebook, 57.A.

of theory and practice (which are themselves traditional divisions of philosophy) that Testa turned in the first place to Castellini's "Filosofia secondo Boetio," wherein is explained the meaning of Philosophy's laddered dress, with pi at the bottom rung and theta at the top. Of this image Castellini writes, " Il Π greco significa pratica, & il Θ Theorica, nelle quali due parti consiste la Filosofia; cosi divisa da Boetio istesso in Porfirio. *Est enim inquit Philosophia genus, species vero eius duae, una quae* θεωϰϱιτιϰή [sic] *dicitur altera quae* πϱαϰτιϰή, *id est speculativa & activa.*"[27] Here, brought together in one place, are three of the pairs of opposites around which the print is constructed and which Testa overlayed as he moved from the diagram to the drawing to the print: the species of active and contemplative philosophy in the diagram; the figures of Theory and Practice, first introduced in the preparatory drawing; and the letters pi and theta that identify those figures in the final print.

In his early elaboration of the base points of his triangular diagram Testa continued to consult the *Iconologia*. Although the simple identification of Sapienza with Minerva at the apex of the triangle follows Ripa's recommendation, Testa would have needed no authority for this, and he cites no particular source. For the figures of Mattematica and Politica, however, he gives specific page references. For the former the reference to page 308 of Ripa can be read easily, and this is in itself interesting, for it is to the Roman edition of 1603, that is, to an edition earlier than the first to include Castellini's discourse on "Filosofia secondo Boetio." This is not the only occasion when it can be shown that Testa consulted more than one edition of the same work—he did the same, for example, with editions of Barbaro's commentary to Vitruvius.[28] Even as he widened his use of Ripa, however, Testa was also beginning to incorporate into his conception of the *Liceo* elements of the various branches of philosophy based upon a much wider direct acquaintance with the ancient sources.

Testa's choice of Aristotle, for example, to represent the human, active, political philosophy depicted on the right-hand side of the *Liceo* may seem to require no explanation (even though Socrates had been Castellini's choice).[29] In fact, his decision was deliberately and carefully made, the result of intensive study that informed the whole of this side of the print. To begin with the most obvious evidence of his evolving thought, the figure of Politica that his diagram indicates was to have appeared here is absent in the final print. Her place is taken by a large statue of Felicità pubblica, derived from the image on the reverse of a coin of Julia Mammea published by Ripa.[30] Behind this statue, in the architectural niche to the right, appears a statue of Ethics, taken from the same source.[31] Although Testa may be seen to be still relying on Ripa for his personifications proper, the *Iconologia* no longer provides the framework for his ideas. The significance of Testa's substitution of Public Happiness for the dominating figure of Politics, and of the subordination of Ethics (which would seem to have been the obvious personification for human, or moral philosophy) to this figure, together with his choice of Aristotle as the representative of active

[27] Ripa, ed. 1625, p. 238.
[28] Compare, e.g., commentary to Notebook, 8 and 54.
[29] Ripa, ed. 1625, p. 240, explains, on the authority of Cicero and St. Augustine, that Socrates was the first to introduce

morality into the state.
[30] *Ibid.*, p. 231.
[31] *Ibid.*, p. 217.

philosophy, all this can only be understood in light of the knowledge that Testa had before him a copy of Bernardo Segni's translation and commentary to the *Nicomachean Ethics*, published in 1550.[32]

This can be established with certainty from the Düsseldorf notes, which contain several references to Aristotle including one specific reference to the *Poetics*. Marabottini believed all of Testa's incomplete citations to be to this work and, finding them inaccurate, dismissed them as evidence of the artist's superficial knowledge.[33] However, there is also on folio 11[r] a single citation of the *Ethics*, and this (as is discussed in more detail in the Commentary on the Notebook) can only be to the Segni edition. Moreover, all Testa's other citations of Aristotle by page number, but without title, accurately refer to Segni's *Ethics*, leaving no doubt that he read not only the text and commentary, but also read them very carefully indeed.[34]

Testa's decision to replace the figure of Politica with one of Felicità pubblica was based upon his intimate knowledge of the *Nicomachean Ethics*, where Aristotle defines the purpose of politics (or the *faculità civile*) as happiness, Felicitá in Segni's translation, the ultimate good that is sufficient in itself.[35] And since Aristotle further observes that, whereas it is desirable to secure the good in respect to individual persons, it is far nobler to secure the good in respect to a whole nation, and since Segni's commentary to this passage concludes that Aristotle therefore meant that politics is more noble than ethics, it is evident why Testa's personification of Ethics takes second place within the right-hand group.[36] It is also evident that Testa, following a process of careful reasoning, realized that to personify Felicità pubblica would express more accurately the true meaning of Aristotle's conception of politics, as he understood it, than a woman with balances representing *politica* would have done. *Felicità pubblica* conveys within her name an indication of the end of politics, as well as the reason for her predominance over ethics.

The figures gathered around the pedestal of Public Happiness are, moreover, directly inspired by Aristotle's statement that beneath the civil faculty are assembled such honored faculties as the government of armies and the family, as well as the faculty of oratory.[37] These Testa represented in a preliminary drawing (Fig. 91) and in the print as a soldier, the family group of a man, woman, and child, and an orator whom he has figured as Aristotle himself. He is not only recognizable from Raphael's portrait of him in the *School of Athens*, but also, in a preparatory drawing in the Uffizi (Fig. 92), Testa represents him holding a book clearly identified as *L'Etica*.

Testa indicated in his original diagram that on the side of the print dedicated to moral philosophy there should also appear representations of the moral virtues. And in fact, read-

[32] *L'Ethica d'Aristotile, tradotta in lingua volgare fiorentina et commentata per Bernardo Segni* (Florence, 1550). All references to the *Nicomachean Ethics* in this chapter are, therefore, to this edition, cited as Segni, 1550.

[33] Marabottini, 1954, p. 241, n. 46, lists Testa's sources as he had been able to identify them; he describes Testa's consistently accurate references as "quasi sempre inesatte," because in most cases he fails to identify the source correctly.

[34] The importance of the work is also confirmed by the fact that Aristotle is shown holding a copy of it in the preparatory

drawing in the Uffizi, for which see below.

[35] Segni, 1550, pp. 42-46.

[36] *Ibid.*, p. 22; on p. 24 Segni comments, "Mostra quivi la consideratione del fine agibile esser' più degno quando e' risguarda a' piu ché quando e' risguarda a un' solo; nel qual modo la Politica apparirebbe più nobile dell' Ethica."

[37] *Ibid.*, p. 22, "Vedesi anchora sotto di lei stare tutte le faculità honorate, come è quello del governare gli eserciti: e quella del governar' la famiglia: e quella del ben' parlare."

ing from right to left, of the six statues in the attic of the right-hand wing of the temple behind, the first four can be identified as the cardinal virtues: Fortitude, shown as Mars leaning on a column; Justice with a sword; Prudence holding a mirror; and Temperance mixing water with her wine. Although it might be argued that Testa in one respect contradicts Aristotle, who in the *Ethics* sets the prime habit of Prudence apart, it is only natural that he should have followed the familiar Ciceronian grouping applied by Segni himself to Aristotle's discussion of virtue, observing that, "quando e' si dice uno haver' tutte le Virtù morali s'intende, che egli habbia le quattro Virtù principali, cioè Prudenza, Fortezza, Temperanza, & Giustitia."[38]

One of these virtues, temperance, Testa chose to emphasize by adding, between the statues of Justice and Fortitude, a tablet representing the Continence of Scipio. Although, according to Aristotle, the virtues are extremes in the sense that there can be no excess or deficiency in their exercise, nevertheless they must be defined by men of practical wisdom in terms of the mean. Temperance is the virtue that lies between the extremes of pleasure and pain—what Segni calls the "Virtù intorno agli affetti concupiscibili."[39] The path between these particular extremes is, again according to Aristotle, the primary concern of both virtue and political science. Testa's choice of the Continence of Scipio is, therefore, the perfect *exemplum* of moral virtue, no less than of the particular virtue of temperance with which the story was conventionally associated.

Aristotle's discussion of the concept of the mean provided Testa with the foundation for his views concerning not only Public Happiness (as we also saw in Chapter One in the context of his vision of Lucca's Golden Age), but also concerning balanced artistic practice. In the Düsseldorf notes he laments that in all of human life the *strada di mezo* is trodden but rarely and that everywhere he sees men flying from one extreme only to be ensnared by the other. In painting this leads to that regrettable excess *maniera* (as we shall see in the next chapter). To understand the significance of the mean in the *Liceo*, where Testa further expressed it in a diagram expressing the ratio 4:6:9 placed on the base of the statue of Public Happiness, just beneath Aristotle's gesturing hand, we must turn again to Segni's commentary. In *Ethics* 2.6 (of Segni's translation), Aristotle investigates the nature of the mean itself showing that it is not necessarily absolute, following exact numerical proportion, but that it is relative; a ration that is considered too small for a Milo would be large for a man just beginning his athletic training. It is this definitional mean, as determined by a prudent man in relation to the agent, that is observed by Virtue.[40] Segni provides a mathematical analysis of this in his commentary where he explains that the mean can be found in three ways, according to arithmetical, geometrical, or musical proportion. The *mezo della virtù* is found by means of geometrical proportion because it has to do not with the object itself but with its relation to us. Segni then illustrates geometrical and arithmetical proportions in a diagram, the *mezo della virtù* being expressed with the ratio 4:6:9 and the arithmetical mean with the ratio 2:6:10.[41] In a drawing of an allegory of the arts, now in the

[38] *Ibid.*, p. 326.
[39] *Ibid.*, p. 107.
[40] *Ibid.*, p. 97: "È pertanto la Virtù un'habito elettivo, che consiste nel mezo, in quel dico, che à noi risguarda, deter-minato con la ragione, & in quel modo, in che l'huomo prudente determinerebbe."
[41] *Ibid.*, pp. 98-101.

Louvre (Fig. 93), Testa made a diagram of the arithmetical mean using the numbers 3:6:9, apparently in order to show the equality of relationship that exists between three allegorical figures who represent painting, sculpture, and architecture.[42] In this case the mean sums up Testa's answer to the *paragone* of the arts of *disegno*. In *Il Liceo della Pittura*, on the other hand, Testa placed Segni's diagram of the geometric ratio 4:6:9 on the base of the statue of Public Happiness in order to indicate that it is through the application of the *mezo della virtù* as determined by a prudent man (rather than by strict arithmetical equality of terms) that public happiness is to be attained; to each according to his needs.

Testa, in associating in his notes the mean with the activities of the artist, was also taking his cue from Aristotle and Segni's commentary wherein comparisons from the arts are often introduced as clarifications of the arguments. For example, in his definition of the mean, Aristotle refers to the popular way of praising a work of art by observing that nothing could be added or removed without detracting from it; good craftsmen always look to the mean. In this way art and moral virtue have similar aims, although Aristotle always insists that moral virtue is superior to any form of art.[43] He also compares the way in which moral virtues are acquired through practice to the way in which men become builders through building, or harpists through playing the harp. The reverse is also true, for just as virtue is destroyed through practice, so bad harpists are produced through playing—one is reminded of Bellori's criticism of mannerist art of the period just before the Carracci as an art based entirely on repetitious *prattica*—which is why there is need for teachers in the arts.[44] Segni's comparisons in his commentary are sometimes even more specific. The virtue of temperance as a mean, for example, is compared to Francesco da Milano's ability to play the lute with great accuracy as well as to the capacity of Michelangelo, Testa's avowed hero, to render figures exactly from life. Segni adds the cautionary note that this kind of mean is quite different from mediocrity.[45]

While moral virtue ensures the rightness of one's choice of an end, it is the intellectual virtue (or habit) of prudence that determines the mean and thus ensures the rightness of the means used to achieve that end.[46] And, however interested Testa was in Aristotle's and in Segni's comparisons between the arts of making and the moral virtues, he was primarily concerned when planning the governing *concetto* of *Il Liceo della Pittura* to come to grips with Aristotle's definition of right reason, in accordance with which the prudent man determines the mean. This entailed careful study of the sixth book of the *Ethics* in which Aristotle sets aside his consideration of the moral virtues in order to examine the five intellectual virtues through which the mind teaches truth. These are Wisdom, Scientific knowledge (Scienza in Italian), Intelligence, Prudence, and Art, and a summary of Testa's understanding of this book is essential if we are to follow the further development of the idea informing the *Liceo*. More detailed references appear in the commentary to Testa's Notebook below, and so it may suffice here to remark his reference on folio 14[r] to page 287

[42] The drawing is inscribed, "ercole," on the lightly sketched sculpture in the right background, and, between the figures of the three arts and Fame, "il nostro studio è quello che fa per fama gli uomini inmortali." Comparison with the more highly finished version in Stockholm (Nationalmuseum, Inv. no. 553/1863), reveals that the illegible note beneath the diagram identifies Minerva.

[43] Segni, 1550, p. 96.
[44] *Ibid.*, pp. 76-77.
[45] *Ibid.*, p. 88.
[46] *Ibid.*, p. 320.

of Segni's commentary (which is to *Ethics* 6.3), entitled *Del numero degli habiti intellettivi & dell' obbietto della Scienza*.[47] Here Segni restates Aristotle's distinction between those intellectual virtues (Wisdom, Intelligence, and Scientific knowledge) that are concerned with the contemplative (or speculative) intellect and whose objects are founded in necessary truth, and those intellectual virtues (Prudence and Art) that are concerned with the active, practical intellect and with the mutable (*il contingente*). This distinction is reinforced by Segni with two diagrams, one of which (Fig. 94) shows the concern of the speculative intellect with the immutable (*il necessario*) and the practical intellect with the mutable, and the other of which (Fig. 95) shows the intellectual habits proper to each.[48]

This distinction, as we have seen in describing Testa's diagram of the parts of the *Liceo*, motivates the left and right sides of the print, where Testa opposed Teorica and Prattica, Mattematica and Felicità pubblica, and the *contemplativa* and *attiva*. Broadly characterized, the distinction made is one between the arts and sciences, as Segni observes when commenting upon Aristotle's discussion of voluntary choice, something not necessary in the sciences but of the greatest importance in the arts, where many doubts exist: "Wherefore Aristotle affirms that Counsel has more to do with the Arts than with the Sciences, because Art is more uncertain, being in the practical intellect, which has the contingent for its object; and Science, on the other hand, being in the speculative intellect, which has for its object the necessary."[49] In Testa's print the different objects of the two parts of the intellect are personified by Mathematics and Public Happiness, and their objects are explicitly expressed by the two figures that appear behind these statues in the architectural niches, left and right: the sciences concern themselves with the immutable, shown as the pure and naked Truth, in contrast to the mutability and conditionality of the arts, shown by Ethics with her plumb.

Testa's notes give further specific references to Segni's edition of Aristotle that demonstrate the broad extent of his study of the *Ethics*; for example, a reference to page 291 shows him concerned with distinguishing the two parts of the practical intellect, the one having to do with Prudence and actions done (*una parte agibile*, in Segni's words), and the other having to do with Art and things made (*una parte fattibile*). In this place Aristotle goes on to define Art as the habit concerned with making that reasons truly. Arguing syllogistically, he concludes that because building skill is both an art and a habit of making something, and because there is no art that is not a rational habit concerned with making, and because there is no habit of this sort that is not an art, then it follows that art and the habit of making something with right reason are the same thing. Nevertheless, Testa's scheme for the *Liceo* does not express explicitly Aristotle's definition of the particular intellectual habit of Art, nor his definitions of the other intellectual habits. Testa was rather concerned to indicate the wider concept that the term "Art" comprises, broadly speaking, all of the sciences, even as the term "Science" comprises, broadly speaking, all of the arts, notwithstanding the fact that Art and Science are also quite different intellectual habits.[50]

[47] Notebook, 53.C.

[48] Segni, 1550, pp. 280 and 290.

[49] *Ibid.*, p. 133: "Onde affirma egli [Aristotele] il Consiglio esser più intorno all'Arti chè intorno alle Scienze, per la ragione cioè che l'Arte è più dubbia, essendo nello Intelletto prattico, che hà per oggetto il contingente; & la Scienza allincontro essendo nello Speculativo, che hà per oggetto il necessario."

[50] See, for example, B. Varchi, in the *Proemio* to *Della maggioranza delle arti*, in Barocchi, ed., 1960, 1: 6, "devemo

He wishes to demonstrate in *Il Liceo della Pittura* that painting and the teaching of it require the exercise of all the intellectual habits and is founded in both the speculative and the practical intellects. The temple of learning he portrayed embraces both the arts and sciences, and Painting in fact appears beneath Mathematics at the left, led there by Optics. Painting is a habit whose foundations are not only in contingent reason but also in necessary truth, as Testa also wrote on folio 13ᵛ of the notes:

> Painting is a habit that has its foundations in scientific and in contingent reasoning; the one has to do with *mores*, decorum, and the affections, while the other is concerned with the principles of sight, with shadows and lights and reflections, with the way forms diminish virtually to a point, how colors diminish in intensity through weakness in light or from distancing, how color harmonies are made according to the rules of music, and other similar things. Painting remains, so to speak, a cadaver, like a body that has no soul, without these sciences, and in sum practice must needs be united with theory.[51]

It is clear that Testa's reading of the *Nicomachean Ethics* is essential to our understanding of his vision of the ideal Liceo della Pittura, not just to the evolution of the iconographical parts of the work itself. It establishes that he was above all else concerned with the art of painting as an activity of the intellect, as a function of the higher cognitive faculty of knowing the truth, and that it was not an activity of the lower cognitive faculty of perception, based on the evidence of the senses. In exercising the habit of painting the artist was putting his trained intellect to work, and, as we shall see, Testa's main concern as a teacher was that in order to do this the student must acquire the ability to reason correctly. Consequently Testa's print, his ideal school, is not an expression of the narrower concerns of the painter, such as learning to draw, mixing colors, the invention of subject matter, style, decorum, securing patronage, and the like. The print is not a demonstration of the poetics of painting, of its economics, or of its purpose. Testa's main aim was rather to understand and present the noumenology of the artist's mind in action.

It is now possible to place *Il Liceo della Pittura* in its broader historical context, for in his adoption of Aristotle's definitions of the intellectual habits and in basing his scheme on the *Nicomachean Ethics*, Testa was treading in the footsteps of the principle Aristotelian theorists of art in the sixteenth century, and in particular he was following those theorists who provided the intellectual foundations supporting the teaching of art in the Accademia del Disegno in Florence.[52] The most comprehensive, and most influential, statement of this position was made by Benedetto Varchi in his *Due lezzioni sopra la pittura e scultura*, first delivered to the Accademia Fiorentina in 1546.[53] In the *proemio* to his discourse *Della maggioranza e nobilità dell'arti* Varchi summarizes Aristotle's definition of the intellectual virtues, after having started out with the primary distinction between particular, or cogitative reasoning, and universal reasoning. The former, which is comparable to the reasoning of animals, depends upon the evidence of the senses (αἰσθητά, or aesthetic, in Aristotle's terminology, meaning things perceived or sensed) and knows only generable and corrupti-

sapere che, sì come questo nome 'scienza' comprende, largamente preso, ancora, tutte l'arti, così questo nome 'arte' comprende, preso largamente, ancora tutte le scienza, non ostante che la scienza e l'arte siano abiti differentissimi."

[51] Notebook, 46.

[52] See, most recently, Dempsey, 1980, esp. pp. 552-559. For more general surveys of Renaissance Aristotelianism, see Schmitt, 1973; Kristeller, 1974.

[53] *Stile fiorentino*; the lectures were, therefore, delivered in Lent, 1547, for which see Barocchi, ed., 1960, 1: 335.

ble things.[54] Art is not a part of this inferior cognitive faculty, but belongs to the superior faculty of universal reasoning. This faculty pertains to understanding and to knowing the truth philosophically, and it considers that which is without matter or passion, has no accidents, and is hence ingenerable and incorruptible. Universal reasoning is in turn divided into two parts, the higher contemplative, or speculative intellect governed by the intellectual habits of Intellect, Wisdom, and Scientific knowledge; and the lower active, or practical intellect governed by the intellectual habits of Prudence and Art. All the sciences, according to Varchi, belong to the contemplative intellect because their purpose is to contemplate the causes of things. The arts, on the other hand, belong to the active intellect, which is concerned with doing and making. Prudence is the habit concerned with doing (the *agibile*), Art the habit concerned with making (the *fattibile*). Varchi here refers directly to the *Nicomachean Ethics* 6.4, adding that anyone who reads this chapter will easily understand what is an art and what is a science. And although he emphasizes, with Aristotle, that Art is the lowest of the five intellectual habits, the significant point is that he agrees that Art is one of their number, and although it deals with things that are variable and contingent, its conclusions are nonetheless true. In support of this Varchi, in the *Disputa prima*, repeats Aristotle's definition of Art as "un abito intelletivo, che fa con certa e vera ragione."[55] On this basis Varchi went on to give his own amplified version of the nature of art, a version that carried the weight of his own considerable authority, and one that provided a defense for the arts in the period of the Counter-Reformation as well as giving philosophical support for the teaching of the arts as academic disciplines based in the Arts and Sciences. Not long afterwards, in 1563, the Accademia del Disegno was founded on this basis, comparing itself to the faculty of letters at the Studio at Pisa, and the conception of the arts voiced by Varchi similarly gave impetus to the rise of the academic movement generally in the sixteenth and seventeenth centuries. In 1584 Raffaello Borghini rehearsed the same summary of Aristotle's definition of the intellectual habits of universal reasoning in the first book of *Il riposo*, concluding with Varchi's expanded definition of Art, feeling it unnecessary to acknowledge either Aristotle or Varchi directly.[56] Testa is heir to this tradition, and of special importance to our investigation is the fact that Daniele Barbaro had earlier undertaken the same summary of the *Ethics* 6.4, in the *proemio* to his translation of Vitruvius, first published in 1556, just ten years after the *Due lezzioni*, in order to demonstrate that Prudence and Art are intellectual habits of the practical intellect, and that whereas Prudence is the "habito moderatore delle attioni humane, e civili," Art is the "habito regolatore delle opere, che ricercano alcuna materia esteriore."[57] It was this that led Testa directly to the study of Segni's translation of the *Ethics*, which he read together with Barbaro's edition of Vitruvius. The purposefulness with which he thereby associated himself with this well-established Aristotelian tradition may be measured by the title he chose for his ideal school: the Lyceum of Painting.

Before turning to the question of how Testa would have the fledgling artist acquire the right reason without which he could not claim to be exercising his intellect (a question Varchi and Barbaro also considered), we must now consider the left-hand side of the *Liceo*,

[54] Varchi, in Barocchi, ed. 1960, 1: 4-6.
[55] *Ibid.*, 1: 9.

[56] Borghini, 1584, 1: 46-49.
[57] Barbaro, ed. 1567, p. 3.

which Testa devoted to the contemplative intellect, presided over by Mathematics, with Euclid appearing as its chief representative.

On folio 14r of the notes Testa refers to the prolegomena of Federico Commandino's translation and commentary to Euclid's *Elements*.[58] Just as he had turned to Segni's edition of the *Ethics* for his amplification of the right-hand side of the *Liceo*, devoted to the active intellect as represented by Aristotle, so he here turned to Commandino, who was famous for his translations of Greek mathematical texts and his Aristotelian commentaries to them.[59] In this note Testa is referring to Commandino's defense of geometry in response to those who claim that it employs the imagination, saying that magnitudes, spaces, and lines are not artificial things, but are in some way conjoined with nature. Although the mathematical sciences are indeed inferior to the divine (shown by Testa in the center of the *Liceo*, and at the apex of the triangle in his diagram), the stability and certainty of mathematical demonstrations compensates for this. Of especial importance, however, is the diagram Testa drew in the margin of folio 14r (discussed more fully in the Commentary to the Notebook 53.B.), also deriving from Commandino, that bears the closest relationship to the print. It shows Testa working through Commandino's distinction between the mathematics that deal with intelligible things and those that deal with sensible things. The former excite the soul for their own sake and are worthy of the more profound study. The two species of this study are arithmetic and geometry, and in the *Liceo* Euclid appears tracing geometrical figures with his compass, while a counting tablet lies on the ground next to him. He is shown therefore as representative of the nobler aspects of mathematics.

The figures of Euclid and those gathered around him are of course derived from Raphael's *School of Athens*, but even so all of them depend upon Commandino's edition of Euclid for their meaning and justification in the print. After having characterized geometry and arithmetic as the two species of the higher form of mathematics, Commandino then gives an account of the lower species of mathematics, whose objects are sensible. These comprise the art of making machines, especially military engines, and this Testa indicated in the *Liceo* by the seated soldier who watches Euclid's geometrical demonstrations;[60] the arts of astronomy and geodesics, which Testa represented respectively by the figures of Zoroaster and Ptolemy; canonics, or music, shown by the man holding a lyre and kneeling behind Euclid; optics, or perspective, shown by the figure who guides Painting toward the group from the center; and finally, the keeping of accounts, which completes Commandino's list, and to which Testa refers through the figure in a cap and long robes to the extreme left of the group, who almost certainly is meant to represent a clerk.

Testa's second reference to Commandino's Euclid in the notes was made with the figure of Euclid himself in mind. The annotation is to Commandino's discussion of the differences between problems and theorems, where he enumerates the six parts of a theorem, and where he illustrates Euclid's Problem I, Proposition I, writing that this first problem will make everything he has been saying quite clear.[61] The problem annotated by

[58] Notebook, 53.B.

[59] See, e.g., Rose, 1973.

[60] This thoughtful soldier, who represents the contemplative aspects of military science that rely on *disegno*, is opposed to the active soldier, hand on sword, who listens to the political discourse of Aristotle. In Valentin's *Four Ages of Man*, National Gallery, London, a similar contemplative figure meditates upon the plan of a military fortification.

[61] Notebook, 27.B.

Testa is the construction of an equilateral triangle above a given straight line, and a close examination of Testa's print reveals that Euclid is engaged in constructing this very figure: with center "A" and radius "AB" Euclid is describing the circle "BCD."

The particular attention Testa devoted to Commandino's distinction between the intelligible and sensible species of mathematics led him to make a small, but significant change in the personification of Mathematics that he took from Ripa's *Iconologia* (Fig. 96).[62] In most respects he followed Ripa quite closely, giving Mathematics a transparent gown, wings on her head, and bare feet, and also showing a putto standing next to her supporting a tablet on which is drawn a circle, point, and triangle; but whereas Ripa shows Mathematics drawing with her compasses upon the tablet in order to demonstrate the notion that mathematics requires practical application, Testa instead shows the compasses in her left hand pointing upwards toward heaven, thereby indicating the derivation of her principles and placing her in the realm of pure intelligence rather than practical application. The useful aspect of mathematics, insisted upon by Ripa, is thus separated from the personification itself and is instead shown by the figures gathered around the base of the statue who learn the principles of mathematics from Euclid in order that they may translate them into practical use. In this respect the statues in the *Liceo* taken together with the figures gathered beneath them illustrate the two parts of the motto—Intelligence and Use—carried aloft by the two putti (who represent *disegno* and *colore*) in the center of the print. As Public Happiness on the one hand stands for the principle of the good that is the end of politics and is translated into active use by Aristotle beneath, so Mathematics as the pure knowledge of its own principles is translated into active use by Euclid with his compasses. In opposing the two, Mathematics on the one side and Public Happiness on the other, Testa has introduced another Aristotelian distinction: each of the sciences, as objects of the contemplative intellect whose principles are necessary, considers its own subject, in this case mathematics, whereas each of the arts, as objects of the active intellect whose principles are contingent and which results in doing or making, considers its own end, in this case the general happiness that is the end of political science. Furthermore, by representing in each section of the print a pure intelligence, personified by the statues, together with men giving this intelligence practical application, Testa has illustrated how in the broader sense the terms "Arts" and "Sciences" mutually comprise all the arts and sciences, notwithstanding the fact that Art and Science are also quite distinct habits of universal reasoning. The science of mathematics is given practical application in the arts of military engineering, geographical surveying, astronomical calculation, music, accounting, and the like; whereas the art of politics derives its principles from a universal intelligence of the good, and even though the objects of that intelligence are variable, nevertheless they can be expressed with certainty, as Testa demonstrated in the mathematical diagram showing the geometrical proportions of the *mezo della virtù*. Within *Il Liceo della Pittura* Theory and Practice are shown as united in each part of the print, represented equally in both the active and contemplative realms of the intellect; it is only outside the temple, as we shall see, that the two are separated and hence both of them helpless.

[62] Ripa, ed. 1625, p. 410.

In his prolegomena Commandino observes that none of the lower arts could fulfill their aim without the help of mathematics, and he notes that both Aristotle and Plato agreed that mathematics gives indispensable aid to the liberal arts.[63] Accordingly, Testa placed the Liberal Arts in the attic of the temple at the left, where they balance the Moral Virtues that appear in the attic at the right. Music is unusually represented as Pythian Apollo, but a more orthodox Astronomy, Arithmetic, and Geometry follow from left to right.[64] Testa appears to have been happier about the clear indication of the *quadrivium*, whose practitioners appear gathered around Euclid below, than he was about the *trivium*, which would seem at first to belong more naturally to the side opposite, where Aristotle applies the skill of oratory in expounding the principles of public happiness. The other three figures are indistinctly represented, but the female figure holding a book, next to Geometry, is apparently Grammar, while for Dialectic, who stands next in line, Testa has clearly employed the image attributed by Ripa to Zeno of a man who holds forth a fist to demonstrate the brevity of his arguments.[65] Rhetoric, however, is strangely represented by a wreathed male figure who occupies a dubious spatial position in the corner. Testa's representation of the liberal arts in this part of the print apparently follows upon Varchi's characterization of the liberal arts as, properly speaking, neither arts nor sciences: insofar as grammar and logic, for example, have as their ends oratory, or speech, they treat of words, not things, and are hence not sciences; and insofar as we do not have complete power to freely exercise them or not, they are not arts.[66] In Aristotle's philosophy it is the exercise of moral virtue in determining the mean that leads to choice and to action, and therefore Testa has appropriately represented the moral virtues in the attic at the right, where they support the active intellect. The liberal arts, on the other hand, are the descriptive techniques in which the noble mind is trained, and therefore they appropriately support the contemplative intellect. It should be clear, however, that neither the moral virtues nor the liberal arts are in themselves part of that universal order that is divided into active and contemplative components.

The unusual choice of Pythian Apollo to represent music can be understood through an examination of the tablet it helps to frame. The relief depicts the death of Archimedes. In his *proemio* Commandino had singled out Archimedes for particular attention, and the great mathematician's meeting with death with his compasses in hand set an example of dedication that most certainly would have appealed to Testa.[67] However, his inspiration was even more specific. The same scene appears immediately below the group of mathematicians in the *School of Athens* that inspired Testa's similar grouping in the *Liceo*. Pythian Apollo completes the allusion, for it is modelled on the giant statue that appears in the left-hand niche of Raphael's fresco.

In the niche to the right of Raphael's *School of Athens*, opposed to Pythian Apollo, stands Minerva, shield and spear in hand, just as Testa showed her in the center of the *Liceo*. This brings us back to an examination of Testa's triangular diagram, the resolution

[63] Commandino, ed. 1619, Prologomena, p. 3.
[64] All three follow the traditional definitions in Ripa.
[65] Ripa, ed. 1625, p. 167.
[66] Varchi, in Barocchi, ed. 1960, 1: 8.

[67] Commandino, ed. 1619, Prologomena, pp. 2ᵛ-3. Commandino also translated Archimedes; the copy of his *Archimedis opera nonnulla* (Venice, 1558) now in the British Museum is from the library of Vincenzo Scamozzi.

of which within the scheme of the *Liceo* presents difficulties, probably because it also puzzled Testa. The essential problem he faced was one of integrating the carefully considered bipartite philosophical structure that informs the foreground of the *Liceo*—natural and moral Philosophy, contemplative and active thought, necessity and contingency, and, as we shall see, theory and practice—with the tripartite structure—natural, human, and divine—of his original definition "secondo Platone."

The figure of Minerva clearly stands for philosophy, which Testa, as we have seen, following Castellini's exposition in Ripa's *Iconologia*, equated with wisdom and virtue and divided into its two component parts, the speculative and the active intellects. In this sense she may seem to require no explanation, especially in light of the sacerdotal figures gathered around her feet, who clearly indicate that the divine things she contemplates not only pertain to metaphysics but also express the principles of true religion, a notion perfectly natural in a painter of the period of the Counter-Reformation. However, instead of the priests who appear in the final version of the *Liceo*, Testa originally had intended to place Plato himself at the foot of Minerva, whom he identified with Sapienza. There are many reasons why he should have chosen to do this. His own reading of Plato would have certainly supported the traditional epithet of "divine" accorded to the philosopher, a meaning that was conspicuously represented by Raphael in the upward-pointing gesture of Plato in the *School of Athens* (and at this point Testa undoubtedly meant to imitate Raphael's Plato, as he did in the case of Aristotle and the group gathered around Euclid). Furthermore, Castellini in his discussion of the attributes of Philosophy in the *Iconologia* (largely taken from St. Augustine) had written that Plato united the two previously existing parts of philosophy, natural and moral, active and contemplative.[68] But Plato's means of uniting the two was dialectic, and this in no way accords with Testa's definition of the third part of the *Liceo* as the contemplation of the divine. As for Testa's dependence on the *School of Athens*, while it might have been possible when he set out to illustrate his original definition of philosophy to disregard the strict equality of Raphael's scheme by giving Plato the place of honor in the center, this in the end would have been entirely out of keeping with a system which, as it evolved, was so purposefully Aristotelian. Thus Testa omitted Plato altogether, and in so doing he turned his adaptation of Raphael's conception on its head. He took Minerva from her niche on the right-hand side of the *School of Athens*, where she appeared in support of Aristotle and the *Ethics*, and he placed her in the center of a truly Aristotelian *liceo*, quite distinct in its name and character from a Platonic academy.

In Testa's diagram of folio 4ʳ (Fig. VI), beneath the plinth (marked "D" for Divina) appears the notation, "Sapiensa/virtù." In *Ethics* 6.7, Aristotle treats of Sapienza as the fifth of the intellectual habits, and in discussing its nature he adduces examples drawn from evaluations of works of art in order to show how the term Wisdom is applied to those who are the most perfect masters of their art; in Segni's words, "di Fidia si dice, che egli è saggio Intagliatore in pietra; & di Policleto, che egli è saggio Statuario."[69] These examples

[68] Ripa, ed. 1625, p. 240. Testa may have intended the Zoroaster figure in the center of the group on the left to represent Plato as author of the *Timaeus* (as in Raphael's fresco), corresponding to the figure of Aristotle on the right; in Uffizi drawing, Inv. no. 774F (114 × 151, cut at top left,

Pen and brown ink over graphite; laid down), this figure is marked by a cross. In the end, however, it is given no especial prominence.

[69] Segni, 1550, p. 299.

only serve, however, to contrast with the meaning of Wisdom in the broadest sense, applied to those who are wise in general rather than in one particular area. In an absolute sense Wisdom is the most perfect of the intellectual virtues, since the contemplative virtues are superior to the active, and since Wisdom combines in itself the other two contemplative virtues of intelligence and scientific knowledge; the wise man must know not only the conclusions that follow from first principles, but also must have a true conception of first principles themselves. Wisdom, in Segni's translation, "sara una Scienza capitanessa di tutte l'altre Scienze più nobili."[70] Aristotle's full discussion of Sapienza as metaphysics and its superiority over the other speculative virtues is in the *Metaphysics* rather than the *Ethics*; however at his point Testa's conception for the *Liceo* parts company from its specific Aristotelian sources.

Although Testa's conception is profoundly determined by Aristotle's treatment of the intellectual virtues in the *Ethics*, none of these virtues is itself personified in the *Liceo*. Had they been, Wisdom, together with Intelligence and Scientific knowledge, would have had to appear as attributes of the contemplative intellect at the left, and Prudence and Art as attributes of the active intellect at the right. Segni, however, in his commentary, writes that only Sapienza considers "sustanze separate, che sono gli enti nobilissimi," and that Metaphysics considers not only these "sustanze astratte," but also God.[71] We have already seen that Testa took this into account by following Castellini's exposition of "Filosofia secondo Boetio," wherein Castellini took Cicero's bipartite definition of Wisdom as the knowledge of things human and divine, and their causes, and showed that the knowledge of divine things was itself divisible into two parts, physics, or natural philosophy, and metaphysics, which contemplates pure intelligences and the very nature of God. In the final print Testa followed this distinction by representing Mathematics as the contemplation of abstract essences as separate from Minerva, personifying Sapienza (which Boethius had equated with virtue and philosophy), which contemplates divinity. Sapienza appears in the center as mistress of the whole, and Testa has doubly emphasized her dominance over the active and contemplative realms by raising her up upon a stepped platform. She appears not simply as Sapienza but specifically in her religious aspect as Sapienza divina. He conceives of her and her followers syncretistically, showing a Roman sacrifice on one side (the figures derived from Raphael and Poussin), a Greek priestess dressed in her *peplos* on the other, and in the center a rabbi and a bishop (who is not, interestingly enough, especially singled out). Fully consonant with this syncretistic position is the obelisk with its hieroglyphs that appears behind Minerva, for it was the Egyptians who were thought to have been the inventors of philosophy and religion, which they taught to Plato and to Moses.[72]

This then is Testa's vision of the temple of Philosophy within which the personified spirit of Painting roams freely. Painters themselves are notably absent from its precincts, as are students of painting. And yet the porch is a place for painters over whose activities Minerva also presides, the "dotto Liceo di Pallade" of Testa's inscription. To understand

[70] *Ibid.*, p. 299.
[71] *Ibid.*, p. 302.
[72] The four identifiable scenes in the central part of the attic, depicting the *Adoration of the Golden Calf, Moses Receiving the Tablets*, the *Sacrifice of Isaac*, and *The Ark of the Covenant*, echo the theme of the knowledge of divine things presented below. For the syncretistic tradition at the Barberini court, discussed in relation to the *Venus and Adonis* in Chapter One, see again Dempsey, 1966.

how Painting operates within it and how the young student is to follow her, we must step back to a point outside the domain of Philosophy for a moment—to the forecourt where Theory and Practice also stand, fruitlessly isolated from one another—and regard the inscription Testa placed on the basement of the building at the left of the steps that lead up to the porch itself:

> Theory by herself is bound, and Practice by herself is blind in her freedom; but whoever from his earliest years in the study of painting learns what is good from the great masters, and then advances to imitating on his own the objects of nature, enters into the learned Lyceum of Pallas; there he discovers and understands the arts of Mathematics, and he joins Theory to Practice; and divesting them of their defects by the happy coupling of Intelligence and Use, he acquires for himself a glorious name, and his virtue increases in the esteem of the world.[73]

In Testa's view Theory and Practice are equally inadequate, exiled and separated outside the *Liceo*. Only those young painters who follow the correct path will be able to unite them effectively within, as do Euclid and Aristotle, bringing together the knowledge and understanding of principles with the acquired habits of usage. Testa's inscription tells us more about theory and practice than it does about intelligence and use, and as he words it the joining of the two pairs of opposites appears to take place simultaneously. The fact that the two sets of terms are almost interchangeable, often being used virtually synonymously by sixteenth-century theorists, makes it difficult to draw too fine a line between them, although an important distinction does exist. Moreover, the fact that Testa chose to make Intelligence and Use the guiding motto for his *Liceo*, while placing Theory and Practice apart outside it, shows that he was keenly aware of this distinction. "Uso," which we might translate as usage, is the habit of acquired practice; and "Intelligenza," which we might translate as understanding and knowledge, is the habit of acquired theory. Intelligence and use must be understood as more general terms proper to the activity of those who have by attaining perfection in theory or practice in fact already united the two; a development is stated from the study of theoretical precepts to understanding and knowledge and from laboriously repetitive practice to the ease of usage.

Aristotle's presentation of the activities of the intellect as habits required that they be exercised. This is true even of those habits that do not have to do with making and doing. Again Varchi summarizes the position most succinctly, in his explanation of the meaning of a habit: "Wherefore, just as all the virtues are habits and not dispositions, so are all the arts; because, in order to be a virtuous or true artificer, disposition (that is being ready and disposed to be able to carry them out) is not enough; but one needs the habit, that is to have practised one's art so much, through usage, that one can exercise it easily, and lose it with difficulty."[74] It is not sufficient simply to have the disposition to be a mathematician,

[73] "La Theorica è per se stessa di leggami avvinta e la Prattica nella sua libertà è per stessa cieca; ma chi in età di freschi anni ne gli studij della pittura il buono di gran maestri apprende; e poi avanzandosi ad imitare da se gli ogetti della natura, entra nell' dotto Liceo di Pallade, e vi ritrova et intende le arti della Mathematica unisce egli la Theorica alla Pratica; e spogliando le de loro difetti con felice acoppiamento dall'intelligenza e dall'uso, a se acquista gloria di nome & al mondo accresce pregi di virtù."

[74] Varchi, in Barocchi, ed. 1960, 1: 10: "Onde, come tutte le virtù, così ancora tutte l'arti sono abiti e non disposizioni, perciochè non basta ad esser virtuoso o vero artefice la disposizione, cioè l'essere atto e disposto a poterle conseguire, ma si ricerca l'abito, cioè l'avervi fatto dentro tale pratica, mediante l'uso, che si possano esercitare agevolmente e malagevolmente perdere." Ripa, ed. 1625, p. 582, also repeats this commonplace in his definition of Sapienza humana, which figure, according to the Lacedemonians, should be shown with four hands, because contemplation must be supplemented by "il molto uso" if one is to be truly wise.

an orator, or an artist, but one must constantly be able to put one's knowledge and skills to effective work. Certainly it would be impossible to demonstrate true knowledge by attempting to teach it without any means of expression, to express the ideas conceived in the mind without the acquired habit of usage.

Many sixteenth-century writers on art, however, tended to assign greater importance to knowledge than to the ability to demonstrate its understanding in practice, and this is especially true of theorists of painting when they sought to assess the balance between the two. The hierarchical placing of intelligence above use still appears, for example, in Romano Alberti's analysis of the relative merits of the intellect and the practical demonstration of its ideas. The quotation from his *Trattato della nobiltà della pittura* (Rome, 1585) that follows is helpful to our understanding of Testa's *Liceo*, in part because of his comparison between the painter, the theologian, the orator, and the mathematician, in part because the primacy that he gives intelligence over use (even while conceding that both are necessary) contrasts so markedly with Testa's conception that the two are in virtual parity:

> And from this we may gather how much this art has to do with the Intellect, and to what mental efforts he who wishes to achieve perfection in it must submit; because the Painter can produce no form, or figure in his imaginative faculty, as one author puts it, if the thing so imagined has not first been reduced to an Idea by the other intrinsic senses, with that integrity that is necessary, so that the Intellect understands it in itself. To put this more clearly, it is necessary for the perfect Painter to be learned in theory without making, and this making does not subsequently diminish the nobility of Painting, contrary to what some people think; for the painter makes use of this to express his concept, which he cannot do without the power of movement, and other extrinsic things, just as the Theologian and the Orator make use of writing, the Mathematician of the compass, tablet, chalk, astrolabe, and many other instruments; these are principally used in that area we have called mechanical, as in the making of instruments of war, machines, weights, spheres, each of which Archimedes made, according to what we read.[75]

An insistence upon the necessity of uniting the speculative and the practical parts of an art did, however, become increasingly common in treatises devoted to the teaching of the arts in the sixteenth century that draw their own justification from Aristotle's distinction between the arts and crafts. Varchi, for example, also emphasizes this, but it is not limited to the visual arts alone.[76] For example, Gioseffo Zarlino, in his *Istitutioni harmoniche* (first published in Venice, 1558), maintained that an understanding of the principles of music was more noble than the performance of it (even as Aristotle argued for the primacy of the theoretician over the mere expert), but he stated that "tuttavia non può lo Speculativo produrre cosa alcuna in atto, che habbia ritrovato nuovamente, senza l'aiuto dell'artefice

[75] Alberti, 1585, pp. 14-15: "E di qui cavaremo quanto Intelletto sia quest'arte, & che fatiche dell'animo si debbia sottometter colui, che d'esse vuol'acquistar le perfettione; perche non puo produrre il Pittore forma, o figura alcuna della sua immaginativa, come dice un'autore, se prima quella cosa cosi imaginata non vien da gli altri sensi intrinseci ridotta in Idea, con quella integrità, che si ha da produrre; talche l'Intelletto l'intenda in se stesso: e per dirla più chiaramente bisogno, che il perfetto Pittore sia theoricamente dotto senza l'operare, il qual operar dipoi non diminuisce la nobiltà, al contrario di quel che pensano alcuni, servendosi di cio il Pittore per esperimere il suo concetto, il che non puo fare senza la potentia motiva & altre cose estrinsiche, si come si serve il Theologo, & Orator dello scrivere, il Mathematico del compasso, tavola, gesso, astrolabij, & altri molti instrumenti, delli quali principalmente si serve in quella parte da noi sopradetta machinaria, come in far instrumenti bellici, machine, pesi, sfere, ciascheduna delle quali leggemo, che fece Archimede."

[76] Varchi, in Barocchi, ed. 1960, 1: 27-28.

overo dell'istrumeno."[77] To be what Zarlino calls a *Musico perfetto*, as opposed to a *Sonatore*, *Compositore*, or even simple *Musico*, the musician must master both the speculative and the performing aspects of his art, especially, it should be emphasized, if he is to create anything new. His determination that the musician must master both parts of the art is different from the attitude of fifteenth-century writers like Gafurio, who treated theory and practice quite separately. Zarlino seems to have been influenced in this by treatises on painting, for he writes:

> But seeing that for anyone who wants to be a good painter, and to achieve great fame in Painting, it is not enough to use colors beautifully, if he does not know how to give an accurate account of the work he has made; so it is that for anyone who wishes to have the name of true Musician, it is not enough, and does not bring much praise, to have united harmonies when he does not know how to explain such union. I have, therefore, set out to treat of those things that pertain both to the practical and speculative sides of this science together; so that those who would like to be numbered among the good musicians may (by reading my book accurately) give an account of their compositions.[78]

This brings us back to Barbaro's commentary on Vitruvius, which was undoubtedly the source for so many of the arguments along these lines. Neither Barbaro nor Vitruvius use the terms intelligence and use, but the concepts of Fabbrica and Discorso, which Barbaro describes as the mother and father of architecture, coincide closely with Zarlino's and Testa's intentions. In his definition of Fabbrica Barbaro introduces the idea of the need for a special kind of use, Assuefatione, "which is nothing other than the frequent and repeated operation of some virtue and power of the mind or the body, whence one says that a man is used to his labors, to be used to, turned to use, usage, and habit. He must, therefore, be used to thinking about his purpose continually."[79] Discourse is defined in several ways by Barbaro, but it has two main aspects: in the first place it is the process of ratiocination by which the means is found to the end (e.g., the discovery of the middle term of a syllogism); secondly it is the explanation of how this was arrived at. Just as Zarlino insisted that his musician be able to explain, or teach, what he had composed, so Barbaro expected the architect to be able to explain what he had done, rather than expecting to be called an architect simply because he could point to something done in this palace or that church.[80]

In *Il Liceo della Pittura*, as we have seen, the many different philosophers are all of them combining their knowledge of causes with practical use. They are exercising intellectual virtue by learning, teaching, explaining their thoughts, and even, in the case of Euclid and Aristotle perhaps, by discovery. No one is idle. Within the temple there is ideal intellectual balance. Outside its walls Theory and Practice stand isolated and both of them

[77] Zarlino, 1573, p. 26, "nonetheless the speculative Intellect cannot execute anything that it has newly discovered without the help of artifice, that is to say with the help of an instrument." It is this treatise that Poussin cites in his famous letter on the modes, for which see Chapter Three below.

[78] *Ibid.*, p. 2: "Ma vedendo, che si come a chi vuol esser buon Pittore, & nella Pittura acquistarsi gran fama, non è abastanza l'adoprar vagamente i colori; se dell'opera, che egli hà fatto, non sa render salda ragione: cosi a colui, che desidera haver nome di vero Musico, non è bastante & non apporta molta laude l'haver unite le Consonanze, quando egli non sappia dar conto di tale unione: però mi son posto a trattare insiememente di quelle cose, lequali, & alla Prattica, & alla Speculativa di questa scienza appartengono: à fin che coloro, che amerano di essere nel numero di buoni Musici, possano (leggendo accuratamente l'opera nostra) render ragione de i loro componimenti."

[79] Barbaro, ed. 1567, p. 9: "la quale non è altro, che spessa, & frequentata operatione d'alcuna virtù, & potenza dell' anima, o del corpo. onde egli si dice esser usato alle fatiche, esser usato, posto in uso, usanza, & consuetudine. Bisogna adunque esser uso di continuamente pensar al fine."

[80] *Ibid.*, pp. 9-10.

ineffectual, and here Testa treats the same theme that Dürer made the subject of his *Melancholia I*, in which Theory and Practice, *Kunst und Brauch*, are each reduced to miserable helplessness in the absence of an effective union.[81]

The nature of theory and practice was, as we have also seen, treated by Castellini in his discourse for Ripa's *Iconologia* on Boethius's personification of philosophy. However, the particular personifications adopted and amplified upon by Testa for theory and practice were the inventions of Fulvio Mariotelli, whose entries on Theoria and Prattica entered the *Iconologia* in its 1618 edition.[82]

Testa's Practice is, like Mariotelli's, old and humbly clad, but in other respects subtly adapted in order to illustrate his own ideas more accurately. Mariotelli described Practice as looking at the ground because she is concerned with the lessons of experience only, and he gave her the attributes of a compass and a rule (Fig. 97).[83] The compass signifies reason, necessary to every human activity, but Prattica holds hers with the points turned downwards, while the compasses on the head of Theoria point upwards to heaven; this is to demonstrate that theory works from universals to particulars, making demonstrative conclusions, while practice reasons inductively, from the particular to the universal. The plumbline (as in the personification of ethics) is also the attribute of Practice because, whereas theory is governed by things that are necessary, eternal, and stable, practice is rooted in mutability, in things that are variable and terrestrial, upon which man must impose some order.

None of these attributes adorns Testa's figure. He altered her instead to refer more particularly to artistic practice. The perceptions of Testa's personification are even more limited than those of Mariotelli's, for she is shown blind in her ignorance, relying only on the evidence of her feet to tell her of the rocks and brambles through which she stumbles. These impediments relate her to those ignorant modern masters who go about blindly, never seizing upon the beautiful, that Testa wrote scornfully of in the notes.[84] The addition of a monkey, who holds a begging bowl, endorses the implied criticism of those contemporary painters who simply ape nature, a criticism that Testa also develops in the notes when he writes that true painters should be distinguished from the scum, the dirty monkeys, the buffoons of nature, whom he also describes as beggars because they are dependent on the objects made by other artisans, without any storehouse of treasure in their own minds.[85] In the print Testa also gives Practice an additional attribute, reflective of his own bitter emotions, and taken from the same page of the *Iconologia* that the personification of Prattica appears upon. Ripa's image of "Povertà in uno ch' habbia bell'ingegno" shows a shabbily dressed woman, one hand fettered to a great rock and the other raised up with wings attached to the wrist (Fig. 98).[86] This image, which is itself derived from Vitruvius and the tradition of commentary to him, is an inversion of the maxim that poverty is the mother of invention. The definition tells us that the wings represent the desire of "alcuni poveri ingegnosi" who aspire to virtue, but who, weighed down by material needs (symbolized by the rock), are compelled by necessity to remain abjectly among the common

[81] Panofsky, 1955, pp. 157-171, esp. p. 164.
[82] Mandowsky, 1939, p. 85.
[83] Ripa, ed. 1625, pp. 522-524.

[84] Notebook, 55.
[85] Notebook, 16.
[86] Ripa, ed. 1625, p. 521.

herd.[87] Accordingly, Testa has given Prattica's right hand, which holds the painter's *mahl-stock*, a pair of wings. We are to understand that as she gropes forward she is hampered not only by intellectual blindness but also by material poverty, which inhibits her pursuit of virtue. Once again Testa, who although he may have tried to make a virtue out of poverty also felt that he suffered on account of it, has turned a handbook image into a personal expression.

Even more personal is the symbol of the snake and the stone which bears Testa's monogram, "PTL," lying on the ground behind Practice. The stone, or *pietra*, crushes by its material weight the head, or *testa*, of the spirited snake. Thus we are presented not only with a monogram, but also a personal emblem of Pietro Testa. Testa devised this emblem in conjunction with his examination of Ripa's Povertà, for in the drawing of Povertà he made in the notes (Fig. XIV) the rock is chained, not to the hand, but around the man's neck, pulling down his head.[88] Here the stone, or *pietra*, represents the worldly burdens that dragged Testa down, forcing his head, his *ingegno*, to the ground, even while his hand seeks to fly upwards toward the exercise of virtue.

Testa's personification of Theoria is, like Mariotelli's (Fig. 99), a young woman with compasses on her head pointing upwards to the heavens.[89] She is young because youth is the age of agility, promptitude, ardor, life, hope, and happiness, all qualities that accompany theory. Between the arms of the compasses Testa placed a misformed theta. The compasses, as we have seen, are turned upwards because theory reasons deductively, drawing particular conclusions from universal principles. Testa's Theory is not, however, the glorious and all-powerful creature that Mariotelli made her. Whereas Mariotelli opposed Theory and Practice in every conceivable way, Testa's pair shares the essential feature in common that neither of them is able to fulfill her function. Just as Practice in her old age is poverty-stricken and blind, so Theory, despite her youth and clear-sightedness, is bound. Her hands are chained before her, so that she can neither reach up beyond the realm of experience nor open the books that lie scattered out of reach behind her; her eyes are not turned upwards, but gaze sadly down at the ground. That theory and practice should thus be placed in parity, rather than hierarchy, is fundamentally foreign to Boethius's vision, in which the steps making up Philosophy's gown lead upwards from lowly Practice to end in lofty Theory. It is also foreign to much of the body of sixteenth-century Aristotelian theory we have briefly reviewed, which, however much it insisted on the need to unite theory and practice, intelligence and use, nevertheless consistently placed speculative endeavor above its practical demonstration. We have seen one expression of this hierarchical arrangement in Romano Alberti's view that the perfect painter is theoretically learned without actually painting, his works serving as the expression of his conceit in the same way that the pen aids the theologian or orator, as an instrument expressing the nobility of his intellect. Testa's rejection of this hierarchical arrangement in favor of parity was no doubt prompted by his own understanding of Aristotle's emphasis in the *Ethics* that theory and practice must needs by united in the exercise of the intellectual habits of superior reason; and even more it was specifically inspired by Vitruvius's insistence on this union in the art of archi-

[87] *Ibid.*, p. 521. [88] Notebook, 29. [89] Ripa, ed. 1625, pp. 666-668.

tecture (presented most forcefully in the quotation that introduces this chapter), as well as by Barbaro's considerable elaboration of Vitruvius's argument on the basis of Aristotle. Nevertheless, the equality of Theory and Practice in the *Liceo*, whether the two are united in ineffective isolation outside the temple or whether united in the fruitful coupling of Intelligence and Use within, is a significantly novel conception by Testa.[90] Before turning to a consideration of it within the broader context of sixteenth-century Aristotelian theory, to which Testa's print is heir, we must first complete our analysis of the information contained in the print itself and in the drawings related to it.

Testa's inscription tells us that theory and practice are to be united, first by the study of the greatest masters, and then by the imitation of nature, after which theory and practice are then joined through the understanding of mathematics. These successive stages are represented by the figures shown on the central steps leading up to the porch. To identify them clearly we must return to the notes, to a drawing on folio 4ʳ, a more detailed drawing on folio 2aᵛ/3ʳ, and a third drawing now in the British Museum (Figs. VI, V, & 100).[91] In the first drawing the steps are clearly labelled, the bottom step as "inmitatione," the middle step as "osservatione," and the top step, corresponding to the floor of the temple itself, as "Perfetione." This progression is again expressed by Testa on folio 9ʳ of the notes where he writes that one passes from imitation to observation, and from there to mathematical certainty, as if by degrees. In the drawing on folio 2aᵛ/3ʳ Testa cancelled the words "inmitatione" and "osservatione" and labelled them "primo grado," "secondo grado" (or "degree one," "degree two"), but his meaning is unaltered. The drawing in the British Museum is the most explicit of all. Here the first step, where those who are still infants in their studies sit, is labelled to show that it represents imitation from art. This in turn helps us to see that the student who sits on this step in the drawing on folio 2aᵛ/3ʳ is in fact making a drawing on a piece of paper, resting on his knee, after a larger drawing or painting that he is holding up in his other hand. The second step, against which there leans a statuette of the Ephesian Diana (a common emblem of Natura), is labelled by Testa to show that the student is now observing from nature.[92] The third step, by which the grown and mature student enters the temple of Philosophy, is labelled to show that he now works with reason. And indeed, the students who rush into the building at this point face toward the area marked "buona ragione" in the drawing on folio 2aᵛ/3ʳ, indicating that they have acquired the habits of right reason outlined by Aristotle in the *Ethics*, and they have consequently turned their backs to the lower area outside the temple, which Testa labelled as the area of "Essperiensa sensa Ragione." The two students who have attained the degree of perfection are greeted by Judgment (which mediates between the universal and the particular), who stretches out his arm to greet them and points with his other arm toward Mathematics, to which Painting is being led by Optics.

[90] And one which finds its immediate parallel in Du Fresnoy's *De arte graphica*; for a brief discussion of the relationship between the two artists' views, see Chapter Four below.
[91] Fig. VI, Notebook, 11. Fig. V, Notebook, 8. Fig. 100 is inscribed as follows: beside the steps, in ascending order, "da Arte primo/da natura secondo/da ragione terzo"; bottom left "Pietro Testa"; illegible scrawls bottom right, and beside the head of Judgment; top right, in black chalk, "Al' Giuditio non si tiene Portiera / è la sua [?] strac[ci]are chi passeggia / di continuo per l'anticamere." The sheet is numbered 114 in the top right corner. See also Turner, 1980, no. 17.
[92] This same figure is embraced by Painting in the Franciotti *Allegory of Painting* (Fig. 13).

In the drawing on folio 2a^v/3^r Testa underlines the notion that this *corso di perfezio-namento* undertaken by the young painter, beginning with the simple imitation of the best masters, followed by the considered observation of nature, ending with perfected judgment, is the only way to enter the realm in which the intellectual habits of right reason are easily and freely exercised. On the base of the porch to either side of the steps Testa wrote the word "inpossibilità," thus indicating that there is no short-cut into this realm. Even the advance up the steps is difficult, for the students have to ignore the malign assaults of an invidious dog. However, even though the way is narrow, difficult, and time-consuming, the last step is easy for those who are ready. There is no barrier, only the threshold to cross. In a note in faint chalk on the drawing in the British Museum Testa explains why: no one guards the door to Judgment, but those who continually walk through the ante-chambers are allowed to tear themselves apart. In other words, while no obstacles are put in the way of students when they reach the gateway, most of them never pass through successfully. In the notes Testa suggests that there are two reasons for this: either the students are not touched by reason, lacking intellectual spark, or they are badly directed by their teachers, so that they lose the way.[93] In either event they simply wear themselves out in the preliminaries.

Testa's personification of Judgment, with his winged head, does not follow Ripa directly, but the identification of him is secure from inscriptions on the drawings discussed above. There is, moreover, yet another drawing of this central group at the head of the stairs, flanked by Theory and Practice, and the inscription on this ("giuditio/carte 185") proves that Testa did indeed consult Ripa in seeking to define the figure (Fig. 101).[94] Ripa shows Judgment naked and ripe in age, as does Testa, but also seated on a rainbow, with a square, a rule, a compass, and a plumb in his hands. He defines judgment as knowledge arrived at through reasoning on the basis of proper measure—that is, the mean.[95] It is knowledge gained through ratiocination that can be expressed as the conclusion of a properly ordered syllogism, which is to say through logical discourse. Such syllogisms (as we have seen) can be expressed geometrically (i.e., as the *mezo della virtù*), and accordingly Ripa argues that the tools of the geometer are appropriate to a personification of the kind of discourse and choice that the human intellect must engage in if it is to know and to understand all sorts of things; someone who judges all actions in the same way does not judge well. The mature image of Judgment with his measuring instruments, in Ripa's image, sits on the rainbow in order to show that judgment must be based on many experiences, just as the rainbow results from the power of the sun to create the appearance of many diverse colors close together. We might say that judgment must base itself upon the full spectrum of experience submitted to dialectic.

Put very simply, Testa's argument is that the arrival of the students at the threshold of the *Liceo*, where they are welcomed by Judgment, marks their mastery of the intellectual habits of dialectical reasoning. Having begun their course of study by practical imitation of

[93] E.g., Notebook, 59.B., 60.A.7., and 60.A.9.
[94] Fig. 101 is inscribed as follows: "giuditio / carte 185," above the figure of Judgment; "Teorica," below Theory; signed "Pietro Testa," bottom left; some numbers in chalk, bottom right. As Brigstocke suggests, 1974, the drawing of Pratica on the verso is also by Testa, despite its rather crude appearance.
[95] Ripa, ed. 1625, p. 276.

the best masters and continued with the considered observation of the principles of nature, they then attain perfection in practice and in theory and are at the stage where they are able to exercise their original disposition toward painting through the acquired habits of intelligence and use. At this point their judgment is freed, allowing them to move at will between the knowledge of universals and the particularities of experience. The perfection they have attained is expressed by the mathematical certainty of the conclusions drawn from the operations of reason, whether in the contemplative sphere of the necessary sciences (presided over by Mathematics herself), or in the active sphere of the arts (whose various objects are expressible in the geometric proportions of the *mezo della virtù*). Testa also expressed this analogy in his notes where he describes mathematical principles as keys that will unlock all difficulties, borrowing the familiar image of the keys of logic that open up the truth.[96] In any event, Testa's *corso di perfezionamento* is clearly based on the pattern of professional university education, claiming that painting is one of the arts and sciences, exercising the intellectual habits of reasoning in any domain. The curriculum he devised for the ideal painter is, in fact, extraordinarily close to the curriculum for the teaching of philosophy in the university. Students of philosophy first received training in logic, based on Aristotle. They were taught to form universals from individual perceptions, to divide and define these general ideas, to move from one definition to one as yet unknown, and then to construct a logical argument. Having mastered logic the student moved on to the study of the same three branches of philosophy illustrated in *Il Liceo della Pittura*—ethics, physics, and metaphysics. It is in this parallel between the areas of knowledge to be mastered by the painter and the philosopher, rather than in the choice of subject matter alone, that the true character of the philosopher-painter is to be found. We should recognize, of course, that Testa's exposition of the artist's preliminary training in logic relates, as it should, to the principles of the methods of his own particular art. In questioning the works of other masters and then of nature the student seeking the virtuous mean would not necessarily have recourse to complex contentions or demonstrative syllogisms but might employ dialectical syllogisms that argue to a contradiction (and it is indeed possible that the word *"inpossibilità"* on either side of the steps in the drawing on folio 2av/3r refers to such contradictions between which the student must find his way). In any event, the dialectical arguments mastered by young artists are conducted through the instrument of drawing, rather than through verbal questioning. It is through his mastery of the dialectic of drawing that the painter, like the philosopher, is in a position to understand and to teach.[97]

Testa's vision of the teaching of painting, like his vision of its practice, directly depends from his definition of Art as an intellectual habit of the practical intellect, concerned with making through the exercise of right reason. In the notes he is especially scornful of those who are interested only in teaching manual skills, and he angrily states that he has no interest in composing a treatise like Bisagno's, which is concerned with the qualities of various pigments and varnishes. At the same time he rejects the foolishness of those who

[96] Notebook, 60.A.9.
[97] For the teaching of philosophy see, most recently, Brockliss, 1981. On dialectical reasoning see Ong, 1958, and, for the various forms of argumentation as defined by John of Salisbury, see McGarry, trans., 1955, esp. pp. 100-107.

support the idea that the artist works in a kind of divine fury.[98] In insisting that this is not so, and that art must rather be taught, Testa naturally drew support from Aristotle's treatment of the intellectual habits in the *Ethics*; far more important at this point, however, as Testa considered how theory was to grow into intelligence and practice into use, were Aristotle's comments at the beginning of the *Metaphysics* (to which we have already referred when discussing Testa's conception of the *diletto* that accompanies learning the truth, which he distinguished from the *voluptà* of sensuality). Here it is that Aristotle describes how it is that men acquire science and art through experience based on memory. He acknowledges that men of experience may succeed more than those who possess theory without experience, but argues nonetheless that artists are wiser than men of experience because they know the reasons for what they do. Artists are superior to craftsmen because they understand the principles of what they do and do not work only from the practical imitation of other artisans, and it is on this basis that we have seen Barbaro asserting that a true artist must be able to explain what he does. The ability to teach is the evidence for the knowledge of theory, and so, says Aristotle, art rather than experience is the foundation of such knowledge, because only the artist can teach what he does to those who would themselves become artists.[99]

Aristotle's definition of art as something that can be taught, that has its origins in experience but involves an understanding of the universals behind experience, had a profound influence on approaches to the teaching of art (not to mention the understanding of art itself) in sixteenth-century Italy. The identification of the arts that we would now call the fine arts (and that academicians of the sixteenth and seventeenth centuries called the arts of design) with Aristotle's category of Art as an intellectual habit concerned with rational making was of equally profound importance. The claim that the arts of design were founded in universal reason is in fact a considerable advance from the old claim, familiar from the time of Alberti, that these arts were on a par with the liberal arts, and ought to be considered among their number.[100] Varchi, whom we have seen distinguishing the liberal arts from the arts and sciences, played a critical role in effecting this advance, and one that was the prelude to the establishment of the first true academy of art, the Accademia del Disegno in Florence. And while the division of art into theory and practice was not new, the argument that the habit of making was part of universal reasoning demanded that theory and practice now be conjoined. This is reflected in the number of treatises written in the sixteenth century concerning the way in which art should be taught.

Even before Varchi read the *Due lezzioni* to the Accademia Fiorentina in 1547, Leonardo da Vinci had given the impetus to the conjoining of theory and practice in his *Treatise on Painting*, a work that had great influence on later treatises devoted to the teaching of art. Leonardo intended such teaching, as did Testa, to have as its goal the freeing of the artist's judgment, for "good judgment is born of clear understanding, and a clear understanding comes of reasons derived from sound rules, and sound rules are the issue of sound

[98] Notebook, 60.A.2. The specific criticism of Bisagno, in a different context, appears in Notebook, 57.B. His treatise is, however, largely devoted to practice. In Notebook, 15.E., Testa describes "maniera di fare" as "un furor matto," and in 16 he criticizes the drawing of those who have "una manac-

cia," based on long use or a "furiosa natura." In 50 he specifically attacks the madness endorsed by so many "big shots."

[99] *Metaphysics* 980 a 22-998 b.

[100] See the summary in Blunt, 1940, pp. 48-57, who cites Castiglione's recognition of the visual arts as liberal.

experience—the common mother of all the sciences and arts."[101] Elsewhere Leonardo writes that practice must always be founded in sound theory, and to this perspective is the guide and the gateway. Looking again at Testa's *Liceo*, where Theory and Practice are united by Judgment and where Painting is introduced into the temple by Optics carrying a tablet upon which appear diagrams of perspective and the perspective of light and shadow (Figs. 89 & 91), it is clear that Leonardo's legacy is to be found here, even as it is to be found in Testa's projected Trattato (to be discussed in the next chapter).[102] In order to understand Testa's concept of the union of theory and practice, however, we must turn again to the more complete Aristotelian exposition of the problem by Daniele Barbaro.

We have seen that Barbaro summarizes sections of the *Ethics* treating of the intellectual virtues in order that he may reach a definition of art. After completing this summary, Barbaro begins to paraphrase and amplify the passages from the beginning of the *Metaphysics* regarding the origins of art in experience wherein Aristotle makes the essential qualification (cited above) that an artist must be able to explain, or teach what he does. This part of Barbaro's *proemio* is so important for an understanding of Testa's position that we must briefly summarize it. After stating that all arts are born of experience, Barbaro goes on to explain that by experience he means knowledge born from many memories of similar things perceived by the senses and judged to be the same.[103] In knowing something the sense perceives first, then comes memory, and then the comparison of things remembered. He takes an example from medicine. A doctor, after perceiving that wormwood cures several people of stomach ailments, draws the universal conclusion: when the stomach hurts wormwood is useful. Such universal propositions based on the memory of experiences are the principles of the arts. Experience is like the footprint of a deer, however, for just as the footprint is not part of the deer but rather a means of finding it, so experience is not part of any art, but a means of finding it. Art and experience operate in the same way, for both descend to individual actions, and when it comes to action the experienced have a greater effect than those who possess only universal reason. The inexperienced artist often makes mistakes, not because he does not know or because his reason is inept, but because he has not practiced his art and does not know the defects of the materials involved, which often resist the intentions of art. Nevertheless (and Barbaro is continuing his exploration of Aristotle here) Art is more worthy than experience because it has to do with understanding and knowing the causes and reasons of things universally, whereas experience belongs to the lower cognitive faculty of sensual perception.[104] Art is therefore closer to the noblest habit of wisdom. The surest sign of knowledge is the ability to teach it because perfection lies in being able to repeat oneself. The artist has this ability, whereas the expert can only display what he does and cannot explain it.

Vitruvius, according to Barbaro, did require knowledge to be accompanied by experience. Experience is of two sorts, however: the first is that which precedes art and is its source; the second is that which is practiced according to the rules of art. Experience is, then, more useful to those arts that are in the process of being discovered than it is to

[101] Richter, ed., 1883, 1:18, §18.
[102] *Ibid.*, §19.
[103] Barbaro, ed. 1567, p. 4.

[104] Barbaro is basing his argument on Aristotle's discussion of the relationship between experience and art in *Metaphysics* 980 a 22-981 b, cited in Note 99 above.

those that are being taught. At their origin the arts are weak, because everything is yet to be learned. Gradually, however, even as the generations succeed one another, the arts are perfected by the accumulation of principle based on experience. Some arts are always more noble than others, in that they involve more *scienza*, and those that require mathematics are the great arts; whereas those that do not (and here he adduces the authority of Plato) are vile and abject, being based entirely on false conjecture, pure experience, or the imagination.[105]

Testa also placed great importance on the mathematical foundations to his art in *Il Liceo della Pittura*, and at this point we may return to the print considering Testa's conception especially in terms of Barbaro's description of how it is that the arts advance through the accumulation of principles learned from extended experience. Testa's personification of practice has been adapted from Ripa's image in a way that makes it conform more closely to the idea of experience freely but blindly learning from her senses. Most significant in this respect is the fact that Testa has taken away her compasses by which Ripa signified her reason, and this reflects his understanding of Barbaro's argument that progress in the arts depends upon the organization of accumulated experience through memory into principles. It follows quite naturally from this that students must begin by studying the established principles and traditions of their arts if they are to make any progress, and this Testa expressed by showing the infant students on the first step of the temple copying from the works of the great masters. Lomazzo also expressed this idea quite clearly in the introduction to his *Trattato*, when he justified his use of the method of teaching by doctrine rather than that of following the order of nature. He begins by aligning himself with Aristotle "who writes that first principles can be proved by sense, by which he meant that sensual proof is more certain than intellectual; and so it is that a thing has a knowable being when it can be seen by the eyes and perceived by the other senses. And this is why Aristotle says in the same place at the beginning of the *Physics* that the particulars are cognizable by nature; and if we could learn and understand all such particulars we would be very wise."[106] Lomazzo then points to the fact, however, that because particulars are infinite they can only be known by one who is also infinite; our inability to know everything lies in our limited nature and not in the intelligibility of particulars. Therefore, he argues:

> Our intellect must not begin to learn things according to the order of nature, because it cannot comprehend all the particulars, which are infinite; but we must begin with the order of doctrine, of which our intellect is capable, because this order proceeds from universal things to particulars, which we can easily know; for by nature our intellect understands the universal, as it is the power of the spiritual soul, rejoicing therefore in universals separated from matter and in some way made spiritual through the work of the active intellect. For this reason, wishing to treat of the art of painting in this book, I have chosen to follow the order of doctrine.[107]

[105] Barbaro, ed. 1567, pp. 3-4.

[106] Lomazzo, 1584, p. 13: "il quale scrive che i primi principij si possono pruovare per il senso: volendo intendere che è più certa la pruova sensuale, che l'intellettuale. E quindi avviene che allora una cosa haverà di sua natura l'essere conoscibile, quando sarà tale che si possa vedere con gl'occhi e sentire con le altre sentimenta. E questa è la ragione perche Aristotele nel medesimo principio de la fisica dice, che i particolari di sua natura sono conscibili; i quali tutti se noi po-

tessimo comprendere et intendere saremmo sapientissimi."

[107] *Ibid.*, p. 14: "E perciò non deve l'intelletto nostro cominciare ad intendere le cose con l'ordine de la natura, poiche non può comprendere tutti i particolari, i quali sono infiniti, ma deve cominciare con l'ordine de la dottrina, del quale lo intelletto nostro è capace. perche quest'ordine procede da le cose universali à le particolari, le quali possono essere facilmente conosciute da noi, per essere l'intelletto nostro di questa natura che propriamente intende l'universale, essendo egli

In showing the youngest pupils learning first from art rather than from nature herself Testa shows himself in accord with this line of reasoning. The argument is worked out in greater detail in his outline of his own *Trattato*, but the principle point is clear enough here. If the young pupil is left alone to learn from practice and experience at the beginning of his course of study, he will simply grow old without ever being able to master the advanced principles of his art, there being too many particulars for him to invent his whole art independently. Indeed, Testa goes even further by implying that devoid of principles such practical study based on experience will ultimately make it impossible for the artist to see anything. Rather, he must begin by imitating other works of art, learning by doctrine what principles have already been established through long usage. In this sense past works of art by the greatest masters represent an evolving process in the accumulated organizing of experience; they preserve the memory of principles earlier discovered.

The steps leading up to the porch in Testa's *Liceo* express the progression of the student from experience, acquired through the senses, to the certainty of art. From imitation he would pass to observation, and from observation to mathematical certainty as he acquired the habits of right reason. And it was mathematics, as Barbaro had also maintained, that ensured for Testa the nobility of painting among the arts.[108] His plan was to lead the student gradually away from the uncertainties of infinite experience towards the perfection of ideal forms and concepts, not only of the beautiful, but also the ugly.[109] The position expressed by Testa in the *Liceo* was, then, very much the same as that of Bellori, given its classic statement in his celebrated lecture of 1664 to the Accademia di San Luca, entitled *L'Idea del Pittore, dello Scultore, e dell'Architetto, scelta delle bellezze naturali superiore alla Natura*.[110] For Testa, however, unlike Bellori, the problem of the relationship between the perception of nature and the ordering of this perception in accordance with an understanding of ideal principle was not purely a critical issue. Bellori wrote as a vitally interested but practically disengaged observer of the artistic process, whose persuasive philosophical synthesis is intellectually sound but unrelated to practice. His is the position of the critic analyzing the products rather than the processes of the artist. Testa wrote as an artist concerned with the teaching of artists a practical discipline founded upon right principle, and it is perhaps therefore not surprising that his writings tend to reveal a greater interest in Aristotle and his interpreters insofar as the relationship between universals and particulars is concerned. In the end, however, Testa and Bellori, writing some twenty years apart, arrived at very similar positions, and indeed it is quite likely that Bellori knew of Testa's thoughts and writings both at first hand and through the intermediary of Poussin, who knew both Testa and Bellori well. But what had begun for Testa as a line of inquiry became in the hands of Bellori a consolidated position. The most formally complete statement of Testa's views appears in *Il Liceo della Pittura*. His further reflections were to have been expressed in his treatise, which he intended to entitle *Della pittura ideale*; and this is the subject of the chapter that follows.

potenza de l'anima spirituale e perciò godendo de le cose universali separate da la materia e fatte in qualunche modo spirituali, per opera de l'intelletto agente. Per questa ragione, volendo io trattare in questo libro de l'arte de la pit-tura, hò voluto seguitar l'ordine de la dottrina."
[108] Notebook, 8.A., 30, 54.A.
[109] Notebook, 44.
[110] See Chapter Four below for further discussion of this.

3. The Garden of Letters

THE SECOND largest group of notes gathered together in the Düsseldorf volume concerns a treatise that Testa planned some day to write. The ideas he struggled to express in these notes are consistent with those he gave expression to in *Il Liceo della Pittura*, and both projects depend upon Testa's careful study of the same closely interrelated group of texts. His two statements about the education of the young artist and about the provinces the true philosopher-painter must conquer would not, however, have been identical. The two schemes must rather be considered as different constructions complementing one another, one expressed in images, the other in letters, but both springing from the same mind.

Although Testa never finished the Trattato, he did describe what kind of book he intended to write, attempting to establish a table of contents and to draft a preface incorporating some of his rough notes.[1] Although what remains is in very rough form, if we keep the logical evolution of the *Liceo* in mind, as well as the nature of the more finished statement he presented in the print, is it perhaps possible to discover some ordered pattern in the notes for the treatise? Can the contents of the unrealized treatise be sufficiently reassembled, if not assembled in final order, to enable us to assess its character in the context of the more familiar and complete discussions of ideal painting in the seventeenth century? We can at least begin by following Testa's own outline as closely as possible, introducing related notes where appropriate in order to clarify the argument.

THE DEFINITION OF PAINTING: INSTRUCTION AND DELIGHT

As the intricate argument of *Il Liceo della Pittura* had grown out of a simple definition of philosophy, so Testa began the Trattato with an equally simple definition of painting: it is an art that imitates visible things on a plane surface for the purpose of instructing through delight. The definition is a conventional one, the first part related to similar statements by sixteenth-century theorists like Pino and Dolce and the second part derived from Horace's well-known definition of the purposes of poetry.[2] As we have seen, however, from our discussion of the conception of Testa's print entitled *Altro diletto ch'imparar non trovo* in the last chapter, his notion of the union of instruction with delight no longer was framed as a balanced duality. Rather, the meaning of "instruction" was incorporated in Testa's mind into the meaning of "delight"; and his understanding of the latter term as denoting the particular delight that comes from learning the truth is further substantiated by the notes

[1] Most of this material appears in Notebook, 57 and 59.

[2] Notebook, 59. For a summary of the importance of Horace's definition, see Lee, 1967, pp. 32-34.

he took relating to the treatise indicating that he intended to undertake an analysis of the training of an artist in pursuit of the truth.

THE ROAD TO PERFECTION

In expanding his initial definition of painting, Testa considered both the teaching of art and teaching through art. First of all he intended to show how perfection in painting is reached, first through the diligent imitation of the works of great artists and then through the study of nature. After the artist has trained his hand in this way, he may then turn to nature in order to progress to an understanding of the principles behind simple imitation. Only when he has perfected himself in these two stages will he then be able to start painting in earnest, discovering then the meaning of invention, disposition, and composition as defined by Aristotle.[3] Thus far the projected argument of the Trattato, which was to have been divided into three books, each with many chapters, follows the progression of the three steps leading into *Il Liceo della Pittura*: imitation is followed by observation and when practice and theory have thus been mastered individually they may then be united within the temple of painting itself. Testa's written argument, however, was directed toward a rather different end. His purpose in the treatise was to lead Painting up to her rightful place beside Poetry on the highest peak of Parnassus.[4] The reunion of the sister arts, as we saw in Chapter One, he also made the theme of another allegorical etching, the *Triumph of Painting* (Fig. 54). In this print Homer, the original philosopher-poet, watches over the arrival of Painting on Parnassus, and his presence serves as a reminder that only those poets and painters who seek out the truth, who are philosophers, are worthy of Parnassus. Testa insists in his notes that, just as a writer cannot claim to be a poet because he has written a body of poetry according to the rules (and far less can he make this claim because he has mastered grammar and other basics), so the painter's mastery of chiaroscuro, perspective, anatomy, and the like (not to mention the diligent copying of art and nature) are only the necessary equipment for his journey.[5]

The convention for comparing the acquisition of the basic skills of painting with the learning of letters had been firmly established by Alberti.[6] Testa extended the comparison by introducing Socrates's distinction, recorded in the *Phaedrus*, between those who know only the preliminaries of rhetoric, such as brachylogies and figures of speech, and who believe that teaching these things is the same as teaching rhetoric itself, and those like Adrastus and Pericles who join skill in dialectic to their own natural abilities.[7] Testa certainly emphasized the importance of thorough grounding in the basic skills of painting, often using the analogy with the learning of the alphabet and the rules of grammar, but when he came to treat of ideal painting he had only contempt for practical manuals that give the impression that once all the materials are ready the work is as good as finished.[8] Among the writers to whom Testa refers in the notes, Bisagno was the most guilty of giving

[3] Notebook, 59.A.
[4] Notebook, 59.A.
[5] Notebook, 59.A.
[6] Grayson, ed., 1972, pp. 96-97, §55; Grayson points to the source for learning letters by progressing from the alphabet to syllables and whole words in Quintilian, 1. 1. 24-31; see also Grayson's further references.
[7] Notebook, 57.A.; the reference to Adrastus and Pericles (*Phaedrus* 269A) immediately precedes the section actually cited by page number.
[8] Notebook, 60.A. and 60.A.8.

such an impression, and Testa took care when citing passages in Vitruvius to avoid discussions of practical matters only. His "Trattato della pittura ideale" would have addressed only those readers who had already mastered the basic techniques of their art through constant practice and the learning of precepts. In this Testa was following Alberti and Leonardo.

THE PARADOX OF WRITING ABOUT DISCOURSE

Testa shared Socrates's view that knowledge was acquired through discourse, and not through reading.[9] He rejected the notion that the simple recording of information was at all useful, and the question thus arises of how it was that Testa was able to justify his own intentions to write about ideal painting. Socrates, although disapproving of recorded knowledge, provided some support by permitting men nonetheless to write for pleasure in their old age. In a passage from the *Phaedrus* that Testa knew well, Socrates says of the philosopher: "The garden of letters he will, it seems, plant for amusement, and he will write, when he writes, to treasure up reminders for himself when he comes to the forgetfulness of old age, and for others who follow in the same path, and he will be pleased when he sees them putting forth tender leaves. When others engage in other amusements, refreshing themselves with banquets and kindred amusements, he will pass the time in such pleasures as I have suggested."[10]

The few treatises on art published in Italy in the first half of the seventeenth century bespeak a general skepticism concerning the efficacy of learning from books. At the same time Albani, Du Fresnoy, Rosa, Poussin (who claimed that he hoped to write when he became too old to paint), and Testa himself all are known to have intended to gather together their mature thoughts about painting. All were practicing artists, and none of their written reflections about art were published while they lived, if ever.[11] The fact that their ideas survive in written form only as notes, or recorded in posthumous biographies, is certainly no accident, but points to the very character of these notes and planned projects as the material laid up in private treasuries, written in the spirit of Socrates's advice, for the purpose of delighting the author and his friends in otherwise barren old age. Rather than indicating by their abbreviated character a disdain for academic issues, as has frequently been suggested, such notes and *obiter dicta* instead testify to the conviction that true learning derives from active discourse in the academies, the studios, or in such evening walks as Poussin used to take with his friends along the Pincio and is not instilled by rote learning and textbook study.[12] Such a method of teaching had been undertaken in the

[9] See especially Notebook, 57.C. and Commentary.

[10] *Phaedrus* 276D (translated from Loeb ed., London and Cambridge, Mass., 1966).

[11] Albani began his collaboration with Zamboni in the early 1640s, the fragments of their work being recorded by Malvasia, for which see Van Schaak, 1969, pp. 44-46, 143-147. Thuillier, 1964, especially p. 196, demonstrates that Du Fresnoy's manuscript should be dated c. 1649 and that the artist probably began to write shortly after his arrival in Rome in 1633/34. For Rosa's plans to compose a "libreccino" in 1652, see Roworth, 1978, pp. 363-369. Poussin himself, in a letter to Chantelou dated August 29, 1650, published in *Correspondance*, Jouanny, ed. 1911, pp. 418-419, refers to the

"avertissemens que je commencés à ourdir sur le fait de la peinture." See also Bellori's statements in *Le vite*, ed. 1976, pp. 472-473, and p. 456, in which the comparison with Leonardo da Vinci is made directly, and also the argument that this is something to be completed in old age.

[12] This tendency may reflect the increased availability of books. For a summary discussion of scepticism, the value of book-learning, the rejection of the "new Scholasticism" in the late sixteenth and early seventeenth centuries, and the arguments of Montaigne, Campanella, and Bacon in favor of learning by experience, see Grendler, 1969, pp. 136-161. It is important to distinguish here between theories of art actively practiced and the systematizing of a theory in the form

Carracci Academy and transmitted to Testa by Domenichino, his first teacher in Rome. Even Bellori's polished discussion of the Idea later in the century, it should be remembered, took the form of a lecture which, in spite of its tremendous influence once printed, cannot be said to constitute a treatise.[13]

Testa could not, as Poussin or Albani might, claim to have reached an age when this kind of diversion was justified, and, as he himself so vigorously opposed borrowed wisdom, he anticipated that some would criticize him for wasting time writing when he should have been working. His first defense was that he was determined to write only about those things that he had often discussed with his friends, that he had discovered through his own observations, or that he had learned from reading the ancients at first hand. In other words, he wanted to record only the results of his own practical and theoretical labors. Many of Testa's notes are based on the writings of established authorities, but he looked to these texts as a guide to help him think through problems for himself, and never as a means for silencing debate.[14]

Socrates recommended the pleasure of writing as an alternative to a gluttonous old age, and Testa's further self-justification was that he took up the pen when he was not working in order to avoid sloth and guzzling.[15] For him *otio* was not the welcome ease of the scholar, but an evil to be shunned. On folio 9r (Fig. XIV) Testa drew the figure of Otio, or Sloth, opposed to that of Povertà, with whose winged hand he had endowed Practice in the *Liceo*.[16] The fat figure leaning over a pig is given over entirely to eating and lust, his life dedicated to the satisfaction of the senses, rather than to the exercise of prudence. The young man burdened by poverty, on the other hand, lacks the good fortune to attain the simple necessities of life that would allow him to exercise the virtue he possesses. For Testa the exercise of his mind through writing provided a way of avoiding either of these extremes. It could not protect him from poverty, which Testa suffered bitterly, but the pursuit of philosophical virtue could raise him above it. Being poor, he could not embrace the habits of a philosophical poverty as a voluntary act, in the manner of Poussin. Being a philosopher, he could not set out to enrich himself materially with the end of sinking into sensual sloth. In the etching known as *The Young Artist Arriving on Parnassus* (Fig. 69) Testa replied to those critics who cruelly charged that it was precisely because he spent so much time in philosophy that he was afflicted with poverty by showing the artist brought to Parnassus guided by the light of Intellect, with only a tablet under his arm, a cloak over his shoulder. Ignorance, Lasciviousness, and Envy are blinded by the light, and Hercules topples Avarice down the slopes. Testa could only hope to make a virtue of dire necessity, as, for example, Vasari had tried to do in his biography of Perugino, by arguing that sometimes poverty could spur the *ingegno*.[17]

of a treatise. A confusion of the two underlies Friedlaender's comments, 1965, p. 53, concerning the lack of theory among painters of the anti-Mannerist style, and his view that "art theory" began to come alive again only in the second half of the seventeenth century. See also Friedlaender's similar comments, 1948, esp. pp. 31ff., and Dempsey's response, 1977, pp. 1-6.

[13] This is important. Even as the descriptions of individual works in Bellori's *Lives* are conscious exercises in epideictic rhetoric, as the choice of Philostratus's *Imagines* as a model dictated, so Bellori's closing comment at the end of the lecture is a direct reference to a work devoted to the ironic power of epideictic itself, that is to say, to Lucian's *The Hall*, for which see Chapter Four below. What Bellori's approach did mean was a fundamental reshaping of the relationship between painter, spectator, and critic, as eloquence became a major category of style. See, e.g. Argan, 1970.

[14] See his comments in Notebook, 57.C. and 60.A.4.
[15] Notebook, 60.A.5.
[16] Notebook, 29.
[17] Vasari-Milanesi 3: 565-566.

In *Il Liceo della Pittura*, as we have seen, Testa answered the contention that philosophy was to blame for his difficulties by reversing the argument to show that poverty is one of the limitations of practice. If forced to repetitive practice only, the artist could never hope to attain true virtue and its rewards. In the notes, Testa defended himself more straightforwardly by comparing himself to Vitruvius. In dedicating his book to Augustus, Vitruvius justified his writings according to Socrates's advice: he was not robust by nature, and age had withered his face, infirmity removed his strength, and so he hoped to win the emperor's favor through his treatise. Barbaro commended the architect's modesty in defending writing and teaching in this way, and Testa sought to adopt the same humble tone, although he was forced to admit that he could not claim, as Vitruvius had, that his free time was entirely the gift of nature, that is, the retirement of old age.[18]

Testa's second principle justification for devoting time to writing followed from his approach to the actual creating of works of art, rather than from his solution to the problem of how to occupy himself when there was no work to do. He believed that an artist should only work when full of spirit and able to give freely of himself. When this is not the case he should turn to writing, giving over his brushes to his pupils.[19] Elsewhere in the notes Testa adopts the essentially Aristotelian position that working within limits, alternating motion with rest, is nature's own way of proceeding. He argues that the artist will succeed in capturing the different qualities of the forms he seeks to represent, from clouds, to terraces, to horses, in no other way.[20] Again, Alberti had restated this ancient viewpoint, recommending that artists should relax from time to time as a way of establishing a prudent speed of execution that would avoid both the tedium of working so slowly that one despairs of finishing and the impatience that leads to hasty work. Alberti also insisted that each work should be brought to completion before another is started, once again showing respect for the notion of working as nature works, toward the achievement of an end.[21] All of this Alberti considered under the heading of diligence, which he recognized was as important as natural talent and which he took care to distinguish from the mindless stubborness of Protogenes who was unable to take his hand from the work.[22]

In advocating the alternation of labor and repose, Alberti was applying Augustus's famous motto, "festina lente," the emblem of prudent behavior, to artistic practice.[23] This was acknowledged in the definition of diligence in Ripa's *Iconologia*, where Protogenes'

[18] Notebook, 60.A.5. For Barbaro's praise of Vitruvius's comments, and for the relevant part of the dedication see the 1567 ed., p. 2; all citations in this chapter are to this edition unless stated otherwise.

[19] Notebook, 60.A.5.

[20] Notebook, 18. Marabottini, 1954, p. 220, n. 5, relates Testa's position to that of Federigo Zuccaro, expressed in *L'Idea de' pittori, scultori e architetti*, 1. 10 (ed. Rome, 1768, p. 28): "Le ragioni poi perchè l'arte imiti la natura è, perchè il disegno interno artificiale, e l'arte istessa si muovono ad operare nella produzione delle cose artificiali al modo che opera la natura istessa." Marabottini, however, associates this with Ficino's distinctions between the essential truth of the principles guiding natural creation and the contingent principles guiding human creation; there is no reason to associate Testa with Ficino here.

[21] Grayson, ed., 1972, pp. 104-105. Clements, 1961, p. 62,

points to the account given of this problem by Giraldi Cinzio (who claims to be quoting Michelangelo), in his *Hecatommithi overo cento novelle*. Clements, p. 430, n. 175, cites this text as follows: "La prestezza poco giova in cosa alcuna, se non nel saper prendere l'occasione, la quale in un momento si offerisce, & nell'istesso momento si fugge a chi non la conosce. Ma nelle cose delle arti, essa prestezza manca di giudicio, & perciò si può dir cieca. Imperoche l'Arte, la quale è imitatrice della Natura, non si dee partire, se vuole, che la sia data loda nell'operare, da quel modo istesso, che noi veggiamo, che la Natura usa nella generatione de gli animali, i quali, quanto son per haver più lunga vita, tanto più di tempo vi spende ella a produrgli per la più."

[22] Grayson, ed., 1972, pp. 103-105, §61.

[23] See especially Erasmus's discussion of this in the *Adagia*, for which see, Phillips, 1964, pp. 171-190.

failure to combine diligence with maturity, not knowing the mean between hastiness and dilatoriness, is also adduced. Because Protogenes worked so hard his mind became exhausted, and he lost his judgment. In other words, evoking the most famous of all metaphors for artistic imitation, although he emulated the industry of the bee, he lost the ability to discern which nectars would produce honey.[24] Vasari, on the other hand, disturbed the balance urged by Alberti of deliberate haste by laying particular emphasis on speed of execution; and the facile repetition of learned formulas that this implies earned Bellori's characterization of mannerist art of Vasari's generation as an art given over, not to true learning, but to practice.[25] Vasari's criticisms of Uccello and Perugino, the one violating nature by endless labor without cease on one thing with the result that he became poor, the other working so hard to make money that he became dry and repetitive, are in complete accord with the positions of Alberti and Testa.[26] But his own practice, virtually a parody of his own advice in the *vita* of Uccello where he wrote that an artist should only work when inflamed by a divine furor, stood in stark contrast to the rational principles for which Testa stood. While there were some like Paolo Pino who argued that the value of a work of art lay in the finished work, not in the speed of execution, the issue with all its economic consequences, as defined by Vasari, was an important one.[27] Indeed, in seventeenth-century Rome artists like Testa who were alienated from the security of local patronage suffered heavily from the pressures of being forced to sell their works on the open market, and the ability to produce on demand became indispensable. Speed and slowness of execution indeed were major preoccupations of the century. Domenichino's dilatoriness was legend, and the extremes of *prontezza* and *tardità* came to be identified with the rival camps of Cortona and Sacchi. The question of finding the true mean was consequently one very much on Testa's mind as he had to defend himself from hostile critics and impatient patrons. He saw Sacchi gradually lose his ability to finish anything, while Cortona worked on many projects simultaneously, with the result that what Testa viewed as the mindless school of *fa presto* flourished.

When Michelangelo rebuked Vasari for taking such pride in the speed with which he painted, by saying that it was obvious, he was quoting from Alberti's account of Apelles's reaction to the same sort of showing off.[28] It was essentially Alberti's vision of the unerring

[24] Ripa, ed. 1625, pp. 176-178.

[25] Vasari's view is stated most concisely in the *Proemio* to Part 3 of the *Lives*, Vasari-Milanesi 4: 13, in which he declares, "che dove prima da que'nostri maestri si faceva una tavola in sei anni, oggi in un anno questi maestri ne fanno sei." For Bellori's comments, see *Le vite*, ed. 1976, pp. 21, and 31.

[26] For Uccello, see Vasari-Milanesi 2: 204, "E non è dubbio che chi con gli studj troppo terribili violenta la natura, sebbene da un canto egli assottiglia l'ingegno, tutto quel che fa, non par mai fatto con quella facilità e grazia che naturalmente fanno coloro che temperatamente, con una considerata intelligenza piena di Giudizio, mettono i colpi a' luoghi loro, fuggendo certe sottilità che più presto recano addosso all'opere un non so che di stente, di secco, di difficile, di cattiva maniera, che muove a compassione chi le guarda, piuttosto che a maraviglia: atteso che l'ingegno vuol essere affaticato quanto l'intelletto ha voglia di operare, e che 'l fu-

rore è acceso." The criticism that Uccello's works moved the spectator to pity rather than wonder is, of course, the same criticism that was levelled at Domenichino, for which see Chapter One, p. 16. For Perugino, see Vasari-Milanesi 3: 555-556, 585-587.

[27] P. Pino, *Dialogo di pittura* (1557) in Barocchi, ed. 1960, 1: 119, "E poi non si giudica nell'arte nostra la quantità del tempo ispeso nell'opera, ma sola la perfezzion d'essa opera, per la qual si conosce il maestro eccellente dal goffo . . . e per ciò vi conviene usar una mediocre diligenzia." Immediately after this statement the second interlocutor in the dialogue, Lauro, remarks, "La povertà è assassina." See also Clements, 1961, p. 61.

[28] Grayson, ed., 1972, pp. 104-105, §61. Clements, 1961, p. 62, cites Michelangelo's use of this riposte (which ultimately derives from Plutarch) at S. Silvestro, as well as in response to Vasari's frescoes in the Sala dei Cento Giorni. See also Pino, *Dialogo*, in Barocchi, ed. 1960, 1: 119.

speed of execution that results from the correct balance of action and contemplation that Testa was seeking to affirm. The task of finding the mean was not easy, for, as we shall see below, Testa was also alive to the element of temperament in all of this, the recognition of which was one of the most important responsibilities of a teacher, and the extremes of which (following Quintilian's analysis of the successful teaching of Isocrates) had to be moderated but not suppressed.[29] Testa clung to the humanist tradition that through the exercise of judgment the middle way could be found, treading between the extremes of theory and practice, contemplation and action, abject poverty and the avarice of Midas. His writings were an attempt to mitigate the extreme of perpetual labor, to keep his discernment sharp, and his life in virtuous balance.

THE MODELS FOR TESTA'S TRATTATO: ALBERTI AND VITRUVIUS

Testa's insistence that he intended to write only of those things that he had discussed with his friends calls to mind Poussin's morning and evening colloquies on the Pincio and in the Piazza of SS. Trinità dei Monte, and in one section of a letter he composed as from Parnassus Testa records an imaginary debate between Perugino and Michelangelo on the very issue of diligence.[30] He did not, however, choose to preserve the illusion of discourse by casting the Trattato in the form of a dialogue. Instead he followed the form employed by the two writers on art he most admired, Alberti and Vitruvius, and in his preface he even proposes to follow Vitruvius's division of the whole into books and chapters. While the influence of *Della pittura* is less clearly stated, except where Testa took notes from it directly, in one respect it is more profound. Both Alberti and Vitruvius claimed the right to record their knowledge on the basis of being practitioners of their arts, but Alberti, seeking to compensate for the loss of ancient works treating of painting as a liberal art, specifically dissociates himself from Vitruvius's interests in practical matters.[31] And Testa, as we have seen, also determined not to treat of simple technical skills, interesting himself almost exclusively in those sections of Vitruvius that relate to the principles underlying practice and the application of them in a decorous way. Barbaro's commentary encouraged this, for it is strongly theoretical, providing arguments about the universality of principles that recommended Vitruvius's text to the nonarchitect. Although he intended to follow Vitruvius's own literary structure, Testa would not have included painterly equivalents for the choice of a site, the making of bricks, or the foundation of walls. His writings were not intended for the young because he felt the simple practice of painting was best learned by an obedient pupil from a competent master and from a study of natural principles. As in the inculcation of morals, discussion confuses rather than enlightens the inexperienced.[32]

In the end Testa's approach to writing about his art differed from that of both his models on an important psychological and theoretical level. Vitruvius greatly admired those who had preserved knowledge in books instead of jealously keeping it to themselves, and he felt it a duty to add to this store, always acknowledging his debts to others. He intended

[29] *Institutio oratoria* 2. 8.
[30] According to Bellori, 1976, p. 451, Poussin's learned discussions were a part of his daily routine. For Testa's dialogue, see Notebook, 63, §5.

[31] In particular by stating that he will deal only with the arrangement of color, not with the problems of acquiring pigments; see Grayson, ed., 1972, pp. 90-91, §48.
[32] Notebook, 60.A.11.

his own book to be useful.[33] Alberti, even while claiming to write in an entirely original way, dismissing Vitruvius's encyclopedic approach, and even while insisting that many things could only be learned from nature, also wrote for posterity. He too intended his book to be useful and invited others to carry on the work.[34] Testa had so little respect for those, like Lomazzo, who took up this invitation, so much distaste for those who taught by precept, that he could allow himself no such consolation. Only nature, he insisted, could teach anything. Writing was a game.[35]

THE TREATISE AS A GAME: COMPETING FOR THE VIRTUE OF ART

Testa's self-justifications are so extended and so logically argued that they go well beyond any conventional *topos* of modesty and must be taken seriously. Like Leonardo he was proud to claim the right to discuss what lay within his own experience, and like Leonardo he believed that with experience as his guide there was no need for apologies about his language, declaring in a confident moment: "ragiono della arte mia con quella favella che mi à dato il paese."[36] What unleashed his tongue and drove him to the game of writing was anger, often very heated anger, provoked by the bad teaching he saw everywhere around him. In one of the longest consecutive passages in the notes he contrasts those good teachers, who point the way to the truth on the basis of their own wisdom, to the bad ones, who presume to teach but rather confuse young minds without themselves having grasped anything of the principles of painting.[37] In the second etching dedicated to Franciotti (Fig. 13) Testa showed Ideal Painting embracing the figure of Nature in the form of Diana of Ephesus. This gesture represents the proper relationship between nature and painting, especially in the early stages of a student's training.[38] Bad teachers, Testa writes, tear their pupils away from the nourishing breast of Mother Nature and feed them instead such weak gruel that they quickly lose heart and fly into the arms of Ignorance. He wanted to encourage young pupils to follow the light of their own reason, if they were blessed with such, and to take refuge in nature before they developed bad habits too deeply ingrained to correct. Testa thought of such habits as mannerisms, stating quite simply that nature is the enemy of the *manieracce*.[39]

Testa claimed to have heard frequent complaints from those bad *maestroni* about the ingratitude of pupils who succeed in escaping from their clutches before they had rendered them completely stupid.[40] Such sarcasm and bitterness about ignorant teaching undoubtedly reflects Testa's early humiliation by Pietro da Cortona and the shock of discovering that Domenichino's reflective approach to painting was not shared by others. His specific criticisms also serve to show, however, that his anger was based on more than this particular experience, and Pietro da Cortona's name is never actually mentioned in the notes. After apologizing for even mentioning such petty issues, he starts out by mocking arguments about technique, going well beyond his original statement that they are not worth

[33] Vitruvius, *On Architecture* 6. Preface, 4-5.
[34] Grayson, ed., 1972, pp. 106-107, §63.
[35] Notebook, 60.A.6. and 57.C.
[36] Notebook, 34. For Leonardo's statement see Richter ed., 1883, 1: 14, §10.
[37] Notebook, 60.A.7.
[38] See also the discussion of this in Chapter Two above, pp. 89-94.
[39] Notebook, 60.A.7. and 60.A.9.
[40] Notebook, 60.A.9.

writing about to take the position that they are not worth talking about either. He mocks teachers who disagree about how to cut lapis, how to make a point and how to blunt it, what kind of bread is good for erasing with, what is the best paper for shading, graining, or hatching, whether tinted grey, or made of sheepskin, or the hide of a wether. If they cannot agree about these foolish things, then they are too ignorant to provide guidance in more important matters. The corollary to such mindless obsession with materials is that these dunces will draw their principles from the lowliest things such as common jugs or flasks. Presumably Testa shared Poussin's vision of the proper accoutrements for the artist's studio where the students are provided with the universal models of the sphere, the cylinder, the cube, and the cone from which to derive the principles of perspective and chiaroscuro.[41]

Naturally Testa's criticism extended to finished paintings of imperfect objects. He was not interested in the simple pleasure evoked among the uneducated by mere representation. The kind of instruction and delight for which he strove required that the painter communicate the movements of the body and the soul if his work was to be morally effective. In Testa's view, the representation of an object like a jug not only encouraged bad practice in the artist, because the object itself was made by a craftsman who lacked any understanding of principles, but also was without purpose because inanimate objects could not be made to express the concepts of the soul. A painter who included the silly, inanimate objects of the artisan in his works had no more right to call himself a painter than a poet who wrote a song describing a chamber pot and a frying pan had a right to claim a place on Parnassus beside Tasso and Virgil.[42]

Even though Testa may have found Pietro da Cortona's treatment of the *affetti* inadequate, such criticism as this could not have been levelled at his old teacher. He was certainly thinking of the Bamb_2cianti when he made this attack, many of whom were his neighbors in Rome and who were enjoying great success among aristocratic collectors, even while Testa was experiencing his severest difficulties.[43] Interestingly enough, Testa does not specifically single out the painters of popular low-life scenes, like Van Laer himself, nor does he attack the kinds of combinations of fruit and flowers or the battle scenes that formed the basis for much of Cerquozzi's success. Rather, he specifies paintings of kitchen implements, which is to say the still-life painters. The sharpness of his criticism, which mentions no names but must have been directed at artists like Jacopo da Empoli, Paolo Antonio Barbieri, at Bergamasque painters like Baschenis, or the Neapolitan Paolo Porpora, serves to indicate how highly the specialized skills of these painters must have been appreciated by Roman collectors before 1650.[44] Indeed, Testa did not view their approach to painting

[41] Notebook, 60.A.10. See below for a discussion of this drawing.

[42] Notebook, 60.A.1. *Cantaro* might also be translated as "goblet," but everything points to Testa's desire to ridicule such painters as strongly as possible.

[43] Haskell, 1963, pp. 131-141, points to Cerquozzi's reputation among aristocratic collectors in Rome, though acknowledging that the early success of the BambOccianti, and of Van Laer in particular, was probably among "uomini di stato mediocre." As his reputation was especially high among the Spanish party, Cerquozzi's career was not interrupted by

the departure of the Barberini. Passeri, ed. 1934, p. 221, points to Miel's success in the great galleries of the city, rather than in lower establishments.

[44] For Italian still life, see De Logu, 1962, esp. figs. 43, 44, for Jacopo da Empoli's dated still life of 1624 and its pendant. See further, Longhi, 1950; Bottari, 1960; Causa, 1961; Riccomini, 1961 (who points to the presence of Dujardin, Lingelbach, Codazzi, and Abraham Breughel in Rome in the 1640s, as well as to the influence of Testa on Cittadini's own figurative paintings); Bottari, ed., 1964.

as a recent development and traced the origins of still-life painting to critics like Lomazzo who had argued that paintings should be appropriate to their locations. The particular locations described by Lomazzo included the vulgar places of the city, as well as palaces, villas, and churches, and Testa condemned the way in which he, and others like him, had helped to drag painting down to the dregs of society, to the taverns, and even the gallows. Lomazzo also approved of Arcimboldo's paintings of the *Elements*, and his famous heads made up of kitchen tools (as well as those scenes of drunkenness and dreams made popular by German and Flemish artists) as things suitable for the decoration of taverns, and it appears that this is where Testa situated the origins of the still-life painting he saw flourishing in Rome. Certainly he believed that Lomazzo was to blame for providing a critical justification for it.[45] Lomazzo's discussion of pictures suitable for the gallows must also have aroused Testa's fury because it could be taken to provide justification for the paintings of wild landscapes and waterfalls upon which many northern European artists, and even Salvator Rosa, were able to build their reputations. Finally, although never mentioned specifically, even the battle scenes of Cerquozzi also fall into the category of unworthy works that Testa believed had been sanctioned by Lomazzo, for the chapter of Lomazzo's *Trattato* to which Testa refers, devoted to paintings suitable for fireplaces and the gallows, concludes with a recommendation that paintings of wild and terrifying stories, all kinds of battles and fights, are suitable for any place where arms are carried.[46]

If Testa was angered by such works because they denied the universality of ideal painting, he was also driven to despair by their success. It was one thing for Lomazzo to imagine paintings of inanimate objects or drunken brawls in their proper settings, but quite another to see them on the open market and finding their way into princely collections. In Testa's mind, given that an artist must desire what he sought to represent, there was a symmetry between an artist's ambitions and the models that he chose to imitate. In the print of *Winter* (Fig. 58) he showed the painter-apes, the imitators of jugs and frying pans, scrambling up a greased pole in order to grasp the temporal trophies of wine and cheese; the winged genius of the ideal painter, on the other hand, even at the end of his life, still struggles to escape the clutches of indolence and envy in the hopes of being rewarded by fame at the close of his days.[47] This drama was daily acted out on the streets of Rome. Testa, like Annibale Carracci before him, scorned his personal appearance and dress, while, according to Passeri, painters like Cerquozzi and Miel, Testa's hated rival, took pains to dress well in order to avoid any resemblance to the rogues they depicted. Testa, the painter of invisible truth, could not adopt the manners of the courtier to help him find work,

[45] Notebook, 57.B. Lomazzo, 1584, 6. 26, pp. 348-350. Lomazzo also refers to works by northern European artists like Roger van der Weyden, Joos van Cleve, and Jerome Bosch in this passage. Even though we cannot be sure which works he had in mind, and even though his knowledge of them was probably based on prints, Lomazzo's appreciative notice, especially of the frightening dreams of Bosch, which he calls "singolare e veramente divine," must have had an influence on attitudes toward later northern art in seventeenth-century Italy. The early reception of Bosch's work as macaronic should be related to Albani's association of the work of the Bambocciati with Folengo in the letter to Sacchi,

cited in note 56 below. See Snyder, 1973, pp. 18-19, for a discussion of Fra José de Sigüenza's discussion of Bosch in these terms; see also pp. 34-41 for Snyder's translation of the relevant passage from Sigüenza's *Historia de la orden de San Jeronimo* (1605).

[46] Notebook, 57.B. For Lomazzo's list of subjects suitable for the gallows, including, "molini finti, precipitii d'acque giú per monti, rupi e balze scoscese, terremoti, nubi, rotte, folgori, saette, abbaccinamenti, uomini neri, impeti, strepiti, violenze, atti sforzati," and for the "historie fiere," suitable for military establishments, see *Trattato* 6. 23, pp. 342-343.

[47] See Chapter One, pp. 46-55.

whereas Miel had remarkable success and Cerquozzi was honored at his funeral by the attendance of the members of the Academy of St. Luke.[48]

Before we dismiss Testa's disgusted criticism of such painters as prompted by his own severe disappointments or motivated by a stylistic penchant for a retardataire classicism, we should acknowledge how closely it reflects the views of many of his contemporaries. Salvator Rosa, in his satire *La Pittura*, provided the most scathing condemnation of all.[49] He attacked those who pretended to be masters but knew nothing, and who spent their days painting melons and ham, pretending to have learned all about painting in the cradle.[50] Rosa claimed there was a saying prevalent among the northern painters in Rome, that an abundance of three things was to be found there: painting, hopes, and the kissing of hands.[51] Like Testa, and like Albani too, he criticized those who exploited all this by producing large numbers of paintings at great speed without diligence or study. As subject matter worthy of the satirist's scourge he lists not only still-life, but also animal paintings by followers of the Bassano who went to school in the cowsheds; insect paintings by artists who spent whole summers making snakes, toads, lizards, and butterflies (and here he was surely thinking of the tradition established by Jacopo da Empoli); paintings of low-life characters, of porters, travelling musicians, urchins and pickpockets who look for fleas, scratch themselves, and defecate; pictures of rogues buying stewed pears; and, as an ultimate absurdity, he ridicules a painting of a man selling tripe to a cat.[52]

Rosa's condemnation was the prerogative of the satirist, although it tells us much about the popularity of all these types of painting among buyers and collectors.[53] Other criticisms were more specific. Andrea Sacchi, in his famous letter to Albani of 1651, complained most violently about little pictures of figures looking for fleas, peasants eating soup or pissing, or of Bacchus vomiting (and here one recalls the drunken, vomiting figures in the background of Testa's print of *Summer* [Fig. 56], who correspond to the deformed apes of nature in the *Winter*).[54] The question of the size and scale of such paintings, to which Testa also turned his attention in a different context, also provoked Sacchi, and it is one related to the market for the kind of painting he deprecates, also called *baronerie* by Passeri and others.[55] Not

[48] Passeri, ed. 1934, pp. 221, 290. See also Salerno, 1970.

[49] For a discussion of Rosa's satire, *La Pittura*, see Roworth, 1978, pp. 111-155, and the bibliography in Schlosser Magnino, 1964, p. 624.

[50] Rosa, *Satire* (n.d.), p. 97. Roworth, 1978, p. 141, n. 4, agrees with Limentani's statement, 1961, p. 164, n. 84, that Rosa's identification of these painters as "I Panfili," is a reference to Pamphilus, the master of Apelles. This is in opposition to A. M. Salvini's identification of this name with the Panfili family, Carlo, Francesco, and Giuseppe, contemporaries of Rosa from Parma, for which see *Satire*, p. 97. It seems more likely to me that Rosa, enjoying the play on words, intended the insult to apply to both.

[51] *La Pittura* in *Satire*, p. 98: "Onde dissero alcuni Oltramontani,/Che di tre cose è l'abbondanza in Roma,/Di Quadri, di Speranze, e Baciamani."

[52] *Satire*, pp. 98-99:
Altri studiano a far solo Animali,
 E senza rimirarsi entro agli specchi
 Si ritraggono giusti, e naturali.
Par che dietro al Bassan ciascuno invecchi,
 Rozzo Pittor di Pecore, e Cavalle,
 Ed Eufranore, e Alberto han negli orecchi.

E son le Scuole loro mandre, e stalle,
 E consumano in far, l'etadi intere,
 Biscie, Rospi, Lucertole, e Farfalle.
E quelle Bestie fan sì vive, e fiere,
 Che fra i Quadri e i Pittor si resta in forse
 Quai siano le Bestie finte, e quai le vere,
Vi è poi talun, che col pennel trascorse
 A dipinger Faldoni, e Guitterie,
 E Facchini, e Monelli, e Tagliaborse.
Vignate, Carri, Calcate, Osterie,
 Stuolo d'Imbriaconi, e Genti ghiotte,
 Tignosi, Tabaccati, e Barberie:
Nigregnacche, Bracon, Trentapagnotte:
 Chi si cerca Pidocchi, e chi si gratta,
 E chi vende ai Baron le Pere cotte.
Un che piscia, un che caca, un che alla Gatta
 Vende la Trippa.

[53] Haskell, 1963, pp. 205-208, also discusses the importance of this genre of painting in the collection of Gaspar Roomer in Naples, of which Rosa would certainly have been aware.

[54] Published by Malvasia, ed. 1841, 2: 179.

[55] Passeri, ed. 1934, p. 73, writes of Bamboccio's subjects

only was Sacchi outraged at the failure of the Bamboccianti to represent ideal beauty with decorum and proper expression, but he was also contemptuous of the literal smallness of their works, matching the smallness of their vision; he called them pygmies dabbling among giants, "pigmei pizzicano di Gigante."

Albani's attitude in reply to Sacchi was more complex.[56] He complained, exactly as Testa had done, that painting had been dragged down to the gallows and into the taverns, but instead of implicating Lomazzo he laid the blame squarely on Caravaggio's shoulders. Not only had Caravaggio imitated superficial appearances rather than searching out the beautiful, but also he had made single half-length figures in shallow spaces the pretext for his canvases, not bothering to express ideas or emotions. This kind of bad example led to bad teaching. Albani could not tolerate the idea that one could learn to paint simply by looking at other paintings. It led the young artist to abandon books, discourse, and the study of perspective. He criticized the laziness and impatience of artists who expected to surpass Raphael without effort. When they failed, they became so desperate in their ignorance that they either gave up painting altogether or devoted themselves exclusively to painting fruits and flowers (or, at best, uncommissioned portraits). This "gothic plague," according to Albani, was delighted to call Michelangelo, Raphael, and the great Italian school divine. In this way they could avoid the effort to understand how such excellence was to be achieved. Albani reassured Sacchi that the popularity of their paintings would quickly pass.

Like Testa, Albani was especially offended by still-life painting. He briskly dismissed the story of Zeuxis's fabled ability to paint grapes by pointing out that it is one thing to deceive birds, and quite another to deceive men of judgment who know how much harder it is to feign the movements of the soul. In an imaginary *apologia* to Raphael that recalls Testa's complaints about jugs and flasks, Albani traces the decline of art: once painters used to represent birds flying around a jug, then painters showed the birds just as they took flight, and in his day artists were content to paint the jug with only a stuffed bird beside it.[57] Albani was mocking low ambitions commonly realized here, for he certainly knew many such still-lifes by Dutch painters as well as the work of painters like Baschenis, Gobbo de'Carracci, and Paolo Antonio Barbieri, the brother of Guercino, in which a stuffed bird would not have been out of place.[58]

While Albani dismissed paintings of birds and cucumbers, he was yet able to discover

as "vili di baronate, e di basse scempiezze," and describes his imitator as producing "una quantità di quadretti di pitture laidi, vili, et inconvenienti al bel decoro della Pittura, che si era ridotta nelle publiche piazze à fare spettacolo di risate, nelle taverne, ne' postriboli, e nelle Calcare à spidocchiare li baroni, et a grattar la rogna a tutti li monelli della birbanteria." Of Jan Miel he writes, p. 224, that he painted "a quel genere baronesco," and of Cerquozzi, p. 286, that after recognizing the success of Bamboccio's "Pittura Berniesca" he began to work at "baronate." Rosa, *Satire*, p. 100, joins the chorus of complaints, stating: "Nè crede oggi il Pittor far cosa buona,/Se non dipinge un gruppo di stracciati,/Se la Pittura sua non è barona."

[56] Malvasia, ed. 1841, 2: 180-181. Haskell, 1963, p. 141, suggests that Malvasia doctored this text. This does not seem justified when the meaning of the letter is carefully considered. Sacchi's despair can be traced, as I argue here, at least

in part to the general situation in which he found himself in 1651. It does not, therefore, necessarily matter that the Bamboccianti had been on the scene for a while (one of the objections raised by Haskell). The critical context itself was changing around them. Sacchi may indeed have been mistaken about the prices fetched by *bambocciate*, or he may rather have quoted a ridiculously low price deliberately, in order to convey his low opinion of their popular appeal. Albani's reply, on the other hand, as I also hope to show here, seems far from the "stream of abuse," described by Haskell. It seems easier, in any event, to suggest an interpretation for these letters than to find a motive for the much-maligned Malvasia to have altered them at a time when the issue was no longer vital.

[57] Malvasia, ed. 1841, 2: 163.

[58] See e.g., Arcangeli, 1961; Bottari, 1965.

some virtue in the low-life subjects of the Bamboccianti. He painted little pictures himself, and the pygmy painters did not distress him so much as they did Sacchi. They clearly amused him, and he was able to perceive that their style of wit could be enjoyed in the same way as the macaronic poetry of Folengo or the mock-epic of Tassoni, even as Passeri recognized the Bernesque humor of Cerquozzi. Although he was careful to point out that while Maro and Merlino both deserve praise they are not equal and that while the *Secchia rapita* of Tassoni gave him pleasure the *Gerusalemme liberata* of Tasso combined instruction with that pleasure, Albani's approval of this particular type of subject is significant.[59] It reveals how *baronerie* were justified critically, without any reference to their realism, and how this popular genre was considered to be quite distinct from still-life and animal paintings.

Albani's age, success, and his absence from Rome perhaps made it easier for him to put things into perspective. On the other hand, Sacchi's lament that in 1651, the year after Testa's death, there were no more than six true painters in the whole of Europe raises important questions about the artistic situation confronting Testa and others like him in Rome at mid-century.[60] With Guido Reni and Domenichino dead, and Guercino in Bologna, there were fewer and fewer artists trained in the academic traditions of the Carracci left in the city itself. Even if Sacchi's six true painters included himself, Poussin, Guercino, Maratta, Albani, and the arch-enemy Pietro da Cortona, the situation must have looked bleak for a Roman artist trained in the Bolognese tradition and committed to the teaching methods of the Carracci Academy.[61] Many of the works Sacchi saw on the market were indeed made by artists who had learned to paint in the worst possible way—simply by looking uncritically at the works of other successful artists.

The case Sacchi knew best was that of Jan Miel. Sacchi himself had tried to teach him how to draw, but soon after 1641 he expelled the stubborn northerner from his studio because he had become so entrenched in his own mannerisms that it was too late to teach him to begin again and to draw properly.[62] Passeri shared Sacchi's judgment and dismissed Miel as an *imitatore*, not even of nature, but of Van Laer's manner.[63] Miel succeeded, according to Passeri, only because Van Laer had left Rome himself; Miel was a rank opportunist, incapable of bringing anything of his own even to this style of painting. Although neither Sacchi nor Testa mention Miel by name in their condemnation of the state of affairs in Rome (and Miel does not exactly fall into the category of a pots-and-pans painter), it is impossible not to conclude that Sacchi's outburst in the letter of 1651 and Testa's scorn for tavern painters and the apes of nature, expressed both in the notes and in his etchings were provoked in part by Miel's success. By the late 1640s Testa knew that his frescoes in S. Maria dell'Anima were to be whitewashed and replaced with new ones by Miel.[64] He did not live to see Miel's frescoes in S. Martino ai Monti condemned on the grounds that

[59] Wallace, 1979, p. 27, also associates Rosa's *Figurine* with the mock epics by Tassoni and Lorenzo Lippi.

[60] Malvasia, ed. 1841, 2: 179.

[61] Du Fresnoy's trip to see Albani and Guercino in Bologna, some time between his departure for Venice in 1653 and removal to Paris in 1656, when he read to them his poem *De arte graphica*, should also be seen in the context of this growing awareness that the heroic generation was receding. See Félibien, 1725, pp. 422-423.

[62] Baldinucci, ed. 1847, 5: 111.

[63] Passeri, ed. 1934, p. 221.

[64] Harris's argument, 1967, pp. 45-48, is most convincing in this regard.

they displayed all the bad habits Miel had acquired as a painter of *baronerie*.[65] Testa died knowing only that the manner of such a one as Miel was preferred to his own and that, as Albani would have put it, his inventions were to be plagiarized by a Tassoni who called himself a Tasso.[66] Sacchi wrote his letter to Albani complaining about the pygmy painters shortly after Testa's death; he more than anyone was in a position to measure Miel's talents and to understand Testa's difficulties in fulfilling fresco commissions speedily, something that had led to his loss of the commission in S. Martino ai Monti. Sacchi shared Testa's melancholy and also his anger.

THE TRATTATO DELLA PITTURA IDEALE: BOOK I, ON IMITATION

Although Testa reserved his more specific criticisms for ignorant practitioners like Miel who were totally dependent on the imitation of the lowly objects around them, he also opposed slavish imitation of any kind. Book I of the Trattato was to have been devoted to a discussion of the initial training of an artist in imitation showing how difficult it is to avoid mannerisms. Young students, Testa warns, are easily corrupted through bad habits, especially if they have poor teachers who fail to lead them toward the right path and who direct them instead into the insane labyrinths of superficial and accidental appearance.[67] From his attacks on wrong teaching and misguided treatises in the draft for his preface, Testa here turns to an attempt to find the right way both to teach and to write about art. His principal approach is announced in his outline for chapter one, where Testa states that he intends to apply Plato's discussion of rhetoric in the *Phaedrus* to the study of painting.[68] Following Plato's criticism of those who confuse the preliminary skills of the rhetorician with the art of rhetoric itself (to which he had referred in the preface), Testa intended to continue by affirming the importance of dialectic for all the arts. He wanted a student to have an inexhaustible treasure upon which to draw before turning to the special concerns of a painter. This treasure, in the form of mastering the dialectician's ability to classify by division and to unify in ideas, Testa placed at the heart of his curriculum, and its importance may be gauged simply by recalling the scheme of *Il Liceo della Pittura* and the emphasis placed there on the acquisition of the intellectual habits of right reason. Acquisition of the principles of classification in order to unify what had thus been learned according to the painter's own idea had also been the objective of the Carracci Academy, to which Testa was heir through the teachings of his first teacher, Domenichino; it would continue to be the stated goal of Sacchi and Maratta.[69] The mastery of dialectic, the means of understand-

[65] Passeri, ed. 1934, pp. 222-223. Harris, 1967, p. 59, n. 110, suggests that Miel attempted to outdo Testa in the S. Martino frescoes by making his figures larger than those in Testa's nearby altarpiece, underscoring their comparative grandeur by borrowing a figure from Testa's print of *The Adoration of the Magi*. Obviously he failed.

[66] See again Albani's letter in Malvasia, ed. 1841, 2: 180.

[67] Notebook, 59.B.

[68] Notebook, 59.E.

[69] See especially *Phaedrus* 273D-E, "we will put our trust in what we said just now, that unless a man take account of the characters of his hearers and is able to divide things by classes and to comprehend particulars under a general idea,

he will never attain the highest human perfection in the art of speech. But this ability he will not gain without much diligent toil, which a wise man ought not to undergo for the sake of speaking and acting before men, but that he may be able to speak and to do everything, so far as possible, in a way pleasing to the gods" (tr. Loeb ed.). See also *Phaedrus* 265D-266C for Socrates's definition of dialectic and for the description of its divisions as natural, and 277B-C, for a further summation. Sacchi, whose diligent study and striving for maturity (in the sense defined above) tipped over into the fault of *tardanza* and *fatica* in the eyes of many of his contemporaries, justified his slow thoroughness in the acquisition of maturity in the same metaphor used by Testa. Ac-

ing philosophical truth, was, in essence, what Albani missed in the work of painters who could only perceive and learn from the appearances of other works of art. Such artists were, in other words, slaves to practice and without the ability to think, and in Testa's view the teaching of such artists could only further confuse others by leading them down winding, labyrinthine paths.

Even with the aid of a good teacher, however, Testa was convinced that this kind of training was long and difficult, affirming once again the words of Socrates in the *Phaedrus*.[70] Testa also wanted to make it very clear at the outset that he did not advocate abstract, theoretical discourse for beginners. In chapter two he intended to repeat the now familiar maxim that long practice and art were required to bring natural disposition to perfection, and that any other road would lead to madness or to the acquisition of mannerisms. Testa was well aware of the dangers of this approach and that excessive practice itself was the cause of painting of the *maniera*. Elsewhere in his notes he was careful to distinguish the important, preliminary exercise of copying that led to ease of execution from the *furor matto* of automatic and therefore mannered painting.[71] In the pursuit of the desirable habit of practical use, according to Testa's outline for chapter three, the young student should be guided only by diligence and by Nature herself, and should even shun the confusing discourse of other painters. This reemphasizes Testa's opposition, expressed in the preface, to those teachers who confuse students by tearing them early away from the breasts of mother Nature; and once again Testa follows the arguments of Socrates in the *Phaedrus* concerning the teaching of rhetoric, saying that inborn talent must be trained by long practice and dialectical reasoning about nature, and not by the confusing arguments of the Sophists.[72] Before a student of oratory will be able to understand any lectures on the subject, he must first study the nature of the human soul, and this study must be inspired by the love of wisdom.[73] Testa also rejected sophistry, and demanded that a born painter should fall in love with nature.[74] In the *Allegory of Painting* (Fig. 13) he represented the three Graces standing in the shade behind a figure of ideal painting; and in his notes Testa argued that they would become more visible the more an artist looked at nature, extending the metaphor to suggest that an artist is impregnated by beauty through his eyes and then gives birth to concepts (literally things conceived in the mind) by means of line and colors and the power of chiaroscuro.[75] The love of nature took pride of place in the career of

cording to Bellori, ed. 1976, pp. 556-557, Sacchi replied to his critics in the following way: "che quelli che non maturavano l'opere e si sodisfanno solo della superficie, sono simili a que' mercatanti ch'apparano una bella mostra di fuori, e poi non hanno niente di dentro il fondaco: e seguitando lo stesso concetto ad uno quale diceva ch'il Domenichino essendo scarso per esso s'avanzava coll' altrui sostanze, intendendo del quadro di San Girolamo, rispose ch'egli non l'intendeva, e voltatosi col signor Carlo Maratti, che allora giovanetto con grand' aspettazione studiosa nutriva nella sua scuola: 'Carlo, disse, se uno andasse in un fondaco per vestirsi e non trovasse altro ch' una sorte di panno, al certo che egli non resterebbe sodisfatto, ma se dopo il primo andasse al secondo, e lo ritrovasse ricco di drappi di lane, tessute di seta e di ricami, senza dubio ch'in tante e sí rare merci rimarrebbe pago e contento, abbondando il fondaco di tutto.' Cosí comparò a questo ricco fondaco le opere del Domenichino, ripieno piú dentro che

nella mostra di tante preziose merci dell'arte." Sacchi's Socratic advice, which is repeated almost verbatim by Passeri, was surely famous enough to be known to Testa, especially as it was used in the defense of Domenichino, who may indeed have first given it to both Sacchi and Testa. For Testa's own description of the ideal painter as a rich merchant, see Notebook, 16, and see 60.A.4. for dialectic as the artist's treasure. For the Carracci Academy, whose motto was "Contentione perfectus," see Dempsey, 1977, esp. pp. 36-60.

[70] Notebook, 59.E.

[71] Notebook, 15.E.

[72] Notebook, 59.E.2., and, for criticism of bad teachers, 60.A.7.

[73] *Phaedrus* 269D, and 278B-E.

[74] Notebook, 60.A.7.

[75] Notebook, 60.A.1.

Testa's ideal artist. Although he was prepared to accept that some principles learned from others might be useful, and even necessary, the passionate love of nature was indispensable in a painter. Like Leonardo, he believed that painting was more natural than poetry, which is based in the human invention of speech.[76]

Testa's emphasis on the diligent study of nature, without the intervention of discourse, in the beginning stages of a young artist's training, immediately raises the question of how the student was to move on from this stage, which, given Testa's views of the apes of nature, he surely must. In chapter four Testa intended to respond to this by arguing that the student should, in fact, start out by imitating only well-proportioned things.[77] It is not at all clear at this point whether Testa is proposing that these first exercises should be set by a master or whether he believed, as Dolce had, that each man has a natural ability to judge beauty and ugliness for himself.[78] He does state clearly that imitation of works by the masters is an essential preliminary to be followed by the study of nature, but at the same time his emphasis on the primacy of nature seems to lead to self-contradiction. In short, he seems himself to come dangerously close to falling into those inevitable traps that attend the recording of processes of learning that he had warned against; but at the same time we can begin to appreciate how fine are the distinctions made between chapters and how closely Testa tried to argue his case. Chapter four is really a qualification of chapter three, explaining more fully what the student must be diligent about. In the same way chapter five sets out to answer the question of the way in which beauty is to be recognized and the order to be followed in imitating art and nature, left unanswered in chapter four.

In the outline for chapter five Testa resolves the apparent contradiction, establishing the relationship between artistic and natural models, by encouraging the young artist to copy those things in nature that he has seen in the works of the great masters. He should compare his own studies after nature with what he has seen in their works, and when he finds that a particular master has a manner similar to his own bent he should imitate that master.[79] In this way Testa effected a compromise between the student's diligent imitation of various natural perfections and the authority of those whose own prior selection and representation of these perfections had already gained respect. The constant practice of comparison and criticism would make it possible for the young painter to begin to take flight in independent ventures of his own. Testa compared this process to Virgil's poetic development, and in this he was following the well-established view that in the *Eclogues* Virgil had fallen short of his first master, Theocritus, but that in the *Georgics* he had taken flight, and had then equalled his third and greatest model, Homer, in the *Aeneid*—a critical view that provided the basis for one form of literary apprenticeship.[80]

In the final chapter of Book I, Testa proposed to show exactly how this critical independence might be achieved by opening the intellect to the principles underlying outward

[76] Richter, 1949, p. 46, n. 1. For Leonardo's statement that "the name of the man changes with change of country; but his form is unchanged except by death," see p. 55, §23. Richter, p. 80, n. 4, also cites Timon of Athen's preference for painting, as opposed to the deceitful, lying nature of poetry: "Painting is welcome. The Painting is almost the natural man." See also Lee, 1967, pp. 58-59.

[77] Notebook, 59.E.3.

[78] Blunt, 1940, p. 84, observes that Dolce was the first to state this directly. Although Dolce restricts the ranks of critics to a special group, he places the greatest emphasis on the practice of criticism itself, and the power of sight, as qualifications.

[79] Notebook, 59.E.4.

[80] Notebook, 59.E.4.

appearances.[81] Just as the student was to select his first artistic models by comparing his own diligent attempts to copy nature with what he had learned from the works of the great masters, so his intellect was also to be liberated through a dialectical process of observation and practical application. This principle is a restatement of the central image of *Il Liceo della Pittura*, the ascent of the student toward judgment by means of the mastery and consequent uniting of theory and practice, and in his conception Testa was quite consciously perpetuating the philosophy of the Carracci Academy where students learned, "ora speculando, ora operando."[82] Whereas Testa's own understanding of this way of teaching is evidence enough that it had not disappeared in Rome with the death of Annibale, the success of the Bamboccianti and the growing demand for swiftly executed fresco commissions, combined with the new sense of historical distance from the heroic days of the Carracci, made him feel that it was essential to reaffirm its principles. The same awareness led Sacchi to appeal to Albani for advice and illumination and prompted Albani's own writings. To those who believed that painting should be based on the liberation of individual judgment, and who encouraged young artists to work in their own style, expressing their own God-given taste while simultaneously respecting aesthetic norms, this principle of rationally combining observation with experience was essential. Some twenty years after Testa made his notes Bernini explained it to the students of the French Academy in Paris quite straightforwardly: only through combining study of the Antinous with making his own statues, by alternating action and contemplation, had he been able to discover many of its hidden beauties. Chantelou added the cautionary example of Antoine Carlier, who had copied for too long without any corresponding dialogue with work of his own, with the result that his art became sterile.[83] Testa would have said that Carlier had not taken flight.

BOOK II: THE POWER OF REASON

After establishing in Book I how the young artist was to begin to imitate art and nature, and how the intellect was to be freed, Testa then intended to devote Book II to an analysis of the usefulness of the power of reason to artistic practice. Clearly, he did not think of Book I as devoted to a purely practical stage and Book II as devoted to a theoretical stage, but rather considered the first book as treating of how students were to proceed in acquiring perfection in imitation and observation, studying art and nature, and the second book as treating of what came next when theory and practice had been effectively mastered and understood and the students stood at the gateway to the Liceo della Pittura itself. At this point they would have been prepared for the free exercise of the mind without depending on sensible objects and would embark upon a study of the elements of mathematics, which Testa, as we saw in Chapter Two, describes as keys that will unlock the underlying order, or *cagione* of everything that the eye sees.[84] It was difficult to explain when this transition was to be established, and Testa grappled with the problem most completely in the draft of the preface.[85] Here he criticizes those teachers who do not realize that it is most proper

[81] Notebook, 59.E.5.

[82] As described by Faberio in his funeral oration for Agostino Carracci, for which see Malvasia, ed. 1841, 1: 307; see also Dempsey, 1977, p. 48.

[83] "Journal du Voyage du Cavalier Bernin en France par M. de Chantelou," Lalanne, ed., 1880, p. 383.

[84] Notebook, 59.F.

[85] For what follows see Notebook, 60.A.9-60.A.11.

for lively minds to spread their wings gradually as they speculate, and then suddenly to take flight away from the bonds of ignorance and opinion into the open countryside of nature. Here they feed their hungry intellects according to their own talents. This sudden flight only occurs when a student is touched by a certain light of reason that reveals in his mind that nature is the true enemy of insidious mannerisms. Like the young man arriving on Parnassus in Testa's etching (Fig. 69), the artist must be prepared to acknowledge this light of reason when it appears to guide him. But, Testa adds, the power of reason, which is strengthened by the knowledge of mathematics, is the key to art that even the most vigorous can barely hold and the very young can never turn. It is at this point that the artist's individual genius, regulated by his sovereign judgment, takes control. Although the possession of such genius is God-given and its workings mysterious, its judgments are however susceptible of posterior demonstration. Many may practice an art, but in the end Testa's ideal painter stands as a goal reached only by a very few. Acquiring the habits of intelligence and use was one thing, but the rational perfection attained by individual genius in the expression of his own taste in his own style was quite another.[86]

Testa's insistence that he wrote for pleasure and his homage to Socrates's contempt for dead letters as opposed to active discourse becomes more understandable as the program of his ideal curriculum unfolds, and his apologies from this point could not smooth over the tensions between his concept of the freed judgment now guiding the chariot of reason and his attempts to define how judgment might still be effectively trained in a course of study. While he attempted to arrange the chapters of his treatise in such a way that the questions raised in one would be answered in the next, the necessary dialogue was missing. Testa himself perceived this and found it increasingly difficult to continue his outline. It was not that he gave up the principle that there was a correct and true way to reason, but rather that this could not be written out as a set of rules. The judgments of individual genius may find many paths to the truth, which are afterwards verifiable by an appeal to reason, but to prescribe one or another particular path is self-defeating. As a result, the projected chapters of Book II tend to reflect Testa's convictions on various issues, rather than laying out a programmatic course. Gradually he gave up trying to organize his ideas altogether, and this often makes it impossible to determine precisely how particular rough notes relating to the project would eventually have been incorporated into the text. We can at least, however, follow his outline to its premature end.

Chapter one of Book II was to have been devoted to the elements of mathematics that would unlock the organizing principles behind everything the artist sees and would have included Testa's thoughts on the principles of chiaroscuro as well as the rules of geometry and perspective on which those principles were based.[87] A discussion of color, which Testa also understood to be governed by the rules of light and by the same mathematical harmonies that regulate music, would almost certainly have also been included here. However, as neither color nor chiaroscuro are mentioned in the outline and as the notes on these subjects are so scattered and fragmentary, they are best discussed separately below.

[86] Here, as elsewhere, Testa emphasizes that he is talking only about those who are born to be painters; see esp. Notebook, 60.A.9.

[87] Notebook, 59.F. Testa's own conventional definition of optics included chiaroscuro, even though this is not specifically mentioned here.

It was at this point, after mastering mathematical principles, that Testa believed the young painter would begin to multiply the treasures that he had promised at the beginning of Book I. In chapter two, therefore, he intended to show how all the foundations laid so far would free the artist from the status of slave or mercenary. He would be able to work from memory, no longer requiring a model before him and accomplishing far more than one who cowardly continues to rely on direct imitation.[88] Emancipation from the model was one of Testa's most consistent aims, and elsewhere in the notes he criticizes even more harshly the artist who remains thus enslaved. Even when such an artist does have a model he will not work well because he has no grasp of the order behind what he sees. Testa gives two examples, one serious and one mocking. In the first, he argues that an artist who relies upon a model may be able to paint armor, but he will not be able to paint the reflection of blood upon it. The example immediately calls to mind Poussin's perfect demonstration of this ability in his *Tancred and Erminia* in the Hermitage; it reminds us too of the twin foundations of Testa's observation—in Leonardo's assertion that an artist must be able to imagine as well as to observe natural effects of light and color and in the vivid coloristic metaphors of poetry.[89] Testa's second example is of a painter whom he claims to have seen string up an old man by means of a laced leather waistcoat when called upon to paint a God the Father. The whole thing collapsed from the strain, ruining the contraption, the old man, and of course the painting. Testa gibed at such inept practice even further by imagining how ridiculous it would be if such a painter were to represent the actual stool upon which his model sits, as if it were so many delicate little clouds.[90]

These artists, the slaves and apes of appearances, were despised by Testa not only for their limitations as painters, but also for their actual dependent status. They were like miserable beggars who had to do the rounds of lowly craftsmen, the carpenters, shoemakers, and potters, in order to secure the things they needed to put into their pictures. The craftsmen at least, in Testa's view, had all mastered their trades, but the beggar-painter needed their help to prosecute his own.[91] In contrast, the ideal painter was (as Sacchi, according to Maratta, also described Domenichino) like a rich merchant. He was able to satisfy everyone and had a cellar full of all the things he needed.

The metaphor of the artist as liberated from slavery extends to the treasures promised him in Book I, and here Testa continues to draw heavily from the *Phaedrus* to justify his position that the artist must possess infinite resources. The more specific issue of whether the artist should draw entirely upon those resources or whether he should rely on support from others, however, is more fully debated in ancient rhetorical theory. Quintilian, whose program for the education of the orator plays such an important role in humanist art criticism, was prepared to accept that it was not possible for the orator to know everything, precisely because oratory was discursive (literally *circumcurrens*, or running from subject to subject).[92] It was enough to be prepared to speak on the subjects an orator had studied

[88] Notebook, 59.F.

[89] Dempsey, 1979, discusses the structure of metaphor in Poussin's work. He cites the *Tancred and Erminia* in this context, tracing the simile of purple on ivory through Virgil to Homer, and back to Ariosto, who employs it to describe the blood coursing over Zerbino's armor: "Così talhora un bel purpureo nastro/ Ho veduto partir tela d'argento,/ Da quella bianca man piu ch'alabastro/ Da cui partire il cor spesso mi

sento." This passage, and the use Poussin made of it, almost certainly lies behind Testa's choice of example. See also Chapter Four below, p. 163, for a relevant passage from Seneca the Elder.

[90] Notebook, 16.

[91] Notebook, 16.

[92] *Institutio oratoria* 2. 21. 7, "eamque artem circumcurrentem vocaverunt quod in omni materia diceret." This same

and to which he had been introduced by his client. To Testa this would have meant either slavery to the limited number of things known or a mercenary relationship to his client. He took instead the position of Cicero in *De oratore* that Quintilian was refuting in the passage just cited: that is, that because there is no difference between what is being said and the means of saying it, the orator must be universal. He must have studied and debated all aspects of life, recognizing (and here Cicero appeals directly to the authority of Plato) the underlying principles that are common to all areas of knowledge.[93]

Ancient writers tended to praise either the means of execution of a work of art or the invention of its subject, rather than following Cicero's perception that the two were inseparable. The inappropriateness of such a disjunction was already becoming clear to some painters and critics in the sixteenth century when the simple pleasure evoked from the conquest of the imitation of reality began to wane. Michelangelo's reaction to the story of the encounter between Apelles and Protogenes, recorded in an anonymous account of 1564, is evidence of this realization. According to Pliny, Apelles painted a single line on an empty panel in Protogenes's studio as a sort of calling card. On his return Protogenes immediately recognized the author of the line and proceeded to paint another finer line on top of it. Of course Apelles, in turn, drew a third even finer line, causing Protogenes to go in consternation in search of him. Pliny records that this large panel with its three superimposed lines, almost invisible, was esteemed more highly than any other masterpiece in Caesar's palace on the Palatine before it was destroyed by fire.[94] This was the kind of virtuoso game, on the lines of the story of Zeuxis, Parrhasius, and the bunch of grapes, that appealed to sixteenth-century tastes for technical perfection. Michelangelo's respone was that one did not have to be a painter in order to draw lines; one had to be able to draw lines.[95]

In Italy in the seventeenth century delight in skill for its own sake was increasingly condemned by one class of critics as more and more artists treated subjects for no other reason than to demonstrate such skill. Albani's example of the birds and the jug stands as a direct challenge to ancient stories of successful illusionism, as we have seen. If a renewed interest in the works of still-life painters in the means of execution rather than in the truth of the subject of paintings, placing skill at times even in opposition to the subject, prompted

passage is cited by Richter, 1949, p. 79, n. 3, in connection with Leonardo's views, so similar in content and expression to Testa's own. Leonardo writes, pp. 79-80, "ma s'esso poeta toglie in prestito l'aiuto dell'altre scientie, potrà comparire alle fere come li altri mercanti portatori di diverse cose fatte da più inventori, e fa questo il poeta, quando sinpresta l'altrui scientia, come del oratore, e del filosofo, astrologho, cosmografo e simili, le quali scienze sonno in tutto separate dal poeta. adonque questo è un sensale, che gionge insieme diverse persone a fare una conclusione d'un mercato, e se tu vorai trovare il proprio ufficio del poeta, tu troverai non esser altro, che uno addunatore de cose rubate a diverse scientie con le quali egli fa un composto buggiardo, o vuoi con più honesto dire, un composto finto, et in questa tal fintione libera esso poeta se equiparato al pittore, ch'è la più debole parte della pittura."

[93] See Crassus's prefatory speech, *De oratore* III.5.19-9. 36, esp. 6. 21-22, concerning the truth expressed by Plato, in Cicero's words, "that the whole of the content of the liberal and humane sciences is comprised within a single bond of union; since, when we grasp the meaning of the theory that explains the causes and issues of things, we discover that

a marvellous agreement and harmony underlies all branches of knowledge" (trans. Loeb ed.).

[94] *Natural History* XXXV. 36. 81-83. Dati, ed. 1821, p. 264, also tries to salvage a different meaning from this story, which would, he feels, constitute a "seccheria," unworthy of the artists involved, if it were indeed only about lines. He summarizes various interpretations, pp. 262-266, citing Carducci's description of Michelangelo's response to the story and Tassoni's mockery in his *Pensieri*. Dati also praises the theory put forward by Louis de Montjosieu that the argument was about the gradation of shadows, from light to splendor, to shadow (basing this upon a comparison with music). This is essentially the argument put forward by Gombrich, 1976, pp. 3-18, esp. 15-16, though Gombrich believes that the lines became progressively lighter. Louis de Montjosieu's explanation, not cited by Gombrich, is the more convincing in that the final addition of a line of shadow, rather than a highlight, provides a more satisfying paradoxical conclusion. For an extensive discussion of the various interpretations, see van der Waal, 1967.

[95] Frey, eds., 1930, 2: 64.

the defenders of ideal painting toward a reexamination of Cicero's demand for the union of *res* and *verba*, it is also true that Cicero's arguments for the marriage of style and content helped to blunt the arguments of Socrates that poetry and painting deceived by their ornaments. For Testa principles could only be mastered through the dialectic of drawing; the truth could only be revealed through lines and colors that expressed the concepts of the mind. It was by these means that the painter, like Cicero's ideal orator, possessed unlimited treasures, not through hiring himself out to satisfy a client's inclinations and not through capitalizing on a particular, limited skill.

The importance of universality in principle, if not in practice, had also been stressed by Barbaro, and in notes that can be related to his reading of Barbaro's Vitruvius Testa used an example drawn from architecture to strengthen his argument. He reasons that if it is foolish for an architect to have to go around borrowing all the things he needs in order to finish a building he has designed, then it is even more foolish for a painter to have to borrow from others, given that his art is founded in drawing itself (here defined as "la ragione del bello intorno alle forme"). Because he bases his work on drawing—and here we remember that for Testa this was the equivalent of dialectic—the painter should be the model for all other artists.[96]

Although Testa advocated the discovery of universal principle, he also discouraged reliance on any kind of abstract formula for beauty. As we have seen, he identified automatic habits as mannerisms. Accordingly he intended to devote chapter three to a reaffirmation of the need to contemplate nature, reasserting the balance between an emphasis on diligent imitation and rational conception. The organizing principles (*ragioni*) of irregular (that is to say contingent) bodies are never so exact that an artist can afford to relax his powers of observation. If he does, then he may fall into what Testa calls "delirij dell'Arte"—artistic ravings—another way of describing the abstractions of mannerism.[97]

Vitruvius's model of the way in which the architect should master the principles of all disciplines, enabling him to judge the works of others, had provided Testa with a model for the ideal painter. Correspondingly, in chapters four and five, he turned to problems of architecture and architectural perspective, basing his right to do so on his knowledge of those rational principles that painting and architecture shared in common. His first discussion was to have been devoted to an attack on the folly of contemporary architects who did not respect these principles, giving precedence instead to the senses.[98] That Testa was not entirely opposed to innovation in architecture is clear from his praise for Michelangelo's enrichment of architectural ornament, appearing in the letter from Parnassus (and indeed Testa's admiration for Michelangelo was unstinted).[99] In opposing regularity and solidity to the novelty of sense and appearance he was probably alluding to recent works by Borromini, such as the interior of San Carlo, the facade of the Oratorio, or Sant'Ivo, the broken curves and spatial illusionism of which had also provoked the criticism of Cassiano dal Pozzo.[100] It is likely that Testa also regarded the cloud architecture of Lanfranco and the

[96] Notebook, 16.

[97] Notebook, 59.F. (the subject of Book 2, chapter 3, of the Trattato).

[98] Notebook, 59.F. (the subject of Book 2, chapter 4, of the Trattato). The summary of Book 2 that follows is based on the outline of chapters included in this section).

[99] Notebook, 63. §4.

[100] Haskell, 1963, pp. 103-104; see also Bellori's criticisms in *L'Idea* of modern architects, each one of whom, "si finge da se stesso in capo una nuova idea e larva di architettura a

illusionism of Tassi's *quadratura* architecture for Guercino's ceiling in the Casino Ludovisi, not to mention the more complicated illusionistic devices of Pietro da Cortona in the Gran Salone of the Palazzo Barberini, as all guilty of appealing primarily to the senses, or perceptions of the spectator, rather than to his reason. Testa's criticism of these works would be that they called attention to their own illusionism and did not therefore indicate the truth, and indeed he voiced his intent when given the commission to fresco the apse of S. Martino ai Monti to avoid the "uso commune" based on the illusionistic devices invented by Correggio. After voicing such criticisms in chapter four, Testa then intended to make true architecture, based on the rational foundations provided by Vitruvius, the subject of chapter five.

In the remaining four chapters of Book II the student was to be reminded constantly that perfection was almost impossible to achieve and must be striven for incessantly. In chapter six Testa wished to stress that to have mastered everything so far was not sufficient. Returning to the analogy with poetry, he repeated the now familiar maxim that without knowing all the characters of script it is impossible to write perfectly. Chapter seven would have proposed the next major challenge to be met: the painter must know history, poetry, and all the disciplines proper to a philosopher. Only in this way could a painter emulate Homer, whose poetry did not lie. At this point Testa claims not to be going beyond what Plato had said about rhetoric in the *Phaedrus*. Regarding Homer, this is not entirely true, given that Plato makes Socrates challenge Homer to tell the truth, rather than passing a favorable judgment on his poetry.[101] Testa's demand, however, that to be divine an artist must pursue the truth through persistent intellectual study is a restatement of his dedication to the importance of dialectic, derived from the *Phaedrus*. This demand was directly opposed to the lazy attitude of those northern artists who, according to Albani, were eager to associate divinity with inimitable grace.[102]

POETRY AND HISTORY

The distinction Testa makes between history and poetry in the outline of chapter seven is not simply a division into conventional literary categories. In the draft of the preface he refines the distinctions by stating that the painter must know histories for his history paintings and poetry for his inventions.[103] The issue of poetic invention lies at the heart of Testa's imaginary arguments with Socrates about the nature of truth and its relation to the fictions of the poet-painter. At the same time, his concern to demarcate the territories of history and poetry, closely associable with the debates surrounding the poetry of Tasso and Marino, responds to an important issue debated widely and heatedly in Testa's day. That he was seriously interested in this debate is suggested by the fact that he read and took notes from

suo modo, esponendola in piazza e su le facciate: uomini certamente vuoti di ogni scienza che si appartiene all'architetto, di cui vanamente tengono il nome. Tanto che deformando gli edifici e le città istesse e le memorie, freneticano angoli, spezzature e distorcimenti di linee, scompongono basi, capitelli e colonne, con frottole di stucchi, tritumi e sproporzioni; e pure Vitruvio condanna simili novità e gli ottimi essempi ci propone." For this and for references to Carlo Dati's discussion of Cassiano's view, see *Le vite*, ed. 1976, p. 24. For Bellori, see Chapter Four below.

[101] See Commentary to Notebook, 59.F.

[102] Malvasia, ed. 1841, 2: 180, publishes Albani's reply to Sacchi, in which Albani writes of the "gothic plague," "stimando l'eccellenza italiana più miracolo di grazia infusa, che guadagno di ostinato studio, avviliti, e disperati precipitano nel baratro di quelle bassezze, a che gli sprona il sollecito della facilità, e l'invito dell'interesse."

[103] Notebook, 60.A.3.

Girolamo Aleandro's *Difesa dell'Adone*, the first part of which was published in 1629.[104] This is one of the more important works written, as the title suggests, in defense of Marino's *Adone*, against the attacks of the supporters of Stigliani, whose *Mondo nuovo* included a sarcastic attack on Marino, provoked in its turn by Marino's criticism.[105] The battle of self-publicizing literature that ensued took up many issues, including the nature of the epic, of invention, and of imitation. In the chapter to which Testa refers Aleandro considers the question of proper subject for the epic, criticizing Stigliani for choosing a recent and relatively well-known story, the conquest of the new world by Columbus, and praising Marino for selecting instead an ancient fable, the story of Adonis, upon which he could elaborate poetically to the limits of his talent. Tasso, one of the two poets Testa places on Parnassus, is less praiseworthy because the story of the conquest of Jerusalem can be established with a certain degree of factual accuracy, making its treatment in the poetic realm of likelihood less felicitous, whereas Virgil, Testa's other model, wisely chose a story the historical truth of which could not be established with any measure of accuracy. Aleandro's distinction, based on Aristotle's *Poetics* and expressed on the page of the *Difesa* to which Testa refers, is that it is the duty of the historian to recount events that actually happened; the poet must never do this, for he has a duty to imitate, by simulation or feigning, actions that might have happened.[106] Testa called these fictions of the poets inventions.

If we knew more about the debates in the Accademia di San Luca in the middle of the 1630s, in which issues of the nature of history painting as opposed to pictured poetry were surely raised, it might be possible to understand Testa's position more precisely. As it is, we can only suggest that Testa, like Poussin, was familiar with the works of two writers who substantially treated the question of the writing of history within the context of an argument that was more truly about poetry, that is to say Castelvetro and Mascardi.[107] Castelvetro, in his influential translation of and commentary to Aristotle's *Poetics*, had argued that because a poet relies upon an understanding of the truth, an art of history must take precedence over, and is a prerequisite for, any art of poetry.[108] Mascardi specifically disagreed with Castelvetro on this issue, but in the process of refuting Castelvetro he went on to attempt the establishment of a comprehensive theory of the writing of history that called into question the identity of history with factual reality.[109] Some of Mascardi's most

[104] Notebook, 19., and Commentary.

[105] For the history of this dispute, see Corcos, 1893; Croce, 1955; Peters, 1969.

[106] See Commentary to Notebook, 19.

[107] Poussin cites Ludovico Castelvetro's *Poetica d'Aristotele vulgarizzata et sposta* (Vienna, 1650; rev. Basle, 1576), in support of his reference to Aristotle's view that it is proper for the poet to write about things that are better than they are in nature; see Bellori, ed. 1976, pp. 478-479. His definition of the "Maniera magnifica," is derived from Mascardi's *Dell'arte historica* (1636), pp. 367-406, for which see Bellori, pp. 479-480. See also Blunt, 1937-1938, for the original publication of these discoveries. It should be pointed out that the extent of Poussin's dependence on Mascardi has not been fully appreciated. His notes entitled, *Dell'azzione*, for example, (Bellori, p. 479) are based on Mascardi, pp. 450-451 (this being the intermediary between Poussin and Quintilian hypothesized by Blunt). Similarly, Poussin's notes, "Come si deve supplire al mancamento del soggetto" (Bellori, p. 481) are derived from Mascardi, pp. 141-142, almost verbatim, including the quotation from Ovid, "Materiam superabat opus." Blunt, 1967, p. 346, recognized this, but was curiously reluctant to accept Mascardi as the source. In his text, p. 365, he points to Mascardi, p. 158 in this context, but this reference is incorrect. A careful reading of Mascardi makes it possible to effect several emendations in the text of Poussin's notes as published. In this last note, for example (Bellori, p. 481), "ma constumi l'ingegno," should read "ma consumino l'ingegno." Similarly, in the section devoted to the "Maniera magnifica" (Bellori, p. 480), "Lo stile è una maniera particolare ed industria di dipingere e disegnare," should read, "Lo stile è una maniera particolare, e *individua*," based on Mascardi, p. 406, an emendation with considerable effect upon the meaning; see further Chapter Four, pp. 158-161.

[108] See Weinberg, 1961, 1: 502-511, esp. 510, where he discusses Castelvetro's notion (ed. 1576, p. 5) that poetry takes "ogni sua luce dalla luce dell'historia."

[109] Mascardi, 1636, pp. 488-503, esp. 494.

important observations were not new; he was following Salviati, for example, when he insisted on the distinction between history as human events and history as the writing about those events. He went beyond his precursors, however, in arguing that although the historian must indeed aim to tell the truth, rather than content himself with likelihood or the verisimilitude of the past, he nonetheless shares with the poet the requirements of eloquence, composition, and the goal of delight.[110] Mascardi's treatise, *Dell'arte historica*, has never received the close attention it deserves, even though it has long been known that Poussin read it carefully and that Mascardi was a friend of Agucchi's and a favorite of the Barberini.[111]

Testa's distinction between poetry and history might be interpreted simply to mean that the painter should turn to history for the material of his theme and then, concealing meaning beneath the veil of action, invent upon that theme in the manner of the epic poet. On the other hand, given the argument of Mascardi's book, it is also possible that his note reflects his awareness of the growing concern to establish principles for history painting as a genre in its own right, rather than as something to be considered in relation to or in combination with poetic invention. Certainly, as we saw in Chapter One, it appears that in his mature work Testa tried to distinguish between a literal representation of recorded events in his histories, such as the *Death of Cato* (Fig. 79), and the invention of *favole* like the *Seasons*, which, according to Passeri, as discussed in Chapter One, expressed the ideal and poetic conceits of his *capriccio*. It is, however, the kind of sharpening of the criteria defining history painting represented by Mascardi that accounts for the emergence of criticism in the second half of the century, especially in France, censuring the anachronisms and selective presentation of events that regularly appeared in historical paintings of the sixteenth and seventeenth centuries. Even Poussin was not guiltless, as appears in the notorious criticism of his *Rebecca and Eliezer at the Well* for omitting the camels that should have been present at the event.[112] This sort of criticism, often ridiculed as pedantic overscrupulosity, stems rather from the continuing debate about the nature of history itself, to which Mascardi was the most important contributor in Testa's and Poussin's immediate circle. Mascardi would not have agreed with those later critics of the French Academy who found fault with historical representations that failed to record all the known information. His desire was to reconcile the demand for the truth, which he derived from Lucian, with the requirement that history also instruct and delight, a position that stands much closer to Poussin's own. Mascardi's book was published in 1636, the year in which, as we have seen, the famous debate between Cortona and Sacchi, together with their respective followers, seems to have reached its climax. It would be instructive to know how he would have compared Pietro da Cortona's ceiling celebrating the policies of Urban VIII with, say, Poussin's *Plague at Ashdod*, given his lively awareness of the different qualities of panegyric

[110] *Ibid.*, esp. pp. 92-105.

[111] The account given by Spini, 1948, pp. 134-135, points to the tremendous popularity of Mascardi's book, but the author is incapable of giving any account of its contents because he finds its rhetorical approach to history unsympathetic. For a more informative and balanced summary see the entry by M. L. Doglio, in *Dizionario critico della Letteratura Ita-* *liana, s.v.* "Mascardi." See also Raimondi, 1966; Bertelli, 1973; Cotroneo, 1971.

[112] As described by Philippe de Champaigne in his lecture to the Royal Academy of Painting and Sculpture on 7 January 1668. For the text of the lecture, as summarized by Guillet de Saint-Georges, see Jouin, 1883, pp. 86-99. The *Fall of Manna* was also criticized on similar grounds.

and history.[113] As things stand, Testa's brief note and Poussin's references to Mascardi provide a tantalizing glimpse into the nature of the issues. Certainly Testa saw history and poetry as having their own distinct roles to play in painting, even as moral philosophy had its role in the understanding and presentation of the passions. In the end the whole argument regarding history and poetry was one revolving around imitation and invention. Much effort could have been saved if the logical solution proposed by Pino that all painting is poetry insofar as it makes what is not seem to be had found favor.[114]

Although Testa has a good deal to say about imitation there is little explicit discussion of invention in the notes, for his proposed section on invention and disposition never materialized. Nonetheless, several important aspects of his attitude about invention are revealed in the material relating to chapter eight, the penultimate chapter to Book II. Here Testa intended to show how ridiculous were those who claimed to deserve the name of painter by any means other than the one he had described. He also wanted to show that those who pretended to judge painting without understanding its organizing principles (*ragioni*) were as stupid as those who, bewildered by such lack of understanding, came to the fatuous conclusion that painting was a matter of opinion.[115] Once again here, the contents of this chapter are much more completely spelled out, together with the relevant sources, in the two drafts of the preface. In these drafts Testa asserts once more that nature and reason are the only true teachers and that a student must learn everything from them, after having admitted his own ignorance. There is nothing worse than the ignorance of people who pretend to know, and it is from such people that blind prejudices are born every day. The seriousness of Testa's concern about the argument of some that painting was just a matter of opinion, and not of judgment, is indicated by the fact that he claims through reference to the argument put forward in the *Alcibiades* that pretended knowledge, and ignorance of what is just, are the sources of discord and war.[116]

IMITATION AND NOVELTY

The kind of critical wars of which Testa was thinking were, according to the notes, marked not only by disagreements born of ignorance and prejudice, but also because of the fact that those who followed the right path toward the truth sometimes made things that were so similar that they appeared to be stealing from one another. Testa's concern with this problem led him to read the poet Marino's letter to Claudio Achillini, included as a self-justificatory preface to the *Sampogna* in 1620.[117] Like the *Difesa* of Aleandro, Marino's letter was written in reply to charges of theft raised against him by Stigliani in his *Mondo nuovo*, in which a Cavaliere Marino appears swimming in the coastal waters of America in the form of a *pesciuom*, a *scimmia di mar*. The argument between the two poets centered around the cognate questions of the nature of ideal imitation and the importance of novelty that in turn raised the issue of literary theft. Far from ending the controversy, Marino's death in 1625 only led to an intensification of hostilities, as attacks upon and defenses of

[113] E.g., Mascardi, 1636, pp. 465-487.

[114] *Dialogo di pittura*, in Barocchi, ed., 1960, 1: 115, "E perché la pittura è propria poesia, cioè invenzione, la qual fa apparare quello che non è."

[115] Notebook, 59.F.

[116] Notebook, 55.

[117] Notebook, 55.

his poetry increased. The fact that Testa's notes document the artist's interest in the battle only confirms his preoccupation with critical debates in Rome in the late 1620s and 1630s, and his reading of Aleandro and Marino shows him alive to the most publicized debate of all, and one that had far-reaching consequences.

Marino's letter in the preface to the *Sampogna* presents a precise analysis of the nature of the problem of artistic theft, and this would have provided the basis for Testa's discussion of the issue in chapter eight of Book II.[118] Marino first recognizes that it is possible for writers to say the same thing either through accident or design. Accidental coincidences often occur because it is impossible for a prolific writer to avoid commonplaces and because beautiful things are few. Men of intellect follow the best guide when they begin to think about something, and so it is hardly surprising that such men often end up in the same place. Marino wanted to claim that this was even more true in his own day than before because most beautiful things had already been discovered.[119] The consideration of literary theft appears in Marino's enumeration of the ways in which similarities between writers could arise as the result of conscious study, rather than by accident. He first discusses translation in this context, by which he means a kind of paraphrastic translation that enlarges and amplifies upon the original, thereby changing it, rather than literal translation. Translated passages may even be incorporated into new poems, as in Virgil's incorporation of passages from Ennius and Catullus into his own poetry. In such a case, however, the originals must always be so well known that there is no mistaking them. Marino likens such passages to gems scattered on the seashore that become the property of whoever finds them without any imputation of theft. He would not, however, pass them off as his own.[120] This shows that in such cases Marino intended the reader to recognize the original to which his translation pointed as a way of appreciating the transformation he had wrought. The principle is applicable to any number of painted "translations" by artists, among which Annibale Carracci's entire gallery of them in the Palazzo Farnese is perhaps the most perfect example.

The other two deliberate actions that lead to close similarities between literary creations, according to Marino, are imitation and theft. In considering imitation Marino adopts the Aristotelian maxim that all men naturally desire to imitate, but then rejects the conclusion that this has anything to do with the imitation of nature. Instead he is concerned to elaborate upon the nature of literary imitation that teaches a writer to follow in the steps of his most celebrated predecessors. This he explains in terms of the *concetto* (which Testa uses to explain instead the imitation of nature) rather than in terms of critical judgment; the inventive intellect receives the phantasms of a pleasing text in the form of seeds and then desires to give birth to the *concetto* it has gained from them, going on to create other fantasies that are similar to the original but often more beautiful. The author of the original text in this case will probably not recognize the source. This kind of imitation can be on the universal level, resulting in invention, at which Ariosto, according to Marino, is a master; or it can be at the level of particulars, of words and sentences, which is Tasso's

[118] The text of the letter is published in Guglielminetti, ed., 1966, pp. 238-256.

[119] *Ibid.*, p. 245; see also Notebook, 55. for Testa's citation of this particular passage.

[120] Guglielminetti, ed., 1966, p. 246.

strength. Imitation, unlike translation should always be concealed, and accordingly Marino awarded Ariosto much higher praise than Tasso for his dissimulation.[121]

Marino, finally turning to the question of theft, underlines the difficulty of distinguishing between the concealed imitation described in the last paragraph and actual theft. He defies his detractors, that is to say Stigliani, even to navigate the deep waters in which he, Stigliani's *pesciuom*, is able to swim, far less to catch him with his prey. He refers the reader to his preface to the *Lira*, in which the stupidity of Caligula in placing his own head on all statues of Jupiter is contrasted to the deception of the sculptor who melted down a statue of Venus and, using the same material, then transformed it without trace into a statue of Diana.[122] Marino admits, with heavy sarcasm, that he may have stolen things here and there, since from his youth he kept a *zibaldone* in which he noted down all kinds of useful things. This is after all the point of reading books, and all writers do the same thing in order to compensate for the weakness of memory. If he has stolen it is because, being poor, he must take from the rich. In an important conclusion Marino argues that the essential element is the choice of what to enter into one's *zibaldone*; this is entirely personal, and because all intellects are different what pleases one writer will not appeal to another. He compares such "thefts" to the manner in which pieces of ancient sculpture, when well placed in a new and ingenious way, enhance the ornamental majesty of a new building. "Theft," in short, in an ingenious paradox, is presented as quintessentially an exercise of artistic judgment, a critical manifestation of the poet's novelty.

In his introduction to the *Lira* Marino, writing under a pseudonym, introduces the metaphor of the bees who now acquire together with their virtues of industry and diligence that of theft.[123] The image of the bees gathering nectar to make honey is, of course, the most familiar ancient metaphor employed in the Renaissance to characterize poetic imitation, and as the reader has long suspected, at this point any distinction in Marino's scheme between dissimulating imitation and well-concealed theft completely disappears (and Marino gratuitously adds that a thief who does not know how to cover his traces deserves all that he gets). If any distinction remains at the end of the letter to Achillini, it is that the element of personal fancy, or *capriccio*, is more influential when a poet steals than when he simply imitates, for in the choice of whom to imitate Marino still refers to the "best" and "most famous" models.[124] There can be no real doubt, however, where his true preference lies. It was Marino's delight in *novità* that enticed him into deep waters, rather than following the familiar sea lanes of the imitation of accepted models.

The issue of *novità*, or originality, of course lay at the heart of the whole argument, for without a concept of originality the whole question of theft was meaningless, and this issue of novelty was what particularly concerned Testa. His preoccupation with it provides the strongest evidence that he was involved in the first critical battle ever waged over an accusation of plagiarism in the visual arts, the battle between those who charged Domenichino with stealing from Agostino Carracci's *Last Communion of St. Jerome* in his own

[121] *Ibid.*, p. 247.

[122] *Ibid.*, p. 249; see pp. 602-605 for the letter to which Marino refers, and which was originally signed by "Onorato Claretti." As Guglielminetti points out, p. 614, n. 1, the correct attribution to Marino was made by Scipione Errico in his *Rivolte di Parnaso*, published in 1625.

[123] *Ibid.*, p. 603.

[124] E.g., *Ibid.*, p. 247, where Marino defines imitation as "quella che c'insegna a seguir le vestigia de' maestri più celebri che prima di noi hanno scritto."

altarpiece of the same subject for S. Girolamo della Carità (Fig. 102), and those who defended Domenichino's painting as second only to Raphael's *Transfiguration* in accomplishment. The issues of this dispute have been reduced in modern scholarship to one of mere professional jealousy between Domenichino and Lanfranco (who lodged the accusation of theft against Domenichino), this rendered more picturesque by Malvasia's account of Domenichino's attempt to do away with his rival by sawing through the scaffolding under the dome of S. Andrea della Valle, expressed in terms of a stylistic challenge between the aesthetic of "classical Baroque" versus "full Baroque."[125] The true argument, however, was on the issue of novelty. Some kind of conflict between the importance of innovation and the tradition of imitation may be seen as inevitable in painting, but it is unimaginable that Lanfranco's animosity toward Domenichino could have taken the form of a charge of plagiarism without the inspiration of the contemporary charges against Marino and his responses to them.

The charges against Domenichino's Roman masterpiece, which apparently were rendered the more effective by Perrier's print of Lanfranco's sketch after Agostino's painting in Bologna (Figs. 103 & 104), no doubt contributed to his decision to leave Rome for Naples and to his subsequent string of disappointments.[126] His supporters must also have perceived this, and Domenichino's miserable death in Naples in 1641 brought the issue alive again.[127] According to Malvasia, it was the publication of a print by Giovanni Cesare Testa (Fig. 105) reproducing Domenichino's painting that stirred up all the old arguments anew.[128] The print is undated, but it is usually placed in the late 1640s or early 1650s on the basis of Malvasia's account that it was made after Domenichino's death at the request of the publisher Collignon.[129] Given that the print was made by Testa's nephew and published by the printer chiefly responsible for his estate, a direct interest in the affair by Testa himself seems indicated, and the notes show him concerned to come to grips with the issues by reading Marino's defense. Even though it may not be possible to prove that the print was published before Testa's death, everything argues in favor of an attempt on his part to salvage the reputation of Domenichino, his first master, the painter whose own training in the Carracci Academy gave the principal foundation to Testa's theories of teaching, and the painter whom Testa placed on his ideal Parnassus together with History, Expression, and the flower of Greece.[130] Testa was not alone in his defense of Domenichino

[125] Malvasia, ed., 1841, 2: 232-233. The opposition of "full Baroque" and "classical Baroque" is pervasive in the modern literature devoted to this period, especially concerning Domenichino in the 1620s. Wittkower, for example, 1973, p. 81, states that, "In his most important commission of the next decade, the choir and pendentives of S. Andrea della Valle . . . , this arch-classicist seemed to be tempted by the new Baroque trend." The most succinct example of this kind of interpretation, however, is by Posner, 1965. This is not the place to enter a discussion of the meaning of Baroque as a stylistic category, but it should be noted that Posner's interpretation of his sources is often misleading. On p. 140, e.g., Posner writes that according to a letter by Ludovico Carracci, dated 1617, Guercino was " 'astonishing everyone' with the baroque exuberance of his art." In fact, the text of the letter, cited but not quoted by Posner, reads as follows: "Qui vi è un giovane di patria di Cento, che dipinge con somma felicità d'invenzione. È gran disegnatore e felicissimo coloritore; e mostro di natura, è miracolo da far stupire chi vede le sua opere." There is, needless to say, no reference to "baroque exuberance" here. Posner's general argument will, in any case, now have to be revised in the light of R. Spear's new documentary evidence for the sequence of the S. Andrea commissions. What follows is a summary of a longer study in progress.

[126] See Bellori, ed. 1976, p. 324, for Perrier's etching.

[127] For the suspicious circumstances surrounding his death, see Malvasia, ed. 1841, 2: 238.

[128] Malvasia, ed. 1841, 2: 224.

[129] Harris, 1967, p. 57, n. 90. The print is inscribed, "Opera in Roma del gran Domenichino, che per la forza di tutti i numeri dell'arte, per l'ammirabile espressione degli affetti, con dono specialissimo della natura si rende inmortale e sforza, non che altri, l'invidia a maravigliarsi e a tacere." Giovanni Cesare died in 1655.

[130] Notebook, 61. §1.

on this issue. Bellori also defended and praised his *Last Communion of St. Jerome* without denying the relationship it bore to Agostino's painting, but calling it a praiseworthy imitation. Passeri found Domenichino's picture superior to its model in many historical details, and in a practical application of Marino's notion of the finitude of beauty, he challenged any artist to avoid imitating Agostino in some way if asked to represent the same story.[131] The issue of plagiarism was not so easily resolved, however, and the demand for *novità* that Marino so cleverly turned against his detractors was what made the charges stick in the first place. Poussin's pointed choice of Domenichino's *Last Communion of St. Jerome* as the greatest example of *novità* in painting serves only to underscore the fact that this was the quality the painting had been judged to lack.[132] Poussin's and Testa's defenses of Domenichino were not based merely on some general notion of the importance of the humanistic traditions of painting nor on stylistic preference. They focus specifically on the case of the *Last Communion of St. Jerome* and can be understood only in terms of the fundamental importance of the aesthetic goal of ideal imitation as set against the demand for novelty.

The principle of imitation had been upheld by Domenichino himself, by Testa, and indeed by all the immediate heirs of the Carracci; for, as Marino expressed it, the brightest minds were led by this principle to follow in the path of the same best models. No one had accused Annibale Carracci of stealing from Michelangelo, of failing to produce something new, for example, when he painted the *Pietà*, now in Naples, in which the study of the Vatican *Pietà* is unmistakable. To understand how it came to matter that two highly regarded works by different artists, master and pupil in the case of Agostino and Domenichino, closely resembled one another we must come to grips with the profound changes that had occurred in the meaning of invention as affected by the increasing emphasis on novelty. When Alberti discussed the nature of invention he had no hesitation about the novelty of his own endeavor, and, in his dedicatory letter to Brunelleschi, delighted in the fact that the artists of his day would be more famous than the ancients because they had to discover things never seen or heard before for themselves.[133] Even though the inventions Alberti suggested to his readers were themselves borrowed from Lucian and Hesiod, he could still present them as new to his contemporaries. Marino's observation that by his day most beautiful things had all been realized reflects the quite different attitude of artists in the seventeenth century in Italy, for whom the ancient texts were no longer novelties and for whom there was even an emerging modern tradition.

In this situation painters were forced to find other ways of achieving that greater glory associated with the presentation of new things. Poussin expressed the issue most clearly from a painter's point of view in his note, *della novità*, in which he deliberately singled out Domenichino's *Last Communion of St. Jerome* as exemplary of novelty as its best. According to Bellori, Poussin wrote: "Novelty in painting does not consist principally in a subject that is no longer seen, but in good and new disposition and expression, by which a subject is transformed from being ordinary and old into something special and new."[134]

[131] Bellori, ed. 1976, p. 324; Passeri, 1934, pp. 40, and 149, n. 2.

[132] Bellori, ed. 1976, p. 481.

[133] *On Painting*, in Grayson, ed., p. 32.

[134] Bellori, ed. 1976, p. 481. "La novità nella pittura non consiste principalmente nel soggetto non piú veduto, ma nella

Domenichino's painting was no theft of Agostino's, therefore, but was original because of the successful new ways in which the *affetti* and *moti* were expressed (and this is the quality also stressed in the inscription to Giovanni Cesare Testa's print), and this is what mattered to Poussin. In contrast, we can imagine that he would have found the results of Salvator Rosa's determination to find new and never before represented subjects at all costs not only unnecessarily obscure but also irrelevant to the issue of true novelty. Rensselaer Lee has shown that Poussin's attitude finds its ultimate authority in Horace, but that it is closest of all to Tasso's claim that novelty in poetry does not depend on a subject that is no longer heard of, but upon the plot and the way the story is unveiled.[135] In terms of painting, however, the way to this point of view had also been prepared by Vasari's discussion of the principle of *novità*.

Vasari's criticism of Pontormo's practice of borrowing compositions and figures from prints by Dürer provides a revealing contrast to the case of Domenichino's *Last Communion of St. Jerome*. Vasari did not object to the fact that Pontormo had taken from Dürer's compositions as such, but to the fact that he had also adopted Dürer's hard, dry manner.[136] Already for Vasari novelty had much more to do with *maniera* than it did with the invention of subject matter. More accurately his understanding of the notion of invention was a greatly expanded one that encompassed *maniera* as well as *materia*. The Venetian Ludovico Dolce expressed this more succinctly than Vasari, and in this case there is no reason to argue that he was expressing a particularly "Venetian" point of view. According to Dolce there are two parts to invention: the *istoria* (by which he means the simple *materia*) and the *ingegno* of the artist. Arrangement, decorum, the attitudes, variety, and the forceful illusion of the figures—in other words those categories borrowed from poetics having to do with feigning—all derive from the *ingegno* at the level of invention. However, the *ingegno* also has its part to play in the second part of painting, *disegno*, which Dolce defined as the realization of the invention in forms, that is, as composition. Clearly, any distinction between the activity of the *ingegno* at the level of invention and at the level of *disegno* remains vague in Dolce's theory.[137] This was intentional on his part, and it is the middle ground between the two in which the sketch plays its special role, providing a means of trying out all the different ideas that a particular story generates in an artist's fantasy, from which he will eventually choose the best. The actual story might be a familiar one, but through the exercise of the individual *ingegno*, both at the level of invention and at the level of composition, a new feigning could be conceived. It was this very capacity for invention in the individual *ingegno*, inseparable from personal manner, and in the expression of which drawing rather than the simple discovery of new subjects played such an important part, that Vasari praised above all others, and to which he ascribed the capacity for *novità*.[138]

An appreciation for novelty could lead to high praise for the imaginative fantasies of the individual *ingegno* or to the technical brilliance and emphasis on the marvelous that

buona e nuova dispozione ed espressione, e cosí il soggetto dall'essere commune e vecchio diviene singolare e nuovo."

[135] Lee, 1967, pp. 16-17, and n. 67.

[136] Vasari-Milanesi 6: 266-270; esp. 270, where Vasari argues, "Nè creda niuno che Iacopo sia da biasimare, perchè egli imitasse Alberto Duro nell'invenzioni, perciocchè questo non è errore, e l'hanno fatto e fanno continuamente molti pittori: ma perchè egli tolse la maniera stietta tedesca in ogni cosa, ne'panni, nell'aria delle teste, e l'attitudini; il che doveva fuggire, e servirsi solo dell'invenzioni, avendo egli interamente con grazia e bellezza la maniera moderna."

[137] Barocchi, ed. 1960, 1: 171; see also Lee, 1967, pp. 70-71.

[138] See, for example, De Angelis d'Ossat, 1974.

characterizes the poetry of Marino and that characterizes the literary excesses collectively condemned in the nineteenth century under the heading of Seicentismo. It was an appreciation of the techniques of invention that Poussin expressed when he sought to establish that novelty lay not in new themes but in the disposition and expression of something well-known. In his eyes, the fact that Domenichino had made variations upon a theme already established by Agostino Carracci only rendered his achievement all the greater.

We know much more about the defense mounted by Domenichino's friends than about the attack itself, except for the fact that it seems to have been successful. Malvasia states without hesitation that the appearance of Testa's print only served to show that Domenichino's picture was the very same as Agostino's, even though partly changed, but his objections to the painting are not at all on these grounds.[139] Malvasia also recognized the inevitability of theft and argued that if everything borrowed from Parmigianino and Dürer had to be returned to them then many famous painters would be left (and here he uses the same simile as Marino) like Aesop's crow without his borrowed feathers.[140] Malvasia even considered Domenichino's painting to be underestimated, although he still found it inferior to its model for quite a different reason: Malvasia did not like the way it was painted.[141]

Was the issue then not about personal style after all, but, as has been suggested, about a general change of taste in the 1620s that favored Lanfranco and allowed him to capitalize upon the *Last Communion of St. Jerome* in order to win one battle in a concerted and victorious campaign against Domenichino's classicism? If this were the case, then the hardness and dryness of manner that Malvasia perceived in the *Last Communion of St. Jerome* would have been more loudly attacked than the borrowed invention, following the pattern of Vasari's criticism of Pontormo. In any case, the painting is not particularly expressive of Domenichino's dry manner, and Malvasia's judgment was almost certainly misled by the exaggeration of the contours in Testa's print. There is in fact no evidence to suggest that this particular battle was fought on grounds of "classical Baroque" versus "full Baroque" stylistic preferences. Lanfranco's evidence against Domenichino was Perrier's crude and apparently hastily made engraving after his own sketch of Agostino's picture. It indicated nothing of Agostino's manner and was not even particularly accurate. However, the print did serve to support the charge of plagiarism by revealing the general lineaments of Agostino's invention. In this regard, Testa's notice of Marino's letter in the preface to the *Sampogna* provides a precious key to the issues involved.

If Domenichino's attackers believed they had caught him out, and that the print was proof of this, then they must also have believed at first that the *Last Communion of St. Jerome* was an original invention of Domenichino's and have valued it accordingly in keeping with their taste for *novità*. In a way Marino warns about this in his letter, as well as spelling out the rules that Domenichino may have been held to have broken. Accidental similarity is out of the question in this case, especially given the fact that Domenichino was

[139] Malvasia, ed. 1841, 2: 224, "Che insomma negar non poteasi esser quell'istessisima di Agostino, ancorchè in parte alterata, ma con debolezza, e detrimento; onde farsi colà tanto rumore, perchè tanto remoto, e lontano l'originale."

[140] *Ibid.*, p. 240.

[141] *Ibid.*, p. 224, "Tutta l'opra poi insieme mostrare così palesemente la fatica, così tagliente per tutto, così dura e forzata, ove quella di Agostino così facile, propria, naturale ed armoniosa, che pare fatta in un soffio." Malvasia also objects to several of Domenichino's changes in the invention, especially the presence of the woman, and the incomplete reference to the Greek rite.

a student of the Carracci and that he also was working directly from Agostino's drawings. Translation, Marino had argued, should be limited to famous works, and imitation should be of the most famous masters. If a poet went deep-sea fishing in the hopes of coming up with something that appeared to be new, then he must not get caught. If we apply Marino's argument to Domenichino's case, it is clear that if Domenichino had imitated something well known in Rome then his picture would have been perceived differently from the very beginning. But Agostino's painting, although the work of a famous painter, was in Bologna, not Rome, and relatively inaccessible in the Certosa. Those who thought Domenichino's picture was entirely original must have assumed that Domenichino wished to present it as such. When Domenichino was caught out, the novelty vanished, and with it all value in the eyes of those for whom imitation was either not enough or not what they felt they had been led to believe was the basis for the work.

Neither Poussin nor Testa shared this view. Testa specifically attacked the *furor matto* of those who tried to proceed without judicious imitation, and Poussin adopted the position that had been most fully spelled out by Mascardi who wrote that wonder should be aroused not by new things but by the excellence of the artist's style.[142] These views on the importance of judicious imitation and on the value of individual style had not yet come to be perceived as opposed. Rather, they were held to be mutually supportive by those painters who had been trained in the traditions of the Carracci to imitate both nature and art, and through such imitation to free their judgment so that they might express ideal beauty in their own style. Neither Poussin nor Testa suffered the disappointment caused by the publication of Perrier's print, but they would in any case have expected Domenichino to have imitated a model in order to show his *novità*. Consequently, Testa's note taken from his reading of Marino reflects his belief in the importance of judicious imitation. Marino's representation of imitation as the means by which old things could be made to look new, and vice versa, and his emphasis on the resources of fertile imaginative powers and inventive intellects reinforced Testa's concept of the trained judgment actively at work. Testa was alive too to Marino's observations that beautiful things are few and that because intelligent people pick out the best models to follow when they start out it is little wonder that they often end up in the same place.

Following in the steps of the best models on the road to knowledge was, of course, one of the cardinal principles of Testa's theory of artistic education, and his reference to theft and to Marino's letter appears, in the draft of his preface to the Trattato, in the context of a consideration of good and bad teaching. For Testa beauty lay in truth and in the expression of its various natural perfections, and because the force of reason draws everyone to the same point, he accepted that apparent plagiarisms often occur.[143] Testa recognized that the paths to truth could be different and perfection grasped by various means, but at the stage of instruction naturally put less emphasis on individual manner than did Poussin, who was considering the work of a mature artist, and more on the importance of the wisdom

[142] Bellori, ed. 1976, p. 481. Poussin's note is headed, "Come si deve supplire al mancamento del soggetto," and reads as follows: "Se il pittore vuole svegliare ne gli animi la maraviglia, anche non avendo per le mani soggetto abile a partorirla, non introdurà cose nuove strane e fuori di ragione, ma constumi l'ingegno in rendere maravigliosa la sua opera per l'eccellenza della maniera, onde si possa dire: *Materiam superabat opus.*" See Note 107 above, for the derivation of this from Mascardi.

[143] Notebook, 60.A.7.

of the teacher. In such a context then the similarity between Agostino's and Domenichino's paintings revealed Agostino's wisdom in first reaching for the ideal himself and then in being able to direct Domenichino toward ideal beauty also; Domenichino, by following in Agostino's footsteps and by simultaneously exercising his own reason, could thereby arrive at an even more perfect approximation of the truth. Testa interpreted Marino to satisfy his own concern for the training of an artist, but by referring to Marino in the first place he was also pointing to the growing tension between the principles of imitation and innovation that were becoming apparent in the seventeenth century, and that had been exploited so successfully by Lanfranco at Domenichino's expense. This conflict also lies at the heart of Testa's difficulties in finding the compromise between freedom and rule that characterizes his second book and that led him to abandon the treatise completely.

The dispute over Domenichino's painting also raises the issue of the growing power of the critic. Testa's outline of chapter eight of Book II, which prompted his consideration of the relation between judicious imitation and innovation in the first place, is concerned as much with critics who do not understand that painting is about truth as it is with painters who hope to succeed without the laborious studies necessary to know it. Testa was a moralist, but not a satirist, and he did not revel in the kind of vituperation that helped to make a Marino or a Salvator Rosa famous. In the end the contemporary tendencies toward specialization in painting, the taste for the bizarre fantasies of the uncontrolled imagination, and the disregard Testa perceived for true critical judgment defeated him. Only one last chapter was planned. In chapter nine of Book II Testa intended "to refute many strange teachings, exposing them as vulgar things about painting."[144] His ultimate dismissal of bad teaching as "vulgar" follows directly upon his insistence on the unity of knowledge and his belief in the universality ideally required of the painter. This sequence of ideas derives from Cicero's argument expressed by the figure of Crassus in *De oratore*, a work fundamental to the understanding of Testa's general approach to the education of an artist.[145] Cicero's insistence on the indivisibility of *res* and *verba* was, as we have seen, matched by Testa's conviction that perfect forms embodied meaning. Like Cicero, Testa believed that talent must be simultaneously trained and respected. Unlike Cicero, however, he seems to have been unprepared to circumvent some of the logical difficulties of writing about how to do this by admitting, as Cicero does at the outset of Crassus's speech in *De oratore*, that the ideal he is describing is a personal, not a universally valid one.[146] As a result, Testa could go no further. Book III in which he wished to show that the perfection of painting, as of poetry, lay in the persuasion to virtue combined with delight was never thought out in detail, save for collecting a few notes from Xenophon and Aristotle.[147] None of the "bellissimi trattati degli affetti" that belong here materialized, and to find out about Testa's ideas concerning the means and purposes of expressing the emotions we have to look beyond the Düsseldorf Notebook to other annotated drawings and to prints such as the *Death of Cato* and the *Triumph of Painting on Parnassus* (Figs. 79 & 54).[148]

[144] Notebook, 59.F.

[145] *De oratore* III. 6; see 21-22 for the unity of knowledge, and 24 for the condemnation of the severance of words from thoughts by the vulgar and half-educated.

[146] *Ibid.*, III. 10. 37.

[147] E.g., Notebook, 38. and 56.

[148] Chapter One, pp. 62 and 45.

CHIAROSCURO

Testa did not abandon another proposition presented immediately after the outline for chapter nine—that he would demonstrate the great proportionality between color and music, as well as between the whole of painting and poetry.[149] The second part of this proposal is familiar and was reiterated in many of Testa's notes. The first part is less so, and Testa does not mention the relationship between color and music anywhere in the outline for his *Trattato* nor is the relationship explored specifically in *Il Liceo della Pittura*. There are, however, several notes concerning the harmonies of color and music interspersed throughout the Düsseldorf Notebook. It is possible, as we have suggested above, that some of the material on chiaroscuro, to which the notes on music and color are closely related, might have been intended for chapter one of Book II, which was to have been devoted to mathematics and perspective. It is impossible, however, to be certain about this. Although Testa's own failure as a painter to harness effectively and consistently the values of chiaroscuro to the hues of *colore* suggests that he never mastered the issues, there is nonetheless a sufficiently large group of notes concerned with the question to indicate that problems of chiaroscuro and color would have constituted an important part of the treatise.

These notes are often repetitive and sometimes difficult to understand. They can, however, be grouped into three main interrelated topics. In the first place Testa was interested in the differing effects of light and shadow that result from changing the relative sizes of the light source and the illuminated object and from changing their positions in relation to the observer. His conclusions are based both on direct observation and upon the observations of others, but he also makes them conform to his principle of establishing a mean for all things. An important purpose of his study was the achievement of the appearance of natural relief. He understood that shadows appear darkest next to the strongest light, and he insisted that the painter reserve this point of contrast to a very small area in order to create the most effective illusion of relief. Even in this small area where light and dark meet, Testa maintained that there must be a softening of the contrast, which naturally leads to the blurring of lines of contour. Failure to reserve contrast in this way or to soften its outlines characterized for Testa one of the forms of mannerism, the "maniera di forza." He associates this in particular with the use of artificial illumination, such as torchlight, whereby "the crudest light ends with a shadow no less terrible." The corresponding lack of harmony serves to produce very weak forms, and yet Testa observes, "many have claimed that this is strong painting."[150] Although he mentions no names, there can be little doubt that he is criticizing the torchlit pictures of the Bamboccianti, the Dutch painters, and the tradition of extreme contrasts in chiaroscuro that goes back to Caravaggio. It is a manner moreover that Testa himself sometimes adopted, as in his *Miracle of St. Theodore* (Fig. 73), and for which he received high praise.[151] He would probably have argued that he used it only where appropriate and not in order to simplify natural appearances.

The effects of certain natural sources of light, on the other hand, Testa argued could lead to an opposite extreme, the "maniera dolce." The diffused light of the open air pro-

[149] Notebook, 59.G.
[150] Notebook, 58.

[151] From Passeri especially; see Chapter One above, pp. 59-60.

duces a very feeble sense of relief, because there is no directed ray of light to produce shadows. He also argued that the rays of the sun converge rather than diverge because the sun is larger than the earth; this means that the shadows thus created are smaller than the object casting them, and also that the light is concentrated in points, resulting in another undesirable extreme. Testa sought to find a mean that combined sweetness with force, and his solution was to recommend working in the pure light of a courtyard.[152]

There is nothing here that is not to be found in Leonardo's writings, which makes the problem of establishing Testa's sources all the more important. Except for references to Daniele Barbaro's edition of Vitruvius in connection with musical harmonies and with the construction of the gnomon, however, there are no exact citations in Testa's notes on chiaroscuro. There can be little doubt that Testa had the opportunity to examine the Leonardo manuscripts that Cassiano dal Pozzo made available to Poussin and that formed the basis for the first publication of the *Trattato della pittura* in 1651.[153] Poussin's interest would have engaged him, as would his own training under Domenichino, who was certainly knowledgeable about Leonardo's ideas. Domenichino had studied with Matteo Zaccolini, one of whose own unpublished volumes on optics, based on his study of Leonardo's manuscripts, was actually lent to Poussin by Cassiano dal Pozzo after they had been acquired by the Barberini.[154] Despite the intense interest in the systematic study of Leonardo in Testa's immediate circle in Rome, however, there is no evidence that Testa ever studied Leonardo's writings at first hand. In Testa's ideal Parnassus Leonardo appears as a *maestosa presenza*, but his words are not reported.[155]

This is not to say that Testa was indifferent to Leonardo's discoveries concerning the effects of light and shade, for these ideas were readily available to him through various intermediary sources, both theoretical and practical. They were often adapted in the works of other writers, who did not always note their origin and who interpreted them in the light of other authorities. These works include Barbaro's *La pratica della perspettiva*, Lomazzo's *Trattato della pittura*, and Armenini's *De' veri precetti della pittura*. In the Commentary I have attempted to establish where Testa may have taken notes from the last two. It is important to recognize, however, that although it is possible to establish a continuous interest in Leonardo's studies of chiaroscuro throughout the sixteenth and seventeenth centuries, the nature and quality of this interest changes. The most notable publication incorporating Leonardo's ideas in Testa's day was Pietro Accolti's *Lo inganno degl' occhi*, published in Florence in 1625. Accolti's book is so important, both in terms of the history of the transmission of Leonardo's theories and in terms of Testa's statements and the concerns that prompted his apparent selection of passages from Lomazzo and Armenini, that we must consider it in some detail.

Pedretti has argued that the brief *Discorso intorno al disegno* that Accolti appended to the book, dedicated to the young students of the Accademia del Disegno, reflects the broad outline of Leonardo's *Trattato* so closely that it merits consideration as the first

[152] Notebook, 58.

[153] Steinitz, 1958, pp. 70-116.

[154] Bellori, ed. 1976, pp. 361, and 427. For a summary of biographical references to Zaccolini in Baglione, Passeri, and Mancini, and of the importance of his manuscripts for Do-

menichino and Poussin, see Pedretti, 1977, 1: 36-47. For much of what follows, with more detailed references, see also Cropper, 1980a.

[155] Notebook, 61. §1.

edition of this selection of his notes.[156] It is further clear that the main text of *Lo inganno degl' occhi* manifests a careful study of Leonardo, although in the critical context of other writers like Barbaro (whose influence appears in the very title), Witelo, and Aguilonius.[157] This main text would probably have been more interesting to Testa than the *Discorso* as he made his notes on chiaroscuro. The *Discorso* would, however, have encouraged him to think even harder about the general question of the training of artists.

Undoubtedly one of the principal attractions of Accolti's book was that it was written especially for the use of artists. The author agreed with Leonardo's belief in the inseparability of theory and practice, referring often to his observations, but he also presented practical advice and optical theory in a logical sequence that was easy to understand (which Leonardo's notes and the published books on optics frequently were not). In fact Accolti starts out in the section entitled "De lumi et ombre" by criticizing Daniele Barbaro and Guidobaldo de'Marchesi del Monte for having nothing to offer painters. Their observations are worthless because they are based on the effects of torchlight, or lamplight, where the rays spread out pyramidally from the source of light.[158] Because the painter is concerned to imitate natural appearances he must rather learn to deal with natural light from the rays of the sun, and these, because of the size and distance of the sun from the earth, are more nearly parallel. He does not at this point suggest that there is a single, ideal light for painters, but rather observes that there are differences in chiaroscuro caused by different kinds of light sources and that these must be respected. The sun also moves in the heavens, and Accolti seeks to help the artist analyze the resultant changes in the relationship between *chiaro* and *scuro*.

Accolti was especially interested in the point of intersection between *chiaro* and *scuro*, "una certa unione, che sfumamento chiamano i Pittori," and this leads us to Testa's second main topic.[159] Testa emphasizes the importance of this union, as we have seen, but he also takes care to warn against the extremes of *sfumato*, "which so many stupidly believe in."[160] He claimed that this often produced unnatural effects and that he had often seen an artist waste a whole day shading infinitely the trunk of an ancient oak tree as if he were polishing a mirror. Accolti also attacks the infinite, even shading of colors, calling this "un equale circolare unione" because it undermines relief, and laments the great popularity of this practice.[161] In another passage warning about the misuse of chiaroscuro, Accolti points to the delights of color and cautions the young students of the Accademia del Disegno not to fall into the very common trap of losing color in great highlights and in intense shadows.[162] These passages are interesting because even while so much of Accolti's book is based in Leonardo, they reflect criticism of the great influence of the continuous quality of Leonardo's *sfumato*, which often sacrifices color to shadow, causing forms to melt away.

It may at first seem surprising to find this kind of advice still being offered as late as 1625, even in Florence, and being repeated by Testa in Rome some fifteen years later. We should remember, however, that the particular reform of color and chiaroscuro effected by the Carracci had not in itself produced a definitive solution. Rather, it seems that their

[156] Pedretti, 1977, 1: 35 and 47.
[157] For Accolti, see further, Kaufmann, 1975.
[158] Accolti, 1625, pp. 95-96.
[159] *Ibid.*, p. 138.

[160] Notebook, 43.
[161] Accolti, 1625, pp. 136-138.
[162] *Ibid.*, p. 150.

discoveries opened the way to a whole new series of speculations about color by helping painters to understand that color and light could be manipulated according to systematic conventions.[163] In this regard, Testa's own historical survey of the unification of *disegno* and *colore* is interesting. In the notes here related to the Trattato he tends to think in terms of abstract demonstrations of the principles of chiaroscuro, but in the scenario on Parnassus he presents a view of an artistic tradition founded primarily on experience. When he has Giulio Romano proclaim that Painting (i.e., color) is a vile woman who must never be allowed to exhaust, far less enslave masculine Drawing, Raphael responds by asserting that experience shows how the two may always be married. A squadron of Venetian and Lombard painters then sets about discovering how to unite sweetness with strength in color (i.e., the harmonies of shading without loss of hue). They restrict shadows and highlights to a very few places, depict harmonious reflections everywhere, and they do this without the kind of debate that takes place between Giulio and Raphael, "come sdegniando que'discorsi tra loro."[164] Finally the search for the best way to find a union between color and chiaroscuro provokes Titian, the father of them all, to take up his own brushes again, without any discussion. He demonstrates how colors must be laid in in three main areas in order to preserve the three primary distinctions, light, dark, and middle tone, that are essential for the illusion of relief. This disciplining of color in the service of chiaroscuro and relief is closely related to the criticisms of *sfumato* that Testa found in Accolti, but at the same time Testa has Titian insist that experience had taught him everything.[165] It is from Titian's demonstration, according to Testa, that Rubens learned how to use color, and Annibale and Agostino Carracci are close observers of the whole drama, for like Raphael they are masters of both drawing and painting. Even in the midst of the collection of maxims on chiaroscuro brought together for his Trattato on folio 7[r] Testa takes care to remind himself of the ease with which one can fall into inaccuracies and of the importance of constant study in the open air.[166] Quite clearly he believed that experience was vital to the mastery of optical problems and that talking about them was no substitute.

It would be quite wrong, however, to conclude from this that Testa believed in the "intuitive" mastery of color, even by Titian himself, or that there is evidence here of some sort of conflict between his "Venetian" and "Roman," his "theoretical" and "practical" *personae*.[167] Experience cannot instruct if there is no way of interpreting and understanding the principles behind it, and Testa believed sincerely that practice was blind without theory. Although he did not approve of discourses on color divorced from experience, he also shows how Titian was able to justify his practice and demonstrate it to others.

A similar balance between experience and theory also characterizes Accolti's book, which is an important exposition of how theoretical and practical optics could be made accessible to painters wanting to achieve scientifically based illusions, to *ingannare gli occhi*. Having pointed out the deficiencies of Barbaro's and Guidobaldo's treatises so far as painters are concerned, Accolti nevertheless introduces much theoretical material into his

[163] For this reform, see again Dempsey, 1977, esp. pp. 7-36.

[164] Notebook, 61. §3.

[165] Notebook, 61. §3.

[166] Notebook, 15. D.

[167] For which conceit, see again Marabottini, 1954, pp. 118-120, and Lopresti, 1921, esp. p. 84; see also Chapter One above.

own. At the same time, he refers regularly to artistic practice. For example, when discussing how to arrange figures in perspective, he first gives a geometrical method, but then goes on to recommend the practical method of using wax models adopted by Passignano, Cigoli, and others.[168] Even though Testa did study Commandino's analysis of the analemma of Ptolemy, Accolti recognized that the theory of sundials and of the analemma were rather out of the way, and beyond the reach of most people. Consequently, he proposed a very simple practical way to design sundials in any situation.[169]

Accolti sought to simplify in order to make his book useful to a special audience, but not to provide simple rules that denied the necessity of intellectual effort. He makes this plain in his discussion of *sfumamento* where he insists that he does not intend the artist to approach the plan and profile of every shadow laboriously and with compasses in hand, despite the fact that he is presenting quite complicated material. He hopes rather "that in this as in other things above and to follow to so open the eyes of contemplation to them and to so convince the mind and the *ingegno* by them that, once having absorbed these demonstrations, and having built upon these maxims, one will not fear to draw freehand that which we have represented geometrically with mathematical demonstrations for the purposes of teaching."[170] Testa, as we have seen, perfectly agreed with this sentiment. The best example of his use of abstract analysis as an approach toward practical mastery in Testa's own work appears in a drawing on folio 12r (Fig. XVIII).[171] Leonardo had recommended the light of a courtyard for ideal illumination, and, in agreement with this, Testa's example of how to combine thereby the sweetness of uniting chiaroscuro with the illusion of relief is rendered by a female bust in three-quarter profile. The face is constructed virtually entirely in chiaroscuro by means of black and white chalks on a brown-grey paper, which provides the middle value. The head is given convexity through the softened juxtaposition of the darkest dark with the brightest light, shown as the highlight on the woman's left temple, and this juxtaposition prevents the drawing from appearing as a surface play of lights and darks, absorbed into the paper. Beside the head Testa drew a circle, which he converted into a sphere by the same softened juxtaposition of the extremes of black and white adjacent to one another. The analysis of light and how to manipulate its effects to achieve the illusion of relief could hardly be more effectively presented and is much simpler to understand in this abstract demonstration than it would be through the observation of infinite irregular bodies. Testa's drawing shows how the artist can learn from such analysis to organize the construction of accidental forms, the head, according to rational principle, the sphere, and it is a precious example of how an artist understood the mutual relationship between the actions of the mind and hand that Accolti was also trying to foster and that was an essential part of his criticism of the tradition of writing on optics.

Testa's example is a simple one, involving very limited lighting. His notes on the analemma and on the construction of cones, on the other hand, demonstrate that he continued his study of the science of shadows in more sophisticated and complex ways. Several

[168] Accolti, 1625, p. 21.
[169] *Ibid.*, pp. 125-128.
[170] *Ibid.*, p. 108: "ma ben intendiamo sì in questo, come nell'altre cose dette di sopra, & da dirsi, tanto aprirgli gl'occhi della contemplazione, e tanto capacitargli la mente, e l'in-gegno, che imbevute queste dimostrazioni, & affodatosi sopra queste massime, non tema, con franchezza eseguir col pennello, quello che geometricamente, & magistralmente con dimostrazioni matematiche vien rappresentatoli da noi."
[171] Notebook, 40.

of his late prints show the fruits of his studies. The *Death of Cato* is a good example, even though in this case the lighting depends upon the sharper effects of torchlight (Fig. 79).[172] In the far corner of Cato's room a lamp creates an aureole of light, but of insufficient strength to penetrate the gloom of the rear wall. It does, however, highlight the sculptured bust in the niche above the door. The niche appears concave through the union of chiaroscuro, and the bust is made to stand out against it by the way in which the deep shadow it casts is projected against the curving surface of the niche, but then suddenly changes direction where the contour of the niche meets the plane surface of the wall. The lower part of the niche and the bust are in shadow, projected upwards from the lintel of the door. Because the head of the man who enters through the door in this back wall is higher than the lamp, and also fairly close to it, a long, slightly diminishing shadow is projected upwards behind, echoing the shadow projected by the bust. The foreground figures are illuminated by a source outside the picture, but the position of which, high in the vault to the right, can be plotted through the shape and density of the shadows it projects. Every shadow has been considered rationally by Testa in terms of its source in this light, from the shadow of Cato's forearm and clenched fist cast onto the skirting around his bed, to the shadow of the tassle and cord attached to the leg of the bed and the dark shadow of the figure in the center foreground, which is distorted where it falls across the mathematical tablet lying on the floor.

The deliberate logic of all this, in comparison to the more atmospheric treatment of shadows in Testa's work of the 1630s, suggests very strongly that Testa's own researches and interests had been reinforced by Poussin's work during the 1640s. It is appropriate that the best example of Poussin's systematic application of his knowledge of shadow projection should be the *Institution of the Eucharist* from the series of the Sacraments that he painted for Cassiano dal Pozzo, who played so important a role in the revival of Leonardo studies in Rome. Here Poussin was more ambitious than Testa, for he set himself the task of analyzing and manipulating the effects of three sources of light within the room, as well as the light that penetrates from the outside through the open door. In so doing he was putting into practice the results of long study of the principles of shadow projection studied abstractly on the basis of the same sources also studied by Testa.[173]

The most succinct demonstration of such study appears in Poussin's drawing of *The Artists' Studio*, now in the Uffizi (Fig. 106).[174] The drawing establishes the manner in which the theoretical legacy of Leonardo was applied to teaching and to practice in the seventeenth century. To the left a student draws from a sphere, a cone, and a suspended cylinder. A second student to the right draws from a small statue, illuminated by a candle. His desk is littered with books, ruler, compasses, and a set square, but he draws freehand. There is a third figure bending over near the easel in the background, whose action is difficult to understand, and a fourth figure works at the easel. The drawing does indeed represent different stages of an artist's training, though not, as Blunt suggested, including drawing from life. The entire work of the studio is devoted to the study of light, beginning at the abstract level with the illumination of geometrical forms, progressing to freehand

[172] The print is dated 1648.

[173] Cropper, 1980a, pp. 579-581, and Fig. 13.

[174] This drawing was first published by Blunt, 1939-1974, 5, as cat. no. 369.

drawing from accidental forms, and culminating in painting. The sphere, cone, and cylinder are illuminated by several lamps mounted on stands, which could be moved around. Their shadows are projected against a folding screen, which could also be moved in combination with the lamps to produce a very wide range of effects. Poussin shows the sphere and the cone resting on a low, raised platform that has an inclined slope at its longer side. The student rests his feet upon this slope, but its surface is intended to be utilized to study the projection of shadows onto an inclined surface. The cylinder is suspended, and obviously its height could be adjusted.

The insistence on the consideration of different arrangements of lights and planes in terms of their projected shadows and of the effects of chiaroscuro and *sfumato* on the curving surfaces of various geometrical solids shown in Poussin's drawing can be related to Leonardo in a general way, to Accolti more directly, but most specifically to the work of Zaccolini. Poussin is known to have borrowed at least one of the four manuscript volumes prepared for publication by Zaccolini from Cassiano dal Pozzo, after they had been acquired by the Barberini after the author's death. The volume he borrowed was entitled *Della descrittione dell'ombre prodotte da corpi opachi rettilinei* wherein Zaccolini shows how geometrical solids (sometimes, like Poussin's cylinder, suspended in mid-air) project shadows according to the position of the light source and the nature of the background.[175] He even illustrates examples where the solids are placed before an inclined surface like that on which Poussin's student rests his feet (Fig. 107). Zaccolini's remarkable method of presentation is also marked by the way in which he gives a diagram as well as a three-dimensional rendering of each example, the one based on geometrical calculation, the other on the analytical observation of appearances that Poussin's student is practicing. This is the method Testa adopted in his drawing of the female head.

Pedretti has suggested that Zaccolini may have been working from a lost Leonardo manuscript on light and shade when he was writing and illustrating his own treatise, and he has also pointed to the similarity between Zaccolini's approach and Accolti's treatment of the effects of light and shade, the "sbattimento delle ombre" in *Lo inganno degli'occhi*.[176] Poussin was probably familiar with all these sources, and there is no doubt that he shared the fundamental principle underlying all of them: a theoretical understanding of the effects of light, based in experience, is essential to sound artistic practice. In terms of the first part of this we should remember that not only has Poussin equipped his studio with the materials illustrated by Zaccolini, but also Testa represented Painting introduced by Optics to Mathematics in *Il Liceo della Pittura*. Theirs is the kind of experience organized by theoretical principle to which Aristotle referred the attainment of true knowledge in the *Metaphysics*. It is also the kind of experience leading to principles that can be taught, to which Testa referred in his characterization of Titian.

If we want to understand how such a relationship between analysis and artistic practice appears in Poussin's works, especially from the 1640s, there are numerous points of departure. In his wash drawings relief is achieved without contour through the contrast of *chiaro* and *scuro*, and in accordance with Zaccolini's observations concerning Raphael, Poussin

[175] Cropper, 1980a, p. 573.

[176] Pedretti, 1977, 1: 35 and 47.

frequently emphasizes this contrast in the foreground of his drawings and softens it in the background.[177] Among the paintings of the 1640s, the *Eucharist* is not the only work to declare its structuring according to the logical order of chiaroscuro; Félibien also correctly related the *Rebecca and Eliezer* to the particular influence of Leonardo's ideas on Poussin (Fig. 108).[178] He recognized how successfully Poussin had achieved relief and space in this painting through the considered manipulation of chiaroscuro. In the case of the *Rebecca and Eliezer* Poussin chose a late-afternoon light, not bright sunlight which would have produced little shadow or relief, and in this respect the painting is a perfect complement to the *Eucharist*, the one illuminated by candlelight, the other by natural light, both employed for the ends of achieving relief. In the former the perfect sphere that Poussin placed on the rectangular pilaster to the right serves as a reminder of the kind of studio exercise that precedes painting. Partially shaded and partially lit, with all harshness at the boundary of *chiaro* and *scuro* removed, it functions as a sundial to indicate the angle of the sun's rays. In the foreground, the faces, arms, and draperies of the figures are all affected by the same light, only slightly modified by reflections from opposing surfaces. The obvious analogy between the shading of the sphere and the irregular human forms, which recalls Testa's illustration of this principle in his juxtaposition of a woman's head with a sphere, is reinforced by the *sbattimento delle ombre* on the vases held by Rebecca's companions. These varied forms mediate between the ideal sphere and the individual, and variously idealized, women.[179] Each one is modelled in chiaroscuro according to its position, the low angle of the sun, the texture of its surface, and the effects of reflected light. In each case, however, an area of highlight is juxtaposed to a dark shadow to create relief. In the middleground the overall contrast of light and dark is not so profound, although the architecture is nevertheless constructed entirely by means of light and cast shadow, and not by contour. In the open countryside, toward the horizon, there is little contrast of *chiaro* and *scuro* at all.

Poussin's organization of the lights and darks in this painting is quite opposed in practice to the infinite *sfumato* of Leonardo, which both Testa and Accolti also rejected. It is, in fact, a perfect illustration of Accolti's proportional system for the degradation of chiaroscuro, whether achieved by calculation or through the arrangement of wax models. At the same time such analysis of the effects of light, so clearly based on general principles induced from observation, is inconceivable without the experiments of Leonardo. Accolti and Zaccolini knew Leonardo's manuscripts at first hand and were prompted by this to present their own versions of the theory and practice of shadow projection and the perspective of colors. Although we cannot be sure of what may have been included in the Leonardo manuscripts that they studied, it appears that it was Accolti's and Zaccolini's understanding of Leonardo's obsession with *sfumato* disciplined by their renewed interest in shadow pro-

[177] E.g., *The View near Villeneuve-lès-Avignon*, Musée Condé, Chantilly, ill. Blunt, 1967, text vol., fig. 231.

[178] Félibien, 1725, 4: Entretien 8, 107. Félibien compares Poussin's painting to Leonardo's views in terms of the arrangement of figures, not only according to age and disposition, etc., but also according to the effects of light and shade. His analysis of the work that follows, 110-115, of Poussin's treatment of color and chiaroscuro in the service of relief is in complete conformity with the view of Accolti and Zaccolini, derived ultimately from Leonardo, described here. When

Félibien, 114, states that in this work Poussin took Raphael for his guide, he is opposing Raphael as a master of aerial perspective and the degradation of hue to the Venetian painters, whose broad masses of light and shade he criticizes in this instance, even as Zaccolini and Accolti criticized painters who forced the juxtaposition of large areas of highlight and darkness. For the history of the Louvre painting, see Blunt, 1966, no. 8.

[179] For these varied beauties, and their relationship to the vases they carry, see Cropper, 1976.

jection and in the perspective of chiaroscuro and color, all in the service of relief, that Poussin and Testa inherited. They also inherited their particular understanding of the union of theory and practice in the science of color and light from these authors.

When Matteo Rosselli was asked his opinion of Leonardo's writings, according to Baldinucci, he made the following reply: "What I know how to do I understand; what I don't know how to do I don't understand; for as far as I'm concerned not knowing how to do something you understand is the same as not understanding it."[180] Both Poussin and Testa would have agreed. Just as Poussin could not accept the role of mere illustrator to Leonardo's text, so could he not set out to understand Leonardo's ideas without making them his own. His tone might have been different from Rosselli's, for he would have made a point of insisting on the artist's responsibility to extend the limits of his capabilities and his understanding, and sometimes Poussin did set out to examine a particular aspect of Leonardo's theories of art. In the end neither Testa's notes nor his prints and paintings exhibit Poussin's mastery. It is possible even, in this respect, to observe that Testa's work suffered from a lesser mastery of the theory required to work in chiaroscuro with confidence and *prontezza*. For, as Rosselli so aptly put it, what one cannot do one cannot say he understands.

In conclusion, then, Testa's approach to the problem of shadows and lights cannot be said to reveal a direct study of Leonardo; but at the same time, as we have seen, it is deeply rooted in the revival of Leonardo studies that occurred in the first half of the seventeenth century. His study of shadows in the particular way we have seen illustrated on folio 12r of the notes can be compared most closely to Poussin's similar studies. It appears very likely that Testa's own systematic inquiry into chiaroscuro and color, both in the notes and in his works of the 1640s, was directly stimulated by the way in which Poussin was also translating and developing his understanding of Leonardo into artistic practice in those years.

THE HARMONY OF COLOR AND SOUND

The kind of analysis of the perspective of chiaroscuro revealed in Poussin's *Rebecca and Eliezer* and the problems of the organization of chiaroscuro for the establishment of relief investigated by Testa are inseparable from the question of how to analyze the values of color. The lesson Testa attributes to Titian touches on this issue, by showing, as we have seen, that colors must be organized according to three main values in order not to undermine the relief of chiaroscuro. Testa describes in his letter from Parnassus how there are more colors in the mantle of Painting than in the flowers of springtime, but that all of them serve under the captaincy of the greatest light and all march without a shadow of confusion under the banner of chiaroscuro.[181] Quite clearly the absence of "shadows of confusion" under the leadership of the greatest light has to do with the rationalization of shadows and the restriction of *sfumamento*. Yet the behavior of the colors themselves in Painting's mantle was explained by Testa in terms of another ordered system: the harmony of music. In

[180] Baldinucci, ed. 1847, 4: 172-173: "Quello che io so fare l'intendo, quello che io non so fare non l'intendo, essendo una stessa cosa appresso di me il non saper fare cio che s'intende, quanto il nulla intendere."

[181] Notebook, 63. §2.

this case it is possible to establish Testa's immediate source in Barbaro's edition of Vitruvius, but as in the case of his analysis of shadows, his particular interest in the relationship between color and music forms part of a much larger concern shared by other artists with whom he was closely associated, and notably Domenichino and Poussin.

Testa expressed the relationship between color and music in terms of harmony. In his most expanded development of this notion he wrote: "By the principles of the rules of harmony in music are to be understood the rules of color, the former having high and low notes as limits, the latter light and shade. We must approach these extremes with those temperaments that are in music like steps, and in this we are assisted greatly by the order of the lights that are secondary, tertiary, and so on *ad infinitum*, which are called reflections."[182] Even as he had insisted upon the organization of *chiaro* and *scuro* on the basis of experience and those authorities who sought to show how to establish relief, so Testa now insists on the same through an appeal to the principles of music. In a shorter note he makes the fundamental point of comparison even clearer by saying that to omit total shadow from painting is like taking the low notes from music. Bass notes, like shadow, are more perceptible when heard together with higher voices, and from this juxtaposition arises the principle of harmony.[183] Barbaro had also made the point that without proportioned intervals between high and low notes (*acuto* and *grave*) there could be no consonance and no music; and he then proceeded in his commentary to Vitruvius 5.4 to explain the different scales, each made up of distinct steps leading upwards from *grave* to *acuto*, the harmonic, the chromatic, and the diatonic.[184] Vitruvius attributes to each of these scales particular affective properties. The harmonic is defined as artistic, conveying gravity and authority; the chromatic is embellished with subtle diligence, supplying sweet delight through its frequent modulations; and the diatonic is called natural, being the easiest for the ear to hear because of the greater distances between its intervals. Barbaro explains the properties of these different scales (which he also calls *genera*, as well as *maniere* because they represent different ideas of harmony) in greater detail, although he professes that this is not the way he would talk about music himself. The harmonic scale is composed of many close, very small intervals, and is the most effective and artificial (or artistic), practiced by only the best musicians because of its difficulty. The diatonic, being composed of large intervals, stretches the voice considerably, but it is the most natural of manners and anyone can master it. The chromatic scale lies between these two, and is full of semitones, being therefore more artificial than the diatonic and only to be practiced by masters. Many exhaust themselves attempting to use it, however, because of the sweet, soft melancholy it elicits. Unlike Vitruvius, however, Barbaro goes on to compare the intervallic structure of scales and their expressive qualities to the colors of the painter. He writes:

> Whenever we want to create an order, or scale (which is like tuning an instrument), we must know which of the three *genera* we want to use; for the Chromatic is required for sweet and mournful matters, the Diatonic for great and heroic, and others for other material, or mixtures of these, for one can take off from these given *genera* in special ways. And these particular divisions of each *genus* impart to it a certain aspect and different form, coloring them almost as

[182] Notebook, 43. [183] Notebook, 15.C. [184] Barbaro, ed. 1567, pp. 227-230.

a painter would, so that they sound according to the desired Idea. And the imitation of things according to their nature, whether large and constant, soft and changeable, tempered and mediocre, is not achieved by accident, and in this consists all the beautiful effects of harmony.[185]

The recovery of the ancient *genera* was one of the principal preoccupations of musical humanists in the sixteenth century, especially among those writers like Mei, Doni, and Galilei who supported the claims of the *anciens* over the *modernes* in musical practice.[186] The most conspicuous practical effect of this interest was the invention of increasingly strange instruments capable of playing chromatic and enharmonic *genera* constructed on the smallest of intervals. The resultant tendency toward infinitely small divisions, spurred on as Barbaro says by the desire to achieve infinite sweetness, evoked a strong reaction from musicians who were concerned that the theoretical effect should be audible in fact. Vincenzo Galilei spoke for this group in his *Dialogo della musica antica e moderna* of 1581 when he said that even if these subtle intervals could be sung they resulted only in a "confusa diversità d'intervalli."[187]

Testa's desire to marshal color under the leadership of chiaroscuro, his condemnation of the infinite subtleties of overpolished *sfumato*, and his wish to find a mean that was capable of uniting sweetness with strength is the equivalent in terms of chiaroscuro of the desire of musical theorists like Galilei to prevent the infinite divisions of harmonic intervals between the extremes of high and low notes. Indeed, Testa's diagram of different kinds of light could as easily illustrate the different scales. An excessive representation of torchlight would have no harmony at all, because there are no intervals between the two extremes of *chiaro* and *scuro* (i.e., *acuto* and *grave*), and this could be described as a use of the diatonic scale unregulated by any mean, producing an effect of excessive naturalism comparable in painting to the more exaggerated paintings by Caravaggio and his followers. In noonday sunlight, on the other hand, there are so many modulations that, although there is harmony, the effect is weak through lack of contrast, and this could be described as a use of a chromatic or enharmonic scale unregulated by any mean, producing an effect of excessive artistry. In the choice of any scale care must be taken to observe a mean, selecting a sufficiently clear division of tones in order to produce a distinct effect.

Testa's embrace of the mean in this case is all the more interesting because it reflects an apparent distancing from Domenichino. Even as the painterly practice of infinite *sfumamento* continued to flourish long enough for Accolti to warn against it, so its musical equivalent of excessive chromaticism was not laid to rest by sixteenth-century critics. As a painter Domenichino created pictures conceived both in relatively broad and relatively narrow value intervals, but in neither case could a charge of excessive deviation from a mean be laid against him. As a musician, however, this is not the case. Domenichino, as a way of passing away the lonely hours while he was in Naples, attempted to make a lute and a

[185] *Ibid.*, pp. 229-230: "Quando adunque sia, che noi vogliamo fare un'ordinanza, overo una scala, che tanto è, quanto accordare uno strumento, necessario è, che sappiamo secondo quale de i tre generi lo vogliamo compartire; perche a materie dolci, e lagrimevoli, ci vuole il Chromatico; & alle grandi, & heroiche il Diatonico, come altre ad altri generi, o ad altre mescolanze di quelli; perche ognuno de i predetti generi a più modi speciali si può partire; & quelli particolari compartimenti di ciascun genere gli danno un certo aspetto, e forma diversa, quasi a guisa di pittori colorandogli, accioche si facciano udire secondo le Idee, che si vuole, e non si faccia a caso la imitatione delle cose, che sono grandi, constanti, molli mutabili, temperate e mediocri, come comporta la lora natura; nel che consiste ogni bello effetto dell'Armonia."

[186] See Walker, 1941-1942, for the problem in general.

[187] Quoted by Disertori, 1966, p. 62, n. 2.

cembalo capable of playing all three *genera*, the diatonic, the enharmonic, and the chromatic; and in a letter to Albani about this he writes that he is currently building a harp on the same principles, but laments that "perché è cosa nuova alli musici del secolo nostro, non ho potuto per anco farlo sonare."[188] Passeri writes that he saw this strange arciliuto when Domenichino fled back to Rome (when Poussin also visited him), that is to say 1634, and he specifically relates Domenichino's interest in building instruments to the fact that the artist had read about musical proportions in Vitruvius.[189] According to Passeri, the instrument was not only designed to play in all three *genera*, but also Domenichino had tried to combine in a single keyboard all the variety of the Dorian, Lydian, and Phrygian modes. The instrument was, however, "impraticabile."

Testa's close study of Vitruvius, as we have seen, must have been encouraged by Domenichino, and here we find him also attracted by the same aspects of Vitruvius's theories. Unlike Domenichino, however, he was not tempted to extend his studies to the practice of music directly, but was content to limit them to their applicability to painting, studying music as it had been studied in the Carracci Academy, in order that by learning the harmonies of music the painter might apply these to the harmonies of color.[190] The means that he explored began with the analogy between *grave* and *scuro, acuto* and *chiaro*.

It is impossible not to recall in this context Poussin's famous letter to Chantelou, written in 1647, in which he compares different methods of representation to the ancient musical modes.[191] While this is not the place to undertake an analysis of Poussin's work in terms of his application of a theory of the modes, it may at least be suggested that a more precise reading of his ideas is possible than has hitherto been established by placing them in a broader context that includes Testa. It has long been known that Poussin was relying on Zarlino's discussion of the modes in *Le istitutioni harmoniche* when he formulated his reply to Chantelou's complaint that Pointel's *Moses Saved from the Waters of the Nile* was more attractive than the *Ordination* painted for him.[192] Paradoxically, precisely because Poussin was quoting from a source, his motives in deciding to read that text and his understanding of it have never been examined satisfactorily. It should first of all be recognized that the subject of Poussin's letter is more truly the nature of judgment and the importance of theory and practice, or reason and sense, in the formulation of good judgments. This also finds its justification in Zarlino's treatise, and everything that we have learned about Testa's views on judgment only serves to underline the fact that in this case, as in instances of other quotations by artists of earlier sources, Poussin was using authority in order to amplify his own arguments, rather than mindlessly groping for a text to use as ammunition against a difficult patron. Almost certainly it was Zarlino's attack on the "fallacia dei Sentimenti" that led Poussin to refer to his definition of the modes.[193] In 1647 Zarlino's treatise

[188] Bellori, ed. 1976, pp. 369-370. Malvasia, ed. 1841, 2: 241, reports that Albani had mentioned letters from Domenichino describing this project. For other experiments in instrument building inspired by the passionate desire to recover ancient chromatic music, see Disertori, 1966, pp. 60-68, and Walker, 1941, p. 120.

[189] Passeri, ed. 1934, p. 67.

[190] Malvasia, ed. 1841, 1: 308.

[191] Jouanny, ed., 1911, pp. 370-375. For a translation of the relevant passages, and for a summary of the history of this problem, see Blunt, 1967, text vol., pp. 225-227.

[192] Blunt, 1967, text vol., p. 226.

[193] Poussin's rebuke (Jouanny, ed., 1911, p. 372) that "Le bien juger est très difficile si l'on n'a en cet art grande Théorie et pratique jointes ensemble. Nos apetis n'en doivent point juger sellment mais la raison," is a summary of Zarlino's statements in *Istitutioni*, pt. 4, chapter 36, "Della fallacia de i Sentimenti; & che'l giudicio non si dè fare solamente col loro mezo: ma si debbe accompagnarli la Ragione," pp. 426-428. Walker, 1941, pp. 220-221, points to the fact that Zarlino's treatise was the most widely read.

would have appeared old-fashioned, quite apart from being extremely well known, and had Poussin wished to present Chantelou with material that was more up-to-date he would have turned to works like Galilei's, which incorporated Mei's discovery that the Greek *tonoi* were not ecclesiastical modes, but keys to transpose the natural Dorian system to a different pitch.[194] Had he wanted to be even more up-to-date, he could have cited Giovanni Battista Doni's *Compendio del trattato dei generi e dei modi della musica* (Rome, 1635).[195]

In fact Zarlino, while demonstrating his mastery of the history of ancient music, warned against attempts to recreate it. He compared the folly of trying to imitate the ancient modes without benefit of any model of the use of the three ancient *genera*. Of those who nonetheless tried to understand the modes perfectly he wrote: "that if they want to look at this closely, they will find without any doubt whatsoever, that having racked their brains with great labor and difficulty they have wasted their time, the most precious thing of all; and that they have been deceived like alchemists in search of that which they will never be able to find; I mean in search of what they call the fifth essence."[196] Such intemperate pursuit of the philosopher's stone of the ancient modes is entirely inconsistent with Zarlino's general definition of the word "mode" as "reason: that is to say, that measure or form that we employ to do anything, which then compels us not to go beyond it; making us work in all things with a certain mediocrity or moderation."[197] While Poussin quoted sections from Zarlino's discussion of particular modes, he also cited this universal definition of mode as "the *ratio* or the measure and the form that we employ to do anything, which compels us not to go beyond it, making us work in all things with a certain middle course or moderation. And so this mediocrity or moderation is simply a certain manner or determined and fixed order in the process by which a thing preserves its being."[198]

Poussin's lesson in criticism to Chantelou is, in this quotation, indeed nothing more than a translation of Zarlino's general definition with the quotations from Pindar and Horace omitted. The idea he intends to convey, however, that in presenting his subject the artist must work within limits according to the mean, in a certain manner, in order to realize the true meaning of what he seeks to represent by discovering its true proportions is as consistent with Poussin's own philosophy of painting as it is with Testa's often repeated view that the artist must follow the mean, maintaining a middle path between slavish imitation and unrestrained *ingegno*. Poussin's appeal to Zarlino's universal definition of the mode as a mean, at the same time, should discourage the view that he was one of those who, like the alchemists, wasted his time trying to analyze the fifth essence. On the contrary, he recognized the existence of a quality in certain paintings, "une certaine manière," that could not

[194] Palisca, 1960, pp. 40-69, esp. p. 56, and p. 106.

[195] See Disertori, 1966, p. 63, for Doni's keyboard with nine registers of keys in six different colors for playing in the Dorian, Phrygian, Lydian, and Enharmonic Modes, and for the dedication of his instrument, the Lyra Barberina, to Urban VIII in 1633. See also Palisca's important study, 1980. Palisca establishes the relationship between Doni's illustrations and drawings in dal Pozzo's collection, and between Doni, Pietro della Valle, Peiresc, and others; see Blunt, 1967, text vol., p. 227, for Doni's friendship with Bellori and Domenichino.

[196] Zarlino, 1573, p. 368: "che si bene vorranno essaminar la cosa, ritroveranno senza dubbio alcuno, doppo l'haversi

lungo tempo lambicato il cervello con molto fatiche e stenti, che haveranno gettato via il tempo, piu pretioso, che ogn'altra cosa; e esser stati ingannati alla guisa degli Alchemisti, intorno il voler ritrovare quello, che mai ritrovar potranno; quello dico, che chiamano Quinta essentia." Walker, 1941, pp. 220-221, also points to Zarlino's caution.

[197] Zarlino, 1573, p. 359, "la Ragione: cioè quella Misura, o Forma, che adoperiamo nel fare alcuna cosa, laqual ne astrenge poi a non passar più oltra; facendone operare tutte le cose con una certa mediocrità, o moderatione."

[198] Translation from Blunt, 1967, text vol., p. 369, where Poussin's letter is also quoted in the original.

be anatomized completely. It was this that the good critic would be able to perceive. What Zarlino called an "ordine di cantare con diversa maniera" would, furthermore, have been understood by Poussin in the context of his close reading of Mascardi's analysis of style and could not have been entirely separated in his mind from the concept of the *genera*, whether musical or literary, and of personal style.[199] Following Mascardi's analysis, Poussin would doubtless have associated the modes, or tropes, with elocution.

Mascardi, in drawing his analogy between painting and literature, followed the tradition of associating the colors of the painter with the rhetorical colors of elocution (although, it should be recognized, he also appears to include drawing in the same category).[200] The most straightforward explanation of Poussin's understanding of the modes, on the basis of what he read in Zarlino, is that he too thought of the modes as equivalent to the various proportions regulating the various types of color harmonies. Poussin himself compared the persuasive colors of the painter to the elocution of poetry. Even though the characters of style, the equivalent of the *genera* described by Barbaro, could establish a mood, it was really by means of elocution that persuasion could sweetly insinuate the soul.[201] In this regard, however, Mascardi warned that elocution unregulated by the organizing structures characterizing the chosen genre as determined by the form of the idea would remain indeterminate and "otiosa."[202] We have seen that Testa saw the scales of chiaroscuro as the equivalent of Barbaro's *genera*, that is as the determinants of the chosen character of style. In his mind also colors (seen here as determining mode, or elocution) would have had to be structured in accordance with these scales, playing the feminine role in relationship to masculine *disegno*, defined by Testa as chiaroscuro employed for the purposes of relief.

[199] Zarlino, 1573, p. 364: "E tale ordine di cantare con diversa maniera, overa aria dimandano Modo: & alcuni lo chiamano Tropo: & alcuni Tuono." Zarlino himself, p. 360, makes the connection between the musical modes and the literary genres, stating, "Onde nacque dapoi, che posero [the ancient poets and musicians] tre Generi de Modi, non havendo consideratione al Suono, overo all'Harmonia, che nasceva: ma solamente alle altre parti aggiunte insieme; l'uno de i quali chiamarono Dythyrambico, l'altro Tragico, & il Terzo Nomica: de i quali le lor specie furono molte; si come Epithalamij, Comici, Encomiastici, & altri simili." My point is that we must remember that Poussin read texts intelligently and critically, presumably seeking to reconcile their meaning; he would have separated the notion of genre, or character, from the notion of a trope (here reconciled, if not confused by Zarlino) on the basis of the much clearer exposition of these same terms in *Dell'arte historica*, especially in Mascardi's "Digressione intorno allo stile," 1636, pp. 330-407.

[200] For Mascardi's definition of elocution, see *Dell'arte historica*, 1636, pp. 350-361. The comparison with the art of painting appears in the discussion of style on p. 406: "Alla maniera de' dipintori può, com'io credo, paragonarsi negli scrittori lo stile; al disegno, al colorito, alla compositione, & al costume si rassomiglian l'elocutione, le forme, e'l carattere della favella." In the context of Mascardi's inclusion of drawing together with color in the category of elocution, it is important that in his own discussion of elocution he insists upon the importance of word order, rather than upon the mere choice of words, whether simple or ornate. In a provocative analogy, pp. 352-353, Mascardi compares words to stones. Some (i.e. the pure words of Latin, Hellenistic Greek, or

Tuscan, as sanctioned by the great authors) are like marble, precious in themselves, straightforward and already stained; others are sculptured and cut with the chisel (i.e. ornate and decorated). However, if they are not equally proportioned and the orders are not respected, they will never form a beautiful palace.

[201] For Poussin's statement, "Li colori nella pittura sono quasi lusinghe per persuadere gli occhi, come la venustà de' versi nella poesia," see Bellori, ed. 1976, p. 481, where Borea points out that this is a quotation from Tasso's *Discorsi del poema eroico*. Blunt, 1937-1938, pp. 347-348, not recognizing this source, suggested that the note might be an original idea of Poussin's because it had to do with "a technical matter directly connected with painting," and because the language was not "the high-flown language of the literary critics." Blunt cannot be criticized for not discovering the source in this case, but the assumptions that the ideas Poussin studied in the works of literary critics were not directly connected with painting, and that the category of color is necessarily a purely technical one, are both misleading and unjustified. These assumptions led Blunt to conclude that Poussin's note "implies scorn for the sensuous charm of color," and that it therefore dates from the later part of his life, "when he had broken away from the Venetian influence which dominated his first years in Rome." Clearly, poetry without *venustà*, like painting without colors, was nothing. For the role of eloquence in persuasion, see Mascardi, 1636, p. 351.

[202] Mascardi, 1636, p. 361: "L'elocutione ancorche nella sua essenza perfetta, rimane però senza i caratteri del dire, e senza le forme, ò sieno idee della favella, indeterminate, & otiosa."

In describing his imaginary Parnassus, Testa showed Raphael rebuking Giulio for his outright attack on colors, and Poussin would have supported him. Both Testa and Poussin would have understood Mascardi's analogy of painting and rhetoric and read his passage about the otiose nature of unstructured eloquence as referring in painting to the inactive nature of color in the absence of the organizing principle that Testa named the greatest light. It is in this sense that Poussin's comparison of colors to "lusinghe" and to the "venustà" of poetry must be understood, rather than indicating a disdain for color itself. Leonardo had said much the same thing when he criticized the bad judgment of those who wanted only colors at the expense of the chiaroscuro that produces relief.[203] Mascardi also censured the bad judgment of those who identified different painters on the basis of differences in palette, ignoring aspects of composition and without understanding personal style.[204]

In attempting to supply simpler definitions of the modes as different styles of singing, Zarlino also suggests that, in accordance with Boethius, a mode is a "certain constitution of voices that differ according to their height and depth, and that this kind of constitution is like a body full of modulation that takes its being from the conjunction of consonances."[205] He also compared it to the form of a melody that is composed with reason and artifice and governed by a determined and proportioned rhythm and harmony, fitted to the material of the oration.[206] In terms of painting, it would seem that this persuasive melodic modulation of the harmony, or system of chiaroscuro, is effected by color. The detailed analogy with musical theory should not be pushed too far, however, given all Zarlino's warnings. It would appear misguided, for example, to attempt to find a painterly equivalent for rhythm, as some have done, for this is a concept very foreign to art criticism of the seventeenth century; and indeed Zarlino says that in his day even musicians ignored its role, believing the affective powers of rhythm to be in the province of poetry.[207] The view of eloquence as color, and vice versa, both of them elements of persuasion, is well established critically, and only a small step had to be taken to relate the affective eloquence of music, in the form of the modes, to painting. Even as the modes and scales themselves were already dependent on the material in the oration they accompanied, and for which the orator had to find the character and elocution, so the painter had to find a system of chiaroscuro and color modulation to suit his subject.

Testa's notes to Barbaro's treatment of scale, in the context of all that Accolti has to say about chiaroscuro, indicate a way of analyzing the gradation of light, and, as we have seen, this kind of analysis was utilized by Poussin himself as he sought to classify different types of light and their effects in paintings like the *Rebecca and Eliezer* and the *Eucharist*. The analysis of Poussin's color would be much more complex and cannot be undertaken here. That Poussin followed up on his general analogy of the affective powers of music and

[203] Leonardo da Vinci, 1651, CCLXXVII: "Se tu fuggi l'ombre, tu fuggi la gloria dell'arte appresso li nobili ingegni, & l'acquisto appresso l'ignorante volgo, il quale nulla più desidera che bellezza di colori, non conoscendo il rilievo."

[204] Mascardi, 1636, p. 406. He criticizes the judgment of "huomini vulgari, che segue d'ordinario la scorta de' sensi," that identifies the differences between painters in terms of their differing uses of color. He points out that painters may change their ways of using color to suit different forms, but,

nonetheless, "non lascia il buon artefice la sua maniera."

[205] Zarlino, 1573, p. 365.

[206] *Ibid.*: "Onde potiamo veramente dire, che il Modo anticamente era una certa & determinata forma di Melodia, fatta con ragione & con arteficio, contenuta sotto un determinato & proportionato ordine de Numeri & di Harmonia, accommodati alla materia contenuta nell' Oratione."

[207] Zarlino, 1573, p. 364.

those of painting with the establishment of more specific equivalences between colors and notes, is suggested, however, by parallel attempts to do just that by artists in his immediate circle. Among these Zaccolini in particular stands in the closest relation to Poussin and to Testa.

In his enumeration of the affective powers of music, from which Poussin made his note concerning Virgil in the letter to Chantelou, Zarlino mentioned only in passing the power of music and dance to cure victims of tarantula bites.[208] Zaccolini, on the other hand, devoted two entire *trattati* to questions relating to the poisonous spider bites in the first volume of his manuscript, entitled "De colore."[209] The tarantella was still danced in Puglia in the seventeenth century, and Zaccolini had doubtless seen it danced when he was in Naples. Unlike St. Vitus's dance, which was itself a symptom of the disease, the tarantella was supposed to have a curative, restorative effect, not unlike the effect of the ancient modes. The poison could have different effects on different people, making them happy or sad, sleepy or full of energy. The dance was to be adapted to the particular case, counteracting the extremes of its particular symptoms. Zaccolini's argument, which is the subject of the eleventh *trattato*, entitled "Della proportione del colore col suono per i Tarantati," was that the power of music must be reinforced by colors. He assigned a number value to each of nine colors from white to black, according to their ability to advance, which he compared to the ability of different chords to carry across distances. Forceful colors like white, or yellow, must accompany forceful chords, languid colors languid chords.[210] In Zaccolini's scheme the colors are considered not only individually, but also the color "notes" can be arranged in chords according to their number, in which some notes advance or recede more than others, leaving a dominant effect.

The use of colors to control the passions induced by the poison of a spider is a peculiar application of the principle of the affective powers of music in modal operation. Zaccolini's attempts to quantify colors in terms of number values are not themselves entirely eccentric, however. Bernard Tessèydre has shown how Cureau de la Chambre, basing his approach to proportionality in music and color on Aristotle, set about devising a similar system of numbering colors from black to white that, though different in detail, was also based on the effects of distance and visibility.[211] At the same time De la Chambre distinguished between the alteration of color through distance, which he compared to the effects of distance on sound, and the changes of color derived from light itself, which he compared to the change from low to high notes. Poussin's paintings of the 1640s in particular follow the first of these principles. The production of color through the modification of light itself was a different problem, and it is in regard to this that Poussin's concept of mode may be understood. Modality provided a structure for the harmonic modulation of color as a quality of light. Most important here is the distinction made by De la Chambre between color as

[208] *Ibid.*, p. 10. See Blunt, 1967a, text vol., p. 370 for Poussin's reference to Virgil in the letter to Chantelou.

[209] Biblioteca Laurenziana MS Ashburnham 1212,i, "De colori," *Trattati* 10 and 11.

[210] Zaccolini writes, for example, on fol. 255, "Per maggior intelligenza della conformità che hanno insieme il colore et il suono, metteremo insieme i colori particolari i quali per regola havranno forza di mandare più vigorosamente la loro spetie all'occhio et l'accoppiaremo con la voce di quelle corde dell'instrumento da sonare, che si farà udire dalle più lontane parti venendo all'orrecchio piu vigorosamente dell'altre, e cosi procederemo con ordine accoppiando ogni colore più languido e meno vigoroso con le corde più languide e men forzose nella forza della voce."

[211] Teyssèdre, 1967, esp. 208-210.

a quality of an object, having to travel through light across a distance, and color as a modification of light itself, like the modification of voices themselves, not changes in voices resulting from being heard across a distance.[212]

The nature of color and the means of perceiving it were not understood in Testa's or Poussin's lifetimes, but they were problems of especial concern to contemporary scholars of optics, like Grimaldi, Descartes, Fermat, and De la Chambre.[213] Nevertheless, both Poussin and Testa understood painting to be fundamentally optical in nature, to be, in a word, an illusion. Paradoxically, it was the fact that painting was the object of the sense of sight, the noblest of all the senses, that made it superior to sculpture. Inseparable from sculpture was the concept of contour, and the sense of touch that reached out to surface lines. Testa, in accordance with the tradition of Leonardo, insisted that all outlines must be removed in the final form of a painting. Poussin too, although he included line in his definition of painting, avoided outline completely in his drawings and paintings. Once contour and the association with sculpture was removed the illusion of form had to be conveyed solely by color and light, by which the eye was fooled into believing in the existence of what it perceived without the residual reference to touch that line provides. It was no accident that Accolti entitled his treatise *Lo inganno degli occhi*, recalling Daniele Barbaro's definition of the aim of perspective as the "inganno della vista." Ronchi has suggested that Barbaro's claim of helping the artist thus deceive the eye of the spectator reflects the teachings of the University of Padua, derived from Alhazen, arguing that sight itself is deceptive, subject to illusion, and not always a medium for truth.[214] Barbaro had still, however, insisted that colors were associated with form and that they extended their existence even in the dark.[215] Poussin, on the other hand, quotes at length from Alhazen and could not have been unaware of the theory put forward by Descartes in 1638 that color too was not permanent, but was a modification of light, which he believed to be corpuscular.[216]

The problem of the perspective of colors in relation to their harmonies was inseparable from the problem of the nature of color as a permanent species travelling from the object, as opposed to color as a modification of light. Testa showed ideal Painting borrowing her colors from the rainbow in his etching of the *Triumph of Painting* (Fig. 54), and in the *Allegory in Honor of Innocent X* (Fig. 67), it is Iris who lends the colors of the rainbow to Peace; but his practical understanding of chiaroscuro was never matched by an ability to manipulate color in painting to deceive the eye of the spectator successfully. Poussin did

[212] See *Ibid.*, p. 210, for the quotation from Cureau de La Chambre's treatise *La Lumière*, pp. 18-20, "que la Lumière qui est foible par l'eloignement du corps lumineux ressemble au Son qui est affoibli par la distance; mais que la Lumière qui se change en couleurs, est semblable au son grave qui passe à l'aigu et qui devient foible par ce changement." Teyssèdre comments on this important distinction as follows: "Pour un lecteur moin accoutumé aux spéculations de Sorbonne qu'aux leçons de Poussin, cette distinction entre deux types de modifications, dont l'un affectait la seule intensité, mais l'autre la qualité, semblait accessoire; plûtot demeurait l'impression globale que le coloris fût un 'affoiblissement', par conséquent que son 'artifice' tint à une 'degradation réglée des lumières', soit en fonction de la distance, selon les règles de 'perspective aérienne', soit sur un même plan, par mélange ou passage entre tons contrastés." I would only add here that, following my argument, Poussin may have been more aware of the speculations of the Sorbonne than those who later interpreted his paintings according to their own models.

[213] Ronchi, 1970, pp. 141-158 provides a summary of seventeenth-century developments.

[214] Ronchi, 1968, p. 63.

[215] Barbaro, 1568, p. 17.

[216] For the text and translation of Poussin's letter to Chambray, March 1, 1665, in which Poussin was quoting from Alhazen, see Blunt, 1967, text vol., pp. 371-372.

become a painter of color and light, however, and was never to distinguish between the limits of *disegno* and *colore*. The debates concerning the nature of light and color continued in the later seventeenth century, and with them the debates among painters about the relationship between form and color, and these latter have confused the understanding of Poussin's approach to color. In his own vocabulary he was unable to escape from the traditional philosophical association of color with music and with rhetoric, especially as he was concerned with the effect of a painting and its subject on the emotions of the judicious spectator. But in his painting, and indeed his drawings, he shows his awareness of the slow revolution being effected in his day, through which color was being liberated from its status as a sort of tinted skin adhering to form to be considered instead as a property of light, governed by physical laws. Without light nothing is seen, and in his first *Self-Portrait* of 1649 Poussin takes this as his theme.

In the portrait Poussin holds in one hand a chalk-holder, the instrument of *disegno*, and in the other a book entitled *De lumine et colore*.[217] His import is that the painter must understand color and light if he wishes to represent anything with his chalks in order to "ingannare gli occhi" of the spectator. Far from opposing *disegno* to *colore*, Poussin understood them to be inseparable, for vision itself is not dependent on the forms of things that project superficial color, but on color and light directly. It is this visual purity and illusion that makes painting superior to sculpture. Accolti, who did not concern himself with color, but did point to the power of light to create illusions, recalled the story of how Apelles had made a sculpture by Praxiteles look completely flat by reversing the effects of light and shade on the three-dimensional form.[218] This calls into question the existence of anything that is seen, in accordance with the title of his book, and Accolti argued that an understanding of chiaroscuro is the foundation of both *disegno* and *pittura*, and that many have gone so far as to say that painting is nothing other than the representation of light and shade. Poussin created the illusion of the presence of himself on the surface of his canvas by means of chiaroscuro and color—and he used the same means to suggest the presence of his own sculptured tomb behind him. The picture is Poussin's tomb, both effigy and epitaph, for while giving a perfect illusion of life it is dead. Both Testa and Poussin relied on experience and the study of nature to lead them to the truth, but both of them believed that the evidence of the senses was illusory and to be disciplined by reason. In the letter on the modes Poussin applied this principle of the rational disciplining of deceptive perceptions to the manner in which a painting should be viewed. His immediate subject was the convention for controlling the illusions of color in order to stir the affections toward an understanding of truth, but the more illusory the evidence of sight came to be seen, the more apparent became the illusory nature of the painted image. It was no wonder that Testa, who struggled so hard to understand the sources of the rainbow, should have hated those mindless painters of simple reality so much. In the end only the idea could be real, and Poussin's *Self-Portrait* exemplifies this. But even this painting, in the end, cannot escape from Socrates's charge of always replying to our questions in the same way.

[217] Blunt, 1966, no. 1.
[218] See Accolti, 1625, p. 95; for Galileo's proposal to make the same demonstration, see Panofsky, 1964, pp. 8-9, and fig. 4.

4. Pietro Testa and Roman Classicism

THIS STUDY of Testa's Düsseldorf Notebook and its sources would not be complete without some attempt to establish the significance of Testa's ideas in relation to better known critical writings from the first half of the seventeenth century in Rome and elsewhere. This is, however, not easily established. Poussin and Du Fresnoy provide obvious points of departure, for they embarked on similar projects, espousing similar positions, at the same time, and in the same milieu. Studies of the literary remains of both artists have, however, generally limited themselves to the identification of sources and models. Their importance has been established more in terms of later influences upon the French Academy than in terms of an integral assessment of the critical positions espoused by the two French painters in the formative Roman years when Testa knew them. Many of the poets, ecclesiastics, and antiquarians who patronized, inspired, criticized, cultivated, and shared the daily lives of Roman painters from Annibale Carracci to Poussin are equally unfamiliar. Some have barely recovered from the censure of Croce, despite the efforts of recent Italian scholarship; others are still neglected because of a modern lack of understanding of their particular brand of conservatism, their moral and intellectual discipline.[1]

Du Fresnoy's *De arte graphica* appears to stand closest in certain important details to Testa's projected treatise. Especially striking is Du Fresnoy's adoption of Testa's image of bound theory and blind practice, and his emphasis on the relationship between the hand and the mind.[2] Du Fresnoy also insists upon the importance of a good master, and the value of studying works of art before turning to works of nature, even while demanding that the student respect nature, Magistra Artis, as much as his own genius. He requires the artist to study geometry and perfect his judgment, avoiding extremes of all kinds.[3] In a passage that recalls Testa's imaginary conversation, furthermore, between Giulio Romano and Raphael, Du Fresnoy argues that though color, the *grata venustas* of painting, has been called a seductress and a procuress, it has always brought honor and praise to drawing.[4] Like Testa, Du Fresnoy includes Raphael, Michelangelo, Giulio, Titian, and Annibale

[1] The work of Ezio Raimondi is a particularly important exception; see especially the essays collected in *Anatomie secentesche*, 1966.

[2] Quotations are from J. Dryden's edition of *The Art of Painting* (London, 1750). Du Fresnoy's second precept, De Speculatione & Praxi, reads as follows:
Utque Manus grandi nil Nomina practica dignum
Assequitur, purum arcanae quam deficit Artis
Lumen, & in praeceps abitura ut caeca vagatur;
Sic nihil Ars operā Manuum privata supremum
Exequitur, sed languet iners uti vincta lacertos;
Dispositumque typum non linguā pinxit Apelles.

See also Precept LXV, Quod Mente conceperis Manu comproba (ll. 464-65).

[3] See especially Precept XIX, Natura Genio accomodanda (ll. 177-183); LVIII, Pictor Tyro (ll. 421-432); LXX, Ordo Studiorum (esp. ll. 508-518).

[4] See ll. 261-266:
Haec quidem ut in Tabulis fallax, sed grata Venustas,
Et complementum Graphidos (mirabile visu)
Pulchra vocabatur, sed subdola, Lena Sororis:
Non tamen hoc lenocinium, fucusque, dolusque
Dedecori fuit unquam; illi sed semper honori,
Laudibus & meritis; hanc ergo nosse juvabit.

among the most excellent modern painters (though, untroubled by Lanfranco's success and Domenichino's sufferings, he also, more typically, includes Correggio).[5] What distinguishes Du Fresnoy's text and his attitude toward it from Testa's, however, is that the author put his ideas together in the form of a Latin poem on the model of Horace's *De arte poetica*. Furthermore, it must be recognized that the poem is still little understood in its own context, being better known through Roger de Piles's interpretation of it.[6]

One further serious obstacle to our understanding of the context in which Testa wrote is the fact that the broad outlines of the history of seventeenth-century Italian art criticism have not been redrawn since Panofsky's grand survey of them in his *Idea*, first published in 1924—and this despite Panofsky's own encouragement in his preface to a later edition that they might be reconsidered.[7] It is because Panofsky's study remains the starting point for any analysis of the theory of art in Testa's day that I must consider it in some detail before turning to the particular issue of Testa's own historical significance.

Panofsky's concern was to plot the history of the Idea virtually as an autonomous concept through tracing the dialectic between the imitation of models and of nature, between Platonism and Aristotelianism, idealism and naturalism, toward a final synthesis in the writing of Bellori that was to become normative. At the risk of distorting Panofsky's beautiful argument, I want to establish his underlying point of view by summarizing his discussion of the "Art Theory" of the modern period, which he divides into Renaissance art theory, "Mannerism," and "Classicism." Art theory in the fifteenth century, according to Panofsky, was fundamentally practical rather than speculative. On the one hand, the idea of the beautiful was to be derived from the study of nature by the individual artist; on the other, it was assumed that some sort of *giudizio universale*, whether undefined, or associated with the authority of history, or the rules of proportion, controlled the artist's selection from nature.[8] The inherent contradiction in this position, between the individual, non-metaphysical derivation of the ideal from the artist's experience and the supra-subjective, supra-objective rules governing this derivation, was not openly recognized. Although the working notion of the Idea adopted by artists such as Alberti and Raphael was not substantially different from that later articulated by Bellori, this notion served only as a practical, if not naïve, theory for art, which should not, in Panofsky's words, "be subjected to the acid test of epistemological criticism."[9] In the period defined as "Early Baroque," or that of "Mannerism," this "unproblematic and tranquil mood" changed. Although the practical theory of the Renaissance prevailed in Venice and Lombardy, the chief characteristic of the new art and its theory was an internal dualism, not only present but now consciously recognized. The relationship between individual genius and rule became a potentially hos-

[5] Du Fresnoy (ll. 514-535) cites these artists as representatives of the Roman, Venetian, Parmesan, and Bolognese schools. His categories differ from those of Domenichino in substituting the Parmesan for the Tuscan school, for which see Mahon, 1947, pp. 119-120.

[6] See Schlosser Magnino, 1967, p. 635, for the editions of Du Fresnoy's poem. Thuillier, 1964, shows that Du Fresnoy probably began to write shortly after his arrival in Rome in 1633/4, and that the manuscript of the *Observations* dates c. 1649; see also Chapter Three above.

[7] Originally published as *Idea: Ein Beitrag zur Begriffsgeschichte der älteren Kunsttheorie*, Studien der Bibliothek Warburg, 5 (Leipzig, 1924). J.J.S. Peake used the second, corrected edition (Berlin, 1960) for his English translation, *Idea: A Concept in Art Theory* (Columbia, 1968). The translation is cited here. In his Preface to the 1960 edition Panofsky asked that his book should be labelled, "Mit Vorsicht zu benutzen."

[8] Panofsky, ed. 1968, pp. 47-68, esp. pp. 63, 67-68.

[9] *Ibid.*, p. 60.

tile antithesis, inseparable from the broader problem of the relationship between mind and nature, subject and object, and for this Vasari prepared the way.[10] The Renaissance state of grace was over, and art theory took refuge in a sort of metaphysics.

Panofsky defended this new turn toward the speculative as unavoidable (a position quite remarkable with regard to Mannerism in 1924) and related it to contemporary developments in poetics. At the same time, however, he believed that this turn was a step away from "live art" toward "aesthetics," and ultimately "art history"; that is, from a theory *for* art toward a theory *of* art, from one for artists, to one about artists, and now in the hands of antiquarians, *letterati*, philosophers, and scholars.[11] The implications of this for the study of seventeenth-century painting are clear. It has, for example, been argued by Mahon and others that the writings of *letterati* and antiquarians, such as Agucchi and Bellori, are indeed writings about art, quite separate from practice, and that when artists speculate about their art this is only an "intuitive" kind of speculation subordinate to particular creative activity.[12] But this is to look ahead, and we shall reconsider this problem later.

Fundamental to Panofsky's analysis of the critical period of what he defines as Mannerism is the notion of a disjunction between ideation and idealization. This is represented by two distinct, though complementary trends; the first is the Aristotelian-Thomistic, represented by Federigo Zuccaro, and the second is the Neoplatonic, represented by Lomazzo.[13] Zuccaro was primarily interested in the formative processes in the artist's mind, or what I have called ideation. In his famous exposition of this Zuccaro defines ideation as the *disegno interno*, the *segno di Dio in noi*. Man's ability to design participates in the creative power of God, though it is also individual and relies on experience. In accordance with Aristotle and Aquinas, Zuccaro validates the process through which works of art are brought into being by making this congruent with the sure process by which Nature achieves her creative ends.[14] The problem of the relationship between the mind and the senses, which Panofsky saw to have been left unstated in the Renaissance, was now solved by subjecting both to the power of the *disegno intellettivo*, derived from God. Imitating God, but emulating nature, the artist produces artificial things similar to natural things, but which may not exist in nature.[15] Panofsky argues that the problem of ideal beauty did not concern Zuccaro, who saw no material obstacle in the path of the creative processes of nature or man.[16]

Among Neoplatonic theorists, on the other hand, the problem of the beautiful was related to the resistance of matter to form. In Lomazzo's *Idea del tempio della pittura* (Milan, 1590) the influence of Florentine Neoplatonism is, again according to Panofsky, particularly strong.[17] Lomazzo defines beauty as the radiant grace of God, which shines first upon the angels, engendering in their consciousness the perception of heavenly bodies

[10] *Ibid.*, pp. 71-84.
[11] *Ibid.*, pp. 83-84.
[12] See, for example, Mahon's discussion of Domenichino, 1947, pp. 117-124, esp. p. 124, n. 50, where Mahon concludes that "Domenichino's reputation seems to have been that of a philosopher in painting rather than of it."
[13] Panofsky, ed. 1968, pp. 85-99.
[14] *Ibid.*, pp. 85-93.
[15] *Ibid.*, pp. 86-88.

[16] *Ibid.*, p. 94.
[17] *Ibid.*, p. 95. Panofsky emphasizes, p. 235, n. 60, that Lomazzo's Neoplatonism did not exclude Aristotelian-Scholastic elements, in accordance with his other recognition that the art theory of the late sixteenth century is synthetic and compendious in nature. Panofsky does believe, however, that certain new elements in theory legitimized "Mannerist" tendencies in the narrower sense.

as Ideas, then into the human soul, where it engenders reason, and only finally into the world of matter, where it appears as form. Matter can only conform to the Idea if it is adapted to it in order, measure, and kind. Through the force of his divinely bestowed reason the artist must discover the Idea in nature, which is rarely adapted to receive it.[18] Unlike the theories of the Renaissance, both Neoplatonic and Aristotelian-Scholastic trends were founded on metaphysical principles.[19]

Having argued for a separation between artistic practice and artistic theory in the late sixteenth century, Panofsky states that from the middle of the seventeenth century Classicism became increasingly important in practice and predominant in theory. It is important to recognize at this point that the two sides of the question, theory and practice, remain severed in his argument, despite the fact that he saw them developing along the same lines. Classicism, as a result, is presented as an aesthetic ideal in relation to the artistic object and not as a theory involving the subjective artistic process. For this reason Panofsky believed it to be potentially at odds with the "painterliness" of certain aspects of Baroque style, even when represented by Bernini.[20] This emphasis upon the separation of theory from practice becomes clearer as Panofsky's analysis proceeds. Its implications are important for our understanding of the whole of the seventeenth century given the fact that, as Panofsky recognized in his preface to the second edition of *Idea*, Agucchi's concept of the Idea anticipated Bellori's by at least half a century.[21]

Panofsky defines Bellori's lecture on the Idea, delivered to the Academy of St. Luke in 1664, as "the 'Magna Charta' of the classicistic interpretation of art."[22] He argues that Bellori found himself in a "double defensive" position, opposing both Caravaggesque "naturalism" and painting "*di maniera.*" In this situation the art of antiquity provided an "infallible measure" of the path between the two extremes. Because ancient art purified the deformities of nature it constituted the *beau idéal*, an art that was "natural" in the perfect sense. Panofsky points to the Neoplatonism of the opening salvo of Bellori's lecture; he then argues that there is a sudden break with metaphysics when Bellori goes on to say that the Idea is derived from the evidence of sensory perception, which is made to conform to an imagined image, and in this way idealized.[23] Bellori finds authority for this in statements by Alberti, Leonardo, and Raphael, which are echoed by Guido Reni. Panofsky, therefore, identifies Bellori's theory of the Idea as "practically identical in content with that of the Renaissance."[24] Even as he recognized, however, a kind of Fall from the Grace of the Renaissance through the eating of the Tree of Knowledge in the metaphysics of "Mannerist" theory, so Panofsky implies that this fall into a kind of self-consciousness could not be denied. Bellori was, therefore, compelled to enunciate "a new and programmatic formula, to establish it systematically." Panofsky presents Bellori's *Idea* as "summarizing the view of a very large number of artists and art theorists and proclaiming itself as a programmatic

[18] *Ibid.*, pp. 96-97.

[19] *Ibid.*, p. 98: "The artistic Idea in general and the Idea of beauty in particular—both, after having been 'empiricized' and 'aposteriorized' in the nature-happy (*naturfrohe*) and self-assured thought of the Renaissance, regained for a short time their apriori and metaphysical character in the art theory of Mannerism, the artistic Idea in general with the help of the Peripatetic and Scholastic philosophy, the Idea of beauty in particular with the help of the Neoplatonic philosophy."

[20] *Ibid.*, p. 103.

[21] *Ibid.*, p. vii. This observation is, of course, based on Mahon's publication of the fragment of Agucchi's *Trattato* in 1947.

[22] *Ibid.*, p. vii.

[23] *Ibid.*, pp. 104-105.

[24] *Ibid.*, p. 108.

manifesto by its physical bulk and its cumbersome historical apparatus."[25] Even as Renaissance art theory was "a constructive theory about art," supporting practice, and "Mannerist" theory was given over to speculative metaphysics, so seventeenth-century Classicism was a "normative philosophy about art," "a law-giving aesthetics."[26] We move, then, from a paradisiacal unconsciousness to knowledge and from knowledge to laws. In terms of more recent developments from the late nineteenth century on, Panofsky relates these positions to distinct notions of artistic "vision," artistic "thinking," and artistic "expression."[27]

Panofsky's assessment of the historical importance of *L'Idea* is based on the profound influence it exerted upon French and German criticism through its wide circulation as the preface to the *Lives*. In his words, "the program of 'idealistic aesthetics' was determined as we understand it," through Bellori's transformation of the Idea into the *beau idéal*.[28] We must recognize, however, that Panofsky's Bellori is not himself an historical figure. Although Panofsky observed that the lecture was not an original statement, and that its importance lies in later interpretations, he did not consider *L'Idea* as a text in context. His method of approach, the analysis of the constituent parts of Bellori's "theory" in terms of their history as discrete ideas, also isolates them from the various fabrics of discourse to which they belong. All of this is in accordance with Panofsky's purpose, which is not strictly historical, but rather to delineate the emergence of the idea of a modern creative genius and to plot the opposition between "idealism" and "naturalism" as a "dialectical antinomy."[29] Dürer and Michelangelo are the heroes of his study. They possessed, in his view, a consciousness of self without participating in the divorce of metaphysics from practice that appeared to deprive art of its vitality in the later sixteenth century. They recognized their own historical identities without sharing the sense of loss or limitation that the same recognition brought to artists in the seventeenth century, limitations that were articulated in Bellori's "programmatic formula."[30] Like Winckelmann, who also accorded a certain respect to *Nachahmer*, Panofsky views the conserving, rational, and historical mission of Classicism sympathetically, if not with admiration.[31] But in the end his own commitment is to the spirit of a more vital genius, a knowing spirit that finds its own path.

Panofsky's interpretation of genius, and his recognition of the principle that artistic consciousness "prescribes" rules to the perceptible world, required that he establish the antithesis between ideation and idealization, between Renaissance making and Mannerist thinking. It must also be recognized that this underlying purpose also necessitated his evaluation of the final resolution of this antithesis in Bellori's hands as a set of Classicistic rules that provided an escape route from epistemological problems at the price of becoming

[25] *Loc. cit.* The notion of a Fall from Grace is Panofsky's and follows from his statement that "the original sin of knowledge could not be undone."

[26] Panofsky, ed. 1968, p. 110.

[27] *Ibid.*, pp. 110-111.

[28] *Ibid.*, p. 109.

[29] See especially *Ibid.*, p. 126, for Panofsky's adoption of a Kantian, Rieglian position. Panofsky argues here that it is important to understand the diversity and presuppositions of solutions to the idealism/naturalism opposition "for history's sake, even though philosophy has come to realize that the problem underlying them is by its very nature insoluble." See also Dempsey, 1977, pp. 70-71, for a discussion of the

impact of the aesthetics of Kant on the tradition represented by Bellori and Malvasia. It does not necessarily follow from what Panofsky says, however, that the history of art and theory can only be analyzed in terms of this antinomy.

[30] Panofsky, ed. 1968, pp. 115-126.

[31] See Mahon's discussion, 1947, pp. 212-214, of Winckelmann's inclusion of the Carracci among the modern *Nachahmer* as an important source for the notion of the Carracci as eclectics in a way that was different from the eclecticism of the High Renaissance. Winckelmann's own views were, of course, deeply influenced by his understanding of Bellori; see Panofsky, ed. 1968, p. 242, n. 22.

an aesthetic that was "about" art, no longer "for" it.[32] Such a recognition is important because Panofsky's book is more often interpreted as a historical survey than as a philosophical study. It is, therefore, with the greatest respect for Panofsky the philosopher that I want to reconsider three major historical issues raised by his presentation of sixteenth- and seventeenth-century art theory. The first is his argument that the metaphysics of art in the late sixteenth century were distinct from problems of making, and that ideation and idealization, Aristotelianism and Platonism in the broad sense, were, if not in conflict, similarly divorced. The second is his view of seventeenth-century Classicism as a normative theory turning away from epistemological problems, and in some way less "live" than the Renaissance theory it so closely resembled. Thirdly, and in consequence of the first two, I want to reexamine Panofsky's approach to Bellori's lecture.

The evidence of Testa's Notebook prompts these questions, especially when confirmed by the arguments of the prints. On the one hand several of Testa's views appear to fit directly into Panofsky's general scheme. In *The Seasons*, for example, the winged soul of the virtuous artist suffers in the sublunar world of sense until, in the *Winter* (Fig. 58), it escapes, leaving behind the apes of nature who imitate only appearances and achieve only material rewards. Testa's condemnation of these "scimie sporche," enslaved by their need for objects to imitate, confirms that he shared Bellori's distaste for "raw naturalism."[33] In one note Testa defined beauty as harmony, mathematically proportioned, in accordance with Platonic principles; at the same time he insisted upon the perception of nature as the origin of the apprehension of the Idea. He shares, then, what Panofsky calls Bellori's "double defensive position."[34] On the other hand, despite the presence of Domenichino, Guido, Raphael, Michelangelo, Titian, the Carracci, and others on his ideal Parnassus and despite the importance of ancient sculpture and the works of these modern masters for his own style, Testa was not content with the sort of practical eclecticism that Panofsky presents as fundamental to Bellori's view. Nor could he have accepted that "idealism and naturalism, the study of antiquity and the study of models, are logically incompatible"—again something Panofsky believes to have become apparent in Classicistic art theory, represented by Bellori.[35]

The imitation of the work of other artists is the first step in the unification of theory and practice in *Il Liceo della Pittura* (Fig. 89). The pupil's own temperament is, however, important in the choice of models, and the study of nature must follow. When the successful student enters the *liceo* he devotes himself not to the *beau idéal*, but to the exercise of intelligence and use in the pursuit of knowledge, the mastery of the full encyclopedia of philosophy through dialectical reasoning. The end of art lies in expression and the persuasion to virtue and knowledge; beauty, for Testa, also lies in the fulfillment of an end.[36] As we saw in Chapter Two, Testa defined art as a habit of the practical intellect of making according to reason. In accordance with Zuccaro's view, as presented by Panofsky, Testa argues that the artist must work in the same rational way as nature.[37] For Testa, however, even though nature and reason are the only true teachers, perception is only reason's guide.

[32] See note 29 above, and Panofsky, ed. 1968, pp. 110, and 248, n. 38.
[33] Notebook, 57.A., 60.A.3.
[34] Notebook, 14.B., 15.D.

[35] Panofsky, ed. 1968, p. 109.
[36] Notebook, 59.D., 57.A.
[37] Notebook, 18.

Sense cannot produce reason, and only those artists who are gifted with it, and blessed with a good master, will arrive at the harmonious, natural and perfected beauty of the Idea. Like a parent teaching morality to his child, the wise teacher makes success possible by instructing his pupil in the true habit of his art, helping him to avoid the labyrinths of false argument and the confusion of information provided to undisciplined senses.[38] All of this preparation endows the artist with an inexhaustible store from which to draw, independent of immediate perception. What distinguishes the true artist from the mere practitioner at this point is, however, not only a well-stocked memory, but the critical power of judgment and dialectical reasoning, which can only be nurtured, not inculcated.

This brief summary of several points discussed in greater detail in earlier chapters serves to establish that, whereas Testa, like Poussin, ultimately defends an artistic tradition (Poussin's *esempio de' buoni maestri*), he does not seek to impose a normative aesthetic as a starting point.[39] In terms of the oppositions set up by Panofsky, he does not separate artistic thinking from making, the traditions of art from new invention. Even while he respects the discoveries of those who have exercised their reason before him, the artist achieves a beautiful and true product through a rational process that must be individual, vigorous, and constantly renewed through reference to nature. As established in Chapter Two, the origins of Testa's association of thinking with making lie in sixteenth-century theory, and here we must consider the first of Panofsky's arguments outlined above—that in the late sixteenth century the metaphysics of art were divorced from problems of making, the problems of ideation from those of idealization.

The story of Zeuxis's selection of the most perfect parts of the virgins of Croton provided Renaissance painters and critics, as well as Bellori, with a fictional authority for idealizing eclecticism, whether from art or nature.[40] Like the bee metaphor it so closely resembles, the story focuses upon the parts to be selected, rather than upon their integration, or mellification.[41] In the later sixteenth century, however, the process of digestion through cogitation was more closely examined. The growing interest in Aristotle's definition of imitation in terms of verisimilitude (based on the study of the *Poetics*) was not an isolated phenomenon, but was only one aspect of the increasingly intense study of Aristotle and his commentators by critics. The notion of verisimilitude had to be reconciled with the definition of art as an intellectual habit presented in the *Nicomachean Ethics*, and of Aristotle's analyses of the processes by which the mind achieves its ends, derived in the main from *De anima* and the *Parva naturalia*. In the formulation of a new theory of imitation the tradition of the imitation of models was not completely set aside, although as we have already seen in the case of Testa, the status of these models changed.

Tasso's approach to the question of imitation (which is also one of invention) is particularly similar to that of Testa. Testa never cites Tasso directly, but he shared Annibale Carracci's reverence for the poet.[42] Tasso's view of the end of poetry as "il piacer d'imparar

[38] Notebook, 57.B., 60.A.11.

[39] Bellori, ed. 1976, p. 478.

[40] See, for example, Panofsky, ed. 1968, pp. 49, 58.

[41] Pigman, 1980, pp. 1-32, provides an excellent summary of the problem of imitation; see pp. 4-11, for digestion and dissimulation.

[42] Notebook, 60.A.1. for Testa's reference to Tasso's presence on Parnassus in the company of Virgil. See Bellori, ed.

1976, p. 85, for Annibale's praise of Giulio Romano's frescoes in the Sala di Costantino by reciting the opening verses of the *Gerusalemme liberata*. For a discussion of the importance of Tasso for painting in the Carracci Academy, see C. Dempsey, "Mythic Invention in Counter-Reformation Painting," to appear in *Rome in the Renaissance: The City and the Myth*, to be published by the State University of New York, Binghamton.

molte cose congiunto con l'onestà," coincides with Testa's pursuit of honest pleasure and the moral of the *Altro diletto ch'imparar non trovo* (Fig. 88).[43] The importance of Tasso in Testa's immediate circle is indicated by Mascardi's admiration of him, and the fact that the *Discorsi*, which are filled with examples from the visual arts, are the single most important source for Poussin's surviving observations on painting.[44] Tasso's most important discussion of the imitative arts of painting, poetry, and sculpture appears in *Il Ficino overo de l'arte*, however. In this dialogue between Ficino and Landino Tasso considers the three arts on an equal footing, with specific reference to the Idea, and to a definition of art as a habit of thought.[45]

Tasso sets up an argument based on Plato in the following way: the forms, like Ideas, are certain and constant, and in order to reach them the human intellect must join the divine without any corporeal intermediary or imitation of nature.[46] This is challenged by Ficino, who argues that art is the very same as prudence (going beyond Aristotle in this identification). Just as God consulted with Himself before making the world, so the artist's intellect figures in itself the forms of things. It is through imitating the divine intellect in this way, and not through complete abstraction, that the mind of the artist becomes "quasi angelico," reaching that complete understanding which is the end of art.[47] Landino, in reply, complains, as many have since, that the art of man lies in his hands (the visual arts) or his tongue (poetry), and not in his intellect; there can be no Ideas of accidental, artificial things, and so there can be no *cause essemplari* of such things in the mind. Furthermore, he asks, why does Ficino argue that art originates in the mind, when Aristotle, in the *Metaphysics*, places its origin in sense, followed by memory and experience?[48] Ficino responds by insisting that the *cause*, or *forme essemplari* of artificial things are indeed in the human intellect, even though they do not exist in the divine. Claiming authority from Aristotle, he argues that these "ragioni artificiali de le cose operate" exist in the mind of the artist before anything is made. These ideas, as Tasso also calls them, are not, it is true, generated *ab aeterno*, but originate in sense and material forms, from which they are separated and despoiled of their sensible qualities. In this way Tasso allows for an artistic tradition, through which a Phidias may look to learn from a Daedalus; but rather than positing the existence of some great Original, or establishing a progressive refinement of art that originates in sense, Tasso asserts that art itself is older than any artifical thing. There was an art of statues before there were statues; the reason of making poetry existed before any poem. This art of making is perhaps born with us in the harmonies of our soul, and it is for this reason that Dante invoked his own mind at the beginning of the *Commedia*.[49]

[43] *Discorsi del poema eroico*, Libro primo, in Tasso, ed. 1964, p. 68.

[44] E. Raimondi, "Alla Ricerca del Classicismo," in 1966, pp. 40-41, points to Tasso's importance for Mascardi, Chiabrera, Testi, Maffeo Barberini, and Monteverdi. On foundations laid by R. W. Lee and A. Blunt, E. Borea has established that Poussin's notes entitled, "Diffinizione della pittura e della sua propria imitazione," part of "Della idea della bellezza," "Della novità," "Delle lusinghe del colore," are all derived from Tasso's *Discorsi del poema eroico*, for which see her notes to Bellori, ed. 1976, pp. 478-481. To these must be added, "Come l'impossibilità è perfezzione della pittura e della poesia," which, despite the reference to Castelvetro,

also derives from Tasso, who makes a similar reference, ed., 1964, pp. 62-63; and also "Della forma delle cose," for which see Tasso, p. 72. Poussin's sources for the few notes remaining are Quintilian, Dürer, and Mascardi.

[45] In *Dialoghi*, ed. 1958, 2: 891-912.

[46] *Ibid.*, pp. 900-901.

[47] *Ibid.*, pp. 901-902. See also Patterson, 1970, pp. 37-40.

[48] *Dialoghi*, ed. 1958, 2: 906-907. In response to Landino's complaint (p. 902) concerning Ficino's definition of the relationship between art, science, and wisdom, Ficino also summarizes here the familiar passage from *Nicomachean Ethics* 6, in which the intellectual habits are defined.

[49] *Dialoghi*, ed. 1958, 2: 907-909.

Through this exchange Tasso is able to answer Plato's charge that works of art are fantastic and without substance. The artist reasons truly toward his end, intending to understand. Although the forms of artificial things originate in sense, the artist imitates the ideas that are in his mind, not appearances. Although the arts are born of necessity and nourished by honor, they are, nevertheless, exact. In accordance with Testa's positioning of metaphysics at the apex of his definition of philosophy for *Il Liceo della Pittura* (Fig. VI), Tasso concludes that human arts tend toward divine philosophy and aspire toward Sapienza di Dio.[50]

Tasso's position is complex, but in a broad sense what he accomplishes is a reconciliation of art as an intellectual habit with the validity of perfectly beautiful models, or the Idea. Like Testa (and, looking ahead for a moment, like Bellori) he accepts both the origin of the forms of artificial things in sense and the higher existence of the ideas, or reasons, of those forms in the mind of the maker. Tasso would not have accepted the distinction between thinking and making, between metaphysics and practical imitation, implicit in Panofsky's argument. How this reconciliation is accomplished is clarified in the *Discorsi*. Here Tasso denies Plato's opposition of icastic and fantastic imitation, of the imitation of things that truly exist as Ideas, and those that do not. Plato did not recognize the intellective fantasy; if he had he would never have separated the fantastic from the icastic. According to Tasso, this intellective fantasy is constant and so poetry (for which we may also read the other arts of imitation) is truly icastic. Artificial beauty is not subject to custom or taste and so the lost works of Phidias and Praxiteles would be as beautiful to us as they ever were. This is because the reasoning power of the artist, through the gift of the intellective fantasy, can make absolutely beautiful things.[51]

Panofsky saw a close relationship between late sixteenth-century poetics and Mannerist theories of art, and Tasso's discussion of the artistic process is similar to that of Federigo Zuccaro in many ways. Like Tasso, Zuccaro argues that the making of images is inseparable from the process of thinking, in which the intellective fantasy and the perception of nature both play important roles. His discussion of *disegno interno* in his *Idea* relies upon the Aristotelian definition of making as a habit of thought.[52] It is an attempt to interpret the process of thinking itself, by which the artist makes figures in his mind or formulates concepts, which cannot be done without mental pictures.[53] These may be put in the memory, but the evidence of the senses continues to support the formation of new ideas. It is not necessarily the case that Zuccaro's theories encouraged the sort of subjectivism Panofsky saw rejected by Bellori, "according to which the artist need look at sensory reality either not at all, or only in order to clarify and enliven his inner images."[54]

What is lacking in Zuccaro's analysis, in comparison with Tasso's, is the principle that there are ideas of style parallel to this process of imaging, and this provides some justifi-

[50] *Ibid.*, 2: 912.

[51] *Discorsi*, ed. 1964, pp. 83-91, and 135-136.

[52] For Zuccaro's description of how a *disegno* is formed in the mind, see Panofsky, ed. 1968, p. 231, n. 42, and *Idea de'pittori, scultori, ed architetti*, ed. Heikamp, 1961, p. 173.

[53] *De anima* 432ᵃ 13; 431ᵇ 2. See also Yates, 1966, pp. 32-33: "The perceptions brought in by the five senses are first treated or worked on by the faculty of the imagination, and it is the images so formed which become the material of the intellectual faculty. Imagination is the intermediary between perception and thought. Thus while all knowledge is ultimately derived from sense impressions it is not on these in the raw that thought works, but after they have been treated by, or absorbed into, the imaginative faculty. It is the image-making part of the soul which makes the work of the higher processes of thought possible." For an important discussion of *fantasia*, with bibliography, see Summers, 1981, pp. 103-143.

[54] Panofsky, ed. 1968, p. 106.

cation for Panofsky's argument that Zuccaro's theory is more aligned to artistic thinking than making. If, however, we turn to the contemporary theories of the Carracci, we find in them the same accommodation of the significance of ideal models to the principle of art as a habit of thought that had been accomplished by Tasso, whose poetic theories the Carracci knew well.[55] In the Carracci academy the Renaissance tradition of the imitation of models was subsumed into the larger educational challenge of the training of the mind toward the realization of a personal style. This personal style was at once individual and judicious, not contingent upon taste or subjective caprice. On the one hand the Carracci sought to free the artist's judgment and stock his memory with universals through a training in the active intellectual process that Zuccaro described. On the other hand, even as Tasso had argued that there were ideal models for style, and that there was a tradition of art by which Phidias might learn from Daedalus, the Carracci also encouraged the study of the works of other artists as ideal models for particular styles.[56] The status of these works was not based on the normative aesthetics of a formula of Classicism, however, but on the fact that they too represented the results of a process of right reason, employing the senses, fantasy, intellect, and memory. If the accumulated memory of tradition could be taught methodically and expeditiously by the straight path described by Testa and Poussin (both heirs to this tradition), then the student would possess a memory that was rich and well-organized. The student would also have a critical understanding of ideas of style that would enable him to put what he had stored in his memory to use in the formulation of his own manner.

In this training of the mind the nourishment of the intellective fantasy governed by judgment that Tasso wrote of was foremost. Through copying by hand from a selected group of ideal models as well as from nature the individual memory was enriched; in this way the individual *ingegno* might continue the art of making according to reason. These two principles are reflected in Agucchi's affirmation of "la perfettione del bello" through the imitation of models in keeping with the reason of nature, and through the uniting of the scattered beauties of both art and nature by the judgment of the individual artist, whose manner is personal, but whose intention to achieve the ideal is held in common with other universal painters with similarly well-stocked memories.[57] Neither the Carracci nor Agucchi sever the principle of imitation of models from the principle of making as a form of knowing. This helps to account for Agucchi's demand for the active participation of educated critics.[58] What distinguishes the understanding of such critics from simple appreciation by the crowd is not the endorsement of an authoritative aesthetic position, but the fact that it is based on the recognition that art is a habit of the intellect.

After Mahon established a close relationship between certain of Agucchi's views and those of Bellori, Agucchi came to be seen, by Panofsky and others, as the harbinger of the law-giving aesthetics of Classicism. In considering Agucchi's writings more closely we must now turn to the second question arising from Panofsky's argument. To what extent is it true that seventeenth-century Italian Classicism was a normative theory, in some way less "live"

[55] Dempsey, 1977, esp. pp. 48-69.
[56] *Ibid.*, p. 69.
[57] See Chapter Three above, and Mahon, 1947, p. 242.
[58] See, for example, the following passage published by

Mahon, 1947, p. 243: "Ma l'huomo intendente, sollevando il pensiero all'Idea del bello, che la natura mostra di voler fare, da quello vien rapito, e come cosa divina la contempla."

than the Renaissance theory it resembled and, at the same time, turning away from the epistemological preoccupations of the so-called Mannerist theory it replaced? In response to the first part of the question one fundamental observation is in order. In his study of the growth of an idealist aesthetic for art Panofsky limited his discussion to criticism of the visual arts. In an historical study of the text of Bellori's *L'Idea*, and its precursors, however, it must be recognized that the question of the formulation of a new Classical style was not limited to discussions of the arts of design. Agucchi and Bellori were not art critics in the limited sense, but professional *letterati* closely allied to the Papal Curia.[59] Broadly speaking, the principles of Classicism in painting, which recognized individual perfection based on judicious imitation and assumed that these individual perfections referred to an ideal, rather than aspiring to licentious innovation, where also those of a new rhetoric that affected all the arts of expression.

This new rhetoric was fostered by the Jesuits, partially in response to the demands for the reform of preaching issued by the Council of Trent.[60] It was established programmatically in the *Ratio studiorum*, first published in 1599. The purpose of the new training, in the formulation of which the treatise *On the Sublime* played an important role, was very similar to that expressed by Agucchi, who had close ties to the Collegium through Gregory XV.[61] The Jesuit orators sought to encourage the formation of a personal style founded on good judgment through the imitation and mastery of selected ancient models, of which Cicero was considered the finest. Through this new urbane eloquence the ancient grandeur of Rome might again be united with the mission of the Roman Church; a Roman rhetoric could serve in the recovery of the Christian empire. This new Ciceronianism was not, however, a return to the exclusive values of Bembo, any more than the new Classicism of the Carracci was a return to the single model of Raphael.[62]

The new Roman Classicism achieved its Golden Age at the court of Urban VIII, himself a former pupil of the Jesuit College. Many *letterati* with close ties to the Jesuits, or to the Accademia degli Umoristi, where the new rhetoric also flourished, found a meeting place at Cardinal Francesco Barberini's private academy in Palazzo Barberini. Among this group were Cassiano dal Pozzo, Lelio Guidiccione, and Leone Allacci—all men whose devotion to the new Classicism held great importance for Testa.[63]

The importance of Jesuit humanist rhetoric, in which a plurality of personal styles was accepted and encouraged under the guiding principle of the Idea in a way that Fumaroli has compared to the gathering of the ribs of a dome into the lantern at its center, cannot be analyzed in detail here.[64] I would not wish to suggest that Testa was in any sense a

[59] See the entries in *DBI* by R. Zapperi and I. Toesca, s.v. "Agucchi," by K. Donahue, s.v. "Bellori."

[60] The most important recent study of the influence of the Jesuit reforms on art and poetry is by Fumaroli, 1978. This study was subsequently republished by Fumaroli in his larger study of seventeenth-century rhetoric, 1980. The great importance of Fumaroli's book for the study of art and rhetoric in seventeenth-century Rome cannot be examined here. I have cited the earlier article throughout because it deals specifically with Roman problems. See also Raimondi, 1966, pp. 27-41.

[61] Fumaroli, 1978, pp. 800-805.

[62] *Ibid.*, *passim*; see especially p. 820 for a translated passage from Possevino's "Cicero" in his *Bibliotheca selecta* (1593) in which Possevino writes of the new style adopted by Paul III and Julius III to respond to a new world, different from that of Bembo and Leo X. Fumaroli defines the Rome of Urban VIII as a Second Renaissance, and makes illuminating connections between the new eloquence and the new classical style of the Carracci, which was promoted by Agucchi and flowered under the patronage of Urban VIII.

[63] *Ibid.*, pp. 813-814, 828-830; see also pp. 806, 809, for the importance of P. Vincenzo Guinigi, the Lucchese in whose villa P. Famiano Strada set his *Prolusiones academicae*.

[64] *Ibid.*, p. 823; on p. 830 he also describes how, "L'ample manteau d'une Beauté miséricordieuse autorise, pour dire la

"Jesuit" artist. He could never have admitted that one of the qualities of eloquence was to adapt style to the character of the audience. As we shall see below, and as should by now be apparent, Testa, like Agucchi, Bellori, and other *letterati* associated not only with the Jesuits but also participating in closed academic society, and like other artists, especially Poussin, sought to appeal to an educated audience prepared to work to understand what he had to say. In this context it is, however, important to suggest how critics close to the Barberini established a close alliance between the rhetoric of literature and the visual arts in terms of a common principle of personally expressive style. Agostino Mascardi, himself a former Jesuit, for whom Urban VIII created a special chair of rhetoric at the Sapienza, was most concerned to demonstrate this. Like Agucchi, with whom he had close ties, Mascardi espoused a *perfetta idea*, founded upon a judicious imitation of the ancients. Like the defenders of Domenichino and Tasso, he was opposed to the *capriccio*, the affected sweetness and eroticism associated with Marino, while at the same time encouraging the realization of a personal style within the norm of the ideal.[65] In his important digression on style in *De arte historica* (1636), which, as we have seen, attracted Poussin's attention, he severs personal style, derived from nature and the individual *ingegno*, from the three major characters, or *genera*, which are not to be called styles, but which are based on art and study, and are independent of the subject in hand.[66]

Mascardi's determination to accomplish this separation was prompted by the sort of critics who rush to pass judgment on great writers on the pretext of criticism of style. Such licentious, ignorant critics pronounce that "This one has no style; this style is too harsh, this other is *malagevole*, this one is confused; this other too hard."[67] Like Agucchi, Mascardi demanded that criticism be educated. Those who really understand the excellences of art do not confuse the quality of style with those elements of art that all excellent painters must possess in common, such as drawing, composition, color, and *costume*. In accordance with the Jesuit orators, Mascardi found the clearest authority for the quality of personal style he sought to define in Cicero's *De oratore*, from which he borrowed a comparative example, giving it new meaning. Cicero pointed to the fact that Myron, Polyclitus, Lysippus, Zeuxis, Aglaophon, and Apelles were all considered excellent in their different ways in defense of his position that there were as many styles of oratory as there were orators.[68] Mascardi applied this principle directly to artists whose works he knew. Raphael, Correggio, Parmigianino, and Titian had all conquered the essential elements of painting, but each had his own style. In his own day the Cavaliere d'Arpino, Reni, Lanfranco, and Pietro da Cortona were outstanding; and yet, while their accomplishments rested on their mastery

même vérité, la même transcendante majesté, toute sorte de détours qui, en dernier ressort, ramenant tous vers leur centre, comme autant de symboles partiels d'une totalité diffractée."

[65] Raimondi, "Alla Ricerca del Classicismo," in *Anatomie*, 1966, p. 32. For Testa's Ciceronianism, see Chapter Three.

[66] See Mascardi, 1636, pp. 329-407 for the whole digression on style; for the independence of character from subject, see pp. 377-381; for the difference between style and character (in which Mascardi disagrees with Scaliger and Vossius), see pp. 397-399.

[67] *Ibid.*, p. 331: "Qual voce è hoggi fra' letterati, e fra gli indotti più dimestica di questa? che non ardisce, ò sappia, ò

non sappia di giudicar degli stili? à qual'huomo, benche di mezzano intendimento non s'odono uscir di bocca le sentenze diffinitive, che dannano gli autori più grandi, e che molto hanno faticato per meritar qualche lode? costui non hà stile; questo è uno stile troppo aspro; quest'altro è stil malagevole; quello è confuso; è duro quell'altro?"

[68] *Ibid.*, p. 405, "Hor pigliato il discorso di Tullio diviso in questa maniera. Quattro sono le cose, che di necessità si richieggono, per far ch'un dipintore sia eccellente nel suo mestiere. Il disegno, il colorito, la compositione, e 'l costume; . . . e se in alcuna di queste parti altri si trova mancante, non si può dire nel suo mestiere eccellente."

of the same elements of painting, there was always something about their works that allowed a knowledgeable person to say, "This is a Lanfranco, that is a Guido."[69] In accepting the possibility that various personal styles could be reconciled with the *perfetta idea*, Mascardi also, in this way, recognized the particular quality of the connoisseur as its corollary. Even as the connoisseur must exercise criticism in the assessment of the essential parts of excellence in painting, he also goes beyond this to make an attribution based on his experience of individual *maniere*.

Mascardi found it easier to recognize style than to define it. Far from setting a series of normative rules, he was interested in the kind of stylistic integrity that, in defiance of complete analysis, could stir his enthusiasm. This is most apparent in his appreciation of Bernini in his *Discorsi morali su la Tavola di Cebete*, which, though well-known, is worth quoting in full because it most completely authenticates his admiration for the works of *ingegno* that bring new life to antique ideals, rather than simply patching them up.

> In the city of Rome I have seen many *botteghe*, which, at first sight, seem to be those of excellent sculptors because you see at the entrance busts, heads, arms, and other broken parts of ancient sculptures. All testify to the skill of the artificers who made them through their honorable remains, whether these have been gnawed by time, or broken into pieces by barbarians, or in some other way. But when I have gone in I have never seen a whole piece of marble from which a sculpture might be made: to this the house of Cavaliere Bernini is the only exception. In his youth he knew how to give a sense of life to stone better than did Amphion with his fabulous song. I saw afterwards the cause of the error: these miserable menders of old stone, abandoned by their *ingegno* and betrayed by art, poor in design, and beggars of invention, wear out their lives making a nose through the Tropean operation; in mending an elbow, in attaching a finger, and, in all, in retouching decrepit figures with new marble, succeeding only in making (as the ancients used to say) a cloth of patchwork.[70]

[69] *Ibid.*, pp. 405-406: "E pur coloro, che ben' intendono l'eccellenza dell'arte, una particolarità nell'altrui tavole riconoscono in virtù di cui, questa Tavola è del Lanfranco, quest' altra è di Guido, quella è opera di Giussepino, quella del Cortonese san dire." See also Agucchi's recognition of each artist's "qualità particolare, e propria à se, che da gli altri lo distingue," in Mahon, 1947, p. 242. Mascardi goes far beyond Agucchi, however, in drawing the conclusion that connoisseurship is the corollary of personal style.

[70] Mascardi, 1627, pp. 320-321, in *Discorso 8*, "Della Critica." Mascardi uses this example to illustrate the way in which literary pedants, like the sculptors who fix up ancient pieces, fix up old texts without adding any wisdom of their own. This calls to mind the principle of digestive imitation, or dissimulation, as opposed to undisguised eclecticism; see Pigman, 1980, pp. 8-9, for a discussion of Erasmus's distinction between a discourse that appears to be a sort of mosaic and one that seems to be "an image breathing forth one's mind or a river flowing from the fountain of one's heart." Raimondi, 1966, p. 64, n. 20 reproduces the original passage by Mascardi: "Ho veduto nella città di Roma molte botteghe ch'a prima faccia sembran di scultori eccellenti; perché nell'entrata si veggono de' busti, delle teste, delle braccia e altre parti rotte di statue antiche, le quali tutto che sieno o rose dal tempo o dalla ferocia de' barbari spezzati, pur non so come nelle loro onorate reliquie la perizia degli artefici da cui furono formate, dichiarano. Ma rivolgendomi bene intorno, non mi venne mai veduto un pezzo di marmo intero da cui un simolacro fabricar si potesse: toltane la sola casa del cavaliere

Bernino, che, nell'età sua giovanile, con lo scarpello sa dar senso di vita alle pietre meglio che non fece col canto favoloso Anfione. M'avvidi poscia della cagione dell'errore: poiché que' miserabili rappezzatori di pietra vecchia, abbandonati dall' ingegno e traditi dall'arte, poveri di disegno e d'invenzione mendichi, logorano l'età loro in rifar un naso all'uso di Tropea; in racconciar un gomito; in attaccar un dito, in somma in rattaconare con marmo nuovo le figure decrepite, con farne riuscire (come dicevano quei buon' uomini) un panno tessuto a vergato." Mascardi's reference to *l'uso di Tropea* in mending noses adds a fascinating dimension to his mockery of attempts to mend statues. This is a reference to the fame of the Vianeo family, who executed successful rhinoplasty in Tropea in the sixteenth century. Campanella testified to the success of the Tropean surgeons, but there was much confusion about the operation, which led some to believe that the nose was to be placed in a hole deep in the arm! For a discussion of the Tropean operation, made famous by Tagliacozzi in Bologna, see Gnudi and Webster, 1950, pp. 115-123, wherein is cited, e.g., the opinion of the famous surgeon Ambroise Paré that the grafted flesh "is not of the same quality nor similar to that of the nose, and even when agglutinated and reformed it can never be of the same color as that which was formerly in the place of the lost nose: likewise the openings of the nostrils can never be as they were originally," *ibid.*, p. 124. That Tagliacozzi had remarkable success with the operation, made most necessary by Sixtus V's decision to punish certain crimes by cutting off noses, and by the frequency of street violence and duelling, does not seem to

Mascardi's enthusiasm for the power of the individual *ingegno* that could bring antiquity to life through emulation and dissimulation, as opposed to the kind of slavish devotion to the past that could only mend its broken remains whether in art or literature, belies Panofsky's view of the new Classicism as a program for art less lively than that of the Renaissance. The Rome of Urban VIII was conscious of its distance from the Rome of Julius II and Leo X; Raphael, Titian, Correggio, and other sixteenth-century masters had joined the ancients as models for emulation. On the other hand, the new generation of critics and collectors could take pride in the *varietas ingeniorum* of the present, which included a Bernini, a Lanfranco, a Reni, and even a Cavaliere d'Arpino. In the new Classicism there was no opposition on stylistic grounds between what modern historians have called Classicism and Baroque, and even the achievements of an artist like d'Arpino, whom Panofsky would consider Mannerist, could be recognized. Within the spectrum of ideal painting traditional order, genius, and the Longinian sublimity of the grand manner were reconciled. Panofsky's comment that "the 'painterliness' of the Baroque was rarely acknowledged, even when represented by Bernini" loses its force in the light of the fact that seventeenth-century Italian Classicism was an ideal with ethical and even political foundations, but not a single style.

The relations between the new Classicism and ethical principles may be quickly sketched. In Mascardi's opinion the traditions upon which the individual *ingegno* could draw to make something new were both natural and moral. Raimondi has shown how the middle way espoused by Mascardi led not only to personal style, but also to a personal morality, in which the traditions of Catholicism and Stoicism were reconciled. Mascardi praised the virtuous man who plays his part on the stage of the theater of life as well as he can and in tranquility.[71] His friend, the poet Cesarini, condemned "l'infinito desio d'ogni piacere" that led to a distancing from nature and to the false pleasure derived from the pursuit of *novità* for its own sake.[72] In their Roman Classicism ethics, poetics, and natural science shared a common faith in the wisdom of the ancients, in nature, and in the individual *ingegno*.

The character of Cesarini, the moral and conservative poet, so beautifully delineated by Raimondi, comes closest to that of Testa, whose moral art, pillaging of ancient wisdom, and embrace of Nature as the only teacher, all find their true context within the broad limits of the new Classicism rather than in the isolated aesthetic of Panofsky's *beau idéal*. Cesarini was deeply affected by his friendship with Galileo, and he wrote that his discussions with the philosopher had led him to "a more secure logic, whose syllogisms, founded on experiences of nature, or on mathematical demonstrations, will open the intellect to the knowledge of truth no less than they may shut the mouths of some vain and impertinent philosophers whose science is opinion, and, what is worse, the opinion of others, not even their own."[73] The position of Cesarini, who died prematurely in 1624, is essentially that of Testa, who shared his faith in the power of the study of nature and mathematical demon-

have impressed Mascardi. My thanks go to Giovanna Perini, wise about all things Bolognese, for helping me to decipher this phrase.

[71] Raimondi, 1966, esp. pp. 61-68.

[72] *Ibid.*, p. 57, n. 16.

[73] Cited by Raimondi, 1966, p. 52, n. 11: "una logica più

sicura i cui syllogismi, fondati su le naturali esperienze o su le dimostrazioni matematiche, non meno aprivano l'intelletto alla cognizione della verità, di quello che chiudessero le bocche ad alcuni vanissimi e pertinaci filosofi la cui scienza era opinione e, quel che è peggio, d'altrui e non propria." Cesarini spent the years 1602-1607 as a guest of Ranuccio Farnese in

strations to unlock the intellect, in the manner of keys, and his rejection of the borrowed opinion of those who talk without knowing anything. At the same time, Cesarini, according to Mascardi's eulogy delivered to the Accademia degli Umoristi, had gathered together "un gran selva di dogmi . . . per valersene in una opera nobile che disegnava."

If it is understood that thinking for, or about, the visual arts in seventeenth-century Rome was not separate from thinking about poetry or natural science, then the second of Panofsky's arguments about Classicism must be rejected. In fact the reconciliation of authority with the new, of tradition and the discoveries of the individual *ingegno*, that Roman Classicism sought to effect was the central intellectual problem of the century, recognized as an epistemological one to varying extents. Testa, as we have seen, tried to reconcile the truth of nature with personal style and judgment in a way that could save the authority of tradition, and may be said to have failed in the attempt. The similarity of his formulation of the problem to that of contemporaries like Mascardi and Cesarini prevents us, however, from dismissing his dilemma as strange, or even evidence of madness. The case of Galileo threatened to destroy any possibility for more successful compromises like theirs, but the ideal of reconciliation was not abandoned.[74]

One of the possible ways to effect the discovery of new things within the bounds set by nature and tradition that Testa did not explore, and which might have helped him out of the impasse that led to the abandonment of his treatise, was the exercise of the intellective fantasy. Tasso, as we have seen, had already reconciled this with the Idea. Among Testa's contemporaries Franciscus Junius, whose *De pictura veterum* was first published in 1637, considered the role of the fantasy, or the imaginative faculty as he often calls it, more fully than any other writer on art. His book has generally been considered only as a compendium of texts from ancient authors, with limited reference to ancient painting; and yet, as the author's own translation of the title as *The Ancient Art of Painting* (London, 1638) indicates, it is rather an attempt to establish the ancient tradition, or art, of painting as the basis for the new. Junius, in other words, argues for the same reconciliation of accumulated tradition and personal style, of the respect for nature and the Idea, as the proponents of the new Roman Classicism. He seeks to accomplish this largely on the basis of the same sources in Cicero, Quintilian, and Longinus, with the important addition of Philostratus the Athenian.

Junius's opening dedication to the Muses, interpreted according to Fulgentius, sets the pattern for what follows, and illustrates how close is his approach to the practice of the art of painting to that of Testa. After identifying each of the Muses with "the severall steps that lead a Novice into the right way of perfection," Junius concludes as follows:

> The whole connexion (of the stages represented by the Muses) is thus linked together. The first degree is, that we desire knowledge: the second that we delight in this desire: the third that we doe eagerly follow the thing wee thus delight in: the fourth, that we doe apprehend

Parma studying Peripatetic philosophy. Like Galileo he broke with authoritarian Aristotelianism, and turned to the study of nature and mathematics, persuading Cesi to follow him in this. When he died, aged 29, Urban VIII had appointed him *maestro di camera*; see the biography by C. Mutini, *DBI*, 24: 198-201.

[74] See, e.g., Fumaroli's discussion of the influence of Huarte on the view of Montaigne and Lipsius that memory impeded the *ingenium*, and of Strada's defense of memory as a "thesaurus et penus Disciplinarum."

the thing followed: the fift, that wee remember that we once apprehended: the sixt, that wee doe invent something like unto the remembred apprehensions: the seventh, that wee examine and discerne our inventions: the eigt, that we choose the best of those things that we have judged and discerned: the ninth, that we doe well expresse the things well chosen.[75]

These words sum up much that has been said above about Testa's description of the steps that a painter must take to reach perfection. The true fame of the artist depends upon his mastery of knowledge, and delight follows upon this. The pursuit of knowledge leads to apprehension, memory, invention, discernment, judgment, and expression. For Junius, unlike Testa, however, this could only be accomplished through the active role of the imagination as well as of memory, and his argument again serves to challenge the notion that Classicism was a purely normative aesthetic, unconcerned with epistemological issues. A rather detailed discussion of his text is necessary here because of the enormous importance of Junius's argument for our understanding of Bellori. While attempts have been made to associate Bellori's method of describing works of art with the rhetorical categories for this defined by Junius, the importance of *De pictura veterum* as a whole for the argument of *L'Idea* has been established only as a source of quotations.[76]

In defining the Idea Junius cites the same passage from Cicero later translated by Bellori in which Cicero describes the referral of works of art to a mentally conceived inner image.[77] Panofsky shows how Bellori altered the meaning of this passage to describe how perceived natural objects are assimilated into an imagined inner image.[78] If we look closely at Junius's exposition, we find that he had already arrived at Bellori's position and that he did this in accordance with the prevailing view, already established by writers like Tasso in the late sixteenth century on the basis of ancient authority, of the relationship between the senses, the intellective fantasy, and ideal style.

Junius concludes his translation of the passage from Cicero in the following way: "There is then in the form and shape of things a certain perfection and excellencie, unto whose conceived figure such things by imitation are referred as cannot be seen. *Plato*, a most grave Author and teacher, not of knowing only, but also of speaking, doth call these figures Ideas." Junius explains the importance of these conceived figures, to which things not perceived by the senses may be referred, for the perfect painter who is able to represent anything he is asked to, without relying on the presence of his subject. The painter must often paint what he has never seen—as Phidias had to represent Jupiter and Minerva—or things that he may only see for a short time, such as the burning of a city, scattered cottages, or a shipwreck. His inspiration here, as in other discussions of the imagination,

[75] Junius, 1638, pp. 16-17. Although the Latin and English versions are not identical they agree as far as the issues discussed below are concerned. I have, therefore, cited Junius in his own English.

[76] See G. Previtali's introduction to Bellori, ed. 1976, pp. LII-LIII, and Borea's notes to the text of *L'Idea*, pp. 13-25. Panofsky also recognized Bellori's debt to Junius (though he established this less thoroughly than Borea), but did not consider the relationship as one between two texts; see e.g., Panofsky, ed. 1968, p. 242, n. 21, where Panofsky states: "It

should be noted, however, that Bellori borrowed those citations which had not yet become the common property of art theorists from the *compilation* [italics mine] by Franciscus Junius." Ellenius provides an important discussion of Junius, 1960, pp. 33-54, 60-96. He makes no reference to Bellori, however, and emphasizes, once again, the antiquarian aspects of Junius's text.

[77] Junius, 1638, p. 20; Bellori, ed. 1976, p. 14.

[78] Panofsky, ed. 1968, p. 107.

is Philostratus's *Life of Apollonius of Tyana*, in which, according to Junius, fantasy is defined as "an Artificer farre exceeding Imitation in wisedome."[79] He also refers especially to one of Seneca the Elder's *Controversies* (in which Bellori would follow him) as support for his argument. This *Controversy* centers around a charge against Parrhasius that he had made Prometheus, not painted him, by torturing a slave to serve for his model. Junius singles out the question raised by one side in the controversy concerning the right of a painter to create a battle in order to paint one, "as if the greatest part of mankind had better perish, than the painter fail."[80] This is, of course, closely related to Testa's challenge to the painter with no store of images to represent blood on armor, or God in Heaven, and his reference to Socrates's discussion of the representation of movement reported by Xenophon.[81] It is in such cases, according to Junius, that the artist needs to be able to call upon a richly stocked memory, a treasury he defined in the same way as Federigo Zuccaro, as a wardrobe or closet, the repository of the fruits of the imagination.[82]

The power of the fantasy by which, according to Junius, the painter could free himself from slavish imitation was not, however, independent of the study of nature. Like Bellori, Junius recognizes that generated things are imperfect, and so only the perfect imitation of conceived or intelligible things can be truly beautiful. Similarly, only the ability to conceive in the mind, rather than the simple imitation of things already made, can produce new inventions—and here Junius means inventions in the radical sense, such as the making of the first ship. At the same time, and again predicting Bellori, he argues that "our mind maketh up the conceivable or intelligible things out of the sensible." Strabo is his authority here, but Junius adduces further evidence from commentaries on *De anima* and *De memoria et reminiscentia* concerning the role of the fantasy in laying up the prints of sense in the memory.[83] He encourages the artist to develop his imaginative powers in order to be prepared for all demands through forecasting all manner of situations and things; in the words of Ovid in exile, the mind is free to go anywhere. From the outset, however, Junius sets bounds on this exercise: not only must the things conceived be based in nature, but the images must be worked up and expressed. This can only be achieved through discipline; the travels of the imagination must be ordered and committed to memory.[84] At this point the close similarity of his views not only to those of Leonardo (who also encouraged travelling in the imagination before sleep in a way that respected nature and memory) but also of Thomas Hobbes (who insisted upon the ordering and registering of the resulting images in the memory), should remind us that we cannot separate his discussion of the formulation of images by the painter from the formation of mental pictures, or thoughts in general, any

[79] Junius, 1638, pp. 20-22; the passage from Philostratus is from the *Life of Apollonius of Tyana* 6. 19.

[80] Junius, 1638, p. 22; Bellori, ed. 1976, p. 16; Seneca the Elder, *Controversiae* 10. 5.

[81] Notebook, 16, 56.

[82] Junius, 1638, p. 24. Mancini also associated the fantasy and intellect with memory in this context, for which see Strinati, 1972, esp. 68, n. 3.

[83] Junius, 1638, pp. 18-19. Junius cites Strabo as follows: "for as our senses doe certifie us of the figure, colour, big-

nesse, smell, softnesse, and taste of an apple; so doth our mind out of these things bring together the true apprehension of an apple." This follows immediately upon his citation of Proclus, *In Timaeum Platonis*, on the importance of the imitation only of intelligible things, and it is easy to see how Bellori came to interpret Plato in accordance with the quotation from Strabo once it is understood that he is following Junius's argument.

[84] Junius, 1638, pp. 26-27.

more than we could in Zuccaro's exposition of the *disegno interno*.[85] Junius's preoccupation with the fantasy belies Panofsky's argument that Classicism renounces epistemology. Nor does Junius's demand for the exercise of the fantasy correspond to the "phantastical Idea" that Panofsky saw as the opposite pole to uncritical naturalism.

For Junius the imagination is inseparable from the evolution of the tradition of art. Imitation may allow a novice to reach the level achieved by his predecessors, but it is fantasy that allows him to progress beyond what is known. His analysis of the education of the painter is derived from Quintilian at this point and closely resembles Testa's statements on emulation.[86] He rejects the slavish imitation encouraged by masters who fetter their students in a maze of laws, denying the supreme values of the individual *ingenium* and nature.[87] In an important passage Junius urges that the imitation of the ancients should involve the avoidance of extremes. Here he rewrites Quintilian rather than quoting him in order to make his argument about the relationship between tradition and innovation refer more specifically to the visual arts.[88] The original passage falls in Quintilian's discussion of the need for moderation in the employment of the ornament of *sententia*; some refuse to use *sententiae* at all because they were not used by the ancients, others use them to excess. In response, Quintilian insists that even in antiquity there were innovations, and one cannot call upon the authority of the past without discrimination; on the other hand, the crudity of the first orators is to be preferred to the *nova licentia* of his own day. The *media via* is best.[89] Junius borrows the passage to support his point about the character of successful emulation that surpasses its models without licentiously ignoring tradition. Demosthenes is replaced by Phidias and Apelles, Cicero by Praxiteles and Protogenes, Cato and the Gracchi by Calamis and Polygnotus. For the extreme proliferation of the ornament of *sententia* Junius substitutes the many painters who "now adayes drown the pure brightness of their Pictures with too much braverie," concluding that "if then wee must needs follow either of both, it is fit that we should prefer the driness of the Ancients before that same new license our times have made choice of." Best of all, however, is a middle way. Junius is translating the analysis into his own present, despite the references to the ancients. The drowning of color by excessive *bravura* can only refer to excessively intense and unstructured chiaroscuro painting in the Caravaggesque paintings of Italy and the North. This is the same quality attacked by Testa in the notes, where he too argues for a middle way in the opposition of light and shade.[90] Bellori took up the same line of attack.

The study and imitation of works of art are described by Junius (who follows Quintilian very closely here) as a great labor. The student needs a good teacher to help him determine what to imitate, to correct his mistakes, and show him how to dissimulate. At the same time he must discover his natural inclination and recognize that even as each artist's personal style is almost inimitable, no one artist provides a perfect model.[91] With all of this

[85] Mopurgo Tagliabue, 1955, p. 158, n. 132, cites an important passage from Hobbes's *De principiis* as an illustration of his argument that, "In realtà il barocco è tutto meno che questa anarchia dell' immaginazione individuale, questo individualismo faustiano caro ai romantici. La sua immaginativa non è per nulla alata o sfrenata pegasea."
[86] Junius, 1638, p. 29.

[87] *Ibid.*, pp. 30-31.
[88] *Ibid.*, pp. 32-33.
[89] *Institutio oratoria* 8. 5. 25-34.
[90] Notebook, 58.
[91] Junius, 1638, pp. 33-41, largely derived from Quintilian, *Institutio oratoria* 10. 2.

Testa would have agreed, and his own view of the early training of the artist follows the Quintilianic model. Where Testa and Junius part company somewhat is over the next step—the step toward independent thought and the discovery of new things. Testa associated this, as we have seen, with crossing the threshold of judgment and the understanding of mathematical principles. Junius introduces a notion of the sublime. He cites from Pliny's letter to Lupercus, in which Pliny defends the daring sublimity of passages in his writings that are grand, ornate, and aspire to dangerous heights. Greatness follows risk, and Pliny, in the passage cited by Junius, compares this to the applause awarded tight-rope dancers at the very moment when they appear to be about to fall.[92] Characteristically drawing back, however, Junius discourages the young from such attempts, for beginners "verie often are so taken up with the love of their Imaginations, that they entertaine them with greater delight than judgement."[93] Junius's criticism of the premature and overreaching quest for *novità* at any price places him firmly in the camp of the Classicists, anti-Marinists, of those like Poussin and Mascardi who embraced the sublime, or grand manner, but within the bounds of the ancient tradition of art. For a defence of judgment in the face of "new-fangled conceits" Junius pointed to the authority of "Longinus" himself.[94]

In seeking to delimit the rightful sphere of the imagination Junius introduces the familiar idea of verisimilitude. He rejects "idle and giddie-headed Imaginations" in favor of "such Phantasies as are grounded upon the true nature of things."[95] The duty to respect nature is placed not only on the artist, or poet, but also on the lover of art. Junius, like Agucchi and Mascardi, and like Bellori, associates unlimited freedom with the pleasure of the vulgar crowd. Because his extensive exposition of the role of the educated critic provides so much insight into Bellori's criticism, for which the author himself provides little in the way of explanation, this analysis of Junius's approach to the practice of the imagination must be extended a little further. Junius places as great a burden on the critic, or well-willer, of painting as he does on the painter and here he is again inspired by Philostratus's *Life of Apollonius of Tyana*, in which the philosopher argues that the viewer of a work of art requires a mimetic faculty that allows him to form his own ideas.[96] He too must exercise his imagination and store up images of beauty, composing pictures based on his own selection from the excellencies of nature and respect for the verisimilar. He must observe and remember all aspects of earth and the heavens, stars, clouds, rainbows, the moving path of the sun through the day, and the coming of night; he must study landscapes—mountains, harbors, woods, meadows and flowers, rivers (including even the noise of brooks), and the forms of cities and villages. He must consider the forms of animals to arrive at an understanding of their perfections; he must imagine the customs of peace and war, including the sounds of drums, trumpets, shouts, and wailing. He must imagine the fall of a city—and here, as if he sees it all, Junius describes in the present tense rape and pillage, whole streets full of captives and spoils, the expressions of the conquerors, the deportment of those who seek to escape and are pursued into the countryside; he reads the minds of those

[92] Junius, 1638, p. 41; see Pliny, *Letters* 9. 26.
[93] Junius, 1638, p. 41.
[94] *Ibid.* Junius insists, however, that the reining in of the imagination is not to be confused with its complete absence in those "ordinary wits" who are not diverted "by the sweet tickling of any sudden and unexpected Imagination."
[95] *Ibid.*, p. 42.
[96] *Ibid.*, pp. 64-72.

who run alone, "lest their flocking and running together should still draw the enemy after them." Junius is not describing an actual scene, nor is he describing a painting. He is propounding to himself the kind of picture the critic must practice designing in his fantasy in order to judge the representations of artists, whose fantasies find expression, but whose mental pictures, including the presentation of the *affetti*, and even of those unrepresentable qualities such as sound, are essentially the same.[97]

When the critic's trained fantasy is joined to a good deal of experience in looking at works of art, he will be able to exercise his judgment, and here Junius refers to Cicero's notion of *intelligens iudicium*, and the discernment of quality by *eruditi oculi* that are not merely keen by nature but by exercise. Unlike the uneducated crowd, which only enjoys or admires pictures, the intelligent judge can also understand the reasons behind them.[98] Junius's intelligent judge who can account for beauty in the manner of Cicero's ideal orator works in a way, therefore, that is parallel to Testa's ideal painter, who can explain the principles of his art and teach them to others. Junius goes so far as to argue that Pliny's statement that there are some things that only an artist can understand must be taken to include the lover of art, who "by a rare and well-exercised Imaginative facultie, is able to conferre his conceived Images with the Pictures and Statues that come nearest to Nature, and is likewise able to discerne by a cunning and infallible conjecture the severall hands of divers great Masters out of their manner of working." He can, in other words, become a connoisseur in the way demanded by Mascardi in his contemporary *De arte historica*, through the recognition of personal style. Junius has also accomplished the same reconciliation of nature, fantasy, and the Idea proposed by Tasso and later embraced by Bellori.

Junius's excursus on the role of the imagination of the critic as the equivalent and complement of the artist's own imagination concludes with a justification for the collecting and enjoyment of works of art, and here he was inspired by the example of his patron the Earl of Arundel, to whose wife *On the Ancient Art of Painting* was dedicated. He argues for the recreative power of art to bring joy and peace of mind, a glimpse of the Golden Age. The possession of works of art by honest men is opposed to the collection of them by those who use beautiful things to help their own plotting and feigning. True lovers of art recognize its civilizing power and also share their collections with others.[99] For this reason it is not necessary for everyone to collect. Nor need the well-willer, or lover of art carry his love into practice—and here Junius is defining the amateur for us. It is the active life of affairs that validates the recreative power of art, and in which the true power of the imagination, now fully conjoined with the realized imaginings of the artist, manifests its strength. When the amateur is confronted by passion, whether this be love, envy, or ambition, he need not become aroused, for he has only "to imagine well-hung chambers and well-furnished galleries," to find peace of mind. Even as the amateur judges the works he collects through recalling from his memory the mental pictures that are the fruits of his own fantasy, so now he can call up in his own imagination the memory of these works. Junius has turned the rhetorical tradition of the value of mental pictures as prompters of

[97] Poussin, for example, represented the urepresentable voice of God in his *Capture of Jerusalem by Titus* (Kunsthistorisches Museum, Vienna), by representing the reaction to it.

[98] Junius, 1638, pp. 73-74.

[99] *Ibid.*, pp. 80-82.

eloquence full circle. Those works about which the well-willer can speak because he has understood their principles through training his eyes and his fantasy now serve his memory, and by that means, rather than through direct appeal to the passions, turn rage to joy. The treasure house of memory and imagination has become its own object.[100]

Junius's scholarly book has received far less serious attention than the more synthetic argument of Bellori. Bellori has found readier acceptance as a source because he provides more information about particular artists and because the polished text of the *Lives* is less frequently interrupted by references to ancient authors. And yet this prose itself, characteristic of the new eloquence of Roman Classicism, and Bellori's close reliance on Junius's formulation of the role of the imagination in the achievement of the Idea, must be taken into consideration if we are to use his text with discretion, and appreciate its motives and character. Panofsky did not undertake this, and so I want to look more closely at the text of *L'Idea* with these considerations in mind. I do not wish to deny the very close relationship between this text and the *Lives*, which were started by 1660 at least, but *L'Idea* must stand as Bellori's most concise formulation in this discussion of the nature of his theory of art, and it is the text to which Panofsky gave greatest attention in his discussion of the history of the Idea.

First of all, we must recognize that Panofsky's description of its "physical bulk" contradicts its character as a lecture that could have taken barely an hour to deliver. Furthermore, in comparison to earlier formulations by, say, Tasso, Testa, or Junius, and despite any future role as a manifesto, *L'Idea*'s importance can hardly be said to depend from its "cumbersome philosophical and historical apparatus."[101] We must also recognize that this "Magna Charta" was based on the common law of precedent: *L'Idea* is not an original statement, any more than is Bellori's famous description of the frescoes in the cupola of S. Andrea della Valle.[102] Although the text is so well known, I must summarize it briefly in order to indicate the character and extent of Bellori's dependence on his sources, something that cannot be conveyed in footnotes to the text and indeed can only be understood through a thorough reading of Junius and Bellori together. Bellori's grand opening concerning God's meditated formulation of Ideas expressed in His creation, the difference between the eternal beauty of celestial bodies and the changeable beauty of sublunar bodies, the existence of the *cause esemplari* of artificial things in the mind of the artificer, was probably inspired by Junius, who starts out with similar praise for God's design, and informed by the tradition of the theory of the ideas of artificial things I have associated with Tasso. Bellori goes on to string together passages from Junius, whom he never cites directly, but whose ancient sources he adopts and whose order of argument he often follows.[103] The famous passage from Cicero mentioned above (*Orator* 3.9) is transcribed and interpreted according to Junius's exposition of the *excogitatis species* as based on nature.[104] There follows a quotation from Proclus concerning the superior beauty of a statue of a man to a natural man, together with Junius's interpretation of it; continuing to follow Junius,

[100] *Ibid.*, pp. 82-85.
[101] Panofsky, ed. 1968, p. 108.
[102] Turner, 1971.
[103] E. Borea established many of Bellori's particular bor-

rowings from Junius, but, like Panofsky (for which see note 76 above) did not acknowledge their consecutive nature and determining importance.
[104] Bellori, ed. 1976, p. 14; Junius, 1638, p. 14.

and only slightly altering the sequence, Bellori cites Cicero's discussion of the virgins of Croton, Maximius of Tyana's similar endorsement of the superiority of the beauty achieved by the artist through the gathering of scattered parts, and Socrates's comments on the same subject recorded by Xenophon.[105] Only at this point does Bellori interject something apparently of his own (if inspired now by Agucchi) by comparing Caravaggio and Il Bamboccio to ancient artists who painted men as they are in nature, and as worse than they are, respectively.[106] He returns, however, immediately to Junius, to a new sequence of passages, but again followed systematically. He repeats Junius's quotation from Cicero (*Orator* 2.8) concerning Phidias's representation of Jupiter and Minerva, followed by the same passage from Seneca's *Controversies*, and the same passage from Philostratus's *Life of Apollonius of Tyana*, in which, as we have seen, Junius found important justification for the role of the imagination. In Bellori's words this faculty "fa ancora le cose che non vede con la relazione a quelle che vede."[107] Once again here Bellori introduces some examples of his own, derived however from Alberti, Leonardo, Castiglione (referring to Raphael), and Agucchi (referring to Guido). These examples all support Junius's argument concerning the role of the imagination in formulating ideas based in nature, and Junius must be seen as his true source, a sort of subtext to the quotations Bellori actually borrowed.[108]

His modern examples given, Bellori turns back to Junius immediately, both to the same passage he had first summarized, and to a later passage, for examples of ancient poets using the models provided by works of art when they wanted to summon up visions of beautiful women. Following the pattern established, Bellori embellishes this with some new examples from Ariosto and Marino.[109] We are now half-way through the lecture and Bellori has hardly deviated from two important passages in Junius. At this point he takes up the argument against Castelvetro's interpretation of Aristotle's *Poetics*. Bellori pleads for a perfection of nature; this may take different forms, for beauty is the perfection of each thing in its own nature. There is nothing here that would be unfamiliar to Tasso, Testa, or Junius. He goes on to point to the importance of the *fantasia* in forming images of the *moti* and the *affetti* based on the study of nature, employing a phrase so similar to Testa's that it must ultimately derive from the same source in Xenophon.[110] In deference to the Academy of St. Luke, Bellori extends the importance of the Idea to architecture, before returning to his definition of the Idea itself as "una perfetta cognizione delle cose cominiciata su la natura." This may be, as Panofsky argues, in blatant contradiction with Plato, but it agrees completely with Junius's interpretation of the Idea based on his assembly of Platonic, Neoplatonic, and rhetorical texts.[111] And here Bellori picks up Junius once again, citing his quotation from Quintilian concerning the derivation of ideal beauty from nature and the perfection of it through *ingegno* and art.[112]

[105] Bellori, ed. 1976, p. 15; Junius, 1638, pp. 6-7.

[106] Bellori, ed. 1976, pp. 15-16. Agucchi compares Caravaggio to Demetrius for having painted men as they are, but his example of an artist who, like Piericus, painted them as worse than they are is naturally not Van Laer but Bassano; see Mahon, 1947, pp. 256-257.

[107] Bellori, ed. 1976, p. 16; Junius, 1638, pp. 19-20.

[108] Borea relates Bellori's citations from Cicero and Seneca the Elder directly to those authors rather than via Junius. The reference to Philostratus she refers both to Junius and the original text. Again, it must be recognized that Bellori is straightforwardly following Junius here, without any direct reference to the original texts.

[109] Bellori, ed. 1976, pp. 18-19.

[110] Bellori, ed. 1976, p. 20, "poiché mai si veggono li moti dell'anima, se non per transito e per alcuni subiti momenti." See Notebook, 56, "perché mai si vedono le cose animate che per transito."

[111] Bellori, ed. 1976, p. 21; Panofsky, ed. 1968, p. 106.

[112] Bellori, ed. 1976, p. 21; Junius, 1638, p. 8.

In the concluding paragraphs of *L'Idea* Bellori moves away from his direct dependence on Junius, though his arguments fall within the broad framework of the problem of the relationship between tradition and innovation, the imitation of nature and models established through our analysis of Testa's notes and Junius's *On the Ancient Art of Painting*. Accordingly Bellori attacks both those who follow only practice and those who borrow the genius of others; he attacks those who lack judgment to form an idea of the best and those who swear by the model, naturalists whose art disappears with it objects. Bellori also takes up the attack, mounted by Agucchi and Mascardi and endorsed by Poussin, on those who approve *novità*, whose uneducated taste enjoys only colors and direct appeals to the senses.[113] Only now does he recommend the study of the emended natural beauty exemplified by ancient sculpture, and he gives equal encouragement to the contemplation of works by "altri eccellentissimi maestri."[114] The emphasis upon the study of ancient architecture that follows is also placed in the context of opposition to *novità* for its own sake, reminding us again of the Domenichino dispute. Bellori laments that the ancients are vilified for having copied from one another without invention while modern architects make up their own ideas only in order to be novel. In his grand conclusion Bellori asserts that the representation of an ideal beauty superior to nature is what makes the ancients great; the Idea is the miracle of art, the providence of the intellect, the example of the mind, the light of the fantasy, and so on. But because the idea of eloquence is as inferior to the idea of painting as words are to the sense of sight, he must stop.[115]

The character of Bellori's own eloquence is what makes *L'Idea* so persuasive. To establish that he relied so heavily on Junius for the material of his text is not to suggest that, confronted with an invitation to lecture, the busy scholar simply turned to an earlier publication he had found important and recast it in a shortened version, stringing together passages and adding a few examples of his own. It is, rather, only through reference to his source, and by understanding the general currency of his ideas, that we can appreciate his manipulation of language to produce a rhetorical work of art quite different from Junius's compendious but simple expository text. This is particularly true if we look at what appears to be one of his most philosophically perplexing and controversial statements, the import of which can now be pinned to a tradition, but which remains a complex example of his ornamented rhetoric. Bellori defines the Idea in the following way (italics mine): "Questa *idea*, overo *dea* della pittura . . . *originata* dalla natura supera l'*origine* e fassi *originale* dell'arte, *misurata* dal compasso dell'intelletto, diviene *misura* della mano, ed *animata* dall'*immaginativa* dà *vita* all'*immagine*."[116] His association of *Idea*/*dea* and emphasis upon the containment of *animata*/*vita*/*immagine* in *immaginativa*, which last becomes the activating power linking all three, realize the same kind of serious playing on words that led Zuccaro to define *disegno* as the *segno di Dio in noi*. In both cases, if for different motives, this play endows the definition with a sort of metaphysical validity through incorporating all meaning in a single word, like a hieroglyph, independent of discourse. The Idea, furthermore, "originates" in nature and becomes the "original" of art by overcoming its "origin." It is "measured" by the compasses of the intellect, becoming in turn the "measure"

[113] Bellori, ed. 1976, pp. 21-22.
[114] *Ibid.*, p. 23.
[115] *Ibid.*, p. 25.
[116] *Ibid.*, p. 14. Italics mine.

of the hand. In this series of arched responses it is again the imaginative faculty that acts as the keystone, animating the idea to give life to the image. It is not surprising that the *Life* of Bellori's friend Domenichino should carry the motto "Conceptus Imaginatio."[117] Bellori raises his eloquence to a climax at the very end of his speech by suddenly denying the power of eloquence itself. Because the idea of eloquence (which he has himself been striving to achieve) is of a lower order than the idea of painting, silent poetry conquers painting in words. Bellori falls silent with the simple word "taccio." Bellori's silencing of himself after summoning up an image of Venus and the Graces and the Loves leaving Cythera to dwell in marble and painting—an image that summons up his own description based on Agucchi's of Annibale Carracci's *Sleeping Venus*—serves to draw attention, not to the power of sculpture and painting alone, but to the power of speech to call their works to mind. It is, in fact, an evocation of a similar paradoxical appeal to silence by one of Bellori's own exemplars. Lucian, in his dialogue *The Hall*, presents an argument about the relationship between eloquence and works of art. One speaker argues that a beautiful work of art (in this case a decorated hall) serves only to stimulate eloquence. He attempts to find rhetorical equivalents for its dazzling beauty, largely through similes and references to Homer. The second speaker, like Bellori, asserts that sight is more effective than hearing, the beauty of things more lasting than words. Paradoxically, however, it is this second speaker who enhances the pleasure of the cultivated spectator by describing the individual scenes, whose themes he identifies. He accomplishes this doubling of appreciation despite his plea, in words echoed by Bellori, that "word painting is but a bald thing."[118]

The description of works of art is the central feature of the *Lives*. Bellori himself states that he was encouraged in this by Poussin, and he draws attention to his models, Lucian and Philostratus.[119] It has also been established that he drew upon more recent descriptions of works included in the *Lives*, notably by Agucchi and Carlo.[120] His motives for working in this way are not to be explained in terms of his antiquarian interests or a commitment to a normative Classicism. They are closely dependent upon his view of the active relationship between painter and critic, between poetry and painting, and of eloquence as a quality of style. Once again Junius's exposition of the role of judicious imagination on the part of painter and educated critic contributes to our understanding of Bellori. In his address to the reader Bellori explains his principles for the description of those works of art he has chosen to "translate" rather than to leave in silence. He wants to be faithful to them, to isolate what is special about their invention and execution, without getting lost in details. He offers his work to those who are erudite and wise about painting, not to those who merely hold opinions.[121] Junius had already made the case for this, following the authority of Philostratus, Lucian, and Callistratus, by arguing that the proper way to look at a work of art is to pick out the remarkable rather than getting lost in the admiration of detail.[122] Bellori's descriptions, like that by Claudian given as an example by Junius, are then not only records of paintings but also a series of models for judging them correctly.

[117] *Ibid.*, p. 305; Previtali, Introduction, p. LV.

[118] Bellori, ed. 1976, p. 8; Lucian, *Works*, Loeb ed., I (London and New York 1913): 199, § 21.

[119] Bellori, ed. 1976, p. 8.

[120] *Ibid.*, pp. 101-103, esp. p. 103, n. 2, and pp. 383-387, esp. p. 384, n. 1.

[121] Bellori, ed. 1976, pp. 8-9.

[122] Junius, 1638, pp. 341-343.

Junius and Bellori differ in one important respect. Junius cites Philostratus's description of *Islands* in support of his argument about the active role of the spectator's well-stocked memory of imagined images in judging a picture as if the scene represented was actually taking place.[123] In this description the orator takes his listener on board ship, sailing in the space of the picture. Sometimes he looks at things in the painting, supplying information about them; sometimes he supplies his own images, also based on his knowledge of nature, but not to be seen in the picture. Bellori declares his determination to speak only of those things that are in the painting, believing that it is wrong to supply more.[124] Nonetheless, writing always in the present tense, he does summon up a vision of the painted scene as if it were really happening, periodically destroying his fiction, and consequently drawing attention to its power of illusion, by withdrawing from the pictorial space to comment on the artifice of the painter.

We need to be reminded, perhaps, of the underlying paradox of Bellori's descriptions. His book was not illustrated and the descriptions were generally read as word-paintings, standing, like those of Lucian's orator, for the works themselves. Despite the admission of the special power of images, for which Junius provides ample proof from ancient writers, based on the fact that they speak a common tongue that can communicate over time and can represent the images of memory and fantasy, it is in fact through words that pictures themselves can be brought to mind. The affinity between poetry, or eloquence, and painting is a mutually dependent one, and when eloquence fails painting cannot stand alone.[125] Although Junius points to the superiority of painting, he also cites Plutarch's view that the only difference between poetry and painting is that painters present scenes as if they were present, whereas poets propound them "as done alreadie."[126] If, as Bellori and his predecessors chose to do, the writer employs the present tense, summoning up images before our eyes, this distinction is collapsed. Bellori frequently draws attention to the power of his eloquence to stir the imagination. In his famous revision of Agucchi's description of Annibale's *Sleeping Venus*, for example, he writes that he could describe the alabaster of Venus's complexion in vivid Petrarchan metaphors, but never make the beauty of her face smile forth, repeating once again that painting is more admirable than eloquence. But then, immediately he points up the paradox of his own descriptive powers by insisting that the reader/visualizer see everything, substituting the imperative "vedi . . . vedi . . . vedi," for Agucchi's conditional "vedrai . . . troveresti . . . conosceresti."[127] We might look beyond this to devices by which, in a complementary way, an eloquent painter like Poussin indicated the unpaintable, or included details unnoticed by those *in* the picture for the attention of those who look *at* it, to summon forth description in words, but this would be to step out of the present discussion into the much wider problem of the role of the new

[123] *Ibid.*, p. 346.

[124] Bellori, ed. 1976, p. 9.

[125] See esp. Junius's quotation from Felix Faber, 1638, p. 117, "*Picture* doth require wit, *Eloquence* also doth demand wit; not an ordinary one, but a high and profound wit. It is a wonderful thing, that *picture* hath ever flourished when *eloquence* did bear a great sway; as the times of *Demosthenes* and *Cicero* teach us; but *eloquence* falling, *picture* also could not stand any longer."

[126] Junius, 1638, p. 54; for the greater power of painting, see pp. 55-59.

[127] Bellori, ed. 1976, p. 102: "Dirai che l'indico alabastro siasi ammollito e tinto leggiermente nella porpora di Tiro, e concetti simili ti farà proferire lo stupore, ma non penso che saprai ridir giamai la venustà del volto: e perciò la pittura tanto dell'eloquenza è piú ammirabile, quanto gli occhi piú atti sono dell'udito a ricevere l'immagini delle cose." Agucchi's description is reproduced by Malvasia, ed. 1841, 1: 360-361.

eloquence in seventeenth-century painting as a whole.[128] One last important point concerning Bellori's *L'Idea* needs to be emphasized. Bellori's quotations concerning the fact that the best writers and orators referred to examples of the greatest statues and paintings in order to celebrate supreme beauty show how, in his view, the fictional beauty of poetry and the feigned beauty of art are mutually referential.[129] In other words, the creations of the artist and the poet are not independently derived from models provided by nature or by God, but exist autonomously as works of art, which refer necessarily to each other. It is in this context that Bellori's own endeavor to write eloquently about works of art must be understood. His notion of the beautiful is primarily associated with the acceptance of the principle of artifice, rather than with a specific ideal style.

This examination of Bellori's text cannot, of course, do justice to his writings as a whole.[130] However, by considering his ideas from this particular point of view I have tried to show how intimately they relate to those of earlier writers from the 1630s and 1640s, especially Junius, but also Poussin, Du Fresnoy, and even Testa. I have also tried to show a continuity of interests among a wider group of writers, from Zuccaro and Tasso, through Roman Classicists like Agucchi, Mascardi, Cesarini, to Bellori. In seeking to establish such a continuity I do not wish to deny significant shifts in thinking, the existence of minorities in conflict with these shifts, or the singular importance of individual figures, especially Bellori.

The question of the precise nature of Bellori's importance is, perhaps, the most pressing in seeking to understand the relationship between art theory and practice in seventeenth-century Rome. As Panofsky recognized, the influence of Bellori upon later French and German criticism was profound. While few would probably now agree with Julius von Schlosser's view that the culture of Louis XIV, possessed of greater vanity than genius, failed to produce any truly grand creations equal to those of other civilized peoples, his observation that the French were quick to assimilate ideas and to formulate them more elegantly and often more rigidly may still stand. To paraphrase Schlosser's quotation from De Sanctis, this assimilation produced not research, but formulas, not speculation but application, producing catechisms, and sometimes propaganda.[131] When the catechism derived from Bellori's work was read back into the period in which it was originally discovered through research, especially by critics propounding their own ideal aesthetic of the beautiful, the historical understanding of the experimental basis for the relationship between theory and practice in seventeenth-century Italy receded.

The study of seventeenth-century painting, sculpture, and architecture in the sixty years since Panofsky wrote his revolutionary essay has produced very rich results. And yet, to a large extent, the arguments he made concerning the severance of theory from practice, the turning away from epistemological issues, the practical character of the imitation of

[128] E.g., *The Return of the Holy Family from Egypt*, Dulwich College Picture Gallery, in which we share only with Christ the vision of the Cross in the sky; the pissing child in *Moses Striking the Rock*, Coll. Duke of Sutherland, seen only by us; the overspilling vase in *Rebecca and Eliezer at the Well*, The Louvre, noticed only by the woman holding it, and ignored by the woman who pours, so that we are also drawn into the action to call attention to it.

[129] Bellori, ed. 1976, pp. 17-19.

[130] See Previtali's bibliography of studies of Bellori in his Introduction to Bellori, ed. 1976, pp. LXXXVII-XC, and his own comments, pp. L-LX. Despite the contributions of Argan, Bottari, Grassi, Ulivi, Palluchini, and Previtali in particular, however, there is no satisfactory study of Bellori's criticism as a whole.

[131] Schlosser Magnino, 1967, p. 627.

antiquity and the High Renaissance, all continue to underline the new historical approaches. We still, for example, align the stylistic categories of the "Classical" and "full" Baroque with a broad division between artists interested in theory and artists who were not, rather than coming to terms with the larger historical situation in which all artists in Rome found themselves toward the middle of the century. Testa, as we have already seen, has been presented as an artist whose interest in theory went hand in hand with a classical style, leading to a loss of his more spontaneous self, which would have been better expressed in a painterly, more "Venetian" manner. Yet to single out a classical style, founded expecially upon the study of ancient sculpture, or upon the more recent models of Raphael or Annibale, as more indebted to theory than other contemporary manners, is to deprive Roman Classicism of the first half of the century of its vitality. This vitality, as I have tried to indicate, drew much of its strength from the tension between the endorsement of a *varietas ingeniorum* that countenanced a Cavaliere d'Arpino, a Lanfranco, a Poussin, and a Bernini and the potentially opposed commitment to an idea of painting restricted by tradition.

This vitality was not unproblematic, and Testa's notes, seen in the context of related contemporary texts, testify to this. In 1620 Alessandro Tassoni argued quite simply that because the arts progress through labor exerted over time, modern exponents of the arts, including grammarians, dialecticians, logicians, theologians, natural and moral philosophers, historians, poets, musicians, painters, and sculptors, were all better than the ancients.[132] Others found the issue more complicated, and in the case of painting this was especially true. The apparent spontaneity of Renaissance painting, as Panofsky saw it, was possible in the absence of ancient painting, if not of ancient poetics. By the seventeenth century painters were on a more equal footing with poets with respect to the problems of imitation. A new Parnassus of moderns had been established, one that included Raphael, Michelangelo, Correggio, Giulio, and Titian. Annibale Carracci came to be counted among this number.

The Domenichino affair provides one insight into the way in which the debate over *novità* might be exploited. Bellori's comments on *novità* in *L'Idea* show how one side might defend itself. Junius provides a creative attempt at reconciliation. Testa's formulation of his *Trattato della pittura ideale*, not as an aesthetic or historical work, but as a treatise on the education of the artist, complementing *Il Liceo della Pittura*, reveals how the new problem of the relationship between imitation and innovation became focussed on artistic training according to the rhetorical model. Junius and Du Fresnoy shared this concern, and Poussin alluded to it. All sought in varying ways, following the examples set by the Carracci Academy, and under the broader influence of the Jesuit reforms, to find a way of liberating personal style within the traditions of the art.[133] The fact that Testa, Du Fresnoy, and Poussin had no academies of their own, and no true pupils, serves only to indicate how thoroughly education had become the metaphor for the discovery and establishment of true methods.

[132] *Pensieri diversi*, 10, "Ingegni antichi e moderni," in Alessandro Tassoni, ed. 1942, pp. 582-628. Fassò, p. 49, and Schlosser Magnino, 1967, pp. 513, 632-633, note the influence of Tassoni's text upon Charles Perrault's *Parallèles des Anciens et des Modernes*. The full extent of the debate over *novità* in seventeenth-century Rome has never been established, however.

[133] Dempsey, 1977, esp. pp. 42-70.

If anything at all can be established through a study of Testa's examination of the training and continuing education of the artist, it is that theory and practice must be united; and that by this Testa did not mean the application of a set of rules, but, put very simply, the habit of thinking about what one is doing. I have tried to show something of the origins of this idea as a prevailing concept in late sixteenth century Aristotelian discussions of art, and its development from Tasso, Zuccaro, and the Carracci through Domenichino, Testa, and Junius to Bellori. Of course the results differed widely, but what is fundamental here is that the epistemological questions and practical problems raised by the adoption of an Aristotelian definition of art as a habit of the intellect concerned with making were not silenced by a genial Classicism, either in theory or in practice. Panofsky sought to tie a sort of Mannerist theory to Mannerist practice, and to see in the reformed Classicism of the seventeenth century a reflection of a new theory. But as the Notebook and contemporary writings indicate, the essential working definition of art stated by Varchi, Barbaro, or Zuccaro had not changed by Bellori's day.

If we look at Testa's own artistic productions, the practical application of his meditations is everywhere apparent. His inventions are new, often unique, but always based in history and poetry. In histories, like *The Death of Cato, Hector and Achilles, The Return of the Prodigal Son* (Figs. 79, 83, 87), he recalled from his memory the ideas of observed transient emotion. In allegories like *The Seasons* or the *Altro diletto* this is also true, and in them he also expressed *concetti* formulated in his mind through understanding, but not fabricated out of whole cloth, and so legible by the educated spectator (Figs. 55-58, 88). In religious commissions he found new ways to appeal to the informed imagination of such spectators. The execution of the prints—Testa's brilliant control of chiaroscuro—reflects his expressed desire to bring not only invention, but also representation under rational control. The very originality of his work is the result of his own determination to put into practice his ability to think.

The Notebook belongs to a tradition of artists' writings on art in the seventeenth century, but it too must be seen as part of Testa's personal endeavor to put theory into practice. He did not, like Bellori, accept a formulation of how to arrive at ideal style from a single, readily accessible source. The texts he read, from Aristotle's *Nicomachean Ethics*, Barbaro's editions of Vitruvius, Plato, Xenophon, and Euclid, among the ancients, to Alberti, Firenzuola, Guidiccione, Ripa, Marino, and Aleandro among the moderns, were texts he chose to read. Although the argument he put forward is not fundamentally in conflict with the encyclopedic philosophy of Junius adopted by Bellori, we must recognize that Testa, like Poussin and Du Fresnoy, set out to master his own philosophy for himself. Domenichino appears to have set an example for this, and, as I have argued, his death served only to encourage others to continue. Testa did not want to establish normative rules to be applied, but through his research hoped to carry into practice his belief that right reason would lead to rational conclusions that would be independent, but defensible and in conformity with the tradition of his art.

In the end Testa was indeed an ancient, addressing an academic elite capable of bringing *eruditi oculi* to bear on his work and seeking to liberate genius only within the confines of tradition. Ancient relief sculpture, the classical Annibale Carracci, and his ancient con-

temporary Nicolas Poussin came to be his greatest sources of inspiration. However, his attempt to work out his understanding of his own art for himself rather than adopting existing, easily mastered justifications, shows how unprepared he was to accept the sort of shortcuts that Panofsky saw in Bellorian Classicism. Others among his contemporaries found easier ways to adapt to the conflict between individuality and tradition. Salvator Rosa, who presented his own genius as free yet balanced (Fig. 109), enjoyed satirical play and professed to disapprove of his own most popular works.[134] Castiglione, who presented his capricious genius nurtured by nature amidst the ruins of tradition (Fig. 110), made a successful career out of conventional ecclesiastical commissions while painting religious scenes crowded with animals.[135] Poussin heroically aspired to a grand manner, emulating his models, both ancient and modern, but favored by the intelligent judgment of educated friends. Testa was less fortunate. His difficulties, however, in being Il Lucchesino in Rome at the wrong moment and with a difficult personality are not the only reasons why he came to see that liberation could only be found in death—the image he presented in *Winter* (Fig. 58), a print that provided the inspiration for Rosa's and Castiglione's prints devoted to genius.

By the end of his life Testa seems, in fact, to have found in the medium of the print a way to bring his *concetti* to the attention of the erudite audience he respected. An unbalanced mind, paranoia about disloyal friends, cannot be ruled out as a reason for suicide, though this could never be substantiated. The profound disappointment over the destruction and rejection of Testa's paintings can be substantiated and surely no personality, however confident, could have overcome it. But the evidence of the notes, together with the prints relating to them, points beyond all this to an unresolvable intellectual despair. The problems inherent in attempting to reconcile a definition of art as a habit of the intellect within the traditions of Classicism were not his alone, nor indeed were they unique to painters. The difficulty of thinking new thoughts about the Old World and the problem of the nature of human understanding itself are both central to the intellectual history of the seventeenth century. Testa wanted to solve these questions for himself, with inadequate resources and without close intellectual companions. From his failure to do so we can learn much about the reasons for the success of rule-bound painting later in the century and about the eventual severance of the art of painting from the inquiries of the natural sciences and the new psychology of the mind.

[134] Roworth, 1978, pp. 69-110.

[135] Percy, 1971, pp. 142-143.

PART TWO

Pietro Testa's Notebook in the Kunstmuseum, Düsseldorf

THE MODERN HISTORY OF THE DÜSSELDORF VOLUME

TESTA's seventeenth-century biographers do not record that he intended to write a treatise, nor do they suggest, as Bellori did in his *Life* of Poussin, that he followed the example of Leonardo da Vinci by writing down his thoughts about painting. The first published indication that he did came in 1928 when Pollak drew attention to a copy of notes and drawings by Testa in the Biblioteca Casanatense in Rome (Codex 1482). Even in the absence of the original Pollak recognized the inaccuracy of the copy, which he believed to have been made in the eighteenth century.[1] The Düsseldorf volume had been attributed to Testa by Lambert Krahe in his inventory of the drawings in the collection of the Electoral Academy, all purchased from himself in 1778, but this inventory was never published.[2] In 1930, however, in the first complete catalogue of the Krahe collection, Budde followed Krahe's attribution, describing the volume as a sketchbook and drawing attention to the notes for the first time.[3] Budde appears to have been unaware of the Casanatense copy, but by 1930 it had been firmly established that there was an autograph notebook in the Staatlichen Kunstakademie in Düsseldorf (transferred to the Kunstmuseum with the rest of the Lambert Krahe Collection in 1932) and a manuscript containing copies of drawings and notes by Testa in the Biblioteca Casanatense in Rome.

This simple and accurate identification of the material was thrown into confusion by Hess in 1934. In his edition of Passeri's *Life* of Testa, Hess noted the original manuscript described by Budde and cited Pollak's opinion about Casanatense 1482. He singled out however, only that part of the copy entitled, "Particolari Perfetioni che fanno la donna bellissima," while adding another section of notes bound into the Casanatense volume, entitled "Proportioni del corpo humano," that cannot be related to Testa at all because it does not appear in the original. Hess also introduced into the discussion an entirely new manuscript in the Biblioteca dei Lincei, the so-called "Trattato della pittura" (Corsini Codex 904). With this reference originated the modern tradition that Testa actually wrote a *trattato*, although, as we shall see, Hess was not responsible for identifying Testa's fragmentary notes this way.[4]

[1] Pollak, 1928-1931, 1: 473, "Cod. 1482: *P. Testa et altri sopra la Pittura*. Gzpgtbd. mit obigem Titel am Rucken, kl. 8°, ff. 1-54. Am Titelblatt: *Trattato di Pittura f. di Pietro Testa Mss. di Cart. 157*. Kopie offenbar 18. Jh. Interessante Zeichnungen von Testa, leider schlecht kopiert. Reden aus der Accada. d S. Luca," no. 149.

[2] For Krahe's inventory see Hauptstaatsarchive Düsseldorf, Inv. No. Bergische Landstände, VIII, 10, Supplément des études, p. 123ᵛ, "Des études de Pietro Testa, 8. 25." For a summary of the history of the Krahe collection see the introduction to Graf, 1973.

[3] I. Budde, *Beschreibender Katalog der Handzeichnungen in der Staatlichen Kunstakademie Düsseldorf* (Düsseldorf 1930), p. 23, no. 132, "Skizzenbuch mit reichem handschriftlichem Material."

[4] Passeri, ed. 1934, p. 184, n. 2.

In the first study devoted to an analysis of Testa's writings, published in 1956, Marabottini did not refer to this new manuscript (and, as we shall see below, it is not to be found in the Biblioteca dei Lincei), but incorporated its title in the title of his article, "Il *Trattato di pittura* e i disegni del Lucchesino." Marabottini was the first to point out that the manuscripts identified by Pollak and Budde in fact contain the same material, the one being a copy of the other. He argued that the Düsseldorf manuscript was the original (something that had never been in dispute) and rightly drew attention to the disjointed character of the notes and to the possibility that other annotated drawings scattered in various collections might well be related to them. In spite of Pollak's observations about the poor quality of the copies of the drawings in Casanatense 1482, however, and in spite of the many differences between the text of the original and of the copy, Marabottini accepted the fidelity of the copy and used it, rather than the original as the basis for his study.[5] Apart from the misconceptions arising from the copyist's inaccurate transcription, this had two important results. The first was that the copyist's practice of joining Testa's brief notes together, as if they constituted sentences, made them completely incomprehensible. Secondly, the title inscribed by the copyist in his copy of Testa's drawing of a cartouche (from Folio I[r]), "Trattato di Pittura f. di Pietro Testa," which both Pollak and Hess had associated only with the copy, now came to be applied to the original notebook as well.

The history of Casanatense 1482 will be discussed below in connection with the earlier history of the Düsseldorf volume, but certain points must be made here before any further discussion of the original manuscript. Above the drawing of the cartouche bearing the title on page 1 of this copy appears the inventory number "Cod. 904." This reveals that the Corsini manuscript cited by Hess is, in fact, the copy now in the Biblioteca Casanatense. The volume must have been taken from the Corsini collection before 1843, for although it is included in the old inventory, it was never assigned a shelf location. We are, then, back in the situation essentially established by 1930.[6] There is a single volume in Düsseldorf containing original drawings and notes by Pietro Testa. There is a single unreliable copy of those notes and drawings in the Biblioteca Casanatense in Rome. This copy is bound into a volume containing other miscellaneous notes, which Pollak recognized to be associated with the Academy of St. Luke. The title page was inscribed when the whole miscellany was collected, for it refers to a manuscript of 157 pages of which only 48 folios contain material taken from Testa. Although the title may have been derived from Testa's notes on the first folios in the Düsseldorf volume, there is no authority for referring to the collection of notes as a whole as a *trattato*.

Budde, following Krahe, called the Düsseldorf volume a sketchbook because it was catalogued in the collection of drawings. This is also misleading because it implies that the pages of notes and drawings actually constituted a sketchbook in the artist's possession, like the sketchbooks of Guglielmo della Porta that also belonged to Krahe.[7] Several of the pages of notes do fall in sequence, and this was respected when the volume was assembled, but

[5] Marabottini, 1954, p. 217, n. 1.

[6] Codice 904 is now listed in the "Elenco dei MSS Corsiniani Mancanti" (Inventario dei Manoscritti Corsiniani, p. 9), where the lack of an original shelfmark and the present location in the Biblioteca Casanatense are also noted. I am grateful to Professore Armando Petrucci for sharing his expert knowledge of the early history of the Corsini library with me.

[7] For the history of the della Porta sketchbooks in Düsseldorf see Gramberg, 1964, textband, pp. 23-26.

more often the pages of notes and drawings bear too little relationship to each other to justify any attempt to reconstitute a sketchbook. It is to avoid suggesting that the collection of notes and drawings now in the Kunstmuseum actually constitutes a treatise or a sketchbook, and to avoid imputing their arrangement in sequence to Testa himself, that the general title Düsseldorf Notebook is used throughout this book.

THE EARLY HISTORY OF THE DÜSSELDORF VOLUME

Testa's interest in reading and writing about art cannot be assigned to any precise moment in his career.[8] The diversity of the material assembled in the Düsseldorf volume makes it impossible to suggest a date for the whole. In most cases the books from which Testa took notes were published long before he was born. Although the drawings sometimes provide a clue, none of the projects to which they are related has been documented securely. Attempts to establish a particular date for individual sheets of notes and drawings can, therefore, only be speculative. Where such an attempt seems possible the date is discussed in the editorial notes to the individual sections.

Given that the gathering together of these notes and drawings was certainly not the work of Testa himself, the question of when they were mounted in this way, and by whom, arises immediately. The sequence was established before the Casanatense copy was made, and this provides a clue, for other manuscripts bound together with Testa's notes in Codex 1482 are based on materials dating from 1675-1688. One of these manuscripts is a copy of Bellori's lecture to the Academy of St. Luke, "Gli Honori della pittura et della scoltura," delivered in November, 1677. The lecture was actually published in Lucca in the same year, but became widely available only in 1695, when it was reprinted together with the *Descrizzione delle imagini dipinte da Rafaello d'Urbino*. . . . Nicholas Turner has identified two other discourses in the manuscript as the work of Giovanni Battista Passeri. One is dated 1675 and entitled *"La Fisionomia overo del aria naturale delle teste. Discorso per l'Accademia Romana nella chiesa di San Luca"* (fols. 61r-67v). The other, *"La Mensogna veridica"* (fols. 86r-88r), is undated, but Turner suggests that it was intended for the celebration of the annual competition in the *Accademia* in 1677. Bellori's "Gli Onori della pittura" would have taken its place.[9] These facts make it certain, therefore, that the miscellany was put together before the end of the seventeenth century, and the various scripts support this view.

If the copy was indeed made in the last quarter of the seventeenth century, rather than in the eighteenth (as Pollak believed), then it is even more likely that the provenance of the Düsseldorf volume is the same as that suggested by Schaar for the main body of the

[8] Marabottini, 1954, p. 240, argues that the notes must have been written c. 1640-50. Hartmann, 1970, p. 17, agrees, suggesting that Testa's attendance at the meeting of the Academy of St. Luke on August 25, 1641, helped to crystallize his theoretical interests. Both Marabottini and Hartmann assume that the collection of notes constitutes a treatise.

[9] Bellori's lecture appears on folios 92r-98v. A note pointing to the fact that the manuscript was published in 1695 seems to have been added later. For the lecture see Previtali's introduction to Bellori, ed. 1976, pp. lxxvii, lxxx. For Passeri's discourses see Turner, 1974. Among the other dated manuscripts in the collection are the following: a sonnet for the festival of St. Luke, 1675; two discourses on anatomy delivered at the academy in 1683; a poem dedicated to Carlo Maratta (celebrating his painting of St. Francis Xavier for the Gesù) by Vincenzo Vittoria, dated January 19, 1679; a letter written by Vittoria to Cosimo III to accompany the painting of *Lo Studio di Pittura*, December 2, 1679; "Discorso per l'Accademia del Disegno in Roma in occasione del concorso dell'anno 1688," by Agostino Scilla. This last has been briefly noted by Turner, 1976, p. 183, n. 33.

collection of drawings that Lambert Krahe brought to the city in 1756.[10] The majority of these drawings, and in particular those by Sacchi and Maratta, were acquired by Krahe from the estate of Pier Leone Ghezzi, who died in 1755. Schaar accepts the traditional view that Pier Leone's collection was based on that of his godfather Carlo Maratta (1625-1713), but argues that he inherited them from his father, Giuseppe Ghezzi (1634-1721) rather than from Maratta directly.[11] This is certainly true of the two volumes of notes and drawings by Guglielmo della Porta also acquired by Krahe from Ghezzi, which Maratta never owned.[12]

Giuseppe Ghezzi himself reports finding the della Porta manuscripts, together with another from the hand of Leonardo, in a chest from the estate of della Porta's heirs in 1689. He was responsible for their present bindings, though not before 1714.[13] Is it possible that Giuseppe also assembled Testa's papers? The copy was certainly made by a member of the Academy of St. Luke, and Ghezzi was elected secretary for life in 1678.[14] At the same time the inclusion of autograph notes by Vincenzo Vittoria in the Casanatense volume raises the possibility that Ghezzi rather acquired the original from Vittoria's teacher, Maratta, to whom there are also many direct references in other manuscripts included in Casanatense 1482.[15] Unfortunately we know nothing of the travels of Testa's papers between the artist's death in 1650 and their probable collection by Giuseppe Ghezzi some twenty-five years later. Baldinucci reports that several of Testa's drawings were engraved after his death in response to a demand from French amateurs.[16] Other compositions were prepared for the press by Testa's nephew, Giovanni Cesare Testa, his only heir in Rome, who died in 1655. The wide dispersal of Testa's drawings must have begun upon his death, and this is reflected in the fact that Krahe obtained only those included in the bound volume, while other sheets of notes and drawings that might have been included in this collection had been dispersed before it was assembled.[17]

Although the 1712 inventory of Carlo Maratta's collection contains no reference to Testa's notes (which indeed it would not if they were already in Ghezzi's hands before the beginning of the century), it has not generally been recognized that Maratta did possess a small book entitled *Documenti di pittura*, not by Testa, but by his friend Nicolas Poussin.[18] This must have been the same book that once belonged to Cardinal Massimi, who lent it to

[10] Schaar and Harris, 1967, p. 75; Schaar and Graf, 1969, no. 13.

[11] See also Graf's summary, 1973, introduction.

[12] Gramberg, 1964, textband, p. 23.

[13] *Ibid.*, p. 26.

[14] Bellori, ed. 1976, p. 634. It was in this capacity that he wrote *Il Centesimo dell'anno MDCXCV*, Rome, 1695, to celebrate the centenary of the academy. He includes Testa's name as a former member.

[15] Vittoria himself, of course, was greatly interested in discussions about the education of artists at this time. His *Academia di Pintura del Senor Carlos Maratti* was written around 1687.

[16] Baldinucci, ed. 1847, 5: 314. These are the drawings first published by Francesco Collignon as *Raccolta di diversi disegni e pensieri di Pietro Testa ritrovati doppo la sua morte*, for which see Speciale, 1977. Harris, 1967, p. 53, n. 33, points to the fact that one state of Bartsch 33, now in the Biblio-

thèque Nationale, published by Collignon is dated 1656. She is surely correct in suggesting that Collignon most fully exploited Testa's name immediately after the artist's death. It was clearly a worthwhile business for Collignon had several of Testa's plates copied, for which see Cropper, 1977, pp. 106-107.

[17] Drawings for *Il Liceo della Pittura* described in Chapter Two, now widely scattered, must once have belonged to the group now mounted in the volume. Two sheets of studies of facial expressions now in the Musée Fabre, Montpellier (864-2-254, 864-2-256) may have been made in connection with Testa's intention to devote part of his treatise to the *affetti*. For these drawings see Cropper, 1974, pp. 378-385, and figs. 21, 22. The fact that several drawings now in Haarlem and Stockholm come from the collection of Queen Christina also points to the interest of Bellori and Maratta in Testa's work.

[18] Galli, 1927-1928, p. 24, no. 108. For the history of Poussin's notes, see Blunt, 1937-1938, p. 344.

Bellori when the latter was writing his *Life* of Poussin.[19] Is it possible that Cardinal Massimi also gathered together some of Testa's literary remains, perhaps when he acquired a painting and a drawing from Giovanni Cesare Testa?[20] Might Bellori have also become familiar with some of Testa's ideas in this way, perhaps even encouraging Massimi to preserve at least some memory of the strange young man he remembered from Domenichino's studio? Did Maratta or Ghezzi then determine to make a copy for the library of the Academy before Massimi's collection was broken up in 1677? These questions will probably never be answered, but they serve as a reminder that this collection of the private papers of a lonely artist who died before his time comes to us by accident rather than by their author's design.

PIETRO TESTA'S DÜSSELDORF NOTEBOOK (BUDDE 132)

Testa's notes and drawings are mounted in a volume comprised of 58 folios of white paper and bound in dark brown leather (355 x 243 mm.). The spine bears an unidentified shelf-mark, "MM 27," and the name "Pietro Testa" in red ink. Inside the front binding appears the modern Kunstmuseum reference: "Pietro Testa, FP 6399-6410, 58 Blatt." On the recto of the first page appear the Krahe inventory numbers: "8," in ink, "Supplément 8 25," in pencil, both in an old hand. The first two pages of the volume are otherwise empty, and the modern system of foliation begins on the third, which is the first to carry a page of Testa's notes. The volume is essentially a scrapbook whose pages have been cut to create window mounts of different sizes for the individual sheets of notes and drawings. Sometimes a large sheet has been mounted across two pages. The work of assembling the notes was carried out with the greatest care, with Testa's papers sometimes mounted on the recto of a page, sometimes on the verso, in order to avoid obscuring any marks at the edges of the sheets as much as possible.

The consistent care with which the sheets were mounted throws into even greater doubt the status of several drawings attached to Folios 27, 28, 30, 31, and 32 at the end of the collection, which are already questionable on stylistic grounds. Some of these drawings are entirely unrelated to Testa's work. Others are variants of original drawings by Testa, but of very poor quality. None of these drawings is mounted in a window cut in the page. Furthermore, none of these drawings, which is to say nothing in the Düsseldorf volume after Folio 25, is included in the Casanatense copy. This means that the original collection of notes made before the end of the seventeenth century extended only to Folio 25, and that five other sheets of drawings were tipped in at a later point. This insertion was almost certainly the work of Lambert Krahe. In the inventory Krahe catalogued the volume as containing twenty-five drawings by Testa and it was probably Krahe who wrote "25 Studien von P. Testa" on Folio 32v. The page mount of each sheet bearing a drawing has been numbered from one to twenty-five in an eighteenth-century hand, presumably Krahe's. The sheets of drawings incorporated after the copy was made are included in this total number, and on Folio 30r there are two numbers on the mount, corresponding to the

[19] For a summary of Camillo Massimi's activities as a collector and patron see Haskell, 1963, pp. 114-119.

[20] Orbaan, 1920, pp. 518, 522, publishes part of the inventory of 1677, which includes "Un paesino, longo palmi 2 scarsi, alto palmi 1½, di mano di Giovan Cesare Testa," and "Un disegno, della Scuola d'Athene, di lapis rosso, di mano di Giovan Cesare Testa." For connections between Massimi and Vittoria, see Blunt, 1967b, pp. 31-32.

drawings on the recto and verso of the tipped-in sheet. Folio 26, now empty, once carried a drawing, for it was numbered 18 by Krahe. The fact that no drawing appears in the Casanatense copy that is lacking in the Düsseldorf volume indicates that this too must have been a later addition.

In addition to Krahe's numbers on the page mounts, there are numbers in the upper right corner of some, but not all, of the mounted sheets themselves. They are not in Testa's hand, but the fact that their sequence does not always coincide with their present order suggests that there was an earlier attempt to arrange the papers, predating both the Düsseldorf volume and the Casanatense copy, which is modelled upon it. The change in the arrangement does not affect any of the consecutive passages, however, and is not significant, given that the earlier sequence was not in any case established by the artist himself.

The numbers on the mounts and any numbers on the original sheets are recorded in the Appendix.

THE TRANSCRIPTION OF THE MANUSCRIPT

The pages of notes and drawings in the Düsseldorf volume present special editorial problems. The notes were not made for anyone but the author to read, and in no sense do they constitute a manuscript ready for the press. Testa often used a single sheet of paper to make notes for several different purposes, and at different times. Sometimes related notes were written in different places, and in different directions on the same page. At the same time, however, some notes more closely resemble a final text than others. At the roughest level are notes of a single word that Testa made as he was reading a book; such a note appears meaningless at first, but can be reinvested with sense once the source is known. At the other extreme are pages of complete paragraphs, the result of several intermediary drafts. The disorder makes it impossible to read the notes, or study their relationship to the drawings, in a strictly consecutive way. Rather than following a nonexistent reading order, therefore, I have tried to reconstruct the order of Testa's thoughts on each folio, grouping related notes in numbered sections.

To these difficulties is added Testa's own erratic pen. Although he set out to educate himself in the classics of Greek and Latin philosophy, the fact that Testa cites exclusively from Italian translations tends to support Passeri's view that he was not highly educated in the formal sense. In Testa's day spelling was by no means standardized, to which the texts of the books he read attest, but his spelling, grammar, and punctuation must nevertheless be considered erratic. Sometimes his inconsistencies and mistakes appear to be the result of carelessness, especially when the text reveals that his passions are aroused. In other instances the sentence structure and punctuation reflect the failure to complete a thought logically, if at all, something that should be expected in private rough notes.

Many of the common misunderstandings about these notes, and consequently about Testa himself, have arisen out of the fact that the copyist of Casanatense 1482 was not only unable to read Testa's hand in many places, but also attempted to edit the notes as if they were all of the same character and level of polish. My aim has therefore been to preserve the rough quality of the notes and of the man who made them, while recovering as much

as possible of their meaning. Although Testa was not a highly educated man, he was not unintelligent, nor was he mad.

I cannot pretend to have succeeded in decoding Testa's mind and meaning in every word. Where the notes present especial difficulties I have not attempted to edit these out completely, but offered them to the reader. In this difficult and often exasperating task I have taken inspiration from Cassiano dal Pozzo's words about his difficulty in deciphering Leonardo's notes. He did all that he could, but added that if there was something that seemed not to make sense or if a word was missing, he left it that way to conform to the original, and so that it might be corrected by someone with better judgment.

Note to the Reader

IN MY ATTEMPT to make this transcription as useful as possible, I have not always followed a strict reading order, though each folio has been treated as a unit, nor have I consistently treated the drawings first in the discussion of each folio. This is because Testa's notes on a single topic, or derived from the same passage in a book, are often scattered over the page, and mixed up with notes on other subjects and with the drawings. I have, then, sought to establish the order in which groups of notes were probably written, and in dividing the notes on each folio into numbered sections I have tried to follow what might be considered Testa's thinking order. Each number introduces a new topic, and each topic may then be broken down further into smaller units identified by letters and roman numerals. In the few long consecutive passages I have numbered the paragraphs. The result should provide a clearer anatomy of Testa's thoughts, as well as making it easier to find the relevant discussion of each numbered section in the Commentary.

The drawings are considered within the context of the whole, and not as independent objects, for in most cases notes and drawings are closely related. A drawing may be assigned a number of its own, or it may be discussed as part of a larger topic. All folios containing drawings are illustrated, together with one or two that do not.

Testa's spelling has been changed as little as possible. Where it confuses the meaning of a word the minimum number of letters required to make the meaning clear have been added in square brackets. The use of *sic* is restricted to refer only to words exhibiting some extraordinary peculiarity that might be taken for a typographical error, such as the inversion of syllables, or to indicate repetition.

Testa uses very little punctuation, and rather than burdening the text with more brackets I present all punctuation and paragraphing (whether in the separation of thematic sections or the division of whole pages of text into paragraphs) as my own.

Where disjointed and/or scattered words and phrases have been grouped together because they relate to the same idea or text, the end of each individual part (usually the end of a line) is indicated by a solidus. Where the text is clearly consecutive the ends of lines have not been indicated. Illegible words, or parts of words, including those subject to physical damage, are enclosed in square brackets with a question mark. Testa's own insertions are indicated by angle brackets. Often insertions or connections are indicated by crosses, asterisks, or letters, and I have generally included these signs to make it clear why a particular section has been inserted in each case.

The Commentary is devoted to establishing Testa's sources, and the purpose of the various notes and drawings. Where no comment is made the number of that section is omitted in the Commentary. Full references to citations are to be found in the Bibliography. The texts consulted by Testa are also listed in Appendix One.

EDITORIAL SYMBOLS

⟨word⟩ A later insertion by Testa.
~~word~~ A cancellation by Testa.
[word] An editorial clarification of Testa's word or words.
[word?] A tentative editorial clarification of Testa's word.

Transcription of the Düsseldorf Notebook and Commentary

Folio 1 recto. Figure I.

1. Drawing of a cartouche bearing the Buonvisi coat of arms surmounted by an ecclesiastical hat, and supported by two putti. Black chalk and dark grey wash, with some pen and brown ink. Above the putto to the right is a line in black chalk, divided into sections and marked with a 4 (upside down as mounted). Below this putto is indicated part of a curved pediment. Inscribed: "Machie dolce che s'unischono con l'isstessi corpi che fanno l'ombra."

1. This drawing may relate to the cartouche, flanked by putti, in the center of the portico in *Il Liceo della Pittura* (Fig. 89). The rich shadows created by the wash, to which the note refers, do not appear there, however. The sculptural quality of the putto to the right, combined with the brief indication of a curved pediment below, suggest, rather, that the drawing is either for or after an architectural sculpture placed over a door or window. For the Buonvisi coat of arms, see also the etching of *The Adoration of the Magi* (Fig. 41).

The drawing itself not only reveals Testa's interest in the projection of shadows, but also, together with the note, suggests that Testa was following Armenini's instructions about the simplified method of drawing in black chalk by which

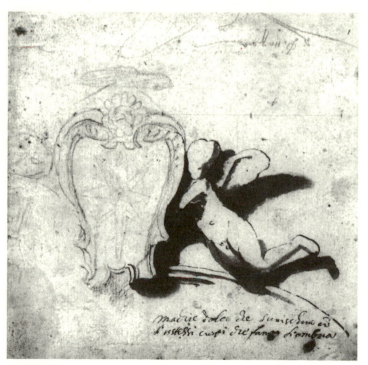

FIGURE I

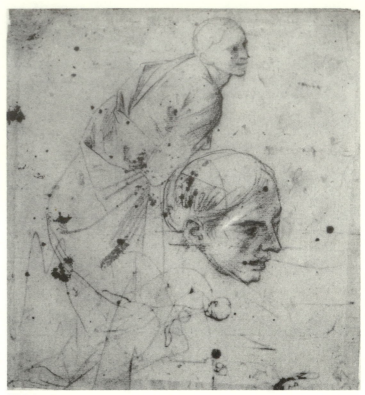

FIGURE II

relief could be achieved through the use of *macchie* and without employing contours. Armenini writes:

Ma à chi vuol diminuir questa fatica di non dover finirli coi tratti soli, poi che il granir li dissegni per tal via ne apporta tempo, & stento poco giovevole; si fà in questa guisa: posti che si hanno li primi tratti vi si pone i secondi un poco diversi da quelli, & di poi con un pennelletto di Vaio spuntato si uniscono quelli, & sfumasi, perche vi si mena sù per tal via, che si converte quei tratti in una macchia, la quale serve come per ombra bene unita, & vien sì ben acconcia sotto, che di poi con pochi tratti, raggiuntovi di sopra si conduce al suo fine, & è più agevole, & atto il sfumare con tal pennello, che non si farebbe con bambace, ò col dito, overo con carta amaccata. (1587, bk.1, ch. 7, pp. 56f.)

Testa appears to have interpreted the *secondi tratti* in terms of lines in pen and ink, but has otherwise illustrated Armenini's description of the technique he had studied in drawings by Michelangelo, Salviati, and the sculptor Giovanni da Nola. It should be recognized that Olszewski's translation of *ammatita*, the basic medium of this technique, as pencil is incorrect (1977, p. 126). Armenini uses the word interchangeably with *lapis*, or chalk, and *ammatita* is not to be confused with the modern pencil, for, as Baldinucci pointed out, it is derived from the Greek *hoematites*, which first gave its name to *matita rossa*. For a discussion of *lapis*, *matita*, and related

media, see Watrous, 1957, pp. 91-106. Testa could also have read the plagiarism of this passage in Bisagno's *Trattato*, 1642, pp. 23-24, which he certainly read, even though he was moved, in 57.B., to make scathing remarks about it. Bisagno's treatise is largely a collection of material borrowed from other writers, and much of his technical information is taken directly from Armenini. Even though Testa may be following one of the two texts here, it was, of course, exactly the kind of book written by Armenini and compiled by Bisagno that he professed to despise.

2. Inscribed in black chalk in the top right corner, upside down as mounted: "di Pittagora."

Folio 1 verso.

Loose charcoal shading.

Folio 2 recto. Figure II.

References: Hartman, 1970, pp. 64f. and 162; Brigstocke, 1976, p 17, and Fig. 25.

3. Studies for the younger shepherdess in *The Adoration of the Shepherds* (Fig. 29). Red chalk heightened with white.

2. Probably derives from Vitruvius's preface to book V, ed. 1567, pp. 205-206, in which he compares the brevity of style suitable for a treatise on architecture to the rules of Pythagoras. Testa certainly read this passage, for which see 34.

3. Hartmann, who first discussed the painting, dates the work and related drawings c. 1637. Brigstocke prefers a date a little later in the 1630s, or even the early 1640s, and this seems likely. There are other studies for the painting in 71 and 72 below.

FIGURE III

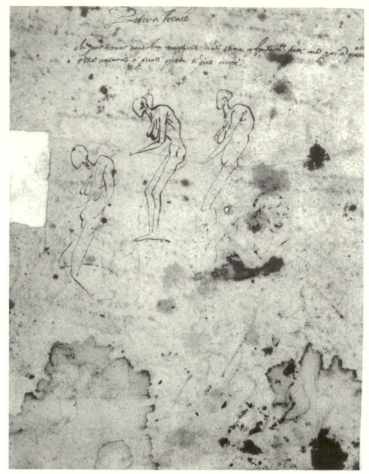

FIGURE IV

Folio 2 verso. *Figure III.*

4. Stooping figure leaning on a staff and approaching an ass-eared figure seated on a pedestal. Pen and brown ink. Only half of the ass-eared figure remains for the drawing is cut at the left edge (the lower edge of the sheet as mounted).

4. The long Midas-ears of the seated figure suggest that the drawing may be connected with an allegory of the arts, but the drawing does not relate to any known composition by Testa.

Folio 2a recto. *Figure IV.*

5. Pittura Ideale.

6. Chi può trovar superbia maggiore di chi stima infinitamente tutti ma poi ad ~~quelli~~ ess[i] esser superiore; e pure questa si dice virtù.

6. Although it is not possible to establish Testa's source here, the note should be compared to Ripa's definition of Adulatione (based in Cicero), ed. 1625, p. 12: "Adulatione, secondo Cicerone nel 2 lib. delle questioni Tusculane è un peccato fatto da un ragionamento d'una lode data ad alcuno con animo, & intentione di compiacere, overo è falsa persuasione, e

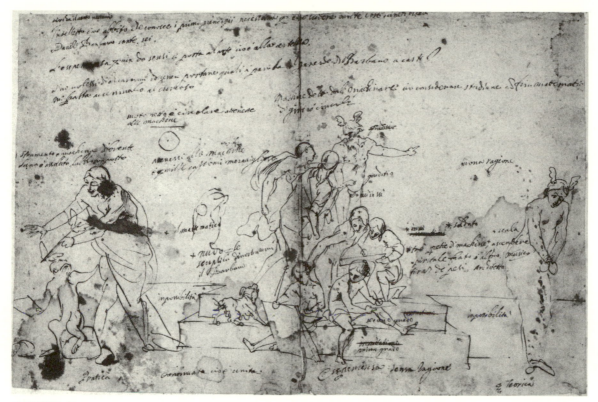

FIGURE V

7. Three drawings of a stooping, hump-backed figure with hanging breasts, facing left. Pen and brown ink.

bugiardo consentimento, che usa il finto amico nella conversatione d'alcuno, per farlo credere di se stesso, e delle cose proprie quello che non è, e fassi per piacere, ò per avaritia." It is also possible that Testa was, rather, considering Aristotle's discussion of irony in *Nicomachean Ethics*, IV, 7, and Segni's comment that this is often interpreted as pride (as in the cases of Socrates and Diogenes), for which see Segni, 1550, p. 208. For the drawing, now in the Teylers Stichting, Haarlem, that Testa made in connection with his study of Aristotle's definition of the opposing qualities of boastfulness and self-depreciation and which may, therefore, be related to this note, see Cropper, 1974, pp. 377f. (and Fig. 14).

7. The drawings almost certainly represent a figure of Invidia, but do not relate to any known composition by Testa.

Folio 2a verso/ 3 recto. Figure V.

References: Marabottini, 1954, p. 244, and pl. LXIV, fig. 2; Hartmann, 1970, pp. 79-81, and 191; Cropper, 1971, p. 267 and pl. 42b.

8. Preliminary drawing for the foreground figures in *Il Liceo della Pit-*

8. The development of the foreground of *Il Liceo della Pittura*, follows the diagrammatic composition of the whole on Folio 4r in 11.C. Like that diagram, it is in the reverse sense to the final print. The notes scattered over the sheet relate both to the drawing for *Il Liceo* and to Testa's reading of Barbaro's translation of Vitruvius, the precise edition of 1556

tura. Pen and brown ink over traces of black chalk.

8.A. circha il vero ne[ce]ssario/ Intelletto cioè abbito che conosce i primi principii necessarii per così vedere molte cose scinetifiche [sic] / Dani[e]l Barbaro carte sei./ L'essperiensa per via de' sensi ci porta al'arte cioè alla certezza.

being established by the page references in 8.A. and 8.B. below. Sometimes Testa's two activities overlap and the whole sheet has, therefore, been treated as a whole in order to preserve this close relationship between Testa's reading of Barbaro and Vitruvius and the genesis of the print.

8.A. The reference to p. 6 establishes Testa's source in Barbaro's own preface to book I of the 1556 edition in which he defines Art. Barbaro, following the Aristotelian tradition, divides the intellectual habits into those that are of the speculative intellect and those that are of the practical intellect. The former are divided by Barbaro into Science, Intellect, and Wisdom. As he read this preface, Testa first noted the discussion of Intellect and Wisdom:

Per sapere adunque concludere molte cose da i propi principij, che altro non è che haver scienza, bisogna prima acquistarsi lo intelletto, cioè l'habito che conosce i principij, che io in questo luogo chiamerei intendimento per non confondere i vocaboli delle cose. Il terzo habito è detto Sapienza, che è pronta e sottile cognitione delle prove alle conclusioni applicate, & come l'acume della Divina intelligenza penetra per entro al mezzo d'ogni cosa, cosi ad uno risvegliamento dello intelletto habituato in molte scienze, & molti principij si ritrova il vero, et i sopradetti habiti sono dello intelletto, circa il vero necessario, cioè circa il vero, che non puo essere, che non sia, ne i quali non si ha ritrovato quello habito, che noi Arte propiamente chiamiamo; dico propiamente, perche hora si ragiona con i propi, & veri vocaboli delle cose. Hora vediamo se ne gli habiti, che sono d'intorno al vero, che contingente si chiama, si trova l'Arte. Dico, che nelle cose fatte da gli huomini, perche dipendono dalla volontà loro, che non piu à questo che à quello è terminata, di manca di quelle necessità, & altre di quelle son pertinenti alla unione, & conversatione, altre convengono alla utilità, & commodo universale. La Regola delle prime è nominata Prudenza, che è habito moderatore delle attioni humane, & civili. La regola delle seconde è detta Arte, che è habito regolatore delle opere, che ricercano alcuna materia esteriore, & si come dalla prima sono gli huomini chiamati Prudenti, Giudici, & Rettori, così dalla Seconda son detti Architetti Soldati, Agricoltori, Fabri, & finalmente Artefici. Dalle già dette cose ritrovato havemo, che l'Arte è habito nella mente humana, come in vero suggetto riposto, che la dispone fermamente à fare, & operare drittamente, & con ragione fuori di se, cose utili alla vita; come Prudenza era habito, che disponeva l'intelletto à regolare la voluntà, perche habituata fusse in quelle virtù, che alla unione, & bene della Republica, & della famiglia, & di se stesso convengono. (ll. 26-40)

Barbaro goes on to discuss the origins of Art, stating "Nasce ogni Arte dalla Isperienza." He asserts, however, that experience is not truly part of an Art, only a way of discovering it, like the tracks of the animal: "Percio che il Cervo non è composto dei orme, cosi l'isperienza è principio di ritrovar le Arti, & non è parte di alcun' Arte, perche le cose a' sensi sottoposte non sono Principij delle Arti, ma occasioni, come chiaramente si vede, perche il Principio delle Arti è univer-

8.B. S'io volessi dichiararmi dover-rei portare quali a' [parola ?] il [parerde ?] che Barbaro a carte 9/ mi basta accemnalo al curioso.

8.C. continuata cioè unita.

8.D. Machine dette dal machinare cio[è] considerare studiare con fini mattematic[i] di giri o circoli.

8.E. tre spetie di machine, + ⟨+scala⟩ ascendere/ * ⟨*soldato⟩ spiritale fiato o altro, musico/ tirar de' pesi, Architetto.

8.F. Strumento e machina dife-rente/ l'uno è assoluto l'altro con-posto.

sale, & non sottoposto a' Sensi humani, benche da Sensi stato sia trovato" (ll. 50-53). Barbaro then introduces the Aristote-lian principle that the true artist can teach the principles of his art, which is therefore closer to the truth.

8.B. This is difficult to read, but it is evident that in order to clarify the statements in 8.A. concerning the importance of both first principles and experience, Testa intends to direct his questions to Barbaro's discussion of the need of both *fa-brica* and *discorso* on p. 9. According to Barbaro in his com-mentary on Vitruvius's Preface to Book I, it is the mastery of both of these sides of his art that sets the architect above the manual expert, on the one hand, and the *letterato* on the other.

8.C. In book X, 1, entitled "Che cosa è machina, in che è differente dall'instrumento, et della origine, et necessità di quella," ed. 1556, p. 254, Vitruvius states: "La machina è una perpetua & continuata congiuntione di materia, che ha gran-dissima forza à i movimenti de i pesi." Barbaro comments: "Bisogna adunque, che la machina sia di legno, ò di qualche materia, che si tegna insieme in qualche modo, altrimenti non si farebbe effetto, perche le cose separate non possono tender ad alcun fine unitamente" (ll. 72-73).

8.D. On pp. 254f., immediately after the passage cited in 8.C., Barbaro writes: "La sollecitudine adunque, & il pensie-ro, che si ha di piegar la natura à nostra utilità, ci fa machi-nare, però volendo noi tirar le pietre sulle fabriche, e alzar l'acque, che tutte sono cose che di natura loro resistono all'uso nostro, è forza, che con la fantasia, che è principio delle arti dal fine investigamo la compositione dello instrumento, la dove la fantasia prendendo alcun lume dallo intelletto habituato nelle mathematice, va ritrovando, una cosa dopo l'altra, & legando insieme per communicar i movimenti, fa quello, che pare ammirabile al volgo, & però dice Vitr. dopo la diffini-tione materiale della machine, *Quella si muove per arte con molti circuiti de giri*. Cioè la forma, & il principio delle ma-chine è il moto circolare."

8.E. On p. 255 Vitruvius defines three types of machine: "Una sorte di machine è per ascendere, questa è detta in Greco acrovaticon, quasi andamento all'insu, l'altra spiritale, che da i medesimi è detta pneumaticon, la terza è da tirare, detta vanauson" (ll. 24-25). A more detailed explanation of each follows, from which Testa drew his examples of their repre-sentative uses. Baldinucci cites both this passage and that cited in 8.F. under Macchina in his Vocabulario, 1681.

8.F. Closely related to 8.C., but drawn more specifically from Vitruvius's explanation of the differences between instru-ments and machines on p. 255: "Di queste trattorie altre si muovono con machine, altre con istrumenti, & pare che tra

FIGURE VI

8.G. moto retto o circolare atte-nente/ alle machine/ attenersi alle/ machine/ e per mille cagioni mera-viglioso.

8.H +il mattematico/ +nudo per le senplici dinostrationi/ il Barbaro/ ~~giuditio~~/ giuditio/ +piu in sù/ *~~in sù osservatione~~/ ~~osservatione~~/ se-condo grado/ ~~inmitatione~~/ primo grado/ inpossibilità/ inpossibilità/ Pratica/ Teorica/ buona ragione/ Es-speriensa sensa Ragione/. In graph-ite at the feet of Theory: "Libri."

machina e strumento ci sia questa differenza, che bisogna che le machine con più opere, overo con forza maggiore conse-guano gli effetti loro, come le baliste, & i preli de i torcolari. Ma gli strumenti col prudente toccamento d'un'opera fanno quello, che s'hanno proposto di fare, come sono gli involgi-menti de gli scorpioni, & de i circoli diseguali" (ll. 48-51).

8.G. This note and the accompanying diagram of a straight line and a circle relate to Barbaro's comments on book X, 8, entitled "Del movimento dritto, e circolare che si richiede a levar i pesi." On p. 259 Barbaro writes: "La propositione di Vitr. è questa, che il movimento dritto, & il circolare, benche siano due cose diverse, & che simiglianza tra se non habbiano pure concorreno à fare i meravigliosi effetti, che tutto dì ve-demo nell'alzar i pesi, ne uno può star senza l'altro" (ll. 34-36)."

8.H. All of these notes relate to details of the drawing. The reference to Barbaro is unclear, except as a general note to his concern for mathematical principles. The distinction be-tween the foreground area given over to experience without

reason and the inner sanctum of the *Liceo* where reason prevails is closely related to the notes taken from Barbaro in 8.A.

Folio 3 verso.

9. Materie per il trattato della Pittura Ideale.

10. .2 .6/ 6 18. Two lines divided into five and eight parts respectively, with several scribbed 8's below. All upside down as the folio is mounted.

10. These numbers can be reduced to the ratio of 1:3 and reflect Testa's interest in the geometrical mean derived from his reading of Segni's commentary on book II, 6, of the *Ethics*. For this see Chapter Two above, and compare also Testa's example of the ratio 1:2 in 54.E.4. below. The division of the lines into five and eight parts suggests that Testa may also have been contemplating the ratio of the golden section.

Folio 4 recto. Figure VI.

References: Winner, 1962, pp. 174f., and fig. 18; Hartmann, 1970, pp. 81f., and 191; Cropper, 1971, pp. 269f. and pl. 42a.

11. Preliminary definition, diagram, and composition drawing for *Il Liceo della Pittura*. Pen and brown ink.

11.A. Filosofia secondo Platone è notitia di tutte le cose cioè Divine, Naturale, Humane.

11.B. Divina cioè separata dai sensi cioè Sapiensa/ Platone/ Naturale cioè Mattematica cioè contenplativa e questa mattematica a carte 308 del' Ripa./ Euchlide/ Humana cioè pulitica cioè attiva, e questa si fa donna con bilance in mano, Rip[a 411] / Aristotile/ qua le virtù morali, e tutte statue

11.C. D[ivina] / Sapiensa/ virtù/ A[ttiva] / Pratica/ C[ontemplativa] / Teorica/ Perfetione/ osservatione/ inmitatione

11. On this folio the basic invention of *Il Liceo della Pittura* is evolved. Together with its annotations given in 11.C. the drawing provides a rational expansion of the simple definition of philosophy given in 11.A. and of the elaboration of that definition in 11.B. The foreground section of this drawing was then elaborated on Folio 2av/3r noted in 8. For a full discussion see Chapter Two above.

11.A. Ripa, *Iconologia*, 1603, p. 163: "Filosofia secondo Platone è una notitia di tutte le cose divine, naturali, & humane." The edition is established in 11.B.

11.B. The reference to the figure of Mathematics in Ripa, p. 308, indicates that Testa was using the 1603 edition here, and this makes it possible to complete the reference to the figure of Politics that was damaged by the cutting of the right side of the sheet.

Folio 4 verso. Figure VII.

12. Two studies of the prow of a chariot. Two studies of women, one veiled and seen in profile, one carrying a vase on her head and seen from the rear. Study of the upper half of a draped figure. Pen and brown ink.

12. The prow of the chariot, seen frontally on the left of the drawing, with its upper part decorated with an animal head holding a ring in its mouth and flanked by two seated figures, and the lower part decorated with a standing figure amid foliated scrollwork, is closely related to those appearing in drawings in the British Museum and The Pierpont Morgan Library (Figs. 47 and 49). Both of these show the poisoned Sinorix being lifted into his chariot as Camma poisons herself, although this type of chariot does not appear in the etching

FIGURE VII

of *The Death of Sinorix* (Fig. 46). The ornament on the chariot in this drawing also resembles that on Venus's chariot in the etching *Venus giving Arms to Aeneas* (Fig. 53). See also the design for a bed at Windsor, Blunt, 1971, p. 122 and fig. 36. None of these other works can be dated with accuracy, however, and if the print of *Venus* is dated to the mid-1630s and the British Museum drawing to c. 1640 (see Chapter One), it would seem that Testa turned to this design at different times. On the basis of the crispness of the pen lines and the partially drawn draped figure on the right, the drawing seems to be closest in style to the sheet of figure studies at Haarlem (Fig. 14), which I have dated c. 1636/7. The female figures do not appear elsewhere in Testa's work.

Folio 5 recto. Figure VIII.

13.A. La veduta si fa mediante un triangolo et in questo consiste tutta la pittura cioè mentre i raggi ànno oppositione.

13. All these notes, with the possible exception of 13.K. are drawn from Testa's reading of Alberti's *De pictura*. No particular edition is indicated, though Testa certainly read an Italian translation. All references below are to the popular

FIGURE VIII

13.B. tre sorte di raggi/ ultimi/ centrici, e più potenti./ mezani/ ultimi.

13.C. questo si dice proportionale/ il rispetto fa le grandezze.

illustrated translation published by Bartoli in the *Opuscoli morali*, 1568.

13.A. Book 1, pp. 312f.: "La onde si suol dire che la veduta si fa mediante un triangolo, la basa del quale è la quantità veduta, & i lati del quale sono quei medesimi raggi che escono da i punti della quantità & vengono sino all'occhio. Et è questa cosa certissima che non si vede quantità alcuna, se non mediante questo triangolo."

13.B. These notes accompany a diagram showing the different types of ray from a single light source spreading out and falling upon a vertical plane. On p. 312, after describing these different rays, Alberti concludes: "Si che noi habbiamo trovati i raggi essere di tre sorte, gli ultimi i mezani, & centrici." The particular strength of the centric ray is defined on p. 315.

13.C. Preceded by two lines of unequal length, each divided into three parts. The diagram and the note represent an abbreviated version of Alberti's views on the proportionality of

13.D. Diagram of rectangular picture plane without explanatory notes on left side of sheet, illustrating the application of perspective construction.

13.E. perché è misura del' orizonte.

13.F. La Pittura divisa in tre parti/ una circonscritione cioè cosa che ocupa luogo e forma il [triangolo] / secondo in che modo si cong[i]ungino insieme diverse superficie, e si dice il componimento/ terzo il ricevimento de' lumi.

each cross section of the visual pyramid to the chosen plane, pp. 320-323. Each section of the short line is here proportional to each section of the longer line, for Alberti states on p. 321: "E perche tutte quelle cose che sono fra loro proportionali, le parti ancor loro son in esse corrispondenti." Testa's interest in Alberti's presentation of the argument that the accident of size is a function of relationship was to bear fruit in the discussion he attributed to Perugino and Michelangelo in 63 below. The division of the lines into three parts may be random, but it may also depend on Alberti's division of the height of a man into three *braccia* on p. 322, especially as Testa goes on to make a diagram of Alberti's system of perspective.

13.D. A brief illustration of Alberti's description of perspectival construction, pp. 322-325. Testa has drawn a rectangle as the equivalent of an open window. He then marked off the base line into *braccia*, established the centric point, drew the horizon line through this, and then connected the centric point to the base line at the corners of the rectangle, not bothering to draw in all the lines to the divisions on the base line. Testa has drawn in one transversal, and the fact that this is at the height of the third of five divisions between the base line and the horizon line on the right side of the rectangle suggests that he was experimenting with the old-fashioned, rule-of-thumb method for establishing the transversals, pp. 323f. For this method see Grayson, ed., 1972, p. 112. The diagonal drawn across the lower half of the rectangle, however, suggests that he went on to read Alberti's description of the correct way to establish transversals, which could be checked by the drawing of such a diagonal, p. 325.

13.E. Repeats the base line, horizon line, and two recessional lines from 13.D., but a row of figures appears along the left recessional line. The heads of the figures are all at the height of the horizon, and the size of the figures diminishes toward the centric point. This illustrates Alberti's observation, p. 325, that in a church the heads of the people all seem to be on the same level as the knees of those who are closest (i.e. to a spectator looking down the nave).

13.F. Alberti, book 2, pp. 330f.

Principalmente quando noi squadriamo qualche cosa, noi veggiamo quella cosa essere un certo che, che occupa luogo. Et il pittore circonscriverà lo spazio di questo luogo, & questo modo del tirare i d'intorni, con vocabolo conveniente chiamerà circonscrittione. Doppo questo nel guardare noi consideriamo in che modo si congiughino insieme le diverse superficie, del veduto corpo, in fra di loro, & disegnando il pittore questi congiugnimenti delle superficie a lor luoghi, potrà & bene chiamarlo, il componimento. Ultimamente nel guardare noi discerniamo piu distintamente i colori delle superficie, & perche il rapresentamento di questa cosa nella pittura, riceve quasi

13.G. velo per far g[i]usta la cosa veduta.

13.H. Moti, esteriori, et interiori./ L'una parte alsata porta seco il resto de' menbri del' isstessa parte.

13.I. del colore. o le cose si vedono per la parte del lume o per l'opposta cioè o chiaro sul scuro o scuro sul chiaro.

13.J. chi camina tien alta la testa/ chi si precipita l'abbassa.

13.K. maggiore/ minore/ lume maggiore/ riflesso/ ombra maggiore.

sempre tutte le sue differentie da i lumi, comodamente noi potremo cio chiamare il ricevimento de lumi. I d'intorni adunque, il componimento, & il ricevimento de lumi fanno perfetta la pittura.

13.G. A diagram of the *velo*, with its vertical and horizontal threads, using a rough sketch of a horse as a model seen through the *velo*. For Alberti's description see pp. 331f.

13.H. Of the movements of the soul and body, Alberti writes, p. 340: "Ma questi moti dello animo si conoscono, mediante i moti del corpo." He gives several examples of the movements of the body, one being that if an arm is raised then every part of the body on that side will follow, p. 343. Testa has made a very schematic sketch of this below the note, showing the right side of a figure with the arm raised.

13.I. This can be related to several of Alberti's statements on light and shade, but resembles most closely his statement in book 2, p. 345: "Debbono segnare diligentissimamente i lumi & le ombre, & debbono considerare che in quella superficie sopra la quale feriscono i Razzi de lumi, esso colore sia quanto piu si puo chiaro & luminoso. & che oltre di questo mancando a poco a poco la forza de lumi vi si metta a poco a poco il colore alquanto piu scuro. Finalmente bisogna avertire in che modo corrispondino le ombre nella parte contraria a lumi, che non sarà mai superficie di alcun corpo che sia per lumi chiara, che nel medesimo corpo tu non ritrovi la superficie a quella contraria che non sia coperta, & carica di ombre."

13.J. Both notes are accompanied by schematic, illustrative figures, greatly reminiscent of those Testa might have seen in Leonardo manuscripts, e.g. Cod. Barb. Lat. 4304, Steinitz, 1958, p. 48. Testa has followed Alberti's recommendation that the painter should observe the movements of the body for himself, and he was probably also influenced by Alberti's discussion of the weight of the head and the need to balance it, p. 337.

13.K. These notes and the diagram they accompany are in lighter ink and finer pen than the rest of the notes in 13. They are not a straightforward illustration of Alberti, but reflect the interpretation of a reader especially interested in chiaroscuro and the *reflessi*. In book 1, pp. 316f., Alberti does touch upon the illumination of curved surfaces that results in an area of highlight and an area of shadow. He goes on to mention the nature of reflected light, though not especially in the context of curved surfaces. Testa's diagram reflects the same interest in studying the effects of light revealed in Poussin's drawing of an artist's studio discussed in Chapter Three. He may have added this note to his page of notes taken from Alberti some time after reading *Della pittura*, recognizing that it belonged under the heading of "ricevimento de' lumi."

Folio 5 verso.

Blank.

Folio 6 recto. Figure IX.

References: Cropper, 1974, pp. 382-385, and figs. 25 and 26; 1976; pp. 374f., and figs. 1 and 2.

14. Schematic illustrations in the left margin of the features of a beautiful woman from her hair to the back of her neck.

14.A. Particulari Perfetioni che fanno la Donna bellissima.

14.A.1. Capelli biondi, sottili, lunghi, rilevati, e senplicemente annodati.

14.A.2. fronte. spatiosa, e serena, conposta di dui quadri, non piana ma a guisa d'arco ver la sua coccha piegante.

14.A.3. cilia con bel'arco e d'ebano, e che dalla sommità vadino al'esstremi con dolcezza diminuendo.

14.A.4. ochio. pupilla tanè osschuro, o di color cilestre, grande, e rilevato e di forma ovata.

14.A.5. orechia. color incarnato, molle, e mezane.

14.A.6. guance. rilevate con dolcezza, candide, e vermiglie.

14.A.7. naso. che penda al piccolo, e afilato un tantino di come nodo e quasi invisibile nel principio della cartilaggine, la qual deve essere di colore simil al orechio cioè incarnato ma mancho acceso. è la sua base piana.

14.A.8. boccha che penda più tosto al piccolo, né aguzza, né piana, e senplicemente aperta solo deve mostrare dal di sopra 5 in 6 denti, di color vermiglio chiaro.

14.A.9. denti uniti, e candidi e

14. All the notes and accompanying drawings are derived from Testa's reading of Agnolo Firenzuola's *Dialogo delle bellezze delle donne*, first published in his *Prose*, I, 1548. The dialogue is arranged in the form of two *discorsi*, both of which Testa read. He gives no indication of which edition he used, and so all references below are to the modern edition by G. Fatini in *Opere scelte di Agnolo Firenzuola*, 1966, pp. 477-549.

14.A. *Discorso secondo della perfetta bellezza d'una donna*, pp. 522-547. Testa follows Firenzuola's enumeration of the

FIGURE IX

come legati dalle gengie d'un nastro incarnato.

14.A.10. mento non aguzzo ma tondo e nel suo rialto colorito di vermiglio con piccola fossicella in mezo.

14.A.11. gola tonda, svelta, candida, e sensa macchia, e al confino del petto una fossicella piena, per dir così, di neve, con certe rig[h]e o cerchietti che la circondino nel piegare e siano (ma quasi insensibilmente) segniate d'incarnato.

14.A.12. spalle quadrate ma dolce.

14.A.13. collo bianco e un poco rosseg[i]ante, e la valletta che il divide non troppo fonda.

Folio 6 verso Figure X.

14.A. Continued. Schematic illustrations in the left margin of the features of a beautiful woman, from her breasts to her arm.

14.A.14. petto biancho machiato di rose, rilevato, e largo, e carnosissimo che sosspetto d'osso non ci sia, e g[i]unga al' esstremo del rilievo con dolcezza non sensibile, e le mammelle con rilievo al' in su acerbette e come desiderose di scappare, e di forma ansi che non piccole, con quella piccola rosettina nel' esstremo.

14.A.15. forma di belli vasi che manifestano come nascha il collo sul petto e il petto su' fianchi.

14.A.16. canba lunga e biancha quanto neve e i talloni rilevati solo quanto si scorgano.

14.A.17. piede piccolo snello e non magro.

14.A.18. mano grande e pienotta e biancha.

individual features of a perfectly beautiful woman, except in the case of the hand and the arm, which he treats in reverse order.

FIGURE X

14.A.19. bracc[i]a carnose, e mus[c]olose, ma con dolcezza e su magg[i]ori rilievi, tinte d'incarnato, il resto bianchissime, e sode, ma atte a essere avallate calcate con dito, ma che ritorna alla sua superficie.

14.B. Bellezza fondata nel'armonia come nella musica il grave l'acuto e altri toni generano quel'armonia di voce/ candida è quella cosa che unisce la bianchezza con lo splendore come l'avorio.

14.B. *Discorso primo della bellezza delle donne intitolato Celso*, pp. 484f., and 486. On p. 484, after referring to Dante's opinion that beauty is harmony, Firenzuola gives his own definition of beauty: "Diciamo che la bellezza non è altro che una ordinata concordia e quasi un armonia occultamente risultante dalla composizione, unione e commissione di più membri diversi e diversamente da sé e in sé, e secondo la loro propria qualità e bisogno, bene propozionati e 'n un certo modo belli; i quali, prima che alla formazione d'un corpo si uniscano, sono tra loro differenti e discrepanti. Dico concordia e quasi armonia, come per similitudine; perciò che come la concordia fatta dall'arte della musica, dell'acuto e del grave e degli'altri diversi tuoni, genera la bellezza dell'armonia vocale; così un membro grasso, un sottile, un bianco, un nero, un retto, un circonflesso, un picciolo, un grande, composti e uniti insieme dalla natura, con una incomprensibil propozione, fanno quella grata unione, quel decoro, quella temperanza che noi chiamiamo bellezza." On p. 486 Firenzuola turns to the question of the ideal color of a woman's cheeks: "Con ciò sia adunque, per tornare al nostro proposito, che alle guance convegna essere candide, candida è quella cosa che insieme con la bianchezza ha un certo splendore, come è l'avorio; e bianca è quella che non risplende, come la neve."

Folio 7 recto. Figure XI.

15. Diagrams in the left margin showing the construction of a cone, light falling on a vase, the effects of light from different sources, and the illumination of a hemisphere, all relating to the notes in 15.

15.A. punto/ asse/ cono.

15. Although all the notes and diagrams in this section relate to Testa's investigation of the effects of light, they are not all drawn from the same source.

15.A. These notes accompany a diagram of the circular base, diameter of that base, and the vertical axis of a cone. They reflect Testa's reading of Barbaro's commentary on Vitruvius IX, 8, "Delle Ragione degli Horologi, & delle ombre de Gnomoni al tempo equinottiale a Roma, e in alcuni altri luogi." The edition is different from that cited in 8, for only the second edition of 1567, and its later reprintings, incorporates Barbaro's discussion of Ptolemy's analemma that relied upon Federigo Commandino's revised Latin version of the *De analemmate*, published together with Commandino's own *De horologiorum descriptione* in 1562. For the importance of Commandino's edition, and its influence on research into conic sections see Rose, 1976, pp. 198f.

On p. 399, ed. 1567, Barbaro describes the construction of a cone: "Cada poi dal punto a. al punto e. che è il centro del circolo, una linea dritta; questa si chiama asse, o perno del Cono, & il punto a. cima, & il circolo b c d. basa del Cono, da questo anche si forma una superficie detta Conica." This is accompanied by a diagram upon which Testa based his own.

FIGURE XI

15.B. Le ombre che terminano col chiaro sono più sensibili cioè più apparente, e per il contrario.

15.C. chi mancha del scuro intiero è quanto levar nella musicha i bassi, i quali medesimamente sono più sensibili con le voce più acute e di qui procede quella grande armonia; che fra le ombre o non si vedono o molto mortificati i colori.

15.B. Testa could have been prompted to make this note about the simple principle of contrast by several sources, including, e.g. Lomazzo, 1584, bk. 4, ch. 2, p. 213: "imperoche le ombre vengono in necessaria consequenza dei lumi, essendo causate da gli sfugimenti d'essi lumi; e pigliando tanto più forza, quanto più il lume percuote maggiormente sopra un corpo." The judicious and economical juxtaposition of the strongest light and the darkest shadow was, of course, recommended by Alberti as the best means of achieving a sense of relief (p. 345).

15.C. This relates closely to Testa's understanding of beauty as harmony expressed in 14.B. The need for both high and low notes in creating such a harmony was explained by Barbaro in his commentary on Vitruvius, V, 4, ed. 1567, p. 228, which Testa refers to in 43: "La voce continua, & d'uno istesso tenore non è sottoposto alla consideratione della Musica, perche dove non è grave & acuto non è consonanza." Armenini, 1587, bk. 2, ch. 7, p. 106, also uses the musical analogy (copied exactly by Bisagno, 1642, p. 93): "percioche una bella varietà

15.D. quanto è facile a dare in in-
proprietà et che però si debbe ogni
minutia bene considerare l'esempio
+ esendo al'aria di campagnia.

15.E. che sia maniera di fare e
come si generi, e quanto si debba
[abborire?] e come sia l'opposto del
copiare; qui l'intendo diversa dalla
pratica si deve havere perché
questa consiste in aver facilità in far
le cose che convengono e quella è
un furor matto.

di colori accordata, rende à gli occhi quello, che all'orecchie
suol fare una accordata musica, quando le voci gravi corris-
pondono all'acute, & le mezzane accordate risuonano."

15.D. The cross after "l'esempio" refers to a diagram in the
left margin that shows a vase illuminated by a ray of light.
Given that Testa appears to have been reading Armenini (or
Bisagno) when he made the notes in 15.G., and possibly in
15.C., it seems most likely that this warning, which, as the
illuminated vase in the diagram indicates, refers especially to
the treatment of chiaroscuro, is based also in Armenini. In
bk. 2, ch. 1, p. 84, after the discussion of the effects of dif-
ferent sources of light mentioned in 15.G., Armenini cautions
the painter to consider what type of light is suitable for the
particular *storia* he is depicting: "perche in una Istoria, nella
qual si finga esser le persone alla Campagna, overo in altro
aperto luogo, non mi par che ci stia bene un lume che sia
debole, e poco, ma più tosto gagliardo, & fiero. Conciosia
cosa, che in essa fingendovi aria, monti, e paesi, si può com-
prendere, che ivi ferisca i raggi del Sole, se ben non lo fanno
veder sul Cielo, il qual batte il suo lume fierissimo, & molto
acceso, dove che all'opposto, non avvien cosi à quelle che si
fingono al coperto, come son quelle che sono ne i tempij, e
nelle case, alle quali la strada del poco lume, à me pare che
vi faccia benissimo, & che si imiti quel natural vero, che pare
che pur cosi sia, e che si convenga." This advice is para-
phrased by Bisagno, 1642, pp. 62f.

15.E. The important distinction Testa makes here between
copying as an important foundation of good practice, and
maniera di fare in the pejorative sense of a sort of madness
also reflects his understanding of Armenini, especially con-
cerning the folly of those who try to copy the *maniera* of
Michelangelo. In bk. 1, ch. 7, p. 52, Armenini stressed the
importance of learning to copy drawings of various parts of
the human form, "di tratti facili, & sottili da huomo prattico."
The aim of this kind of imitation is to produce a copy indis-
tinguishable from the original. One of the benefits resulting
from such diligence is that it keeps the hand agile and also
restrains those who have a "furia" for drawing, another ex-
ample of the moderation of extremes discussed in Chapter
Three. Armenini criticizes the lack of diligence and the care-
lessness he perceives in the work of his contemporaries in
bk. 2, ch. 10, but Testa's comment about *maniera* is more
closely related to his discussion of imitation in bk. 1, ch. 8.
Here Armenini cites Perino del Vaga as an example of an
artist who created his own style by drawing from (*ritrarre*)
many works of art, p. 65: "in modo tale, con quella sua leg-
giadra maniera, ch'era cosa difficile da' ben prattichi à co-
noscere di dove egli cavate le havesse, sì che si conchiude
alla fine, che presa che si hà la bella maniera, si può servire

con facilità delle cose altrui, & con poca fatica adoperarle; come sue proprie, & farsi honore senza riportarne biasimo da niuno."

Maniera in the bad sense, according to Armenini, could result from attempting to form a personal style on the basis of copying the style of a single artist, but without mastering every aspect of the chosen model. This is very often the case with those who seek to imitate Michelangelo, but only in part, and who try to mix his style with elements from another. Armenini says of such foolish combinations, p. 67 (slightly altered by Bisagno, 1642, p. 30): "Et per certo ch'io non sò qual sia maggior pazzia, che di questi tali, i quali si veggono essere così ciechi alle volte, che pongono per le loro opere delli ignudi, che sono ridiculosi, à i quali li fanno i lor capi leggiadri, dipoi le braccia morbide, & il corpo, & le rene ripiene di muscoli, & il rimanente poi si vede essere con dolcissimi contorni lasciati, & con ombre leggieri. Et con questi modi essi si credono, & tengono dover haver trovato il fiore di tutte le maniere."

For a summary of the origins of the idea of *maniera* as a form of bad practice, beginning with Dolce, see Smyth, 1963, pp. 4-7, and notes, esp. n. 26 and n. 38. It would seem, however, that Testa's understanding of the "goffezze" of the *maniere* of those who assemble diparate elements of style described by Armenini should qualify Smyth's statement, p. 41, n. 26, that seventeenth-century writers did not attribute the decline in painting "to exclusive, uncomprehending imitation of one previous style or to imitation of previous masters at all." See also the comments of Olszewski in his notes to the relevant passages in Armenini, 1977, pp. 123-125, 136-139, 196-198.

15.F. tutti i lumi si difondono se i corpi non l'inpediscono, il che facendo fan l'ombra che è la parte che non vede ma in tanto non è intiera in quanto altre reflesione che sono infinite la vanno temperando; questa in somma è l'unione maravigliosa.

15.F. This should be compared to Armenini, 1587, bk. 2, ch. 2, p. 85 (slightly altered by Bisagno, 1642, p. 63): "Dunque egli è da saper prima che non si può fare ombra mai altrimenti, se non quando un corpo impedisce che la luce non si vegga, di modo che, quanto quel corpo è più grosso, & spiccato, tanto l'ombra si fa più densa, & negra: Ma in questa ci vuole una certa destrezza di mezi, che quando arrivano vicino à congiungersi co i lumi, elle vengano morendo di modo, che lascino à poco à poco il scuro, e rimangan come in fumo, & ciò sia con tale unione di mezi chiari, che non si possa discernere dove finisca l'uno, e cominci l'altro, la qual arte per essercitatione, e per isperienza, e giuditio si conseguono, perche à voler far ciò bene, convien che si vada caminando a i più scuri con gran risguardo fino à gli estremi." For the idea of *unione* and *sfumamento* see also, however, Accolti, 1625, pt. 3, ch. 12, p. 108. Again, the idea expressed here is a familiar one, and Testa is not quoting a source verbatim, as far as can be established; but the close similarity of notes

15.G. lume/ ombra/ sensa armonia/ di torca/ crudo/ con reflessi, con armonia. di sole/ debbole/ di lume eletto/ ~~suave~~/ vero.

15.H. Per la ragione che i corpi si vedono per il suo contrario cioè il chiaro sul lo scuro e per il contrario, debbono i contorni esser del tutto levati via con una certa insensibile maniera che pochissimi sanno, essendo che i reflesi levano che non g[i]unga al contorno quel' intiero scuro che g[i]unto genererebbe crudezza per il suo contrario, come si è detto, che si oppone.

15.C.-15.G. to passages in Armenini suggests that he, or Bisagno, may be Testa's source.

15.G. The types of chiaroscuro that result from three different sources of light are illustrated diagrammatically here. An unbroken line shows the crude manner in which torchlight illuminates, creating strong light and strong shadow, but without any mediating reflections. The line divided into four parts shows the weak chiaroscuro resulting from sunlight, caused by the multitude of harmonious reflections that make the distinctions between light and dark imperceptible. The third line, divided into two equal sections, illustrates the ideal effects of chiaroscuro that result from a selected light; the division of the line indicates that the major areas of light and shade can be distinguished from each other, with neither too many reflections nor too few. Testa incorporated these observations into a more extended text in 58 below.

Alberti had pointed to the effects of different types of light, especially from the sun, the moon, the morning star, and from lamps and fires (p. 318), but the true study of this is most closely associated with Leonardo; see, e.g. Richter, 1883, §117, 118, for the description of different sources of light, and §516 for their effects, in which Leonardo also stresses the importance of the mean for the representation of relief. Armenini incorporated these ideas in his discussion of light in bk. 2, ch. 1, pp. 80-94 (Bisagno, 1642, pp. 51-62). Armenini mentions the use of torchlight, firelight, etc., by Titian, Correggio, Parmigianino, and Maccarino (according to Olszewski, 1977, p. 154, n. 1, Beccafumi), but says that very few artists succeed in using this kind of light in a pleasing way. Testa's outright condemnation of this type of light, which is not found in the sixteenth-century sources, was probably prompted by his dislike of the crudity of chiaroscuro among painters influenced by Caravaggio. Armenini points to the fact that sunlight is treated in two different ways; some artists present it as very bright, others as much more shadowy, or *debole*, which is how Testa describes it. Armenini recommends working with natural light, placed high but not directly above the subject, from a single source, in order to be able to achieve a combination of sweetness and relief. The artist must use his discretion to procure this effect even when the particular light does not reveal it to the senses. For the transmission of these principles derived from Leonardo see also Lomazzo, 1584, bk. 4, esp. chs. 5, 6, 7, 20, 21. See also 40 below for Testa's search for a combination of sweetness and relief.

15.H. This principle, that contours should be eliminated because forms are made visible through the contrasts of chiaroscuro, which must not, however, be extreme, follows logically from the notes above in 15.F. and 15.G. It can also be related to the advice given by Armenini concerning drawing

15.I. che lo scuro sia più sensibile, cioè più apparente dove sia maggior lume; questa ne è semplice dimostratione.

16. Io dico che chi sa, cioè chi à le prime notitie, hopera sensa oggetti e tutto nel suo genere farà otimamente e qui parrà a chi considera l'acidenti cosa troppo vasta e da non capirsi da un intelletto, ma cio non è, perché infinite cose stanno stotto [sic] un certo numero come si mostrerà. E chi non ha queste ragioni, dico non poter hoperar bene né meno col' aver l'ogetti avanti li ochi. Questo si prova con più ragioni, per ora una sia questa: dipingerà un capitano moribondo che fra lucidissime arme versi il suo sangue, potrà far e le armi, ma non saprà far reflettere il rosso del sangue in esse, per non veder quel acidente + [followed by a symbol of a vase].

Dico dunque si debbe alle ragioni aver sem

Folio 7 verso.

sempre l'intelletto per operar felicissimamente avendo in sé la ragione di tutte le cose, e come ricchissimo mercadente ch'abia in suo fondico ogni sorte merci, quelle le usi e adopri a suo talento sensa infelicemente andar accatando dallo scarparo, dal legni[ai]olo e da ogni vilissimo professore la sua arte, non avedendosi il meschino che (come s'è detto) debbe esser lui norma e regola a tutti li altri; e pure a confusione di tali, noi vediamo il sediaro, il vasaro farsi propria la sua professione. E io ho visto con risso [= riso] e compassione che a un dio Padre farli il g[i]ubbone allac[i]ato con stringa, messo per via di puntelli a giacere e dal patimento tremare con rui[na] della machina del vecchio e della povera dipintura.

in chalk that Testa illustrated in 1. The note is closest of all, however, to Lomazzo's advice concerning the elimination of contour through the correct use of chiaroscuro in Book 6, ch. 20, "D'alcune regole universali della pittura," which immediately precedes the chapters devoted to the question of adapting paintings to their locations that Testa certainly read and criticized, for which see 57.B. Lomazzo writes, 1584, p. 337:

Poi è d'avvertire che doppo fatta l'inventione, & quella stabilità, ò fiera, ò soave, sopra il tutto non si gli lasci contorno nelle parti ò d'intorno che questi solamente per regola, & norma della forma, & ordine c'hà da servarsi nella figura sono stati introdotti. E ciò si può veder chiaramente nel naturale, dove altro non si scorge se non divisione da l'un corpo à l'altro, & lume, & ombra che quello circondano secondo le sue parti. Principal cura oltra di ciò hà d'haversi nell'esercitio di quest'arte che i lumi con prudenza si dispensino con le ombre, & gl'oscuri à suoi luoghi fieri, & intensi si come ricerca l'ordine del disegno, & l'altre parti di subito sfuggano, & si perdano di tal modo, che ne venga poi à nascere quel miracoloso sfugimento, & rilievo eminente, & basso de i membri; il qual fà si che quelli che li veggono, mentre ch'osservano cotal spiccamento, & rilievo pargli d'esser fatti pittori per gl'occhi se non fossero per prattica, come era Masaccio, che solamente allumava, & ombrava le figure senza contorni.

Lomazzo goes on to discuss the effect of distance upon chiaroscuro, using Polidoro, Correggio, and Michelangelo as his exemplars.

15.I. This note refers to a small diagram of a shaded hemisphere in pen and ink in the left margin, to which it is connected by a cross. The lower half is shaded by cross-hatching, but in the upper half small, darkened circles are placed next to small unshaded circles. It seems that Testa may have been trying to suggest that the dark spots on the upper half appear darker than the shadows on the lower half because they are placed near to areas of light.

16. Testa's opening comments about the marshalling of the infinite accidents of experience under a limited number of principles should be compared to Barbaro's explanation of the nature of experience in his preface to Vitruvius, book 1, to which Testa referred in 8.A. Barbaro describes experience as the source of the arts, but praises those who have hastened their development by the discovery of principles, ed. 1556, p. 6:

Il nascimento dell'Arti da principio è debole, ma col tempo acquista forza, & vigore. Imperoche i primi inventori hanno poco lume delle cose, & non possono raccorre molte universali propositioni, per le quali l'Arte s'ingagliardisca, perche tempo non hanno di farne l'Isperienza per la brevità della vita; ma lasciando a i posteri le cose da loro trovate, scemano la fatica di quelli, aggiugnendoli occasione

Era ridicolosa che tal dipintore, astratto forse, e solevato a un certo estasi, havea delineato lo sgabellacio dove appogg[i]ava il petto, pretendendo fussero leggerissime nuvolette.

Accenno questa, lasciandone infinite, per non tesser comedie. E tornando, dico che se l'architetto, volendo far una fabrica dalla sua idea e dai fondamenti, li dà il principio e la conpisce, che sarebbe ridicolosa cosa che andasse togliendo in prestito quello che è suo e che lui dà a altri, e qui mi dichiaro. Tanto più il pittore debbe soprastare, avendo per fondamento il disegnio, cioè la ragione del bello intorno alle forme, e qui debbo levar li abusi di chi si dice disegniar bene per aver una manacc[i]a, o da longo uso, o da furiosa natura usata, e sempre scio[lta] a inbrattar carte con finissimi, egualissimi e bizarissimi tratti.

Tornando, consideriamo dunque la gofferìa di tali che, avendo inbratata una teletta con padelle, fiasc[h]i vec[c]hi, e simile, espongano l'opera per aquistarne lode, il che anche li riesce, tanto può il senso ne' goffi, e forsa contro il mio genio; in tempi antiqui parendomi per i contrari le ragioni più si manifestino e questa era la ragione di bello ingegno, vedendolo sì spesso far reflessione sulle gofferie che ciò faceva per parare a fuggire il goffo, dove sì spesso par di natura inc[i]anpiamo, e come le ombre in somma dànno forsa ai chiari e rilevano sfondando, così dai goffi possiamo cavar molti insegniamenti.

17. come si debbe e poeticamente et apropriatamente dipingere i siti.

18. in quel modo che la natura opera, par che il buon pittore debba hoperare, cioè con termine e riposo, e sensa questo non vedo in

d'aumentare le loro Arti, per la molta forza, che ne pochi principij si trova. perche si come nella mente si concepe la moltitudine de suddeti sotto un Principe, cosi molti concetti dell'Arte al suo principio si riferiscono, e per questo di gran lode sono degni gli Inventori delle cose i quali trovato hanno i principij senza risparmio di fatica, da i quali il componimento, & la perfettione dell'Arti perviene dove egli si puo dire, che la metà del fatto, è nel cominciar bene.

Testa's note also recalls Lomazzo's comments in his "Divisione di tutta l'opera," 1584, pp. 13-16, about the two ways of treating of an art or a science: the *ordine de la natura*, in which principles are derived from the knowledge of particulars, and the *ordine de la dottrina*, which procedes from the universal to the particular. Lomazzo argues for the second, p. 14: "E perciò non deve l'intelletto nostro cominciare ad intendere le cose con l'ordine de la natura; poiche non può comprendere tutti i particolari, i quali sono infiniti, ma deve cominciare con l'ordine de la dottrina, del quale lo intelletto nostro è capace. perche quest'ordine procede da le cose universali à le particolari, le quali possono essere facilmente conosciute da noi, per essere l'intelletto nostro di questa natura che propriamente intende l'universale, essendo egli potenza de l'anima spirituale, e perciò godendo de le cose universali separate da la materia, & fatte in qualche modo spirituali, per opera de l'intelletto agente."

Testa's statement, which is echoed elsewhere in the manuscript, especially in his attacks on bad teaching in 60, is not intended to discourage learning from experience, but to insure that experience is always directed toward an end. It should be compared with Leonardo's belief that "those who fall in love with practice without science are like a sailor who enters a ship without a helm or a compass, and who can never be certain whither he is going," Richter, 1883, §1161.

Testa's choice of example, the painting of the reflections of the red blood of a wounded soldier upon his shining armor, is not one he himself ever attempted to paint. Poussin, however, admirably demonstrated his ability to paint just this in the Hermitage *Tancred and Erminia*; see Chapter Three above. For Vasari, inspired by Leonardo, it was precisely this type of effect, the transient reflections on horses and armor in battle, that was the special province of painting, for which see Barocchi, ed., 1960, 1:63, and Smyth, 1963, p. 16.

17. This may be related to Testa's understanding of Armenini's discussion of the importance of the appropriate kind of light for the particular setting of an *istoria*, referred to in 15.D. It is, however, interesting that Testa chooses to associate the painter with the poet in this particular context.

18. In arguing that the artist must work in the way that nature works, Testa aligns himself with those, like Federigo Zuccaro and Leonardo, who believed that the artist should imitate

far terrazzi, nuvoli, e simile, andar diversissimo dal far l'homo, il cavallo, erba e altro.

19. della Poetica vedi l'Aleandri carte 33.

Folio 8 recto. Figure XII.

References: Marabottini, 1954, pl. LXIV, fig. 1.

20. L'amore che l'huomo à a sé stesso che si cava dalla moral filosofia è pur ne[ce]ssario intendere per essprimerc l'affetti, come in qualche rissa prima sé e poi il compagnio senpre si vede salvare, e di questo ne faremo l'istoria.

21. Arte così bella e nobile ch'ogni segnio à ragione, ogni punto, quindi nascono tante opinioni e confusioni, e quasi ardiscono proferire che sia opinione, non conoscendo la loro ing[n]ioransa ⟨come vasaro, scarparo e simili/ che un non conoscer sè metendo nelle pitture le forme che il goffo vasaro dà ai vasi e simile⟩.

natura naturans rather than *natura naturata*, for which see Bialostocki, 1963, pp. 19-30. His notion that the artist must also imitate nature by taking rests and working within limits in order to create different forms is particularly interesting here. It relates both to the idea that one of the principal bad effects of Mannerism, the undisciplined *furor matto* of 15.E., was that it led to repetitive uniformity (for which see Smyth, 1963, pp. 5f., and n. 35) and to Testa's emphasis on the prudent diligence of the ideal painter, who makes haste slowly by interspersing periods of rest with periods of labor, for which see Chapter Three above.

19. A reference to G. Aleandro's *Difesa dell'Adone*, pt. 1, 1629. The work is a defense of Marino against the criticism of Stigliani, and in chapter 9, pp. 33-38, Aleandro sets out to define the difference between history and poetry. The first sentence on p. 33 presents the argument succinctly: "Niuna cosa è più lontana dall'arte del poeta, quanto la verità delle cose, perche questa è propria dell'historica: e in quella parte ch'alcun Poeta le attioni veramente succedute narra, si scosta dall'ufficio di poeta, il qual ufficio consiste nell'imitare, cioè nel finger attioni, quali verisimilmente succeder potrebbono." Aleandro goes on to praise Ariosto, Homer, and Virgil for building their inventions around figures who are famous but whose stories are not perfectly recorded by history and to criticize Tasso for writing about the historically familiar story of the conquest of Jerusalem.

Part 2 of the *Difesa* was published in 1630, but the text is not appropriate to Testa's note.

20. Testa must have been influenced by Aristotle's discussion of friendship in the *Nicomachean Ethics*, IX, here. For the self-esteem of the good man see IX, 4, Segni, 1550, pp. 457-462. For a summary of the various types of self-love, good and bad, see also Ripa, *Amor di se stesso*, 1625, pp. 29-32. Testa's analysis of how a man reacts in the face of danger, saving first himself and only then his companion, which may seem unusual in its perception of how moral behavior works in practice, is entirely in keeping with Aristotle's views and Testa's own ideas about the moral purposes of art.

21. Marabottini, 1954, p. 236, is very seriously misled by the copyist here, for in the Casanatense manuscript this becomes "il goffo Vasari."

22. Testa's recommendation is both dependent upon and a reaction against Vitruvius, as expounded by Barbaro. In the preface to book I, Vitruvius explains how it is possible for the architect to master all the many different disciplines he needs because of the fact that they share common principles. In

FIGURE XII

22. che il pittore debbe essere architetto non per i precetti dell'architettura, ma per propria natura havendo in sé il fondamento che è il disegnio, e qui il disegnio intendo tutto quello che è suggetto a forma e al senso del'ochio. Non dico però che debba conoscere la qualità delle pietre, del aria del sito, e tante altre parte perché queste si separano.

23. che debbe ogni arte pigliare i termini dal disegnio, e l'usansa del vestire da altri non dover derivare che dal giuditioso pittore.

distinguishing between the practical problems of the architect (his examples also being drawn from Vitruvius) and the principle of design upon which his work relies, Testa is following Vitruvius's distinction between *opera* and *ragione*, ed. 1567, p. 22. Vitruvius also states that the architect needs to be able to draw, but Barbaro, p. 13, interprets *disegno* in this instance as a purely practical facility at the service of Geometry. Testa's actual definition of *disegno* here is probably derived from Armenini, 1587, bk. 1, ch. 4, p. 37 (Bisagno, 1642, pp. 14f.):

Gli huomini intelligenti di queste nobili arte, che più delle altre arti si trovano essere unite insieme, i quali sono i Pittori, gli Scultori, & gli Architetti; si sono sforzati tutti di voler dare la sua diffinitione al Dissegno, si come quello ch'è il lume, il fondamento, & il sostegno delle predette arti, nè si sono curati essere stati varij fra essi, poiche tutti tendono à un fine. Onde alcuni hanno detto dover essere quello una speculation nata nella mente, & un'artificiosa industria dell'intelletto, col mettere in atto le sue forze, secondo la bella Idea. Altri poi dicono più tosto dover essere una scienza di bella, & regolata proportione di tutto quello che si vede, con ordinato componimento, dal quale si discerne il garbo per le sue debite misure, al

che si proviene per lo studio, & per la divina gratia d'un buon discorso, primamente nato, & nodrito in quello, le quali opinioni, & considerationi tutte da noi si sono concesse, & ricevute, si come cose, che per tal materia poco ci importa, perche solamente questo vogliamo noi che ci basti, che il dissegno sia come un vivo lume di bello ingegno, & che egli sia di tanta forza, & cosi necessario all'universale, che colui che n'è intieramento privo, sia quasi che un cieco, io dico per quanto alla mente nostra ne apporta l'occhio visivo al conoscere quello, ch'è di garbato nel mondo, & di decente.

In discussing this passage Panofsky points to the fact that Armenini really preferred the conceptualistic interpretation of *disegno* as an inner eye, separate from perception, even though he does record the opinion of those who relate it to the ordering of things seen. It is this second opinion, which Panofsky associates particularly with Vasari, that Testa singled out by emphasizing the "senso del'ochio." Given his constant emphasis on nature as the perfect teacher, it could not be otherwise. For the discussion of Vasari and of the opposing view shared by Armenini, Zuccari, and Bisagno, see Panofsky, 1968, pp. 60-63, 81-83, esp. n. 22 on pp. 223f.

24. magiore/ minore/ Terminato/ infinito, si riferisce alla grandezza.

25. Two studies of allegorical figures. Pen and brown ink with some black chalk, probably traced from the verso.

24. These notes accompany four lines, two of unequal length, a third with its ends clearly marked, and the fourth without such markings at its ends; they identify these lines as greater, smaller, finite, and infinite. All of this is in paler ink than the other notes on Folio 8r, and, therefore, more closely related to the notes in 27 on Folio 8v, which are similarly written in paler ink. The notes in 24 are also derived from the same source indicated in 27, Federigo Commandino's *De gli elementi libri quindici*, his translation and edition of Euclid's *Elements*. On p. 8 (for which see 27 below) Commandino comments on Euclid's axioms. He distinguishes between the different parts of problems and theorems and chooses as an example of a proposition, Proposition III, Problem III, "Date due linee rette disuguali tagliare dalla maggiore una, che sia uguale alla minore." Here size is a given, for, writes Commandino: "Le linee sono date per grandezza, perche il maggiore, il minore, il terminato, l'infinito si riferiscono alla grandezza." He contrasts this to givens of position, proportion, and species.

25. These two figures also appear on the verso of Folio 8, and have been traced through from one side of the sheet to the other. It is difficult to be sure which drawing is the original, but it is more likely that Testa made the drawings on the verso first. In tracing the figure with the helmet and breastplate on the recto, he has changed the position of the right arm, which now bends clumsily at the elbow, and he omitted the club, which makes the position of the left hand meaningless. For a complete discussion of these figures, therefore, see 26 below.

FIGURE XIII

Folio 8 verso. Figure XIII.

26. Drawing of two allegorical figures. Pen and brown ink.

26. These figures almost certainly precede their mirror images on Folio 8r in 25. The figure on the right, corresponding to the one on the left in 25, holds a snake in her hand, and probably represents Prudence. The figure on the left wears a helmet, as she does in 25, but she also bears the attributes of a branch, probably an olive, in her left hand and the club of Hercules in her right. Her Minerva-like appearance, and the attribute of the olive, the Golden Bough of Virgil, surely indicate that she is Wisdom (see e.g. Ripa, 1625, p. 582). She has, however, been endowed with the added attribute of the club, the heroic virtue and the strength of Hercules. For Testa's drawing of Hercules, based on Cartari's description, see 39.A. below.

In order to understand the relationship of the two figures to each other and why Testa drew them, we must turn to Barbaro's commentary to Vitruvius's preface to book I. On p. 15, ed. 1567, in a passage related to the discussion of the knowledge required by an architect cited in 22, Barbaro sets out to demonstrate that architecture is most truly worthy of

praise, "perche nel conoscimento, & nel giudicio ella può essere con la Sapienza, & con la prudenza meritamente paragonata, & per l'operare tra le arti come Heroica Virtù chiaramente riluce." Preoccupied as always with the importance of both theory and practice, Testa has, then, illustrated here the virtues attributed to the theoretical and practical aspects of architecture by Barbaro. The fact that the majority of the notes on this folio also derive from Barbaro's Vitruvius supports the view that these drawings were made before those in 25.

The figures should be compared with the figures of Prudence and Fortitude in the *Allegory Celebrating the Arrival of Cardinal Franciotti as Bishop of Lucca* (Fig. 6) and related drawings, for which see Chapter One above. Although the date of the drawings on folio 8 recto and verso cannot be established with certainty, the similarity of the figures to the drawings for the Franciotti print and the delicate pen style employed suggest a date c. 1637.

27. All the notes in this section, like the related notes in **24**, are in paler ink. Their source in Commandino's translation and edition of Euclid's *Elements*, *De gli elementi libri quindici*, ed. 1619, is established below in 27.B.

27.A. spatio/ termine +/ +e si dice figura che è anche quella che contiene più termini.

27.A. These notes accompany a circle, the area of which is marked "spatio" and the circumference "termine." The whole is based on Testa's reading of Euclid's definitions, together with Commandino's commentary. In Definition 13, p. 3r, Euclid states, "Il termine è fine di qualche cosa." Commandino explains:

Non bisogna che 'l termine si riferisce ad ogni grandezza, come scrive Proclo, perche della linea dicesi termine, & fine, ma si deve riferire alli spatij, che sono nelle superficie, & a corpi solidi, chiamando hora termine quel circuito, over giro, che determina ogni spatio, & cotal termine dice essere fine, non gia come il punto si dice fine della linea, ma come quello che rinchiude, & separa dalle cose che gli stanno intorno, & questo nome è proprio dell'antica Geometrica, per mezzo della quale misuravano i campi, & i lor termini distintamente conservavano. onde poi acquistorono la cognitione di questa scienza. chiamando Euclide questo giro esteriore termine, bene e meritamente l'ha constituito fino de spatij, imperoche per questo ogni cosa, che è contenuta, si determina, come nel cerchio la circonferenza è termine, & fine, & esso piano è un certo spatio, & parimente nel triangolo tre lati; e nel quadrilatero, i quattro lati sono termini, & fini. Spatio poi è quello che dentro di questi lati vien contenuto.

In Definition 14, p. 3r, Euclid defines a figure as "quella che è contenuta da uno, o da più termini." Commandino comments: "Delle figure, altre sono piane altre solide: & delle figure piane è il cerchio, & la ellipse. delle solide la sphera, & lo sphaeroide, che da un sol termine, & altre, che da più termine sono contenute."

27.B. propossitione, dimostratione, conchlusione/ qui vedi a carte 8. il Comandino + .

28.A. il vero non necessario, Contingente/ Arte sette distinte i tre intorno al parlare/ il resto cercha la quantità/ parlare/ Gramatica Rettorica Logica/ [qua]ntità/ Geometria Musica Astrologia Arithmetica.

28.B. Geometria madre del disegnio.

28.C. eurithmia madre della Gratia che nasce dal' numero.

28.D. Triglifo in ordine dorico.

27.B. On p. 7ᵛ Commandino states that there are six necessary parts to all problems and theorems, but adds, "ma le più necessarie, & che si trovano in tutti sono la Propositione, la Dispositione, & la Conclusione. percioche bisogna primamente conoscere quel che si cerca, & poi dimostrarlo per i mezi, & finalmente concludere quello, che si è dimostrato. di queste tre niuna ne può mancare." On p. 8, to which Testa refers, this is followed by Problem 1, Proposition 1, the construction of an equilateral triangle. At the beginning of his commentary on p. 8ᵛ, referring to the preceding definition of the parts of problems from which Testa took his note, Commandino states: "Tutte le cose, che si sono dette di sopra, si possono considerare in questo primo problema." The cross after the reference to Commandino probably indicates a connection with 27.A.

28. All the notes are based on Testa's reading of Barbaro's Vitruvius. It seems most likely that he was using the 1556 edition here, even though no specific edition is cited, for the order of the Liberal Arts in 28.A. follows the order given by Barbaro in that edition, rather than the slightly different one of the later editions. All references below are, therefore, to the edition of 1556.

28.A. In the preface to book I, p. 6, Barbaro writes: "Dico adunque nelle menti humane esser un habito del vero, che di necessità avviene, & un altro habito di quel vero, che non è necessario, che avegna, detto da filosofi contingente" (ll. 16-17). He explains that the arts are concerned with this contingent truth, and then specifies that his subject will be the art of architecture, saying on p. 7: "Lascierò à dietro quella significatione universale di questo vocabulo Arte, che abbraccia l'Arti liberali, delle quali tre sono d'intorno al parlare, & quattro circa la quantità; d'intorno al'parlare, è la Gram. la Reth. la Logica. Circa la quantità, è la Geometria, la Musica, l'Astrologia, l'Arithmetica" (ll. 2-4).

28.B. In the preface to book I, p. 11, after considering Vitruvius's emphasis on the usefulness of the art of measuring to the architect, Barbaro concludes that "si può dire la Geometria esser madre del dissegno" (ll. 4-5).

28.C. In book I, 2, p. 24, Vitruvius states: "Il bel numero, è maniera bella, & aspetto accommodato nelle compositioni de i membri" (l. 31). Barbaro concludes his commentary on this by saying: "Questa bella maniera si nella Musica, come nell'Architettura è detta Eurithmia, madre della gratia, e del diletto" (ll. 42-43).

28.D. In book I, 2, p. 24, commenting on Vitruvius's discussion of the use of the width of a column or triglyph as a module, Barbaro states: "Triglifo è membrello scannellato, che si

28.E. proportione intorno alla quantità. per l'architettura due, cioè continua———— +/⟨+detta Geometrica⟩ /.1.2.3.4./ disg[i]unta/ ⟨Aritmetica⟩ /+questo con questo è proportione/ la quantità eguale e diseguale/ ~~L'Armonia s'atien la mescolata/~~ la mescolata genera l'armonica.

28.F. fondamenti per le colonne.

mette nella cornice, ò nel fregio, quasi trisolco nominato, perche tre solchi ò canaletti contiene; con questo Vitr. misura grā parte dell'opera Dorica, come al terzo cap. del quarto lib. sara dichiarato" (ll. 74-75). The note is accompanied by a brief sketch of a triglyph.

28.E. In the preface to book III, p. 57, Barbaro states that in a broad sense all similarities between things fall into the category of proportion. He, however, wishes to use the term more specifically, saying:

Diremo solamente della vera proportione, che sotto la quantità è compresa, non che la proportione sia quantità, ma perche è propria della quantità. Trovansi due maniere di quantità, una è detta continua, come linea, superficie, corpo, tempo, e movimento. L'altra è detta quantità partita e separata, come è nel numero una, dua, tre & quattro, & nel parlar nostro quanto al proferire che una sillaba, & una parola, & una parte è distinta dall'altra. Dell'una, & dell'altra quantità è propio che secondo ciascuna si dica le cose esser eguali, ò disseguali. . . .

Espedita adunque la diffinitione della proportione, manifesto è, che ritrovandosi ella nella quantità alcuna apartenera alle misure, alcuna à i numeri, alcuna serà mescolata d'amendue.

Quella che apartiene alle misure, che Geometrica è detta, serà nelle quantità continue, lequali tutte cadono sotto misura.

Quella, che apartiene à i numeri, che è detta Arithmetica, è nelle distinte e separate, come è quando si fa comparatione da numero a numero. La mescolata che Harmonica si chiama, insieme aspetta à i numeri, & alle misure, come quella, che compara i tempi, e gl'intervalli delle voci, come si dirà nel quinto libro. (ll. 31-50)

28.F. This accompanies a small diagram showing the bases of two columns linked together by an inverted arch. In book III, 3, p. 83, Barbaro actually recommends a stepped stereobate for the foundation of columns, but here Testa seems to be interpreting his comment on Vitruvius's statement, l. 42, "Et ancho disopra la grossezza del parete si deve servare." Barbaro comments: "Cioè che la parte inferiore sia di quella disopra piu grossa, ma gli spatij, che sono tra un piedestallo & l'altro, cioè nelle fondamenta deonsi legare in questo modo, che overo si facciano in volti, come è lo Impie d'un Tempio ritondo nel quarto" (ll. 43-45).

Folio 9 recto. Figure XIV.

References: Cropper, 1971, p. 285, and fig. 44a.

29. Drawing of two allegorical figures labelled "povertà" and "otio." Pen and brown ink.

29. The drawing was engraved by Collignon for the *Raccolta di diversi disegni e pensieri*, for which see Speciale, 1977, p. 27, no. 21.

Testa's figures are based on personifications in the *Iconologia*. The figure of Povertà is an adaptation of Ripa's figure of *Povertà in uno ch'habbia bell'ingegno*, ed. 1625, p. 521, and is related to the figure of Prattica in the *Liceo della Pittura*, for which see the discussion in Chapter Two above.

FIGURE XIV

30. Dal'inmitatione e si passa al'osservatione e di lì alle certezze mattematiche come per gradi, e ciò solo però può fare chi ci nasce, cioè che è di spirito aperto e chiaro; e riescono vanissimi e scabrosi e violenti le regole e precetti che da tanti pedanti tuttodì vengono insegnate, che fanno sbigottire il goffo e meravigliare, e chi à ingegnio l'abborrisce ridendo. Confesso però che anch'io cascho in pedanteria perché doverei operare e tacere.

Folio 9 verso.

Blank.

Folio 10 recto. *Figure XV.*

References: Hartmann, 1970, pp. 64f. and 162; Brigstocke, 1976, p. 25, n. 9.

31. Study of a half-length figure

Otio, shown as a fat young man reclining in slumber upon a pig, is also derived from Ripa's description, ed. 1625, p. 493, although once again adapted slightly. The two figures represent two extremes, both undesirable: the figure of poverty has an active mind, but lacks the material goods necessary to support his virtue; the figure of laziness is so given over to the enjoyment of physical pleasure that he has no thoughts of virtue. For this opposition see Chapter Three above.

30. The first part of this is closely related to the scheme presented in *Il Liceo della Pittura* and the attack on bad teaching in the Introduction to the Trattato in 60.A.

31. Hartmann connected this drawing to *The Adoration of the Shepherds* now in the National Gallery of Scotland (Fig. 29) on account of the gestures of the two figures and because

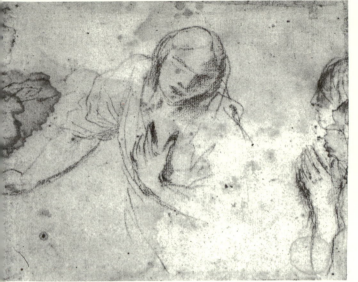

IGURE XV

FIGURE XVI

making a gesture of adoration; a profile of the head and praying hands of a second figure to the right. Red chalk.

Folio 10 verso. Figure XVI.

See References for Figure XV.

32. Drapery study. Red chalk.

Folio 11 recto.

33. il vedere, che si fa per i raggi del'ochio, i quali da un punto d'esso spiccandosi vanno a trovar l'oggetto, e non potendosi veder meno quantità del punto, e che si slargino piramidalmante.

it is in red chalk, which is the medium used in the other three drawings in the Notebook directly connected with the painting (Folios 2r, 3, and 25$^{r \& v}$, 71 & 72). Brigstocke was not convinced because the figures do not correspond to any in the final work. It does appear likely, however, that this drawing is contemporary with the other studies and that it should, therefore, be dated to the late 1630s or early 1640s, for which see 3 above.

32. Brigstocke questions Hartmann's association of this drawing with *The Adoration of the Shepherds* because of the very general nature of the drapery study. Taken together with the drawing on the recto, this study can, however, be dated to the late 1630s, or early 1640s.

33. Although this may be based on a general understanding of Alberti's remarks about the visual pyramid and the point, it is curious in that Testa specifically describes rays of light going from the eye to the object. In *De pictura* Alberti recognizes that there are differences of opinion about the direction in which light travels, but does not choose to try to resolve the problem, a position that is echoed by Accolti when he declares the problem one for philosophers to solve and outside his province, 1625, p. 97. As Grayson has shown, however (ed. 1972, pp. 108-109), Alhazen, translated by Witelo in the thirteenth century, had resolved the issue in favor of the movement of light from the object travelling to the eye, and Alberti's discussions of light actually reveal that he agreed with this.

34. Io non entro in materie di stato che gran parte degli huomini il famno [fanno] e riescono ridicoli perché son robbe da prencipi; io non in teologare, non in altre scense, ma ragiono della arte mia con quella favella che mi à dato il paese.

35. In darker ink and enclosed by a line: "Che i precettori in quest' arte non sono nec[e]ssarii ma però i buoni possono abreviare col' il loro buon abito, e per il contrario i cattivi."

36. Divido la pittura intorno a quel che si vede dar le ragioni perché, e come in piana superficie debbesi inmitar che arte ci vol, o circha le linere, o circha il colore, poi che cosa debbesi inmitare aciò habia la Pittura quei fini che son suoi di dilettare e insegnare, ributtando tutti li altri acidemti [accidenti] come fecc[i]a delle cose e non apartenenti al buon pittore, la qual ridurò in idea./ si che mi fermo in ragioni ferme e in contingense.

37. Che sia meglio, o da principio pigliare i fondamenti, o spraticarsi, essendo che l'uno e l'altro egualmente deve essere nel buon pittori e chi d'una d'esse mancha è ridicolo volendo discorrerne.

38. In darker ink: "Che siano veramente affetti vedi Aristotile nel' *Eticha* Libro 2 carte 92."

Folio 11 verso. Figure XVII.

39.A. Ercole con tre pomi d'oro e la clava e d'aspetto sì terribbile che spavent[evole].

34. Guided by Barbaro's modesty and his emphasis on the simple, expository character of Vitruvius's style, Testa is here taking Vitruvius for his model. Defining his subject in his own preface, Barbaro not only excludes the universal signification of the word "Art" that includes all the liberal arts, a passage from which Testa took the notes in 28.A., but he also excludes theology: "Non ragionerò di quelle Arti, & Dottrine, che ci sono da Iddio inspirate come è la nostra Christiana Teologia, perche hora non si tratta à questo fine."

In his *Vita di M. Vitruvio*, which precedes the text of the translation, Barbaro praises Vitruvius for his "semplicità di vocaboli, e proprietà di parole," and points to Vitruvius's own justification for this in the preface to book V, which he wishes to be read first. Here, on pp. 127f., Vitruvius points to the difference between the aim of poetry and history to delight, and of a treatise, which aims to instruct. He argues that manuals of instruction should employ the simplest and the briefest arguments, and compares their character to Pythagorean rules. This may account for Testa's reference to Pythagoras in 2.

In writing in his native tongue Testa could, of course, take great comfort from Barbaro's own dedication to the vernacular.

38. Testa's reference is to Segni's translation and edition of the *Nicomachean Ethics: L'Ethica d'Aristotile*, Florence, 1550. Page 92 falls in book II, 5, "Che la Virtù non è affetto, nè potenza, ma che ella è habito." The whole chapter, together with its commentary, is important for an understanding of Testa's approach to the *affetti*, but the specific reference points to Aristotle's list of the different kinds of emotion: "Affetti chiamo io Concupiscenza, Ira, Animosità, Paura, Ardire, Invidia, Allegrezza, Amore, Odio, Desiderio, Emulatione, & Misericordia: e finalmente tutte quelle perturbationi, alle quali conseguita piacere ò dolore." This note may be related to Testa's preparation of the "bellissimi tratti degli affetti," he proposed to write in 59.H.

39. The notes and the drawings they accompany are based on Testa's reading of Cartari's *Le imagini de i dei degli antichi*. The description of Hercules with the three golden apples in 39.A. does not appear in the edition of 1556 cited in 70, but it does in the Venetian edition of 1580, and so it can be established that he used two editions of the work. All references in 39 are to the 1580 edition.

39.A. On p. 345, referring to a description by Pliny of a statue of Hercules, Cartari writes: "che in Roma ne fu una di Her-

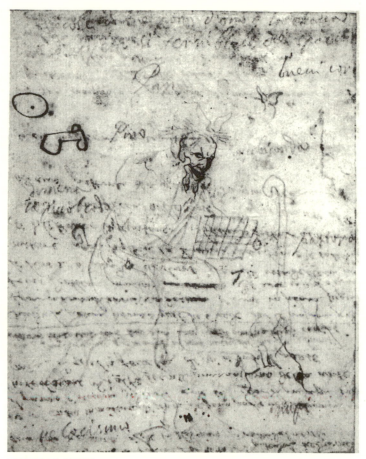

FIGURE XVII

39.B. Drawing of Pan with pine needles on his head. Graphite with some pen and brown ink. Pan holds the seven-piped *zampogna*, inscribed "7." To the right is a shepherd's crook, and to the left, two small diagrams. The notes, in faint lead, around the figure identify his various features as follows: "Pan/ dimena/ la piccola còda/ Pino/ rubiconda/ brevi cor[ni] / pastora[le] / rupi/ velocissimo."

cole terribile nell'aspetto, & vestita di una tonica alla Greca." On p. 349 he includes among the labors of Hercules: "che amazzasse un fero drago, e levi di certi horti gli pomi d'oro, che da quello erano guardati." Cartari records as another labor: "che menasse legato un spaventevole toro." This supports the reading of *spaventevole* here.

These notes should be related to the red chalk drawing of *Hercules in the Garden of the Hesperides* in the National Gallery of Scotland, for which see Brigstocke, 1974, D4999. This drawing was engraved by Collignon for the *Raccolta*, for which see Speciale, 1977, p. 21.

39.B. The drawing is after the plate in Cartari, 1580, p. 133, (Fig. 111). The notes accompanying the drawing are derived from Cartari's description of Pan on p. 135. Most of them are drawn from his rather free translation of the *Punica* of Silius Italicus, XIII, 327-335:

Lieto delle sue feste Pan dimena
La picciol coda, e ha d'acuto pino

Le tempe cinte, e dalla rubiconda
Fronte escono due breve corne, e sono
L'orecchie quel di Capra lunghe, e hirte,
L'hispida barbar scende sopra il petto
Dal duro mento, e porta questo Dio
Sempre una verga pastorale in mano,
Cui cinge i fianchi di timida Dama
La maculosa pelle, il petto, e 'l dorso.

Cartari continues in his own words: "E seguita poi, ch'ei camina per l'erte rupi e siano quanto vogliono ruinose, e che nel correre è velocissimo, si come il mondo parimente con somma velocità si gira mostrato nella imagine di questo Dio, il cui nome è greco, e tirato in nostra lingua significa l'universo."

Folio 12 recto. *Figure XVIII*

40. Study of a female bust in three quarter view juxtaposed to a shaded sphere. Black and white chalk on coarse, greyish brown paper. The notes are in black chalk: "li scuri più aparenti nel suo chiaro per i contrarij/ L'unione è meravigliosa/ non si può dire quanta sia la dolcezza eschludendo i contorni del tutto./ e dove non è chiaro una certa mortificatione di colori infinita che quasi è quanto il suo campo, e ciò per i reflesi che tingono."

Folio 12 verso.

Blank.

Folio 13 recto.

41. Divisione per più chiarezza in pittura che inmita puramente in un certo habito fatto sotto maestro, e questo è l'inferiore, e un'idea, cioè l'eletione del bello in ogni genere, e questo è il più perfetto.

40. The notes accompanying the drawing should be compared to the notes in 15.F.-15.H., where Testa is also concerned with the effective union of chiaroscuro for the achievement of relief, without the use of outline. The drawing itself is particularly interesting, for it presents both an abstract analysis and a practical application of a problem of chiaroscuro modelling, the same approach used both by Zaccolini in his manuscripts and by Poussin in his drawing of *The Artists' Studio* (Fig. 106), for which see Chapter Three. To the right is a circle, which Testa turns into a sphere by juxtaposing a patch of dark shadow and of bright highlight, leaving the colored paper as a middle value. This lesson is then applied to the head of the woman on the left, whose head is lent solidity by the similar juxtaposition of a small area of bright light and dark shadow on her temple, which is closest to the source of light (the nose being less prominent given the three-quarter view), and by the juxtaposition of a more subdued light and shadow on her cheekbone.

41. Testa is again making the distinction here between the two ways of forming an artist's style; either he can imitate a single master (which in 15.E. he describes as often leading to mannerism), or he can select the best in everything. These two ways are described by Armenini, 1587, bk. 1, ch. 8, pp. 59-69; for a more complete discussion in the context of the rhetorical tradition see Battisti, 1960, pp. 86-104.

Testa's opposition of pure imitation to an idea, something that does not appear in Armenini in this context, is interesting here. It seems that Testa perceived, quite logically, a parallel between the artist trained only in a certain practice by a master and the pure imitation of nature, and the artist trained by selecting the best from all types of things and the painting of an idea (*Pittura ideale*).

42. Perché nel' hoperare ci è ancho una certa satietà, et io che mi sono dilettat[o] molto della speculatione abrac[i]ando sì nobil arte tanta bella materia, ho deliberato scriverne in quel modo che serve a esplicare il mio concetto.

43. del'armonia vedi Vitruvio Libro quinto Carte 228.

Le ragioni del'armonia nella musicha sono per intendere quelle del colorire havendo quella il grave e l'acuto per termini, e questa il chiaro e 'l schuro, ai qual' estremi dov[i]amo acostarci con que' temperamenti che sono nella musica come gradi, e ciò molto aiuta la ragione dei secondi lumi, e terzi, et infiniti, che reflessi si dicono, stando in questa avertenza che i colori siano ubidienti a il detto chiaro oschuro, i quali più saranno al senso quanto più da li estremi saranno disg[i]unti. Questa è quel' unione che l'ochio tanto si conpiace. Non dico sfumatione come tanti goffamente si persuadono, ma un certo castigamento e freno dei colori messoli dal rigore del chiaro e dello scuro; di ciò goffamente si persuadono perché moltissime cose nella natura sono lontane da questa ragione di sfumare il colore, essendo che i corpi lucidi solamente vadino così lisciati, et io ho visto perdere il tenpo un' intiera g[i]ornata in sfumare un certo troncone d'albero di rusticissima quercia come se havesse voluto rappresentar un tersissimo specchio.

Ma perché l'estremo del' oschuro e del chiaro non l'haviamo nel senso in perfetione, dico perfetione in quanto conporta la materia, doviàno, cavandolo dalla ragione più che si può, manifestar nel' hopere rist[r]ingendo in brevisima quantità lo scuro e il chiaro intorno ai corpi, riservando sempre un certo,

42. Testa is comparing himself to Vitruvius and to Barbaro here; see 34 and 60.A.5.

43. The reference to Barbaro's Vitruvius is not to the edition of 1556, cited in 8, but to the edition of 1567, or a later reprinting. In book I, 4, p. 228, Vitruvius contrasts the continuous movement of the voice, as in a scale, with the distinct movements of the voice in a song in which changes in pitch are quite clear:

La voce quando con mutationi si piega, alcuna fiata si fa grave, alcuna fiata si rende acuta, & a due modi si move, de i quali uno ha gli effetti continuati, l'altro distinti. La continuata non si ferma nè in termini, nè in alcun luogo, ma suol fare le sue terminationi non apparenti, & gli intervalli di mezo manifesti, come quando parlando dicemo. Sol. Fior. Mar. Ben. perche cosi nè dove comincia, nè dove termina si conosce, ma ne di acuta s'è fatta grave, nè di grave acuta appare alle orecchie. per lo contrario adiviene quando la voce si

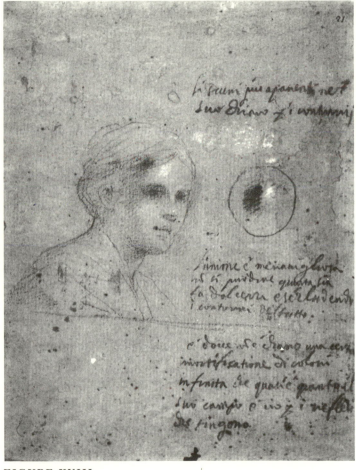

FIGURE XVIII

per così dire, grado più di lume e d'ombra per dar quel più e meno che tanto è ne[ce]ssario per rilevare le cose da una piana superficie, e di questo ne debbo dir molto.

Folio 13 verso. Figure XIX.

44. Che in tutte le forme ci debbe essere la sua idea, cioè il suo perfetto, e questo al buon pittore debbe essere manifesto dalla ragione, etiandio del brutto si fa l'idea.

move con distanza, perche quando la voce nel mutarsi si piega viene a fermarsi nella terminatione d'alcun suono, da poi si muta in un'altro, & facendo questo spesse volte di quà, e di là appare inconstante a i sensi, come adiviene nelle canzoni, nelle quali piegando le voci facemo variare il canto: & però quando la voce con intervalli è rivolta, egli appare in manifeste terminationi di suoni, dove comincia, e dove finisce.

44. Testa seems to be characterizing the Idea as the intentional forms of nature, revealed to the true painter by reason, rather than as the result of judicious imitation, which is implied in 41. For the coexistence of both of these concepts of the Idea in the writings of Agucchi see Mahon, 1947, pp. 135-141. Given Testa's interest in the passions and the deformities caused by expressions of them, which verge on carica-

FIGURE XIX

45.A. Che con i colori si levino i contorni (il che poco è usato) g[i]ungendo con somm[a] dolcezza a que' confini, il che fa pareri anche quelle parti che non si vedono. Questo però non sempre, ma solo quando è l'ochio vicino al mezo della cosa che si vede, perché dato alto un corpo e il suo lume, per la ragione della veduta il più chiaro sarà nella linea del contorno.

45.B. Diagrams of two circles marked with dots and crosses, and of a three-sided rectangular box whose interior angles are marked with crosses corresponding to the note, "ombra maggiore e insensibil[e]," followed by a shaded sphere.

46. La Pittura è abito ch'à i suoi fondamenti nella ragione scientifica e contingente; l'una è intorno ai costumi, al decoro, a[g]li affetti, l'altr[a] circha le ragioni del vedere, del'ombre e lumi e reflessi, come i corpi sminuischano quasi in un punto, come perdino i colori o per mancansa di lume o per distansa, come si generi l'harmonia dei colori, il che corre con le ragioni della musicha, e simili. E restando per così dire cadavere, come il corpo che non ha hanima, sensa le dette sciense; a dovendo insomma essere unita la praticha alla teorica, si fann[o] ridicoli quelli non meno che sensa nisuna considerationе tutto dì inbratano le tele con una gofissima praticacha [praticaccia], che chi non fa altro che cinguettarne sensa mai sapere che è pennello. Io che daché naqui con ogni premura mi sono non meno esercitato nel disegnio e al colore che contemplatone le ragioni, posso, se bene stimo, trattarne con quella semplicità che mi tocca per non mettere il piede con risicho

ture, it is tempting to interpret his statement here about forming an idea even "del brutto" as an echo of Annibale's justification of caricature, as recorded by Massani. For this see Mahon, 1947, pp. 260-265. It is also possible, however, that Testa intended the artist to realize the beautiful form that nature had intended, even in something apparently ugly and is not recognizing the potential playfulness of nature here. His close association with Domenichino, famous as a caricaturist, however, lends support to the former interpretation.

45.A. Testa is concerned with the same issue discussed in 15.H., the creation of the illusion of relief and form through the successful use of reflected light and color, rather than outline. In this note he shows that he is aware of the fact that the relationship between reflected light and contour depends upon the relative positions of the light, the object, and the eye. As in the case of 15.H. there is no exact source for Testa's note, but his ideas are closest to the reflections of Leonardo's ideas found in Lomazzo's *Trattato*. In the second part of bk. 6, ch. 20, after the passage on the elimination of outline cited in 15.H., Lomazzo, 1584, pp. 337-338, discusses how to create a sense of relief in paintings of facades, or loggias, placed high and illuminated from above (giving Correggio as a model). See also Lomazzo's observations concerning the effects of light and shade, "secondo la veduta anottica," and "secondo la veduta ottica," 1584, bk. 4, chs. 23, 24, pp. 242-243.

45.B. The diagrams provide simple illustrations of the notes in 45.A. The upper circle represents an object placed above eye level; the cross above it is the source of light, which strikes most strongly on the contour closest to it; a dot placed below the lower contour indicates the area of darkest shadow. The second circle represents an object placed at eye level; the cross to the right represents a source of light placed at the same level; the cross and dot juxtaposed in the centre of the circle represent the highlight and shadow following from this light, which create the sense of relief and turn the circle into a sphere, as in 40. The three-sided box shows how shadows are created by arrangements of plane surfaces and is, therefore, reminiscent of the moving screen that Poussin, inspired by Zaccolini, included in his drawing of *The Artists' Studio* (Fig. 106), for which see Chapter Three. The lowest of the four diagrams shows a sphere with clearly delineated contours and an inner ring of shadow within its lower half. This probably illustrates the same principle as the first diagram, the effect of a light placed higher than an object that is also above eye level.

47. Closely related to 15.E., where Testa, probably advised by Armenini, distinguishes between mannerisms and copy-

FIGURE XX

[rischio] di sdruciolarne fuora de il mio confino.

47. Il disegnio deve esser per freno a tutti (e regola) li artefici che dan forma alla materia.

48. Le prime notitie con l'acidenti fan la sciensa, cioè il senso fa guida alla ragione, e questo si praticha nella pittura.

49. Ombra è dove il corpo opaco inpedisce i raggi del luminoso.

Folio 14 recto. *Figure XX.*

50. Che il disegnio è intorno alla quantità et in specie di ciò che ha forma e proportione con la ragione

ing. Copying the drawings of good masters down to the last detail, according to Armenini, disciplines the hand, and restrains those who draw furiously. Of the effect of such copying on such artists he writes, 1587, bk. 1, ch. 7, pp. 53f.: "li raffrena, & li tiene avvertiti, percioche posto che si sono i primi lineamenti, o vero tratti, dove si siano, se quelli per sorte non vengon ben tirati, o che non siano à punto à i proprij luoghi loro, essi non li possono già scancellare, che non vi resti la macchia, o poco, o molto che si sia." See also 50 below.

49. See 15.F.

50. The first part of the note in which Testa insists upon the delicacy of the lines that describe fields of color, or areas of *chiaro* and *scuro*, recalls Alberti's advice that circumscription

del' otica e ciò s'eseguisce con sottilissime linere per circoscrivere i siti dei colori per i quali si vedono le cose; e con essi si scancelano i detti segni, il che solo i bravis[s]imi sanno fare, servando quella esatta simetria che dà l'eccelen[sa] alle forme; e qui non importa se i detti segni siano fatti con più ho [sic] meno franchezza, dovendo, come ho detto, essere del tutto tolti via. Ben è vero che diletta una certa franchezza, ma per il più è nimicha del' esattezza, la qual sempre deve haversi a chuore, e fuggire del tutto quella fuoria [furia] pazza che tanto da li huomi[ni] grossi è usata e commendata talmente che par che in non altro habino riposto l'eccellensa. Qui fuggo d'accennare l'esenpi, potendo io però essere inteso.

51. Per fare uno che corra, l'apuntellano in aria una gamba, se uno che grida l'aprono con li stecchi la boccha e simile/ vedi carte 374, Guidiccioni.

should be done with the finest possible, barely visible lines, and that the midpoints between light and dark should be marked with lines, as an aid to coloring. Testa's warning about placing too much value on freedom in drawing at the expense of accuracy is not in response to anything in *Della pittura*, however. It reflects the same criticism of the concept of creative *furor* (which in Testa's view led to mannerisms) that he expresses in 15.E. Testa's example is interesting because it shows that in the end drawing, in his mind, in the practical sense was there to provide the structure for color. Even though he valued freshness in invention, as he himself states in the letter of August 29, 1642, for which see Chapter One, p. 40, he was not interested in the appearance of technical spontaneity in drawing for its own sake. As Armenini explains, in the passage cited in 15.E., it is only through diligent practice, not *furia*, that an artist can develop facility in his hand that will make his drawings correct from the start, avoiding constant reworking.

51. Testa's mockery of artists who have to string up the model's leg in order to represent a running figure, and prop open his mouth with sticks in order to depict a figure who shouts, is very closely related to his criticism in 16 of artists who are unable to work without the object. In 16 his examples have to do with accidents of light (the reflection of blood on armor) and perspective (the representation of God the Father in heaven). Here he is concerned with movement, both of the body, and, in the case of the shout, of the effects of the movements of the soul upon the body. Such movements lie at the heart of Testa's vision of ideal painting, which moves the spectator, and here he mocks those who seek to represent them in the manner of a still life. Testa believed, rather, that having organized his observations according to principles the painter should be able to represent transitory movement from memory. Such systematization of movement, based on observation, was recommended by Alberti and was taught in the Carracci Academy.

The reference to Guidiccioni is to Lelio Guidiccioni's *Eneide toscana* (Rome, 1642), which was dedicated to Cardinal Antonio Barberini and which provides a *terminus post quem* for this note. Page 374 corresponds to book VI, 455-480, wherein Aeneas meets the dead Dido in the Mourning Fields and repents of leaving her. Testa has chosen the passage as an example of the importance of the expression of the *affetti*, the sorrow and pain of the weeping Aeneas, and the sadness and compassion of Dido. It provides an example of the kind of expressions that the painters who are criticized in the first part of the note are unable to represent. The drawings described in 73-76 below, which are all of scenes from the *Aeneid*, suggest that Testa was planning to make a whole series of

52. nella pittura, per essere non meno d'inteligenza che d'uso composta, deve precedere l'uso cioè il praticharsi per essere atione più facile e dove molto tempo si deve consumare.

53. Per la Pittura.

53.A. Ragioni mattematiche e contingenti: quelle intorno al' optica, e queste circha il costume, il che può far hoperare sensa ogetti, ansi quelli possono esser d'inpedimento. Delle une ne tocherò così in grosso la superficie, essendo che detta sciensa ne sia statto trattato da sapientissimi huomini; nel' altra mi difonderò, ridividendo e l'una e l'altra in molte parti, le quali per ordine metterò.

53.B. Diagrams in the left margin relating to notes on proportion and the functions of geometry and optics: two profiles of a face divided into parts, with the brow and chin marked 3/2 and 2/1 respectively; below is a diagram of a square, marked "geo," surmounted by a triangle inscribed "otica," illustrating the distinction between the geometry of plane surfaces and optics, which is concerned with how such surfaces are seen from a particular point.
Geometria per le proportioni, l'otica per la ragione dei piani, dei lumi, de[l]le ombre e tutto ciò che hapare al ochio per la ragione d'un pun[to], diverso da quello e in sustanza/ vedi il Commandino nel suo preanbolo, carte 2.

53.C. Arte è di far con ragione la cosa dove s'habia l'abito, detto intelletto pratico, Aristotele Libro 6, Carte 291 e Carte 287/ subalterni cioè l'uno contenuto dal'altro 293 Aristotele/ che preceda alla generatione, cioè al'opera, contemplatione e dispozitione.

illustrations to the poem. He does not appear to have made a drawing of the meeting of Dido and Aeneas to which he refers here, however, and only two completed compositions exist, *Venus giving Arms to Aeneas* (fig. 53) and the *Death of Dido* (engraved by G. C. Testa). For a discussion of this latter composition see Thiem, 1970. See also Brigstocke, 1978, p. 125 and fig. 44, for a painted version of the same subject, there attributed to Pietro.

53. In this section, under the heading "For Painting," Testa develops the distinction between those arts concerned with necessary truth and those concerned with mutability that he derives from Barbaro in 28.A. This distinction finds its clearest expression in the left and right sides of the print *Il Liceo della Pittura* (Fig. 89).

53.A. Testa points to optics as a branch of mathematics, and therefore concerned with necessary truth, whereas *costume* is concerned with mutability. He repeats the warning about depending upon the object given in 16 and 51 and goes on to say that his main focus will be upon the contingent aspects of painting, given that the mathematical, optical aspect has been treated so fully by the wisest of men.

53.B. Even though he did not intend to treat of mathematics in detail Testa wished to define the differences between optics and geometry carefully. The reference to Commandino is to his translation of Euclid's *Elements, De gli elementi libri quindici*, also cited in 24 and 27 above, where it is established that Testa was using the edition of 1619. This is also the case here, for in the first edition of 1575 the Prolegomena are unpaginated. On p. 2 Commandino denies that mathematics exists only in the realm of the imagination, asserting that it is "in un certo modo con la Natura congiunte." He goes on to define the difference between the kind of Mathematics concerned with intelligible objects and the kind concerned with sensible objects. Arithmetic and geometry are of the purest kind, concerned with the former, and optics originates in a combination of them: "perciochè l'Optica, ò perspettiva si serve de' raggi della vista, come di linee, & angoli, che da esse nascono." For a discussion of these Prolegomena, see Rose, 1976, pp. 205-206. Testa's lower diagram (Fig. XX) refers to this distinction.

53.C. Testa continues his examination of the necessary and contingent aspects of painting. All the references to Aristotle here are to Segni's edition and translation of the *Ethics: L'Ethica d'Aristotile tradotta in lingua volgare fiorentina et comentata per Bernardo Segni*, Florence, 1550.
Book VI, p. 291, refers to chapter 4 of that book, entitled *Dell'arte*. Here Aristotle defines an art as, "l'habito di fare con retta ragione una cosa." The reference to p. 287 is to

53.D. Si de[v]e da principio entrare a spraticarsi per dover la pratica genera[r]si da una longa esperiensa d'ogni particolare.

53.E. Sideways in lower left margin: "che si debbe sempre considerare e riguardare tutti li effetti della natura ricerchandone la cagione per bene hoperare."

Segni's commentary on book VI, 3, entitled *Del numero degli habiti intellittivi & dell'obbietto della scienza*. Segni restates Aristotle's distinction between Science, Wisdom, and Intellect, which always arrive at the truth, and Prudence and Art, which do not. Testa must have inserted "detto intelletto pratico" above the line here after he read p. 292 of Segni's commentary to book VI, 4, where he states that after his examination of a speculative habit he is now discussing, "un' habito dell'Intelletto prattico chiamato Arte." The commentary on this chapter continues on p. 293. Concerning Aristotle's distinction between effect and action, Segni writes: "Intende l'effettione, & l'attione non esser' generi subalterni; dove l'uno sia contenuto dall'altro: ma essere spetie diverse." On p. 291, again in Book VI, 4, Aristotle states: "Tutta l'arte consiste circa la generatione, & circa l'inventione, & consideratione in che modo far' si debba qualcuna di quelle cose, che possono essere, & non essere, & delle quali il principio stà in colui, che le fà, & non nella cosa, che è fatta." Segni comments upon this on p. 292: "Ma nell'essecutione l'Artefice da prima contempla quello, che ei vuol fare; dappoi trova, e dispone: e ultimamente genera."

53.D. Testa insists once again upon the importance of long practice at the beginning of an artist's training.

Folio 14 verso.

54.A. Quelle arti che più partecipano delle mattematiche sono più nobili perché hopera[no] con più vere ragioni. La pittura hopera con l'arte e dimostrationi matematiche, havendo di bisognio del numero per l'armonia e della geometria per la quantità con le ragioni del vedere, del che è eschluso del tutto la s[c]ultura, e si fa chiaro quanto più sia inferiore.

54. All the notes in this section are based on Testa's reading of Daniele Barbaro's edition and translation of Vitruvius. The references in 54.D. establish that he was using the 1567 edition or a later reprinting of it rather than the first edition of 1556.

54.A. Testa's position is the logical result of his Aristotelian bias toward the supremacy of reason and principle, but his application of this to the practical arts reflects his reading of Barbaro. Although not an exact quotation, this statement would appear to be a rephrasing of Barbaro's conclusion in his preface to book I, p. 5, with Testa substituting painting for architecture as the most worthy art: "Donde nasce, che alcune Arti hanno piu della scienza, & altre meno. & a conoscere l'Arti piu degne, questa è la via. Quelle, nelle quali fa bisogno l'Arte del numerare, la Geometria, e l'altre Mathematice, tutte hanno del grande, il rimanente senza le dette Arti (come dice Platone) è vile, & abietto, come cosa nata da semplice imaginatione, fallace coniettura, e dal vero abbandonata isperienze." Testa's criticism of the art of sculpture finds no counterpart in this passage, and it is also quite different from his approach to the *paragone* of painting and sculpture in 54.C. below.

54.B. se lo architetto, conforme la sentensa di Vitruvio, può dar giuditio e regola di tutto ciò che si fa, il che però non so come sia, molto più lo può il disegnio, che è fondamento di quest' arte e che abracc[i]a tutte le cose suggette al vedere: il Barbaro Libro primo Carte 7.

54.C. Per esser l'arte riposta nel'intelletto, è ridicoloso il far quistionar la scultura con la pittura, mentre allegano per cose molto dificili la durezza del marmo, la stabilità e simili, ponendo il tutto del valore nella materia.

54.D. Circa l'arte varie

54.D.1. Disegnio è facilità di mano e certa termin[a]tione in punti di linee e angoli, parti della mente e del' intelletto. + Il Barbaro Carte 13 Libro primo.

54.B. On p. 7 Barbaro comments upon Vitruvius's statement in book I, 1, p. 6: "Architettura è scienza di molte discipline, e di diversi ammaestramenti ornata, dal cui giudicio s'approvano tutte le opere, che dalle altre Arti compiutamente si fanno." Barbaro adds: "Ma lo Architetto solo per giudicare & approvare le opere perfette dalle altre Arti: perfette, dico, over compiute, come dice Vitr. però che non si può giudicare se non le cose finite, accio niuna scusa sia dello Artefice. Vero è anche questo, che lo Architetto soprastando mentre che si fanno le opere, giudica se elle si fanno bene, ò male, & approva questa, e biasma quella, secondo il giudicio, e la cognitione, che egli ha; e forse questa è migliore espositione che di sopra. . . . Il giudicare è cosa eccellentissima, & non ad altri concessa, che a' savi, e prudenti, percioche il giuditio si fa sopra le cose conosciute, e per quello (*S'approva*) cioè si da la sentenza, e si dimostra, che con ragione si è operato."

54.C. On p. 11, commenting on book I, 1, Barbaro writes: "E però mi pare, che molti vaneggiano nel decidere qual sia piu nobile, o la Scultura, o la Pittura; imperoche vanno alla materia, al tempo, & a molti altri accidenti, che non sono dell'Arte. perche l'Arte è nello intelletto, la dove tanto è pittore, e scultore il divino Michiel Angelo, dormendo, e mangiando, quanto operando il pennello, o lo scarpello, però egli si doveria considerare, quale è piu degno habito nello intelletto, la Pittura, o la Scultura, e così lasciati i marmi, gli azzurri, i rilievi, e le prospettive, la facilità, o la difficultà delle dette Arti, & allhora egli si potrebbe dire qualche cosa, che havesse del buono, ma hora non è tempo di decidere questa quistione."

54.D. On p. 13 Barbaro comments: "Tutte le Matematiche hanno sottoposte alcune arti, le quali, nate da quelle, si danno alla practica & all' operare." This is prompted by Vitruvius's statement in book I, 1, p. 13, to which reference is made in 25 above, that the architect needs to be able to draw: "Appresso habbia disegno, accioche con dipinti essempi, ogni maniera d'opera, che egli faccia formi, & dipinga." All the notes that follow in 54.D. are based on Barbaro's examples of the various arts of drawing governed by geometry and arithmetic.

54.D.1. On p. 13, shortly after the statement cited above, Barbaro writes of Vitruvius's determination of the arts required by the perfect architect:

Vitr. vuole che non solamente habbiamo quelle prime, & communi, che rendeno le ragioni delle cose; ma anche le pratiche, & gli esercitij nasciuti da quelle. & però quanto al disegno vuole che habbiamo facilità, & pratica, & la mano pronta a tirar dritte linee. & vuole, che habbiamo la ragione di quelle: che altro non è che certa, &

ferma determinatione concetta nella mente espressa con linee, & anguli, approvata dal vero, il cui ufficio è di prescrivere a gli edificij luogo atto, numero certo, modo degno, & ordine grato. Questa ragione non va dietro alla materia, ma è la istessa in ogni materia. perche la ragione del circolo, è la medesima nel ferro, nel piombo, in cielo, in terra, & nell'Abisso. Fa dunque bisogna havere la peritia de i lineamenti, che Vitr. chiama (*Peritiam graphidos*) che è peritia de i lineamenti, che serve a pittori, scultori, intagliatori, & simiglianti. La quale in quel modo serve alle arti predette, che le Mathematiche serveno alla Filosofia. Questa peritia contiene la dimensione, & la terminatione delle cose, cioè la grandezza, & i contorni. la grandezza s'ha per le squadre, & per le regole, che in piedi, & once distinte sono. Il contorno si piglia con uno instrumento del Raggio, & del finitore composto, del quale ne tratta Leon Battista: & da quello si piglia le comparationi di tutte le membra alla grandezza di tutto il corpo; le differenze, & le convenienze di tutte le parti tra se stesse, alle quali la pittura aggiugne i colori, & le ombre. Bisogna dunque, che lo Architetto habbia disegno.

54.D.2. che sia prospettiva vedi il Barbaro Carte 14 Libro primo +.

54.D.3. numero è misura del tempo.

54.D.4. principii sono universali e possono addattarsi a tutte le cose, e però chi à quelli di tutti può discorrere, ma la praticha diferensia. Libro primo Carte 23, Barbaro.

54.D.2. On p. 14 Barbaro comments on Vitruvius's statement in book I, 1: "Per la Prospettiva anche nelle fabriche si pigliano i lumi da certe, e determinate parti del Cielo." He provides a general and a specific definition of perspective. Generally, perspective demonstrates the three orders of sight, i.e. by direct, reflected, and refracted light. More specifically perspective has to do with the practice of the architect (and by implication, of the painter). It can give a sense of relief, distance, and recession to bodies represented on plane surfaces. It also governs the optical refinements recommended by Vitruvius in book III, 2, and the painting of scenery discussed in book V.

54.D.3. Book I, 1, p. 19. Barbaro comments on Vitruvius's statement that the architect must be knowledgeable about music. He writes on pp. 18f.: "Dimostra Vitr. che & quanto alla pratica, & quanto alla ragione la Musica è utile allo Architetto, per quelle parole (*Regolata*) che nel latino si dice (*Canonica*) & Mathematica. La Canonica appartiene alle orecchie, come la prospettiva a gli occhi & è presa da Musici pratichi, come fondamento della loro arte usitata, & è quella che misura le altezze, & le lunghezze delle voci. L'altezza delle voci da' Greci e detta Melos, cioè canto, & la misura del durare, & del tenere la voce, è chiamata rithmus, cioè numero, ch'è misura del tempo."

54.D.4. Book I, 1, p. 23. Barbaro defends Vitruvius's criticism of Pythius, who stated that the architect must be skilled in the actual practice of all the arts, drawing no distinction between *fabrica* and *discorso*. He writes: "Però non è incommodo alcuno che nella ragione convenghino molti artefici, i quali siano nelle opere differenti; e questo nasce dal valore

54.D.5. + da due sciense si fonda la prespettiva [prospettiva]: dalla geometria la linea piglia e dalla naturale la veduta, che unite si può dirli raggio. Barbaro 24.

54.E.1. conveniensa e decoro.

54.E.2. ordine in prima e poi.

54.E.3. + proportione nata dai numeri/ proportione nella forma non nella materia, e dove non sono parti non può esserci proportione + .

de i principij, i quali essendo universali, & indifferenti abbracciano più cose, & non dipendeno da soggetto alcuno."

54.D.5. Book I, 1, pp. 24f. Barbaro comments on Vitruvius's example of the relationships between astrology and music and astrology and geometry in support of his argument about the community of principle among the arts. The astrologer needs an understanding of geometry in order to master perspective, necessary for plotting the movements of the planets. Barbaro writes: "Prende il suo soggetto la prospettiva da due scienze, dalla Geometria la linea: dalla naturale la veduta: & ne fa una sola, che io chiamerei Raggio."

54.E. All of these notes reflect Testa's attempt to understand Barbaro's ordering and definition of the parts of architecture in his commentary on Vitruvius's statement at the beginning of Book I, 2, p. 26: "L'Architettura consiste in Ordine, in Dispositione, in bel Numero, in Compartimento, in Decoro, & in Distributione."

54.E.1. On p. 27 Barbaro divides architecture into those aspects of form that are absolute (*overo in se*), and those that are relative (*overo riferita*). Decorum belongs to this last group, and Barbaro places "overo alla convenevolezza, così è il Decoro," under the division "overo riferita" in his scheme.

54.E.2. Under the division "overo in se," Barbaro places the sub-category of those things having to do with quantity; this is then further divided. One of these last categories is "Secondo il prima e poi delle misure, cosi è l'ordine." Following Vitruvius he chooses to discuss order first. On p. 28 he points to its broadest meaning: "Certo è che l'ordine in se, e secondo la natura sua nel generale, è quando una cosa di sua ragione pone un'esser dopo l'altro: e però ne segue, che dove è ordine sia prima, & poi, e questi sono termini communi, e che abbracciano molto."

54.E.3. On p. 33 Barbaro begins his commentary on Vitruvius's definition of "bel numero," which states: "Il bel numero detto Eurithmia, è aspetto grazioso, & commoda forma nelle compositioni de i membri. questa si fa quando i membri dell'opera sono convenienti, come dell'altezza alla larghezza, della larghezza alla lunghezza, & in fine ogni cosa risponda al suo compartimento proprio." Barbaro relates Eurythmy to the aspect (*aspetto*) of form, i.e. to one of the subcategories of the relative aspect of form described in 54.E. above. He then discusses the importance of proportion to Eurythmy: "E perche ogni proportione è nata da i numeri, però egli si ha servato il nome predetto in ogni cosa, dove sia proportione, & perche la larghezza, altezza, & lunghezza delle opere, deve esser grata allo aspetto, & questo non si fa senza proportione, & dove è proportione, è necessario, che si truovi numero; però il nome di Eurithmia è stato pigliato."

In his discussion of symmetry on p. 34 Barbaro continues his definition of proportion: "& si come il maestro della natural proportione è lo instinto della natura, cosi il maestro dell'Artificiale è l'habito dell'Arte, donde ne nasce, che la proportione è propria della forma, & non della materia, e dove non sono parti non puo essere proportione." Barbaro adds that the whole question of proportion will be discussed later.

54.E.4. Two unequal lines each divided into halves and quarters, inscribed: "2 4. 4 8 proportione doppia."

54.F. Se da il corpo humano si pigliano le simetrie per l'archittetura, il buon pittore, che deve essere di quelle e quello intendentissimo, sarà adunque architetto. Parlo circha la bella conpozitione e la gratia.

54.E.4. Testa must have followed this reference for the last part of the note is taken from Barbaro's preface to book III, where that discussion is taken up. On p. 98 Barbaro divides proportion into multiple (e.g. 3:9, or 2:4) and superpartient (e.g. 3:5). Concerning multiple proportion he writes on p. 99: "La moltiplice adunque si divide in questo modo. se la maggior quantità contenerà due fiate, & non piu la minore, ne nascerà la proportione che si chiama doppia, se tre tripla, si quattro quadrupla, & cosi va in infinito. quattro a due è doppia, nove a tre tripla, otto a due quadrupla."

Both of the lines Testa has drawn before the numbers here are divided into halves and quarters, with each half marked 2, thus demonstrating the principle of double proportion. However, the fact that one of the lines is twice as long as the other, and that they are accompanied by numbers indicating the ratios 2:4::4:8, suggests that he went on to consider the question of the proportionality of different examples of double proportion. On p. 100 Barbaro writes of this: "& si come la proportione è rispetto, & convenienza di due quantità comprese sotto un istesso genere, cosi la proportionalità è rispetto, & comparatione non d'una quantità all'altra, ma d'una proportione all'altra. Come sarebbe a dire la proportione, ch'è fra quattro, & due, esser simile alla proportione, ch'è fra otto, & quattro. imperoche & l'una, & l'altra è doppia."

54.F. After turning to book III for the notes in 54.E., Testa continued to read in it. Chapter 1 is entitled, "Delle compositioni, & compartimenti de i tempij. Et della misura del corpo humano." On p. 109 Vitruvius states: "Perche non puo fabricare alcuna senza misura, & proportione haver ragione di componimento, se prima non haverà rispetto, & consideratione, sopra la vera, & certa ragione de i membri dell'huomo ben proportionato." Testa's note is drawn from Barbaro's commentary on p. 110:

La natura maestra ci insegna come havemo a reggerci nel compartimento delle fabbriche imperoche non da altro ella vuole, che impariamo le ragioni delle simmetrie, che nelle fabbriche de' tempij usar dovemo, che dal sacro tempio fatto ad imagine, et simiglianza di Dio, che è l'huomo, nella cui compositione tutte le altre meraviglie di natura sono comprese, e però con saggio avvedimento tolsero gli antichi ogni ragione del misurare dalle parti del corpo humano, dove molto a proposito Vitruvio dice, che opera niuna può havere

ragione di componimento, se prima non haverà riguardo alla simmetria delle membra humane. . . . Gli antiche oltra la proportione attendevano alla gratia per satisfare allo aspetto, e però facevano i corpi alquanto grandi, le teste picciole, la coscia lunga. nel che era posto la sveltezza: parlo hora de' corpi perfetti: perche altra misura conviene ad un corpo puerile, altra ad un corpo asciutto, o grasso, o tenue, che si voglia fingere.

Folio 15 recto.

55. quello è ingniorante incurabile che le cose che non sa e pensa saperle e per questo mai le cerca, *L'Alcibiade*, in Platone, carte 7. Quei che tra loro discordono non si dicono maestri perché la verità delle cose è una, in che l'intende[nti] sempre colpiscono, e qui pare che molte volte l'uno a l'altro le belle cose si rubino. Marino, *Sanpognio*. E qui si mostra che per cagione delle varie maniere, sono i moderni maestri ingnioranti ché caminando alla cieca mai colpiscono il bello. L'ingnioransa del giusto è il fondamento della discordia e della guerra. Si erra per questo stimando di sapere quello che non si sa: vedi tutto il primo *Alcibiade*. Ché chi è saggio può rendere altri tale.

55. The reference to Plato's *Alcibiades I* is to the Italian translation included in *Di tutte l'opere di Platone*, tr. D. Bembo (Venice, 1601), vol. 3. The whole dialogue is concerned with the dangers of ignorance among statesmen and the importance of self-knowledge, but p. 7, which corresponds to 109C-110D, falls in Socrates's discussion of how it is impossible to learn what is just and what is unjust from the multitude, whose ignorance is demonstrated by their constant disagreements.

The related reference to Marino's *Sampogna* is not to the collection of poems, but to the introductory letter addressed to Claudio Achillini that appeared in its complete form as the preface to reprintings of the first edition of *La Sampogna* of 1620 (only an abbreviated form appeared in the first printing). The letter is reprinted in *Giambattista Marino: Lettere*, ed. M. Guglielminetti (Turin, 1966), pp. 238-256. In this last, the key passage for Testa's note appears on p. 245, where Marino defines theft, imitation, and translation as the chief ways in which one writer may deliberately appropriate the work of another. He writes:

L'incontrarsi con altri scrittori può adivenire in due modi: o per caso, o per arte. A caso non solo non è impossibile, ma è facile essermi accaduto, e non pur con latini o spagnuoli ma eziandio d'altre lingue, perciochè chi scrive molto non può far di non servirsi d'alcuni luoghi topici communi, che possono di leggieri essere stati investigati da altri. Le cose belle sono poche, e tutti gl'intelletti acuti, quando entrano nella specolazione d'un suggetto, corrono dietro alla traccia del meglio, onde non è meraviglia se talora s'abbattono nel medesimo; né mi par poco in questo secolo, dove si ritrova occupata la maggior parte delle bellezze principali, quando tra molte cose ordinarie si reca in mezo qualche dilicatura gentile. Ad arte ed a bello studio si può fare altresí per uno di questi tre capi: o a fine di tradurre, o a fine d'imitare, o a fine di rubare.

Marabottini, 1954, p. 240, n. 42, points to the correct source for this note and relates it to a similar remark in Mancini. However, he cites an edition of 1637, which should not be considered a *terminus post quem* given that Testa may well have known earlier editions of the *Sampogna*.

The second reference to *Alcibiades I* is to the whole dialogue, but Testa draws particular attention to Socrates's statement (111A) that those who are going to teach anything must first know it themselves. This complements Aristotle's state-

56. Le cose, come si partono dalla sua purità e semplicit[à], perdono la bellezza, e qui si dannano le maniere nella pittura + ⟨ + e ciò si prova dalla maniera delle statue antic[h]e e moderne⟩; si prova con cosa sensibilissima, dei cibi buoni e del buon vino, che chi li altera con condimenti li guasta. Vedi Platone nella *Retorica*.

E qui può nascere un dubio stringendoci alla Pittura, come sia tanta diferensa tra artefice e artefice, dicendosi che le cose puramente inmitate siano le belle. Si risponde, le cose sì, ma le perfette in suo genere e con arte, cioè con ragione. questo vedi meglio. ⟨Antic[h]e egitie essere più pure delle romane e grec[h]e, ma per qual cagione non più belle si dirà? e qui si scoprirà dove l'arte sia riposta.⟩

E a questo vi vol grandissima aprensiva e retentiva, perché mai si vedono le cose animate che per transito, come chi tira pesi, chi l'alsa, chi teme, chi si ralegra, e tutti gl'affetti in somma; e l'altra pittur[a] fuori che di queste cose non va a conto di Pittura nè rende perito. Qui vedi Zenofonte, quanto dice Socrate per gl'affetti. Le ragioni poi per i lumi, per i movimenti, per i colori, le degradationi et altre molte cose.

ment in the *Metaphysics* (981b), cited in Chapter Two above, that the ability to teach is a sign of knowledge. Testa found support in both statements for his views on the interdependence of theory and practice.

The notes in this section provided material for §vii of the draft of the preface to the Trattato in 60.A.

56. Testa's first statement, concerning the importance of purity, and the comparison he makes between purity in the form of things and purity in food and drink, which can be ruined by the addition of condiments, almost certainly reflects his reading of Xenophon's *Memorabilia*, to which he refers later in this section. In *Memorabilia* III, xiv, 5-7, Xenophon describes how Socrates criticized greediness, especially of those who eat many things at the same time. It is wrong, says Socrates, for a man to ruin the food provided by his cooks by adding ingredients to what they have prepared, asking: "Yet it is surely ridiculous for a master to obtain highly skilled cooks and then, though he claims no knowledge of the art, to alter their confections" (1923 ed., p. 261).

The subsequent reference in the note to Plato's *Retorica* points to a development of the culinary metaphor. Testa is almost certainly referring to the *Gorgias*, to which Dardi Bembo gave the subtitle *La Retorica* in his translation of 1601 (for Testa's use of which see 55 above). In this dialogue Socrates asks whether rhetoric is to be considered flattery, with no concern for truth or the improvement of human life. He argues that even as we are justified in asking what kind of figures Zeuxis painted so are we justified in asking what kind of persuasion, and of persuasion dealing with what, is rhetoric the art (435B-454B). He argues that there are two kinds of persuasion, one that brings knowledge and one that brings only seeming or belief (454-455) and that, as rhetoric is concerned only with the latter, it is not truly an art, but rather a sort of practical skill that produces delight and gratification (454C-466A). It is in this discussion that Socrates makes the analogy between cookery and rhetoric to which Testa appears to refer. Cookery and rhetoric are both flattery: just as cookery is flattery disguised as medicine, so rhetoric is flattery disguised as administrative justice. To this Socrates adds the further example of self-adornment as flattery disguised as gymnastic. The delights offered by cookery (Testa's *condimenti*) will deceive, and by giving pleasure will confuse the understanding of the goodness or badness of food prescribed by a physician. In the same way self-adornment, "deceives men by forms and colours, polish and dress," making them neglect the true beauty that comes through gymnastic (*Loeb ed.*, London and Cambridge, Mass., 1966, p. 319, 465B). Plato is not concerned with the problem of representation of beauty here, but this definition of the relationship between true beauty

57. La Pittura è arte inmitatrice di tutto che à corpo e colore, con fine d'insegnare dilettando ⟨e questo è il fine del vero Pittore, che per il che fare inpara tutte le suddette (ora sono molte) cose. E qui si entra a mostrare che le cose suddette non sono la Pittura, ma cose atenenti a essa, e qui sia il principio del Libbro: dopo questo tutto verrò alla dotrina delle sue parti, con l'ordine di Vitruvio⟩. [Material in angled brackets inserted from top of folio 15ᵛ, where the passage is labelled "Principio," and connected to 57 by semicircles.]

57.A. L'esercitio della Pittura è è [*sic*] una continua osservatione del bello e d'esso inpregniarsi, per così dire, per gl'ochi e con la mano per far buona pratica per via di linee e colori, e chiaro e scuro, cercando nel tempo istesso perché la cosa veduta così sia et apaia, di continuo inmitando. E chiamo belle tutte le cose della natura che stiano nel suo genere, come [che] il cavallo che sia agile al corso e forte, l'huomo atto a tutti gl'ofitii suoi, c̣ome il giovine di lottare, il vechio d'insegniare e simili, la donna femina che, essendo giovine, innam[orata], atempata governi, e simili. Di qui nasce l'espressione et il bello, a che tanto i bravi Pittori devono essere aplicati, come fu Rafaello, e tanto si dice delle cose innanimate

***Folio 15 verso. Cancelled.
Figure XXI.***

e di queste cose tutte poi servirsi come di caratteri a esprimere i concetti del'animo e le cose humane di buono costume e divine + ⟨ + come della rettorica si dice che, avendo per fine il persuadere, studino prima il parlar, le sentense, i lumi, e che so io⟩ per insegnare a' riguardanti ciò che si debbe e fuggire et abraciare per rendersi fe-

and the flattering delight of ornament must have interested Testa, leading him to associate the culinary analogy, which is quite opposed to the usual association of spice with grace and *non so che*, with his reading of Socrates's remarks about the greediness of mixing foods together.

The comparison of ancient Egyptian and Greek sculpture depends upon another dialogue by Plato, this time the *Laws*. Whereas he was concerned in 55 with the similarities between the works of different artists, Testa now considers the problem of the existence of different manners if the purest imitations are said to be the most beautiful. In *Laws* II, 656D-E, Plato praises the unchanging and universally valid forms of Egyptian art and music. Testa questions this judgment here, agreeing that Egyptian art may be purer than Roman or Greek, but not necessarily more beautiful, given that beauty lies in the rational, or artistic, perfection of things according to their nature. Personal style for Testa, then, in this note lies in the differing ways of perfecting nature. For this passage from Plato see Panofsky, 1968, pp. 4 and 6.

The explicit reference to Xenophon, as indicated above, is to *Memorabilia*. Testa is pointing to III, x, where Socrates's conversations with artists are recorded, especially to his discussions with Parrhasius and Cleiton. He persuades Parrhasius that it is possible to portray the character of the soul through facial expressions and the movements of the body. The conversation with Cleiton, which is also about the importance of representing the movements of the soul, is particularly interesting in terms of Testa's vision of the role of discourse and of the wise critic in helping an artist to understand his work. Cleiton is able to give his figures the illusion of life, but cannot explain how he achieves this. Socrates helps him to see that it is the result of representing the feeling of the body, the threatening look of a fighter, for example, as well as the effect of a pose on the figure, the wrinkling of flesh, or tautness of muscle. Testa would have agreed with Xenophon that such reasoning about art was essential to its judicious practice.

57. Testa's definition of painting, which is expanded in the subsequent paragraphs in this section, would have formed the preface to his treatise. This whole section must be considered a draft for the clearer versions in 59 and 60, something that the cancellation of part of these notes, on Folio 15ᵛ confirms. This draft, as well as the more complete version, is discussed in Chapter Three.

For Testa's understanding of Vitruvius's ordering of the parts of architecture, following a definition of the art itself, see 54 above, especially 54.E.

57.A. The reference to the *Phaedrus* is to p. 233 of Dardi Bembo's translation of 1601, *Di tutte l'opere di Platone*, vol.

lice + ⟨ + e per ciò fare è nec[es]sario esser aplicatissimo al'istoria et alle bellissime Poesie et alle dottrine morali et, in una parola, esser filosofo per non mendicare le cose che gli apartengono. E qui per non parere di voler trapiantar la Pittura in cielo a certi che, per poco intendere, poco la stimano facendo un fascio de' poc[h]i buoni con tanti goffi, riferirò quello dice Platone parlando della rettorica nel *Fedro*: vedi a carte 233, dove dice qualunque delle arti grandi ànno bisognio d'esercitarsi nella Dialettica e nella contemplatione delle cose sublimi della natura⟩. E qui giustamente si sgrideranno quelle pitturaccie che non solo sono otiose, ma ànno forza d'introdurre costumi pessimi e lordi. Separiamo dunque i pittori dalla feccia di questi, chiamandoli scimie sporche e ridicole della natura, e quelli riponiamoli tra i divini poeti in Parnaso, quando il severo Platone ci eschludesse dalla sua republica, come dei meglio Poeti anco fa.

57.B. Vederò dove Platone caccia dalla sua republica i poeti, se possono i pittori cader sotto l'istessa: si risponderà per quanto si può. Credo sia il penultimo libbro della *Republica*. Si mostra l'ingnioranza di chi à scritto di pittura e special. Qui esamino le cogli[o]nerie che sono molte et in specie dove adatano secondo i luog[h]i le Pitture, tirando i pittori come vilissimi artisti a vari luog[h]i della città, in fine per l'osterie e per i patiboli, Lomazzo e Fra Francesco Bisagnio e altri.

57.C. E scriverò quelle cose solo che molte volte col [*sic*] gl'amici son cadute in discorso et ho ritrovate esercitando la mente e la mano, ma sento chi gravemente mi amonisce io intraprendere cosa del

2. This corresponds to *Phaedrus* 269D-270B, where Socrates speaks of the importance of dialectic.

57.B. Testa's reference to the *Republic* is to the discussion of poetry in book X, which in Bembo's translation (for which see 57.A. above) is indeed in the penultimate book, for he divides book X, adding book XI.

Testa's criticism of Lomazzo refers specifically to bk. 6, ch. 23, entitled "Quali pitture vadono posti in luochi di fuoco & patiboli." The reference to Fra Francesco Bisagno is to his *Trattato della pittura fondato nell'auttorità di molti eccellenti in questa professione*, Venice, 1642, pp. 193f., "Che sorte di pitture sono più appropriate a' luoghi di fuoco, e di patiboli." This section, like much of the Trattato, is plagiarized from Lomazzo. On p. 201 Bisagno considers, "Quali pitture convengano alle scuole, e Ginnasij; quali ad hosterie, e luoghi simili," and this too is taken from Lomazzo, bk. 6, ch. 26. For

FIGURE XXI

tutto vana, che mentre mi è dato
l'oparare [*sic*] io intraprenda il dis-
correre + [+probably corresponds
to the one below] e lo scrivere, il
qual nelle menti dei giovani genera
più presto lasezza et oblivione che
acutezza e chiarezza, riferendosi
alle fatic[h]e altrui non procure-
ranno colla mente farsi famigliari
della ragione, Platone, *Fedro*, 238,
e più presto saranno litig[i]osi, ser-
vendosi ogni poco delle ragioni al-
trui, che saggi, il che si otiene dal
filosofare dagl'effetti. Si risponde
che ⟨che non per fine d'insegniare
debbono gl'huomini intraprendere
lo scrivere, ma per fine di giu[o]co
dolce et onesto dopo le maggiori
fatic[h]e, parendomi che
gl'inge[g]ni che sono rozzi e sono-
lenti, sia inpossibile lo svegliarli
alle ragione delle belle cose, se ciò
non può fare in un corso di vita la
natura, con tanti suoi meravigliosi
effetti; li spiritosi poi e gli svegliati
ànno altri fonti che le scritture per
farsi ricchi di sapienza, che è la na-
tura. +Vedi qui, quello che at-
tacca, che si può intraprendere lo
scrivere in tempo che li spiriti re-
stano freddi per il dipingere⟩. Vedi
il fine del foglio dove tratto d'archi-
tettura.

Testa's view that these authors provided justification for low-
life and still-life subjects painted by his contemporaries see
Chapter Three. For the more specific use of paintings at the
gallows, and of subjects other than those suggested by Lo-
mazzo, see Edgerton, 1972, pp. 84-86. Again, this was exactly
the kind of painting that Testa felt to be beneath the true
vocation of the artist.

57.C. *Fedro*, p. 238, in *Di tutte l'opere di Platone*, tr.
D. Bembo, vol. 2, corresponds to *Phaedrus*, 274E-275E. In
this passage Socrates tells the story of the invention of letters
by Theuth, condemned by Thamus as an elixir of reminding,
not memory. The justification of writing, when undertaken
for pleasure, that follows in Testa's note is based on Socrates's
statements in *Phaedrus* 276D.

Folio 16 recto.

58. [che] la strada di mezo sia sì
poco calcata in tutte l'ationi hu-
mane, ogni cosa ce lo manifesta per
essere quella che contiene la perfe-
tione, e tutto dì si vede che fug-
gendo un estremo s'incappa
nel'altro: questo si ci fa chiaro, ci
[sono] i termini della pitura nella
parte del tingere e lumegg[i]are e
onbrare le figure, e ciò nasce per
non aver que' termini che fan far la
cosa come conviene, che chiamo
ragion di fare. Ànno certi uni, o

58. Testa's discussion of different manners of applying chia-
roscuro, and the effects of light from different kinds of sources,
is a development of the ideas put forward in 15 above, espe-
cially 15.F.-15.I. Testa has added the important observation
that shadows derived from the rays of the sun are smaller
than the object, whereas those from other light sources are
larger. A similar reminder is presented by Accolti in *Lo In-
ganno degli occhi*, 1625, pp. 95f., although he describes the
rays of the sun as being parallel, rather than meeting at a
point. Testa himself restates his position more clearly in 69
below, where he points out that a light source larger than the
object will produce shadows smaller than the object and vice
versa. This concern for the effects of light sources of different

per non straccarsi o perché altro, racch[i]uso la varietà infinita della natura per i suoi acidenti in brevissimi termini, che o l'uso o la loro conpiacensa, o il loro torto vedere, à dettato, e ciò chiamarò maniera di fare, la qual per ora disting[u]erò in dua circha il colore: cioè maniera dolce e di forsa, e ciò fanno conbattendo ostinatissimamente [*sic*] l'una parte col nero e l'altra col biancho, non amettendo ne' lor confini una brevisima particella del suo contrario. L'esenpii sarebbono infiniti, i quali lascio, e ~~de loro ragionamenti . . . e quel che . . . non se ne tratta~~

Li acidenti fanno le cose convenienti nel suo genere (e qui per ora parlo de' lumi e d'onbre). Se le cose doverano esser lumate di lume acidentale, cioè di fiacola, da qualche foro di muro, e che altro, le più vicini e senpre le parti più essposte ai raggi de' detti lumi saranno caric[h]e di maggior lume, e per il contrario, e lì per ultimo sarà il colmo del'ombra, dove nessuna parte di reflesso potrà g[i]ungere, il qual però riuscendo fiacchissimo fa vedere le cose con tanta pocha armonia, perché un crudissimo chiaro è terminato d'un' onbra non meno terribile, e questa molti àn voluto esser pittura di forsa. Restano i lumi più naturali ché sono d'aria velata o di sole o d'altro luminare. L'aria produce i chiar morti perché quasi per tutto alluma, fuori che le parti che sono al'oposto della terra, le quali però ~~non vengono rischiarate~~ riescono morte per non essere, come s'è detto, lume che habia raggi e ferisca il corpo, i quali ronpe e genera l'onbra come fa il sole: con questa diferensa però, che essendo non che delle parti maggiore di tutta la terra, opera il contrario d'ogni altro lume, ché dove quelle per il difondersi dilatan l'on-

sizes relative to the object, which does not appear in Armenini or Lomazzo, seems to reflect the revival of interest in the study of such variables by Leonardo (see e.g. Richter, 1883, §160) that lies behind Accolti's remarks.

bra, questi unendosi a un punto la diminuiscono.

E perché il fin mio è di scoprir la perfetione di questa nobile arte, toccherò, come in tutte le altre parte io facio, toccherò quel bel modo d'onbrare e lumare c[h]e si rachiude nel mezo, riducendolo dove non g[i]ung[h]ino le ragioni dimostrative a quel'idea che, come dico, ho per fine, cioè che il lume non sia di sole, come tropo acuto, non d'aria, come molle, non di fia-cole, come crudo ma scansandosi da tutti questi estremi, pigliare un mezo che renda forsa e dolcezza, il che aviamo dal senso quando ve-diamo i lumi d'aria purgata che [prendevano?] da gran cortile o simile. Qui si risponde per via d'in-terogatione che se, secondo quello si à a fare, si deve tenere [. . .] si sbriga che si debba, e poi conferma le sue ragioni ideali, che fuori di lì non dà +⟨+ l'eccellensa della pit-tura ma la chiama serva⟩.

Folio 16 verso.

Blank.

Folio 17 recto.

59. Che la Pittura è Arte inmita-trice delle cose visibile in piana su-perficie, a fine di dilettando insegniare.

59.A. Data la difinitione, si vede per quali mezi si va alla perfetione, e questi sono per fondamento la di-ligensa intorno alla pura inmita-tione prima delle cose degl'altri ar-tefice, poi della natura. Così fatto una buona pratica di mano si passa al'intendere per le sue chause. In-teso questo come ricco di sciensa e ben disposto, si dà opera alla pit-tura, ritrovando che cosa è inven-tione, dispositione, conpositione e altro, e qui vedrò ciò che sta nella

59. Testa provides a detailed outline of the proposed Trattato, beginning with a variation of the definition of painting and the expansion of that definition (which would have formed a preface to the whole) that are also found in 57 and 60. This definition, preface, and outline is discussed in detail in Chapter Three. Only specific references to cited sources are given below.

59.A. Testa gives no indication of which edition of the *Poetics* he read, but as he used Segni's translation and edition of the *Nicomachean Ethics* he may have consulted Segni's *Rettorica et poetica d'Aristotile*, Florence, 1549.

Poetica d'Aristotile; per le ragioni
le mattematiche, siché dividerò in
tre libbri il tutto, et ogni libro [in]
molti capitoli, sempre ascendendo
sinché porto la Pittura tra la Poe-
sia, nel più alto di Parnaso, eschlu-
dendo tutta quella che non giunge
a questa Perfetione. Come dei
poeti si fa chi non fa un corpo di
Poesia con tutte le sue regole,
tanto meno chi per essere buon
grammatico o in altre particelle che
precedono alla poesia, volesse il ti-
tolo di poeta; così per l'apunto chi
sarà sciente delle ombre dei corpi,
dei lumi, della ragione del vedere,
della notomia, dei moti, dei colori
e molte cose simili, non si dirà per
questo essere pittore, ma sciente di
cose alla Pittura atenenti; tanto
meno dunque chi sarà usato a co-
piare opere di gran maest[r]i e
della stessa natura con molta dili-
gensa, tanto che anco le dette cose
le faccia similissime, non potrà aver
questo nome per la ragione sudd-
detta, ma di diligente e bene abi-
tuato, atto a far gran rius[c]ita nella
Pittura.

59.B. Questo sarà il primo libro,
mostrando come si dà principio a
questa inmitatione e come sia ne-
cessario tenersi forte in non dar in
maniere, le quali sì facilmente cor-
ronpono i giovini, e come i
maest[r]i se non mostrano il fine,
inpediscono i voli ai più belli spi-
riti, tirandoli per li acidenti in pazzi
laberinti.

59.C. Nel secondo mostrerò la
forza delle ragioni far operar bene
e meglio di chi si serve degli
ogetti, avendo i primi fondamenti
del'inmitatione di tutte le cose
della natura e del'arte.

59.D. Nel terzo mostrerò l'idea e
perfetione della Pittura consistere
nel'espressione e persuatione alla
virtù non sensa dilettatione, ca-

vando tutte le ragioni da la Poetica, essendo l'istesse.

59.E. Il primo capitolo o argomento mostrerà quanto dice Platone nel *Fedro* del'arte oratoria, dove io ho segniato. +

59.E.1. + Nel secondo, come dei poeti, vedere se la natura dispone che così con lungo uso et arte si riesce perfetto e che in altro modo è pazzia.

59.E.2. + Nel terzo elegere la diligensa e la natura per maestra, sfuggendo i discorsi di qual si sia maestro, perché non essendo il suo tenpo né anco atti a ricevere i semi di ragioni, rendere confusi i giovinetti.

59.E.3. Nel quarto mostrerò da che cose da inmitarsi si principia, che siano più proportionate e come e a quale via via [*sic*] si possa.

59.E.4. Nel quinto come si copia nella natura quelle cose che si è osservato nei gran maestri e come a quelle si paragonano e quando si vede molta somigliansa attacarsi al'inmitatione d'uno simile e principiare a far dei voli, come di Virgilio si vede e d'altri buoni poeti, lui nelle sue *Eglog[h]e* e simile.

59.E.5. Nel sesto si mostra come s'apre l'intelletto alle ragioni perché le cose sono così, col vedere, et aplicare; e qui termina il primo libro.

59.F. 1º. Il Primo capitolo del secondo sarà nel mettersi a intendere gl'elementi delle matematic[h]e per poter con essi, come con chiave, ritrovare le chagioni di tutte le cose che vediamo.
2º. Si mostra come con questi fondamenti si diventa patrone e libbero di schiavo e mercenario che era nel'arte, siché può sensa ve-

59.E. Testa is certainly referring to Plato's insistence upon the importance of dialectic, something that he would have wished to state in the first chapter of the Trattato. For his note taken from *Phaedrus* 269D-270B see 57.A. and 60.A.4. In his comparison of the progress of the young artist, from the imitation of a sympathetic model to the moment when he takes flight independently, to Virgil's development as a poet, Testa is referring to the tradition that Virgil had failed to master his model, Theocritus, in the *Eclogues*, but that he had then taken flight and surpassed his second model, Hesiod, in the *Georgics*, equalling his supreme third model, Homer, in the *Aeneid*.

The reference to the *Phaedrus* in the outline of Book II, 7, is to 278B-D, where Socrates challenges writers and poets, including Homer, to become philosophers by writing of the truth and showing that actual written words are of little worth.

runo oggetto colla memoria delle
cose già esercitate far più che chi
sta crepando colla pura inmitatione.
3º. S'avertisce però a mai lasciar di
contenplare la natura delle cose e
specialmente quando di quelle à da
servirsi, ché altrimenti per tutte le
ragioni si mostra facilmente darsi
dandosi ne' corpi inregolari così
esatta ragione che possa far sprezzare
la continua osservatione col' ochio.
4º. Si mostra che l'Architettura e la
prespetiva di essa, essendo di cose
regolari e ferm[e], sono ridicoli
quelli che si vagliono del senso,
come tanti ho veduto moderni ar-
chitetti.
5º. Si mostra qual sia la vera ar-
chite[tt]ura; su che salde ragioni
fondata e come sia molto temerità
lo stacarsi da esse e specialmente
da Vitruvio Padre.
6º. Si mostra che fin qui non basta,
ma doversi come chi è per scrivere
aver la sciensa di tutti i caratereri
[sic] che la scrittura formano,
altrimenti mancandovene poesi[a],
e tanto più molti e principali
non potersi mai scrivere perfetta-
mente

Folio 17 verso.

perfettamente né farsi intendere.
7º. Si farà dunque chiaro quale
cose anco precedono e sono neces-
sarissime per il buono Pittore, e
questo si dirà essere l'istoria e la
poesia, e brevemente ogni buona
disciplina come i veri filosofi sono,
perché per dire il vero, come sarà
Omero Poeta divino se la sua Poe-
sia fusse piena di ciance e non di fi-
losofia. Qui vedrò et aditerò il testo
di Platone per non far credere io
voler anplificare Platone nel *Fedro*
della rettorica.
8º. Mostrerà, come per i contrarij,
come sono ridicoli quelli che in al-
tro modo vogli[o]no il nome di Pit-
tore, e quelli che sensa ragione di

essa vogliono dar giuditio, mos-
trando essere ingnioransa non
meno di chi poi, stordito per non
intendere, fa quella sciocca con-
chlusione la Pittura essere opi-
nione.
9°. Si confuta tanti strani insegnia-
menti come cose plebee intorno
alla pittura.

59.G. Si mostra la gran proportione
che à il colorire alla musica et alla
poesia tutta la Pittura.

59.H. Si farà bellisimi trattati degli
affetti e delle sconvenevolezze dei
goffi intorno a quelli.

59.I. Si mostrerà che sia inven-
tione, che dispozitione.

Folio 18 recto. Figure XXII.

60. ~~Principio vedi il foglio C~~. Difi-
nitione ne' dui primi libri. Mos-
trerò come si conseguisce questa
intelligensa del corpo e colore e
come si mette in atto nella piana
superficie; nel terzo come si con-
segu[i]sce il diletto col' utile, ul-
timo fine della vera Pittura.

60.A. Pittura è Arte inmitatrice di
tutto che à corpo e colore in piana
superficie, con fine di dilettando
insegnare. Et ho per fine in questa
prefatione di mostrare dove sia la
eccellensa della Pittura e di ri-
muovere dui falsi principij +
⟨+ tra di loro contrarij⟩ per inse-
gniare i giovinetti.

60.A.1. L'esercitio per la pittura è
una continua osservatione del
bello, con il perché, e di esso, per
così dire, farsi pregnio per gli ochi
e e [sic] con la mano in esso eserci-
tarsi, e partorire poi per via di li-
nee e colori, con la forza del chia-
roscuro, i concetti del'animo, per
radrizare i costumi, e insieme di-
lettare: belle poi chiamo tutte le

60. The cancelled notes probably refer to 57. In this section
Testa is reworking parts of the outline of the Trattato that
appears in 59. He begins with a restatement of the main themes
of the three books projected in 59.B.-59.D., and then sets
out to refine the preface, of which there are drafts in 57 and
59. This preface is discussed in detail in Chapter Three. The
notes below serve to identify sources where they are cited,
and to indicate which notes elsewhere in the manuscript can
be considered preparatory for the synthesis Testa is making
here.

60.A. This definition, which would have introduced the Trat-
tato, is a third variation on the definitions found in 57 and
59. 60.A.1.-60.A.6. represent the development of ideas put
forward in a more disconnected form in 57.A.-57.C.

cose nel suo genere ferme, cioè
conpite o ideali* ⟨*e qui si fa ridi-
colo chi per l'imitatione di cose di-
sanimate e goffe degli artefici vole il
tittolo di Pittore, come se uno che
con il canto dichiarando che sia il
cantaro e la padella pretendesse la
corona in Parnaso tra Virgilio e
Tasso; qui vedi il foglio co' questo
segnio⟩; e di qui nasce l'espressione
in che tanto ~~Rafaello~~ i meglio mae-
stri si fonda[no].

60.A.2. Ora sono molte cose che
apartegono a quest' arte, e delle
quali molti ne ànno dati insegnia-
menti. Desidero però s'asten-
g[h]ino da quel titolo usato da
essi, e generi[c]o di tratato di Pit-
tura+ ⟨+perché tanto è questo
quanto chi pretendessi perché à
pronto calcina, legni, pietre, di
aver fatto il Palazzo⟩. Ma se tratte-
ranno della Simetria, Simetria, dei
moti, dei moti, dei colori, e simile*
⟨*come gli oratori che, avendo per
fine il persuadere, studiano prima
il parlar le sentense, i lumi, e che
so io⟩ colori; cose tutte atenenti alla
Pittura, e di queste cose tutte poi,
servirsene come di caratteri a espri-
mere i concetti, come dissi,
del'animo intorno alle cose divine
et Humane di buono costume, per
insegniare ciò che sia bene di fug-
gire, e ciò che [sia] d'abraciare, a
somigliansa dei Poeti migliori, per
rendersi felice quanto si può.

60.A.3. E qui giustamente ci adi-
reremo e contro a certe pitturacce
et ai maestri di esse, ché non solo
sono otiose ma ànno forza d'intro-
durre pessimi costumi. Separiamo
dunque i Pittori dalla feccia di co-
storo, chiamandoli scimie sporche e
ridicole della natura; e quelli sa-
ranno riposti tra i divini Poeti in
Parnaso, quando ~~il severo Platone~~
qualche severo pure li eschludesse

FIGURE XXII

60.A.3. For the reference to Plato, which is quite explicit
even though his name is cancelled, see 57.A.-57.B.

dalla sua republica come dei poeti
fa. E per ciò conseguire è necessa-
rissimo essere ⟨oltre che dotto di
tutte quelle cose che al far il tutto
con ragione si apartengono, cioè
prespettiva, simetria, e via via . . .⟩
[insertion indicated by crescent
moons] al'istoria aplicatissimo +
⟨+ per l'istoria, ma poi filoso[fo]
per non h[a]ver bisognio di chi sia
e quest' è la perfetione⟩ e alle bel-
lissime Poesie A ⟨A per l'inven-
tione⟩ e nelle morali virtù B ⟨B per
gl'affetti⟩ bene inbe[v]uto, et in una
parola esser filosofo, per non men-
dicare tante cose che li aparten-
gono.

60.A.4. E qui per non parere di
volere trapiantare la Pittura in cielo
a certi che per poco intendere
poc[h]issimo la stimano, facendo un
fascio dei poc[h]i buoni con tanti
goffi, riferirò quello dice Platone
parlando della Retorica nel *Fedro*;
vedi a Carte 233, dove dice qua-
lunque delle arti grandi àn[n]o bi-
sognio d'esercitarsi nella Dialettica,
e nella contemplatione delle cose
sublimi della natura, e con queste
inpinguato, e fatto ricco di gran te-
sori maneggerà con molta facilità la
propria arte; ma io non mi trovo
atto a tanto volo, e scriverò solo
quelle cose che con gli amici sono
più volte caduto in discorso, et ò
ritrovate dagl'effetti e visto per altri
propositi in grand' huomini an-
tic[h]i con qualche esercitio di
mente e di mano.

60.A.5. Ma sento qui chi grave-
mente mi amonisce io intrapren-
dere cosa del tutto vana, e che
mentre mi è dato l'operare mi
perdi nel scrivere, essendo che le
menti dei giovini per le cose ritro-
vate e registrate riescono lasse e
piene d'oblivione che

60.A.4. For the reference to the *Phaedrus* see 57.A., and 59.E.

60.A.5. Testa's comparison of himself to Vitruvius at the end of this paragraph, in terms of making good use of his time by writing is based on Vitruvius's dedications to Augustus in the prefaces to book II and book VI, to which Barbaro drew attention in the brief *vita* of Vitruvius that he placed at the beginning of his translation of *De Architectura*.

Folio 18 verso.

⟨più⟩ che acute e chiare, perché ri-
posandosi sulle fatic[h]e altrui non
mai procurano farsi famigliari della
ragione, e più presto servendosi a
ogni tempo delle ragione altr[u]i
saranno garuli e litigiosi che saggi,
il che nella pittura si otiene dal fi-
losofare degli affetti. Si risponde
che avendo il pittore certo tempo
determinato al'operare, cioè fin
quanto si sente generoso, e di spi-
rito ripieno, mancato questo deve
(essendo prudente) riposare i pe-
nelli in mano dei più giovini, e per
fuggire il brutto otio, e le crapule
può per la domestic[h]ezza della
sua cara poesia, pigliar la penna.
Agiunto che a me è rimasto più
otio di quello mi concedeva la Na-
tura, parendomi (come di sé scrive
Vitruvio) di meritar di esser cer-
chato nella mia atione.

60.A.6. Non per fine dunque d'in-
segniare (parendomi per la sud-
detta ragione vano) ma per un
dolce et onesto giuoco, maggior-
mente che l'ingeni che sono sono-
lenti e duri sia inpossibile muoverli
e svegliarli alle ragioni, se ciò non
può fare in un corso di vita la Na-
tura medesima con tanti suoi mera-
vigliosi effetti. Li spiritosi poi e li
svegliati ànno altri fonti che le
morte scritture per svegliarsi; che
come delle belle pitture si dice che
paiano vive ma interogate mai ri-
spondono, così le scritture che ai
nuovi dubi che in leggendole su-
geriscono mai sodisfano con altre
risposte che con le medesime: siché
la natura e la ragione sono le vere
maestre di quest'Arte e professan-
dosi non saper niente cerchar da
esse quanto ci possono dare,
perché è ingnioransa incurabile
pensare di sapere quelle cose che
non si sanno, essendo che mai da

questi si cerchano, e da cotali
nas[c]ono tutto dì i brutti e vari
mostri di tante opinionacce tra di
loro contrarie e ciec[h]e.

60.A.7. La verità delle cose è una,
e lì solo i veri maestri (benché per
vari mezi) sempre colpiscono, a
segnio che molte volte pare che le
cose medesime, incontrando tra di
loro, si rubino; ma questo non è al-
tro che la forza della ragione che
tira tutti in un punto; e solo chi è
saggio può rendere altri tali, al-
meno col' aditarli il luogo della ve-
rità. Et io per me stimo che la cor-
rutione di tanti ingegni nella
Pittura da altro non derivi che dalla
temerità di certi, che non sapendo
né meno i principij di un'arte così
profonda, si mettono con tanta fa-
cilità a insegnare o, per meglio
dire, inbrogliare la mente a chi li
càpita sotto, e staccandoli, per così
dire, dalle materne poppe della la
[*sic*] natura, di dove i più chiari in-
gegni ànno suchiato latte di tanta
sustansa, li dànno certi beveroni i
più insipidi et indigesti, che per
necesità in breve Tempo

Folio 19 recto.

Tempo perdendo tutto lo spirito,
muoiono in braccio all' Ingnioranza:
sarà charità dunque avertire i giovi-
netti e sgridar costoro; questi a ver-
gogniarsi d'insegniare quella via
nella qual essi, come ciechi,
sempre incianpano e cadono; quelli
ad armarsi di patienza e, come le-
gittimi figli, non mai stacarsi dai
fianc[h]i di essa natura. E parlando
più chiaro ai giovinetti, o ai Padri
di essi, dico che chi pensa fare
un'otima riuscita se non vol restare
infetto di quel'ingnioransa di che
costoro sono ripieni, e chi è che
presuma di sapere più della gran
maestra Natura? Questa, sensa
tante opinioni, si espone a gli ochi

60.A.7. The beginning of this paragraph is based on material
drawn from Plato and Marino collected together in 55.

di tutti; chi più lei osserva, a quello più comunica le sue gratie, aprendoli a poco a poco i maggiori suoi se[c]reti: ma bisognia di lei inamorarsi, e quelli se innamorano che nascono alla pittura.

60.A.8. Io non nego poi che certi principij apresi da altri non siano per facilitare, come si vede nelle lett[e]re, che i giovinetti ne' primi mesi non sc[h]ifano colla spessa repetitione mettersi in mente l'ordine del'alfabeto, poi sopra ogni qual sia libracio conporne le silabe, poi le parole, e via via; e chi dirà che questi picolissimi semi non siano necessari per ascendere poi alla divinità del Poetare non dirà bene; vi vogliono sì, ma si aprendono da ogni vile vechiarella. Or qui è chiara la somiglianza benché la Pittura molto più pura e naturale sia della Poesìa, parendomi quella havere i suoi principij nel parlare, che è inventione degl' huomini, e per tanto è forza che pieg[h]i allo studio di quelli.

60.A.9. Ma sù, io per non esser tanto rigido voglio permettere tali necesità a chi è per incaminarsi nella Pittura, ma chi non vede quanto presto si libererà dalle mani di costoro, quello come che dissi che sarà nato per essere pittore? Et qui più volte non sensa riso io ho sentito questi maestroni così spesso ramaricarsi dell'ingratitudine et incostansa (dicono essi) di i giovini loro, per esserli scappati di mano prima che li habino resi del tutto rozzi et ingnioranti; e non si acorgono questa essere la proprietà dei più bell'ingeni, di metter speculando di continuo, a poco, a poco, le ali (per così dire) e così al'inproviso dànno un volo trapassando da un infelice tetto ove cova l'ingnioransa colle brutte opinione, alla libera campagnia della natura,

60.A.8-60.A.9. For a very brief statement of Testa's views on bad teaching expressed here see 30.

e lì a lor talento si pascono l'intel-
letto per longo tempo stato
dig[i]uno; e questo si fà quando i
giovinetti sono tochi da un certo
lume di ragione, dichiarandoli che
la natura è afatto nimica delle ma-
nierace.

60.A.10. Debbe per tanto

Folio 19 verso.

tanto il giovinetto aconsentire a
questo vero lume di ragione, e
presto sbrigandosi da certi debolis-
simi principij per non invisc[h]iarsi
insensibilmente sotto di costoro in
qualche male abitacio, dificilissimo
poi a poterlo las[c]iare; e questi
principij (come dico) sono di debo-
lissime cose, e anco ridicole ché
come dissi si può far di meno che
non già il Poeta, e simili. Ma non
mi voglio pentire, voglio ametterli
per non levare afatto tante facende
a questi maestroni. Saranno dun-
que questi (non vorrei qui abassare
il mio scrivere con cosa che tiene
del ridicolo, ma pure il dirò) sarà il
modo con che si sega il lapis, come
si fa la punta, come si spunta, qual
pane è buono a cassare, qual carta,
se berretta, o pecora, o castrone,
che sia meglio sfumare, granire, o
trattegiare. E come in queste ba-
gattelle questi cotali tanto discor-
dano, così fanno nelle principali
cose, chiarissimi segni di vera in-
gnioransa. Ma di gratia non così
presto saltiamo in scena. Seria-
mente dunque ripigliando, piglie-
ranno i principij da cose debolis-
sime, cioè una brocca, un fiasco, e
simile.

60.A.11. Deve per tanto il giovi-
netto nei principij suggettarsi a una
estrema patiensa di mano e di
ochio per arrivare col inmitatione
tutto quello si metterà a fare; ché
essendo il fine della Pittura inmita-

60.A.10. Testa is attacking those writers like Armenini, Lo-
mazzo, and Bisagno, who offered advice about just these
questions.

60.A.11. For further affirmations of the principle that the stu-
dent must begin with thorough and diligent practice see 52
and 53.D.

tione delle cose visibili, e questo
facendosi colla pratica e la teorica,
chi non vede esser più propia ai
giovinetti la pura inmitatione a
forza di diligenza sensa il perché
durissimo di digerirsi? esendo che
questo solo si fa colla forza delle
Matematiche. Siché prima sia per
chi s'incamina la sola cieca diligenza,
poi la pura osservatione che la cosa
è così, poi la ragione perché così
sia. Questo perché poi è quella
gran chiave che apre nel'arte tutte
le dificultà, e che a pena i più vigo-
rosi possono reggerla, non che i
putti voltarla. Non dico però che
come principij a suo tempo necesa-
rii non si debbano dai putti prima
inparare ma, imparati, come tesori
si riporranno tutto quel tempo che
si consuma intorno alla natura. E
per maggi[o]r chiarezza servianoci
[*sic*] spesso delle somigl[i]anse; os-
serviamo nei costumi che mai ve-
dremo il padre comandare il figliolo
e quello voler la ragione prima d'u-
bidire. Il princip[i]o dunque di ben
costumarsi è l'ubidienza; il prin-
cip[i]o parimente per un gran Pit-
tore sarà la patiensa e diligensa in-
torno alle cose che vede. Ma altri
dira che tal conparatione camin[a]
ma

Folio 20 recto.

61. §1. Eravi da una parte quel
Domenichino che tutto questo se-
colo non che Bologna rende chiaris-
simo e vedevo, ma così alla sfug-
gita, con quanto zelo e altamente
discorreva; st[a]va appogg[i]ato
al'Istoria e al'Espressione, et ha-
veva intorno il fiore della Grecia,
dove spesso vedevo gagliardamente
ribattere e spesso anche cedere, e
con conposta e atentissima atitu-
dine sentire e apprendere quelle
fondatissime conchlu[si]oni che per
i lor labbri inmortali spargono i
Mattematici. E di qui poi con fa-

61. These notes, together with those in 63, form a separate
section in which Testa describes his vision of the ideal Par-
nassus. As indicated in the notes to 63, they are written in
the form of a letter to Girolamo Buonvisi.
§1. Testa's description of his old teacher Domenichino (1581-
1641) leaning on, or supported by, History and Expression
reflects the same assessment of his work presented by Mas-
sani in recounting the story of the old woman's preference of
Domenichino's work in S. Gregorio Magno to that of Guido
Reni. Massani records this as a story first told by Annibale
Carracci, who concluded that he had learned from the old
lady "à conoscere, quale delli nostri due Dipintori habbia più
vivamente espressi gli affetti, e più chiaramente la sua Hi-
storia dichiarata" (Mahon, 1947, pp. 252, 271-272, where Pous-
sin's preference for Domenichino's fresco for the same rea-

ceto discorso vedevo rossarlo e pro-
ronpere in riso per quelli che con
tanto fasto sopra niuno fondamento
alsano muri che ogni v[e]nticello li
scuote e gl'atterra. Spesso, per di-
spute intrigatissime, muovevono
gl'ochi e gli orechi di tutti verso
loro, disposti più alla meraviglia
che a altro. Veddi più volte il gran
Leonardo con quella sua maestosa
presensa dar forsa a' suoi detti, e
staccati da tutti hamic[h]evolmente
tra loro passegg[i]are. Più a parte
s'era ritirato quel Guido, che anche
chi lo segue conduce alla gloria.
Stava circondato dalle Grat[i]e e
dal Decoro, e discorreva con quel
ingenu[i]tà che è solo dei bravi,
del suo errore; che ciò che per le
tele avansò, le carte gli havevano
tolto, e che il gran G[i]ulio e ~~raf-
faello~~ il divino Raffaello ultima-
mente con esso havevano fatto del
resto. Qui vidi ridere le Gratie e
raddopiare la loro bellezza, confor-
tandolo a star per loro chausa di
buonissima voglia. E ciò detto, con
corona di vag[h]issimi fiori ma non
sfacc[i]ati lo corononno. Vi maravi-
glieresti, Carissimo Signore, veder
quel nobilissimo vechio così ornato;
quanto si rende grato, quanto
suave.

§2. St[a]va dalla contraria parte
quel gran Romano, G[i]ulio, che
parea si ridessi di quanti intorno si
vedeva, non havendo che una
penna d'oro al'orechio, havesse po-
·tuto con poche carte, dico poche
ben che fossero molte in risguardo
della loro eccelle[n]sia, hav[e]sse
dico con tutti saputo farli del resto.
E con voce alquanto rozzetta in
vero, esschlamava lui haver pocho i
colori adoperati perché vedeva la
Pittura esser femmina et il Dise-
gnio maschio, e che volendosi
unirsi spesso vediamo l'una parte e
l'altra talmente indebilitarsi che a

sons is also recorded). While this mastery of the *affetti* and of
history painting in general was certainly what later writers
like Bellori and Passeri saw as being the salient feature of
Domenichino's style, this judgment, which reflects traditions
reestablished in the Carracci Academy, does not appear in
Baglione's or Mancini's account of Domenichino's life. Testa's
view of Domenichino surrounded by the flower of Greek phi-
losophy and in deep discussion with mathematicians must be
set against Mahon's argument that Domenichino was not "an
aesthetic theorist of the *letterato* type," disregarding for the
moment the puzzling distinction he makes between a "seri-
ous" (his quotation marks) painter, or "philosopher in paint-
ing," and a philosopher of painting, p. 124, n. 50.

Testa does not praise Domenichino at the expense of Guido
Reni (1575-1642). He does, however, point to Reni's weak-
ness for gambling at cards, something that is not explicitly
stated by Mancini, who mentions only his tendency to spend
too much, and which was first recorded in print by Malvasia,
ed. 1841, 2:26, 34, 35, 42. Testa also underlines the impor-
tance of Raphael (whose sketchbook containing one hundred
drawings Guido had bought in Rome), and of Giulio as Reni's
models. The characteristic of Reni's style presented here is
grazia, a critical judgment on Testa's part that reflects the
opinion of his contemporaries.

§2. Testa's presentation of Giulio Romano (1492-1546) as a
master of *disegno* who despised *colore* has no sources in ear-
lier biographies, though it is in keeping with Vasari's state-
ments about the very great success of his drawings, Vasari-
Milanesi, 5: cf. 550-551. Bellori's accounts of the importance
of Giulio's work for Algardi, Poussin, and Sacchi reflect the
same high esteem for Giulio's drawings and inventions that
attracted Testa to his work, and led him to include him in
the ideal Parnassus, even though not without criticism. Ra-
phael (1483-1520) is presented not only as the complete painter
supported by the Graces, Knowledge, and Experience, but
also as the perfect teacher who is able to move his audience
easily, a role that Maratta also gave him, according to Bellori,
ed. 1976, p. 628.

pena si sostengono. E qui alsava
gagliardamente contro quegli che
tanto con i colori cerchano dilet-
tarne il senso e far servo il disegno
a una vilissima feminella che chia-
mava la Pittura. Vi erano molti del
suo parere, [mancaro?] molti qui da
descriversi, ma fu dal divino Raf-
faello, che con la Pittura sotto il
portico passeg[i]ava, fatto tacere
mostrandoli col essperie[n]sa che
poteva sensa questo suo indebili-
mento unirsi sempre, ansi che di-
suniti potevano cadaveri nominarsi,
il che fu dalla Pittura confermato.
E perché vedeva [che farlo s'a-
vesse?] con saldissime ragioni per
fermarlo e gli riuscì, le quali io da
parte notai e sono queste. Si fe'
cerchio subito a quel d[i]vino
huomo e vedevi che le Gratie et il
Sapere al'Essperiensa li porgevano
con tanto tempo proportionato le
parole, che sensa sentir le conchlu-
sioni tutti unitamente col capo face-
vano segnio d'affermare. Solo quel
Romano qualche v[o]lta scuoteva e
pareva volesse entrare di che,
avi[s]tosi più di una volta, il
maest[r]o li diede il canpo, e a suo
luogo sentirete le replic[h]e.
§3. E prima seguiterò descrivervi
tutto a parte a parte quel nobilis-
simo e spiritosissimo senato. Sta-
vansi in un drappello come [s'una?]
tal republic[h]etta que' gra' Venetia-
ni e Lombardi che tanto ai colori
ànno ag[i]unto e odore e
v[a]g[h]ezza, e come sdegnia[n]do
que' discorsi tra loro andavano ri-
cerchando dove la dolc[e]zza fosse
riposta unita colla forsa, e come i
refellsi [sic] nei corpi generassero
gran armonia nei corpi, e che gli
scuri in pochissimi luog[h]i do-
veano con i chiari collocarsi. A che
Titiano, che lì pareva di tutto lor
Padre e ma[e]stro, sensa tanti dis-
corsi dando di mano ai pennelli con
meraviglia d'ogniuno mostrò con

§3. For Testa's analysis of color and chiaroscuro see Chapter
Three. Just as Guido represents grace, and Giulio Romano
disegno, so Titian stands for experience and *colore*. Raphael,
of course, combines all of these with knowledge, of which
Leonardo is probably the epitome here. Bellori, ed. 1976, p.
268, follows the same view that Rubens carried Venetian color
out of Italy. These are the different talents referred to in 62.

l'essperie[n]sia che in tre parti
principali dovevano collocarsi i co-
lori e conforme i conchlusi siti an-
darsi essi colori colloca[n]do, ché
altrimenti si pregiudicava al chiaro
et allo scuro et alla meza tenta,
parti principalissime che dàno il ri-
lievo, e che il tutto l'esperie[n]sa
gl'hav[e]va insegniato. Il che da
essi fu sempre con somma di-
lige[n]sa havertito e si sparse, non
che tra loro, tal sentensa per tutta
la Fiandra, che la portò come del
paese amico e con essa ripassò i
monti quel gran Rube[n]sse, che e
per questo e per i suoi poetici con-
cetti, gode di questa gloria.

§4. Sentirono con avidità i fratelli
Carracci, e di valore e di spirito e
di fortuna non meno ma spinti da
maggior gloria, chi qui si staccorno
per sentire ciò che là si discorreva,
e questi bravissimi, standovi come
si dice a cavallo del fosso, sono pa-
troni del' una riva e del'altra. Chi
pol spiegare abasta[n]sa le loro
hopere famose non meno in pittura
che in disegnio! e quanto prati-
cando fussero dalla Fortuna agitati,
e lacerati dal'Invidia. Ma qual glo-
ria perg[i]u[n]to [verle?] del farlo
presentemente non ne riportarò.
Qui facio che Raffaello piglia il dis-
corso contro G[i]ulio. Sopra, dove
si disse essere la [storia?] della Pit-
tura, si ci farà il decoro, l'espre-
sione e tutte quelle

§4. In writing of the *fratelli* Carracci Testa is, of course, re-
ferring to the family relationship between Agostino and An-
nibale, the two brothers, and their cousin Ludovico. For their
emergence as historical figures, and of Annibale's importance
in particular as a victim of envy and fortune see Chapter One.
See also Baglione, 1649, 1:108.

Folio 20 verso.

parti se alla pittura sono
ne[ce]ssarie.

62. Talenti di vari Pittori.

Folio 21 recto

63. §1. [Toccato?] quel mostro con
tutti i suoi malanni, Signore mio
G[irolamo], g[i]unsi alla sommità,
che altro che l'ali del'ingegnio non

63. In these notes, which, together with those in 61, form a
separate group, Testa imagines himself arriving on Parnassus.
He describes his arrival and the conversations he hears there
in the form of a letter to his patron Girolamo Buonvisi (1607-

può condurcivi. Non è mio talento
poter descriver l'amenità, la purità,
la vag[h]ezza di quel'aria, di quel
sito. Vi basti sapere che fu eletto
da ingenii sì gra[n]di per un teatro
della lor gloria, e che d[o]ve man-
cha la natura, sepur innerte,
manch[and]o, [= manchó?] i più
fini ingegni s'adoperono per farlo
vago e riguardevole [e] meravi-
glioso. Mi fur[o]no intorno di fatto
varii gentillissimi spiriti, tra i quali
era . . . , e dopo mille interoga-
tioni, e che volevo e di dove ve-
nivo e come havevo saputo far forza
al'Invidia, che tanti sotto di essa
erano restati, a tu[t]to risposi et a
quest'altro quesito mostrai, come
dovevo, non io, ma il mio mece-
nate havermi quasù condotto. Il
che da essi inteso con facc[i]a alle-
grisima dentro mi inviorno, aver-
tendomi che s'io fossi stato dalla lor
regina scoperto e interogato come
costì fossi sensa par[o]la in
me[g]lio, mostrassi quella stella che
tanto ha saputo felicitarmi
sogg[i]un[gen]do da me essere lon-
tano quel desidero sfacc[i]atissimo
del'utile quanto vicino il desiderio
d'inparare e sentire sempre con in-
finita atentione i più bravi. Io ren-
dendoli quelle gratie che dovevo,
son qua, di dove scrivendovi e
mandandovi i soliti disegnini di
quanto vedo, penso conos[c]erete
quanto indegnamente dai goffi sia
sì alta profesione in basso stato te-
nuta. Non vi potrebbi esplicare il
timore e la maraviglia che a un
tratto per quanto veddi, come in
ponposissima scena in me si ge-
nerò.

§2. Veddi unitamente spartati tutti
que' bravissimi huomini che al nos-
tro secolo sono fioriti, e come la
Pittura regina tra essi stansiava.
Chi può essplicare mai la
vag[h]ezza, la gratia di quella Si-
gnora? *Non ha moto che non pro-
ceda dalle Gratie non servando che*

1677). This literary form of the letter from Parnassus had been
made famous earlier in the century by Traiano Boccalini's
Ragguagli di Parnaso, for which see Robb, 1947-1948. Harris
and Lord, 1970, p. 20, relate Boccalini's book to Testa's print
of *The Young Artist Arriving on Parnassus* (Fig. 69), pointing
out, however, that Testa did not adopt Boccalini's satirical
approach. In many ways this print is illustrative of the first
part of the letter in 63, in which Testa describes escaping
from Envy to arrive on Parnassus.

§1. The star to which Testa is to point if questioned by Paint-
ing is the star of his patron, Girolamo Buonvisi's *stella colo-
rita*.

§2. The description of Painting is partially based on the figure
of *Pittura* in the *Iconologia*, 1625, pp. 516-517. Ripa explains
that the dress she wears is made up of changing colors, to
indicate the delights of *varietà*. Testa describes the dress as
full of more colors than there are in the flowers of Spring. He
describes the beauty of her ornaments as a metaphor for the
ornaments of painting, the colors that never conceal the beauty
of underlying proportion. This too is an adaptation of Ripa's
explanation of the fact that the gown of Painting covers her
feet to indicate how colors conceal proportions, the founda-
tion of art that is laid by drawing, and in so doing make the
work seem artless to all but the most intelligent. Ripa ex-
plains the fact that the mouth of Painting is bound by arguing
that silence and solitude are good for painters, rather than
through any reference to silent poetry. Testa is specifically
taking issue with this interpretation when he says that he
could not see the band across her mouth. Clearly, in his view,
painters should not keep silent, but discourse together in the
evening.

dilettando non t'instupidischa, or-
nata poi che è meraviglia, perché
quantunque gli abigliamenti in essa
siano infiniti, non coprono mai né
confo[n]dono le sue proportionatis-
sime e vag[h]issime membra. Il suo
manto richissimo per natura è tem-
pestato di qua[n]te gioie sono alla
luce; non ha tanti colori ne' suoi
fioretti la vag[h]issima primavera.
Ma che maraviglia poi il vederli,
per così dire, con tanta ubi-
die[n]sa, sensa una pur ombra di
confusione militar tutti sotto il gran
capitano del maggior lume, sotto
l'ingegnio [possibly *ingegnia* for *in-*
segna] *del chiaroscuro.* Solo quella
fascia che li si cinge la rosata bocca
non ho saputo vedere, ma sento
che parla tra i suoi e che ogni pa-
rola e sente[n]sa replicando spesso
che si debba inmitare ma con ra-
gione, verso la sera, per quanto
inte[n]do, col far una gita sul più
rilevato di questo sito, e lì tutti
presenti discorrere per tener in
essi salda la verità e sca[ccia]rne
ogni ombra d'opinione—errore
(dice lei) che à potuto legar molti
quando non ànno inteso ciò che sia
e dov'è fondata la Pittura. Questa
sera non mancherò essere anch'io,
e con somma avidità sentire e ra-
cogliere quanto dice e a cui, poi
con tenue foglio mandare.
§3. Per ora m'inge[g]nerò descri-
vervi quest'accademia onoratissima
di spiriti supremi. Ma chi può mai
la bizzaria, la maestà, la
gra[n]dezza, i moti varii, spiritosi,
gl'ammantamenti, i gussti di così
sollevati ingengni rappresentarvi?
Un senplice schizzo potrebbi adi-
tarvene e, se tanto mi soverrà, in
questa lettera *ma[n]darvi*, *d'una*
fiorita scuola che dipinse il gran
Raffaello nel Palazzo Pontificio dei
più famosi Ateniesi che intorno a
diverse scie[n]se s'adoprano; ma
non vi è paragone perché qui
maggi[o]re è il numero, più vasto e

§3. Testa compares Parnassus to Raphael's fresco in the Stanza della Segnatura, not the *Parnassus* but the *School of Athens*. This fresco also provided him with a model for the basic design of *Il Liceo della Pittura* (Fig. 89).

ameno il sito, più bravi et eccelenti
gl'huomi[ni]. Certo che è
merav[i]glia, e di qui non so
uscirne.

§4. Ma dandomi a contenplare i
particolari, veggo di primo sotto un
degl'archi di questo logg[i]one ap-
pog[gi]ato quel *gran Michelangelo*,
che vinse la Grecia e Roma con
tanta felicità di questo secolo; sta
mostrando come si possa sensa of-
fendere il gran Vitruvio e tutti
gl'antic[h]i ampliare et arichiar il
manto del'Architettura, ormai logro
et a una sua pari troppo fru[s]to e
sproportionato. Vari famosissimi ar-
chitetti lo sentono e ne pigliano il
modo che esso in un de' pilastri
dove s'apporrà con tanta facilità gl'
va m[o]stra[n]do, averte[n]do con
[cose?] oltra non passar però que'
segni che si pericolava di generar
de' mostri, documento che da po-
chi è stato penetrato e tenuto in sè;
siché molto meglio era non dar
questo campo a niuno, essendo che
molto meglio era lasc[i]ar quella
Signora colla sua antichissima
v[e]ste perché per il meno gli si
vedeva e non nascondeva le nobi-
lissime sue proportioni, le quali
adesso o non ci sono, o sì mala-
mente con vestacc[i]a di zoticio e
sfac[ci]ato [pannaccio?] la vestono,
che non humana figura ma fagotto
si rassembra.

§4. For other discussions of Michelangelo's enrichment of the
mantle of architecture, and of the dangers and benefits of
novità in architecture see Barocchi, 1962, 3: 814-822. Testa's
view is closest of all to that expressed by Cigoli in his letter
to Galileo, for which see *ibid.*, p. 815. See also Summers,
1972.

Folio 21 verso.

§5. Poco più in dentro st[a]va quel
Pietro Perugino con quella sua
flemma sedendo; quasi padre si
vantava con certi moderni modesta-
mente d'aver lui indirizato colla di-
lige[n]sa e l'amore, per strada tanta
gloriosa il div[in]o Rafaello,
ripre[n]dendo qui certi sfacc[i]ati
che con un tiro vogliono, per dir
così, far l'uomo e il cavallo. E per
dar forsa a questa sua ragione ha-
veva l'amorosissimo e diligentis-

§5. There appear to be no sources for Testa's imaginary con-
versation between Perugino and Michelangelo, in which the
grandezza of Michelangelo's drawing is justified (see also Ba-
rocchi's citation of it, 1962, 3: 1393). As Barocchi points out,
the argument that it is better to draw on a large, rather than
a small scale has a long tradition, going back to Alberti's point
that: "Chi saprà ben dipignere una gran figura, molto facile
in uno solo colpo potrà quest'altre cose minute ben formare;
ma chi in questi piccioli vezzi e monili arà usato suo mano et
ingegnio, costui facile errerà in cose maggiori" (Barocchi, 1962,
3: 1390). Barocchi underlines the fact that this advice, which
would be repeated by Armenini and Bernini, became, in the

simo vechio racolto varii animaletti
e nichiarelli, osservando e facendo
osser[var]e con sommo stupore l'e-
strema dilige[n]sa della natura
anche in cose minimissime. E se,
diceva egli, la natura ogni dì tante
gran cose partorisce non sdegna in
queste picolissime, e mostrava un
nichietto, un[a] formica, usar ogni
dilige[n]sa, la quale, sogg[i]u[n]se,
se da principio sarà tra[s]churata
non più si speri perché il tempo et
il g[i]udit[i]o, per gra[n]de che sia,
non mai ce la potrà dare. Sentì Mi-
chelangelo e voltatosi fece atto di
ridere, il che dispiacendo al vec-
chietto, rizandosi gli si fe'
inna[n]zi. Il che visto, quel
grand'huomo per opposito e con-
trariare i suoi detti, data mano a un
carbone così alla grossa rappresentò
nel piano in pochi segni una bellis-
sima e grandissima testa, che tutti
maravigliorno. Parve a Pietro restar
affrontato e chiede[n]do tempo,
dopo aver fatta sottilissima punta,
si messe nel naso di detta testa a
copiare l'istessa testa colla g[i]unta
di tutta la vita, e dato al conpasso
di piglio, presciò che *Michelangelo*
ritrovasse le medesime parti in
quella sua piccolissima che nella da
lui fatta, e conchluse che più mera-
viglia era in poc[h]issimo spatio
rappresentare i giganti, e ciò essere
effetto delle proportioni, e che lì
l'arte tutta del disegno si riponeva.
Parve veramente affrontato Michel-
angelo ma, osservando che la na-
tura non fa mai cosa a caso, si
fermo colla consideratione intorno
al'huomo e brevemente trovò esser
falsissima, l'ecedere in grandezza et
in manchare di quello che vera-
mente sia l'huomo et ogni altro
corpo, perché, diceva egli, se è
vero che il fondame[n]to sia nelle
proportioni, sarà vero sarà vero
[sic] che le cose inpicolite di quel
che per natura sono, non saranno

hands of Vasari, subjective and qualitative rather than objec-
tive. In this sense De Piles's argument that it was the study
of Michelangelo that enabled Raphael to escape from the dry
manner of Perugino (*ibid.*, p. 1393) comes closest to Testa's
meaning.

Testa's imaginary dialogue is not only about the correctness
of drawing large, however. It also touches upon the whole
problem of scale in painting—something that Michelangelo
was apparently about to discuss at the end of this passage.
Only a brief outline of the problem can be provided here.
Alberti introduces the problem of the relativity of appear-
ances (in the section from which Testa took his notes in 13.C.
above) by giving some examples. He cites Virgil's statement
that Aeneas seems like a giant compared to other men, but
next to Polyphemus will seem a pygmy, and also the famous
description by Pliny of a painting by Timanthes in which the
painter succeeded in making a small figure look like a giant
by showing very small satyrs embracing his thumb, for which
see Grayson, 1972, pp. 54-55. Giulio Romano reconstructed
this work in fresco in the Palazzo Madama, and, according to
Vasari, it was Giulio who encouraged Giulio Clovio to be-
come the Michelangelo of *cose picciole*, for which see Web-
ster Smith's illuminating discussions, 1964, cf. p. 400, and
[1976], cf. introduction, pp. 9-32. In Testa's day the distinc-
tion that Smith believes Vasari made between *miniatore* and
dipintore di cose piccole (1964, p. 399) was highly relevant.
It could be used to distinguish between the *cose piccole in
maniera grande* painted by Albani and the miniatures of art-
ists like Ligozzi. It could also be used to distinguish between
the little figures of the *bamboccianti* which Sacchi attacked
(for which see Chapter Three) and the two-feet high figures
of Poussin that Bernini so admired (see again Smith, 1964, p.
396, n. 14).

The fact that Testa draws particular attention to Perugino's
taking hold of the compasses when challenging Michelangelo
to measure the proportions of the two heads raises yet a third
point. Michelangelo points to the fact that when size changes
adjustments have to be made, and that it is not possible sim-
ply to square a figure up or down. Testa is not only alluding
to the famous rule, repeated by Armenini, 1587, p. 96, and
Bisagno, 1642, p. 77, that the painter must have his com-
passes in his eyes, but also seems to be arguing that Michel-
angelo was in favor of a sort of natural scale.

con proportione e conseguente-
mente non buone. "Vediamo
l'huomo", sogg[i]unse, "la sotti-
gliezza del suo capello esser tale
che, per mano diligente che sia,
pena a g[i]ungere a inmitarlo. Se
voi quest'huomo mi volete ridurre
la metà meno della sua quantità,
converrà, per mantenere la *forza
delle proportioni, ridursi il capello,
che quanto sia malagevole ogniuno
di voi se 'l vede. Che sara dunque*
di questo," rovolto a Pietro, "vostro
fantocino, che non più è grande di
mezzo dito? La ragione in tutto il
resto milita che, sminuendo quelle
gra[n]dezza che à fatto la natura,
non si salvano le proportioni: vedia-
molo negli animali gra[n]di e mi-
nimissimi." Voleva Pietro replicare,
ma unitamente da tutti a l[u]i fu
dato il torto.

§6. Io vi scrivo queste minutie,
aciò sentiate che qua non si perde
il tempo, se bene si restassi d'ope-
rare, perché nel buon pittore deve
non meno esserci la contemplatione
che l'atione. E qui si fanno incom-
portabili que' goffi che dal poco
hoperare g[i]udicano il pittore
otioso. E pigl[i]ando qui forza e
lume Micche[l]angelo, tornando tra
i suoi, dannava l'alteratione dei
corpi di quello siano dalla natura
prodotti, perché diceva egli, se
dalle proportioni conoscano le gran-
dezze

Folio 22 recto. *Figure XXIII*.

References: Hartmann, p. 165.

64. Study for a *Flight into Egypt*,
including the Holy Family, the An-
gel helping the Virgin into a boat,
and a boatman. Pen and brown
ink.

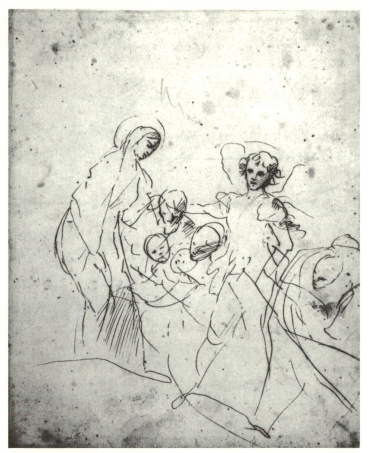

FIGURE XXIII

64. This drawing cannot be connected with any known paint-
ing, but is very closely related to a drawing in the Uffizi, Inv.
no. 12007F, which is in pen and ink with light brown wash
(Fig. 112). Hartmann questions this second drawing, which
represents a later stage in the composition. The Uffizi draw-
ing does not seem to be a copy, however. I would date both
drawings, c. 1640-1642, given the similarity of the hatching
of the faces of figures in 64 to that employed in the 1642
Bertini drawing (Fig. 35), rather than grouping them with the
drawings for the prints of c. 1637 dedicated to Franciotti.

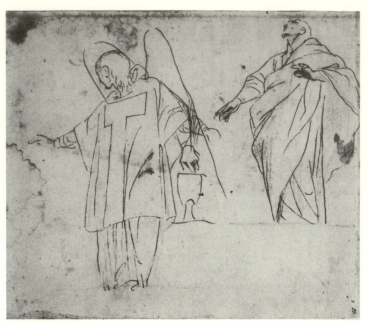

FIGURE XXIV

Folio 22 verso.

Blank.

Folio 22a recto. Figure XXIV.

65. Two figure studies for the apse of S. Martino ai Monti, one of an angel in ecclesiastical vestments who touches a chalice with his left hand, the other a male figure swathed in drapery. Pen and brown ink over traces of red chalk.

65. For the apse of S. Martino ai Monti see 66 below. This drawing relates most closely of all to a detailed study in the British Museum for the upper register of the apse (Fig. 113), also discussed in 66. It should be noted that the fact that Folios 22aʳ and 23 are formed of a single sheet of rather thicker paper than the other sheets in the volume supports the argument that these figures are indeed studies for the apse design in 66 on the same sheet.

Folio 22a verso/23 recto. Figure XXV.

References: Marabottini, 1954, p. 240; Hartmann, 1970, p. 237; Brigstocke, 1978, p. 124, pl. 40.

66.A. Preliminary study for the decoration of the apse of S. Martino ai Monti. Black chalk with some lines reinforced with pen and brown ink. Inscribed: "7 angeli con sette lucerne, i vechioni, l'agnello accanto a Dio, i 4 animali/ questo panno azurro scuro, con stelle d'oro che acenna il firmamento come s[q]uarciato/ i quattro angeli/ parole del'Apocalissi/ Aria chiara e che in sù scurisce in azurro fondissimo/ più chiaro più viene al'orizonte/

66.A. Payments to Testa for his work in S. Martino ai Monti were first published by [Sutherland] Harris in 1964, cf. p. 62, and p. 117. The payments between October, 1645, and January, 1646, were for the altarpiece of the *Vision of San Angelo Carmelitano*, and not for the apse. Subsequently (1967, pp. 43-45) Harris suggested that the payment of 6:60 scudi made in July, 1647, may well have been made in connection with designs for the apse. She suggests, further, partially on the basis of the use of the past tense in 66.C., that Testa already knew that he would not be given the commission by 1647/8, and that this disappointment contributed to his suicide. Her argument, which seems entirely acceptable, would mean, therefore, that this drawing should be dated c. 1647.

Harris also suggested (1967, p. 44) that in this design Testa set out to criticize Lanfranco, who was working on the apse of S. Carlo ai Catinari in 1646/7, and indeed Passeri states

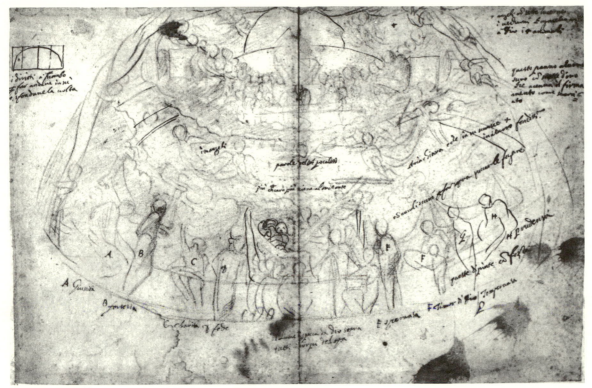

FIGURE XXV

con nuvoli scuri per far sopra spic-
car le figure/ il lume spicca da Dio
sopra tutti i corpi del'opera." Cor-
responding with the letters identi-
fying figures ranged around the
lower register of the semi-dome:
"A Giustitia/ B fortezza/ C charita/
D fede/ E speransa/ F Timor di
Dio/ G Temperansa/ H prudensa."

quite clearly that in this commission Testa wanted to attack
the manner of Correggio, whose cloud-filled Heavens pre-
sented nothing but "turbolenza, et oscurità." This is reflected
in the design, for Testa's apse would have been legible and
clear in the manner of an Early Christian apse mosaic. This
would also have been in keeping with the desire of the Prior,
Giovanni Antonio Filippini to emphasize the ancient tradi-
tions of the church, for which see Bandes, 1976. The com-
position itself should be compared to Raphael's *Disputà*, where
the curving banks of clouds are similarly arranged to form a
clear register, and where the Sacrament is also the central
focus.

Testa imagines the apse as covered by the mantle of the
heavens, which has been drawn back around the semi-circle
of the triumphal arch to reveal, in the upper part, the Apoc-
alyptic vision of St. John from *Revelation*, IV. 1-2, and VII.
9-17. God the Father sits upon a throne supported by a rain-
bow, accompanied by the Lamb, the seven lamps, the four
beasts, and surrounded by the twenty-four elders. None of
this is easy to see in the drawing, except for the rainbow,
which has been reinforced in ink, but all these figures are
identified by Testa's notes. This upper part of the design was
clarified in a drawing now in the British Museum (Fig. 113),

first published by Harris (1967, p. 44, Pl. 62). This drawing shows the throne of God, the four beasts, and the twenty-four elders who reach out to be fed by the Lamb of God, and who have cast their crowns upon the steps of His throne. The steps are inscribed with their words, "Santus/ Santus/ Santus (*sic*)." Though the angel in vestments in 65 does not appear here, this figure would almost certainly have appeared in this section, dispensing the Sacrament at the Mass of the Martyrs before the throne of God (VII. 9-17). The draped figure in 65 must be a study for one of the elders.

The lower part of the design is more difficult to understand. It seems that in the centre Testa would have presented the Victory of the Cross, a theme he had studied before in a drawing now in the Albertina (Fig. 114), made in connection with the whole series of drawings from c. 1636/7 for the print of *The Allegory of the Flight into Egypt* (Fig. 26). The apse design, however, would have been much more severe, a criticism not only of Lanfranco and Correggio, but also of his own earlier drawing, filled with billowing clouds and angels.

On either side of the Victory of the Cross Testa intended to place four personifications of virtues, the three Theological Virtues together with the Fear of God, and the four Cardinal Virtues. A drawing in the Uffizi (Fig. 115), must be considered a study for at least one of these figures. In the lower right half appears a study of a seated woman, accompanied by two putti. She wears her hair in a topknot and embraces a vase with her right hand. Even though the drawing is soft and indistinct, being in the same loose style as the composition drawing, these two details serve to identify her as Temperance, for which see the two descriptions of the figure in Ripa, 1625, pp. 660-661. The seated male figure in the upper half of the drawing has no attributes. This could be a study for another Virtue, or even for one of the figures in the upper register. Certainly the style and medium of the drawing is consistent with the composition drawing, and the angle from which the figures are seen, slightly *dal di sotto in su*, serves to support the argument that the Uffizi drawing is closely related to our 66.

The same arrangement of the figure, seated on a ledge, and seen *dal di sotto in su*, characterizes another drawing in black chalk, this time on white paper, which appeared on the market in Milan in 1969 (Fig. 116), for which see *Disegni italiani e stranieri del Cinquecento e del Seicento*, Edizioni "Stampa della Stanza del Borgo" (Milan, 1969), p. 75, n. 48, repr. The figure is there identified as a Melancholia, but there can be no doubt that it is a study for the San Martino project.

In addition to the Uffizi drawing Testa made another study for the figures of Temperance and Prudence, recorded only

in an engraving by Collignon, Fig. 117 (Speciale, 1977, p. 19, no. 6r, there identified as Truth). Prudence, seated behind Temperance, holds up her mirror. Temperance is identified once again by her vase and also by the hourglass she holds in her left hand, which indicates that Temperance moderates the human spirit according to the times, for which see Ripa, 1625, p. 661. This drawing appears to be even closer to the arrangement of the Virtues in 66, for not only are the same two Virtues beside each other and seated on the ledge that Testa envisaged running around the level of the entablature, but they also face from right to left, that is, toward the center of the apse, which the figure in the Uffizi drawing does not.

The strange, curved shape to the left of the *Prudence and Temperance* is difficult to read. The hatching suggests a concave surface, and one explanation is, therefore, that this represents part of a niche. This possibility, together with the identification of the figure in the Uffizi drawing as Temperance raises another question. The same figure, with topknot and two putti, though without the vase, and now seen from a different angle, together with another figure in a pendentive, appears in a drawing, now in the Albertina (Inv. no. 1085), which was also engraved by Giovanni Cesare Testa. Speciale, 1977, p. 31, no. 29, identified the two figures in the pendentive as Temperance, presumably on the basis of the topknot, and Fortitude, who carries not only a sword, but also compasses, indicating that this Fortitude is not only tempered, but also measured. This pendentive design is one of a group, known to us through drawings or through Giovanni Cesare's prints after drawings. Because they pose many problems extending well beyond the publication of the manuscript, a detailed study of the drawings for the S. Martino project in general, and of these studies for pendentives in particular, must be reserved for another publication.

All of the "pendentive" drawings, however, must date to the last five years of Testa's career. They have never been connected with any particular project, and Baldinucci, ed. 1847, 5: 321, describes them only as Virtues for pendentives. The apse of S. Martino as it appears today is the result of a new decorative campaign in the eighteenth century, and Testa's design, as recorded in the manuscript, did not include pendentives. Given that he is supposed, however, to have spent so much time working out his ideas for the project, he must have made many preparatory drawings. I suggest here, therefore, that these "pendentive" drawings may be related to the San Martino ai Monti project, and that the allegories would have appeared in the rectangular spaces on either side of the two windows in the apse, which could have been framed by arches in order to create the impression that there were

pendentives between them, supporting the semidome of the apse. The figures in the "pendentives" would have been placed in illusionistic niches, and traces of one of these may appear in the *Prudence and Temperance* print. The design and iconography of these groups of Virtues cannot fail to recall Domenichino's pendentives in San Carlo ai Catinari. If indeed Testa was setting out to challenge Lanfranco's work in the apse of that church and to come to the defense of Domenichino, then nothing could have been more appropriate.

66.B. Diagram in upper left corner showing the arch of the apse enclosed in a rectangle, which is divided into quarters by three vertical lines. This provides a brief indication of how Testa would deal with the perspective of the apse, as indicated in the accompanying note: "i diritti a piombo per far andare in sù e sfondare la volta."

66.B. Testa could have learned about the use of string with lead pendulums attached from Accolti, who devoted a chapter to the problem, *Lo inganno degli occhi*, 1625, ch. 34, "Del disegnare di sotto in sù nelle volte, e Cupole," pp. 54-56. Testa had no experience of painting domes or semidomes on a large scale, and though he could have watched other painters at work, the fact that he made this simple little drawing suggests that he was trying to work out the problems for himself, probably with the aid of Accolti's book.

Folio 23 verso.

66.C. Quest' Opera si doveva dipingere nella Tribuna di San Martino in Monti.

Folio 24 recto. Figure XXVI.

67. Mercurio con pocha lanugine/ Ercole coronato di piopo/ Marte con lupo.

68. Catone che per fuggire la tiranide di Cesare s'amazza/ il farlo in atto dolente è inproprio, così è di Dido e altre. Questo into[r]no l'esspresione de[g]li affetti.

69. Dei lumi et ombre.

69.A. Il lume cava quel raggio che si parte da[l]la sua sfera luminosa per ferire il corpo opaco. Che s'intendono come i raggi del vedere è un opositione e necessar[i]amente fa onbra e sbatimento (dicono i Pittori) quando fa oppositione in un altro corpo, il quale sbattimento o cresce quasi in infinito o in infinito diminuisce; dico quando il corpo luminoso sia maggiore che l'allumi-

67. On the basis of the reference in 70, it can be established that these notes are based on Testa's reading of the 1556, Venetian edition of Cartari's *Le imagini de i dei degli antichi*. The notes in 70 were probably made first as Testa seems to have followed the order of his reading. The description of Mercury is taken from p. LVI, which also relates to p. LXIII[v]; for Hercules see p. LXVIII; for Mars see p. LXXXI[v]. The note on Hercules here is derived from a different edition of Cartari from that to which Testa refers in 39.

68. Possibly related to the "bellisimi trattati degli affetti" that Testa proposed to write in 59.H. It is certainly closely related to Testa's decision to illustrate the *Death of Cato* and the *Death of Dido*. In the former, published in 1648, Testa's inscription insists upon the essential virtuousness of Cato's suicide, which would explain why it is wrong to show him suffering. For this print, and a discussion of Testa's Stoic attitude toward suicide see Cropper, 1974, pp. 378-382.

69. There does not appear to be a particular source for these notes on light and shade, concerning the relative sizes of shadows, and the effects of reflected light on colors. They are,

nato: in quel caso i raggi si strin-
gono e fanno l'onbra inferiore, e
con la distansa riesce un punto e
per il contrario.

69.B. Diagram of rays from a larger
light source falling upon a smaller
body and reaching a point, illus-
trating A. Inscribed: "lume mag-
giore/ corpo/ minore."

69.C. E così come i lumi intieri in
superficie non piana si stringono in
punti quasi indivisibili, per l'istessa
ragione li scuri; restano dunque le
meze tinte che fan corpo, causate o
che i raggi sono sdrucc[i]olosi, e ciò
per necessità salvando la piana su-
perficie, o che l'onbrata parte ri-
ceve i secondi raggi che chiamo il
reflesso, il qual veramente usato
con modo, genera quel'armonia e
quel legamento di superficie che
tanto piace. Lascio d'accennare il
tingere che fanno i detti secondi
raggi di quel colore di che il corpo
è tinto che ribatte e i più e meno
violenti colori che riescono più sen-
sibili e meno, e il bianco salvando
il resto e ogni corpo lucido e tras-
parente è il più capace.

FIGURE XXVI

however, entirely consistent with other notes in the manu-
script on the same themes. Testa's notes in 69.A. and 69.B.
provide the clearest expressions of his interest in the way in
which the size of shadows is affected by the size of the light
source in relation to the object. They are most closely con-
nected with those in 58.

Folio 24 verso.

70. Saturno/ Jano/ Apollo, 7 per il
numero dei pianeti, orbi celesti 9.

Diana al carro giovenchi, e la
face et anche cervi.

Pan, dio per l'universo, cinto di
pelle maculosa pantera, in signifi-
cato del'ottava sfera stellata, coro-
nato da pino o di anna, o finochio,
o giglij, ⟨firmam[ento] 8. 7. cieli, la
fistola di Pan⟩.

Giove mezo in giù vestito, la
quercia a lui consecrata.

Giunone messa per l'Aria Iride
sua ministra, giglii a corona fatti da
suo latte.

Imineo, giovane, coronato di
fiori, alla mano destra una facella, il

70. The first three gods are also identified by signs after their
names. All these iconographical notes are taken from the 1556
edition of Cartari's *Le imagini de i dei degli antichi*, the edi-
tion and title being established in the reference to the winds.
Marabottini misunderstood this reference to mean that Testa
was referring to p. 49 of his own illustrations for the Trattato
(see 1954, p. 217, n. 1). The references are to the following
pages: Saturn, pp. X-XII; Janus, pp. XII-XIIII; Apollo, pp.
XIIII-XXIII Diana, p. XXIII, XXIIII, XXIIII; Pan, pp. XXIX,
XXX[r&v]; Jupiter, pp. XXX, XXXV; Juno, Iris, and the Milky
Way, pp. XXXVI-XXXVII, XXXIX; Hymen, p. XXXIX; Ops,
p. XXXXI; Neptune, Glaucus, Tritons, etc., pp. XXXXV-
XXXXVI; Winds, p. XXXXIX; Nile, p. L; Vertumnus, p. L;
Pluto, Cerberus, Furies, pp. LIII, LIII, LIIII-LV; Sphinx,
p. LVII; Chimera, pp. LVII, LVIII.

Testa continued his notes on the other side of the sheet,
for which see 67 above.

velo con che coprivansi il viso le nuove spose.

Ope con corona di torri, la veste di rari erbi, con scetro in mano, con tinpani significanti i dui emi-sferi, con carro di 4 ruote e leoni.

Nettuno. Glauco e tritoni mini-stri, con bucina e mezi pesci algosi e canuti, con ale a guisa di pesci, nereide ninfe del mare in specie Galatea.

Venti con ali e capo rabbuffato in atto di soffiare, vedi carte 49 del' *Inmagini*.

Nilo fiume finto negro per il passo da[g]li Etiopi.

Vertunno cang[i]a tutte forme, coronato di frutti.

Plutone con scetro e corona afu-mati e neri, con Cerbero triuface, corona di cipresso, Furie ministre, cioè Aletto, Tisifone, e Megera, con faci ardente, perturbatrici delle umane menti.

Sfinge metà donna con gli ali grandi e metà leone, il nome Tebe, e proponeva enigmi che chi non sc[i]oglieva retava uciso.

C[h]imera, il capo di leone, il ventre di capra, coda di drago, tutti questi mostri d'inferno con le Parche.

Folio 25 recto. Figure XXVII.

References: Hartmann, pp. 64f. and 162; Brigstocke, 1976, p. 17 and fig. 27.

71. Study of the upper torso, head, and right arm of a shepherd for *The Adoration of the Shepherds* (Figure 29). Red chalk.

Folio 25 verso. Figure XXVIII.

References: Hartmann, pp. 64f. and 162; Brigstocke, 1976, p. 17 and fig. 26.

72. Studies of the upper torso, head and hands of a shepherd for *The Adoration of the Shepherds* (Figure 29). Red chalk.

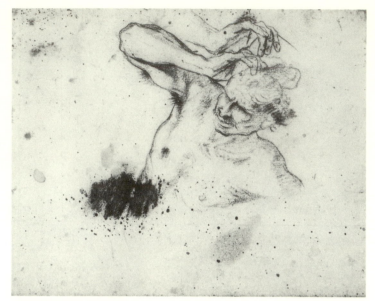

FIGURE XXVII

FIGURE XXVIII

71. See 72 below.

72. Brigstocke, 1976, dates *The Adoration of the Shepherds* in the National Gallery of Scotland (Fig. 29) c. 1640. The figure study in 3 above is also for this work.

FIGURE XXIX

Folio 26 recto.

No mounted sheet.

Folio 26 verso.

No mounted sheet.

Folio 27 recto. Figure XXIX.

References: Hartmann, 1970, p. 168.

73. Copy after Pietro Testa. Study of *Venus Interceding with Jupiter.* Pen and black ink. Tipped in rather than mounted.

Folio 27 verso.

No mounted sheet.

Folio 28 recto. Figure XXX.

74. Copy after Pietro Testa. Study of *Venus Meeting Aeneas.* Pen and black ink. Tipped in rather than mounted.

Folio 28 verso.

No mounted sheet.

73. The subject is from *Aeneid,* I, 223-300. Another version of this composition, from Testa's own hand, is in the Graphischen Sammlungen, Staatsgalerie, Stuttgart, Inv. no. 1382 (Fig. 118), for which see Thiem, 1977, p. 216. Thiem identifies the subject incorrectly, however, as an allegory of art. A drawing in the Staatliche Graphische Sammlung, Munich (Inv. no. 2374), is also a copy of the same lost drawing upon which 73 is based. For the possibility that Testa was planning a series of illustrations to the *Aeneid,* see 76 below.

74. This feeble drawing appears to be copied from the problematic version of the same composition in 76, q.v.

FIGURE XXX

FIGURE XXXI

Folio 29 recto. Figure XXXI.

75. Copy after Pietro Testa. *Study of Venus Giving Arms to Aeneas.* Pen and black ink. Tipped in rather than mounted.

Folio 29 verso.

No mounted sheet.

75. For a discussion of these copies as a group, and the possibility that Testa was planning a series of illustrations to the *Aeneid* see 76 below.

The original drawing from which this copy was probably made is now in the National Gallery of Scotland (Fig. 119). This is in pen and brown ink and measures 180 x 268 mms., which means that the copy was probably traced directly from it, for it is almost exactly the same size. For this drawing see Brigstocke, 1978, p. 122, fig. 26. Brigstocke also reproduces another drawing in the National Gallery of Scotland, Inv. D. 2251 (his fig. 28) that is Testa's more complete version of the first; it is larger, presents the whole composition, with the figures in a landscape, and clearly represents the final stage of preparation for the etching of *Venus giving Arms to Aeneas* (Fig. 53). This print of c. 1635/6 is the only one based on Testa's study of the *Aeneid* to be printed during his lifetime.

Folio 30 recto. Figures XXXII and XXXIII.

76. Recto: Anonymous. Study of *Venus Meeting Aeneas.* Pen and brown ink over red chalk. Verso: Anonymous. Study of the walls of the Villa Medici. Pen and brown ink with grey wash. The sheet is tipped in rather than mounted.

Folio 30 verso.

No mounted sheet.

76. The original drawing in red chalk on the recto may be from Testa's hand, but the overdrawing in pen is clumsy and superficial. This pen drawing was copied, probably by the same hand, in 74. The composition, based on *Aeneid*, I, 305-401, where Venus appears to her son in the guise of Diana, is more complete here and includes *amorini* hiding behind a tree. The design is strongly influenced by Pietro da Cortona's representation of the same theme, which dates to c. 1630-1635. Cortona's work probably also lies behind Marracci's design of the frontispiece to Guidiccioni's *Eneide Toscana,* the translation to which Testa refers in 51.

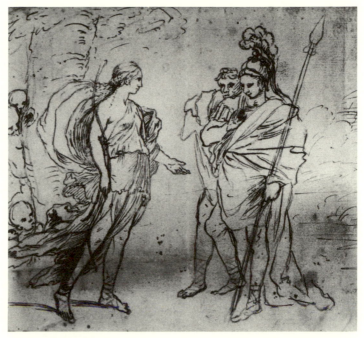

FIGURE XXXII

FIGURE XXXIII

Guidiccioni's book was published in 1642, but Testa's drawings of scenes from the *Aeneid* must have been made in the mid-1630s, when the print of *Venus giving Arms to Aeneas* is generally dated, and a date with which the other related drawings agree. It seems that Testa was hoping to produce a series of illustrations to the *Aeneid*, perhaps even for this translation by his fellow Lucchese, which was dedicated to

Cardinal Antonio Barberini. Original drawings exist for the *Venus before Jupiter* (73), *Venus giving Arms to Aeneas* (75), and possibly, in the form of the red chalk underdrawing in 76 for *Venus meeting Aeneas*. There are drawings of the same period for the *Death of Dido*, for which see Thiem, 1970. Hartmann, 1970, p. 103, describes a drawing in the Academia di San Fernando, Madrid, representing *Venus Sprinkling Ointment into Aeneas's Wounds*. It is also possible that he planned a series of independent prints.

The copies themselves present particular problems. Their feeble quality and lifelessness give the impression that, rather than being free copies, they are at least partially based on tracings. The only clue to their origin lies in the drawing on the verso of 76 (Fig. XXXIII). This is a much freer drawing in pen and brown ink with grey wash. It is not from Testa's hand, but could possibly be by Pier Leone Ghezzi (compare e.g. Düsseldorf FP 3206, of the *Fontanile del Genio*, 1726, or FP 3180, of the Tiber near San Giovanni dei Fiorentini). They are not, however, by the hand that made the drawings in the Casanatense copy.

77. Possibly another copy by the same hand who drew the copies in 73-76, but this cannot be firmly established.

Folio 31 recto. Figure XXXIV.

77. Anonymous: Study for an *Annunciation*. Pen and black ink. Numbered top left "127," inscribed at bottom edge "Cento Venti Sette." Mounted on stiff white card, cut across the corners, and tipped in.

Folio 31 verso.

No mounted sheet.

FIGURE XXXIV

Folio 32 recto. Figure XXXV.

78. Anonymous: Study of Venus admiring the shield of Aeneas supported by two putti. Pen and brown ink. Cut at the corners, and tipped in.

Folio 32 verso.

Inscribed, probably by Lambert Krahe: "25 Studien von P. Testa."

78. This drawing is even clumsier than the copies in 73-76. The combination of harsh, unmodulated hatching, and lack of form, with the unrestrained lines of the woman's hair, is very like the strange, clumsy turbulence found in the print of the *Martyrdom of a Bishop*, Bellini 40. Harris, 1967, p. 50, n. 12, dismissed the latter as a *pastiche* of Testa's various manners, and rejected Donati's attribution to Testa. No original drawing by Testa of this subject is known.

FIGURE XXXV

Appendix One. Sources Cited by Testa in the Düsseldorf Notebook

* Indicates precise editions cited by Testa.

+ Indicates sources cited by Testa, but for which no precise edition can be established.

? Indicates sources probably used by Testa.

? Accolti, P. *Lo Inganno degl'occhi, prospettiva pratica*. Florence, 1625.

+ Alberti, L. B. *On Painting and Sculpture*.

+ ————. *Opuscoli morali . . . ne' quali si contengono molti ammaestramenti, necessarij al viver de l'huomo, così posto in dignità, come privato. Tradotti, & parte corretti da Cosimo Bartoli*. Venice, 1568.

* Aleandro, G. *Difesa dell'Adone, poema del Cav. Marini . . . Per risposta all'Occhiale del Cav. Stigliani*, Pt. 1. Venice, 1629.

+ Aristotle. *Rettorica et poetica d'Aristotile. Tradotte . . . da Bernardo Segni*. Florence, 1549.

* ————. *L'Ethica d'Aristotile tradotta in lingua vulgare fiorentina et commentata per Bernardo Segni*. Florence, 1550.

? Armenini, G. B. *De' veri precetti della pittura . . . libri tre*. Ravenna, 1586.

* Bisagno, Fra F. *Trattato della pittura fondata nell'auttorità di molti eccellenti in questa professione*. Venice, 1642.

* Cartari, V. *Le imagini, con la spositione de i dei de gli antichi*. Venice, 1556.

* ————. *Le imagini, con la spositione de i dei de gli antichi. Con molta diligenza reviste e ricorrette*. Venice, 1580 (or another later edition).

* Euclid. *De gli Elementi d'Euclide libri quindici con gli scholii antichi volgarizzati . . . del matematico F. Commandino, e con commentarii illustrati*. Pesaro, 1619.

+ Firenzuola, A. *Dialogo delle bellezze delle donne*, in *Opere scelte*.

* Guidiccioni, L. *Eneide Toscana dal Sig^r L. Guidiccioni . . . co' suoi discorsi*. Rome, 1642.

+ Lomazzo, G.P. *Trattato dell'arte de la Pittura di G. P. Lomazzo, Milanese Pittore, diviso in sette libri ne' quali si contiene tutta la Theorica & la prattica d'essa pittura*. Milan, 1584.

+ Marino, G. *Giambattista Marino: Lettere* (for the preface to *La Sampogna*).

* Plato. *Di tutte l'opere di Platone tradotte in lingua volgare da Dardi Bembo*, 5 vols. Venice, 1601.

* Ripa, C. *Iconologia, overo descrittione di diverse imagini cavate dall'antichità. . . .* Rome, 1603.

* ————. *Novissima Iconologia*. Padua, 1625 (or another later edition).

Segni. See Aristotle.

* Vitruvius. *I dieci libri d'architettura di M. Vitruvio tradutti et commentati da Monsignor Barbaro eletto Patriarca d'Aquileggia*. Venice, 1556. Also ed. Venice, 1567 (repr. 1584, 1629).

+ Xenophon. *Memorabilia*.

Appendix Two. Mounting, Size, and Numbering of Folios

	Orientation	Height in mms	Width in mms	No. on folio	No. on mount
Folio 1	recto	178	186	1	6
Folio 2	recto	205	185	None	7
Folio 2A recto				2	8
Folio 2A verso }	verso	272	416	None	None
3 recto }	recto				
Folio 4	recto	255	200	3	9
Folio 5	recto	264	198	4	10
Folio 6	recto	270	195	5	None
Folio 7	recto	265	197	6	None
Folio 8	recto	274	204	7	11
Folio 9	recto	294	214	8	12
Folio 10	recto	154	185	None	13
Folio 11	recto	192	152	9	None
Folio 12	recto	258	207	21	14
Folio 13 verso }	verso	265	191	10	None
Folio 14 recto } *	recto	265	194	11	None
Folio 15	verso	265	195	12	None
Folio 16	recto	267	193	13	None
Folio 17	recto	267	198	14	None
Folio 18 recto }	recto	267	195	15	None
Folio 19 verso } *	verso	267	194	16	None
Folio 20	recto	266	197	17	None
Folio 21	verso	266	197	18	None
Folio 22	recto	265	210	None	15
Folio 22A recto				20	16
Folio 22A verso }	verso				
Folio 23 recto }	recto	270	410	None	None
Folio 24	verso	201	200	19	None
Folio 25	recto	256	210	None	17
Folio 26	tipped in	—	—	—	18
Folio 27 recto	"	191	254	None	19
Folio 28 recto	"	188	246	None	20
Folio 28 verso	—	—	—	—	21
Folio 29 recto	tipped in	194	254	—	—
Folio 30 recto	"	200	241	—	22/23
Folio 31 recto	"	134	121	—	24
Folio 32 recto	"	151	187	—	25

* Indicates that two folios are probably a single sheet, folded and bound as two.

Bibliography

Abbrescia, D. and G. Lera. 1966. *Chiesa di San Romano: il centenario 1666-1966.* Lucca.

Accolti, P. 1625. *Lo inganno degl'occhi, prospettiva pratica.* Florence.

Alberti, L. B. 1972. *On Painting and Sculpture.* Edited and translated by C. Grayson. London.

———. 1568. *Opuscoli morali . . . ne' quali si contengono molti ammaestramenti, necessarij al viver de l'huomo, così posto in dignità, come privato. Tradotti, & parte corretti da Cosimo Bartoli.* Venice.

Alberti, R. 1585. *Trattato della nobilità della pittura.* Rome.

Aleandro, G. 1617. *Antiquae tabulae marmorae solis effigie, symbolisque exsculptae explicatio.* Rome.

———. 1629. *Difesa dell'Adone, poema del Cav. Marini . . . Per riposta all'Occhiale del Cav. Stigliani,* Pt. 1. Venice.

Allacci, L. 1633. *Apes urbanae.* Rome.

Angelini, L. 1969. *La Festa della Libertà a Lucca e Pieve Fosciana nel IV° centenario.* Lucca.

Appel, C., ed. 1901. *Die Triumphe Francesco Petrarcas.* Halle.

Arcangeli, F. 1961. "Il fratello di Guercino." *Arte antica e moderna* 13/16: 325-343.

Argan, G. C. 1970. "La 'rettorica' e l'arte barocca." In *Studi e Note dal Bramante al Canova,* pp. 167-176. Biblioteca di storia dell'arte l. Rome.

Aristotle—see Segni.

Armenini, G. B. 1587. *De' veri precetti della pittura . . . libri tre.* Ravenna.

Bacou, R. and F. Viatte. 1968. *Dessins du Louvre: école italienne.* Paris.

Baglione, G. 1649. *Le vite dei pittori, scultori, et architetti. Dal pontificato di Gregorio XIII. del 1572. In fino a' tempi di Papa Urbano Ottavo nel 1642.* Rome.

Baldinucci, F. 1681. *Vocabulario toscano dell'arte del disegno.* Florence.

———, ed. 1847. *Notizie dei professori del disegno da Cimabue in qua.* 7 vols. Edited by F. Ranelli. Florence.

Bandes, S. J. 1976. "Gaspard Dughet and San Martino ai Monti." *Storia dell'Arte* 26: 46-60.

Banti, O. 1970. "Un anno di storia lucchese (1369-70): dalla dominazione pisana alla restaurazione della Libertà." In *Accademia Lucchese di Scienze, Lettere e Arti, Studi e Testi* 4, pp. 33-53. Lucca.

Barbaro, D., ed. 1556. *I dieci libri d'architettura di M. Vitruvio tradutti et commentati da Monsignor Barbaro eletto Patriarca d'Aquileggia.* Venice.

———, ed. 1567. *I dieci libri d'architettura di M. Vitruvio. . . .* Venice. Reprint 1584, 1629.

———. 1568. *La pratica della perspettiva.* Venice.

Barilaro, A. 1968. *San Domenico in Soriano.* Mileto.

Barocchi, P., ed. 1960. *Trattati d'arte del Cinquecento fra Manierismo e Controriforma.* 3 vols. Scrittori d'Italia 219. Bari.

———, ed. 1962. *Giorgio Vasari: La vita di Michelangelo, nelle redazioni del 1550 e del 1568.* 5 vols. Documenti di Filologia 5. Milan and Naples.

Battisti, E. 1960. "Il concetto d'imitazione nel Cinquecento italiano." In *Rinascimento e barocco,* pp. 175-215. Turin.

Bean, J. 1959. *Dessins Romains du XVIIe siècle.* Exhibition catalogue, Cabinet des Dessins, Musée du Louvre. Paris.

———. 1979. *17th Century Italian Drawings in the Metropolitan Museum of Art.* New York.

Belli Barsali, I. 1960. "Problemi sulla tarda architettura di Bartolommeo Ammanati: Il Palazzo Pubblico di Lucca." *Palladio,* n.s. 10: 50-68.

Bellini, P. 1976a. *L'opera incisa di Pietro Testa.* Vicenza.

———. 1976b. "Giovanni Cesare Testa." *Print Collector* 32:15-34.

Bellori, G. P., ed. 1976. *Le vite de' pittori, scultori e architetti moderni.* Edited by E. Borea with an introduction by G. Previtali. Turin.

Bembo, D., ed. 1601. *Di tutte l'opere di Platone tradotte in lingua volgare da Dardi Bembo.* 5 vols. Venice.

———, ed. 1604. *Commento di Ierocle filosofo sopra i versi di Pitagora, detti d'oro.* Rome.

Berendson, O. P. 1957-1959. "A note on Bernini's Sculptures for the Catafalque of Pope Paul V." *Marsyas* 8:67-69.

Bernini in Vaticano. 1981. Exhibition catalogue, edited by A. Gramiccia, Vatican Museums. Rome.

Bertelà, G. G. and S. Ferrari. 1973. *Incisori bolognesi ed emiliani del sec. XVII.* Catalogo generale della raccolta di stampe antiche della Pinacoteca Nazionale di Bologna, Gabinetto delle Stampe 3. Bologna.

Bertelli, S. 1973. *Ribelli, libertini e ortodossi nella storiografia barocca*. Florence.

Bertolotti, A. 1880-1885. *Artisti belgi ed olandesi a Roma nei Secoli XVI e XVII. Notizie e documenti raccolti negli archivi romani*. Florence and Rome.

———. 1886. *Artisti bolognesi, ferraresi ed alcuni altri del già Stato Pontificio in Roma nei secoli XV, XVI, e XVII. Studi e ricerche tratte dagli archivi romani*. Bologna.

Bialostocki, J. 1963. "The Renaissance Concept of Nature and Antiquity." In *Acts of the Twentieth International Congress of the History of Art*, vol. 2. Princeton.

Bisagno, Fra F. 1642. *Trattato della pittura fondata nell'auttorità di molti eccellenti in questa professione*. Venice.

Blunt, A. 1937-38. "Poussin's Notes on Painting." *Journal of the Warburg and Courtauld Institutes* 1:344-351.

———. 1939-1974. *The Drawings of Nicolas Poussin. Catalogue Raisonné*. 5 vols. Studies of the Warburg Institute V, edited by W. Friedlaender and A. Blunt. London.

———. 1940. *Artistic Theory in Italy 1450-1600*. Oxford.

———. 1966. *Nicolas Poussin: A Critical Catalogue*. London.

———. 1967a. *Nicolas Poussin: The A. W. Mellon Lectures in the Fine Arts, 1958*. 2 vols. Bollingen Series 35. New York.

———. 1967b. "Don Vincenzo Vittoria." *The Burlington Magazine* 109:31-32.

———. 1979. "Further Newly Identified Drawings by Poussin and his Followers." *Master Drawings* 17:119-146.

Blunt, A. and H. L. Cooke. 1960. *The Roman Drawings at Windsor Castle*. London.

Boase, F.S.R. 1939-1940. "A seventeenth century Carmelite legend based on Tacitus." *Journal of the Warburg and Courtauld Institutes* 3:107-118.

Borghini, R. 1584. *Il Riposo*. 2 vols. Florence.

Boschetto, A. 1968. "Ancora su Pietro Testa." *Paragone* 217:65-66.

Bottari, G. and S. Ticozzi. 1822-1825. *Raccolta di lettere sulla pittura, scultura ed architettura*. 8 vols. Milan.

Bottari, S. 1960. "Due 'nature morte' dell' Empoli." *Arte antica e moderna* 9:75-76.

———, ed. 1964. *La natura morta italiana*. Milan.

———. 1965. "Per Paolo Antonio Barbieri." *Arte antica e moderna* 29:3-11.

Bousquet, J. 1960a. "Les Relations de Poussin avec le milieu romain." In *Nicolas Poussin: Actes du Colloque International*, 2 vols., C.N.R.S., edited by A. Chastel, 1:1-18. Paris.

———. 1960b. "Chronologie du séjour romain du Poussin et de sa famille d'après les archives romaines." In *Nicolas Poussin: Actes du Colloque International*, 2 vols., C.N.R.S., edited by A. Chastel, 2:1-10. Paris.

Brigstocke, H. 1974. "Pietro Testa: 1611-1650." *National Galleries of Scotland Bulletin* 2: n.p.

———. 1976. "Testa's *Adoration of the Shepherds* in Edinburgh and Some New Thoughts on his Stylistic Development." *Paragone* 321:15-28.

———. 1978. "Some further thoughts on Pietro Testa." *Münchner Jahrbuch der bildenden Kunst* 29:117-148.

Brockliss, L.W.B. 1981. "Philosophy Teaching in France 1600-1740." *History of Universities* 1:131-168.

Brown, J. 1973. *Zurbarán*. Classici dell' Arte Rizzoli 69. Milan.

Buoni, T. 1604. *Nuovo thesoro de' proverbi*. Venice.

Campi, I. 1878. *Innocenzo X Pamfili e la sua corte: Storia di Roma 1644-1655*. Rome.

Campori, G. 1866. *Lettere artistiche inedite*. Modena.

Cardella, L. 1792-1797. *Memorie storiche de' Cardinali della Santa Romana Chiesa*. 9 vols. in 10. Rome.

Cartari, V. 1556. *Le imagini, con la spositione de i dei de gli antichi*. Venice.

———. 1580. *Le imagini, con la spositione de i dei de gli antichi. Con molta diligenza reviste e ricorrette*. Venice.

———. 1614. *Le vere e nove imagini de gli dei delli antichi*. Padua.

Causa, R. 1961. "Un avvio per Giacomo Recco." *Arte antica e moderna* 13/16:344-353.

Ciacconius, A. and A. Oduini, S.J. 1677. *Vitae et res gestae Pontificum Romanorum: et S.R.E. Cardinalium ab initio nascentis Ecclesiae usque ad Clementem IX P.O.M.* Rome.

Clements, R. J. 1961. *Michelangelo's Theory of Art*. New York.

Cocke, R. 1972. *Pier Francesco Mola*. Oxford.

Commandino, F. 1619. *De gli Elementi d'Euclide libri quindici con gli scholii antichi volgarizzati . . . del matematico F. Commandino, e con commentarii illustrati*. Pesaro.

Conti, G. 1974-1975. "Un taccuino di disegni dall'antico agli Uffizi." *Rivista dell' Istituto Nazionale d'archeologia e storia dell'arte* n.s., 21-22:141-168.

Corcos, F. 1893. *Appunti sulle polemiche suscitate dall'Adone*. Cagliari.

Cotroneo, G. 1971. *I trattatisti dell'ars historica*. Naples.

Croce, F. 1955. "I critici moderato-barocchi," pt. 1, "La discussione sull'Adone." *La rassegna di letteratura italiana* 59:422-427.

Cropper, E. 1971. "Bound Theory and Blind Practice: Pietro Testa's Notes on Painting and the *Liceo della*

Pittura." *Journal of the Warburg and Courtauld Institutes* 34:262-296.

⸻. 1974a. "Virtue's Wintry Reward: Pietro Testa's Etchings of the *Seasons.*" *Journal of the Warburg and Courtauld Institutes* 37:249-279.

⸻. 1974b. "*Disegno* as the Foundation of Art: Some Drawings by Pietro Testa." *Burlington Magazine* 116:376-385.

⸻. 1976. "On Beautiful Women, Parmigianino, *Petrarchismo*, and the Vernacular Style." *Art Bulletin* 58:374-394.

⸻. 1977. "Pietro Testa and Lucca: Mythology of a Republic." *Grafica Grafica* 1:88-108.

⸻. 1980a. "Poussin and Leonardo: The Evidence of the Zaccolini Manuscripts." *Art Bulletin* 62:570-583.

⸻. 1980b. "A Scholion by Hermias to Plato's *Phaedrus* and its Adaptations in Pietro Testa's *Blinding of Homer* and in Politian's *Ambra.*" *Journal of the Warburg and Courtauld Institutes* 43:262-265.

Cumont, F. 1942. *Le symbolisme funéraire des anciens Romains*. Paris.

Dati, C.R. 1664. *Delle lodi di Cassiano dal Pozzo*. Florence.

⸻, ed. 1821. *Vite dei pittori antiche scritte ed illustrate*. Padua.

De Angelis d'Ossat, G. 1974. *Disegno e Invenzione* nel pensiero e nelle architetture del Vasari." In *Il Vasari storiografo e artista*, Atti del congresso internazionale nel IV centenario della morte, pp. 773-782. Florence.

De Beer, E. S., ed. 1955. *The Diary of John Evelyn*. 6 vols. Oxford.

DeGrazia Bohlin, D. 1979. *Prints and Related Drawings by the Carracci Family: A Catalogue Raisonné*. Washington, D.C.

De Logu, G. 1962. *Natura morta italiana*. Bergamo.

Dempsey, C. 1966. "The Classical Perception of Nature in Poussin's Earlier Works." *Journal of the Warburg and Courtauld Institutes* 29:219-249.

⸻. 1977. *Annibale Carracci and the Beginnings of Baroque Style*. Villa I Tatti Monographs 3. Glückstadt.

⸻. 1979. Review of R. W. Lee, *Names on Trees: Ariosto into Art*. *Art Bulletin* 61:323-326.

⸻. 1980. "Some Observations on the Education of Artists in Florence and Bologna during the later Sixteenth Century." *Art Bulletin* 62:552-569.

⸻. 1981. "Annibal Carrache au Palais Farnèse." In *Le Palais Farnèse*, vol. 1, École française de Rome, pt. 1; pp. 269-311. Rome.

Disertori, B. 1966. *Il Domenichino trascrittore di musica e musicologo*. Biblioteca di "Quadrivium," Serie Musicologica 8. Bologna.

Donati, L. 1961. "Note su alcuni prodotti grafici italiani (secoli XVII e XVIII)." *Miscellanea Bibliothecae Hertzianae, Römische Forschungen der Bibliotheca Hertziana* 16:437-445.

D'Onofrio, C. 1966. "Un Dialogo-recita di Gian Lorenzo Bernini e Lelio Guidiccioni." *Palatino* 10:127-134.

Du Fresnoy, Ch. A. 1750. *The Art of Painting*. Edited by J. Dryden. London.

Edgerton, S. Y. 1972. "Maniera and the *Mannaia*: Decorum and Decapitation in the Sixteenth Century." In *The Meaning of Mannerism*, edited by F. W. Robinson and S. G. Nichols, Jr., pp. 67-103. Hanover, N.H.

Ellenius, A. 1960. *"De Arte Pingendi": Latin Art Literature in Seventeenth-Century Sweden and its International Background*. Studies and Sources Published by the Swedish History of Science Society 19. Uppsala.

Emiliani, A. 1975. *Mostra di Federigo Barocci*. Bologna.

Ettlinger, L. D. 1961. "Exemplum Doloris: Reflections on the Laocoon Group." In *De Artibus Opuscula XL: Essays in Honor of Erwin Panofsky*, edited by M. Meiss, pp. 121-126. New York.

Euclid—see Commandino.

Faldi, I. 1957. "Paolo Guidotti e gli affreschi della *Sala del Cavaliere* nel palazzo di Bassano di Sutri." *Bollettino d'Arte*, ser. 4, 42:278-295.

⸻. 1959. "Le 'Virtuose operationi' di Francesco Duquesnoy scultore incomparabile." *Arte antica e moderna* 5:52-62.

⸻. 1961. "Il Cavalier Bernini, il Cavalier Baglione et il Cavalier Guidotti." *Arte antica e moderna* 13/16:297-299.

Félibien, A. 1725. *Entretiens sur les vies et sur les ouvrages des plus excellens peintres anciens et modernes: avec la vie des architectes*. Trevoux, repr. Farnborough, 1976.

Firenzuola, A. 1966. *Opere scelte*. Edited by G. Fatini. Turin.

Franciotti, C. 1613. *Historie delle miracolose imagini e delle vite de' Santi, i corpi de' quali sono nella città di Lucca*. Lucca.

Frangipane, S. 1621. *Raccolta de' miracoli et grazie adoperate dall' Immagine del Padre S. Domenico di Soriano*. Messina.

Frey, K. and Frey, H. W., eds. 1930. *Der Literarische Nachlass Giorgio Vasaris*. 2 vols. Munich.

Friedlaender, W. 1948. "The Academician and the Bohemian: Zuccari and Caravaggio." *Gazette des Beaux Arts* 33:27-36.

⸻. 1965. *Mannerism and Anti-Mannerism in Italian Painting*. New York.

Fumaroli, M. 1978. "Cicero Pontifex Romanus: La tra-

dition rhétorique du collège romain et les principes inspirateurs du mécenat des Barberini." *Mélanges de l'École Française de Rome* (Moyen Age-Temps Modernes) 90:797-835.

———. 1980. *L'Age de l'éloquence: Rhétorique et "res literaria" de la Renaissance au seuil de l'époque classique*. Centre de recherches d'histoire et de philologie V (Hautes études médiévales et modernes) 43. Geneva.

Galli, R. 1927-28. "Tesori d'arte di un pittore del '600: L'inventario delle opere d'arte di Carlo Maratti." *L'Archiginnasio*: 3-44.

Gesualdo, G. A. 1541. *Il Petrarcha colla spositione di Messer Giovanni Andrea Gesualdo*. Venice.

Gigli, G., ed. 1958. *Diario Romano (1608-1670)*. Edited by G. Ricciotti. Rome.

Gombrich, E. H. 1944. "The Subject of Poussin's Orion." *Burlington Magazine* 134:37-41.

———. 1976. *The Heritage of Apelles: Studies in the Art of the Renaissance*. Ithaca and Oxford.

Gordon, D. J. 1975. "Poet and Architect: The Intellectual Setting of the Quarrel between Ben Jonson and Inigo Jones." In *The Renaissance Imagination: Essays and Lectures by D. J. Gordon*, edited by S. Orgel, pp. 77-101. Berkeley and Los Angeles.

Gotch, J. A. 1923. *Inigo Jones*. London.

Gnudi, M. T. and J. P. Webster. 1950. *The Life and Times of Gaspare Tagliacozzi, Surgeon of Bologna*. New York.

Graf, D. 1973. *Master Drawings of the Roman Baroque from the Kunstmuseum Düsseldorf*. London.

Gramberg, W. 1964. *Die Düsseldorf Skizzenbücher des Guglielmo della Porta*. 3 vols. Berlin.

Grayson, C., ed. 1972. L. B. Alberti, *On Painting and Sculpture*. London.

Grendler, P. 1969. *Critics of the Italian World*. Madison, Milwaukee, and London.

Guglielminetti, M., ed. 1966. *Giambattista Marino: Lettere*. Nuova Universale Einaudi 70. Turin.

Guidiccioni, L. 1642. *Eneide toscana dal Sigr. L. Guidiccioni . . . co'suoi discorsi*. Rome.

Harris, A. Sutherland. 1964. "The Decoration of S. Martino ai Monti." *Burlington Magazine* 106:58-69, 115-120.

———. 1967. "Notes on the Chronology and Death of Pietro Testa." *Paragone* 213:35-69.

———. 1977. *Andrea Sacchi*. Oxford.

Harris, A. Sutherland and C. Lord. 1970. "Pietro Testa and Parnassus." *Burlington Magazine* 112:15-20.

Hartmann, K. 1970. "Pietro Testa: The Chronology of his Work and Evolution of his Style." Ph.D. dissertation, London University.

Haskell, F. 1963. *Patrons and Painters: A Study in the Relations between Italian Art and Society in the Age of the Baroque*. New York.

Haskell, F. and S. Rinehart. 1960. "The dal Pozzo Collection, Some New Evidence." *Burlington Magazine* 102:318-326.

Heideman, J. 1980. "The Dating of Gaspard Dughet's Frescoes in San Martino ai Monti in Rome." *Burlington Magazine* 122:540-546.

Heikamp, D. 1957. "Vicende di Federigo Zuccaro." *Rivista d'Arte* 32:178-192, and 219-221.

———, ed., 1961. *Scritti d'Arte di Federigo Zuccaro*. Fonti per lo studio della storia dell'arte inedite o rare. Florence.

Hyginus. 1587. *Poeticon Astronomicon*. Paris.

Jouanny, Ch., ed. 1911. *Correspondance de Nicolas Poussin*. Archives de l'art français, n.p. 5. Paris.

Jouin, H. 1883. *Conférences de l'Académie Royale de Peinture et de Sculpture*. Paris.

Junius, F. 1638. *On the Ancient Art of Painting*. London.

Kaufmann, T. da Costa. "The Perspective of Shadows: The History of the Theory of Shadow Projection." *Journal of the Warburg and Courtauld Institutes* 38:258-287.

Koerte, W. 1935. *Der Palazzo Zuccari in Rome*. Römische Forschungen der Bibliotheca Hertziana 12. Leipzig.

Kristeller, P. O. 1974. "Thomism and the Italian Thought of the Renaissance." In *Medieval Aspects of Renaissance Learning*, edited and translated by E. P. Mahoney, pp. 29-91. Duke Monographs in Medieval and Renaissance Studies 7. Durham, N.C.

Lalanne, L., ed. 1880. "Journal du Voyage du Cavalier Bernin en France par M. de Chantelou." *Gazette des Beaux Arts* 21, ser. 2: cf., 378-392.

Lavin, I. 1968a. "Five New Youthful Sculptures by Gianlorenzo Bernini and a Revised Chronology of his Early Works." *Art Bulletin* 50:223-248.

———. 1968b. *Bernini and the Crossing of St. Peter's*. College Art Association Monographs on Archaeology and the Fine Arts 17. New York.

———. 1980. *Bernini and the Unity of the Visual Arts*. 2 vols. London and New York.

Lee, R. W. 1967. *Ut Pictura Poesis: The Humanistic Theory of Painting*. New York.

Leonardo da Vinci. 1651. *Trattato della pittura*. Paris.

Limentani, U. 1961. *La satira nel Seicento*. Milan.

Lomazzo, G. P. 1584. *Trattato dell'arte de la Pittura di G. P. Lomazzo, Milanese pittore, diviso in sette libri ne' quali si contiene tutta la theorica & la prattica d'essa pittura*. Milan.

Longhi, R. 1916. "Gentileschi, padre e figlia." *L'Arte* 19:245-314.

———. 1950. "Un momento importante nella storia della natura morte." *Paragone* 1:34-59.

Lopresti, L. 1921. "Pietro Testa, incisore e pittore." *L'Arte* 24:10-18, 74-84.

Lumbroso, G. 1874. *Notizie sulla vita di Cassiano dal Pozzo*. Turin.

McGarry, D. D., trans. 1955. *The Metalogicon of John of Salisbury: A Twelfth-Century Defense of the Verbal and Logical Arts of the Trivium*. Berkeley and Los Angeles.

McGrath, R. L. 1962. "The 'Old' and 'New' Illustrations for Cartari's *Imagini dei dei degli antichi*: a Study of 'Paper Archaeology' in the Italian Renaissance." *Gazette des Beaux-Arts*, ser. 6, 59:213-226.

Mahon, D. 1947. *Studies in Seicento Art and Theory*. London.

————. 1960. "Poussin au carrefour des années trente." In *Nicolas Poussin: Actes du Colloque International*, 2 vols. C.N.R.S., edited by A. Chastel, 2:237-264. Paris.

————. 1962. *Poussiniana: Afterthoughts Arising from the Exhibition*. Editions de la *Gazette des Beaux-Arts*. Paris.

Mâle, E. 1932. *L'Art religieux après le Concile de Trente*. Paris.

Malvasia, C. C., ed. 1841. *Felsina pittrice: Vite de' pittori bolognesi*. 2 vols. Edited by G. Zanotti. Bologna.

Mancini, A. 1950. *Storia di Lucca*. Florence.

Mancini, G., ed. 1956. *Considerazioni sulla pittura*. 2 vols. Edited by A. Marucchi, with an introduction by L. Venturi. Accademia Nazionale dei Lincei, Fonti e documenti per la storia dell'arte 7. Rome.

Mandowsky, E. 1939. *Ricerche intorno all'Iconologia di Cesare Ripa*. Florence.

Manni, D. M. 1816. *Le Veglie piacevoli, ovvero notizie de' più bizzari e giocondi uomini toscani*, 9 vols. in 3. Florence.

Marabottini, A. 1954. "Novità sul Lucchesino": Pt. 1, "Il percorso artistico"; Pt. 2, "Il *Trattato di Pittura* e i disegni." *Commentari* 5:116-135, 217-244.

Marabottini, A. Marabotti. 1963. "Il Naturalismo di Pietro Paolini." In *Scritti di storia dell'arte in onore di Mario Salmi*, 3 vols., edited by V. Martinelli and F. M. Aliberti, 3:307-324. Rome.

Marias, F. and A. Bustamente Garcia. 1981. *Las ideas artisticas de El Greco*. Madrid.

Marino—see Guglielminetti.

Martin, J. R. 1965. *The Farnese Gallery*. Princeton.

Martone, T. 1969. "Pietro Testa's *Triumph of Painting*." *Marsyas* 14:49-57.

Mascardi, A. 1627. *Discorsi morali su la Tavola di Cebete*. Venice.

————. 1636. *Dell'arte historica*. Rome.

Mazzarosa, A., 1843. *Guida di Lucca*. Lucca.

Mezzei, R. 1977. *La società lucchese del Seicento*. Lucca.

Minto, A., 1953. *"Le Vite dei Pittori Antichi" di Carlo Roberto Dati e gli studi erudito-antiquario nel Seicento*. L'Accademia Toscana di Scienze e Lettere "La Columbaria," Studi 1. Florence.

Mitchell, C. 1937-1938. "Poussin's *Flight into Egypt*." *Journal of the Warburg and Courtauld Institutes* 1:340-343.

Moir, A. 1967. *The Italian Followers of Caravaggio*. 2 vols. Cambridge, Mass.

Montagu, J. 1970. "Alessandro Algardi's Altar of S. Nicola da Tolentino and Some Related Models." *Burlington Magazine* 112:282-291.

Mopurgo Tagliabue, G., 1955. "La Retorica Aristotelica e il Barocco." In *Retorica e Barocco*, edited by E. Castelli. Atti del III congresso internazionale di studi umanistici. Rome.

Nanni, P.F.M. 1650. *Vita del glorioso patriarca S. Domenico*. Urbino.

Nava Cellini, A. 1966. "Duquesnoy e Poussin: Nuovi contributi." *Paragone* 195:30-59.

Olszewsky, E. J., ed. and trans. 1977. *Giovanni Battista Armenini (1533?-1609): On the True Precepts of the Art of Painting*. New York.

Ong, W. 1958. *Ramus, Method and the Decay of Logic*. Cambridge, Mass.

Orbaan, J.A.F. 1920. *Documenti sul barocco a Roma*. Rome.

Ottani, A., 1963. "Per un caravaggesco toscano: Pietro Paolini (1603-1681)." *Arte antica e moderna* 21:19-35.

Palisca, C. V. 1960. *Girolamo Mei (1519-1594): Letters on Ancient and Modern Music to Vincenzo Galileo and Giovanni Bardi*. Musicological Studies and Documents 3. N.p.

————. 1980. "G. B. Doni, Musicological Activist, and his 'Lyra Barberina.'" In *Modern Musical Scholarship*, edited by E. Olleson, pp. 181-205. Boston and London.

Panofsky, E. 1955. *The Life and Art of Albrecht Dürer*. Princeton.

————. 1960. *A Mythological Painting by Poussin in the Nationalmuseum Stockholm*. Nationalmusei Skriftserie 5. Stockholm.

————. 1964. *Galileo as a Critic of the Arts*. The Hague.

————, ed. 1968. *Idea: A Concept in Art Theory*. Translated by J.J.S. Peake. Columbia, S.C.

Parker, K. T. 1956. *Catalogue of the Collection of Drawings in the Ashmolean Museum II: Italian Schools*. Oxford.

————. 1962. *Catalogue of Paintings in the Ashmolean Museum*. Oxford.

Pascoli, L. 1730-1736. *Vite de' pittori, scultori, ed architetti moderni*. 2 vols. Rome.

Passeri, G. B., ed. 1934. *Vite dei pittori, scultori et architetti dall'anno 1673*. Edited by J. Hess. Leipzig and Vienna.

Pastor, L. von, ed. 1938. *The History of the Popes from the Close of the Middle Ages*. Vol. 29. Translated by E. Graf. St. Louis.

Patterson, A. M. 1970. *Hermogenes and the Renaissance: Seven Ideas of Style*. Princeton.

Pauli, S. 1740. *Modi di dire Toscani ricercati nella loro origine*. Venice.

Pedretti, C. 1977. *The Literary Works of Leonardo da Vinci: A Commentary to Jean Paul Richter's Edition*. 2 vols. Oxford.

Percy, A. 1971. *Giovanni Benedetto Castiglione: Master Draughtsman of the Baroque*. Philadelphia.

Peters, S. N. 1969. "The Quarrel of the *Adone*: A Chapter in the History of Seventeenth Century Italian Poetic Theory." Ph.D. dissertation, The Johns Hopkins University.

Petrucci, A. 1936. "Originalità del Lucchesino." *Bollettino d'arte* 29:409-419.

Pfeiffer, R. 1952. "The Image of Delian Apollo and Apolline Ethics." *Journal of the Warburg and Courtauld Institutes* 15:20-32.

Phillips, M. M. 1964. *The "Adages" of Erasmus*. Cambridge.

Pigman, G. W., III. 1980. "Versions of Imitation in the Renaissance." *Renaissance Quarterly* 33:1-32.

Pillsbury, E. P. and L. S. Richards. 1978. *The Graphic Art of Federico Barocci*. New Haven.

Pizzi, I. 1976. "La Provincia e il palazzo ducale." *La Provincia di Lucca* 16, 2:3-9.

Plato—see Bembo.

Poch-Kalous, M. 1961. *Akademie der bildenden Künste: Katalog der Gemäldegalerie*. Vienna.

Pollak, O. 1928-1931. *Die Kunsttätigkeit unter Urban VIII*. 2 vols. Quellenschriften zur Geschichte der Barockkunst in Rom. Vienna.

Pope-Hennessy, J. 1938. "Zacchia il Vecchio and Lorenzo Zacchia." *Burlington Magazine* 72:213-223.

————. 1948. *The Drawings of Domenichino in the Collection of His Majesty the King at Windsor Castle*. London.

Posner, D. 1965. "Domenichino and Lanfranco: The Early Development of Baroque Painting in Rome." In *Essays in Honor of Walter Friedlaender, Marsyas*, supplement 2, edited by W. Cahn et al., pp. 135-146. New York.

Raggio, O. 1958. "The Myth of Prometheus." *Journal of the Warburg and Courtauld Institutes* 21:44-62.

Raimondi, E. 1966. *Anatomie secentesche*. Saggi di Varia Umanità 3. Pisa.

Riccomini, E. 1961. "Pier Francesco Cittadini." *Arte antica e moderna* 13/16:362-373.

Richa, G. 1754-1762. *Notizie istoriche delle chiese fiorentine divise ne' suoi quartieri*. 10 vols. Florence.

Richter, I. 1949. *Paragone: A Comparison of the Arts by Leonardo da Vinci*. London.

Richter, J. P., ed. 1883. *The Literary Works of Leonardo da Vinci*, 2 vols. London.

Ridolfi, M. 1844. *Scritti vari riguardanti le Belle Arti*. Lucca.

Ripa, C. 1603. *Iconologia, overo descrittione di diverse imagini cavate dall'antichità* Rome.

————. 1625. *Novissima iconologia*. Padua.

Robb, N. 1947-1948. "A Reporter on Parnassus: Traino Boccalini." *Italian Studies* 111:163-180.

Robert, C. 1919. *Die Antiken Sarkofag-reliefs*. Vol. 3, in 3 parts. Berlin. Reprint Rome, 1969.

Ronchi, V., ed. 1968. *Scritti di ottica*. Classici italiani di scienze tecniche e arti. Milan.

————. 1970. *The Nature of Light*. London.

Rosa, S. (n.d.). *Satire*. Cosmopoli.

Rose, P. L. 1973. "Letters Illustrating the Career of Federigo Commandino." *Physis* 15:401-410.

————. 1976. *The Italian Renaissance of Mathematics: Studies on Humanists and Mathematicians from Petrarch to Galileo*. Travaux d'humanisme et Renaissance 145. Geneva.

Ross, J. and N. Erichsen. 1912. *The Story of Lucca*. London.

Roworth, W. W. 1978. *Pictor Succensor: A Study of Salvator Rosa as Satirist, Cynic, and Painter*. London and New York.

Rubinstein, N. 1958. "Political Ideas in Sienese Art: The Frescoes by Ambrogio Lorenzetti and Taddeo di Bartolo in the Palazzo Pubblico." *Journal of the Warburg and Courtauld Institutes* 21:179-207.

Salerno, L. 1960. "The Picture Gallery of Vincenzo Giustiniani." *Burlington Magazine* 102:21-27, 93-104, 135-148.

————. 1967. *La Piazza di Spagna*. Naples.

————. 1970. "Il dissenso nella pittura." *Storia dell'Arte* 5:34-65.

Sandrart, J. von. 1680. *Iconologia*. Nuremberg.

————, ed. 1925. *Academie der Bau-, Bild- und Mahlerey-künste von 1675*. Edited by A. R. Peltzer. Munich.

Saxl, F. 1936. "Veritas Filia Temporis." In *Philosophy and History: Essays Presented to Ernst Cassirer*, edited by R. Klibansky and H. J. Paton, pp. 197-222. Oxford.

Schaar, E. and A. Sutherland Harris. 1967. *Die Handzeichnungen von Andrea Sacchi und Carlo Maratta*. Kataloge des Kunstmuseums Düsseldorf 3, Handzeichnungen, vol. 1. Düsseldorf.

Schaar, E. and D. Graf. 1969. *Meisterzeichnungen der Sammlung Lambert Krahe*. Düsseldorf.

Schilling, E. [1971]. *The German Drawings in the Collection of Her Majesty the Queen at Windsor*

Castle and Supplements to the Catalogues of the Royal Collections of Drawings with a History of the Royal Collection of Drawings by A. Blunt. London and New York.

Schleier, E. 1970. "An unknown late Work by Pietro Testa." *The Burlington Magazine* 112:665-668.

Schlosser Magnino, J. von. 1967. *La letteratura artistica*. Translated by F. Rossi and edited by O. Kurz. Il Pensiero Storico 12. Florence.

Schmitt, C. 1973. "Towards a Reassessment of Renaissance Aristotelianism." *History of Science* 11:159-193.

Segni, B. 1549. *Rettorica e poetica d'Aristotile. Tradotte . . . da Bernardo Segni*. Florence.

————. 1550. *L'Ethica d'Aristotile tradotta in lingua vulgare fiorentina et commentata per Bernardo Segni*. Florence.

Sismondi, J.C.L., ed. 1906. *History of the Italian Republics in the Middle Ages*. Translated and edited by W. Bolting. London and New York.

Smith, W. 1964. "Giulio Clovio and the *Maniera di Figure Piccole*." *Art Bulletin* 46:395-401.

————. [1976]. *The Farnese Hours*. New York.

Smyth, C. H. 1963. *Mannerism and "Maniera."* Locust Valley, N.Y.

Snyder, J. 1973. *Bosch in Perspective*. Englewood Cliffs, N.J.

Speciale, O. 1977. "*P. Testa delineavit*": Pietro Testa nei rami della Calcografia, Mostra di rami e stampe. Rome.

Spini, G. 1948. "I trattatisti dell'arte storica nella controriforma." In *Contributi alla Storia del Concilio di Trento e della controriforma*, edited by L. Russo. Quaderni di "Belfagor" 1. Florence.

Stampfle, F. and J. Bean. 1967. *Drawings from New York Collections II: The Seventeenth Century in Italy*. New York.

Steinitz, K. Trauman. 1958. *Leonardo da Vinci's "Trattato della Pittura."* Library Research Monographs, vol. 5, University Library Copenhagen, Scientific and Medical Department. Copenhagen.

Sterling, Ch. 1960. "Biographie." In Musée du Louvre, *Exposition Nicolas Poussin*. Paris.

Strinati, C. M. 1972. "Studio sulla teorica d'arte primoseicentesca tra Manierismo e Barocco." *Storia dell'arte* 13:67-82.

Summers, D. 1972. "Michelangelo on Architecture." *Art Bulletin* 54:146-157.

————. 1981. *Michelangelo and the Language of Art*. Princeton.

Tasso, T., ed. 1958. *Dialoghi*. 3 vols. Edited by E. Raimondi. Florence.

————. ed. 1964. *Discorsi dell' arte poetica e del poema eroico*. Edited by L. Poma. Scrittori d'Italia 228. Bari.

Tassoni, A., ed. 1942. *Opere*. Edited by L. Fassò. Rome.

Teyssèdre, B. 1967. "Peinture et musique: La notion d'harmonie des couleurs au XVIIe siècle français." In *Stil und Ueberlieferung in der Kunst des Abendlandes*, 3 vols. (Acts of the 21st International Congress of the History of Art, Bonn, 1964), 3:206-214. Berlin.

Thiem, C. 1970. "Pietro Testas Entwürfe zum *Tod der Dido*." *Jahrbuch der Staatlichen Kunstsammlungen in Baden-Wurttemberg* 7:77-84.

————. 1973. "A Collage by Pietro Testa in Weimar." *Master Drawings* 11:20-25.

————. 1977. *Bestandskatalog der Graphischen Sammlungen der Staatsgalerie Stuttgart: Italienische Zeichnungen 1500-1800*. Stuttgart.

Thuillier, J. 1960. "Poussin et ses premiers compagnons français à Rome." In *Nicolas Poussin: Actes du Colloque International,* 2 vols., C.N.R.S., edited by A. Chastel, 1:71-116. Paris.

————. 1964. "Les *Observations sur la peinture* de Charles Alphonse Du Fresnoy." In *Walter Friedlaender zum 90. Geburtstag*, edited by G. Kauffman and W. Sauerlaender, pp. 193-210. Berlin.

Toffanin, G. 1929. *Il Cinquecento*. Storia letteraria d'Italia. Milan.

Tommasi, G. 1847. *Sommario della Storia di Lucca dall'anno MIV all'anno MDCC*. La Storia d'Italia, 10. Florence.

Turner, N. 1971. "Ferrante Carlo's 'Descrittione della cupola di S. Andrea della Valle depinta dal Cavalier Gio: Lanfranchi': A source for Bellori's descriptive method." *Storia dell'arte* 12:297-325.

————. 1973. "Four Academy Discourses by Giovanni Battista Passeri." *Storia dell'arte* 19:231-247.

————. 1976. "An Attack on the Accademia di San Luca: Ludovico David's *L'Amore dell'Arte*," *The British Museum Yearbook* 1:157-186.

————. 1980. *Italian Baroque Drawings*. British Museum Prints and Drawings Series. London.

Valeriano, P. 1625. *Hieroglifici*. Venice.

Van Schaak, E. 1969. "Francesco Albani, 1578-1660." Ph.D. dissertation, Columbia University.

Vermeule, C. 1960. "The dal Pozzo-Albani Drawings of Classical Antiquities in the British Museum." *Transactions of the American Philosophical Society* 50, pt. 5:3-78.

Vitruvius—see Barbaro.

Vitzthum, W. 1964. Review of "Entwurf und Ausführung." In *Master Drawings* 2:296-297.

Voss, H. 1957. "Die Flucht nach Aegypten." *Saggi e memorie di storia dell'arte* 1:27-61.

Waal, H. van der. 1967. "The *Linea summae tenuitatis* of Apelles: Pliny's Phrase and Its Interpreters." *Zeitschrift für Aesthetik und allgemeine Kunstwissenschaft* 12:5-32.

Walker, D. P. 1941-1942. "Musical Humanism in the 16th and early 17th Centuries." *The Musical Review* 2:1-13, 111-121, 220-227, 288-308, and 3:55-71.

Wallace, R. 1979. *The Etchings of Salvator Rosa.* Princeton.

Waterhouse, E. 1976. *Baroque Painting in Rome.* Oxford.

Watrous, J. 1957. *The Craft of Old Master Drawings.* Madison, Wis.

Weinberg, B. 1961. *A History of Literary Criticism in the Italian Renaissance.* 2 vols. Chicago and Toronto.

Werner, G. 1977. *Ripa's "Iconologia": Quellen, Methode, Ziele.* Bibliotheca Emblematica 7. Utrecht.

Wind, E. 1967. *Pagan Mysteries in the Renaissance.* London.

Winner, M. 1957. "Die Quellen der Pictura-Allegorien in gemalten Bildergalerien des 17. Jahrhunderts zu Antwerpen." Ph.D. dissertation, Cologne.

———. 1962. "Gemalte Kunsttheorie: Zu Gustave Courbet's *Allegorie réelle* und der Tradition." *Jahrbuch der Berliner Museum* 4:150-185.

Wittkower, R. 1966. *Gian Lorenzo Bernini: The Sculptor of the Roman Baroque.* London.

———. 1973. *Art and Architecture in Italy 1600-1750.* Harmonsworth.

Wittkower, R. and M. Wittkower, eds. 1964. *The Divine Michelangelo.* London.

Xenophon, ed. 1923. *Memorabilia.* Vol. 6. Translated by E. C. Marchant. Loeb edition. London and New York.

Yates, F. 1966. *The Art of Memory.* London.

Zarlino, G. 1573. *Le Istitutioni harmoniche.* Venice. Repr., Ridgewood, N.J. 1966.

Zeri, F. 1954. *La Galleria Spada in Roma: catalogo dei dipinti.* Biblioteca di "Proporzioni." Florence.

Index

Academy of St. Luke, 11, 24, 25n, 37-38, 95, 106, 118, 150, 168, 180-83

Accademia del Disegno, 52, 77-78, 92, 130-31

Accademia degli Oscuri, 12n

Accademia degli Umoristi, 157

Accolti, Pietro, 130-33, 135-36, 139, 143, 145-46, 207, 219, 238-39, 264, 273

Achillini, Claudio, 120, 122, 234

Aglaophon, 158

Agucchi, Giovanni Battista, 5, 16-18, 57, 63, 119, 149-50, 156-58, 159n, 165, 168-72, 224

Aguilonius, Franciscus, 131

Albani, Francesco, 4, 57-58, 105n, 106-110, 112, 115, 117, 140, 258

Alberti, Leon Battista, 92, 97-103, 124, 148, 150, 168, 174, 198-201, 205, 208, 219, 226-27, 257-58, 273

Alberti, Romano, 85, 88

Aleandro, Girolamo, 47n, 52, 118, 120-21, 174, 211, 273

Algardi, Alessandro, 16, 252

Alhazen, 145, 219

Allacci, Leone, 61n, 157

Allori, Alessandro, 66

Angeloni, Francesco, 17, 57

Apelles, 101, 106n, 115, 146, 158, 164

Aquinas, Thomas, 149

Arcimboldo, Giuseppe, 105

Ariosto, Ludovico, 121-22, 168, 211

Aristotle, 43, 45, 57n, 68n, 71-72, 75, 80-82, 85, 89, 91, 95, 97, 128, 149, 154; *Metaphysics*, 66-67, 83, 92-93, 135, 154, 234-35; *Nicomachean Ethics*, 67, 73, 75-78, 82-83, 88-89, 92-93, 153, 154n, 174, 240; *Physics*, 94; *Poetics*, 73, 118, 153, 240-41. *See also* Segni

Armenini, Giovanni Battista, 130, 189-91, 205-208, 210, 212-13, 222, 225-27, 239, 250, 257-58, 273

Baglione, Giovanni, 58, 252

BambLoccianti, 17, 55, 63, 104, 105n, 107-108, 112, 129

Bamboccio, *see* Van Laer

Barbalonga, 15n

Barbaro, Daniele: *La pratica della perspettiva*, 130-32; translation of and commentary on Vitruvius, *I*

dieci libri d'architettura, 8, 33n, 47n, 65-68, 72, 78, 86, 89, 92-95, 100, 102, 116, 130, 138, 143, 145, 174, 193-97, 204-205, 209, 211-14, 216-17, 220, 223-24, 228-34, 246, 273. *See also* Vitruvius

Barberini, 42, 56
 Antonio, Cardinal, 12n, 14, 227, 270
 Francesco, Cardinal, 157
 Maffeo, *see* Urban VIII, Pope

Barbieri, Paolo Antonio, 104, 107

Barocci, Federico, 32, 35

Bartolommeo, Fra, 30

Baschenis, Evaristo, 104, 107

Bassano, family of painters, 106, 168n

Beccafumi, Domenico, 208

Bellori, Giovanni Pietro, 5, 7, 15n, 17-18, 52-53, 59, 75, 95, 99, 101, 124, 141n, 148-52, 155-58, 162, 164, 166-74, 179, 181, 183

Bembo, Dardi, 234-38

Bembo, Pietro, 157

Bernardini, Cosimo, 26, 30n, 59n

Bernini, Gian Lorenzo, 8, 30, 39-40, 56, 112, 150, 159-60, 173, 257-58

Bertini, Loriano, collection, 40, 43, 46, 259

Bisagno, Fra Francesco, 91, 92n, 97-98, 191, 205-208, 213, 237, 250, 258, 273

Boccalini, Traiano, 255

Boethius, 71, 88

Bonone, Carlo, 31n

Borghini, Raffaello, 78

Bornia, Giovanni della, 49

Borromini, Francesco, 116

Bosch, Jerome, 105

Bottalla, Raffaellino (Giovanni Maria), 19n

Bottifango, Giulio Cesare, 14

Brebiette, Pierre, 18n

Breughel, Abraham, 104n

Brunelleschi, Filippo, 124

Buontalenti, Bernardo, 51

Buonvisi, Girolamo, 12, 30n, 34, 38-39, 41, 43, 45-47, 56, 59n, 68, 189, 251, 254-55

Calamis, 164

Calamech, Lazzaro, 51

Callistratus, 170

Campanella, Tommaso, 159n

Canini, Giovanni Angelo, 12, 18n
Capitelli, Bernardino, 14
Caravaggio, 17, 63, 107, 129, 139, 168, 208
Caravaggio, Polidoro da, 13, 15n, 209
Carlier, Antoine, 112
Carlo, Ferrante, 170
Caroselli, Angelo, 12
Carracci, Academy, 5, 7, 15, 99, 108-110, 112, 123, 140, 153, 156, 173, 227, 252
Carracci, Agostino, 30n, 32, 63n, 112n, 122, 123-28, 132, 254
Carracci, Annibale, 13, 15, 17, 24, 56-59, 63-64, 67, 105, 112, 121, 124, 132, 147, 153, 170-71, 173-74, 225, 254, 251
Carracci, Antonio, 16n
Carracci, family of painters, 15, 17n, 32, 36, 43, 57, 58n, 75, 124, 127, 131, 151-52, 156-57, 254
Carracci, Gobbo de', 107
Carracci, Ludovico, 16n, 254
Cartari, Vincenzo, 214, 220-22, 264-65, 273
Castellini, Giovanni Zarattino, 37n, 70-72, 82-83, 87
Castelvetro, Ludovico, 118, 154n, 168
Castiglione, Baldassarre, 168
Castiglione, Giovanni Benedetto, 8, 25n, 31, 61n, 63n, 175, Fig. 110
Catalano, Francesco, 25
Cerquozzi, Michelangelo, 104-106, 108
Cesarini, Virginio, 160-61, 172
Cesi, Federico, 161n
Chiabrera, Gabriello, 154n
Cicero, 50, 57n, 71, 115-16, 128, 157-58, 161-62, 164, 166-68, 192
Cigoli, Ludovico, 133, 257
Cittadini, Pier Francesco, 104n
Claude Lorraine, 18n
Claudian, 170
Cleiton, 236
Clovio, Giulio, 258
Codazzi, Viviano, 104n
Collignon, François, 50, 55, 182n, 217, 221, 263, Figs. 60 and 117
Commandino, Federico, 79-81, 133, 204, 213, 215-16, 228, 273
Correggio, 61, 117, 148, 158, 160, 173, 208-209, 225, 261-62
Cortona, Pietro da, 16-20, 24, 36, 42-44, 56, 101, 103-104, 108, 117, 119, 158, 268
Cozza, Francesco, 18n
Cureau de la Chambre, 144-45

Daedalus, 15, 156
Dante, 154
Danti, Vincenzo, 51
d'Arpino, Giuseppe Cesari, 58, 158, 158n, 160, 173

Demetrius, 168n
Descartes, René, 145
Dolce, Ludovico, 96, 111, 125, 207
Domenichino, 4-7, 12, 14-19, 32, 42-43, 57-58, 61, 64-65, 99, 101, 103, 108-109, 110n, 114, 122-28, 130, 138-40, 148, 149n, 152, 158, 169-70, 173-74, 183, 225, 251-52, 264, Fig. 102
Doni, Giovanni Battista, 139, 141
Du Fresnoy, Charles Alphonse, 5, 8, 89n, 98, 108n, 147-48, 172-74
Dughet, Gaspard, 56, 60
Dujardin, Karel, 104n
Duquesnoy, Francesco, 13-14, 18n, 24-25, 35-36, 38-39, 41
Dürer, Albrecht, 87, 125-26, 151, 154n
Düsseldorf Notebook, 3-4, 6-8, 68, 96, 179-271, *et passim*
 INDIVIDUAL SECTIONS OF: 1, Fig. I, 189-91; 2, 191, 220; 3, Fig. II, 191, 266; 4, Fig. III, 191-92; 5, 192; 6, 192-93; 7, Fig. IV, 193; 8, Fig. V, 65n, 72n, 89-90, 95, 193-97, 204, 209; 9, 197; 10, 197; 11, Fig. VI, 69-70, 82, 89, 155, 197; 12, Fig. VII, 197-98; 13, Fig. VIII, 198-201, 258; 14, Figs. IX and X, 152, 202-205; 15, Fig. XI, 91-92, 110, 132, 138, 152, 204-210, 222, 225-27, 238; 16, 87, 92n, 110n, 114, 116, 209-210, 227-28; 17, 210; 18, 100, 152, 210-11; 19, 117-18, 211; 20, 211; 21, 211; 22, 211-12, 214; 23, 212; 24, 213, 215, 228; 25, Fig. XII, 213-15, 230; 26, Fig. XIII, 214-15; 27, 79, 215-16, 228; 28, 65n, 216-17, 220, 228; 29, Fig. XIV, 51n, 88, 99, 217-18; 30, 95, 218, 249; 31, Fig. XV, 218-19; 32, Fig. XVI, 219; 33, 219; 34, 103, 191, 220, 223; 35, 220; 36, 220; 37, 220; 38, 128n, 220; 39, Fig. XVII, 220-22, 264; 40, Fig. XVIII, 44n, 133, 208, 222; 41, 222, 224; 42, 223; 43, 34, 65n, 131, 138, 205, 223-24; 44, 95, 224; 45, Fig. XIX, 225; 46, 77, 225-26; 47, 225-26; 48, 226; 49, 226; 50, 92n, 226-27; 51, 227-28, 268; 52, 228, 250; 53, Fig. XX, 15n, 75-76, 79, 228-29, 250; 54, 65n, 72n, 95, 229-34, 236; 55, 87, 120, 121n, 234-36, 248; 56, 43, 128n, 168, 235-36; 57, Fig. XXI, 22n, 25n, 45, 55, 67n, 71, 91, 92n, 96-99, 103, 105, 152-53, 209, 236-38, 240, 244-46; 58, 129-30, 208, 238-40, 265; 59, 15n, 90, 96, 109-114, 116-17, 120, 128-29, 152, 220, 240-44, 246, 264; 60, Fig. XXII, 15n, 19, 45, 90-92, 97, 99, 100, 102-104, 110, 112-13, 117, 127, 152-53, 218, 223, 235, 240, 244-51; 61, 57, 64, 123, 130, 132, 251-54; 62, 253-54; 63, 64, 102, 116, 137, 200, 251, 254-59; 64, Fig. XXIII, 259; 65, Fig. XXIV, 260, 262; 66, Fig. XXV, 61, 260-64; 67, 264-65; 68, 264; 69, Fig. XXVI, 238, 264-65; 70, 220, 264-66; 71, Fig. XXVII, 191, 266; 72, Fig. XXVIII, 191, 266; 73, Fig. XXIX, 267, 270-71; 74, Fig. XXX, 267-68, 71;

75, Fig. XXXI, 268, 270-71; **76**, Figs. XXXII and XXXIII, 267-68, 271; **77**, Fig. XXXIV, 270-71; **78**, Fig. XXXV, 271

Empoli, Jacopo da, 104, 106
Erasmus, 100n, 159n
Euclid, 79-80, 174. *See also* Commandino
Evelyn, John, 14n

Faber, Felix, 171
Farnese, Ranuccio, 160n
Fermat, Pierre, 145
Ferri, Simone, 31n
Filippini, Giovanni Antonio, 60-61, 261
Firenzuola, Agnolo, 174, 202-204, 273
Folengo, Teofilo, 105n, 108
Franciotti, Marcantonio, Cardinal, 29-30, 32, 35, 39, 41, 259
French Academy, 7, 112, 147
Fulgentius, 161

Galilei, Galileo, 146n, 160-61, 257
Galilei, Vincenzo, 139, 141
Gessi, Francesco, 16n
Gesualdo, Giovanni Andrea, 66-67
Ghezzi, Giuseppe, 182-83
Ghezzi, Pier Leone, 182, 270
Giovanni del Campo, 25
Gimignani, Giacinto, 19n
Greco, El, 8
Gregory XV, Pope (Alessandro Ludovisi), 157
Grimaldi, Francesco Maria, 145
Gualdo, Francesco, 14
Guercino, 4-5, 58, 108, 117
Guidiccione, Alessandro, 30
Guidiccioni, Lelio, 12-13, 39, 57, 157, 174, 227, 268-69, 273
Guidobaldo de' Marchesi del Monte, 131-32
Guidotti, Paolo, 11
Guillain, Simon, 57
Guinigi, Vincenzo, 157n
Giustiniani, collection, 26; Vincenzo, 16

Henry, Prince of Hesse, collection, 38-39
Hesiod, 242
Hierocles, 53, 54n
Hobbes, Thomas, 163, 164n
Homer, 44, 61, 97, 117, 211, 242-43
Horace, 96, 148
Huarte, Juan, 161n

Innocent X, Pope (Giovanni Battista Pamfili), 56

Jones, Inigo, 65

Julius II, Pope (Giuliano della Rovere), 160
Julius III, Pope (Giovanni Maria Ciocchi del Monte), 157n
Junius, Franciscus, 161-69, 171-74

Kant, Immanuel, 151
Krahe, Lambert, 179-80, 182-84, 271

Lanfranco, Giovanni, 16, 58, 61, 116, 123, 126, 128, 148, 158-60, 173, 260, 262, 264
Leo X, Pope (Giovanni de' Medici), 157n, 160
Ligozzi, Giacomo, 258
Lingelbach, Johannes, 104n
Lippi, Lorenzo, 108n
Lipsius, Justus, 161n
Lomazzo, Giovanni Paolo, 94, 103, 105, 107, 130, 149, 205, 208-210, 225, 237-39, 250, 273
Longinus, 161, 165
Lorenzetti, Ambrogio, 22-23
Lucian, 49, 99, 170-71
Lysippus, 158
Leonardo da Vinci, 7, 15, 38, 64, 67n, 92-93, 98, 103, 111, 114, 115n, 130-31, 133-37, 143, 145, 150, 163, 168, 179-80, 185, 201, 208, 210, 225, 239, 252-53

Macrobius, 37, 47n, 53
Malpiglio, Vincenzo, 12n
Mancini, Giulio, 163n, 234, 252
Maratta, Carlo, 108-109, 110n, 114, 181n, 182-83, 252
Marino, Giambattista, 6, 117-18, 120-24, 126-28, 158, 168, 174, 211, 234, 248, 273
Mariotelli, Fulvio, 87-88
Marracci, Giovanni, 20n, 268
Mascardi, Agostino, 118-20, 127, 142-43, 154, 158-61, 165-66, 169, 172
Massani, Giovanni Antonio, 13n, 17, 57-58, 63, 225, 252
Massimi, Camillo, Cardinal, 182-83
Mei, Girolamo, 139
Menghini, Niccolò, 37
Michelangelo Buonarroti, 51-52, 64, 66, 78, 101-102, 107, 115-16, 124, 147, 151-52, 173, 190, 200, 206-207, 209, 230, 257-59
Miel, Jan, 41, 104n, 105-109
Mignard, Nicolas, 57
Mignard, Pierre, 25, 39, 57
Milano, Francesco da, 75
Mola, Pier Francesco, 8, 15, 19n, 26, 59n
Montaigne, 161n
Monteverdi, Claudio, 154n
Myron, 158

Nola, Giovanni da, 190

Ovid, 163

Panofsky, Erwin, 7, 148-57, 160-62, 164, 167-68, 173-75
Paolini, Pietro, 12, 15n, 20n, 30
Pamphili collection, 52
Pamphilus, 106n
Panfili, family of painters, 106n
Paré, Ambroise, 159n
Parmigianino, 35, 126, 158, 208
Parrhasius, 115, 163, 236
Passignano, Domenico, 133
Paul III, Pope (Alessandro Farnese), 30n, 157n
Paul V, Pope (Camillo Borghese), 12
Peiresc, Nicolas-Claude Fabri de, 141n
Perino del Vaga, 206
Perrault, Charles, 173n
Perrier, François, 123, 126-27, Fig. 103
Perugino, Pietro, 99, 101-102, 200, 257-59
Petrarch, 27, 59, 65-67
Phidias, 154-56, 162, 164, 168
Philostratus the Elder, 99n, 161, 163, 165, 168, 170-71
Piericus, 168n
Pino, Paolo, 96, 101
Plato, 53, 61, 69, 81-82, 154-55, 162, 168, 174, 245, 273; *Alcibiades*, 120, 234, 248; *Gorgias*, 235-36; *Laws*, 236; *Phaedrus*, 71, 97-98, 109-110, 114, 117 236-38, 242-43, 246; *Republic*, 68, 237
Pliny, 165-66, 220, 258
Plutarch, 44, 61, 171
Polyclitus, 158
Polygnotus, 164
Pontormo, Jacopo, 125-26
Possevino, Antonio, 157n
Porpora, Paolo, 104
Porta, Guglielmo della, 180, 182
Poussin, Nicolas, 3-8, 13-15, 17-20, 24, 26, 29n, 36-40, 42-44, 46, 47n, 48n, 50n, 52, 55, 56n, 61-62, 67-68, 83, 95, 98-99, 102, 104, 108, 114, 118-20, 124-27, 130, 134-38, 140-47, 153-54, 156, 158, 165, 166n, 169-75, 179, 182-83, 201, 210, 222, 225, 251-52, 258, Figs. 106 and 108
Pozzo, Cassiano dal, 7-8, 13-16, 20n, 23-24, 26, 34, 38, 40-41, 52, 56, 116, 130, 134-35, 141n, 157, 185
Praxiteles, 146, 155, 164
Primaticcio, 47n
Proclus, 163n, 167
Protogenes, 100-101, 115, 164
Pythagoras, 191, 220

Quintilian, 102, 154n, 161, 164-65, 168

Raimondi, Francesco, 39, 41
Raphael, 13, 15n, 33, 57-58, 61, 64, 69, 73, 79, 81-83, 107, 123, 132, 135, 143, 147-48, 150, 152, 157-58, 160, 168, 173, 236, 252-54, 256-57, 261
Rembrandt, 35
Reni, Guido, 57-58, 108, 150, 152, 158-60, 168, 251-52
Riegl, Alois, 151n
Ripa, Cesare, 45, 48, 51, 67-70, 72, 74, 76, 80-82, 84n, 87-88, 90-91, 94, 100-101, 174, 192, 197, 211, 214, 217-18, 255, 262-63, 273, Figs. 96-99
Romanelli, Giovanni Francesco, 11n, 18
Romano, Giulio, 48n, 132, 143, 147, 153n, 173, 252-54, 258
Roomer, Gaspar, 106n
Rosa, Salvator, 8, 24n, 32, 98, 105, 106n, 125, 128, 175, Fig. 109
Roselli, Matteo, 31n, 137
Rubens, Peter Paul, 132, 253-54
Ruggieri, Giovanni Battista, 16

Sacchetti, Giulio, Cardinal, 12
Sacchetti, Marcello, 12
Sacchi, Andrea, 3-4, 11n, 19, 24, 25n, 43, 56, 58, 63, 101, 105n, 106-109, 110n, 112, 114, 117n, 119, 182, 252, 258
Salviati, Francesco, 190
Sale, Nicolas, 39
Sandrart, Joachim von, 13-14, 18, 53, *et passim*
Saraceni, Carlo, 59n
Scamozzi, Vincenzo, 81n
Scilla, Agostino, 181n
Segni, Bernardo, 73-75, 78, 82-83, 193, 197, 211, 220, 228-29, 240, 273. *See also* Aristotle
Sementi, Giovanni Giacomo, 16
Seneca, 61, 70-71, 114n, 163, 168
Siguenza, Fra José de, 105n
Simonelli, Nicolò, 25
Sixtus V, Pope (Felice Peretti), 159n
Spada, Cardinal Bernardino, 41
Stigliani, Tommaso, 118, 120, 122, 211
Strabo, 163
Strada, Famiano, 157, 161n
Swanevelt, Herman van, 25

Tagliacozzi, Gaspare, 159n
Tassi, Agostino, 117
Tasso Torquato, 11, 12n, 104, 108-109, 117-18, 121-22, 142n, 153-56, 158, 161-62, 166-68, 172, 174, 211, 245
Tassoni, Alessandro, 108-109, 115n, 173
Testa, Fulvio, 154n
Testa, Giovanni Cesare, 39, 123, 125, 182-83, 228, 263-64, 270, Fig. 105

Testa, Pietro: death, 4, 11, 64, 175, *et passim*; life and career, 11-64

DRAWINGS BY LOCATION, Berlin-Dahlem, Staatliche Museen Preussischer Kulturbesitz, (Fig. 48) 43; Calenzano, collection of Loriano Bertini, (Fig. 35) 40, 43, 46, 259; (Fig. 36) 40n; Cambridge, Mass., Fogg Art Museum, (Fig. 43) 43-44; Chatsworth, collection of the Duke of Devonshire, 19n; (Fig. 74) 59-60; Edinburgh, National Gallery of Scotland, 221, 268; (Fig. 101) 90; (Fig. 119) 268; Florence, Gabinetto dei Disegni, Gallerie degli Uffizi, 82n; (Fig. 21) 34; (Fig. 24) 34; (Fig. 44) 43; (Fig. 50) 43-44; (Figs. 62 and 63) 52; (Fig. 68) 56; (Fig. 92) 73; (Fig. 112) 259; (Fig. 115) 262-63; Frankfurt, Städelsches Kunstinstitut, 45n; Haarlem, Teylers Stichting, 41n; (Fig. 14) 33, 198; (Fig. 51) 43; (Fig. 72) 59; London, British Museum, (Fig. 10) 28-29; (Fig. 15) 33; (Fig. 47) 43-44, 197-98; (Fig. 100) 89-90; (Fig. 113) 260-62; London, The Victoria and Albert Museum, (Fig. 45) 43; Madrid, Academia di S. Fernando, 270; Milan, Stanza del Borgo, (Fig. 116) 262; Munich, Staatliche Graphische Sammlung, 267; New York, Metropolitan Museum of Art, 60n; (Fig. 32) 39; (Fig. 37) 40; (Fig. 39) 41; New York, The Pierpont Morgan Library, (Fig. 49) 43-44, 197; (Fig. 66) 53; Oxford, Ashmolean Museum, (Fig. 4) 21-22; (Fig. 8) 27-28, 67; (Fig. 33) 39; Paris, Cabinet des Dessins, Musée du Louvre, (Fig. 5) 21-22; (Fig. 9) 28; (Fig. 17) 34; (Fig. 39) 44; (Fig. 40) 42; (Fig. 82) 62; (Fig. 91) 33, 73, 93; (Fig. 93) 75; Rome, collection of Henry, Prince of Hesse, (Fig. 30) 38-39; Stuttgart, Graphischen Sammlungen der Staatsgalerie, (Fig. 118) 267; Stockholm, Nationalmuseum, 75n; (Fig. 11) 28-29; (Fig. 52) 43; (Fig. 59) 46; Vienna, Graphische Sammlung Albertina, 263; (Fig. 114) 262; Weimar, Staatliche Kunstsammlungen im Schlossmuseum, (Fig. 7) 27; Windsor, Royal Library, 42n; (Fig. 38) 41, 44; (Fig. 70) 56. *See also* Düsseldorf Notebook

PAINTINGS BY LOCATION: Cologne, Wallraf-Richartz Museum (formerly), 60-61; Edinburgh, National Gallery of Scotland, (Fig. 29) 38, 40, 191, 218-19, 266; Florence, Opere publiche, (Fig. 75) 60; Leningrad, Hermitage, (Fig. 34) 31-32, 40-41; Lucca, Palazzo degli Anziani, Cortile degli Svizzeri (formerly), 20-23, 54; S. Paolino, (Fig. 73) 59-61, 129; S. Romano, (Fig. 12) 30-32, 35, 38, 40, 60; Oxford, Ashmolean Museum, (Fig. 78) 60, 61n; Potsdam-Sanssouci, Bildegalerie, 26; Rome, Galleria Spada, (Fig. 28) 35-36, 40-41, 43; (Fig. 76) 41, 60; Pinacoteca Capitolina (rejected attribution), 19; S. Maria dell'Anima (destroyed), 41-42, 44, 55; S. Martino ai Monti, (Fig. 71) 40, 59, 260; uncom-

pleted project for apse, 61, 109, 117, 260-64, *see also* Düsseldorf Notebook **65** and **66**; Naples, Capodimonte, (Fig. 77) 60-61; Vienna, Gemäldegalerie der Akademie der bildenden Künste, (Fig. 27) 35-37, 44-45, 60

PRINTS ACCORDING TO SUBJECT: *Achilles* series (Figs. 81 and 83), 45, 62-64, 174; *Adoration of the Magi* (Fig. 41), 24n, 43, 109n, 189; *Allegory of the Flight into Egypt* (Fig. 26), 34, 36, 38, 262; *Allegory in Honor of the Arrival of Cardinal Franciotti as Bishop of Lucca* (Fig. 6), 26-30, 32, 35-36, 54, 215; *Allegory in Honor of Innocent X* (Fig. 67), 39n, 56, 145; *Allegory of Painting* (Fig. 13), 26-27, 32-33, 38, 43-45, 89n, 103, 110; *Altro diletto ch'imparar non trovo* (Fig. 88), 28, 58-59, 62, 65-68, 96, 154, 174; *Autumn* (Fig. 57), 46-47, *see also Seasons*; *Death of Cato* (Fig. 59), 61-64, 119, 128, 134, 174, 264; *Death of Sinorix* (Fig. 46), 43-44, 197-98; *Elephant* (Fig. 1), 13-14; *Garden of Love* (Figs. 18 and 19), 18n, 33-34; *Garden of Venus* (Figs. 20 and 25), 34, 59; *Il Liceo della Pittura* (Fig. 89), 6, 25, 33, 41-45, 51n, 52, 68-97, 100, 109, 112, 129, 135, 152, 155, 173, 182n, 189, 217-18, 228, 256; *Martyrdom of St. Erasmus* (Fig. 2), 19-20, 24n, 34, 64; *Prodigal Son* series (Figs. 84-87), 62-63, 174; *Sacrifice of Iphigenia* (Fig. 42), 43-44; *Saint Jerome in the Wilderness* (Fig. 16), 33-34; *Saints Interceding with the Virgin on Behalf of Victims of the Plague* (Fig. 3), 20; *Seasons* (Figs. 55-58), 46-55, *see also* individual titles; *Spring* (Fig. 55), 46-47; *Summer* (Fig. 56), 46-51, 54, 58, 106; *Symposium* (Fig. 80), 61; *Triumph of Painting* (Fig. 54), 41, 43n, 45-46, 54, 56, 97, 128, 145; *Venus and Adonis* (Fig. 22), 34, 37, 42, 44-45, 52; *Venus giving Arms to Aeneas* (Fig. 53), 44, 198, 228, 268-69; *Winter* (Fig. 58), 41, 46-48, 50-51, 54, 58, 105-106, 152, 175; *Young Artist Arriving on Parnassus* (Fig. 69), 56, 58, 99, 113, 255

Theocritus, 242

Timanthes, 258

Titian, 36-37, 132, 135, 137, 147, 152, 158, 160, 173, 208, 253-54

Tortebat, François, 25n

Uccello, Paolo, 101

Urban VIII, Pope (Maffeo Barberini), 12, 30, 31n, 39, 40n, 41n, 43, 56, 119, 154n, 157-58, 160, 151n

Valentin de Boulogne, 22, 79n

Valle, Pietro della, 14, 141n

Van Cleve, Joos, 105n

Van der Weyden, 105n

Van Laer (Il Bamboccio), 25, 64, 104, 106n, 107n, 108, 168

Vanni, Francesco, 32
Varchi, Benedetto, 66n, 77-78, 81, 84-85, 98, 174
Vasari, Giorgio, 52, 99, 101, 125-26, 149, 210, 213, 258
Vianeo family, 159n
Virgil, 44, 104, 108, 111, 118, 144, 153, 211, 214, 227, 242, 245, 258, 268-69
Vitruvius, 17, 38, 66-67, 88-89, 93, 98, 100, 102-103, 116-17, 140, 191, 236, 243, 247, 257. *See also* Barbaro
Vittoria, Vincenzo, 181n, 182

Wadding, Luke, 39
Winckelmann, Johann Joachim, 151

Witelo, 131, 219
Wölfflin, Heinrich, 6
Wyngaerde, Frans van den, 35n

Xenophon, 43, 61, 128, 163, 168, 174, 235-36, 273

Zacchia il Vecchio, 23
Zarlino, Gioseffo, 85-86, 140-43
Zaccolini, Matteo, 130, 135-36, 144, 222, 225
Zeuxis, 107, 115, 153, 158, 235
Zuccaro, Federigo, 49-52, 149, 152, 155-56, 163-64, 172, 174, 210, 213
Zurbarán, Francisco, 31n

Illustrations

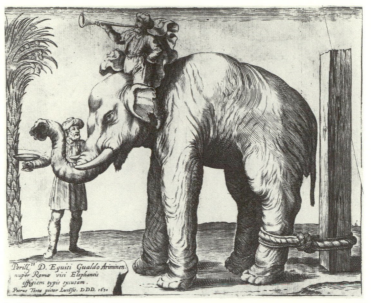

1. *Elephant*, Bellini 41.

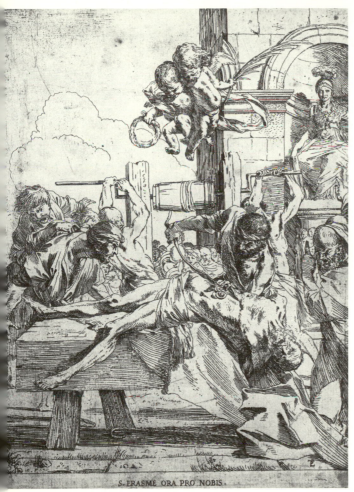

S·ERASME·ORA·PRO·NOBIS·

The Martyrdom of Saint Erasmus, Bartsch 14; Bellini 7

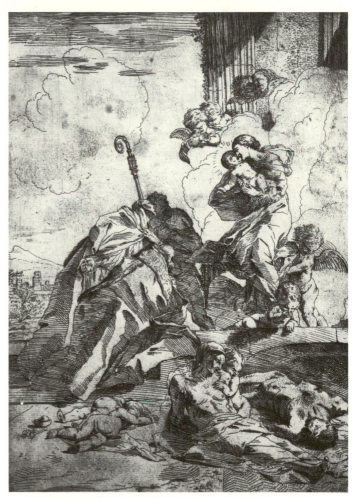

3. *Saints Interceding with the Virgin for the Victims of the Plague*, Bartsch 13, Bellini 8

4. Study for the fresco of Liberty, Ashmolean Museum, Oxford

5. Study of Justice, Cabinet des Dessins, Musée du Louvre, Paris

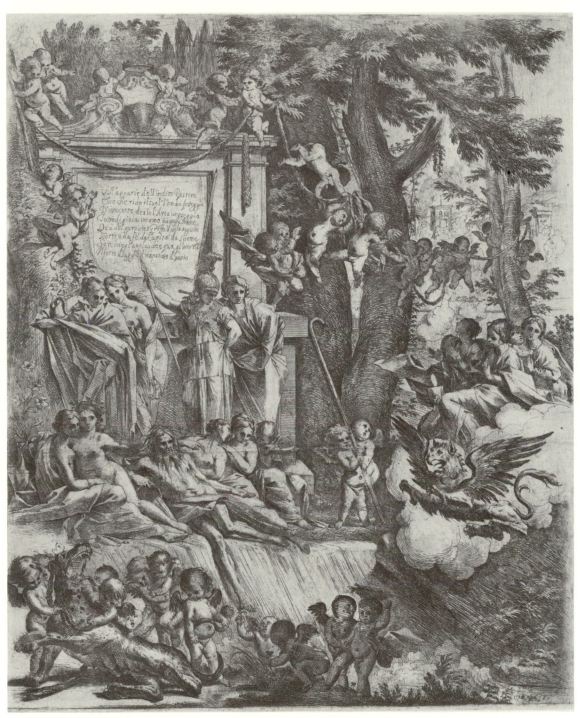

6. *Allegory in Honor of the Arrival of Cardinal Franciotti as Bishop of Lucca*, collection of A. Percy, Philadelphia

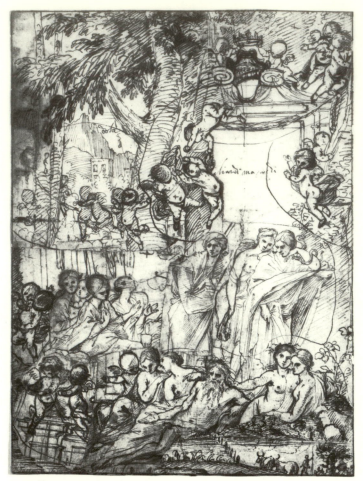

7. Collage of studies for *Allegory in Honor of the Arrival of Cardinal Franciotti as Bishop of Lucca*, Staatliche Kunstsammlungen im Schlossmuseum, Weimar, DDR

8. Study of *The Triumph of Honest Pleasure*, Ashmolean Museum, Oxford

Study of *Venus Submitting to the River Serchio*, Cabinet des Dessins, Musée du Louvre, Paris

10. Study of *Venus Submitting to the River Serchio*, British Museum, London

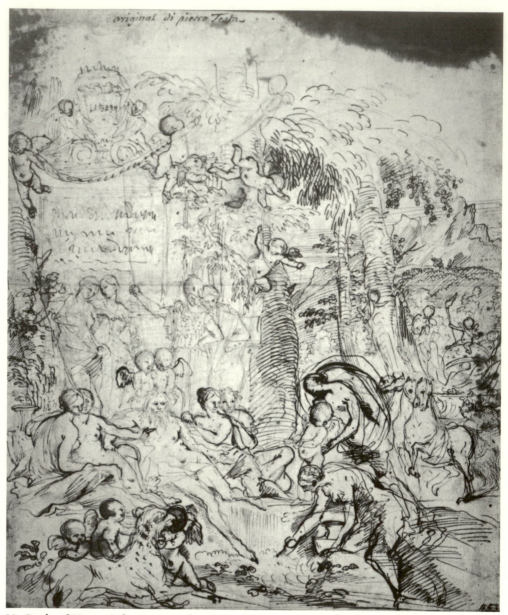

11. Study of *Venus Submitting to the River Serchio*, Nationalmuseum, Stockholm

12. *The Vision of St. Dominic of Soriano*, S. Romano, Lucca

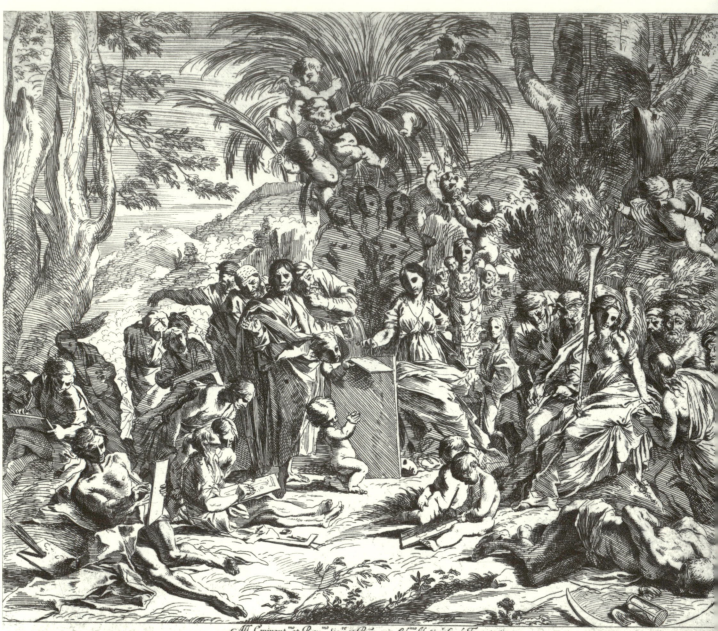

All Eminent.^{mo} et Reu.^{mo} Sig.^{re} et Pron mio Col^{mo} Il Sig. Card. Franciotti

Diuotiss.^{me} e l'osseouio mio uerso V. Em. ma tanto abbandonato dalle forze, che non' troua modo da comparire. Compensero il difetto della fortuna, con l'ingegno dell'arte, e ch mando la Pittura co suoi seguaci, otterrò forse, che riceua trà l'ombre sue un debil lume almeno del mio synceriss. affetto, e co suoi colori riduca, come si può sotto gli oce di V. Em. una forma di sua natura inuisibile, cioè l'animo mio colmo di riuerenza, e di fede. Di V. Em. diuotiss.^{me} seruitore Pietro Testa

Gio. Iac. Rossi le stampa alla Pace

13. *Allegory of Painting*, Bartsch 29, Bellini 15

14. Figure Studies, Teylers Stichting, Haarlem

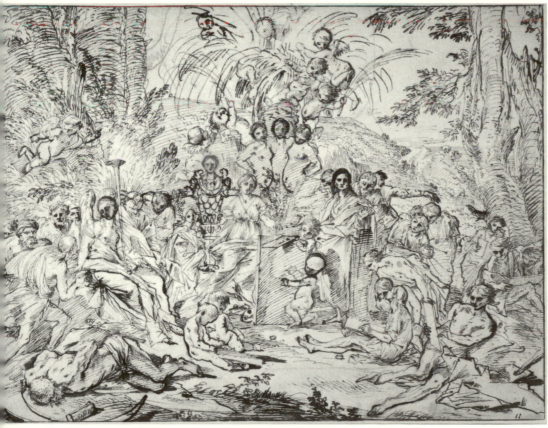

5. Study for the *Allegory of Painting*, British Museum, London

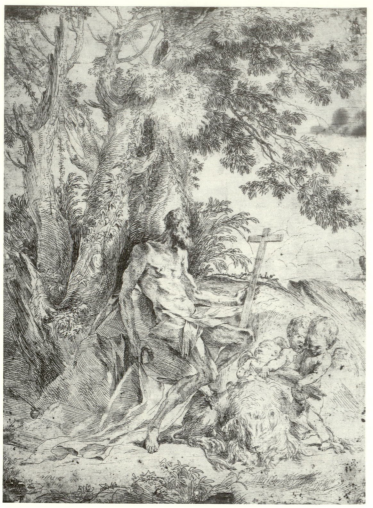

16. *St. Jerome in the Wilderness*, Bartsch 15, Bellini 9

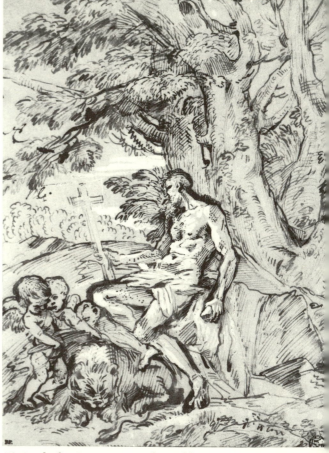

17. Study for *St. Jerome in the Wilderness*, Cabinet des Dessins, Musée du Louvre, Paris

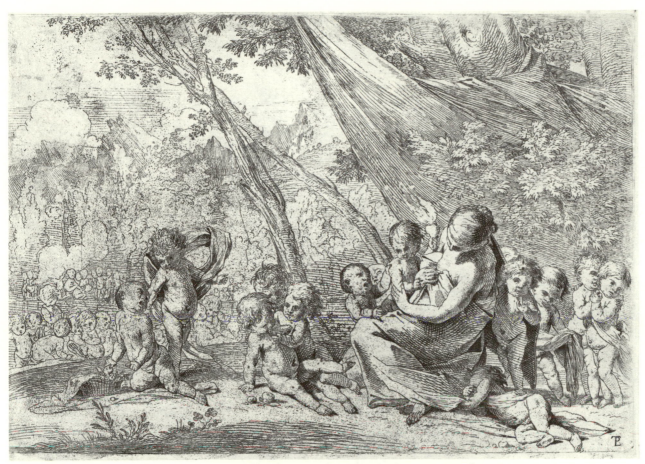

18. *The Garden of Love* (horizontal version), The Metropolitan Museum of Art, New York

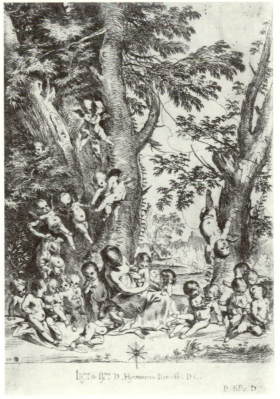

19. *The Garden of Love* (vertical version), Bartsch 28, Bellini 11

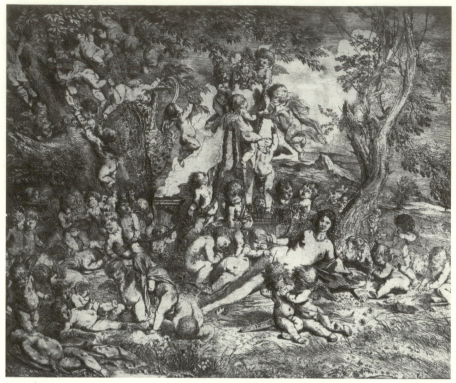

20. *The Garden of Venus*, Bartsch 26, Bellini 12

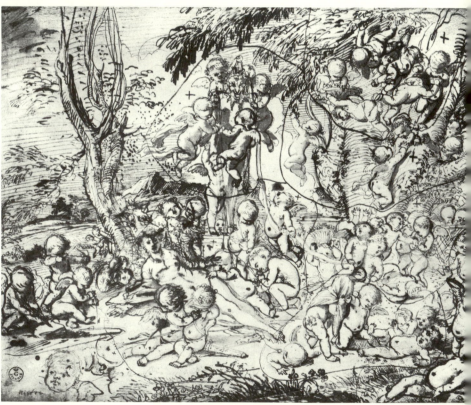

21. Study for *The Garden of Venus*, Gabinetto dei Disegni, Gallerie degli Uffizi, Florenc

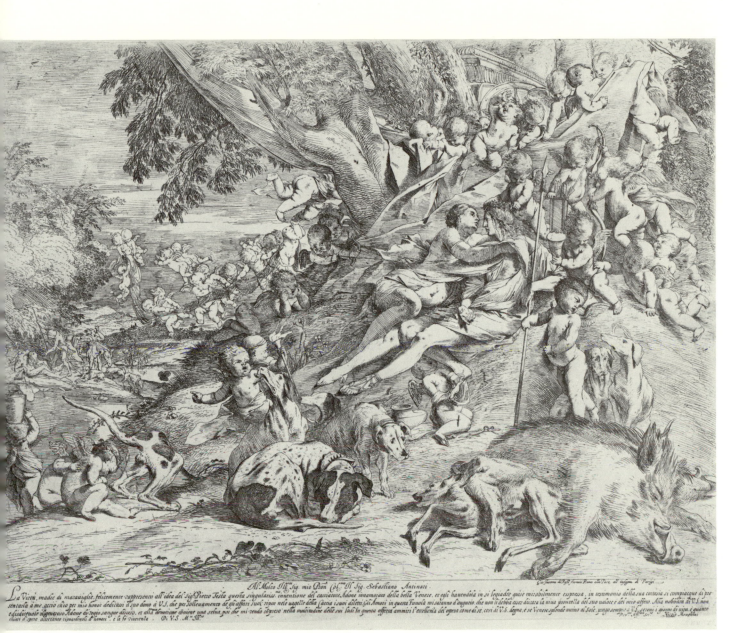

2. *Venus and Adonis*, The Metropolitan Museum of Art, New York

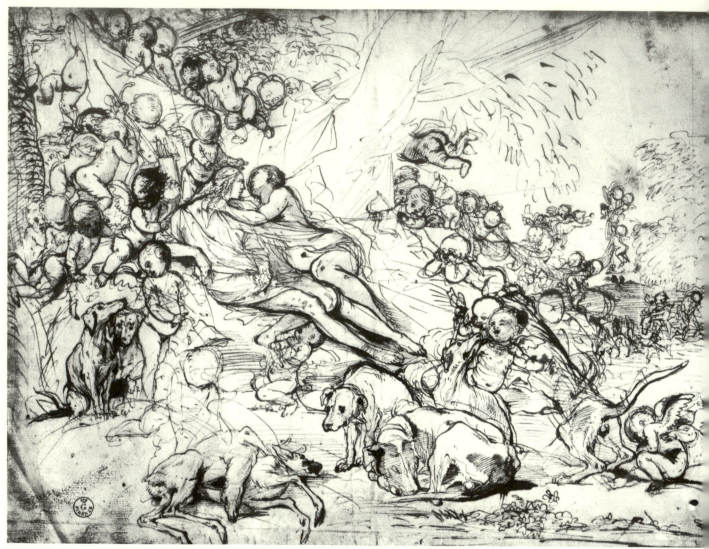

23. Study for *Venus and Adonis*, Gabinetto dei Disegni, Gallerie degli Uffizi, Florence

24. Fragment of study for *Venus and Adonis*, Gabinetto dei Disegni, Gallerie degli Uffizi, Florence

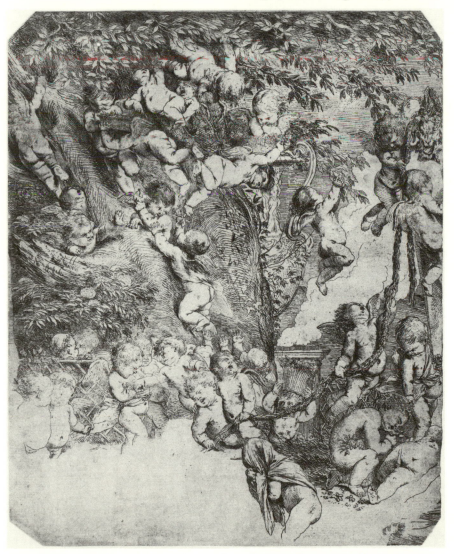

25. Artist's proof of a section of *The Garden of Venus*, The Metropolitan Museum of Art, New York

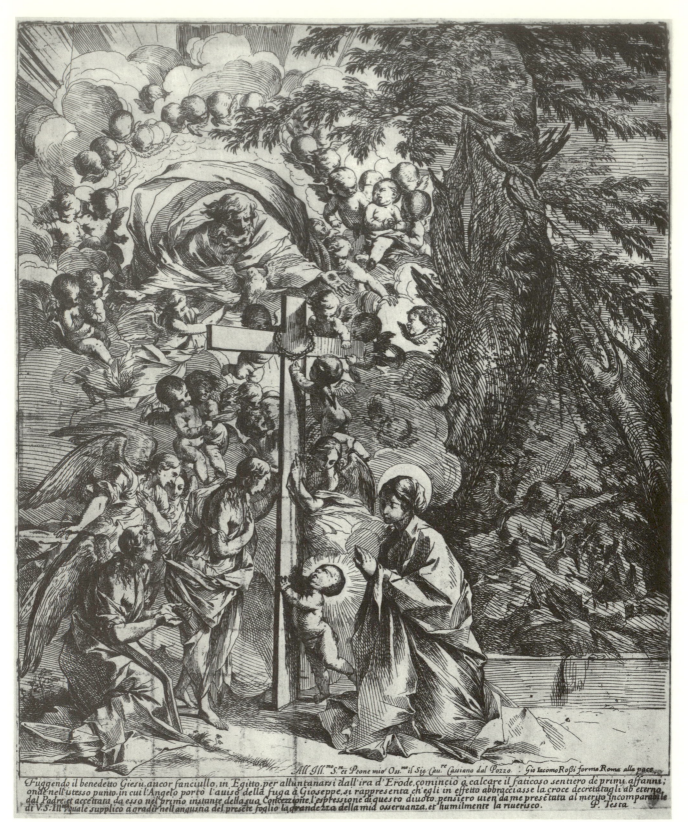

All. Ill.mo S.re et Prone mio Oss.mo il Sig. Caü.re Cassiano dal Pozzo. Gio Iacomo Roßi forma Roma alla pace

Fuggendo il benedetto Giesù, ancor fanciullo, in Egitto, per allontanarsi dall'ira d'Erode, cominciò à calcare il faticoso sentiero de primi affanni;
onde nell'utesso punto, in cui l'Angelo portò l'auiso della fuga à Gioseppe, si rappresenta ch'egli in effetto abbracciasse la croce decretatagli ab eterno,
dal Padre, et accettata da esso nel primo instante della sua Concezzione; l'espressione di questo diuoto pensiero uien da me presétata al merito incomparabile
di V.S. Ill.re quale supplico à gradir nell'anguina del presete foglio la grandezza della mia osseruanza, et humilmente la riuerisco. P. Testa

26. *Allegory of the Flight into Egypt*, Bartsch 4, Bellini 10

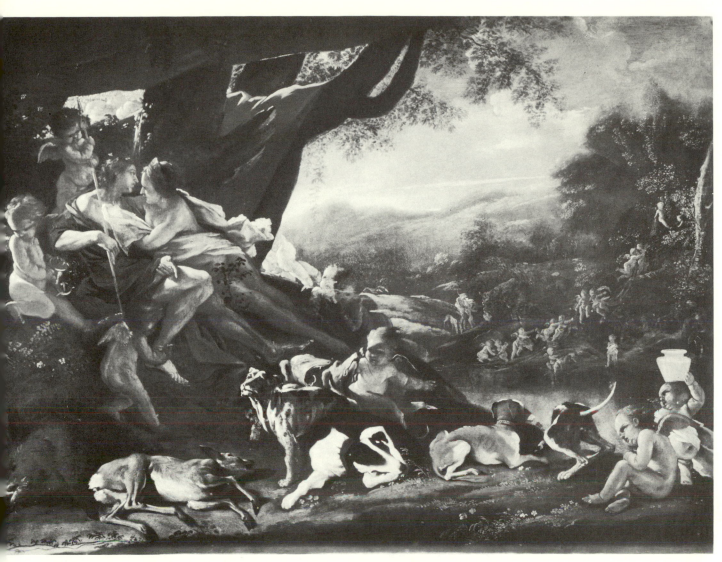

Venus and Adonis, Gemäldegalerie der Akademie der bildenden Künste, Vienna

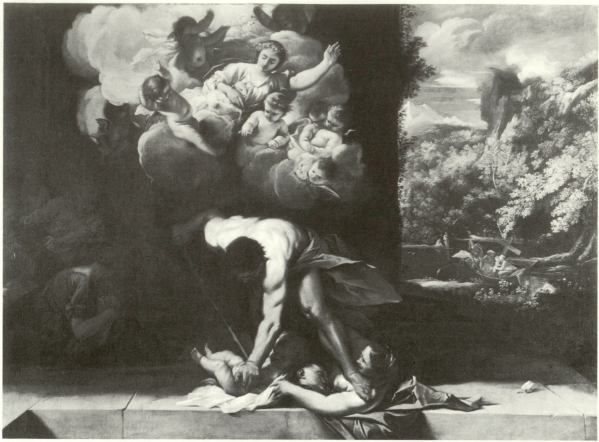

28. *The Massacre of the Innocents*, Galleria Spada, Rome

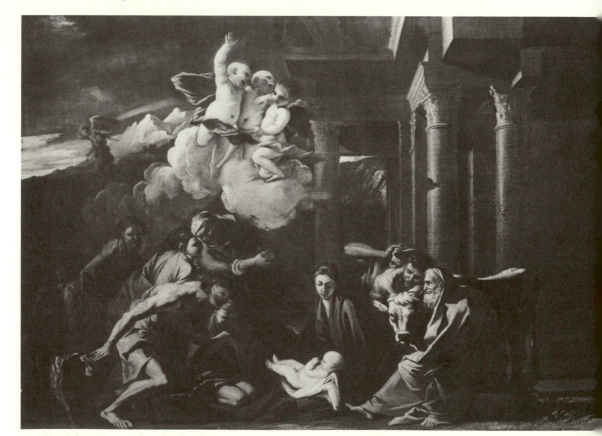

29. *The Adoration of the Shepherds*, National Gallery of Scotland, Edinburgh

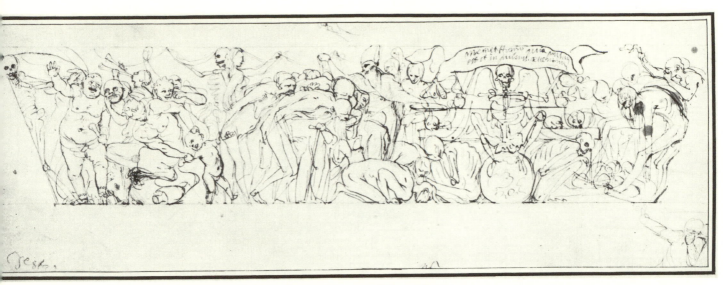

. Study for *Allegory of Carnival and Lent*, collection of Henry, Prince of Hesse, Rome

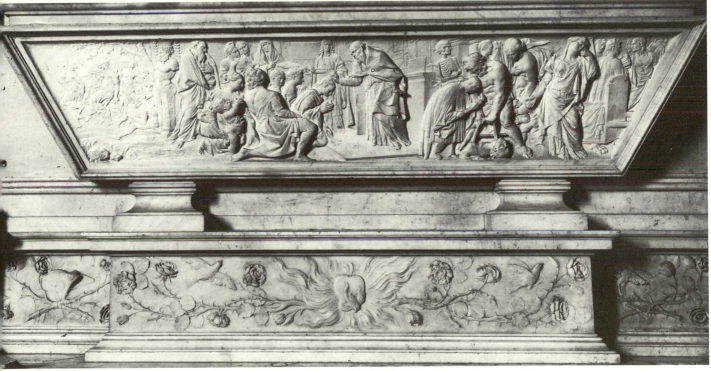

. Nicolas Sale (?), relief of *Allegory of Carnival and Lent*, Raimondi Chapel, S. Pietro in Montorio, Rome

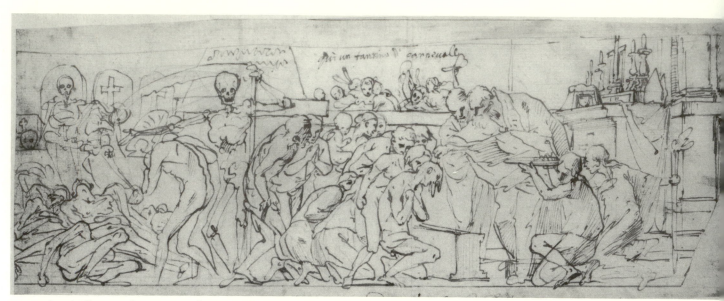

32. Study of *Allegory of Penance and Death*, The Metropolitan Museum of Art, New York

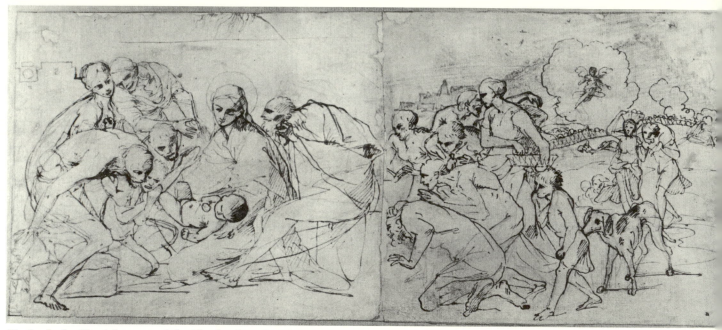

33. Study for *The Adoration of the Shepherds*, Ashmolean Museum, Oxford

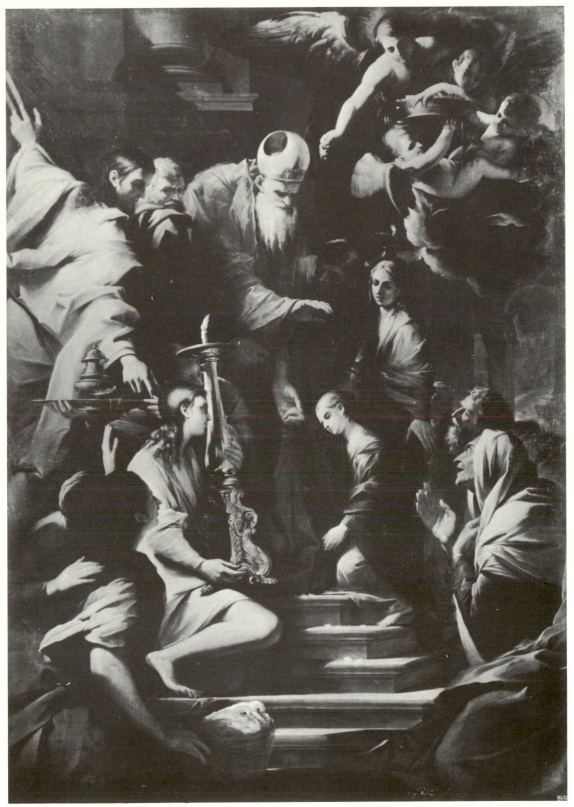

34. *The Presentation of the Virgin*, Hermitage, Leningrad

35. Study of *The Consecration of the Church*, collection of Loriano Bertini, Calenzano

36. Study of *The Confiscation of Spoils by the Church*, collection of Loriano Bertini, Calenzano

37. Study for *The Presentation of the Virgin*, The Metropolitan Museum of Art, New York

38. Study for *The Apotheosis of St. Lambert*, Royal Library, Windsor Castle

39. Study for *The Apotheosis of St. Lambert*, Cabinet des Dessins, Musée du Louvre, Paris

40. Study of *Fame Conquering Time and Envy*, Cabinet d Dessins, Musée du Louvre, Paris

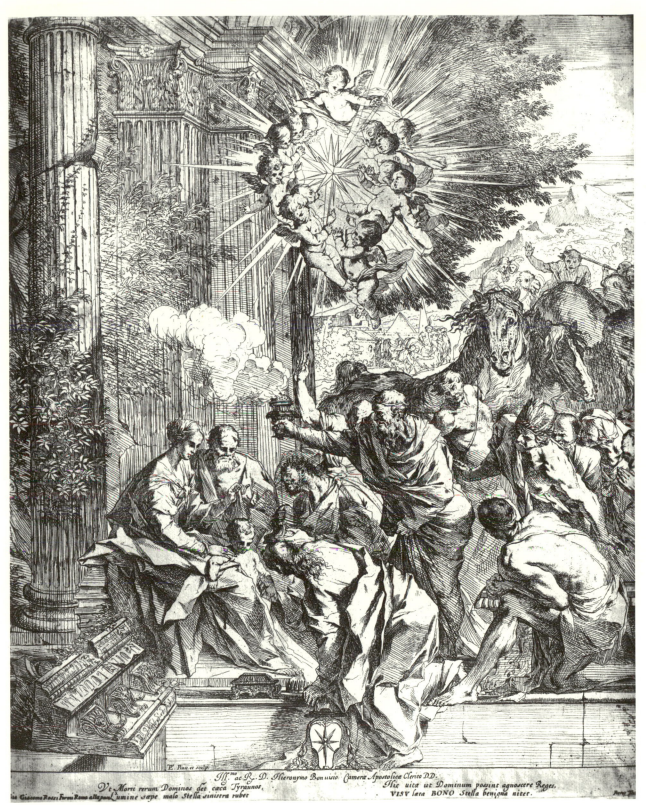

41. *The Adoration of the Magi*, Bartsch 3, Bellini 16

42. *The Sacrifice of Iphigenia*, Bartsch 23, Bellini 18

43. Study for *The Sacrifice of Iphigenia*, Fogg Art Museum, Harvard University, Cambridge, Mass.

44. Study for *The Sacrifice of Iphigenia*, Gabinetto dei Disegni, Gallerie degli Uffizi, Florence

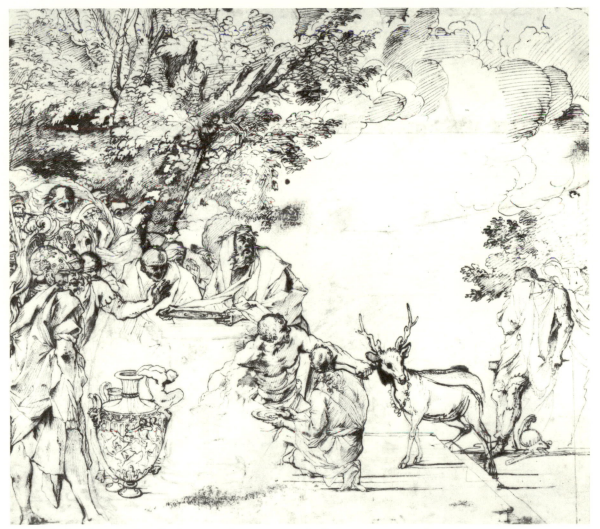

45. Study for *The Sacrifice of Iphigenia*, The Victoria and Albert Museum, London

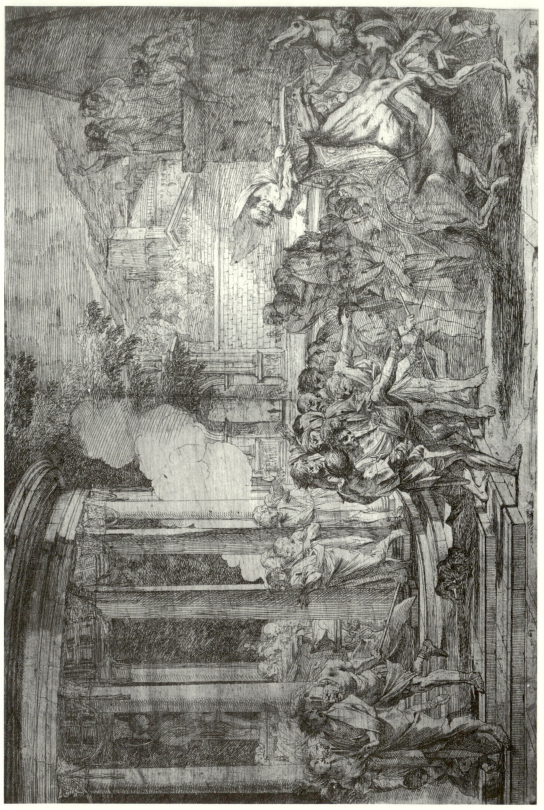

46. *The Death of Sinorix*, Bartsch 19, Bellini 19

48. Study for *The Death of Sinorix*, Staatliche Museen Preussischer
Kulturbesitz, Berlin-Dahlem

47. Study for *The Death of Sinorix*, British Museum, London

49. Study for *The Death of Sinorix*, The Pierpont Morgan Library, New York

50. Study for *The Death of Sinorix*, Gabinetto dei Disegni, Gallerie degli Uffizi, Florence

51. Study for *The Death of Sinorix*, Teylers Stichting, Haarlem

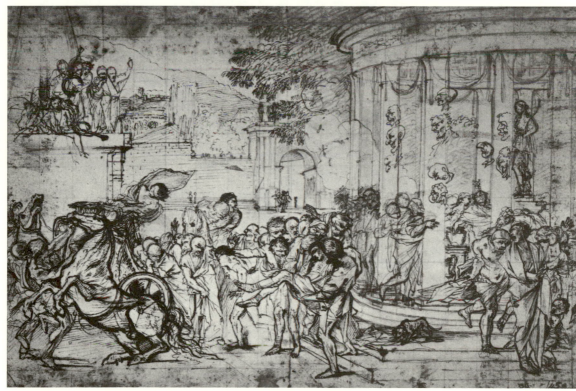

52. Study for *The Death of Sinorix*, Nationalmuseum, Stockholm

53. *Venus Giving Arms to Aeneas*, Bartsch 24, Bellini 17

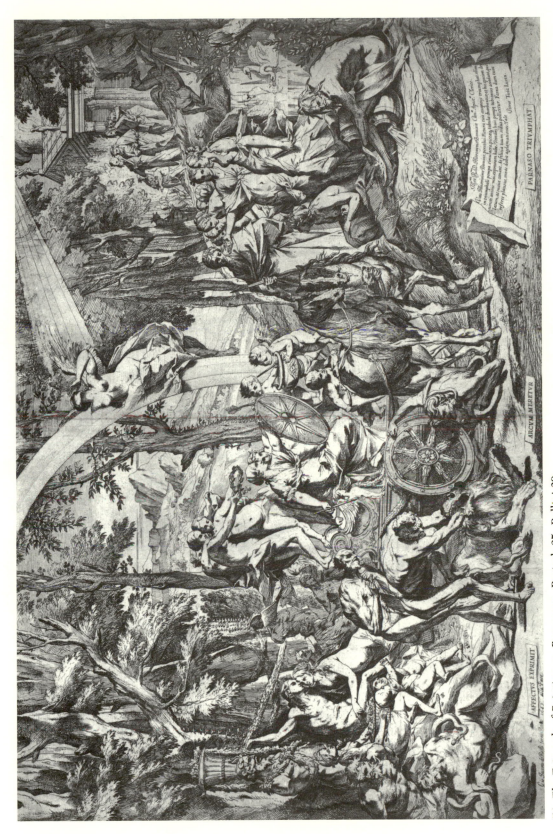

54. *The Triumph of Painting on Parnassus*, Bartsch 35, Bellini 29

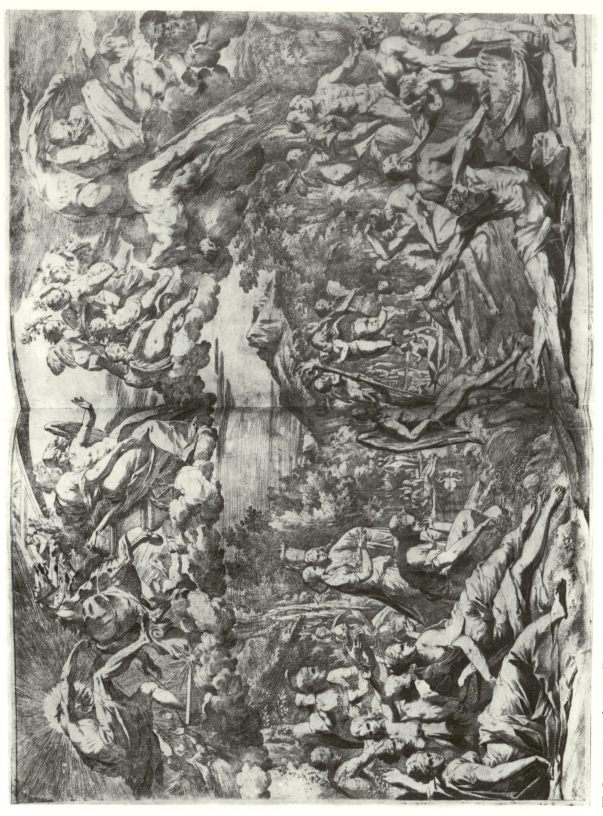

55. *Spring*, Bartsch 36, Bellini 30

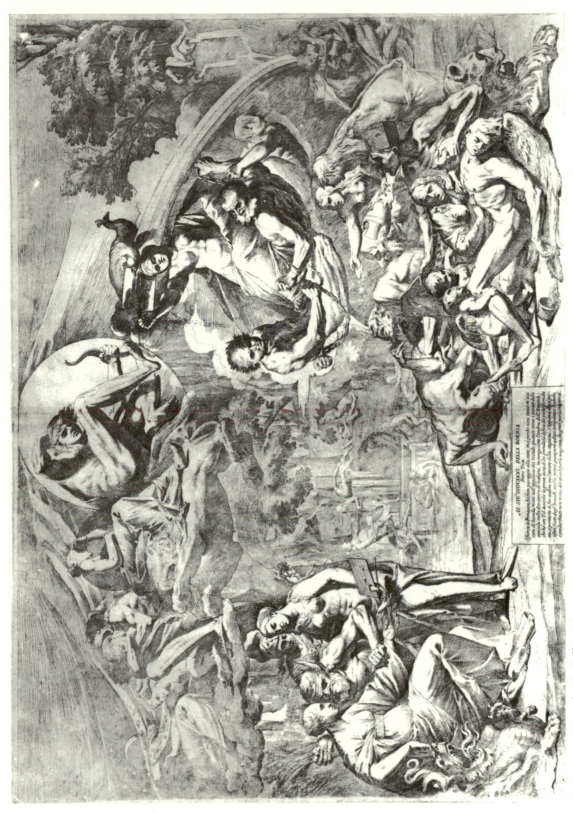

56. *Summer*, Bartsch 37, Bellini 31

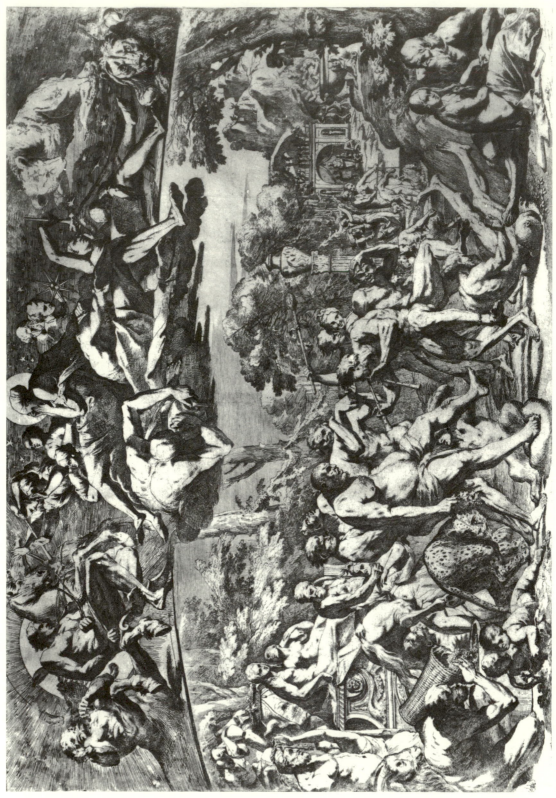

57. *Autumn*, Bartsch 38, Bellini 32

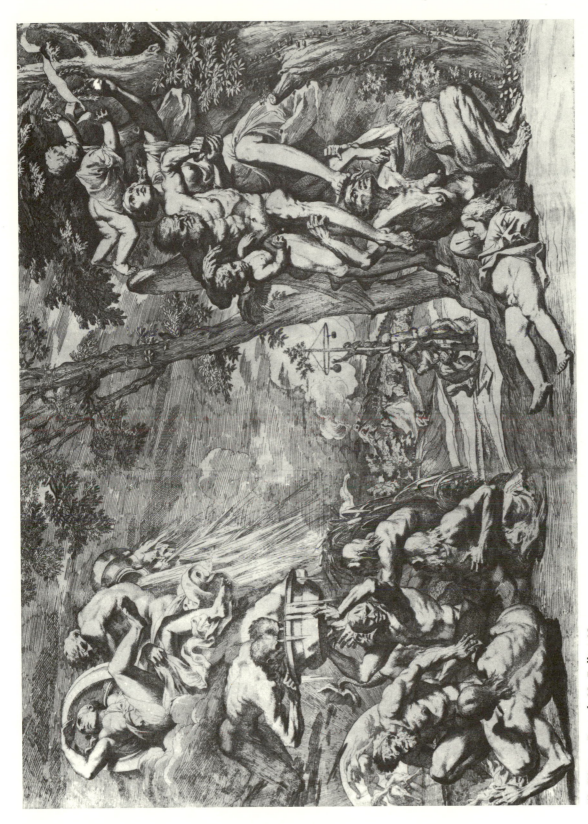

58. *Winter*, Bartsch 39, Bellini 28

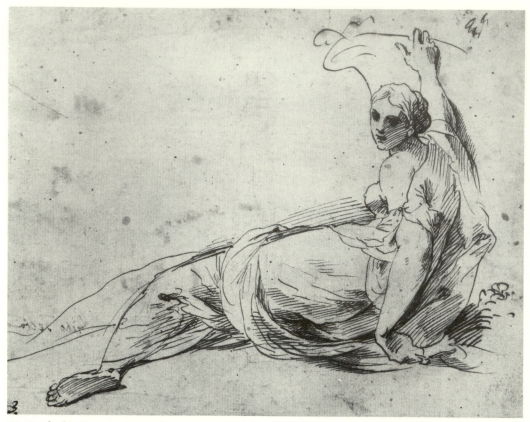

59. Study for *Spring*, Staatsgalerie, Stuttgart

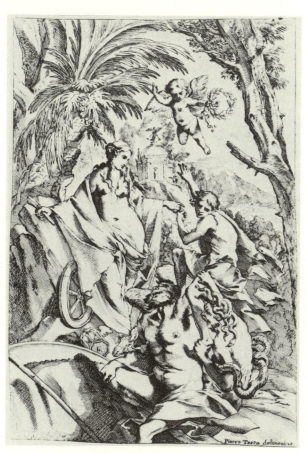

60. F. Collignon, after Pietro Testa, *Virtute Duce Comite Fortuna*

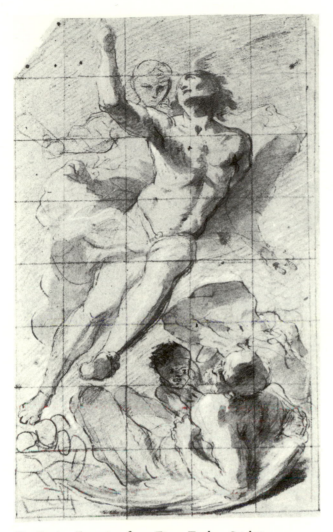

62. Drawing after Prometheus Sarcophagus, Gabinetto dei Disegni, Gallerie degli Uffizi, Florence

61. *Genius Escaping from Time*, Teylers Stichting, Haarlem

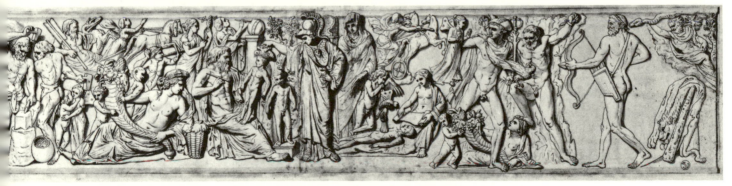

Drawing after Prometheus Sarcophagus, Gabinetto dei Disegni, Gallerie degli Uffizi, Florence

64. P. S. Bartoli, Prometheus Sarcophagus, from *Admiranda romanarum antiquitatum*, Rome, 1691

65. P. S. Bartoli, Prometheus Sarcophagus, from *Admiranda romanarum antiquitatum*, Rome, 1691

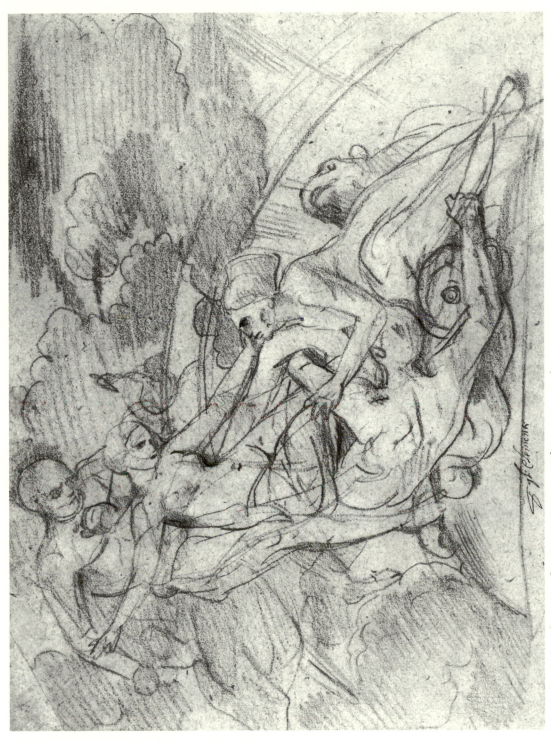

66. Study of *The Elements*, The Pierpont Morgan Library, New York

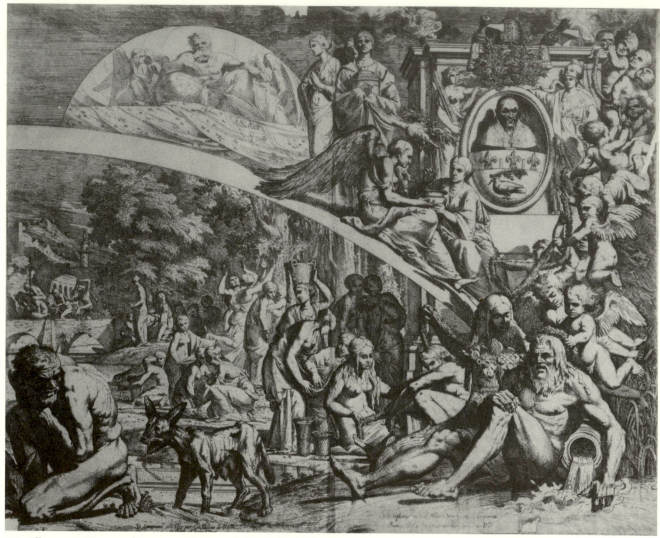

67. *Allegory in Honor of Innocent X*, Bartsch 31, Bellini 25

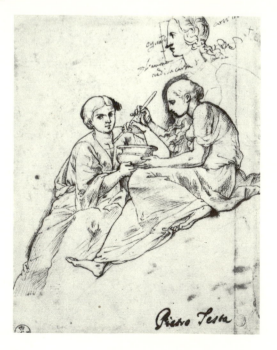

68. Study of Iris and Peace for the
Allegory in Honor of Innocent X,
Gabinetto dei Disegni, Gallerie degli
Uffizi, Florence

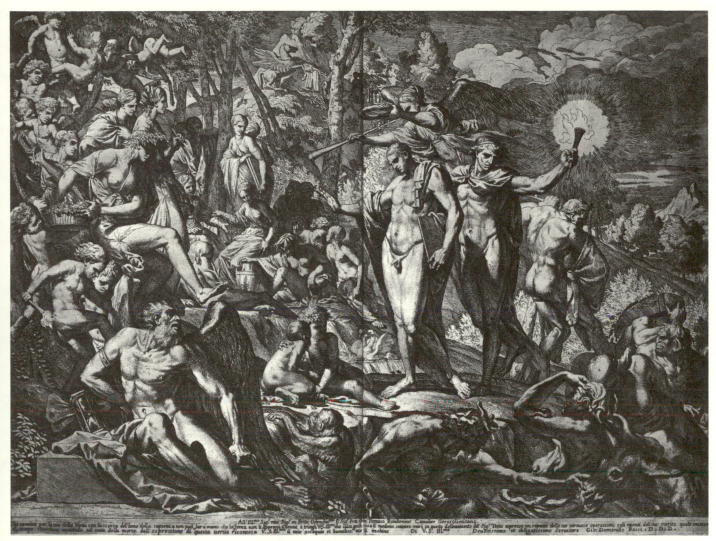

69. *The Young Artist Arriving on Parnassus*, Bartsch 33, Bellini 33

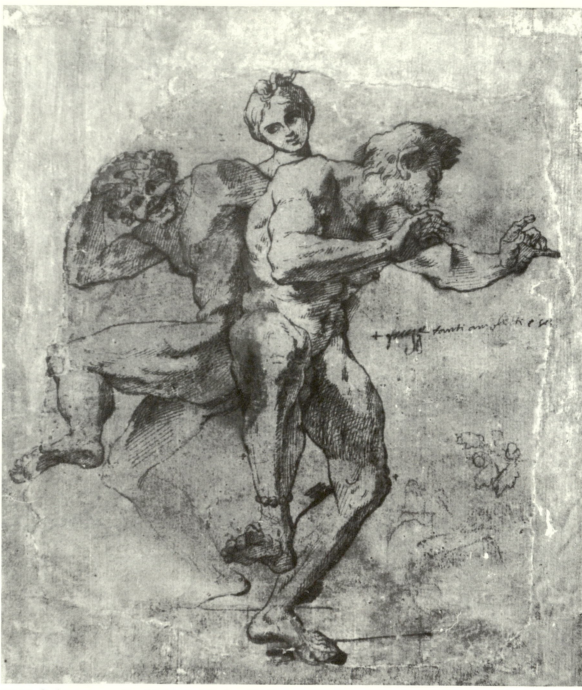

70. Study for *Autumn*, Royal Library, Windsor Castle

71. *The Vision of S. Angelo Carmelitano*, S. Martino ai Monti, Rome

72. Study for *The Vision of S. Angelo Carmelitano*, Teylers Stichting, Haarlem

73. *The Miracle of St. Theodore*, S. Paolino, Lucca

74. Study for *The Miracle of St. Theodore*, Collection of the Duke of Devonshire

75. *Galatea*, Soprintendenza ai Monumenti e Gallerie per le Provincie di Pisa, Livorno, Lucca e Massa Carrara

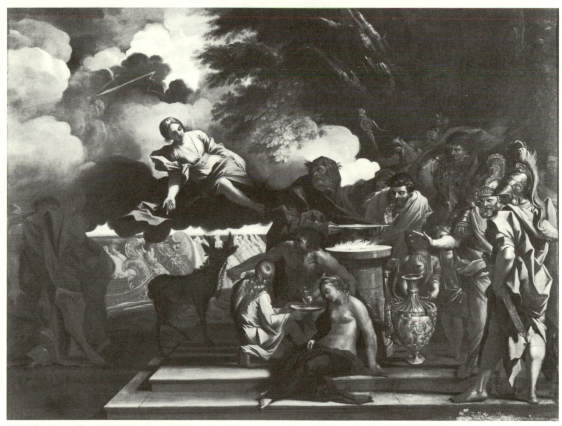

76. *The Sacrifice of Iphigenia*, Galleria Spada, Rome

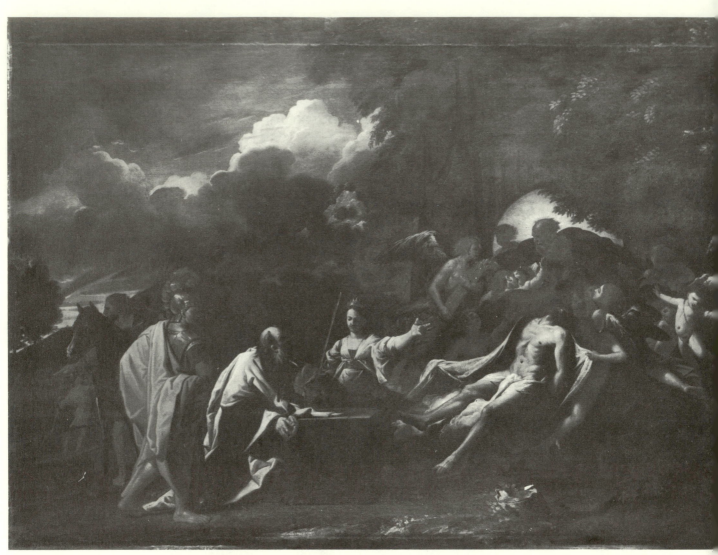

77. *The Prophecy of Basilides*, Museo di Capodimonte, Naples

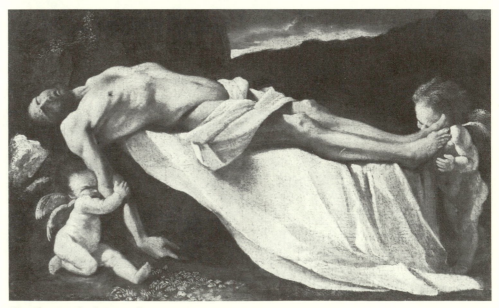

78. *The Dead Christ*, Ashmolean Museum, Oxford

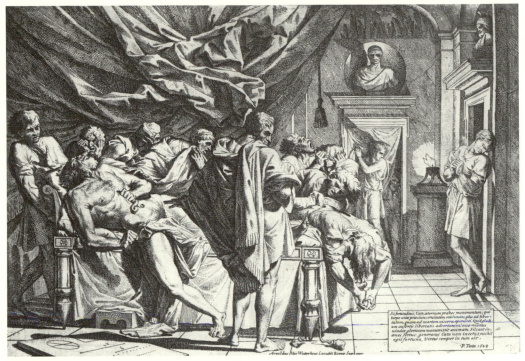

79. *The Death of Cato*, Bartsch 20, Bellini 39

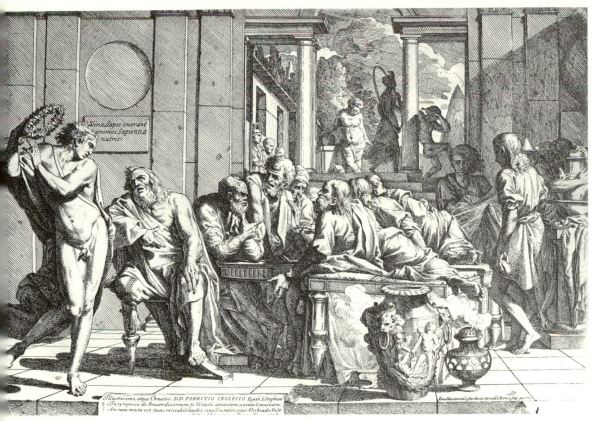

). *The Symposium*, Bartsch 18, Bellini 38

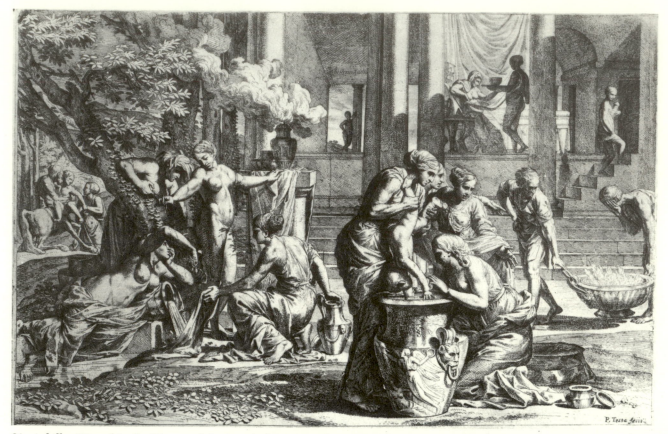

81. *Achilles Dipped in the Waters of the Styx and Consigned to Chiron*, Bartsch 21, Bellini 36

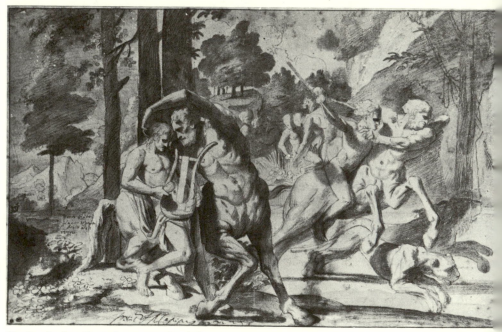

82. Study for *The Education of Achilles*, Cabinet des Dessins, Musée du Louvre, Paris

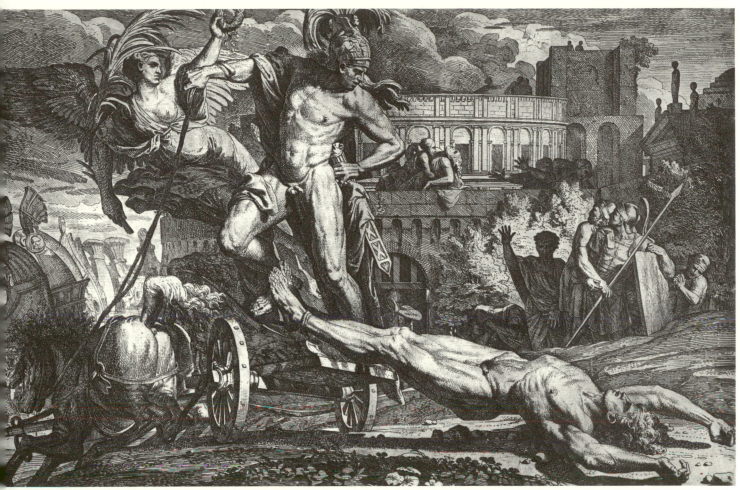

Achilles Dragging the Body of Hector, Bartsch 22, Bellini 37

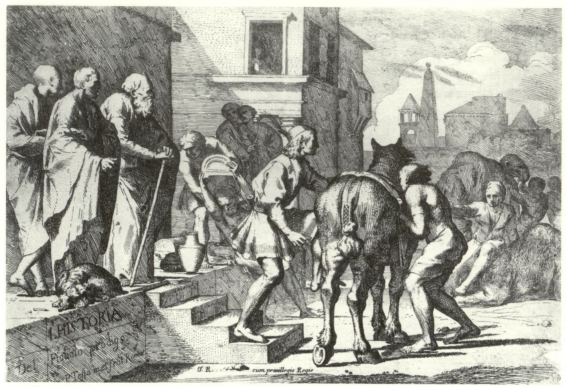

84. *The Prodigal Son: Departure*, Bartsch 5, Bellini 21

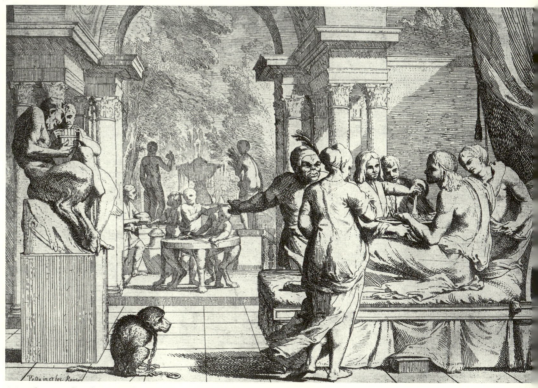

85. *The Prodigal Son: The Wasting of his Substance*, Bartsch 6, Bellini 22

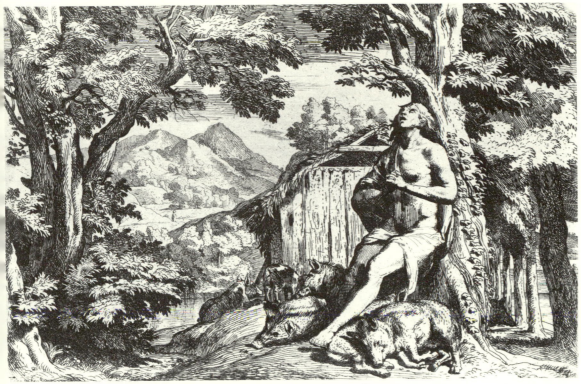

86. *The Prodigal Son: The Prodigal among the Swine*, Bartsch 7, Bellini 23

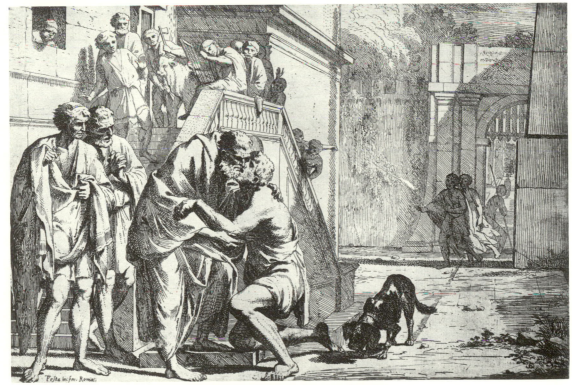

87. *The Prodigal Son: The Return of the Prodigal*, Bartsch 8, Bellini 24

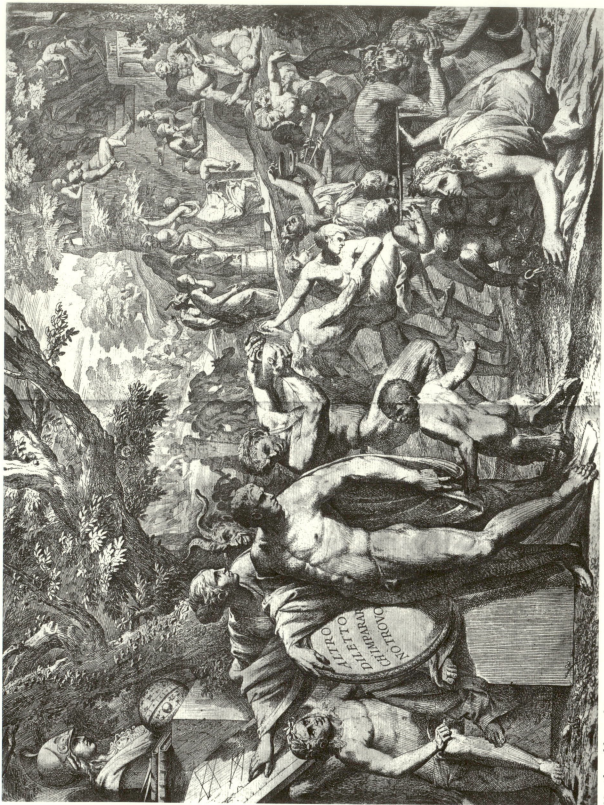

88. *Altro diletto ch'imparar non trovo*, Bartsch 32, Bellini 34

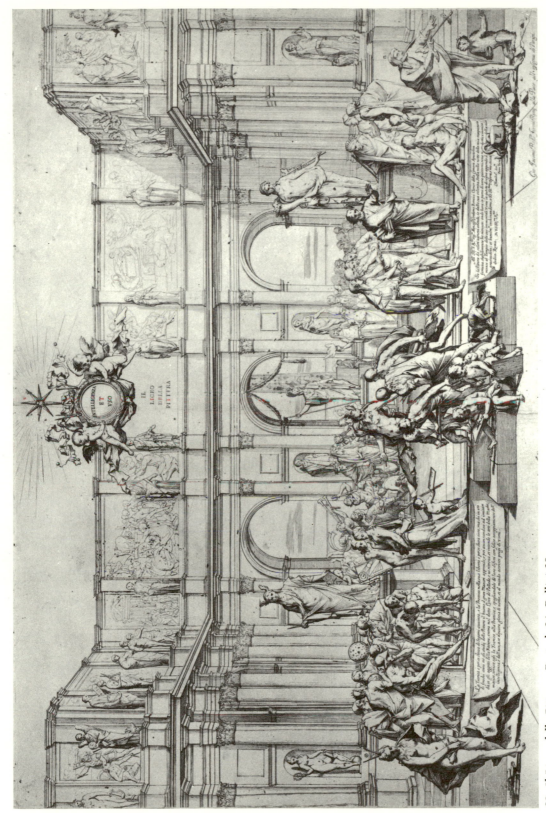

89. *Il Liceo della Pittura*, Bartsch 34, Bellini 20

90. *Filosofia secondo Boetio*, from
C. Ripa, *Iconologia*, Padua, 1625,
p. 234

91. Fragments of studies for *Il Liceo della Pittura*, Cabinet des Dessins, Musée du Louvre
Paris

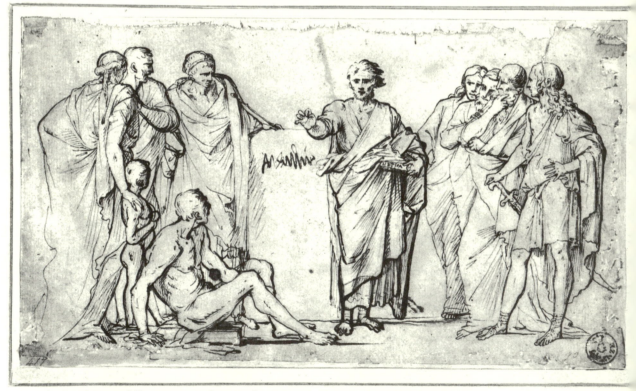

92. Study for *Il Liceo della Pittura*, Gabinetto dei Disegni, Gallerie degli Uffizi, Florence

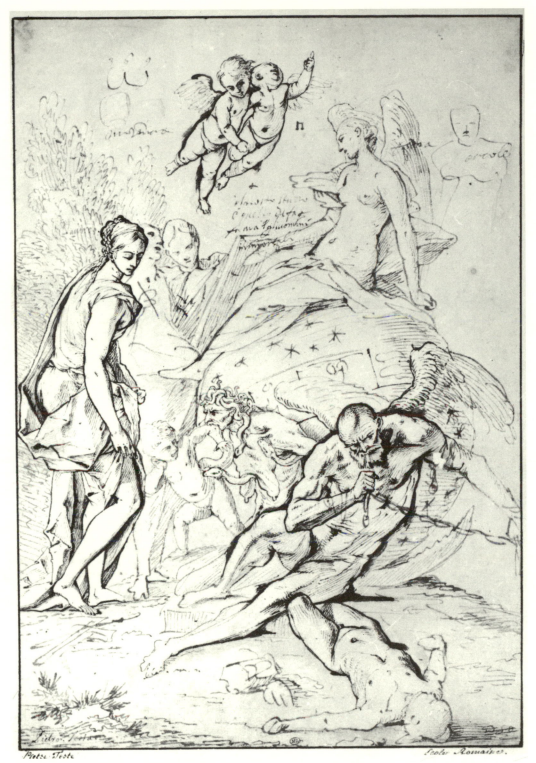

93. Study of *The Immortal Fame of the Arts Overcoming Time and Envy*, Cabinet des Dessins, Musée du Louvre, Paris

94. Diagram of the divisions of the soul, from B. Segni, *L'Ethica d'Aristotile*, Florence, 1550, p. 280

95. Diagram of *Potenza ragionevole*, from B. Segni, *L'Ethica d'Aristotile*, Florence, 1550, p. 290

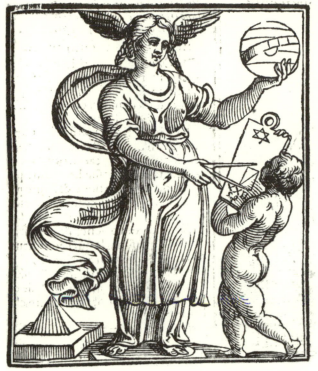

96. *Mattematica*, from C. Ripa, *Iconologia*, Padua, 1625, p. 410

97. *Prattica*, from C. Ripa, *Iconologia*, Padua, 1625, p. 522

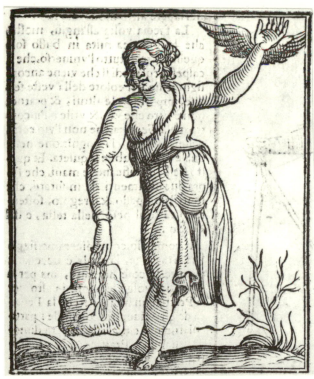

98. *Povertà in uno ch' habbia bell'ingegno*, from C. Ripa, *Iconologia*, Padua, 1625, p. 521

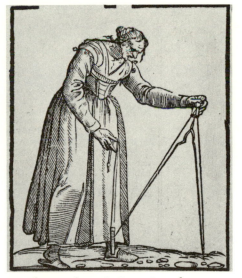

99. *Theoria*, from C. Ripa, *Iconologia*, Padua, 1625, p. 666

100. Study for *Il Liceo della Pittura*, British Museum, London

101. Study for *Il Liceo della Pittura*, National Gallery of Scotland, Edinburgh

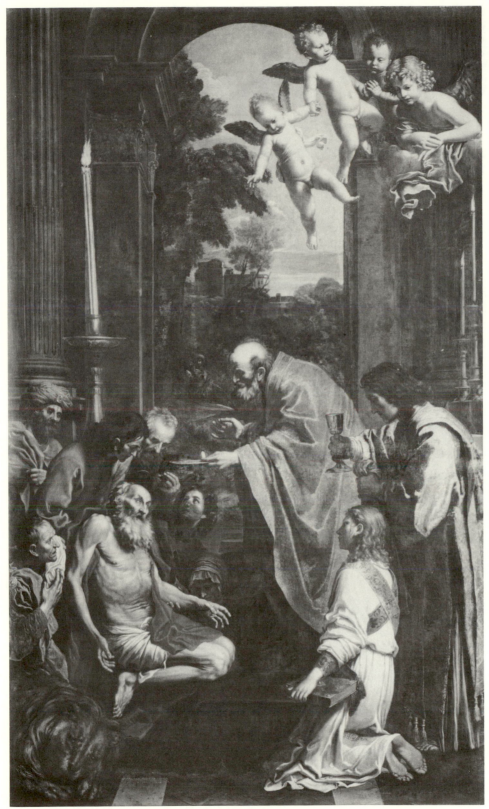

102. Domenichino, *The Last Communion of St. Jerome*, Pinacoteca Vaticana

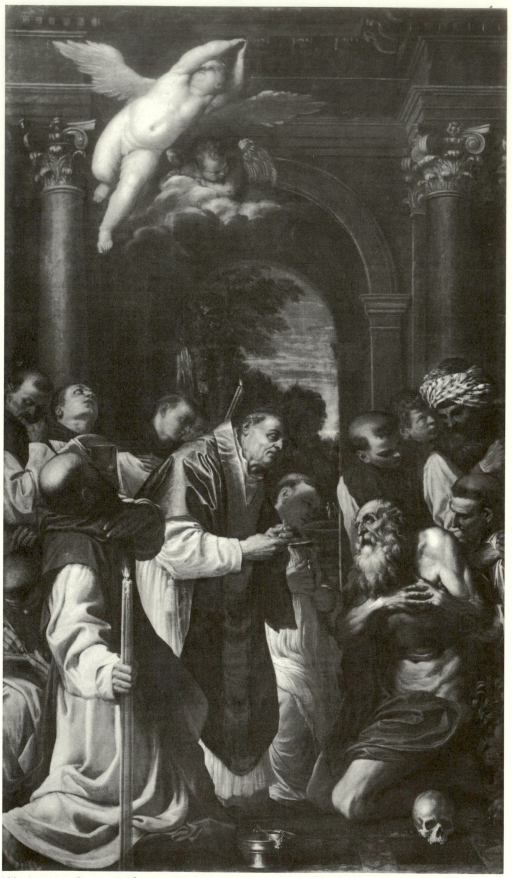

103. Agostino Carracci, *The Last Communion of St. Jerome*, Pinacoteca Nazionale, Bologna

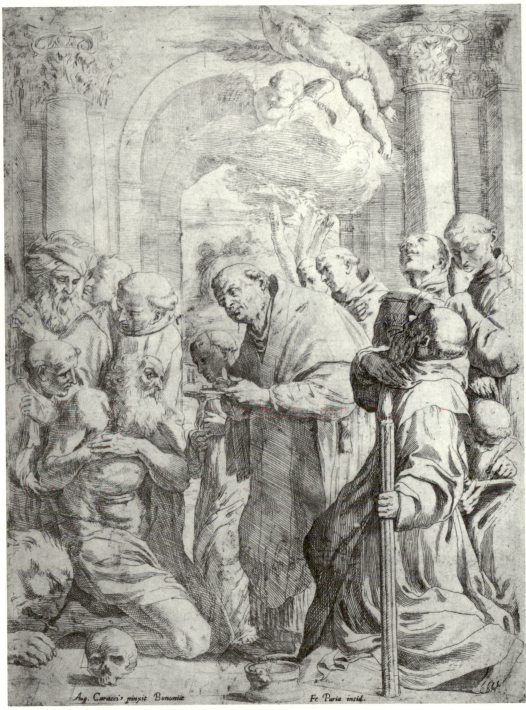

104. François Perrier, *The Last Communion of St. Jerome*, after Agostino Carracci, The Metropolitan Museum of Art, New York

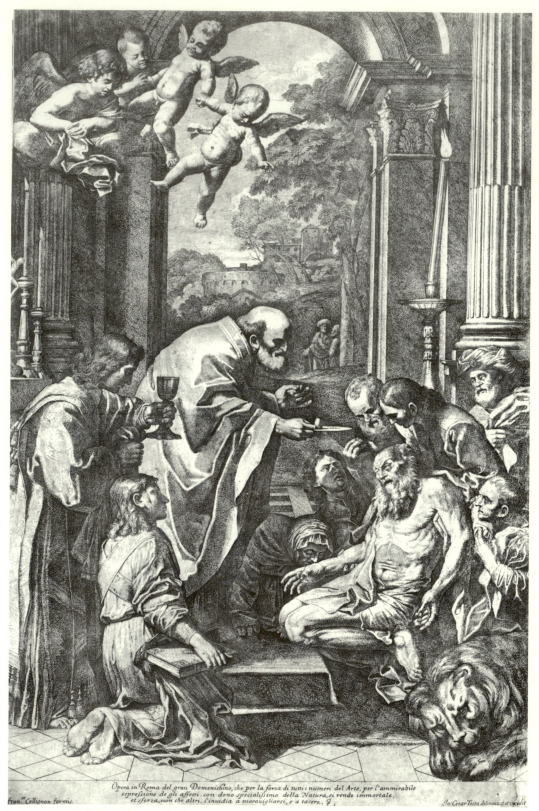

Opera in Roma del gran Domenichino, che per la forza di tutti i numeri del Arte, per l'ammirabile
espressione de gli affetti, con dono specialissimo della Natura, si rende immortale,
et sforza, non che altri, l'inuidia à marauigliarsi, e a tacere. 9,

fran.ᵉᵒ Collignon formis. Jo: Cesar Testa delineau:t et inculsit

105. Giovanni Cesare Testa, *The Last Communion of St. Jerome*, after Domenichino, The
Metropolitan Museum of Art, New York

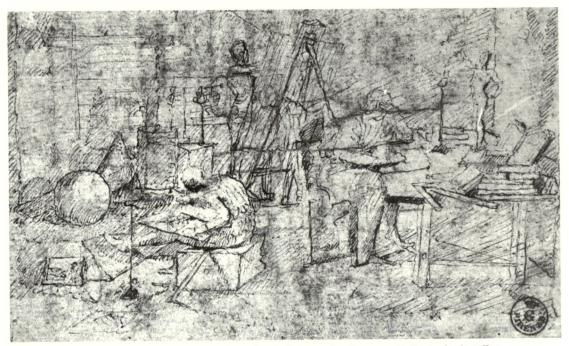

106. Nicolas Poussin, study of *The Artists' Studio*, Gabinetto dei Disegni, Gallerie degli Uffizi, Florence

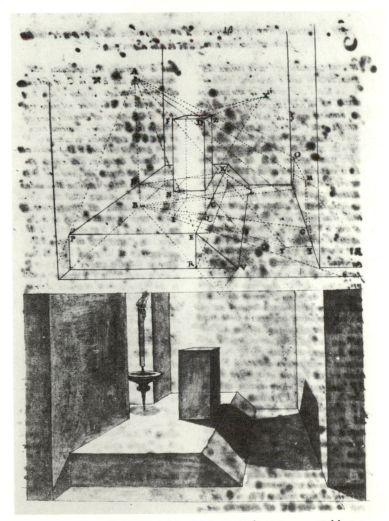

107. Matteo Zaccolini, MS Ashb. 1212, iv, Folio 13 verso, Biblioteca Laurenziana, Florence

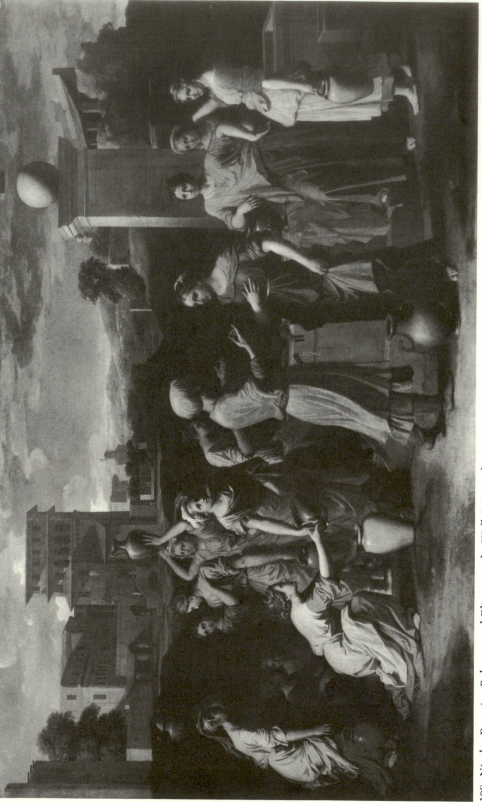

108. Nicolas Poussin, *Rebecca and Eliezer at the Well*, Musée du Louvre, Paris

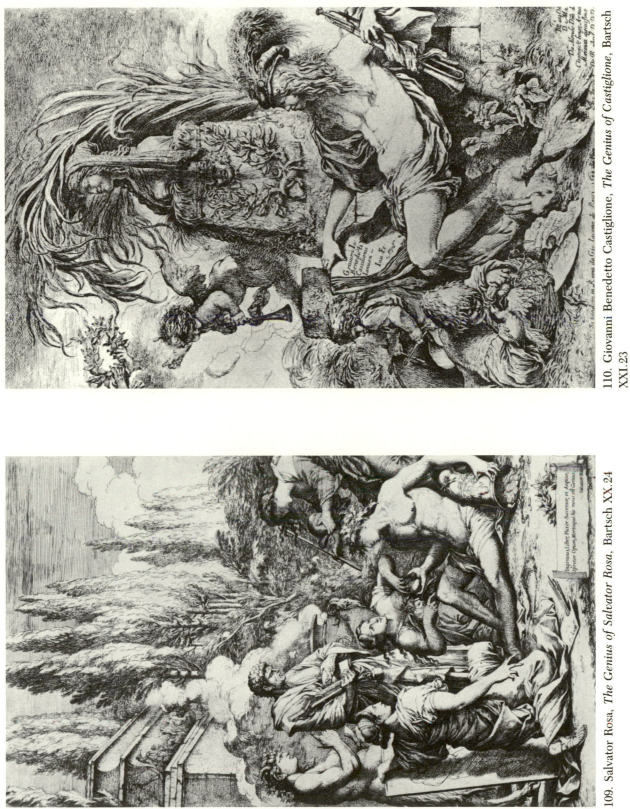

110. Giovanni Benedetto Castiglione, *The Genius of Castiglione*, Bartsch XXI.23

109. Salvator Rosa, *The Genius of Salvator Rosa*, Bartsch XX.24

111. *Pan*, from V. Cartari, *Le Imagini* . . . ,
Venice, 1580, p. 133

112. Study of *The Flight into Egypt*, Gabinetto dei Disegni, Gallerie degli Uffizi, Florence

113. Study for the decoration of the apse of S. Martino ai Monti, British Museum, London

114. Study of *The Victory of the Cross*, Graphische Sammlung
Albertina, Vienna

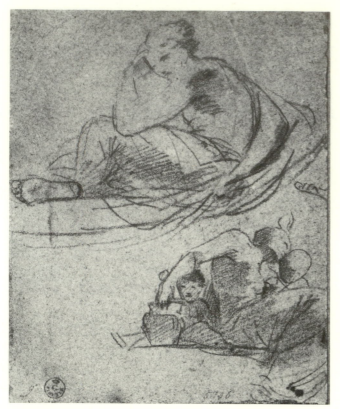

115. Figure studies, including Temperance, for the apse of
S. Martino ai Monti, Gabinetto dei Disegni, Gallerie degli
Uffizi, Florence

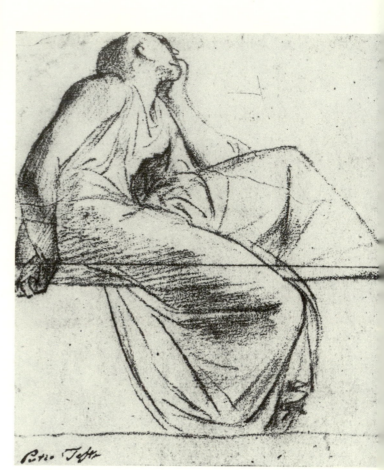

116. Figure study for the apse of S. Martino ai Monti, Stanza del Bor;
Milan

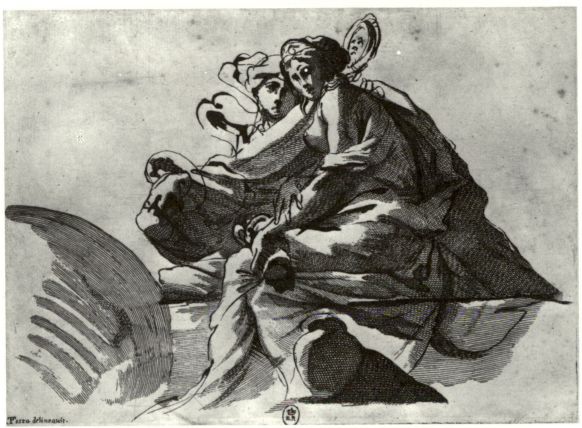

117. F. Collignon after a drawing by Pietro Testa, *Temperance and Prudence*, Bibliothèque Nationale, Paris

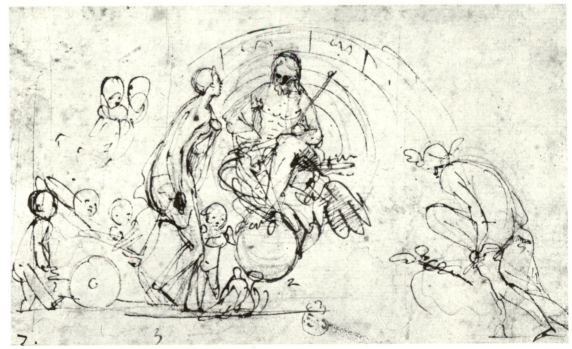

118. Study of *Venus before Jupiter*, Graphischen Sammlungen der Staatsgalerie, Stuttgart

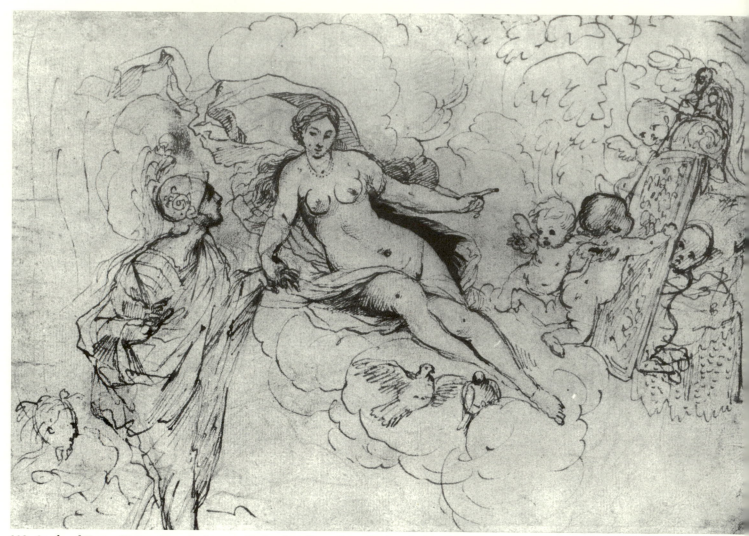

119. Study of *Venus Giving Arms to Aeneas*, National Gallery of Scotland, Edinburgh

Library of Congress Cataloging in Publication Data

Cropper, Elizabeth, 1944-
The ideal of painting.

Bibliography: p.
Includes index.
1. Painting—Early works to 1800. I. Testa, Pietro, 1612-1650.
II. Kunstmuseum Düsseldorf. III. Title.

ND1130.C76 1984 759.6 83-42595
ISBN 0-691-04021-4 (alk. paper)